D1172699

BOOKMAN'S GUIDE TO AMERICANA

9th edition

by
J. NORMAN HEARD
and
CHARLES F. HAMSA

The Scarecrow Press, Inc.
Metuchen, N.J., & London
1986

Library of Congress Cataloging-in-Publication Data

Heard, J. Norman (Joseph Norman), 1922–
 Bookman's guide to Americana.

 1. America--Bibliography--Catalogs. 2. Out-of-print
books--Bibliography--Catalogs. I. Hamsa, Charles F.
II. Title.
Z1207.H43 1986 [E18] 016.97 86-6467
ISBN 0-8108-1894-9

PREFACE

The first edition of Bookman's Guide to Americana was published in 1953. A second edition was published in 1960 and a third in 1964. Since that time five more editions have been published at intervals of three to five years. The first three editions were compiled by J. Norman Heard; the fourth and fifth by Robert Hamm; the sixth by J. Norman Heard and Jimmie H. Hoover; the seventh by Heard, Hoover, and Charles F. Hamsa; and the eighth by the senior editor following his retirement from university library employment. The present edition, probably the last for the senior compiler since he is writing a five-volume reference work on the American frontier, was prepared principally by Charles F. Hamsa.

The ninth edition, like its predecessors, is an alphabetically arranged compilation of quotations gleaned from out-of-print booksellers' catalogs. It is intended to provide the bookseller or book buyer with a record of prices asked for out-of-print titles in the broad field of Americana, including factual or fictional works relating to America or written by Americans. Reflecting the varied interests of the junior compiler, the edition devotes particular attention to books relating to the history, government, foreign relations, business and industry, and agriculture of all of the Americas.

In considering titles for inclusion the compilers have selected those believed to be of interest to libraries and collectors. These were offered for sale in catalogs issued since the last edition of Bookman's Guide was published. Many of these titles were listed in earlier editions, but there is no repetition of quotations from one edition to the next.

Bookman's Guide to Americana is not intended to be a bibliography, and the compilers have not hesitated to take liberties with bibliographic form. As economy of space is

iii

essential, abbreviations occur throughout the book. Long titles have been shortened and names of joint authors have been omitted. Physical condition of books is described as briefly as possible. Unless defects are described it should be assumed that books are sound internally and satisfactorily bound in some type of hard covers.

Every title has been checked in standard bibliographic sources, and none has been included that could not be identified (although some editions appear that could not be verified). Many errors were eliminated by careful checking, but in a work consisting of so much transcription it is inevitable that others remain. These will be corrected, it is hoped, in future editions.

The price data presented here should be interpreted carefully in terms of edition, date of publication, association interest, and condition of book. Some editions command high prices, while others are valueless. The price of a limited edition autographed by the author may vary greatly from that of the trade edition without association interest.

It should not be assumed that all quotations listed here are "in line" with prices other dealers would charge. It is believed, however, that a reasonably accurate estimate of the commercial value of most books can be made by consulting quotations listed in dealers' catalogs. This compilation should, therefore, assist the bookseller and book buyer in determining prevailing prices of books with American authors, subjects, or settings.

J. Norman Heard
Formerly Associate Director,
 Dupre Library
The University of Southwestern
 Louisiana

Charles F. Hamsa
Collection Development Bibli-
 ographer, Dupre Library
The University of Southwestern
 Louisiana
Lafayette, Louisiana

DIRECTORY OF BOOK DEALERS

Catalogs from the book dealers listed below have been examined in the preparation of this guide.

William H. Allen, Bookseller, 2031 Walnut Street, Philadelphia, PA 19103

Argonaut Book Shop, 786-792 Sutter Street, San Francisco, CA 94109

Austin Book Shop, 82-60A Austin Street, Kew Gardens, NY 11415

Bolerium Books, 2141 Mission, Suite 300, San Francisco, CA 94110

Andrew Cahan, Box 30202, Philadelphia, PA 19103

Canadiana House, Box 306, Station "F," Toronto, Ontario, Canada M4Y 2L7

Carry Back Books, Haverhill, NH 03765-0068

Arthur H. Clark Company, P.O. Box 230, Glendale, CA 91209

Paul Cook Antiquarian Books, 2943 NE 178th Street, Seattle, WA 98155

Cragsmoor Books, P.O. Box 66, Cragsmoor, NY 12420

Ken Crawford, Books, 2735 E. 18th Avenue, North St. Paul, MN 55109

Q.M. Dabney & Company, Inc., P.O. Box 42026, Washington, DC 20015

Jordan Davies Books, 356 Bowery, New York, NY 10012

Harold B. Diamond, Bookseller, Box 1193, Burbank, CA 91507

Bob Fein Books, 150 Fifth Avenue, New York, NY 10011

David H. Frid, P.O. Box 5266, San Pedro, CA 90733

Michael Ginsburg Books, Inc., Box 402, Sharon, MA 02067

Glenn Books, Inc., 1227 Baltimore, Kansas City, MO 64105

Goodspeed's Book Shop, Inc., 7 Beacon Street, Boston, MA 02108

Ideal Book Shop, 1125 Amsterdam Ave., New York, NY 10025

The Jenkins Company, Box 2085, Austin, TX 78768

J.A. Johnson, Box 16193, St. Paul, MN 55116

John Johnson, R.D. 2, North Bennington, VT 05257

Robert Loren Link, Booksellers, 1855 Wisconsin Avenue, Redding, CA 96001

T.N. Luther, Books, P.O. Box 6083, Shawnee Mission, KS 66206

M & S Rare Books, Inc., Box 311, Weston, MA 02193

George S. MacManus Company, 1317 Irving Street, Philadelphia, PA 19107

May and May, Ltd., Arundell House, Tisbury, Salisbury, SP3 6QU, England

Willis Monie, Books, R.D. 1, Box 336, Cooperstown, NY 13326

Edward Morrill & Son, Inc., 25 Kingston Street, Boston, MA 02111

O.P. Books, P.O. Box 78, Rylstone, N.S.W. 2849 Australia

Ohio Book Store, Inc., 726 Main Street, Cincinnati, OH 45202

David O'Neal, Antiquarian Booksellers, Inc., 263 Elmwood Hill Road, Peterborough, NH 03458

Pegasus Press/Books, P.O. Box 1350, Vashon Island, WA 98070

R. & A. Petrilla, Booksellers, Box 306, Roosevelt, NJ 08555

Phoenix Book Shop, 22 Jones Street, New York, NY 10014

The Rare Book Room, 125 Greenwich Avenue, New York, NY 10014

Frank E. Reynolds, Bookseller, P.O. Box 805, Newburyport, MA 01950

J.E. Reynolds, Bookseller, 3801 Ridgewood Road, Willits, CA 95490

Irene Rouse, Bookseller, 905 Duke Street, Alexandria, VA 22314

John Rybski, Bookseller, 2319 W. 47th Place, Chicago, IL 60609

Scholars' Bookstore, 310 Wilbrod Avenue, Ottawa, K1N 6M4, Canada

Strand Book Store, 828 Broadway, New York, NY 10003

Sylvester & Orphanos, P.O. Box 2567, Los Angeles, CA 90078

Talisman Press, P.O. Box 455, Georgetown, CA 95634

Western Hemisphere, P.O. Box 178, Stoughton, MA 02072

Wheldon & Wesley, Ltd., Lytton Lodge, Codicote, Huntchin, Herts. SG4 8TE, England

William P. Wreden, P.O. Box 56, Palo Alto, CA 94302

Clark Wright, Bookdealer, 409 Royal Street, Waxahachie, TX 75165

Zeitlin & Ver Brugge, Booksellers, P.O. Box 69600, Los Angeles, CA 90069-0600

John T. Zubal, Inc., 2969 W. 25th St., Cleveland, OH 44113

- A -

Aaron, Daniel--Men of Good Hope. N.Y., 1951. 1st ed. $10.00
--Writers on the Left.... N.Y., (1961). 1st ed. $15.00
Abbey, Henry--The Poems of.... N.Y., 1904. $25.00 (in-
 scribed by author, orig. cloth, bookplate)
Abbot, Joel--Trial of Lieutenant Joel Abbot.... Bost., 1822.
 1st ed. $35.00 (orig. boards, ex-lib., covers loose, lacks
 label)
Abbott, Allen O.--Prison Life in the South.... N.Y., 1865.
 1st ed. $12.50 (backstrip repaired)
Abbott, Charles Conrad--Ten Years' Diggings in Lenape
 Land.... Trenton, 1912. $85.00 (boards)
--Upland and Meadow. N.Y., 1886. $6.00
Abbott, Clayton--Missouri History in Cedar County. (Stock-
 ton, Mo., 1971). $15.00 (cover spotted)
Abbott, Edward Charles--We Pointed Them North. N.Y.,
 (1939). $65.00
 Norman (1971). $12.50
Abbott, John Stevens Cabot--The Life of General Ulysses S.
 Grant. Bost., 1868. 1st ed. $10.50
Abbott, Lawrence Fraser--The Story of Nylic. N.Y., 1930.
 $15.00
Abbott, Othman A.--Recollections of a Pioneer Lawyer. Lin-
 coln, 1929. $25.00, $10.00 (ink inscription on endpaper)
Abbott, Stephen G.--The First Regiment New Hampshire Vol-
 unteers in the Great Rebellion. Keene, 1890. $40.00
Abbott, Wilbur Cortez--Colonel John Scott of Long Island....
 New Haven, 1918. $22.50 (orig. boards)
Abel, Annie Heloise, ed.--Chardon's Journal....
 See: Chardon, Francis A.
--Tabeau's Narrative....
 See: Tabeau, Pierre Antoine
Abels, Jules--The Rockefeller Billions. N.Y., 1965. $15.00
--The Truman Scandals. Chi., 1956. $10.00
Abernathy, Francis Edward--J. Frank Dobie. Austin, (1967).
 $7.50

Abernethy, Thomas Perkins--Western Lands and the American
Revolution. N.Y., 1937. 1st ed. $17.50

Abert, James William--Western America in 1846-1847. (S.F.),
1966. $80.00 (one of 3000 copies), $72.50

The Aborigines of Minnesota. St. Paul, 1911. $375.00 (half
leather, spine heel scuffed)

About Cape Cod. (Bost., 1936). $12.50 (orig. boards, spine
chipped, front hinge cracking)

Abrams, Le Roy--Flora of Los Angeles and Vicinity. Stan-
ford, 1904. 1st ed. $17.50 (edges worn)

Ab-Sa-Ra-Ka, Home of the Crows
See: (Carrington, Margaret Irvin [Sullivant])

Acheson, Sam Hanna--35,000 Days in Texas. N.Y., 1938.
1st ed. $20.00 (1st printing)

Adair, Anna B.--Indian Trails to Tollways. N.p., 1968.
$17.50

Adair, James--The History of the American Indians. Lond.,
1775. 1st ed. $1,200.00 (leather and boards, lacks half-
title, small blind lib. stamps, rubbed)

Adair, John--The Navajo and Pueblo Silversmiths. Norman,
1946. $25.00 (cloth)
Norman, (1954). $7.50 (owner name)

Adams, Adeline Valentine Pond--John Quincy Adams. N.Y.,
1912. $25.00 (one of 1000 copies)

Adams, Alexander B.--Geronimo. N.Y., (1971). 1st ed.
$20.00

Adams, Andy--The Corporal Segundo. Austin, 1968. $45.00
(orig. boards, one of 750 numbered copies)

--The Log of a Cowboy. Garden City, (196-?). $7.50

--A Texas Matchmaker. Bost., 1904. 1st ed. $25.00 (orig.
cloth)

Adams, Ansel--An Introduction to Hawaii. S.F., (1964).
$20.00

--My Camera in the National Parks. Bost., 1950. $300.00
(signed by author)

Adams, Arthur T.--The Explorations of Pierre Esprit Radis-
son. Minne., 1961. 1st ed. $10.00

Adams, Ben--Hawaii, the Aloha State. N.Y., (1959). $12.50

Adams, Brooks--The Emancipation of Massachusetts. Bost.,
(1919). $25.00

Adams, Charles Francis--Charles Francis Adams, 1835-1915.
Bost., 1916. $12.00

--Trans-Atlantic Historical Solidarity. Oxford, 1913. $20.00
(worn)

Adams, Eleanor Burnham--A Bio-Bibliography of Franciscan

Authors in Colonial Central America. Wash., 1953. $7.50
(orig. cloth)
--Bishop Tamaron's Visitation of New Mexico, 1760
See: Tamaron y Romeral, Pedro
Adams, Ephraim, 1818--The Iowa Band. Bost., (1901).
$12.50
Adams, Ephraim Douglass, 1865--Great Britain and the Amer-
ican Civil War. Lond., 1925. 2 vols. 1st ed. $22.50
(cloth)
N.Y., (1957). 2 vols. in 1. $12.50
Adams, Frederick Upham--Conquest of the Tropics.... Gar-
den City, 1914. 1st ed. $12.50, $10.00
Adams, Hannah--A Summary History of New-England.... Ded-
ham, 1799. 1st ed. $375.00 (orig. calf)
Adams, Henry Brooks--The Degredation of the Democratic
Dogma. N.Y., 1929. $15.00
--Democracy, an American Novel. N.Y., 1880. 1st ed.
$50.00 (covers bit soiled, inscription on fly)
--The Great Secession Winter of 1860-61, and Other Essays.
N.Y., (1958). 1st ed. $25.00
--A Henry Adams Reader. Garden City, 1958. $10.00
--History of the U.S. N.Y., 1890-91. 9 vols. $195.00
--History of the U.S. During the Administration of Thomas
Jefferson.... N.Y., 1930. 9 vols. in 4. $75.00
--Letters of Henry Adams. Bost., 1938. $20.00
--Letters to a Niece and Prayer to the Virgin of Chartres.
Bost., 1920. $10.00
Adams, James N.--Illinois Place Names. N.p., 1968. 1st ed.
$20.00
Adams, James Truslow--The Adams Family. N.Y., (1930).
$15.00 (cloth), $10.95
--America's Tragedy. N.Y., 1934. 1st ed. $12.50
--Dictionary of American History. N.Y., 1940. 5 vols., and
index vol. $50.00
--History of the U.S. N.Y., 1933. 4 vols. $50.00 (ltd. ed.,
bookplates)
Adams, Joey--On the Road for Uncle Sam. (N.Y., 1963).
$10.00
Adams, John--The Adams Papers
See his Diary and Autobiography of John Adams
--A Defence of the Constitutions of Government of the U.S.A.
Phila., 1797. 3 vols. $450.00 (contemp. calf)
--Diary and Autobiography of John Adams. Camb., 1961. 4
vols. $100.00
--Legal Papers of.... Camb., 1965. 3 vols. $45.00

--The Selected Writings of John and John Quincy Adams.
N.Y., 1946. 1st ed. $15.00

Adams, John Quincy--An Eulogy; on the Life and Character of
James Monroe.... Bost., 1831. 1st ed. $15.00 (wraps.)

--The Lives of James Madison and James Monroe.... Bost.,
1850. 1st ed. $22.50 (edgewear)

--Memoirs of John Quincy Adams. Phila., 1874-77. 12 vols.
$250.00, $250.00 (cloth, ex-lib., some chipping)

Adams, Ramon Frederick--Charles M. Russell. Pasadena,
(1954). $45.00

--Come an' Get It! Norman, (1952). $27.00, $20.00 (1st
printing)

--The Cowman Says it Salty. Tucson, (1971). $20.00

--A Fitting Death for Billy the Kid. Norman, 1960. 1st ed.
$25.00

--From the Pecos to the Powder
See: Kennon, Bob

--The Old-Time Cowhand. N.Y., 1961. 1st ed. $25.00,
$20.00

--The Rampaging Herd. Norman, (1959). 1st ed. $195.00

--Six-Guns and Saddle Leather. Norman, (1954). 1st ed.
$65.00 (cloth)

--Western Words. Norman, 1944. 1st ed. $38.50 (front
cover lightly spotted), $15.00

Adams, Randolph Greenfield--British Headquarters Maps and
Sketches.... Ann Arbor, Mi., 1928. $25.00

Adams, Richard N.--Social Change in Latin America Today.
N.Y., (1960). 1st ed. $9.00

Adams, Samuel Hopkins--Incredible Era. Bost., 1939. $15.00

Adams, Sherman--Firsthand Report. N.Y., (1961). 1st ed.
$17.50 (cloth, signed by author), $12.50, $10.00

Adams, Walter--Monopoly in America. N.Y., (1955). $8.00

--The Structure of American Industry. N.Y., 1950. 1st ed.
$12.00

Adams, William Taylor--Brave Old Salt. Bost., (1894). $6.00

--The Soldier Boy. Bost., 1893. $10.00

Addams, Jane--Democracy and Social Ethics. N.Y., 1902.
$10.00 (cloth, mended, ex-lib.)

--Twenty Years at Hull-House. N.Y., 1911. $12.50

Addenbrooke, Alice B.--The Mistress of the Mansion. Palo
Alto, Ca., (1950). 1st ed. $7.50 (wraps., autographed
by author)

Ade, George--Chicago Stories. Chi., 1963. $17.50

Adleman, Robert H.--Alias Big Cherry. N.Y., 1973. $10.00

Adler, Jacob--Claus Spreckels.... Honolulu, 1966. 1st ed.
$20.00, $15.00

Adney, Edwin Tappan--The Bark Canoes and Skin Boats of
 North America. Wash., 1964. 1st ed. $45.00, $35.00,
 $25.00
Aflalo, Frederick George--Sunset Playgrounds. N.Y., 1909.
 $20.00
Africa, J. Simpson--History of Huntington and Blair Counties,
 Pennsylvania. Phila., 1883. 1st ed. $150.00 (rebound)
Agar, Herbert--The Price of Power. (Chi., 1957). $10.00
 (cloth, ex-lib.)
--Pursuit of Happiness. (Bost.), 1938. $15.00 (cloth)
--Who Owns America? Freeport, (1970). $10.00
Agassiz, Louis--The Intelligence of Louis Agassiz. Bost.,
 1963. $125.00 (boards)
Agatha, Sister--History of Houston Heights. Houston, 1956.
 $15.00
Agee, James--Permit Me Voyage. New Haven, 1934. 1st ed.
 $300.00 (owner name on front paste down)
The Agrarian Tradition in American Society. Knoxville,
 (1976?). $8.00
Aguirre, Lily--The Land of Eternal Spring. N.Y., (1949).
 $8.50
Ahern, Albert M.--Fur Facts. (S.L.), 1922. $10.00
Ahern, Patrick Henry--The Life of John J. Keane.... Mil-
 waukee, (1955). $10.00
Aiken, Conrad--Blue Voyage. N.Y., 1927. $75.00 (rebacked)
--The Clerk's Journal.... N.Y., 1971. $50.00 (cloth, signed
 and inscribed)
--The Coming Forth by Day of Osiris Jones. N.Y., 1931.
 $70.00 (1st state of this text, quite light wear)
--Conversation.... N.Y., 1940. 1st ed. $40.00 (cloth,
 signed and inscribed)
 Lond., 1940. $40.00 (name on front fly)
--Costumes by Eros. N.Y., 1928. $50.00 (rebacked, light
 chipping)
--Earth Triumphant and Other Tales in Verse. N.Y., 1914.
 $65.00 (light wear at spine)
--Great Circle. N.Y., 1933. $37.50 (piece missing from front
 panel)
--A Heart for the Gods of Mexico. Lond., 1939. $275.00
 (cloth)
--The Kid. N.Y., (1947). 1st ed. $50.00 (signed and in-
 scribed), $25.00 (cloth)
 Lond., 1947. $15.00 (cloth)
--King Coffin. N.Y., 1935. $50.00 (cloth, rebacked)
--Landscape West of Eden. Lond., 1934. $225.00 (boards,

copy inscribed by Aiken in year of publication), $55.00
(boards)
--A Letter From Li Po.... N.Y., 1955. 1st ed. $50.00
(cloth, signed and inscribed)
--Mr. Arcularis. Camb., 1957. $25.00 (cloth)
--The Morning Song of Lord Zero. N.Y., 1963. $20.00
(boards)
--Preludes for Memnon. N.Y., 1931. $75.00
--Priapus and the Pool and Other Poems. N.Y., 1925. $50.00
(signed and inscribed)
--A Reviewer's ABC. N.Y., 1958. $15.00 (cloth)
Lond., 1961. $10.00 (cloth)
--A Seizure of Limericks. (N.Y., 1964). 1st ed. $35.00
(signed and inscribed)
--Selected Letters of.... New Haven, 1978. $15.00 (boards)
--Selected Poems. N.Y., 1929. $50.00 (rebacked)
N.Y., 1931. $4.50 (cloth, binding dull and slightly worn)
N.Y., (1968). $30.00 (cloth, signed and inscribed)
--Skylight One.... N.Y., 1949. $20.00 (cloth)
--The Soldier. Norfolk, 1944. $30.00 (boards)
--Thee. N.Y., (1967). 1st ed. $75.00 (cloth, signed and
inscribed)
Lond., 1973. $50.00 (leather spine over cloth, one of
100 signed and numbered copies)
--Ushant. N.Y., 1971. $45.00 (cloth, signed and inscribed)
Aikman, Duncan--Calamity Jane and the Lady Wildcats. N.Y.,
(1927). 1st ed. $26.50, $25.00 (cloth)
--The Taming of the Frontier. N.Y., 1925. 1st ed. $27.50,
$17.50
Ainsworth, Edward Maddin--California. L.A., 1951. $16.50
(signed by author)
--The Cowboy in Art. N.Y., (1968). $250.00 (leather,
boxed, signed presentation copy of author's wife, one of
1000 copies), $30.00 (cloth, 1st printing)
--Golden Checkerboard. Palm Desert, (1965). $90.00
Ainsworth, Katherine--In the Shade of the Juniper Tree.
Garden City, 1970. $15.00, $10.00
Aiton, Arthur Scott--Antonio de Mendoza, First Viceroy of
New Spain. Durham, N.C., 1927. 1st ed. $20.00
Akers, Charles W.--Called Unto Liberty. Camb., 1964. $12.50
Alabama. Dept. of Archives and History--Revolutionary Sol-
diers in Alabama.
See under Title
Albaugh, William A.--Confederate Edged Weapons. N.Y., 1960.
$55.00

--Tyler, Texas, C.S.A. Harrisburg, (1958). 1st ed. $18.50

Albee, Edward--Tiny Alice. N.Y., 1965. $110.00 (cloth, signed)

Albee, Ruth Sutton--Alaska Challenge. Lond., (1943). $20.00 (cloth)

Alberts, Robert C.--The Golden Voyage. Bost., 1969. $12.50

--The Good Provider. Bost., 1973. $12.50

Albion, Robert Greenhalgh--The Rise of New York Port. N.Y., 1939. 1st ed. $25.00 (cloth, slight foxing)

Albrecht, Arthur Emil--International Seaman's Union of America. Wash., 1923. $12.00 (boards)

Albright, Horace Marden--"Oh, Ranger!" Stanford, 1928. 1st ed. $15.00 (cloth)

Album de Cartagena de Indias.... (Paris, n.d.). $20.00

Alcantara, Ruben R.--The Filipinos in Hawaii. Honolulu, 1977. $10.00

(Alcarez, Ramon)--Apuntes Para la Historia de la Guerra Entre Mexico y los Estados-Unidos. Mexico, 1848. 1st ed. $750.00 (contemp. calf)

--The Other Side. N.Y., 1970. $20.00

Alcocer, Ignacio--Apuntes Sobre la Antigua Mexico-Tenochitlan. Tacubaya, 1935. $65.00

Alcott, Amos Bronson--Concord Days. Bost., 1872. 1st ed. $15.00 (ex-lib.)

Alcott, Louisa May--Aunt Jo's Scrap-Bag: Shawl-Straps. Bost., 1872. 1st ed. $45.00 (orig. cloth, spine ends slightly frayed, inner hinges weak)

--Louisa May Alcott. Bost., 1891. $17.50

Aldana, Abelardo--Chile and the Chileans. Lond., 1910. $12.50 (morocco)

Alden, Carroll Storrs--Lawrence Kearny.... Princeton, 1936. $15.00 (presentation copy)

Alden, Dauril--Royal Government in Colonial Brazil. Berkeley, 1968. $18.00

Alden, John Richard--Pioneer America. N.Y., 1966. $12.50, $7.50

Aldrich, Lorenzo D.--A Journal of the Overland Route to California & the Gold Mines. L.A., 1950. $52.50 (boards)

Aldrich, Peleg Emory--Massachusetts and Maine.... Worcester, 1878. $7.50 (orig. wraps.)

Aldrich, Thomas Bailey--From Ponkapog to Pesth.... Bost., (1883). 1st ed. $7.50

--Pampinea, and Other Poems. N.Y., 1861. $25.00 (State A, bookplate, corners and edges slightly worn)

--Works. Bost., 1896. 8 vols. $65.00 (orig. cloth)

Aldridge, Reginald--Life on a Ranch. N.Y., 1966. $25.00

(orig. cloth, one of 750 copies)

Alegria, Ciro--El Mundo es Ancho y Ajeno. Santiago de Chile, 1941. $25.00 (sun-faded cloth, inscribed and signed)

Alemparte, Julio--El Cabildo en Chile Colonial. (Santiago de Chile), 1966. $15.00 (wraps.)

Alessio Robles, Vito--Francisco de Urdinola y el Norte de la Nueva Espana. Mexico, 1931. 1st ed. $150.00 (wraps. bound in)

Alexander, Charles C.--The Ku Klux Klan in the Southwest. Lexington, Ky., 1965. 1st ed. $25.00

(Alexander, Charles Wesley)--Poor Lizzie Lee. Phila., 1884. $32.50

Alexander, Edward Porter--Military Memoirs of a Confederate. N.Y., 1908. $25.00 (ex-lib.)

Alexander, Herbert E.--Financing the 1972 Election. Lexington, 1976. $20.00

Alexander, Holmes Moss--Aaron Burr, the Proud Pretender. N.Y., 1937. $12.50

--The American Talleyrand. N.Y., 1935. 1st ed. $20.00

Alexander, James Edward--Transatlantic Sketches.... Phila., 1833. $150.00 (full leather, mildly foxed, front panel somewhat stained, joints and extremities moderately worn)

Alexander, Richard Henry--The Diary and Narrative of.... Rich., B.C., (1973). $25.00 (orig. cloth, one of 500 numbered copies)

Alexander, Robert Jackson--The Peron Era. N.Y., 1951. 1st ed. $15.00 (cloth)

--Trotskyism in Latin America. Stanford, (1973). $7.00

Alexander, Thomas Benjamin--The Anatomy of the Confederate Congress. Nash., 1972. $17.50

Alfange, Dean--The Supreme Court and the National Will. Garden City, 1937. 1st ed. $7.50

Alford, Robert R.--Party and Society. Chi., (1963). $12.50

Alinsky, Saul David--Reveille for Radicals. Chi., (1946). 1st ed. $10.00

--Rules for Radicals. N.Y., 1971. 1st ed. $10.00

All About Alaska. S.F., 1888. $150.00

Allan, Iris Constance Sommerville--White Sioux. Sidney, B.C., (1969). $15.00 (review copy)

Allanson, George G.--Stirring Adventures of the Joseph R. Brown Family. Wheaton, Mn., (1947). $15.00

Allbeck, Willard Dow--A Century of Lutherans in Ohio. (Yellow Springs), 1966. $20.00, $15.00

Allen, Alexander Viets Griswold--Life and Letters of Phillips Brooks. N.Y., 1901. 3 vols. $40.00

Allen, Alice Benson--Simon Benson: Northwest Lumber King.
 Portland, 1971. $12.50
Allen, Catherine Blanche (Ward)--Chariot of the Sun. Denver,
 (1964). $12.50
Allen, Durward Leon--Our Wildlife Legacy. N.Y., (1954).
 1st ed. $7.50 (owner name)
Allen, Elizabeth--Sketches of Green Mountain Life. Lowell,
 1846. $12.50 (rubbed, covers partly stained)
Allen, Frederick James--The Shoe Industry. (Bost., 1916).
 1st ed. $30.00
Allen, Frederick Lewis--The Great Pierpont Morgan. N.Y.,
 1949. 1st ed. $10.00
--The Lords of Creation. N.Y., 1935. 1st ed. $10.00
--Only Yesterday. N.Y., 1931. 1st ed. $9.50
Allen, Gardner Weld--Commodore Hull
 See: Hull, Isaac
--Our Naval War With France. Bost., 1909. 1st ed. $15.00
 (bookplate), $10.00
--Our Navy and the Barbary Corsairs. Bost., 1905. 1st ed.
 $20.00 (bookplate, author's presentation pasted in)
Allen, Harrison--Monograph of the Bats of North America.
 Wash., 1864. $25.00 (wraps.)
Allen, Hervey--Sarah Simon.... Garden City, 1929. 1st ed.
 $35.00 (one of 311 signed copies, boxed)
Allen, Irene Taylor--Saga of Anderson. N.Y., 1957 (i.e.
 1958). 1st ed. $21.50
Allen, Ivan Earnest--Atlanta from the Ashes. Atlanta, 1928.
 $25.00 (ltd. ed., cloth)
Allen, James B.--The Company Town in the American West.
 Norman, (1966). $20.00
Allen, John Houghton--Southwest. Phila., (1952). 1st ed.
 $15.00 (advance presentation copy, signed by author)
Allen, John W.--Legends & Lore of Southern Illinois. Carbon-
 dale, 1963. 1st ed. $12.50
Allen, Jules Verne--Cowboy Lore. San Antonio, 1935. $20.00
 (some dampstaining)
Allen, Leslie Henri--Bryan and Darrow at Dayton. N.Y.,
 (1925). 1st ed. $27.50 (cloth)
Allen, Richard Sanders--Covered Bridges of the Northeast.
 Brattleboro, Vt., 1957. 1st ed. $15.00
Allen, Robert Porter--Birds of the Caribbean. N.Y., (1961).
 $30.00
--The Roseate Spoonbill. N.Y., 1942. 1st ed. $25.00
 (printed wraps.)
--The Whooping Crane. N.Y., 1952. $40.00 (printed wraps.)

Allen, Robert Sharon--Lucky Forward. N.Y., (1947). 1st ed.
$25.00

Allen, William Harvey--Woman's Part in Government, Whether
She Votes or Not. N.Y., 1912. $27.00

Allen, William R.--The Chequemegon.... N.Y., 1949. $20.00
(author's signed inscription)

Allen, William Wallace--California Gold Book. S.F., 1893. 1st
ed. $50.00 (bookplate)

Allende, Salvador--La Via Chilena Hacia el Socialismo (Madrid,
1971). 1st ed. $10.00 (wraps.)

Allende's Chile. N.Y., 1976. $12.50

Allhands, James Lewellyn--Gringo Builders. (Iowa City),
1931. 1st ed. $150.00 (cloth, cover wear and staining,
inscribed and signed)

--Uriah Lott. San Antonio, (1949). $30.00

Allinson, Edward Pease--Philadelphia 1681-1887. Phila., 1887.
$17.50

Allison, Charles Elmer--The History of Yonkers.... N.Y.,
1896. $60.00 (rebound in cloth, upper corner of first 60
pages slightly stained)

Allison, George William--With Christ in Kansas. Topeka,
(1934). $25.00 (orig. cloth)

Allison, Young Ewing--The Curious Legend of Louis Philippe
in Kentucky. Lou., 1924. $35.00 (wraps.)

Allred, Berten Wendell--Flat Top Ranch.... Norman, (1957).
$40.00

Allsop, Kenneth--The Bootleggers. New Rochelle, N.Y.,
(1968). $12.50

Allsopp, Fred William--Albert Pike. Little Rock, 1928. $65.00

Allston, Washington--Outlines & Sketches. Bost., 1850. 1st
ed. $300.00 (orig. cloth, rebacked)

Allyn, Joseph Pratt--The Arizona of.... Tucson, (1974).
$12.50

Allyn, Stanley C.--My Half Century With NCR. N.Y., (1967).
1st ed. $10.00

Almeida, Manuel Antonio de--Memoirs of a Militia Sergeant.
Wash., 1959. $7.50

Almon, John--A Collection of Interesting, Authentic Papers....
Lond., 1777. 1st ed. $150.00 (tree calf, spine head
chipped, lib. bind stamps)

Alter, J. Cecil--Early Utah Journalism. S.L.C., 1938. 1st
ed. $21.00 (wraps.)

--James Bridger, Trapper, Frontiersman, Scout and Guide....
Columbus, 1951. $65.00 (one of 1000 signed by author)

--Jim Bridger. Norman, 1962. $25.00, $10.00 (name on front
endpaper)

Altshuler, Alan A.--The City Planning Process. Ithaca, (1965). $15.00

Alvardo, Pedro de--An Account of the Conquest of Guatemala in 1524. N.Y., 1924. $100.00 (one of 250 numbered copies)

Alvarez, Ignacio--A Yaqui Easter Sermon. Tucson, 1955. 1st ed. $5.00

Alvarez, Raphael--Guia de Nueva York. N.Y., 1863. $200.00 (cloth, lacks map)

Alvarez, Walter Clement--Incurable Physician. Englewood Cliffs, (1963). $17.50

Alvarez Elizondo, Pedro--El Presidente Arevado y el Retorno a Bolivar. Mexico, (1947). $10.00 (owner stamp)

Alverson, Margaret Blake
 See: Alverson, Rosana Margaret (Kroh) Blake

Alverson, Rosana Margaret (Kroh) Blake--Sixty Years of California Song. Oakland, 1913. 1st ed. $28.00 (covers badly edge worn, backstrip partly detached)

Amado, Jorge--The Violent Land. N.Y., 1965. $10.00

Amaral, Anthony A.--Comanche, the Horse That Survived the Custer Massacre. L.A., 1961. 1st ed. $25.00

Ambler, Charles Henry--A History of Transportation in the Ohio Valley. Glendale, 1932. $75.00

--A History of West Virginia. Englewood Cliffs, 1933. $12.50 (ex-lib.)

Ambrose, Stephen E.--Upton and the Army. Baton Rouge, 1964. $20.00

American Bankers Association--The Commercial Banking Industry. Englewood Cliffs, 1962. $15.00

American Dredging Company--Four Times Panama. (Phila., 1967). $25.00

American Flange & Manufacturing Co., Inc.--The Story of Nellie Bly. (N.Y., 1951). $14.00

American Heritage--Texas and the War With Mexico.
 See: Downey, Fairfax Davis

The American Indian, 1926-1931. N.Y., 1970. 2 vols. $60.00 (one of 250 sets)

The American Legion and the Communists Discuss Democracy. N.Y., 1938. $15.00

The American Nation: a History, From Original Sources.... N.Y., 1905. 27 vols. $150.00
 N.Y., 1907-08. 27 vols. $500.00 (ltd. autographed ed. of 164 numbered copies, buckram)

An American Omnibus.... N.Y., (1933). $13.50

American Party. New York. New York (City).... Principles and Objects of the American Party.

See under Title

The American Revolution. Honolulu, 1977. $10.00

Ames, Azel--Sex in Industry. Bost., 1875. 1st ed. $75.00
(wear to extremities)

Ames, Herbert Brown--The City Below the Hill.... Toronto,
(1972). $15.00

Ammon, Harry--James Monroe. N.Y., (1971). $20.00

Amsden, Charles Avery--Navaho Weaving.... Chi., 1964.
$25.00

Amuchastegui, Axel--Studies of Birds and Mammals of South
America.... Lond., 1967. $22.00 (cloth)

Amunategui, Miguel Luis--La Dictadura de O'Higgins.... San-
tiago de Chile, 1914. $47.50 (stamp, scuffed)

Amundsen, Roald--Our Polar Flight. N.Y., 1925. $30.00

(Anburey, Thomas)--Travels Through the Interior Parts of
America. Lond., 1789. 2 vols. 1st ed. $650.00 (orig.
half calf)

Bost., 1923. 2 vols. $40.00 (boards, cover water-stained)

Ancient Hawaiian Civilization. Rutland, Vt., (1965). $24.00

Ancient Hunters of the Far West. (San Diego, Ca., 1966).
$30.00 (ltd. and numbered ed.)

Andersch Bros., Minneapolis, Minn.--Andersch Bros. Hunters
and Trappers Guide. (Minne.), 1906. $60.00 (cloth),
$30.00

Anderson, A.H.--A Brief Sketch of British Honduras. (Be-
lize), 1958. $8.00 (wraps.)

Anderson, Donald F.--William Howard Taft. Ithaca, (1973).
$25.00

Anderson, Edward--Camp Fire Stories. Chi., 1896. 1st ed.
$25.00

Anderson, Jack--McCarthy. Bost., (1952). $12.50

Anderson, James Arthur--Centennial History of Arkansas Meth-
odism.... Benton, Ark., 1935. $40.00 (cloth)

Anderson, John Q.--John C. Duval; First Texas Man of Let-
ters. Austin, (1967). $4.00 (orig. wraps.)

Anderson, Marion--My Lord, What a Morning. N.Y., 1956.
1st ed. $25.00 (owner's signature)

Anderson, Martin--The Federal Bulldozer. Camb., 1965.
$12.50

Anderson, Nels--Desert Saints. Chi., (1942). 1st ed.
$50.00
Chi., (1968). $15.00

Anderson, Robert--An Artillery Officer in the Mexican War....
N.Y., 1911. $30.00

Anderson, Rudolph E.--The Story of the American Automobile.
(Wash., 1950). 1st ed. $8.00

Anderson, Sherwood--Kit Brandon. N.Y., 1936. 1st ed.
$8.50 (cloth, slight wear, name on endpaper)
--Mid-American Chants. Highlands, N.C., 1964. $375.00
(spiral-bound wraps.)
--The Triumph of the Egg. N.Y., 1921. 1st ed. $15.00
Anderson, William Marshall--The Rocky Mountain Journals....
San Marino, 1967. $47.50
Andre, Alexander--A Frenchman at the California Trinity
River Mines in 1849. N.Y., 1957. $28.50 (wraps., one
of 300 numbered copies)
Andre, John--Andre's Journal.... Bost., 1903. 2 vols. 1st
ed. $450.00 (vellum, boxed, ltd. to 487 sets)
Andreae, Percy--The Prohibition Movement. Chi., (1915).
$17.50
Andreano, Ralph L.--The Economic Impact of the American
Civil War. Camb., 1962. $7.00 (boards)
Andreas, Alfred Theodore--History of the State of Kansas....
Chi., 1883. $125.00 (leather backed, title margins mended),
$100.00 (lacks state map, some chipping of edges of title
and prelim. pages without loss of text)
--History of the State of Nebraska. Chi., 1882. $125.00
(edges rubbed)
Andrews, Charles McLean--The Colonial Period of American
History. New Haven, 1934-38. 4 vols. $75.00
Andrews, Edward Deming--The People Called Shakers. N.Y.,
1953. 1st ed. $17.50
N.Y., (1963). $7.50 (wraps.)
Andrews, Israel Ward--Washington County and the Early Set-
tlement of Ohio. Cinci., 1877. $65.00 (wraps.)
Andrews, Kenneth Richmond--Nook Farm.... Camb., 1950.
1st ed. $16.50
Andrews, Matthew Page--The Founding of Maryland. Balt.,
1933. 1st ed. $42.50 (binding stained, hinges gashed)
--History of Maryland. Garden City, 1929. $25.00
--Tercentenary History of Maryland. Chi., 1925. 4 vols.
$150.00 (half leather)
Andrews, Ralph Warren--Historic Fires of the West. Seattle,
(1966). $15.00
--Redwood Classic. Seattle, (1958). $17.50
Andrews, Robert W.--The Life and Adventures of.... Bost.,
1887. $50.00 (wraps.)
Andrews, Wayne--Architecture, Ambition and Americans.
N.Y., (1955). 1st ed. $30.00
--Architecture in New England. Battleboro, Vt., (1973). 1st
ed. $20.00

--Battle for Chicago. N.Y., (1946). 1st ed. $15.00 (cloth, 1st printing)

--The Vanderbilt Legend. N.Y., (1941). $20.00

Andrist, Ralph K.--The Long Death. N.Y., (1964). 1st ed. $25.00

 N.Y., (1964). $20.00

Andros, Thomas--The Old Jersey Captive. Bost., 1833. 1st ed. $35.00 (old wraps.)

Anecdotes of the American Indians. N.Y., 1844. $25.00 (cloth, spine ends lightly worn)

(Angel, Myron)--History of Nevada. Berkeley, 1958. $65.00

Angle, Paul McClelland--Lincoln, 1854-1861. Springfield, Il., (1933). $20.00

--The Lincoln Reader. New Brunswick, N.J., 1947. 1st ed. $15.00 (cloth), $12.50

--A Pictorial History of the Civil War Years. N.Y., (1967). 1st ed. $15.00

--A Shelf of Lincoln Books. New Brunswick, 1946. 1st ed. $7.50

--Three Years in the Army of the Cumberland
 See: Connolly, James Austin

Angoff, Charles--A Literary History of the American People. N.Y., 1931. 2 vols. 1st ed. $12.50

Angus, Alexander D.--Old Quebec.... Montreal, 1949. $35.00 (cloth)

Anthony, Irving--Paddle Wheels and Pistols. Phila., (1929). $26.50

Anthony, Susan Brownell--Out of the Kitchen, Into the War. N.Y., 1943. 1st ed. $27.50

Anza, Juan Bautista--Colonel Juan Bautista de Anza.... (Santa Fe, 1918). $7.50 (d.j. information glued to half-title)

Apes, William--A Son of the Forest. N.Y., 1831. $60.00 (half leather, boards rubbed)

An Appeal for Clemency
 See: Pritt, Denis Nowell

Appel, Joseph Herbert--The Business Biography of John Wanamaker.... N.Y., 1930. $20.00, $15.00

Appelbaum, Richard P.--San Ildefonso Ixtahuacan, Guatemala. Guatemala City, 1967. $4.00 (wraps.)

Applegate, Frank Guy--Native Tales of New Mexico. Phila., (1932). $30.00 (owner name)

Appler, Augustus C.--The Younger Brothers. N.Y., 1955. $12.50

(Appleton, Elizabeth Haven)--Narrative of the Imprisonment

and Escape of Capt. Chas. H. Brown. Bost., 1854. $50.00
(orig. cloth, lightly foxed, chipped and frayed at extrem-
ities)

Appleton, Robert, pseud.
See: Zubof, Roman Ivanovitch

Appleton's Illustrated Hand-Book of American Travel. N.Y.,
1857. 1st ed. $45.00 (orig. cloth, binding lightly stained
and faded)

Apuntes Para la Historia de la Guerra Entre Mexico y los Es-
tados Unidos
See: (Alcarez, Ramon)

Arabs in America: Myths and Realities. Wilmette, Il., 1975.
$17.50

Archer, Gleason Leonard--On the Cuff. Bost., (1944). $10.00

Arciniega, Rosa--Don Pedro de Valdivia.... Santiago, (1943).
$20.00

Arciniegas, German--Caribbean, Sea of the New World. N.Y.,
1946. $30.00 (cloth), $12.50 (spine faded)

--Los Comuneros. Mexico, (1951). $15.00 (boards, spine base
torn)

--Este Pueblo de America. Mexico, (1945). 1st ed. $15.00
(owner signature)

--The Green Continent. N.Y., 1944. $12.50

--The Knight of El Dorado. N.Y., 1942. 1st ed. $12.50

--Latin America. N.Y., 1967. $11.00

Arevalo, Juan Jose--The Shark and the Sardines. N.Y.,
(1961). $12.50

Argo, William Vincent--No Place for Revenuers. N.Y., (1962).
$7.50

Armer, Laura (Adams)--Southwest. N.Y., 1935. $28.50 (au-
thor's presentation inscription), $10.00

--Waterless Mountain. N.Y., 1931. 1st ed. $21.00

Armes, Ethel Marie--The Story of Coal and Iron in Alabama.
Birmingham, 1910. $20.00

--Stratford Hall. 1936. $15.00

Armitage, George Thomas--Long Before Pearl Harbor. Hono-
lulu, 1945. 1st ed. $12.50

Armitage, Merle--Homage to the Santa Fe. Yucca Valley, Ca.,
(1973). $26.00

--Pagans, Conquistadores, Heroes and Martyrs. Santa Fe,
1960. $45.00 (orig. cloth, one of 1500 copies)

Armor, William Crawford--Lives of the Governors of Pennsyl-
vania.... Phila., 1872. 1st ed. $25.00

Armour, Jonathan Ogden--The Packers, the Private Car Lines,
and the People. Phila., 1906. 1st ed. $75.00 (orig. cloth,
inscribed by author), $40.00 (cloth, owner's signature)

Armstrong, Benjamin G.--Early Life Among the Indians. Ashland, Wis., 1892. 1st ed. $35.00

Armstrong, Edward, ed.--Correspondence Between William Penn....
See: Penn, William

Armstrong, Louise Van Voorhis--We Too Are the People. Bost., 1941. $12.50 (inscribed copy)

Armstrong, Moses Kimball--The Early Empire Builders of the Great West. St. Paul, Mn., 1901. 1st ed. $35.00, $31.50 (binding scarred), $12.50 (binding slightly spotted)

Armstrong, Orland Kay--Old Massa's People. Ind., (1931). $10.00

Armstrong, Perry A.--The Sauks and the Black Hawk War. Springfield, 1887. 1st ed. $110.00

Arndt, Walter Tallmadge--The Emancipation of the American City. N.Y., 1917. $14.00 (ex-lib.)

Arnold, Oren--Arizona Under the Sun. Freeport, (1968). $18.50

--Hot Irons; Heraldry of the Range. N.Y., 1940. 1st ed. $40.00

--Roundup of Western Literature. Dallas, (1949). $8.50

--Savage Son. Albuquerque, 1952. $20.00 (cloth)

--Sun in Your Eyes. Albuquerque, (1947). $20.00, $10.00, $7.50 (signed)

--Thunder in the Southwest. Norman, (1952). $26.50, $20.00

--Wild Life in the Southwest. Dallas, (1935). $22.00, $15.00 (bookplate)

Arnold, Ralph--The First Big Oil Hunt.... N.Y., 1960. $25.00 (owner stamp)

Arnow, Harriette Louisa (Simpson)--Flowering of the Cumberland. N.Y., 1963. $25.00

--Seedtime on the Cumberland. N.Y., 1960. 1st ed. $25.00

(Arthur, Timothy Shay)--The Little Pilgrims. Phila., 1843. $15.00 (orig. wraps., soiled and lightly worn)

--The Stolen Wife. Phila., 1843. $125.00 (foxed)

--Sweethearts and Wives. N.Y., 1843. 1st ed. $50.00 (orig. cloth)

Arthur Young & Company--Arthur Young and the Business He Founded. N.Y., 1948. $12.50

Artrip, Louise--Memoirs of the Late Daniel Fore (Jim) Chisholm.... (Booneville, Ark., 1959). $28.50 (signed)

Asbury, Herbert--The Barbary Coast. Garden City, 1933. $14.50

--Carry Nation. N.Y., 1929. $15.00

--The French Quarter. N.Y., 1936. 1st ed. $12.50

--The Great Illusion. Garden City, 1950. $12.50, $7.50
--Sucker's Progress. N.Y., 1938. 1st ed. $10.00
--Ye Olde Fire Laddies. N.Y., 1930. 1st ed. $35.00 (cloth)
Ashbery, John--Some Trees. New Haven, 1956. $165.00
 (cloth, signature of ownership of Kenneth Hanson)
Ashbrook, William S.--Fifty Years. Phila., 1915. $10.00
 (covers lightly soiled)
Ashby, LeRoy--The Spearless Leader. Urbana, (1972). $8.95
Ashe, Thomas--Travels in America Performed in 1806....
 Lond., 1808. $400.00 (orig. cloth)
Asher, Louis E.--Send No Money. Chi., 1942. $17.50
Ashford, Gerald--Spanish Texas. Austin, 1971. $15.00
Ashman, Charles R.--The Finest Judges Money Can Buy....
 L.A., (1973). $10.00
Ashmead, Henry Graham--Historical Sketch of Chester, on
 Delaware. Chester, 1883. 1st ed. $75.00 (orig. cloth)
--History of Delaware County, Pennsylvania. Phila., 1884.
 1st ed. $75.00 (some pages supplied in facs.)
--History of the Delaware National Bank. Chester, 1914.
 $12.50 (orig. cloth)
Ashton, Wendell J.--Voice in the West. N.Y., 1950. $20.00,
 $15.00 (name on endpaper)
Askins, Charles--Texans, Guns and History. N.Y., (1970).
 $10.00
The Assassination of Abraham Lincoln.... Wash., 1867.
 $150.00 (orig. morocco, two small tears on bottom blank
 portion of title, one of 100 copies for foreign distribution)
Asselineau, Roger--The Evolution of Walt Whitman. Camb.,
 1960-62. 2 vols. $30.00 (orig. boards)
Assher, Ben, pseud.--A Nomad in North America. Lond.,
 1927. $20.00 (spine faded)
Assuncao, Fernando O.--El Gaucho. Montevideo, 1963. $20.00
 (half calf, inscribed)
Astaire, Fred--Steps in Time. N.Y., (1959). 1st ed. $25.00
Aston, George--Secret Service. N.Y., 1930. $20.00
Astor, Brook--Patchwork Child. N.Y., (1962). 1st ed.
 $20.00 (signed presentation copy)
Athearn, Robert G.--Forts of the Upper Missouri. Englewood
 Cliffs, N.J., (1967). 1st ed. $15.00, $12.50
--High County Empire. N.Y., (1960). 1st ed. $17.50
--Soldier in the West
 See: Hough, Alfred Lacey
Atherton, Faxon Dean--California Diary.... S.F., 1964. 1st
 ed. $21.00
Atherton, Gertrude Franklin (Horn)--California, an Intimate
 History. N.Y., (1935). $15.00

--Golden Gate Country. N.Y., (1945). $10.00

Atherton, Lewis Eldon--The Cattle Kings. Bloomington, (1961). 1st ed. $20.00

--The Southern Country Store.... Baton Rouge, 1949. 1st ed. $20.00

Atherton, William Henry--Montreal, 1535-1914. Montreal, 1914. 3 vols. $100.00 (orig. three-quarter leather and cloth rubbed)

Atkins, Daisy--'Way Back Yonder.' El Paso, 1958. $17.50

Atkins, Gaius Glenn--History of American Congregationalism. Bost., 1942. $20.00

Atkinson, George Wesley--Prominent Men of West Virginia. Wheeling, 1890. $75.00

Atwater, Isaac--History of the City of Minneapolis.... N.Y., 1893. $125.00 (front hinge weak, some chipping of back-strip)

Atwood, A.--The Conquerors. Cinci., (1907). 1st ed. $25.00

Atwood, Wallace Walter--The Rocky Mountains. N.Y., (1945). $13.50, $12.50

Aubert de Gaspe, Phillippe--The Canadians of Old. Quebec, 1864. $90.00 (printed wraps., chipped and soiled, wants back wrap.)

Auchincloss, Louis--A World of Profit. Bost., 1968. 1st ed. $10.00 (cloth, signed)

Audubon, John James--Audubon and His Journals. N.Y., 1897. 2 vols. 1st ed. $95.00 (bookplates and shelf labels removed)

--Audubon's America. Bost., 1940. $95.00 (uncut fore and bottom edges, cloth, one of 3025 copies signed by editor, Donald C. Peattie), $20.00 (cloth), $15.00 (bookplate)

--The Birds of America. N.Y., 1937. $50.00 (bookplate) Lond., 1937. $66.00 (orig. buckram)

--Delineations of American Scenery and Character. N.Y., 1926. $44.00

--The Life of John James Audubon.... N.Y., 1869. $25.00, $25.00 (cloth, margins dampstained, spine ends torn, back-hinge starting)

--The Original Water-Color Paintings.... for Birds of America. N.Y., 1966. 2 vols. 1st ed. $125.00

--The Quadrupeds of North America. N.Y., 1849-51. 32 separate parts. $8,500.00 (orig. parts with printed wraps., some loose, one part stained, slipcased)

--N.Y., 1854-55. 3 vols. $5,500.00 (contemp. morocco, re-backed with orig. spines, boxed), $5,500.00 (orig. morocco,

covers of two vols. reattached, one plate newly inserted,
presentation copy)

Audubon, John Woodhouse--Audubon's Western Journal: 1849-
1850. Cleve., 1906. $225.00 (orig. cloth)

--The Drawings of.... S.F., 1957. $200.00 (one of 400 cop-
ies, bookplate), $110.00 (one of 400 copies, orig. cloth,
dampstaining)

Audubon, Lucy Green (Blakewell)--The Life of John James
Audubon, the Naturalist
See: Audubon, John James

Audubon, Maria Rebecca, ed.--Audubon and his Journals
See: Audubon, John James

Augur, Helen--An American Jezebel. N.Y., (1930). 1st ed.
$17.50 (backstrip darkened)

Aurand, Ammon Monroe--Historical Account of the Mollie Ma-
guires. Harrisburg, Pa., (1940). $10.00 (wraps.)

Auslander, Joseph--Cyclop's Eye. N.Y., (1926). $10.00

--Hell in Harness. Garden City, 1929. $15.00

--Letters to Women. N.Y., 1929. $13.00

Austin, H. Russell--The Wisconsin Story. Milwaukee, (1948).
$16.50

Austin, Jane Goodwin--Betty Alden. Bost., 1892. 1st ed.
$15.00

Austin, Mary Hunter--The Land of Little Rain. Bost., 1903.
1st ed. $100.00, $80.00, $25.00 (cloth, ex-lib. stamps)
Bost., 1904. $175.00 (orig. cloth, edges and spine lightly
worn, signed and inscribed)

--Starry Adventure. Bost., (1931). $12.50

Austin, Walter--A Forgotten Duel. Bost., 1914. $25.00
(orig. boards, presentation copy)

Automobile Club of Southern California--The Mother Lode of
California. N.p., 1963. $5.00

Avary, Myrta (Lockett)--Dixie After the War. Bost., 1937.
$27.50

--A Virginia Girl in the Civil War. N.Y., 1903. 1st ed.
$25.00

Averell, William Woods--Ten Years in the Saddle. San Rafael,
Ca., 1978. $25.00

Avery, Benjamin Parke--California Pictures in Prose and
Verse. N.Y., 1878. $37.50 (cloth, spine tip fray, book-
plate removed)

Avery, Elroy McKendree--A History of the U.S. and its Peo-
ple.... Cleve., 1904. 7 vols. $250.00

The Aves Island Case. Wash., 1861. 1st ed. $50.00 (cloth,
ex-lib.)

Avey, Elijah--The Capture and Execution of John Brown....
 Chi., (1906). 1st ed. $20.00 (cloth, front cover lightly
 dampstained), $12.50
Avila Martel, Alamiro de--Impresos Relativos a la Declaracion
 de la Independencia de Chile. Santiago, 1969. $20.00
Axelrad, Jacob--Patrick Henry, the Voice of Freedom. N.Y.,
 (1947). 1st ed. $10.00
Axford, Joseph--Around Western Campfires. N.Y., (1964).
 1st ed. $10.00
Ayer, Frederick--Before the Colors Fade. Bost., (1964).
 1st ed. $12.50
Azevedo, Aluizio--A Brazilian Tenement. N.Y., 1926. $10.00
Azevedo, Fernando de--Brazilian Culture. N.Y., (1950). 1st
 ed. $27.00

- B -

Babbit, Charles Henry--Early Days at Council Bluffs. Wash.,
 1916. 1st ed. $28.50
Babcock, Bernie Smade--The Daughter of a Republican. Chi.,
 1900. 1st ed. $13.50 (orig. wraps., slightly chipped)
Babcock, Glenn D.--History of the United States Rubber
 Company. (Bloomington, 1966). $15.00
Babcock, Willoughby--Selections From the Letters and Diaries
 of.... Albany, 1922. $12.50
Babson, Roger Ward--Our Campaign for the Presidency in
 1940. Chi., 1941. $15.00
Babst, Earl D.--Michigan and the Cleveland Era. Ann Arbor,
 1948. 1st ed. $5.50
Baca, Carlos C.--Vicente Silva. Palmer Lake, Co., 1978.
 $10.00
Bache, Richard Meade--American Wonderland. Phila., 1871.
 $25.00
Bache, William--Historical Sketches of Bristol Borough....
 Bristol, Pa., 1853. $85.00
Bacheller, Irving--Silas Strong. Lond., 1906. $35.00 (end-
 papers lightly browned)
Baciu, Stefan--Cortina de Ferro Sobre Cuba. Rio de Janeiro,
 1961. $15.00
Backman, Jules--The Economics of the Electrical Machinery
 Industry. N.Y., 1962. $12.50 (a bit bumped)
Backus, Isaac--Isaac Backus on Church, State, and Calvanism.
 Camb., 1968. $25.00 (orig. cloth)
Backus, Manson Franklin--Gold Horizon. Seattle, 1937. $21.50

Bade, William Frederic, ed.--The Cruise of the Corwin
 See: Muir, John
--Steep Trails
 See: Muir, John
Badlam, William H.--Kearsarge and Alabama. Prov., 1894.
 $7.50 (wraps. detached, one of 250 copies)
Baedeker, Karl, firm--The Dominion of Canada, with Newfound-
 land, and an Excursion to Alaska. Leipzig, 1900. $25.00
 (orig. card covers)
Baer, Kurt--Painting and Sculpture at Mission Santa Barbara.
 Wash., 1955. $10.00
Baez, Joan--Daybreak. N.Y., 1968. 1st ed. $20.00
Baeza Flores, Alberto--Haya de la Torre.... Buenos Aires,
 (1962). $12.50 (wraps., fore-edges foxed)
Bagley, Clarence Booth--The Acquisition and Pioneering of
 Old Oregon. Seattle, 1924. 1st ed. $125.00 (orig. wraps.)
Bagu, Sergio--El Plan Economico.... Rosario, Argentina, 1966.
 $15.00
Bailey, Dana Reed--History of Minnehaha County, South Dakota.
 Sioux Falls, 1899. $117.50 (leather, spine repaired)
Bailey, Emma--Sold to the Lady in the Green Hat. N.Y.,
 1962. $10.00
Bailey, Florence Augusta (Merriam)--My Summer in a Mormon
 Village. Bost., 1894. 1st ed. $15.00 (some cover wear)
Bailey, Francis Lee--The Defense Never Rests. N.Y., (1971).
 $8.00
Bailey, Hiram Percy--Shanghaied Out of 'Frisco in the 'Nine-
 ties. Bost., (1925). $20.00
Bailey, Hugh C.--John Williams Walker. University, Al.,
 (1964). $20.00
Bailey, Joseph Cannon--Seaman A. Knapp, Schoolmaster of
 American Agriculture. N.Y., 1945. 1st ed. $20.00
Bailey, Kenneth Kyle--Southern White Protestantism in the
 Twentieth Century. N.Y., 1964. 1st ed. $6.00
Bailey, Lynn Robison--Indian Slave Trade in the Southwest....
 Tucson, (1966). $12.50
Bailey, Paul Dayton--For Time and All Eternity. Garden City,
 1964. $12.50
--Grandpa Was a Polygamist. L.A., 1960. $38.50
--Jacob Hamblin, Buckskin Apostle. L.A., 1948. 1st ed.
 $60.00
 L.A., 1961. $35.00
--Sam Brannan and the California Mormons. L.A., (1953).
 $27.50
 L.A., (1959). $8.50

--Those Kings and Queens of Old Hawaii. Tucson, (1975). $21.50

Bailey, Pearl--The Raw Pearl. N.Y., (1968). 1st ed. $22.50

Bailey, Philip A.--Golden Mirages. N.Y., 1940. 1st ed. $37.50 (spine faded)
N.Y., 1944. $12.50 (ex-lib., wear at edges)

Bailey, Ralph Edward--An American Colossus. Bost., (1933). $10.00

Bailey, Thomas Andrew--Woodrow Wilson and the Great Betrayal. N.Y., 1945. 1st ed. $7.50

Bailie, William--Josiah Warren.... Bost., 1906. 1st ed. $15.00

Bailyn, Bernard--Education in the Forming of American Society.... Chapel Hill, 1960. $15.00

Bainbridge, John--Biography of an Idea. Garden City, 1963. $12.50

--Garbo. N.Y., 1971. $20.00

Baird, Charles W.--History of Rye.... N.Y., 1871. $50.00 (cloth, hinges starting, light foxing, lacks one plate, bookplate, owner's signature)

Baird, Robert--Impressions and Experiences of the West Indies and North America in 1849. Phila., 1850. $30.00 (rebacked)

Bakeless, John Edwin--Background to Glory.... Phila., 1957. $15.00

--The Eyes of Discovery.... Phila., (1950). 1st ed. $12.50

Bakenhus, Reuben Edwin--The Panama Canal.... N.Y., 1915. $17.50

Baker, Howard--A Letter From the Country and Other Poems. Norfolk, Ct., (1941). $17.50

Baker, Hozial H.--Overland Journey to Carson Valley & California. S.F., 1973. $75.00 (one of 450 copies)

Baker, Newton Diehl--Why We Went to War. N.Y., (1936). $18.00 (inscribed by author, bookplate)

Baker, Rachel (Mininberg)--The First Woman Doctor. N.Y., 1944. $17.00 (head of spine frayed)

Baker, Robert Andrew--The Blossoming Desert. Waco, (1970). $17.50

Baker, William Spohn--Itinerary of General Washington.... Phila., 1892. $25.00 (backstrip darkened and worn on top)

Balbontin, Manuel--La Invasion Americana 1846 a 1848. Mexico, 1883. $150.00 (new sheep, corners of a few leaves torn and mended, few losses supplied in pen facs.)

Balbuena, Bernardo de--Siglo de Oro en las Selvas de Erifile. Madrid, 1821. $150.00 (later calf, lacks frontis. portrait)

Balch, Thomas, 1821-1877--Letters and Papers Relating Chiefly
to the Provincial History of Pennsylvania.... Phila., 1855.
2 vols. 1st ed. $100.00 (three-quarter morocco, uncut,
bookplates)
Balch, Thomas Willing--The Alabama Arbitration. Phila., 1900.
1st ed. $12.50
--The Alaska Frontier. Phila., 1903. $35.00 (orig. cloth, ex-
lib.)
--The Cradle of Pennsylvania. Phila., 1921. $10.00 (orig.
cloth)
Baldridge, Michael--A Reminiscence of the Parker H. French
Expedition Through Texas & Mexico.... L.A., 1959.
$45.00 (boards, one of 300 numbered copies)
Baldrige, Letitia--Of Diamonds and Diplomats. Bost., 1968.
1st ed. $20.00 (signed presentation copy)
Baldwin, Christopher Columbus--Diary of.... 1829-1835. Wor-
cester, 1901. 1st ed. $35.00 (orig. cloth)
Baldwin, James--Giovanni's Room. Lond., 1957. $65.00
Baldwin, Leland Dewitt--Pittsburg. Pitts., 1937. 1st ed.
$15.00
--Whiskey Rebels. (Pitts.), 1939. 1st ed. $30.00, $27.50
Baldwin, Simeon Eben--Life and Letters of.... New Haven,
(1919). 1st ed. $20.00 (orig. cloth)
Balikci, Aspen--The Netsilik Eskimo. Garden City, 1970. $15.00
Balinky, Alexander--Albert Gallatin. New Brunswick, 1958.
$20.00
Ball, Eve--Maam Jones of the Pecos. Tucson, (1969). $25.00
--Ruidoso. San Antonio, (1963). $20.00
Ball, John McNickle--Reclaimed Rubber. N.Y., 1947. $10.00
Ball, Max Waite--This Fascinating Oil Business. Ind., 1965.
$12.50
Ball, Nicholas--The Pioneers of '49. Bost., 1891. 1st ed.
$53.50 (lower covers and few endleaves waterstained)
Ballantine, Bill--High West. Chi., (1969). $7.50
Ballantyne, Robert Michael--Hudson Bay. Lond., 1897.
$45.00 (small tear in cloth top back, corners rubbed)
--Snowflakes and Sunbeams. Bost., 1859. $75.00 (cloth,
worn along joints and extremities, owner's signature)
Ballard, Colin Robert--The Military Genius of Abraham Lincoln.
Lond., 1926. 1st ed. $50.00 (author's presentation to
Oliver R. Barrett)
Cleve., (1952). $15.00
N.Y., 1965. $7.50
Ballesteros, Tomas de--Tomo Primero de las Ordenenzas del
Peru. Lima, 1685. $525.00 (vellum, shaken, some damp-
staining, some worming not affecting text, lacks half-title)

Ballou, Adin--History of the Town of Milford, Worcester
County, Massachusetts. Bost., 1882. $150.00 (orig. cloth)
Ballou, Maturin Murray--History of Cuba. Bost., 1854. $12.50
(ex-lib. stamps)
--The Naval Officer. Bost., 1845. 1st ed. $65.00
--Red Rupert, the American Buccaneer. Bost., 1848. $60.00
(orig. wraps., some fraying)
Baltzell, Edward Digby--Philadelphia Gentlemen. Glencoe, Il.,
(1958). 1st ed. $6.50
Bancroft, Caroline--Gulch of Gold. Denver, 1958. $17.50
Bancroft, Frederic--The Life of William H. Seward. N.Y.,
1900. 2 vols. 1st ed. $30.00, $12.50 (ex-lib.)
Bancroft, George--History of the U.S.A., From the Discovery
of the Continent. N.Y., 1885-86. 6 vols. $175.00
--Memorial Address on the Life and Character of Abraham
Lincoln.... Wash., 1866. $50.00 (cloth, joints and ex-
tremities worn), $14.50
--Oliver Hazard Perry and the Battle of Lake Erie.... New-
port, 1912. $10.00 (orig. wraps.)
Bancroft, Hubert Howe--California Inter Pocula. S.F., 1888.
1st ed. $55.00 (half leather, light wear and chipping)
--History of California.... S.F., 1884-90. 7 vols. $280.00
--History of Central America., S.F., 1883. 3 vols. $150.00
(orig. sheep)
--History of Nevada.... S.F., 1890. $49.50
--History of Oregon.... S.F., 1886-88. 2 vols. $45.00
--History of the Life of Leland Stanford. Oakland, 1952.
$25.00 (one of 750 copies)
--Literary Industries. S.F., 1891. $37.50 (advertising circu-
lar laid in)
--The Native Races. S.F., 1883. 5 vols. $250.00 (buckram)
Bandel, Eugene--Frontier Life in the Army, 1854-1861. Phila.,
1974. $15.00
Bandelier, Adolph Francis Alphonse--An Outline of the Docu-
mentary History of the Zuni Tribe. Bost., 1892. 1st ed.
$100.00 (rebound, new cloth, some marginal water spots)
--The Southwestern Journals of.... Albuquerque, 1970.
$27.50
Bandini, Jose--A Description of California in 1828. Berkeley,
1951. 1st ed. $45.00 (one of 400 copies)
Banfield, Alexander William Francis--The Mammals of Canada.
Toronto, 1974. 1st ed. $22.50
Bang, Roy T.--Heroes Without Medals. Minden, Ne., 1952.
$55.00

Bangs, John Kendrick--In Camp With a Tin Soldier. N.Y.,
1892. 1st ed. $50.00 (orig. cloth, covers soiled, spine a
bit darkened, head and foot of spine slightly worn, owner
inscription on front endpaper)
--Jack and the Check Book. N.Y., 1911. $35.00 (orig.
cloth, edges and corners lightly worn, covers lightly soiled)
Bank of the Manhattan Company, New York--Early New-York
& the Bank of the Manhattan Company. (N.Y., 1920).
$12.50
Bankhead, Tallulah--Tallulah. N.Y., (1952). $10.00
Banks, Clinton Stanley--The New Texas Reader. San Antonio,
(1960). $12.00
--The Texas Reader. San Antonio. (1947). 1st ed. $20.00
Banks, Elizabeth L.--The Autobiography of a "Newspaper
Girl." N.Y., 1902. $18.00
Banning, William--Six Horses. N.Y., (1930). $50.00, $35.00,
$25.00 (newspaper clippings attached to endpapers), $12.50
Bannon, John Francis--Herbert Eugene Bolton: the Historian
and the Man. Tucson, 1978. $14.00
Banvard, John--Description of Banvard's Panorama of the Mis-
sissippi River. Bost., 1847. 1st ed. $250.00 (orig.
wraps.)
Barbara, Frederico--El Libro Alegre. Buenos Aires, 1877.
$42.50 (crude one-quarter cloth)
Barbarities of the Enemy, Exposed in a Report.... Troy,
1813. $37.00 (some pages and cover dampstained, lacks
blank leaves before title)
Barbe-Marbois, Francois--The History of Louisiana.... Phila.,
1830. $400.00 (orig. boards neatly rebacked, scattered
foxing)
--Our Revolutionary Forefathers. N.Y., 1929. $12.50
Barbeau, Charles Marius--Indian Days in the Canadian Rockies.
Toronto, 1923. 1st ed. $45.00 (water stain along outer
edge of some leaves, covers worn, back hinge cracked),
$30.00 (some wear)
Barber, Edwin Atlee--American Glassware Old and New. Phila.,
(1900). $15.00 (ex-lib.)
Barber, John Warner--The History and Antiquities of New
England, New York, and New Jersey.... Worcester, 1841.
1st ed. $50.00 (contemp. calf, map repaired, blank edges
of four pages ragged)
--The Loyal West in the Times of the Rebellion. Cinci., 1865.
$25.00 (backstrip worn and crudely taped)
Barber, Joseph--Good Fences Make Good Neighbors. Ind.,
(1958). 1st ed. $7.50

--Hawaii. Ind., (1941). $18.00, $10.00 (spot on spine)

Barbour, Philip Norbourne--Journals.... N.Y., etc., 1936.
$27.50 (orig. cloth, uncut, one of 1000 numbered and
signed copies), $25.00 (one of 1000 signed by editor,
slightly worn cloth, owner signature)

Barbour, Thomas--A Naturalist in Cuba. Bost., 1945. $8.00

--A Naturalist's Scrapbook. Camb., 1946. $7.50

--That Vanishing Eden.... Bost., 1944. 1st ed. $10.00

Barcena, Jose Maria Roa
See: Roa Barcena, Jose Maria

Barcia Carballido y Zuniga, Andres Gonzalez de--Chronological
History of the Continent of Florida.... Gainesville, 1951.
$85.00

Bard, Floyd C.--Horse Wrangler. Norman, (1960). $17.50
(owner name)

Bard, Samuel A., pseud.
See: (Squire, Ephraim George)

Bari, Valeska--Course of Empire. N.Y., 1931. $27.50

Baringer, William Eldon--A House Dividing. Springfield, 1945.
$17.50

--Lincoln's Vandalia. New Brunswick, 1949. 1st ed. $12.50

Barker, Benjamin--Francisco, or the Pirate of the Pacific.
Bost., 1845. $85.00 (orig. wraps., front wrap. frayed,
back wrap torn, margins torn)

Barker, Charles Edwin--With President Taft in the White House.
Chi., 1947. $20.00

Barker, Charles R.--Philadelphia in the Late Forties....
Phila., 1931. $7.50

Barker, Elliott Speer--When the Dogs Bark 'Treed.' Albuquer-
que, 1946. 1st ed. $15.00 (inscribed copy, ex-lib.)

Barker, Eugene Campbell--Lester Gladstone Bugbee
See under Title

Barker, Rowland--The Night They Raided Minsky's. N.Y.,
1960. $10.00

Barker, Ruth Laughlin
See: Laughlin, Ruth

Barkley, Alben William--That Reminds Me. Garden City, 1954.
$10.00

Barler, Miles--Early Days in Llano. (N.p., 1915?). $75.00
(wraps.)

Barlow, Joel--The Columbiad, a Poem. Phila., 1807. 1st ed.
$125.00 (contemp. calf, very worn, spine part missing,
light foxing)

--The Vision of Columbus. Hart., 1787. 1st ed. $75.00
(contemp. calf, lightly rubbed, lightly foxed)

Barnard, Evan G.--A Rider of the Cherokee Strip. Bost.,
 1936. $42.50 (covers lightly soiled)
Barnard, Harry--The Forging of an American Jew. N.Y.,
 (1974). $12.50
--Independent Man. N.Y., (1958). $10.00
Barneby, William Henry--Life and Labour in the Far, Far West.
 Lond., 1884. 1st ed. $47.50 (author's presentation copy,
 inner hinges cracked)
Barnes, Harry Elmer--Perpetual War for Perpetual Peace.
 Caldwell, 1953. $20.00
Barnes, William Croft--Apaches & Longhorns. L.A., 1941.
 1st ed. $60.00
--Arizona Place Names. Tucson, 1935. $25.00 (slightly soiled
 and worn wraps., title page torn and partially detached,
 writing on front cover and spine)
Barnes, William Wright--The Southern Baptist Convention....
 Nash., (1954). $20.00 (ex-lib.)
Barnett, Homer Garner--Indian Shakers. Carbondale, 1957.
 1st ed. $25.00
Barney, Libeus--Letters of the Pike's Peak Gold Rush....
 San Jose, 1959. $23.50 (one of 975 copies)
Barney, Ralph A.--Laws Relating to the Osage Tribe of In-
 dians.... Pawhuska. Ok., 1929. 1st ed. $75.00
Barnhart, John Donald, ed.--Henry Hamilton and George Rog-
 ers Clark in the American Revolution. Crawfordsville, In.,
 1951. 1st ed. $35.00 (half cloth, ltd. to 800 copies)
Barnitz, Albert Trovillo Siders--Life in Custer's Cavalry.
 New Haven, 1977. $15.00
Barns, George C.--Denver, the Man.... Wilmington, Oh.,
 1949. 1st ed. $15.00
Barnum, Frances Courtenay (Baylor)--Behind the Blue Ridge.
 Phila., 1887. $12.00
Barnum, Phineas Taylor--The Life of.... N.Y., 1855. $75.00
 (minor shelf wear and staining)
 Lond., 1855. $25.00 (light foxing, rebacked, worn along
 extremities)
--Struggles and Triumphs. N.Y., 1871. $25.00 (lacks blank
 leaves at end)
 Buffalo, 1872. $36.00 (backstrip faded)
 Buffalo, 1873. $37.50
 Buffalo, 1889. $75.00 (morocco, minor shelf wear)
 N.Y., 1927. 2 vols. $30.00 (cloth)
Barra, Ezekiel I.--A Tale of Two Oceans. S.F., 1893. 1st ed.
 $125.00 (orig. wraps., spine a bit chipped)

Barreda y Laos, Felipe--General Tomas Guido.... Buenos
Aires, 1942. 1st ed. $16.00 (wraps., foxing inscribed)

Barrett, J. Allen--Lykens-Williams Valley History.... (Har-
risburg, 1922). $37.50

Barrett, Patricia--Religious Liberty and the American Presi-
dency. (N.Y., 1963). $10.00

Barringer, Edwin Charles--The Story of Scrap. Wash.,
(1947). $16.00, $10.00

Barringer, Emily Dunning--Bowery to Bellevue. N.Y., 1950.
1st ed. $12.50

Barron, Clarence Walker--The Mexican Problem. N.Y., 1917.
$12.50

Barros Arana, Diego--Un Decenio de la Historia de Chile....
Santiago de Chile, 1905. 2 vols. 1st ed. $90.00 (covers
lightly bumped and chipped)

Barrows, John R.--Ubet. Caldwell, 1934. 1st ed. $25.00
(cloth, somewhat rubbed, owner's signature)

Barrus, Clara--The Life and Letters of John Burroughs.
Bost., 1925. 2 vols. 1st ed. $40.00 (bookplate)

Barry, Theodore Augustus--Men and Memories of San Fran-
cisco.... S.F., 1873. 1st ed. $100.00 (light wear to ex-
tremities)

--San Francisco, California 1850. Oakland, 1947. $75.00
(boards, rear endleaf browned)

Barrymore, Lionel--We Barrymores. N.Y., (1951). $10.00

Barth, John--Lost in the Funhouse. Garden City, 1968.
$125.00 (cloth, one of 250 signed copies)

--The Sot-Weed Factor. Garden City, 1960. 1st ed. $150.00
(cloth), $100.00 (cloth and boards, name on endpaper)
N.Y., 1966. $8.50 (stiff wraps.)

Bartholdt, Richard--From Steerage to Congress. Phila.,
(1930). $10.00

Bartholomew, Ed Ellsworth--Jesse Evans, a Texas Hide-Burner.
Houston, 1955. 1st ed. $15.00 (autographed by author)

--Wyatt Earp. 2 vols. 1st ed. Toyahvale, Tx., 1963-64.
$40.00 (vol. 1 autographed by author)

Bartlett, John Russell--Personal Narrative of Explorations and
Incidents.... N.Y., 1854. 2 vols. 1st ed. $600.00
(orig. cloth, neatly rebacked, occasional light foxing),
$600.00 (cloth, a bit worn along joints and extremities,
hinges cracked, bookplates, mild foxing)
Chi., (1965). 2 vols. $50.00, $45.00 (bookplates)

Bartlett, Lanier, ed.--On the Old West Coast
See: Bell, Horace

Barton, Albert Olaus--La Follette's Winning of Wisconsin.
Madison, 1922. $10.50

Barton, Clara--The Red Cross. Wash., 1898. 1st ed. $20.00

Barton, George--Walks and Talks About Old Philadelphia.
Phila., (1928). $10.00

Barton, O.S., comp.--Three Years With Quantrell.
See: McCorkle, John

Barton, William Eleazar--The Women Lincoln Loved. Ind.,
(1927). $17.50

Bartram, William--Travels Through North and South Carolina,
East and West Florida.... Lond., 1794. $1000.00 (later
full morocco)

Baruch, Bernard Mannes--Baruch. N.Y., 1957-60. 2 vols.
$15.00

Basadre, Jorge--El Condede Lemos y su Tiempo. Lima,
(1945). 1st ed. $14.00 (wraps.)

--Historia de la Republica del Peru. Lima, (1946). 2 vols.
$27.50 (wraps. dog-eared)

Basch, Samuel Siegfried Karl--Memories of Mexico. San An-
tonio, (1973). $11.00

Baskin, Robert Newton--Reminiscences of Early Utah. (S.L.C.),
1914. 1st ed. $45.00

Bass, Robert Duncan--Gamecock. N.Y., (1961). $12.50

Bass, Sophie Frye--Pig-Tail Days in Old Seattle. Portland,
1973. $7.50

Bassett, John Spencer--The Middle Group of American Histo-
rians. N.Y., 1917. $20.00

Basso, Hamilton--Beauregard, the Great Creole. N.Y.,
(1933). $15.00

The Bastile in America. Lond., 1861. $6.00

Bateman, James--The Orchidaceae of Mexico and Guatemala.
N.Y., 1974. $240.00 (cloth)

Bates, Charles Francis--Custer's Indian Battles. Bronxville,
N.Y., (1936). $35.00 (signed), $35.00, $25.00 (orig.
wraps.)

--Westchester-Hudson River-West Point. N.Y., (1926).
$30.00

Bates, D.B., Mrs.--Incidents on Land and Water. Bost.,
1858. $35.00 (loose in binding, foxed, edge chipping and
wear)

Bates, Daisy (Gaston)--The Long Shadow of Little Rock, a
Memoir. N.Y., 1962. $25.00

Bates, Edward--The Diary of.... Wash., 1933. $22.50

Bates, Henry Walter--The Naturalist on the River Amazons....
Lond., 1892. $51.00 (cloth)

Bates, James Hale--Notes of a Tour in Mexico and California.
N.Y., 1887. $175.00 (orig. cloth, light binding wear)

Bates, Samuel Penniman--Our County and its People. Bost.,
1899. $150.00 (rebound)

Battine, Cecil William--The Crisis of the Confederacy. Lond.,
1905. $125.00

Battle, J.H.--History of Bucks County, Pennsylvania. Phila.,
1887. $75.00 (some pages supplied in facs.)

--History of Columbia and Montour Counties. Chi., 1887.
1st ed. $165.00 (three-quarter leather)

Battle Monument Association, West Point--History of the Battle
Monument....
See: Larned, Charles W.

Batty, Beatrice (Stebbing)--Forty-Two Years Amongst the
Indians and Eskimo. Lond., 1893. 1st ed. $75.00 (orig.
cloth)

Batty, Joseph--Over the Wilds to California.... Leeds, 1867.
1st ed. $475.00 (orig. cloth, spine restored)

Bauer, Arnold J.--Chilean Rural Society.... Camb., 1975.
$18.00

Bauer, Helen--Hawaii.... Garden City, 1960. $12.00

Bauer, Raymond Augustine--Advertising in America. Camb.,
1968. 1st ed. $15.00

Bauersfeld, Marjorie Edith (O'Neill)--Tales of the Early Days....
Hollywood, (1938). $25.00 (author's presentation, cloth)

Baughman, Robert William--Kansas in Maps. Topeka, 1961.
$50.00 (buckram)

Baumann, Hans--Gold and Gods of Peru. (N.Y., 1963).
$15.00

Baumann, John--Old Man Crow's Boys.... N.Y., 1948.
$12.50

Baumhoff, Richard G.--The Dammed Missouri Valley. N.Y.,
1951. $22.50

Bausman, Joseph Henderson--History of Beaver County, Penn-
sylvania.... N.Y., 1904. 2 vols. 1st ed. $150.00

Bayard, Ralph Francis--Lone-star Vanguard; the Catholic Re-
Occupation of Texas. S.L., 1945. $40.00

Bayer, Henry G.--The Belgians, First Settlers in New York....
N.Y., 1925. $17.50 (binding dampstained)

Bayh, Birch Evans--One Heartbeat Away. Ind., (1968).
$12.50

Baylies, Francis--A Narrative of Major General Wool's Cam-
paign in Mexico.... Albany, 1851. 1st ed. $250.00
(wraps., small piece lacking from spine, stain along top
edge, mild foxing), $225.00 (orig. printed wraps.)
Austin, 1975. $12.50

Baylor, Francis Courtenay
 See: Barnum, Frances Courtenay (Baylor)
Baylor, George--Bull Run to Bull Run. Rich., 1900. 1st ed.
 $50.00
Beach, Allen C.--The Centennial Celebrations of the State of
 New York. Albany, 1879. $25.00 (half leather, dampstain-
 ing on few leaves; some pages torn)
Beach, Joseph Warren--American Fiction.... N.Y., 1942.
 $10.00 (orig. cloth, covers dull)
Beadle, Erastus Flavel--To Nebraska in '57. N.Y., 1923. 1st
 ed. $43.50 (wraps.)
Beadle, John Hanson--Life in Utah. Phila., (1870). 1st ed.
 $53.00 (fly replaced, lower margin of map supplied in facs.),
 $12.50 (newly rebound)
Beal, John Robinson--Pearson of Canada. N.Y., (1964).
 $8.50
Beal, Merrill D.--"I Will Fight No More Forever." Seattle,
 1963. 1st ed. $30.00 (1st printing)
--The Story of Man in Yellowstone. Caldwell, 1949. 1st ed.
 $20.00 (signed by author)
Bealle, Morris Allison--The Drug Story. Wash., (1950). 1st
 ed. $10.00
Beals, C.S.--Science, History and Hudson Bay. Ottawa, 1968.
 2 vols. $100.00 (orig. cloth)
Beals, Carleton--America South. Phila., 1938. $5.00 (initial
 pages a bit waterstained)
--Brimstone and Chile. N.Y., 1927. $10.00, $8.50 (plates,
 stamp)
--Dawn Over the Amazon. N.Y., (1943). $12.50
--Eagles of the Andes.... Phila., (1963). $12.50
--Fire on the Andes. Phila., 1934. 1st ed. $12.50
--House in Mexico. N.Y., (1958). $8.00
--The Long Land. N.Y., (1949). $9.00
--Mexican Maze. Phila., (1931). 1st ed. $7.50 (d.j. infor-
 mation glued to half-title page)
--Nomads and Empire Builders. N.Y., 1961. 1st ed. $12.50
--Rio Grande to Cape Horn. Bost., 1943. $7.50
--The Stones Awake. Phila., 1936. $17.50 (worn some)
--War Within a War. Phila., (1965). $12.50 (ex-lib., front
 endpaper out)
--What the South Americans Think of Us. N.Y., (1945).
 $12.50
Beals, Charles Edward--Passaconaway in the White Mountains.
 Bost., 1916. $17.50 (some dampstaining)
Beals, Ralph Leon--Preliminary Report on the Ethnography of

the Southwest. Berkeley, 1935. 1st ed. $20.00 (spine
bit worn)

Bean, Leon Leonwood--My Story. Freeport, Me., 1960.
$17.50

Bean, Theodore Weber--History of Montgomery County....
Phila., 1884. $100.00

Beard, Charles Austin--America in Midpassage. N.Y., 1939.
2 vols. 1st ed. $15.00

--The Future Comes. N.Y., 1933. 1st ed. $12.50 (cloth)

--The Supreme Court and the Constitution. N.Y., 1938.
$5.00

Beard, Daniel Carter--Hardly a Man is Now Alive. N.Y.,
1939. 1st ed. $15.50 (untrimmed)

--Moonblight. N.Y., 1892. 1st ed. $32.50 (signed and in-
scribed)

Beardley, Harry Chase--A Symbol for Safety. Garden City,
1923. $17.50

Beardsley, Harry Markle--Joseph Smith and His Mormon Em-
pire. Bost., 1931. $35.00, $30.00

Bearss, Edwin C.--Fort Smith; Little Gibraltar on the Arkan-
sas. Norman, (1969). 1st ed. $15.00

Beasley, Norman--The Continuing Spirit. N.Y., (1956).
$10.00

--The Cross and the Crown. N.Y., (1952). 1st ed. $12.50

--Freighters of Fortune. N.Y., 1930. $15.00

Beaton, Kendall--Enterprise in Oil. N.Y., 1957. $38.00

Beattie, Kim--Brother, Here's a Man! N.Y., 1940. $15.00

Beaty, John--Memoirs of a Volunteer, 1861-1863. N.Y., 1946.
1st ed. $10.00

Beaty, John Owen--The Iron Curtain Over America. Dallas,
1952. $40.00 (spine worn)

Beauchamp, William Martin--A History of the New York Iro-
quois. Albany, 1905. 1st ed. $40.00

--Horn and Bone Implements of the New York Indians. Al-
bany, 1902. 1st ed. $25.00 (new wraps.)

Beaujour, Louis Auguste Felix--Apercu de Etats-Unis....
Paris, 1814. 1st ed. $150.00 (half morocco)

Beaumont de la Bonniniere, Gustave Auguste de--Marie, ou
l'Esclavage aux Etats-Unis. Paris, 1836. 2 vols. $50.00
(half leather and marbled boards, rubbed and worn, scat-
tered foxing)

--On the Penitentiary System in the United States.... Phila.,
1833. $150.00

Beaver, Herbert--Reports and Letters, 1836-1838.... (Port-
land, Or.), 1959. $35.00 (one of 750 copies)

Beaver, Ninette--Caril. Phila., 1974. $15.00
Beaver, Robert Pierce--Pioneers in Mission. Grand Rapids,
 (1966). $20.00
Beazley, Charles Raymond--John and Sebastian Cabot. N.Y.,
 1898. 1st ed. $20.00 (cloth)
Bechdolt, Frederick Ritchie--Giants of the Old West. N.Y.,
 (1930). 1st ed. $20.00
--Tales of Old-Timers. N.Y., (1924). $37.50
--When the West Was Young. N.Y., (1922). $28.50, $25.00
Beck, Henry Charlton--The Roads of Home. New Brunswick,
 N.J., (1956). 1st ed. $12.50
Beck, Lewis Caleb--A Gazetteer of the States of Illinois and
 Missouri.... Albany, 1823. 1st ed. $650.00 (orig.
 boards, later cloth spine)
--Mineralogy of New-York. Albany, 1842. 1st ed. $45.00
 (orig. cloth)
Becker, Carl Lotus--Detachment and the Writing of History.
 Ithaca, 1967. $10.00 (paper)
--Everyman His Own Historian. N.Y., 1935. $20.00
--The Heavenly City of the Eighteenth-Century Philosophers.
 New Haven, (1935). $10.00
--How New Will the Better World Be? N.Y., (1947). $10.00
--Modern Democracy. New Haven, 1959. $5.00 (ex-lib.)
--Progress and Power. N.Y., 1949. 1st ed. $10.00
Becker, Robert H., ed.--Thomas Christy's Road Across the
 Plains
 See: Christy, Thomas
Beckwourth, James Pierson--The Life and Adventures of....
 Minne., (1965). $12.50, $10.00
Bedau, Hugo Adam--The Death Penalty in America. Chi.,
 (1967). $10.00
Beebe, Charles William--Book of Bays. N.Y., (1942). 1st
 ed. $12.50
--Edge of the Jungle. N.Y., 1921. $8.00
--Jungle Days. N.Y., 1925. $7.50
--Nonsuch. N.Y., 1932. $12.50
Beebe, Lucius Morris--The American West. N.Y., 1955. 1st
 ed. $25.00, $17.50, $12.50
--A Bibliography of the Writings of Edwin Arnold Robinson.
 Camb., 1931. 1st ed. $50.00 (orig. boards, one of 350
 copies)
--The Big Spenders. Garden City, 1966. $10.00
--The Central Pacific & the Southern Pacific Railroads.
 Berkeley, 1963. $35.00
--Comstock Commotion. Stanford, (1954). $17.50

--Dreadful California
 See: Helper, Hinton Rowan
--Highball.... N.Y., 1945. $15.00
--Legends of the Comstock Lode. Stanford, (1954). $15.00
--Mansions on Rails. Berkeley, 1959. $20.00
Beebe, William
 See: Beebe, Charles William
Beecher, Catherine Ester--The Duty of American Women to
 Their Country. N.Y., 1845. 1st ed. $39.50 (orig. cloth,
 worn and stained, foxed)
Beeler, Joe--Cowboys and Indians. Norman, (1967). $5.00
 (wraps.)
Beers, Frank--The Green Signal.... K.C., (1904). $15.00
Beers, Henry Putney--Bibliographies in American History.
 N.Y., 1942. $15.00 (cloth)
Beeson, Emma (Burbank). The Early Life & Letters of Luther
 Burbank. S.F., (1927). 1st ed. $20.00 (minor extremity
 wear to binding).
Beichman, Arnold--Nine Lies About America. N.Y., 1972.
 $20.00 (cloth)
Beilharz, Edwin A., ed.--We Were 49ers!
 See under Title
Beirne, Francis F.--Shout Treason. N.Y., (1959). $15.00
Belaunde, Victor Andres--Bolivar and the Political Thought
 of the Spanish American Revolution. Balt., 1938. 1st ed.
 $10.00 (ink underlining)
--La Crisis Presente.... Lima., (1940). $14.00 (wraps., fox-
ing)
Belaunde Terry, Fernando--La Conquista del Peru por los
 Peruanos. Lima, 1959. $10.00 (foxing)
Belden, Bauman Lowe--Indian Peace Medals Issued in the U.S.
 New Milford, Ct., (1966). $20.00
Belden, G.H.--Letters to the People of the U.S.... N.Y.,
 1840. $125.00 (disbound)
Belden, Henry Marvin--Ballads and Songs Collected by the
 Missouri Folk-Lore Society. Columbia, (1940). 1st ed.
 $45.00 (wraps. worn)
Belden, Thomas Graham--The Lengthening Shadow. Bost.,
 1962. $10.00
Belfrage, Cedric--The American Inquisition. Ind., (1973).
 $6.50
Belgrano, Mario--La Francia y la Monarquia eu el Plata (1818-
 1820). Buenos Aires, 1933. $25.00 (occasional underlining
 in red pencil, inscribed)
Belisle, David W.--History of Independence Hall. Phila.,
 1859. $35.00 (orig. cloth), $15.00

Belknap, Helen Olive--The Church on the Changing Frontier. N.Y., (1922). $15.00 (some pages lightly stained)

Bell, Charles Henry--History of the Town of Exeter, New Hampshire. Exeter, 1888. $50.00

--Memoirs of John Wheelwright. Camb., 1876. $17.50 (one of 50 copies)

Bell, Horace--On the Old West Coast. N.Y., 1930. $20.00

--Reminiscences of a Ranger.... Santa Barbara, 1927. $25.00, $25.00

Bell, Jack--The Splendid Misery. Garden City, 1960. $10.00

Bell, John--Moccasin Flower. St. Paul, 1935. $7.50

Bell, John R.--The Journal of Captain.... Glendale, 1957. 1st ed. $45.00 (cloth, unopened)

Bell, Lilian Lida--A Little Sister to the Wilderness. Chi., 1895. 1st ed. $85.00 (orig. cloth, spine lightly faded, corners lightly bumped)

Bell, Marcus A.--Message of Love. Atlanta, 1860. 1st ed. $50.00 (orig. wraps.)

Bell, Martin L.--A Portrait of Progress. S.L., 1962. $15.00

Bell, Michael--Painters in a New Land. Toronto, 1973. $20.00

Bell, Solomon--Tales of Travels West of the Mississippi. Bost., 1830. 1st ed. $450.00 (contemp. boards)

Bell, Winthrop Pickard--The "Foreign Protestants" and the Settlement of Nova Scotia. (Toronto), 1961. $30.00

Bellamy, Edward--The Duke of Stockbridge, N.Y., 1900. 1st ed. $10.00

--Equality. Lond., 1897. $65.00 (endpapers foxed)

--Looking Backward. Bost., 1888. 1st ed. $350.00 (orig. cloth, 1st state, front inner hinges weakening, binding lightly rubbed at extremities)

Bellamy, Francis Rufus--Blood Money.... N.Y., 1947. $15.00

Beller, Jacob--Jews in Latin America. N.Y., (1969). $15.00

Bellow, Saul--Henderson, the Rain King. Lond., 1959. $125.00

--Humboldt's Gift. Lond., 1975. $35.00

--Mr. Sammler's Planet. N.Y., (1970). 1st ed. $50.00 (signed), $35.00 (boards, signed), $25.00

--The Portable Saul Bellow. N.Y., 1974. 1st ed. $7.50

Belmont, Eleanor (Robson)--The Fabric of Memory. N.Y., 1957. 1st ed. $30.00 (signed and inscribed)

Beltrami, Giacomo Constantino--A Pilgrimage in Europe and America.... Lond., 1828. 2 vols. $200.00 (rebound in leather, bookplates, a few waterstains)

--A Pilgrimage to America.... Chi., (1962). $25.00

Beltrami, J.C.
 See: Beltrami, Giacomo Constantino
Beltzhoover, George M.--James Rumsey.... (Charleston, W.
 Va.), 1900. $21.00 (wraps.)
Bemis, Samuel Flagg--Guide to the Diplomatic History of the
 U.S. Gloucester, Ma., 1963. $10.00 (cloth, ex-lib.)
--John Quincy Adams. N.Y., 1949. $22.50
--The Latin American Policy of the U.S. N.Y., (1943). 1st
 ed. $8.50 (some pencil underscoring)
Ben-Allah
 See: Newman, Ben-Allah
Benavides, Alonso de--The Memorial of Fray Alonso de Bena-
 vides. Chi., 1916. $650.00 (ltd. ed., cloth, lightly soiled
 and worn, crown of spine lightly bumped)
Bender, Averam Burton--The March of Empire. Lawrence,
 Ks., 1952. 1st ed. $35.00
Bendire, Charles Emil--Life Histories of North American Birds...
 Wash., 1892-95. 2 vols. $102.00 (orig. cloth, neatly re-
 fixed, spines faded), $75.00 (three-quarter leather)
Benedict, Ruth--An Anthropologist at Work. Bost., 1959.
 $20.00
--Race and Racism. Lond., (1959). $7.00
Benet, Stephen Vincent--Burning City. N.Y., (1936). 1st
 ed. $100.00 (orig. morocco, one of 275 signed copies,
 slipcased)
Benet, William Rose--The Burglar of the Zodiac and Other
 Poems. New Haven, 1918. 1st ed. $75.00 (presentation
 copy from author to his aunt, orig. boards)
Benitez, Jose R.--Historia Grafica de la Nueva España. Mexico,
 1929. $20.00 (buckram, orig. wraps. bound in)
Bennet, John C.--Outlaws in Swivel Chairs. N.Y., 1958.
 $10.00
Bennett, Charles O.--Facts Without Opinion. Chi., 1965.
 $15.00
Bennett, Edna Mae--Turquoise and the Indian. Denver, (1966).
 1st ed. $18.00
Bennett, Emerson--Forest and Prairie. Phila., (1860).
 $35.00 (cloth, hinges cracked, spine worn, lightly foxed)
--Kate Clarendon.... Cinci., 1848. 1st ed. $100.00
--Viola. Phila., (1852). 1st ed. $225.00 (wraps., some light
 text stains)
Bennett, Estelline--Old Deadwood Days. N.Y., (1928). 1st
 ed. $35.00, $31.50, $20.00 (1st printing)
(Bennett, Fremont O.)--The Chicago Anarchists and the Hay-
 market Massacre. Chi., 1887. $100.00 (orig. wraps., re-
 backed)

Bennett, Harry--We Never Called Him Henry. N.Y., (1951).
1st ed. $8.00

Bennett, Ira Elbert--History of the Panama Canal. Wash.,
1915. $85.00 (moderate rubbing, half leather)

Bennett, James--Overland Journey to California. N.Y.,
(1932?). $22.50

Bennett, Melba Berry--The Stone Mason of Tor House. (L.A.,
1966). $50.00, $25.00

Bennett, Nöel--The Weaver's Pathway. Flagstaff, 1974.
$12.50

Bennett, Russell H.--The Compleat Rancher. N.Y., (1946).
1st ed. $6.00

Bennett, Wendell Clark--The Tarahumara. Chi., 1935. 1st
ed. $35.00 (1st printing)

Benson, Adolph Burnett--Americans From Sweden. Phila.,
1950. 1st ed. $25.00

Benson, C. Randolph--Thomas Jefferson as Social Scientist.
Rutherford, (1971). $20.00, $15.00

Benson, Henry Clark--Life Among the Choctaw Indians....
Cinc., 1860. 1st ed. $100.00 (orig. cloth)

Benson, Lee--Turner and Beard. Glencoe, 1960. 1st ed.
$22.50, $10.00 (stamp marks)

Benson, Luther--Fifteen Years in Hell. Ind., 1879. $8.50

Benson, Lyman David--Cacti of Arizona. Tucson, 1950.
$10.00

Benson, Robert--Great Winemakers of California. Santa
Barbara, Ca., 1977. $15.00

Bent, Allen Herbert--Bibliography of the White Mountains.
Bost., 1911. 1st ed. $40.00

Bent, George--Life of George Bent Written From His Letters.
Norman, 1968. $25.00, $20.00

Bent, William--The Hell Hole. Yuma, Az., 1962. $7.50

Benton, Frank Weber--The Golden West. L.A., 1928. $12.50
(lacks backstrip, cover and page edges waterstained)

--Semi-Tropic California. L.A., 1915. $15.00

Benton, Jesse James--Cow by the Tail. Bost., 1943. $10.00

Benton, Joel--Life of Hon. Phineas T. Barnum.... (Phila.),
1891. 1st ed. $25.00 (cloth)

Benton, Josiah Henry--The Story of the Old Boston Town
House.... Bost., 1908. $35.00 (orig. boards, one of
350 copies, presentation copy)

--Voting in the Field. Bost., 1915. $25.00 (orig. boards,
some rubbing)

--Warning Out in New England. Bost., 1911. 1st ed. $25.00
(half cloth)

Benton, Peggie--One Man Against the Drylands. Lond., 1972.
$8.00
Benton, Thomas Hart, 1782-1856--Abridgement of the Debates
of Congress, From 1789 to 1856. N.Y., 1857-61. 16 vols.
$375.00 (half morocco)
--Thirty Years' View. N.Y., 1854-57. 2 vols. $45.00 (re-
bound). $38.50 (binding dull and worn)
Benton, Thomas Hart, 1889--An Artist in America. N.Y.,
(1937). $30.00, $15.00 (name on endpaper, spine and
cover edges darkened)
N.Y., (1939). $15.00
Columbia, (1968). $20.00
--Benton Drawings. Columbia, Mo., (1968). $30.00
Benton, William--The Voice of Latin America. N.Y., (1961).
1st ed. $8.00
Bequai, August--White-Color Crime. Lexington, 1978. $10.00
Berelson, Bernard--Voting. Chi., 1954. 1st ed. $12.50
Berg, Lillie Clara--Early Pioneers and Indians in Minnesota
and Rice County. San Leandro, Ca., 1959. $25.00 (one of
1000 copies)
Berger, Meyer--The Story of the New York Times. N.Y.,
(1951). $18.00
Berger, Michael L.--The Devil Wagon in God's Country. Ham-
den, 1979. $15.00
Berghold, Alexander--The Indians' Revenge. S.F., 1891.
1st ed. $50.00
Berkman, Alexander--Prison Memoirs of an Anarchist. N.Y.,
1912. 1st ed. $27.50
Berky, Andrew S.--Practitioner in Physik. Pennsburg, Pa.,
(1954). $12.50
Berlandier, Jean Louis--The Indians of Texas in 1830. Wash.,
1969. $60.00 (orig. cloth), $40.00
Berle, Adolfe Augustus--Latin America. N.Y., 1962. 1st
ed. $6.00 (ink underscoring)
Berman, Eleanor Davidson--Thomas Jefferson Among the Arts.
N.Y., (1947). $20.00
Bermudez Miral, Oscar--Historia del Salitre. Santiago de
Chile, 1963. $12.50 (minor ink underlining on few pages)
Bernal, Ignacio--The Olmec World. Berkeley, 1969. $25.00
Bernard, William, pseud.
See: Williams, Bernard
Bernard de Russailh, Albert--Last Adventure. S.F., 1931.
$60.00 (one of 475 copies, corners lightly bumped, book-
plate)
Bernhardt, Christian--Indian Raids in Lincoln County, Kan-
sas.... Lincoln, 1910. $9.00

Bernikow, Louise--Abel. N.Y., (1970). 1st ed. $15.00

Bernstein, Burton--Thurber. N.Y., (1975). 1st ed. $18.00

Berquin-Duvallon-Vue de la Colonie Espagnole du Mississippi,
ou des Provinces de Louisiana et Floride Occidentale....
Paris, 1803. 1st ed. $750.00 (full contemp. calf, front
hinge mended)

Berrigan, Daniel--Encounters. Cleve., (1960). $15.00

Berry, Don--A Majority of Scoundrels.... N.Y., (1961).
1st ed. $45.00 (ex-lib. stamps), $35.00

Berryman, John--Homage to Mistress Bradstreet. N.Y.,
(1956). 1st ed. $125.00
Lond., 1959. $50.00 (cloth, bookplate of Leonard Clark)

Berryman, John B.--An Old Man Looks Back. Chi., 1943.
$12.50

Berryman, Opal Leigh--Pioneer Preacher. N.Y., 1948. $10.00
(cloth), $8.50

Berthrong, Donald J.--A Confederate in the Colorado Gold
Fields
See: Conner, Daniel Ellis
--The Southern Cheyennes. Norman, (1963). 1st ed. $20.00
(cloth)

Berton, Pierre--The Klondike Fever. N.Y., 1958. 1st ed.
$12.50

Besault, Lawrence de--President Trujillo.... Santiago, Santo
Domingo, 1941. $10.00

Besio Moreno, Nicolas--Buenos Aires. Buenos Aires, 1939.
$25.00 (half calf, inscribed)

Best, Katharine--Las Vegas, Playtown, U.S.A. N.Y., (1955).
$10.00

Best, Mary Agnes--Thomas Paine. N.Y., (1927). 1st ed.
$17.50

The Best of True West. N.Y., (1964). $17.50

Beston, Henry--The St. Lawrence. N.Y., (1942). 1st ed.
$15.00

Betancourt, Romulo--Venezuela, Duena de su Petroleo. Ca-
racas, 1975. $8.50 (wraps.)

Bethune, Alexander Neil--Memoir of the Right Reverend John
Strachan.... Toronto, 1870. $30.00 (spine edges chipped)

Betts, Charles Henry--Betts-Roosevelt Letters.... Lyons,
N.Y., 1912. $15.00

Betzinez, Jason--I Fought With Geronimo. N.Y., (1959).
$4.95

Beveridge, Albert Jeremiah--Abraham Lincoln.... Bost.,
1928. 2 vols. 1st ed. $16.00
--The Life of John Marshall. Bost., (1916-19). 4 vols. $37.50
Bost., 1929. 4 vols. in 2. $30.00

Beverley, Robert--The History and Present State of Virginia. Chapel Hill, 1947. $20.00

Beyer, Walter Frederick--Deeds of Valor. Detroit, 1903. 2 vols. $55.00 (cover of vol. 2 stained)

Beymer, William Gilmore--On Hazardous Service. N.Y., 1912. $20.00

Bianchi, Manuel--Chile and Great Britain. Lond., 1944. $8.50

Biart, Lucien--The Aztecs. Chi., 1887. $25.00, $15.00

Bickersteth, John Burgon--The Land of Open Doors. Lond., 1914. $17.50 (spots on cover, paper browning)

Biddle, Charles--Autobiography.... Phila., 1883. 1st ed. $50.00

Biddle, Francis--Mr. Justice Holmes. N.Y., 1943. $12.50

Biddle, Henry D., ed.--Extracts From the Journal of Elizabeth Drinker
 See: Drinker, Elizabeth Sandwith

Bidwell, John--A Journey to California.... S.F., 1937. $57.50 (ltd. ed.)

--Life in California Before the Gold Discovery. Palo Alto, 1966. $40.00 (one of 1950 copies), $28.50 (boards)

Bidwell, Percy Wells--Economic Defense of Latin America. Bost., 1941. $7.50 (ex-lib.)

Bierce, Ambrose--The Collected Works of.... Wash., 1909-12. 12 vols. $175.00

Bierstadt, Edward--Picturesque St. Augustine.... St. Augustine, (1891). $35.00

Bigelow, John, 1817-1911--The Life of Samuel J. Tilden. N.Y., 1895. 2 vols. $40.00

--Memoir of the Life and Public Services of John Charles Fremont.... N.Y., 1856. 1st ed. $50.00 (general binding wear, light foxing to some pages and endpapers)

--Retrospections of an Active Life. N.Y., 1909-13. 5 vols. 1st ed. $125.00

Bigelow, John, 1854-1936--On the Bloody Trail of Geronimo. L.A., 1958. 1st ed. $41.50, $35.00 (one of 750 copies)

Bigg-Wither, Thomas Platagenet--Pioneering in South Brazil. N.Y., (1968). 2 vols. $20.00

Bigger, Henry Percival--The Voyages of Jacques Cartier. Ottawa, 1924. 1st ed. $85.00

Biggers, Don Hampton--From Cattle Range to Cotton Patch. (Bandera, Tx.), 1944. $25.00

Biggs, Asa--Autobiography.... Raleigh, 1915. 1st ed. $25.00 (orig. wraps., ex-lib. stamp)

Biggs, Donald C.--Conquer and Colonize. San Rafael, 1977. $12.95

(Biggs, James)--The History of Don Francisco de Miranda's
 Attempt to Effect a Revolution in South America.... Bost.,
 1808. 1st ed. $75.00 (orig. calf, one hinge starting)
 Bost., 1810. $57.50 (buckram, ex-lib.)
 Bost., 1811. $45.00 (new cloth)
Bigly, Cantell A., pseud.
 See: (Peck, George Washington)
Bill, Alfred Hoyt--Campaign of Princeton.... Princeton, 1948.
 1st ed. $10.00 (inscribed by author)
--Valley Forge. N.Y., (1952). $15.00
Bill, Buffalo, pseud.
 See: Cody, William Frederick
Bill, Ledyard--Minnesota; its Character and Climate.... N.Y.,
 1871. 1st ed. $25.00
Billias, George Athan--General John Glover and His Marble-
 head Mariners. N.Y., 1960. $12.50
--George Washington's Generals. N.Y., 1964. $12.50
Billings, John Davis--Hardtack and Coffee.... Chi., n.d.
 $15.00 (ex-lib., inner hinges cracked)
Billington, Ray Allen--America's Frontier Heritage. N.Y.,
 1966. 1st ed. $12.50
--The Far Western Frontier.... N.Y., (1956). 1st ed.
 $15.00
--The Frontier and American Culture. (Berkeley), 1965.
 $7.50 (one of 1000 copies)
Binford, Laurence L.--Birds of Western North America. N.Y.,
 (1974). $18.00
Bingham, Hiram--Across South America.... Bost., 1911. 1st
 ed. $20.00
--An Explorer in the Air Service. New Haven, 1920. 1st ed.
 $35.00
--Lost City of the Incas.... N.Y., (1948). 1st ed. $15.00
 (bookplate)
--Machu Picchu.... New Haven, 1930. 1st ed. $750.00 (one
 of 500 copies, bookplate)
--The Monroe Doctrine. New Haven, 1915. 1st ed. $15.00
Bingham, Millicent Todd--Ancestors' Brocades. N.Y., 1945.
 $21.00
Bining, Arthur Cecil--Pennsylvania Iron Manufacture in the
 Eighteenth Century. Harrisburg, 1938. 1st ed. $20.00,
 $10.00
 Harrisburg, Pa., 1973. $17.50
Binns, Archie--Northwest Gateway. Garden City, 1941.
 $16.50
 Garden City, 1946. $10.00

A Biographical History of Central Kansas. N.Y., 1902. 2
 vols. $75.00 (leather and boards, back hinges weak, front
 hinges separated)
Bird, Harry Lewis--This Fascinating Advertising Business.
 Ind., (1947). $10.00
Bird, Isabella Lucy--The Hawaiian Archipelago. Lond., 1876.
 $45.00 (inscription on fly, spine chipped)
--Six Months in the Sandwich Islands. Honolulu, 1964. $18.00,
 $15.00 (boards)
Bird, William Richard--Done at Grand Pre. Toronto, 1955.
 1st ed. $35.00 (corners rubbed)
--These Are the Maritimes. Toronto, (1959). $7.50
Birge, Julius Charles--Awakening of the Desert. Bost.,
 (1912). 1st ed. $50.00 (orig. cloth), $27.50
Birkbeck, Morris--Notes on a Journey in America.... Lond.,
 1818. $50.00 (orig. boards, rebacked, part of bookplate)
Birmingham, George A., pseud.
 See: (Hannay, James Owen)
Birmingham, Stephen--The Right People. Bost., (1968). 1st
 ed. $8.50
Birney, Hoffman--An Eagle in the Sun. N.Y., 1935. $28.50
--Vigilantes. Phila., (1929). 1st ed. $45.00, $27.50
--Zealots of Zion. Phila., (1931). $45.00, $42.50
Bischoff, William Norbert--The Jesuits in Old Oregon....
 Caldwell, 1945. $30.00
Bishop, Curtis Kent--Lots of Land. Austin, (1949). $18.50
Bishop, Elizabeth--Questions of Travel. N.Y., (1965).
 $30.00 (cloth)
Bishop, Harriet E.--Floral Home.... N.Y., 1857. 1st ed.
 $50.00
Bishop, Jim--The Day Lincoln Was Shot. N.Y., (1955). 1st
 ed. $12.50
Bishop, John Peale--The Collected Poems of.... N.Y., 1948.
 1st ed. $75.00 (orig. cloth)
Bishop, Joseph Bucklin--A Chronicle of One Hundred & Fifty
 Years. N.Y., 1918. $28.00
Bishop, Morris--Champlain. N.Y., 1948. 1st ed. $40.00
 (orig. cloth), $20.00
--The Odyssey of Cabeza de Vaca. N.Y., (1933). 1st ed.
 $20.00
Bishop, William Henry--Old Mexico and Her Lost Provinces.
 N.Y., 1883. $20.00 (lower margins stained)
Bissell, Richard Mervin--The Reign of Terry and Mitchell....
 Hart., 1940. $17.50
Bjorklund, Richard C.--R.S. Solinsky. Chi., 1969. $10.00

Black, A.P.--The End of the Long Horn Trail. Selfridge,
 N.D., (1936). 1st ed. $15.00 (frontis. dampstained)
Black, Forrest Revere--Ill-Starred Prohibition Cases. Bost.,
 1931. 1st ed. $17.50
Black, Harry G.--The Lost Dutchman Mine. Bost., 1975.
 $10.00 (signed)
Black Hawk, Sauk Chief--Life of Black Hawk.... Chi., 1916.
 $20.00
Black, Ryland Melville--A History of Dickey County, North
 Dakota.... Ellendale, N.D., 1930. 1st ed. $20.00
Black, Winifred (Sweet)--Dope. N.Y., 1928. $15.00
Blackbird, Andrew J.--Complete Both Early and Late History
 of the Ottawa and Chippewa Indians.... Harbor Springs,
 Mich., 1897. $35.00
Blackburn, Benjamin Coleman--Trees and Shrubs in Eastern
 North America. N.Y., 1952. $7.50
Blacker, Irwin R.--Days of Gold. Cleve., (1961). $11.00
Blackford, Susan Leigh (Colston)--Letters From Lee's Army.
 N.Y., 1947. 1st ed. $12.50
Blackford, William Willis--War Years With Jeb Stuart. N.Y.,
 1945. 1st ed. $25.00, $20.00, $18.50, $15.00
Blackman, Emily C.--History of Susquehanna County, Pennsyl-
 vania. Phila., 1873. $50.00
Blackwelder, Bernice--Great Westerner. Caldwell, 1962.
 $15.00
Blackwell, Alice Stone--Lucy Stone, Pioneer of Women's Rights.
 Bost., 1930. $20.00
Blackwell, Bunyan--Tales From the Brush Country. San An-
 tonio, (1963). $8.00
Bladen, Vincent Wheeler--Canadian Population and Northern
 Colonization. (Toronto), 1962. $12.50
Bladh, Carl Edward--La Republica de Chile, 1821-1828. San-
 tiago de Chile, (1951). $12.50 (wraps.)
Blaine, Harriet Bailey (Stanwood)--Letters of Mrs. James G.
 Blaine. N.Y., 1908. 2 vols. $28.00
Blaine, James Gillespie--Twenty Years of Congress. Norwich,
 1884-86. 2 vols. $30.00 (calf), $25.00 (owner name),
 $20.00, $20.00
Blair, Clay--Silent Victory. Phila., (1975). $15.00
Blair, Walter--Horse Sense in American Humor. Chi., (1942).
 1st ed. $25.00
--Tall Tale America. N.Y., (1944). $10.00
Blake, Emmet Reid--Birds of Mexico. Chi., (1953). $10.00
 (cloth)

Blake, Wilfrid Theodore--The Pampas and the Andes. Lond., (1953). $8.00

Blake, William--Cross and Flame in Wisconsin. Sun Prairie, Wi., (1973). $20.00

Blake, William Hume--Brown Waters. Toronto, 1940. $400.00 (cloth, one of 1000 copies)

Blanchard, P.--San Juan de Ulua ou Relation de l'Expedition Francaise au Mexique... Paris, 1839. 1st ed. $1,500.00 (three-quarter morocco and boards, lightly foxed, large paper issue)

Blanco, Antonio de Fierro--The Journey of the Flame. N.Y., 1933. $12.00

Bland, John Otway Percy--Men, Manners & Morals in South America. N.Y., 1920. $10.00 (stamps)

Blanlot Holley, Anselmo--Historia de la Paz Entre Chile y el Peru. Santiago de Chile, 1919. $20.00

Blasco Ibanez, Vicente--Mexico in Revolution. N.Y., (1920). $10.00 (covers and upper page corners water stained)

Blashfield, Edwin Howland--Mural Painting in America. N.Y., 1913. 1st ed. $45.00 (cloth, inscribed)

Blasingame, Ike--Dakota Cowboy. N.Y., (1958). 1st ed. $45.00, $37.50

Blasio, Jose Luis--Maximilian, Emperor of Mexico. New Haven, 1934. 1st ed. $12.50

Bledsoe, Albert Taylor--An Essay on Liberty and Slavery. Phila., 1856. 1st ed. $45.00

--The War Between the States. Lynchburg, 1915. $25.00 (orig. cloth)

Bledsoe, Anthony Jennings--Indian Wars of the Northwest. S.F., 1885. 1st ed. $275.00

Blegen, Theodore Christian, ed.--The Civil War Letters of Colonel Hans Christian Heg
See: Heg, Hans Christian

--The Kensington Rune Stone. St. Paul, Mn., 1968. $10.00

Blickhahn, Harry Miller--Uncle George of Kilauea. N.p. (1961). $8.00

Bliss, Frank Chapman--St. Paul, its Past and Present.... St. Paul, 1888. $7.50

Bliss, George Newman--Duffie and the Monument to his Memory. Prov., 1890. $17.50 (half leather, rubbed)

Bloch, E. Maurice--George Caleb Bingham. Berkeley, 1967. 2 vols. $75.00

Bloch, Herbert Aaron--Crime in America. N.Y., (1961). $5.00 (worn)

Blochman, Lawrence Goldtree--Doctor Squibb. N.Y., 1958.
$12.50

Block, Eugene B.--Great Stagecoach Robbers of the West.
Garden City, (1962). $10.00

Bloor, Ella Reeve--We are Many. N.Y., (1940). 1st ed.
$25.00

Blotner, Joseph Leo--The Modern American Political Novel....
Austin, (1966). $20.00

Blum, John Morton--Joe Tumulty and the Wilson Era. Bost.,
1951. $20.00

Blumberg, Arnold--The Diplomacy of the Mexican Empire....
Phila., 1971. $2.00 (wraps.)

Boardman, Harvey--A Complete and Accurate Guide to and
Around the White Mountains. Bost., 1859. $35.00

Boas, Franz--Kutenai Tales. Wash., 1918. $25.00

--The Religion of the Kwakiutl Indians. N.Y., 1930. 2 vols.
1st ed. $50.00 (slipcased)

Boas, Maxwell--Big Mac. N.Y., 1976. $5.00

Boatner, Mark Mayo--The Civil War Dictionary. N.Y., (1961).
$20.00

Boatright, Mody Coggin--Gib Morgan, Minstrel of the Oil Fields.
El Paso, 1945. $20.00
Dallas, 1965. $22.50

Bobb, Bernard E.--The Viceregency of Antonia Maria Bucareli
in New Spain.... Austin (1962). $9.75, $8.50 (bookplate)

Bobst, Elmer Holmes--Bobst. N.Y., (1973). $10.00

Bode, Carl--The American Lyceum. N.Y., 1956. 1st ed.
$5.00 (cloth, ex-lib.)

Boeringer, Marian--My Life Between Two Flags. N.Y., 1977.
$27.50

Bodley, Temple--Our First Great West. Lou., 1938. $30.00

Bogart, William Henry--Daniel Boone, and the Hunters of Ken-
tucky. Auburn, 1854. 1st ed. $30.00 (cloth)

Boggs, Mae Helene Bacon--My Playhouse was a Concord
Coach.... (Oakland, 1942). $250.00 (orig. cloth)

Bohn, Dave--Kinsey, Photographer--S.F., 1978. 2 vols. in
1. $15.00 (wraps.)

Bok, Edward William--A Man from Maine. N.Y., 1923. $30.00
(signed ltd. ed., one of 260, corners chipped, spine frayed)

Boland, Charles Michael--They All Discovered America. Garden
City, 1961. $15.00 (inscribed)

Bolingbroke, Henry--A Voyage to the Demerary ... and ...
Rivers of Guyana. Lond., 1809. $150.00 (half morocco,
some sigs. disbound but complete)

Bolivar, Simon--Memoirs of Simon Bolivar....
 See: Ducoudray-Holstein, Henri La Fayette Villaume
Bollaert, William--William Bollaert's Texas. Norman, 1956.
 $12.50
Boller, Henry A.--Among the Indians. Chi., 1959. $20.00
 (cloth)
Bolles, Albert Sidney--Pennsylvania, Province and State.
 Phila., 1899. 2 vols. 1st ed. $37.50
Bolton, Herbert Eugene--Anza's California Expeditions....
 Berkeley, 1930. 5 vols. 1st ed. $375.00 (orig. cloth),
 $325.00 (bookplates), $300.00
--Coronado, Knight of Pueblos and Plains. Albuquerque,
 (1949). $50.00 (signed by the author)
 N.Y., (1949). 1st ed. $30.00, $27.50, $22.50
 Albuquerque (1964). $20.00 (light warping, ex-lib.),
 $17.50, $15.00, $15.00
--Font's Complete Diary....
 See: Font, Pedro
--Outpost of Empire. N.Y., 1931. 1st ed. $70.00
--Wider Horizons of American History. N.Y., (1939). 1st
 ed. $15.00
Bolton, Reginald Pelham--A Woman Misunderstood, Anne, Wife
 of William Hutchinson. N.Y., 1931. $25.00
Bolton, Whitney--The Silver Spade. N.Y., (1954). $10.00
Bomberger, Christian Martin Hess--Twelfth Colony Plus.
 Jeanette, Pa., (1934). $10.00
Bonadio, Felice A.--North of Reconstruction. N.Y., 1970.
 $8.97
Bond, Beverley Waugh--The Civilization of the Old North-
 west.... N.Y., 1934. $25.00
--The Courses of the Ohio River....
 See: Hutchins, Thomas W.
Bond, Carrie (Jacobs)--The Roads of Melody. N.Y., 1927.
 1st ed. $25.00 (cloth, covers lightly soiled, ex-lib., in-
 scribed and dated by author)
Bond, Frank Fraser--Mr. Miller of "The Times." N.Y., 1931.
 $12.50
Bond, John Wesley--Minnesota and its Resources. N.Y., 1854.
 $40.00
Bond, Marshall--Gold Hunter. (Albuquerque, 1969). $17.50,
 $7.50
Bond, Mary Wickham--Far Afield in the Caribbean. Wynne-
 wood, 1971. $6.00
Bond-Jacobs, Carrie
 See: Bond, Carrie (Jacobs)

Boney, F.N., ed.--A Union Soldier in the Land of the Vanquished
See: Woodruff, Mathew
Bonham, Jeriah--Fifty Years' Recollections. Peroia, 1883.
$55.00
Boni, Margaret Bradford--Songs of the Guilded Age. N.Y.,
1960. $12.50
Bonnell, Clarence--The Illinois Ozarks. (Harrisburg, Il.,
1946). $30.00
Bonelli, William G.--Billion Dollar Jackpot. Beverly Hills,
(1954). $23.00 (wraps.)
Bonner, T.D., ed.--The Life and Adventures of James P.
Beckwourth
See: Beckwourth, James Pierson
Bonner, Thomas N., ed.--Journey Through the Rocky Mountains....
See: Schiel, Jacob Heinrich Wilhelm
Bonner, Willard Hallam--Captain William Dampier, Buccaneer-
Author. Stanford, (1934). $15.00
--Pirate Laureate.... New Brunswick, 1947. $10.00
Bonney, Orrin H.--Battle Drums and Geysers. Chi., (1970).
1st ed. $35.00, $15.00
Bonnycastle, Richard Henry--Spanish America.... Lond.,
1818. 2 vols. 1st ed. $400.00 (orig. boards, skillfully
rebacked)
Bononcini, Eugene--Autobiography of Rev.... St. Paul, Ks.,
1942. $8.50
Booth, Edwin Gilliam--In War Time.... Phila., 1885. $150.00
(half morocco)
Booy, Theodoor Hendrik Nikolaasde--The Virgin Islands....
Phil., 1918. $20.00 (cloth)
Borden, Morton--Parties and Politics in the Early Republic....
Lond., 1968. $10.00
Borden, Norman E.--Dear Sarah. Freeport, Me., (1966).
$12.50
Borges, Jorge Luis--Texas. Austin, 1975. $30.00 (wraps.,
one of 275 copies)
Borland, Hal--An American Year. N.Y., 1946. 1st ed. $6.00
Borneman, Henry Stauffer--Early Freemasonry in Pennsylvania.
Phila., 1931. $30.00 (boards)
Borsodi, Ralph--Flight From the City. Suffern, N.Y., 1947.
$12.00 (front hinge broken)
Borth, Christy--True Steel. Ind., 1941. $10.00
Borthwick, J.D.--The Gold Hunters. N.Y., 1924. $35.00

--3 Years in California. Oakland, 1948. $30.00 (orig. cloth, ltd. ed. of 1000 copies), $28.50, $25.00

Bosch, Juan--The Unfinished Experiment. N.Y., (1965). $6.50

Bosqui, Edward--Memoirs. Oakland, 1952. $76.50 (one of 350 copies)

Boswell, Peyton--Modern American Painting. N.Y., 1940. $25.00 (cloth)

Bosworth, Allan R.--Ozona Country. N.Y., 1964. $17.50

Botkin, Benjamin Albert--Sidewalks of America. Ind., (1954). 1st ed. $20.00

--A Treasury of American Folklore. N.Y., 1944. 1st ed. $10.00 (cloth, bookplate)

--A Treasury of New England Folklore. N.Y., (1947). 1st ed. $10.00 (cloth), $8.50
N.Y., (1965). $10.00

--A Treasury of Western Folklore. N.Y., (1951). 1st ed. $8.50 (1st printing)

Bottineau County Diamond Jubilee, 1884-1959. Bottineau, N.D., 1959. $10.00 (wraps.)

Boucher, John Newton--A Century and a Half of Pittsburg.... (N.Y.), 1908. 4 vols. $85.00 (half leather)

Boucher, Jonathan--Reminiscences of an American Loyalist, 1738-1789.... Bost., 1925. 1st ed. $50.00 (boards, one of 575 copies printed)

Bouchette, Joseph--A Topographical Description of the Province of Lower Canada.... Lond., 1815. 1st ed. $400.00 (recent calf, moderately foxed, top of title remargined)

--A Topographical Dictionary of the Province of Lower Canada Lond., 1832. $450.00 (contemp. half calf)

Boudreau, Eugene--Trails of the Sierra Madre. Santa Barbara, Ca., 1973. $4.50 (orig. wraps.)

Bourke, John Gregory--An Apache Campaign in the Sierra Madre. N.Y., 1886. 1st ed. $300.00 (orig. cloth, light outer wear)

--On the Border With Crook. N.Y., 1891. 1st ed. $125.00 (cloth). Columbus, Ohio, 1950. $45.00

Bourke-White, Margaret--Portrait of Myself. N.Y., 1963. 1st ed. $17.50

Bourne, Edward Gaylord--The History of the Surplus Revenue of 1837. N.Y., (1968). $5.00

Bourne, Eulalia--Woman in Levis. (Tucson, 1967). $10.00

Bourne, Richard--Political Leaders of Latin America. N.Y., 1970. $12.50, $7.50

Bowden, Witt--The Industrial History of the U.S. N.Y., (1970). $14.00

Bowditch, Nathaniel Ingersoll--Suffolk Surnames. Bost., 1858. $20.00 (presentation copy)

Bowditch, Vincent Yardley--Life and Correspondence of Henry Ingersoll Bowditch. Bost., 1902. 2 vols. 1st ed. $35.00 (orig. cloth)

--Family Portrait. Bost., 1970. $10.00

--John Adams and the American Revolution. Bost., 1950. 1st ed. $7.50

--Miracle at Philadelphia. Bost., (1966). $20.00, $15.00 (inscribed), $10.00, $10.00

--Yankee From Olympus. Bost., 1944. 1st ed. $8.50

Bowen, Daniel--A History of Philadelphia.... Phila., 1839. $200.00

Bowen, James Lorenzo--Massachusetts in the War, 1861-1865. Springfield, Ma., 1889. $35.00, $25.00

Bowen, Louise Hadduck (de Koven)--Open Windows. Chi., 1946. $12.50

Bowen, William A.--Uncle Zeke's Speculation. Arlington, 1910. $225.00 (orig. printed wraps., author's presentation inscription)

Bower, B.M., pseud.
 See: Sinclair, Bertha (Muzzy)

Bowering, Clifford H.--Service; the Story of the Canadian Legion, 1925-1960. Ottawa, (1960). $25.00

Bowers, Claude Gernade--Beveridge and the Progressive Era. (Bost.), 1932. $25.00 (cloth)

--Making Democracy a Reality. Memphis, 1954. $10.00 (endpaper clipped)

--Mision en Chile.... Santiago de Chile, (1957). $8.00 (wraps.)

--The Party Battles of the Jackson Period. Bost., (1922). 1st ed. $20.00 (cloth)

--The Tragic Era. (Camb.), 1929. $20.00 (cloth), $12.00 (lettering on spine faded)

Bowles, Jane Auer--Two Serious Ladies. N.Y., 1943. 1st ed. $450.00 (cloth). Lond., (1965). $100.00 (boards)

Bowles, Paul Frederic--The Delicate Prey, and Other Stories. (N.Y., 1950). 1st ed. $35.00 (cloth)

Bowles, Samuel--Across the Continent. Springfield, 1865. 1st ed. $55.00 (backstrip lightly worn and covers lightly spotted), $35.00 (cloth, map slightly torn, scattered foxing, owner's signature and stamp), $25.00

Bowman, Elizabeth Skaggs--Land of High Horizons. Kingsport,
Tn., (1944). $6.00

Bowman, Heath--Westward From Rio. Chi., 1936. $7.50,
$6.00 (signed by authors, binding top faded)

Bowman, James Cloyd--Pecos Bill, the Greatest Cowboy of All
Time. Chi., 1941. $12.00

Bowman, Samuel Millard--Sherman and His Campaigns. N.Y.,
1865. 1st ed. $40.00 (rebound in cloth, some pages
waterstained but text not affected)

Box, Michael James--Capt. James Box's Adventures and Ex-
plorations in New and Old Mexico. N.Y., 1869. $475.00
(orig. cloth)

Boyce, Warren Scott--Economic and Social History of Chowan
County, North Carolina. N.Y., 1917. 1st ed. $7.50
(orig. wraps.)

Boyd, E.
See: Hall, Elizabeth Boyd White

Boyd, James Penny--Life and Public Services of Hon. James
G. Blaine.... (Phila.), 1893. $12.50 (some edge wear)

--Military and Civil Life of Gen. Ulysses S. Grant. Phila.,
1885. 1st ed. $15.00, $12.50

--Recent Indian Wars.... (Phila., 1891). 1st ed. $30.00
(front endpapers cracking)

Boyd, Jesse Laney--An Abstract History of the Simpson County
Baptist Association.... N.p., (1928). $15.00 (cloth)

Boyd, Thomas Alexander--Mad Anthony Wayne, N.Y., 1929.
$15.00, $12.50

--Simon Girty, the White Savage. N.Y., 1928. $27.50

Boyer, Glenn G.--Suppressed Murder of Wyatt Earp. San
Antonio, (1967). $8.50

Boykin, Edward Carrington--Congress and the Civil War.
N.Y., (1955). $17.50

Boynton, Edward Carlisle--History of West Point. N.Y., 1863.
1st ed. $75.00 (spine worn, inner front hinge starting)

Boynton, Henry Van Ness--Sherman's Historical Raid. Cinci.,
1875. 1st ed. $25.00

Bracke, William B.--Wheat Country. N.Y., (1950). $12.50

Brackenridge, Henry Marie--History of the Western Insurrec-
tion.... Pitts., 1859. $125.00 (orig. cloth, spine head
lightly worn)

--South America. Wash., 1817. 1st ed. $175.00 (disbound)

--Voyage to South America. Balt., 1819. 2 vols. 1st ed.
$300.00 (contemp. calf)

Brackett, Albert Gallatin--History of the U.S. Cavalry....
N.Y., (1968). $17.50

Braddy, Haldeen--Cock of the Walk. Albuquerque, 1955.
1st ed. $35.00 (orig. cloth)
--Mexico and the Old Southwest. Port Washington, 1971.
$15.00 (signed)
Bradford, Gamaliel--Lee the American. Bost., 1927. $14.50
--Portraits of American Women. Bost., 1919. $11.00
Bradford, Thomas Lindsley--The Bibliographer's Manual of
American History.... Phila., 1907-10. 5 vols. $75.00
(orig. cloth)
Bradlee, Francis Boardman C.--Blockade Running During the
Civil War. Salem, Ma., 1925. 1st ed. $50.00
--A Forgotten Chapter in Our Naval History. Salem, Ma.,
1923. $25.00 (cloth, orig. wraps. bound in)
Bradley, Arthur Granville--Captain John Smith. Lond., 1905.
$10.00
Bradley, Erwin Stanley--The Triumph of Militant Republicanism.
Phila., (1964). $15.00
Bradley, Glenn Danford--Winning the Southwest. Chi., 1912.
$25.00, $15.00
Bradley, Van Allen--Music for the Millions. Chi., 1957.
$10.00
Bradsbury, Henry C.--History of Luzerne County, Pennsyl-
vania. Chi., 1893. $125.00
Brady, Cyrus Townsend--The Conquest of the Great South-
west. N.Y., 1905. 1st ed. $15.00 (snip off free end-
paper)
--Indian Fights and Fighters. Garden City, 1913. $36.50
--Northwestern Fights and Fighters. Garden City, 1907.
$45.00
Garden City, 1913. $25.00 (cover stained)
Williamstown, Ma., 1974. $6.50
--Recollections of a Missionary in the Great West. N.Y.,
1900. $24.50
--Three Daughters of the Confederacy. N.Y., (1905). $7.50
Brailsford, Mabel Richmond--The Making of William Penn. N.Y.,
1930. 1st ed. $7.50
Brainard, David Legge--The Outpost of the Lost. Ind.,
(1929). 1st ed. $15.00 (binding lightly soiled)
Brainerd, David--The Life of David Brainerd.... Bost., 1821.
$12.50 (contemp. calf, lacks leaves before title)
--Mirabilia Dei Inter Indicos.... Phila., 1746. 1st ed.
$900.00 (calf, wanting last four leaves)
Brainerd, George Walton--The Maya Civilization. L.A., 1954.
1st ed. $7.50

Braman, D.E.E.--Braman's Information About Texas. Phila.,
 1858. $400.00 (new cloth, moderate foxing)
Branagan, Thomas--A Preliminary Essay.... Phila., 1804.
 $125.00 (contemp. calf, spine chipped, covers crudely
 sewn)
Branch, Douglas
 See: Branch, Edward Douglas
Branch, Edward Douglas--The Cowboy and His Interpreters.
 N.Y., 1926. 1st ed. $42.50 (ex-lib.)
 N.Y., 1976. $12.00
--Hunting of the Buffalo. N.Y., 1929. 1st ed. $41.50
--Westward.... N.Y., 1930. 1st ed. $45.00, $35.00
Brandau, Roberta Sewall, ed.--History of the Homes and
 Gardens of Tennessee
 See: Garden Study Club of Nashville
Brandeis, Louis Dembitz--The Social and Economic Views of
 Mr. Justice Brandeis. N.Y., (1930). $15.00
--The Words of Justice Brandeis. N.Y., (1953). 1st ed.
 $10.00
Brandenburg, Frank Ralph--The Making of Modern Mexico.
 Englewood Cliffs, (1964). 1st ed. $9.00
Brandes, Ray--Frontier Military Posts of Arizona. Globe, Az.,
 (1960). 1st ed. $20.00, $17.50
Brandon, William--The Men and the Mountain. N.Y., 1955.
 1st ed. $30.00, $25.00, $15.00, $12.50
Brandt, Francis Burke--The Majestic Delaware.... Phila.,
 (1929). 1st ed. $15.00
Brandt, Herbert--Arizona and its Bird Life. Cleve., 1951.
 $102.00 (cloth)
Brandt, Richard B.--Hopi Ethics. Chi., (1954). $20.00
Brann, William Cowper--Brann, the Iconoclast. Waco, Tx.,
 (1898). 2 vols. $150.00 (orig. cloth)
Brannon, William T.--"Yellow Kid" Weil. Chi., 1948. $20.00
(Bransten, Richard)--The Fat Years and the Lean. N.Y.,
 (1940). $18.00
--Men Who Lead Labor. N.Y., (1937). 1st ed. $6.00
Brant, Irving--James Madison. Ind., 1941-61. 6 vols.
 $120.00 (cloth, ex-lib.)
Brashler, William--City Dogs. N.Y., 1976. 1st ed. $12.50
--The Don. N.Y., 1977. $15.00
Brasseur de Bourbourg, Charles Etienne--Monuments Anciens
 du Mexique. Paris, 1866. $8,500.00 (orig. fasciles, slip-
 cased)
Braxton, Allen Caperton--The Fifteenth Amendment. Lynch-
 burg, 1934. $15.00 (orig. cloth)

Bray, Jane W.T.--A Quaker Saga. Phila., (1967). $75.00
(cloth)

Bray, Warwick--The Gold of Eldorado. Lond., 1978. 1st ed.
$20.00

Brayer, Garnet M.--American Cattle Trails.... Bayside,
N.Y., 1952. 1st ed. $30.00, $15.00

Brayer, Herbert O., ed.--Pike's Peak....
See: Hedges, William Hawkins

Brayton, George Arnold--A Defense of Samuel Gorton and the
Settlers of Shawomet. Prov., 1883. 1st ed. $25.00
(orig. wraps., one of 250 copies)

Brayton, Matthew--The Indian Captive. Cleve., 1860. 1st
ed. $1,500.00 (boards, 1st state)

Brazier, Arthur M.--Black Self-Determination. Grand Rapids,
(1969). $15.00 (signed)

Brebner, John Bartlett--The Neutral Yankees of Nova Scotia.
N.Y., 1937. 1st ed. $12.50

Breeden, Marshall--The Romantic Southland of California.
L.A., 1928. $17.50, $17.50, $12.50

Breihan, Carl W.--Badmen of the Frontier Days. N.Y.,
(1957). $19.50

--The Bandit Belle. Seattle (1970). $12.00

--The Complete and Authentic Life of Jesse James. N.Y.,
(1953). $12.50

Bremer, Fredrika--The Homes of the New World. N.Y., 1853.
2 vols. $37.50 (inner hinge frayed on vol. 1)

Brener, Milton E.--The Garrison Case. N.Y., (1969). $12.50

Brenner, Anita--Idols Behind Altars. (N.Y.), 1929. 1st ed.
$15.00 (cloth)

--The Wind That Swept Mexico. N.Y., 1943. 1st ed. $75.00,
$75.00 (cloth), $20.00 (bookplate)

Brent, William--The Complete and Factual Life of Billy the
Kid. N.Y., (1964), $12.50

Brett, David--"My Dear Wife...." (Little Rock, 1964). $12.50

Brevoort, Elias--New Mexico, Her Natural Resources and At-
tractions.... Santa Fe, 1874. $400.00 (orig. cloth, neatly
rebacked, some staining on last two leaves)

Brewer, William Henry--Up and Down California in 1860-1864.
New Haven, (1931). $27.50
Berkeley, 1966. $30.00

Brewerton, George Douglas--In The Buffalo Country. Ash-
land, Or., 1970. $20.00 (one of 1400 copies)

--Incidents of Travel in New Mexico. Ashland, Or., 1969.
$20.00 (one of 1400 copies)

--Overland With Kit Carson. N.Y., (1930). $17.50 (back-
strip tip worn, some fading, very foxed), $12.50

Brewington, Marion Vernon--Shipcarvers of North America.
Barre, Ma., 1962. 1st ed. $30.00 (cloth)

Brewster, George--Lectures on Education.... Columbus, 1833.
1st ed. $27.50 (leather, hinges weak, ex-lib.)

Brewster, William--Concord River. Camb., 1937. $25.00

Brick, Charles J.--California-Album.... S.F., 1883. 1st ed.
$75.00 (orig. cloth, extremities rubbed, inner hinge start-
ing)

Bridenbaugh, Carl, ed.--Gentleman's Progress
See: Hamilton, Alexander

--Vexed and Troubled Englishmen.... N.Y., 1968. $12.00

Bridgeman, Thomas--The American Gardener's Assistant.
N.Y., 1872. $35.00 (cloth, name on fly, spine faded,
cover stained)

Bridges, Leonard Hal--Lee's Maverick General, Daniel Harvey
Hill. N.Y., (1961). $15.00

A Brief and Impartial History of the Life and Actions of An-
drew Jackson
See: (Snelling, William Joseph)

A Brief Description and a few Testimonials Concerning the
Sun Belt of S.D.... Yankton, S.D., 1893. $125.00
(orig. wraps.)

A Brief Explanation of the Established Principles and Regula-
tions of the United Society of Believers Called Shakers.
N.Y., 1851. $50.00 (disbound)

Brier, Howard M.--Sawdust Empire. N.Y., 1958. 1st ed.
$15.00

Briggs, Guy Morton--The Goal of the Builders. Chi., 1925.
$15.00

Briggs, Harold Edward--Frontiers of the Northwest. N.Y.,
1940. 1st ed. $15.00 (break in cloth of top rear cover
edge)

Briggs, Lloyd Vernon--Arizona and New Mexico, 1882; Califor-
nia, 1886; Mexico, 1891. Bost., 1932. 1st ed. $85.00
(orig. cloth)

Briggs, Walter--Without Noise of Arms. Flagstaff, 1976.
$40.00 (orig. cloth)

Brigham, Clarence Saunders--Fifty Years of Collecting Amer-
icana for the Library of the American Antiquarian Society....
Worcester, 1958. $15.00

--History and Bibliography of American Newspapers.... 2
vols. Worcester, 1947. $150.00

--Journals and Journeymen. Phila., 1950. 1st ed. $25.00
(cloth), $15.00
--Paul Revere's Engravings. Worcester, 1954. 1st ed. $75.00
(bookplate removed)
Brigham, William Tufts--The Volcanoes of Kilauea and Mauna
Loa.... Honolulu, 1909. $85.00 (wraps.), $75.00
Bright, Adam S.--"Respects to All." (Pitts., 1962). $10.50
Bright, Robert--Life and Death of Little Jo. Garden City,
1944. $16.00
Brill, Charles J.--Conquest of the Southern Plains. Okla-
homa City, 1938. 1st ed. $67.50, $50.00, $35.00
Brimlow, George Francis--Cavalryman Out of the West. Cald-
well, 1944. $45.00
--Harney County, Oregon, and its Range Land. Portland, Or.,
(1951). 1st ed. $37.50
Brininstool, Earl Alonzo--Crazy Horse.... L.A., (1949).
$56.50 (signed)
--Fighting Indian Warriors. Harrisburg, 1953. 1st ed.
$30.00, $25.50
--Pony Trails in Wyoming
See: Rollinson, John K.
--Trailing Geronimo
See: Mazzanovich, Anton
--Troopers With Custer. Harrisburg, (1952). $20.00
--Wyoming Cattle Trails....
See: Rollinson, John K.
Brinkerhoff, Sidney B.--Lancers for the King. Phoenix,
1965. $125.00
Brinnin, John Malcolm--The Third Rose. Bost., (1959). 1st
ed. $12.50
Brinton, Crane--The U.S. and Britain. Camb., 1948. $7.50
(cloth, ex-lib.)
Brinton, Daniel Garrison--Aboriginal American Authors and
Their Productions. Chi., 1970. $12.50 (one of 500 copies)
--American Hero-Myths. Phila., 1882. 1st ed. $125.00
(orig. cloth, light wear to spine extremities)
--The American Race. Phila., 1901. $75.00 (orig. cloth, ex-
lib.)
Bristow, Arch--Old Time Tales of Warren County. (Meadville,
Pa.), 1932. $35.00
British Headquarters Maps and Sketches....
See: Adams, Randolph Greenfield
Britt, Albert--The Hungary War.... Barre, 1961. $8.50
Britt, George--Forty Years--Forty Millions. N.Y., (1935).
1st ed. $12.50

Britten, Evelyn (Barrett)--Chronicles of Saratoga. Saratoga
Springs, N.Y., (1959). $15.00 (inscribed copy)

Britton, Nan--The President's Daughter. N.Y., 1927. 1st
ed. $25.00, $10.00

Broadfoot, Lennis Leonard--Pioneers of the Ozarks. Caldwell,
1944. 1st ed. $35.00

Brock, Henry Irving--New York Is Like This. N.Y., 1929.
$25.00 (cloth, crown of spine lightly bumped)

Brockett, Linus Pierpont--Famous Women of the War.... N.Y.,
1894. $30.00 (head and tail of spine frayed)

--Woman's Work in the Civil War.... Phila., 1867. 1st ed.
$15.00 (leather, front hinge tender)

Brodie, Fawn (McKay)--No Man Knows My History. N.Y.,
1960. $22.50

Brodsky, Alyn--Madame Lynch & Friend. N.Y., (1975). 1st
ed. $12.50

Brogan, Denis William--The American Character. N.Y., 1944.
1st ed. $8.00

--The Price of Revolution. Lond., 1952. $12.00

Brogan, Phil F.--East of the Cascades. Portland, Or., 1964.
$15.00 (inscribed)

Brokaw, Dennis--The Pacific Shore. N.Y., 1974. $22.50

Bronfman, Samuel--From Little Acorns. (Montreal, 1970).
$12.50

Bronson, Edgar Beecher--Reminiscences of a Ranchman.
N.Y., 1908. 1st ed. $42.50

Bronson, William--Still Flying and Nailed to the Mast. Garden
City, 1963. $20.00, $10.00

Brooke, George--With the First City Troop on the Mexican
Border.... Phila., 1917. $450.00 (orig. cloth, one of
500 numbered copies), $35.00 (one of 500 numbered cop-
ies)

Brooks, George R., ed.--The Southwest Expedition of Jedediah
S. Smith
See: Smith, Jedediah Strong

Brooks, John--The Fate of the Edsel and Other Business Ad-
ventures. N.Y., (1963). $10.00

Brooks, John Graham--American Syndicalism.... N.Y., 1913.
1st ed. $20.00

Brooks, John S.--First Administration of Oklahoma. (Okla-
homa City, 1908). $21.00

Brooks, Juanita--John Doyle Lee. Glendale, 1973. $25.00

--The Mountain Meadows Massacre. Stanford, (1950). 1st
ed. $65.00, $50.00 (bookplate)

Brooks, Nathan Covington--A Complete History of the Mexican
War.... Phila., 1849. 1st ed. $25.00 (rebound in cloth)
Brooks, Noah--First Across the Continent. N.Y., 1901. 1st
ed. $25.00 (cloth, hinges cracked, a bit rubbed), $16.50,
$15.00 (cloth, 1st printing)
Brooks, Van Wyck--The Confident Years: 1885-1915. (N.Y.),
1952. 1st ed. $15.00
--The Flowering of New England, 1815-1865. (N.Y.), 1936.
1st ed. $15.00 (cloth)
N.Y., 1937. $10.00 (boxed)
Bost., 1941. $75.00 (cloth, slipcased, signed)
--New England: Indian Summer, 1865-1915. N.Y., 1940.
$58.00 (uncut, one of 997 numbered copies, each signed
by the author)
--The Opinions of Oliver Allston. Lond., 1941. $12.50
--The Times of Melville and Whitman. (N.Y.), 1947. 1st ed.
$7.50 (bookplate)
Brophy, Frank Cullen--Arizona Sketch Book. (Phoenix, 1952).
$37.50, $17.50
Brosnan, Cornelius James--Jason Lee, Prophet of New Oregon.
N.Y., 1932. $25.00, $7.50
Brotherhood of Railroad Trainmen--Main Street, Not Wall
Street. (Cleve.), 1938. $15.00 (wraps., some water
staining)
Browder, Earl Russell--Communism in the United States. N.Y.,
(1935). $25.00
--Marx and America. Lond., 1959. $12.50
--The People's Front. N.Y., (1938). $6.50
Brower, David Ross--Not Man Apart; Lines From Robinson
Jeffers. S.F., (1965). 1st ed. $60.00
Brown, Alexander--The First Republic in America.... Bost.,
1898. 1st ed. $45.00 (orig. cloth)
Brown, Alexander Crosby--Steam Packets on the Chesapeake.
Camb., 1961. $15.00
Brown, Annie G.--Fireside Battles. Chi., (1900). $12.50
Brown, Charles H.--Narrative of the Imprisonment and Es-
cape....
See: (Appleton, Elizabeth Haven)
Brown, Charles Henry--The Correspondents' War. N.Y.,
(1967). $8.50
Brown, David Paul--The Forum. Phila., 1856. 2 vols. $75.00
(cloth, rebound)
Brown, Dee Alexander--Grierson's Raid. Urbana, 1954. 1st
ed. $30.00
--Trail Driving Days. N.Y., 1952. 1st ed. $32.50, $30.00

Brown, Donald Mackenzie, ed.--China Trade Days in California. Berkeley, 1947. $18.50

Brown, Douglas (Summers)--A City Without Cobwebs. Columbia, 1953. 1st ed. $20.00

Brown, Elijah--The Real Billy Sunday. N.Y., 1914. 1st ed. $17.50

Brown, Elinor L.--Architectural Wonder of the World. (Ceresco, Nb., 1965). $15.00 (cloth)

Brown, Estelle (Aubrey)--Stubborn Fool.... Caldwell, 1952. 1st ed. $12.50

Brown, Everett Somerville--The Constitutional History of the Louisiana Purchase.... Berkeley, 1920. $50.00 (orig. cloth, ex-lib.)

Brown, George Washington--Old Times in Oildom.... Oil City, Pa., 1911. $50.00 (orig. cloth)

Brown, Glenn--1860-1930.... Wash., 1931. $22.50 (one of 300 signed copies)

Brown, Harry James, ed.--Letters From a Texas Sheep Ranch See: Kendall, George Wilkins

Brown, Henry Collins--Book of Old New-York. N.Y., 1913. $175.00

--The Lordly Hudson. N.Y., 1937. $125.00 (signed, ltd. ed., cloth, soiled and rubbed)

--Old New York Yesterday & Today. N.Y., 1922. $15.00

Brown, James Cabell--Calabazas. Tucson, 1961. $12.50, $10.00

Brown, James Stephens--Life of a Pioneer. S.L.C., 1900. $135.00 (orig. cloth)

Brown, Jean M.--A History of Kiowa.... (Lawrence, Ks.), 1979. $16.50

Brown, Jennie Broughton--Fort Hall on the Oregon Trail. Caldwell, 1934. $36.50

Brown, Jerry Wayne--The Rise of Biblical Criticism in America.... Middletown, 1969. $17.50

Brown, Jesse--The Black Hills Trails. Rapid City, S.D., 1924. 1st ed. $125.00, $122.00, $85.00

Brown, Joe Evan--Laughter is a Wonderful Thing. N.Y., (1956). $12.50

--Your Kids and Mine. Garden City, 1944. $25.00 (inscribed)

Brown, John--Two Against the Amazon. N.Y., 1953. $10.00

Brown, John Henry, 1810-1905--Reminiscences and Incidents of Early Days in San Francisco. S.F., (1933). $75.00 (ex-lib.)

Brown, John Henry, 1820-1895--Indian Wars and Pioneers of Texas. Austin, 1896. 2 vols. 1st ed. $475.00 (publisher's leather neatly rebacked)

--Life and Times of Henry Smith. Dallas, 1887. 1st ed.
 $35.00 (orig. cloth, first few leaves have some dampstain-
 ing)
Brown, John Mason, 1837-1890--The Political Beginnings of
 Kentucky. Lou., 1889. $30.00 (wraps.)
Brown, John Mason, 1900-1969--The Ordeal of a Playwright.
 N.Y., (1970). $15.00
--The Worlds of Robert E. Sherwood. N.Y., (1965). $15.00
Brown, Lilian Mable Alice (Roussel)--Unknown Tribes, Un-
 chartered Seas. N.Y., 1925. $8.50 (binding lightly
 scratched)
Brown, Marianna Catherine--Sunday-School Movements in
 America. N.Y., 1901. 1st ed. $20.00
Brown, Mark Herbert--The Flight of the Nez Perce. N.Y.,
 (1967). 1st ed. $25.00, $20.00
--The Plainsmen of the Yellowstone. N.Y., (1961). 1st ed.
 $27.50, $20.00
Brown, Richard Maxwell--The South Carolina Regulators.
 Cambridge, 1963. $25.00
Brown, Robert Leaman--An Empire of Silver. Caldwell, (1968).
 $20.00
--Ghost Towns of the Colorado Rockies. Caldwell, 1968.
 $20.00 (1st printing)
Brown, Stanley H.--Ling; the Rise, Fall and Return of a Texas
 Titan. N.Y., 1972. $10.00, $10.00
Brown, Stuart--A Man Named Tony. N.Y., (1976). $8.00
Brown, William Carey--The Sheepeater Campaign, Idaho-1879.
 (Boise, 1926). $45.00
Brown, William Horace--The Glory Seekers. Chi., 1906.
 $20.00 (bookplate)
Browne, Daniel Jay--Field Book of Manures. N.Y., 1855.
 $15.00 (cloth, foredges dampstained)
--The Trees of America. N.Y., 1846. 1st ed. $35.00 (rub-
 bed, lacks most of backstrip, owner's inscription on title)
Browne, Francis Fisher--Bugle-Echoes. Denver, 1886. $13.50
Browne, George Waldo--The St. Lawrence River, Historical--
 Legendary--Picturesque. N.Y., (1976?). $20.00 (cloth)
Browne, John Ross--Adventures in the Apache Country. N.Y.,
 1869. $125.00 (previous owner's inscription)
 N.Y., 1974. $8.50
--A Dangerous Journey.... Palo Alto, (1950). $21.50
--J. Ross Browne; His Letters.... Albuquerque, (1969).
 $10.00
--Muleback to the Convention. S.F., 1950. 1st ed. $41.50,
 $40.00 (one of 400 copies)
--A Peep at Washoe.... Balboa Island, Ca., (1959). $12.00

--A Tour Through Arizona, 1864. Tucson, 1950. $58.50
(one of 500 numbered copies)
--Washoe Revisited. Oakland, 1957. $25.00 (one of 500 cop-
ies), $20.00 (one of 500 copies)
Browne, Junius Henri--Four Years in Secessia.... Hart.,
1865. 1st ed. $15.00, $12.50
Browne, Nina--A Bibliography of Nathaniel Hawthorne. Bost.,
1905. $50.00 (orig. cloth, one of 550 copies, spine label
lightly worn)
Browne, Waldo Ralph--Altgeld of Illinois.... N.Y., 1924.
$15.00 (cloth, ex-lib.)
Brownell, Baker--The Other Illinois. N.Y., (1958). $17.50
Brownlee, Richard S.--Gray Ghosts of the Confederacy.
Baton Rouge, 1958. 1st ed. $20.00
Bruce, Florence Guild--Lillie of Six-Shooter Junction.... San
Antonio, (1946). $15.00 (ltd., numbered, and signed ed.),
$7.00
Bruce, Henry Addington Bayley--The Romance of American
Expansion. N.Y., 1909. $18.50
Bruce, John Roberts--Gaudy Century. N.Y., (1948). $17.50
Bruce, Miner W.--Alaska: Its History and Resources....
Seattle, 1898. $10.00 (worn copy, lacks map)
Bruce, Robert, 1873--The Fighting Norths and Pawnee Scouts.
Lincoln, 1932. $28.50 (wraps.)
Bruce, Robert V.--1877: Year of Violence. Ind., (1959).
1st ed. $20.00
--Lincoln and the Tools of War. Ind., (1956). 1st ed. $17.50
Bruce, Wallace--The Connecticut by Daylight.... N.Y., 1874.
1st ed. $35.00
--The Hudson River by Daylight. N.Y., 1873. 1st ed.
$20.00
Bruce, William Cabel--John Randolph of Roanoke.... N.Y.,
1922. 2 vols. 1st ed. $50.00
Bruchesi, Jean A.--History of Canada. Toronto, 1950. $4.50
Bruchey, Stuart Weems--Robert Oliver, Merchant of Baltimore..
Balt., 1956. 1st ed. $15.00
Bruff, Joseph Goldsborough--Gold Rush. N.Y., 1944. 2 vols.
$185.00 (boards), $170.00
N.Y., 1949. $60.00
Bruffey, George A.--Eighty-One Years in the West. Butte,
Mt., 1925. $75.00 (orig. wraps.), $42.50 (wraps. bound in
Brumbaugh, Martin Grove--A History of the German Baptist
Brethren in Europe and America. Elgin, Il., 1899. $50.00
(orig. cloth)

Brundage, Burr Cartwright--Lords of Cuzco. Norman, (1967). $12.50

Brunner, David B.--The Indians of Berks County, Pa. Reading, Pa., 1881. 1st ed. $60.00 (cloth, rebound)

Bruno Ruiz, Luis--Breve Historia de la Danza en Mexico. (Mexico, 1956). $12.50 (wraps., ex-lib.)

Brunson, Alfred--A Western Pioneer. Cinci., 1872-79. 2 vols. $35.00 (ex-lib.)

Brunter, Marian Chaddock--California--Its Amazing Story. L.A., 1949. $6.00 (boards)

Brunvand, Jan Harold--The Study of American Folklore. N.Y., (1968). 1st ed. $10.00 (cloth)

Brush, Daniel Harmon--Growing Up With Southern Illinois.... Chi., 1944. $10.00

Brussel, Isidore Rosenbaum--A Bibliography of the Writings of James Branch Cabell. Phila., 1932. 1st ed. $40.00 (orig. cloth, one of 350 copies, presentation copy inscribed)

Brutus, pseud.
 See: (Turnbull, Robert James)

Bryan, Enoch Albert--Orient Meets Occident. Pullman, Wa., (1936). $17.50 (ex-lib.)

Bryan, George Sand--Edison, the Man and His Work. Garden City, (1926). $12.50

Bryan, Jerry--An Illinois Gold Hunter in the Black Hills. Springfield, Il., 1960. 1st ed. $7.50

Bryan, William Jennings--The First Battle. Chi., (1896). 1st ed. $20.00 (cloth, ex-lib.)

--The Memoirs of.... Chi., (1925). $50.00 (front hinge mended, signed note laid in)

Bryan, William Smith--A History of the Pioneer Families of Missouri.... S.L., 1876. $200.00 (bit of wear to extremities)

Bryant, Billy--Children of Ol' Man River. N.Y., (1936). $25.00 (cloth)

Bryant, Charles S.--A History of the Great Massacre by the Sioux Indians, in Minnesota. Cinci., 1864. $60.00

Bryant, Edwin--Californien, en Skildring af Landet.... Stockholm, 1850. $175.00 (orig. printed wraps.)

Bryant, Harold Child--Outdoor Heritage. L.A., (1929). $17.50

Bryant, Keith L.--Alfalfa Bill Murray. Norman, (1968). $8.50

--Arthur E. Stilwell.... Nash., 1971. $10.00

Bryant, William Cullen--Poems. Camb., 1821. 1st ed. $650.00 (three-quarter calf, spine very worn, cover nearly loose)

N.Y., 1840. $35.00 (head of spine and one corner lightly worn)

--A Popular History of the U.S.... N.Y., 1876-80. 4 vols. $125.00 (half leather, some shelf wear, one frontis. missing)

Bryce, James Bryce--The American Commonwealth. Lond., 1888. 2 vols. 1st ed. $150.00 (half leather, rubbed and chipped, owner's signatures)

Lond., 1891. 2 vols. $35.00 (cloth, ex-lib.)

--South America. N.Y., 1912. 1st ed. $12.50

Bryn-Jones, David--Frank B. Kellogg.... N.Y., 1937. $15.00 (cloth)

Buaken, Manuel--I Have Lived With the American People. Caldwell, 1948. $16.00

Buchanan, Isaac--The Relations of the Industry of Canada, With the Mother Country and the United States.... Montreal, 1864. 1st ed. $65.00 (author's presentation copy, orig. cloth)

Buchanan, James--Mr. Buchanan's Administration on the Eve of the Civil War. N.Y., 1866. 1st ed. $35.00

Buchanan, Lamont--A Pictorial History of the Confederacy. N.Y., (1951). 1st ed. $15.00

Buck, Daniel--Indian Outbreaks. Mankato, Mn., 1904. 1st ed. $45.00 (presentation copy, some clippings tipped in)

Buck, Franklin Augustus--A Yankee Trader in the Gold Rush. Bost., 1930. $30.00

Buck, Pearl (Sydenstricker)--Essay on Myself. N.Y., 1966. $25.00 (one of 1000 copies)

--The Good Earth. Garden City, 1949. $7.50

Buck, Samuel M.--Yanaguana's Successors. San Antonio, (1949). 1st ed. $25.00

Buck, Solon Justus--Travel and Description, 1765-1865. Springfield, Il., 1914. 1st ed. $50.00 (orig. cloth)

Buck, William Joseph--History of Montgomery County.... Norristown, Pa., 1859. $50.00 (rebound)

--History of the Indian Walk.... Phila., 1886. 1st ed. $100.00 (orig. cloth, one of 210 copies)

--Local Sketches and Legends.... (Phila.?), 1887. $100.00 (cloth, one of 200 copies)

--William Penn in America. Phila., 1888. $25.00 (one of 300 copies)

Buckbee, Edna Bryan--Pioneer Days of Angel's Camp. Angel's Camp, Ca., (1932). $20.00 (owner name)

Buckeridge, Justin O.--Lincoln's Choice. Harrisburg, (1956). $35.00

Buckingham, Nash--Blood Lines.... N.Y., (1938). 1st ed.
$225.00 (cloth, one of 1250 copies)
--Mark Right! N.Y., (1936). 1st ed. $200.00 (cloth, top
of spine bit scuffed, one of 1250 copies)
--Ole Miss'. N.Y., (1937). 1st ed. $200.00 (cloth, one of
1250 copies)
Buckler, Helen--Daniel Hale Williams.... N.Y., (1968).
$12.50
Buckley, William Frank--McCarthy and His Enemies. Chi.,
1954. $10.00
Budd, Thomas--Good Order Established in Pennsylvania and
New Jersey. Cleve., 1902. $37.00 (orig. boards, one of
250 copies)
Budenz, Louis Francis--This Is My Story. N.Y., (1947).
$12.50, $6.50
Buder, Stanley--Pullman. N.Y., 1967. 1st ed. $20.00
Buel, James William--The Authorized Pictorial Lives of James
Gillespie Blaine and John Alexander Logan. N.Y., 1886.
$12.50 (front inner hinge frayed)
--The Standard Bearers. N.Y., 1886. $19.00 (front inner
hinge frayed)
Buell, Augustus C.--History of Andrew Jackson.... N.Y.,
1904. 2 vols. 1st ed. $25.00
Buffalo Bill's Wild West Show and Congress of Rough Riders
of the World. Chi., 1893. $25.00 (wraps., lightly frayed)
Buffum, Edward Gould--The Gold Rush. N.p., 1959. $35.00
--Six Months in the Gold Mines. Phila., 1850. 1st ed.
$200.00 (badly chipped at spine ends, well rubbed along
edges, previous owner's signature)
(L.A.), 1959. $30.00
Buffum, George Tower--Smith of Bear City, and Other Frontier
Sketches, N.Y., 1906. 1st ed. $31.50 (rear cover lightly
damaged)
Buhler, Kathryn C.--Mount Vernon Silver. Mt. Vernon, Va.,
1957. $10.00
Buick, Harry Arthur--The Gringoes of Tepehuanes. Lond.,
1967. $7.50
Buley, Roscoe Carlyle--The American Life Convention....
N.Y., 1953. 2 vols. $35.00
--The Equitable Life Assurance Society of the U.S.... N.Y.,
(1967). 2 vols. $35.00
Bulfinch, Thomas--Oregon and Eldorado. Bost., 1866. 1st
ed. $75.00 (orig. cloth)
Bull, William Perkins--From Medicine Man to Medical Man....
Toronto, 1934. $65.00 (one of 1000 copies, cloth soiled)

Bullard, Frederic Lauriston--Abraham Lincoln & the Widow
 Bixby. New Brunswick, 1946. 1st ed. $10.00
Bullett, Gerald--Walt Whitman. Phila., 1925. $30.00 (boards,
 one of 780 copies, endleaves browned)
Bulloch, James Dunwody--The Secret Service of the Confed-
 erate States.... N.Y., (1959). 2 vols. $30.00, $25.00
Bullock, W.H., pseud.
 See: Hall, William Henry Bullock
Bullock, William--Six Months' Residence and Travels in Mexico.
 Lond., 1825. 2 vols. in 1. $325.00 (half morocco, light
 spine ruling, scuffed, lightly foxed)
Bullrich, Francisco--New Directions in Latin American Archi-
 tecture. N.Y., (1969). $6.00
Bulnes, Francisco--The Whole Truth About Mexico. N.Y.,
 1916. $20.00
Bulnes, Gonzalo--Las Causas de la Guerre Entre Chile y el
 Peru. Santiago de Chile, 1919. $35.00 (contemp. cloth)
Bunkley, Allison Williams--The Life of Sarmiento. Princeton,
 1952. 1st ed. $12.50
Bunnell, Lafayette Houghton--Winona.... Winona, Mn., 1897.
 1st ed. $27.50
Bunster, Enrique--Chilenos en California. Santiago de Chile,
 (1958). $15.00 (loose in wraps.)
Bunzey, Rufus S.--History of Companies I and E, Sixth
 Regt.... Morrison, Il., 1901. $55.00
Buranelli, Vincent--The King & the Quaker. Phila., (1962).
 $8.50
Burbank, Addison--Mexican Frieze. N.Y., 1940. $12.50
Burbank, Luther--Luther Burbank, His Methods and Discov-
 eries.... N.Y., 1914-15. 12 vols. $350.00
Burch, John P.--Charles W. Quantrell. (Vega, Tx., 1923).
 1st ed. $45.00 (cloth), $25.00, $23.00, $20.00, $10.00
Burdett, Charles--Life of Kit Carson. Phila., 1862. 1st ed.
 $15.00 (binding very worn)
 N.Y., 1902. $7.50
Burdette, Robert Jones--The Drums of the 47th. Ind., (1914).
 $27.50 (ex-lib.)
Burdick, Usher Lloyd--The Last Battle of the Sioux Nation.
 Stevens Point, Wi., (1929). 1st ed. $50.00
--Tragedy in the Great Sioux Camp. Balt., 1936. 1st ed.
 $8.50 (wraps., inscribed)
Burge, Dolly Sumner (Lunt)--A Woman's Wartime Journal.
 N.Y., 1918. 1st ed. $10.00 (tiny hole in spine)
Burgess, John--Pleasant Recollections of Characters and Works
 of Noble Men.... Cinci., (1887). 1st ed. $25.00 (presen-
 tation copy)

Burgess, Thomas--Greeks in America. Bost., 1913. 1st ed.
 $25.00 (orig. cloth)
Burgin, Miron--Aspectos Economicos del Federalismo Argentina.
 Buenos Aires, 1969. $9.00 (wraps., ex-lib.)
Burke, Fred C.--Logs on the Menominee. Menasha, Wi., 1946.
 $30.00
Burke, John McDonald--Buffalo Bill. N.Y., (1973). 1st ed.
 $20.00
Burke, William Jeremiah--American Authors and Books....
 N.Y., (1943). $15.00
Burkhalter, Lois (Wood)--Gideon Lincecum.... Austin, (1965).
 1st ed. $10.00
Burkhart, Kathryn Watterson--Women in Prison. Garden City,
 1973. $17.00
Burkitt, Robert--The Hills and the Corn. Phila., 1920.
 $6.00 (wraps.)
Burkley, Francis Joseph--The Faded Frontier. Omaha, 1935.
 $27.50 (spot on front cover, owner stamp)
Burks, Arthur J.--Bells Above the Amazon. N.Y., (1951).
 $6.50
--Land of Checkerboard Families. N.Y., (1932). $6.50
Burleigh, Thomas Dearborn--Georgia Birds. Norman, (1958).
 1st ed. $70.00 (cloth)
Burlend, Rebecca--A True Picture of Emigration. Lond.,
 (1848). 1st ed. $150.00 (half morocco)
 Chi., 1936. $10.00
Burlingame, Roger--The American Conscience. N.Y., (1960).
 $12.00
--Endless Frontiers. N.Y., (1959). $20.00
Burmeister, Eugene--Early Days in Kern. Bakersfield, Ca.,
 (1963). $7.50
Burnaby, Andrew--Travels Through the Middle Settlements in
 North-America.... Lond., 1775. 1st ed. $450.00
Burnett, Frances Hodgson--T. Tembarom. N.Y., 1913. 1st
 ed. $35.00 (orig. cloth, edges lightly worn, owner signa-
 ture on fly)
Burnett, Peter Hardeman--Recollections and Opinions of an
 Old Pioneer. N.Y., 1880. 1st ed. $150.00
Burney, James--History of the Buccaneers of America. Lond.,
 1816. $750.00 (orig. boards, endpapers discolored and
 some offsetting from maps)
 Lond., 1912. $45.00 (orig. cloth)
Burnford, Sheila Every--Without Reserve. Lond., (1969).
 $25.00 (cloth)
Burnham, Frederick Russell--Scouting on Two Continents.
 Garden City, (1926). $7.50

L.A., 1934. $15.00 (cloth, lacks front free endpaper)

Burnham, James--Congress and the American Tradition. Chi., 1965. $10.00

Burns, Edward McNall--The American Idea of Mission. New Brunswick, 1957. 1st ed. $25.00

Burns, Eugene--The Last King of Paradise. N.Y., (1952). $10.00

Burns, James MacGregor--The Deadlock of Democracy. Englewood Cliffs, (1963). $15.00

Burns, Robert Elliott--I Am a Fugitive From a Georgia Chain Gang! N.Y., 1932. $7.00 (lacks free endpaper)

Burns, Walter Noble--The One-Way Ride. Garden City, 1931. $25.00

--The Saga of Billy the Kid. N.Y., 1926. 1st ed. $7.50

--Tombstone. Garden City, 1927. 1st ed. $35.00

Burns, William John--The Masked War. N.Y., (1913). 1st ed. $55.00

Burpee, Lawrence Johnstone--The Search for the Western Sea. Toronto, 1935. 2 vols. $35.00 (ex-lib.)

Burr, Frank A.--"Little Phil" and His Troopers. Prov., 1888. 1st ed. $17.50

Burr, Nelson Rollin--The Story of the Diocese of Connecticut. (Hart., 1962). $20.00

Burroughs, Edgar Rice--The Land That Time Forgot. N.Y., 1962. $25.00 (owner name and initials)

--Tarzan and "The Foreign Legion." Tarzana, (1947). 1st ed. $60.00

Burroughs, John--Accepting the Universe. Bost., 1920. $7.50

--Birds and Bees.... Bost., 1921. $6.00

--Locusts and Wild Honey. Bost., 1921. $6.00 (insect damage)

--Riverby. Bost., 1894. 1st ed. $20.00 (orig. cloth, 1st issue, ends of spine worn)
 Bost., 1895. $7.50

--The Summit of the Years. Bost., 1913. 1st ed. $17.50 (orig. cloth, bookplate)
 Bost., 1922. $7.50

--Under the Maples. Bost., 1921. $25.00 (orig. cloth, edges lightly worn, bookplate)

--Winter Sunshine. Bost., 1917. $6.00 (insect damage)

Burroughs, John Rolfe--Headfirst in a Pickle Barrel. N.Y., 1963. $10.00 (signed)

Burroughs, Stephen--Memoirs of the Notorious Stephen Burroughs of New Hampshire. N.Y., 1924. $24.00 (uncut and unopened)

Burroughs, William--The Naked Lunch. Paris, (1959). $125.00 (stiff wraps., name on first blank leaf, lightly worn, 1st state)

Burrows, Edwin Grant--Hawaiian Americans.... New Haven, 1947. $12.00

Burt, Alfred LeRoy--The United States, Great Britain and British North America From the Revolution to the Establishment of Peace After the War of 1812. New Haven, 1940. 1st ed. $65.00 (orig. cloth)

Burt, Henry Martyn--Burt's Illustrated Guide to the Connecticut Valley.... Northampton, Ma., 1868. $30.00 (cloth)

Burt, Maxwell Struthers--The Diary of a Dude-Wrangler. N.Y., 1924. 1st ed. $22.50
N.Y., 1938. $7.50

--Powder River; Let 'er Buck. N.Y., (1938). $15.00, $7.50 (covers stained)

Burt, Olive Woolley--American Murder Ballads and Their Stories. N.Y., 1958. 1st ed. $9.50 (boards, lightly worn, ex-lib.)

Burt, Struthers
See: Burt, Maxwell Struthers

Burton, David Henry--Theodore Roosevelt: Confident Imperialist. Phila., 1968. 1st ed. $12.50

Burton, Gideon--Reminiscences.... Cinc., 1895. $25.00

Burton, Harrison W.--The History of Norfolk, Virginia. Norfolk, 1877. $22.50 (ex-lib., rubbed and faded)

Burton, Richard Francis--The City of the Saints. N.Y., 1862. $145.00 (map crudely repaired, spine ends frayed)
N.Y., 1963. $31.50, $30.00

Busch, Francis Xavier--Guilty or Not Guilty? Ind., 1952. $15.00

--Prisoners at the Bar. Ind., 1952. $15.00

Bushnell, Horace--California. S.F., 1858. $275.00 (orig. wraps., stained, ex-lib.)

Bushnell, Oswald A.--Molokai. Cleve., (1963). 1st ed. $16.00

Busto Duthurburu, Jose Antonio del--Francisco Pizarro, el Marques Gobernador. Lima, 1978. $10.00 (wraps.)

Butcher, Harry Cecil--My Three Years With Eisenhower. N.Y., 1946. $12.50

Butcher, Solomon Devore--Pioneer History of Custer County.... Broken Bow, Nb., 1901. 1st ed. $115.00 (spine chipped, boards, covers bent)

Butler, Benjamin Franklin--Autobiography and Personal Reminiscences of.... Bost., 1892. 1st ed. $20.00

--The Military Profession in U.S.... N.Y., 1839. $30.00
(disbound)

Butler, Charles--The American Lady. Phila., 1836. 1st ed.
$75.00 (foxing)

Butler, David F.--U.S. Firearms. Harrisburg, 1971. $15.00

Butler, Ellis Parker--Mike Flannery On Duty and Off. N.Y.,
1909. $10.00 (name on endpaper)

Butler, John Wesley--Sketches of Mexico. N.Y., 1894. $12.50

Butler, Joseph T.--American Antiques.... N.Y., (1965).
$15.00

Butler, Ovid McOuat--American Conservation in Picture and
in Story. Wash., 1935. 1st ed. $10.00

Butler, Ruth Lapham--Doctor Franklin, Postmaster General.
Garden City, 1928. 1st ed. $20.00

Butler, William--Mexico in Transition. N.Y., 1892. $12.50
(plate loose, ex-lib.)

Butt, Archibald Willingham--The Letters of Archie Butt.
Garden City, 1924. 1st ed. $10.00 (lettering dull)

Butterfield, Consul Willshire--History of the Discovery of the
Northwest.... Cinci., 1881. 1st ed. $65.00 (orig. cloth,
lib. stamp on title)

--Washington-Irvine Correspondence. Madison, 1882. 1st ed.
$150.00 (orig. cloth)

Butterfield, Roger Place--The American Past. N.Y., (1947).
1st ed. $12.50

Butterworth, Hezekiah--South America. N.Y., 1904. $10.00
(spine faded)

Butts, Francis Banister--The Monitor and the Merrimac. Prov.,
1890. $10.00

Byam, George--Wild Life in the Interior of Central America.
Lond., 1849. $150.00 (orig. cloth, binding a bit worn)

Byars, William Vincent--"An American Commoner." S.L.,
(1900). $20.00

Bye, John O.--Back Trailing in the Heart of the Short-Grass
Country. (Everett, Wa., 1956). $50.00 (signed by author)

Byrd, Richard Evelyn--Alone. N.Y., 1938. 1st ed. $12.50
(signed copy)

--Little America. N.Y., 1930. 1st ed. $25.00 (cloth)

--Skyward. N.Y., 1928. 1st ed. $10.00 (1st issue)

Byrd, Sigman--Sig Byrd's Houston. N.Y., 1955. $6.00

Byrd, William--Another Secret Diary of William Byrd of West-
over, 1739-1741. Rich., 1942. $15.00

Byrne, Bernard James--A Frontier Army Surgeon. N.Y.,
(1962). $7.50

Byrnes, Thomas F.--Professional Criminals of America. N.Y.,
(1886). $400.00 (half leather)

- C -

Cabell, Branch
See: Cabell, James Branch
Cabell, James Branch--The Eagle's Shadow. N.Y., 1904. 1st
ed. $750.00 (orig. cloth, slipcased)
--The First Gentleman of America.... N.Y., (1942). $25.00
(orig. cloth, edges lightly worn)
--Jurgen. N.Y., 1919. $12.50
--The Line of Love. N.Y., 1905. 1st ed. $275.00 (cloth,
spine faded)
--The St. Johns. N.Y., (1943). $15.00
--Special Delivery. N.Y., 1933. $35.00 (orig. cloth, corners
and edges lightly worn)
--Works. N.Y., 1927-30. 18 vols. $750.00 (one of 1590
sets, each vol. signed by author)
Cabeza de Vaca, Alvar Nunez--The Journey of Alvar Nunez
Cabeza de Vaca. Chi., 1964. $25.00
--Relation That Alvar Cabeza de Vaca Gave. S.F., 1929.
$400.00 (orig. boards, one of 300 copies)
--Spanish Explorers in the Southern U.S., 1528-1543
See under Title
Cable, George Washington--The Grandissimes. N.Y., 1880.
$250.00 (orig. gilt-decorated blue cloth, white endpapers
printed in brown), $100.00 (orig. cloth)
--Old Creole Days. N.Y., 1879. 1st ed. $350.00 (orig.
cloth, bookplate of Joan Whitney, slipcased)
N.Y., 1897. $60.00 (one of 204 numbered copies, owner
inscription, crown of spine lightly chipped)
Cadwallader, Sylvanus--Three Years With Grant. N.Y., 1955.
1st ed. $16.50
Cady, Edwin Harrison--The Gentleman in America. (Syracuse,
1949). 1st ed. $15.00
--John Woolman. N.Y., 1966. $10.00
Cady, John F.--Foreign Intervention in the Rio De La Plata....
Phila., 1929. $15.00 (ex-lib. stamps)
Caemmerer, Hans Paul--Manual on the Origin and Development
of Washington. Wash., 1939. $17.50
--Washington, the National Capital. Wash., 1932. $37.50
Caen, Herbert Eugene--Only in San Francisco. Garden City,
1960. $8.50

Caesar, Gene--Incredible Detective. Englewood Cliffs, (1968).
 $12.00, $7.50
--King of the Mountain Men. N.Y., 1961. $30.00
Cahill, Holger--American Folk Art. N.Y., 1932. $35.00
 (wraps., worn at edges)
Cahn, William--A Matter of Life and Death. N.Y., (1970).
 $12.50
--A Pictorial History of American Labor. N.Y., 1972. $17.50
Cairn, James--Heart of Hollywood. Lond., 1945. $12.50
Cairns, Mary Lyons--Grand Lake: Pioneers. Denver, 1946.
 1st ed. $20.00 (signed)
Calamity Jane--Life and Adventures of.... N.p., 1896.
 $10.50 (wraps.)
Calder, Isabel MacBeath--Colonial Captivities, Marches and
 Journeys.... N.Y., 1935. 1st ed. $35.00 (orig. cloth)
Calderon de la Barca, Frances (Inglis)--Life in Mexico....
 N.Y., 1946. $7.50 (top of spine worn)
 Mexico, 1952. $15.00 (calf)
--La Vida en Mexico.... Mexico, 1959. 2 vols. $20.00
Caldwell, Bettie D.--Founders and Builders of Greensboro....
 Greensboro, N.C., 1925. 1st ed. $15.00 (signed by au-
 thor)
Caldwell, Cyril Cassidy--Henry Ford. N.Y., (1947). $15.00
Caldwell, Erskine--Kneel to the Rising Sun. N.Y., 1935.
 1st ed. $10.00 (cloth, deluxe ed., one of 300 signed cop-
 ies)
--Southways. N.Y., 1938. 1st ed. $20.00 (spine lightly
 faded)
Caldwell, J.R.--A Hitory of Tama County, Iowa. Chi., 1910.
 2 vols. $75.00
Caldwell, Martha Bell--Annals of Shawnee Methodist Mission....
 Topeka, 1939. 1st ed. $15.00 (wraps.)
Calhoun, Arthur Wallace--A Social History of the American
 Family From Colonial Times to the Present. Cleve., 1917-
 19. 3 vols. 1st ed. $125.00 (cloth)
Calhoun, James S.--The Official Correspondence of James S.
 Calhoun While Indian Agent. Wash., 1915. $75.00 (front
 endpaper cracked)
Calhoun, John Caldwell--Life of John C. Calhoun. N.Y., 1843.
 $15.00 (boards, ex-lib., rubbed and spine torn)
Calkins, Ernest Elmo--"And Hearing Not--".... N.Y., 1946.
 $15.00
--They Broke the Prairie. N.Y., 1937. 1st ed. $12.50
Callacott, George H.--History in the U.S. Balt., (1970).
 $8.00

Callahan, James Morton--American Foreign Policy in Canadian
Relations. N.Y., 1937. $17.50

Callahan, North--Daniel Morgan, Ranger of the Revolution.
N.Y., (1961). 1st ed. $12.50 (bookplate)

--Henry Knox, George Washington's General. N.Y., (1958).
$15.00, $8.50

Callan, Louise--The Society of the Sacred Heart in North
America. Lond., 1937. $40.00 (slight dampstain at the
top)
N.Y., 1937. $25.00

Callcott, Maria (Dundas) Graham--Diario de mi Residencia en
Chile en 1822. Santiago de Chile, (1956). $10.00 (loose
in wraps., some ink underlining)

Callcott, Wilfrid Hardy--Church and State in Mexico.... Dur-
ham, (1926). 1st ed. $10.00 (ex-lib.)

--Liberalism in Mexico, 1857-1929. Hamden, Ct., 1965. $10.00
(ex-lib., stamps)

Calleros, Cleofas--The Mother Mission (El Paso, Tx.), 1952.
$15.00

Calles, Plutarco Elias--Mexico Before the World. N.Y., 1927.
$10.00 (wraps., corner missing from first few pages)

Calmon, Pedro--Historia Social do Brasil. Sao Paulo, 1937-39.
2 vols. of 3. $20.00

Calverton, Victor Francis--Where Angels Dared to Tread.
Ind., (1941). 1st ed. $20.00

Calvin, Ross--River of the Sun. Albuquerque, 1946. $35.00

--Sky Determines. Albuquerque, (1948). $25.00, $15.00

Cameron, Edward Hugh--Samuel Slater, Father of American
Manufactures. (Freeport, Me., 1960). $12.50

Cameron, Frank J.--Hungry Tiger. N.Y., (1964). $12.50

Cameron, John--John Cameron's Odyssey. N.Y., 1928.
$15.00, $12.50

Cameron, Roderick--Pioneer Days in Kansas. Belleville, Ks.,
(1951). $15.00

Cameron, Roderick William--Viceroyalities of the West. Bost.,
(1968). $20.00, $10.00

Camp, Charles Lewis--Desert Rats. (Berkeley), 1966. 1st
ed. $25.00

--Earth Song. Berkeley, 1952. 1st ed. $21.00 (boards)

--George C. Yount and His Chronicles of the West
See: Yount, George Calvert

--Journal and Letters From the Mines.
See: Doble, John

--Narrative of a Cruize....
See: White, Philo

Camp Travis and Its Part in the World War. N.Y., 1919.
$35.00

Camp, William Martin--San Francisco. Garden City, 1948.
$15.00

Campbell, Albert H.--Pacific Wagon Roads. Wash., 1859.
$225.00 (cloth)

Campbell, Charles--History of the Colony and Ancient Dominion
of Virginia. Phila., 1860. $50.00 (spine repaired with
tape)

Campbell, Douglas--The Puritan in Holland, England and
America. N.Y., 1892. 2 vols. 1st ed. $10.00

Campbell, Helen Jones--Confederate Courier. N.Y., (1964).
1st ed. $20.00

Campbell, Helen Stuart--Darkness and Daylight. Hart., 1896.
$22.50

(Campbell, Henry Colin)--Wisconsin in Three Centuries....
N.Y., (1906). 4 vols. $75.00

Campbell, Horace Wilbert--A Short History of California.
Phila., (1949). $8.50

Campbell, Jane--Old Philadelphia Music. Phila., 1926. $7.50

Campbell, John Francis--A Short American Tramp in the Fall
of 1864.... Edinburgh, 1865. 1st ed. $125.00 (orig.
cloth)

Campbell, Mary Emily (Robertson)--The Attitude of Tennes-
seans Toward the Union, 1847-1861. N.Y., 1961. $10.00

Campbell, Murray--Herbert H. Dow, Pioneer in Creative Chem-
istry. N.Y., (1951). 1st ed. $12.00

Campbell, Robert E.--I Would Do It Again. Toronto, 1959.
$7.50

Campbell, Thomas Joseph--Pioneer Laymen of North America.
N.Y., 1915. 2 vols. $22.50 (ex-lib.)

Campbell, Thomas Nolan--The Payaya Indians of Southern
Texas. San Antonio, 1975. $5.00 (owner name)

Campbell, Walter S.--The Book Lover's Southwest. Norman,
(1955). $25.00

Campbell, William Bucke--Old Towns and Districts of Philadel-
phia. (Phila.), 1942. $10.00 (wraps.)

Campbell, William Carey--A Colorado Colonel and Other Sketches
Topeka, n.d. $17.50

Campbell, William W.--Annals of Tryon County. N.Y., 1924.
$30.00

Campbell, William Wilfred--Canada. Lond., 1907. $30.00
(cloth)

Campos, Ruben M.--El Folklore y la Musica Mexicana. Mexico,
1928. $75.00 (orig. boards that are foxed)

Canby, Courtlandt--Lincoln and the Civil War. N.Y., 1960. $10.50

Canedo, Lino Gomez--Primeras Exploraciones y Poblamento de Texas.... Monterey, 1968. $125.00 (orig. wraps., one of 500 copies)

Canham, Erwin D.--Commitment to Freedom. Bost., 1958. $15.00 (cloth, 1st printing, inscribed and signed by author)

Cannon, Frank Jenne--Brigham Young and his Mormon Empire. N.Y., (1913). $21.50

--Under the Prophet in Utah. Bost., 1911. 1st ed. $35.00, $30.00 (light staining on cover)

Cannon, George Quayle--The Life of Joseph Smith, the Prophet. S.L.C., 1888. 1st ed. $50.00 (calf)

Cannon, George William--The First Casting Must Be Good. Muskegon, Mi., 1964. $15.00

Cannon, James Patrick--The History of American Trotskyism. N.Y., 1944. $5.00 (orig. wraps., ex-lib.)

Cannon, Miles--Waiilatpu.... Boise, Id., 1915. 1st ed. $35.00 (wraps.), $20.00 (wraps.)

Canse, John Martin--Pilgrim and Pioneer. N.Y., (1930). $11.50

Cant, Gilbert--America's Navy in World War II. N.Y., (1943). $12.50

Canton, Frank M.--Frontier Trails. Bost., 1930. 1st ed. $48.50

Cantor, Bert--The Bernie Cornfield Story. N.Y., (1970). $10.00

Cantor, Eddie--My Life is in Your Hands. N.Y., 1928. 1st ed. $12.50 (cloth, lightly worn)

Cantwell, Robert--Alexander Wilson. Phila., (1961). $45.00

Capen, Oliver Bronson--Country Homes of Famous Americans. N.Y., 1905. $20.00

Capers, Gerald Mortimer--John C. Calhoun, Opportunist. Gainesville, 1960. $20.00

Capote, Truman--A Christmas Memory. N.Y., (1966). $20.00 (cloth and boards, slipcased)

--The Grass Harp. N.Y., (1951). $60.00 (bookplate)

--In Cold Blood. N.Y., (1965). 1st ed. $150.00 (cloth, one of 500 signed copies), $20.00, $10.00 (cloth)

--The Thanksgiving Visitor. N.Y., (1967). 1st ed. $40.00 (boards, boxed)

The Capture of Havana in 1762.... (Camb.), 1898. $15.00 (lacks back wrap. and part of spine)

Caraman, Philip--The Lost Paradise. N.Y., 1976. $15.00, $10.00, $10.00

Carbia, Romulo D.--La Cronica Oficial de las Indias Occiden-
tales. La Plata, 1934. 1st ed. $35.00 (orig. wraps. bound
in)
Carden, Maren Lockwood--Oneida. Balt., (1969). $17.50
Cardinell, Charles--Adventures on the Plains. S.F., 1922.
$75.00 (orig. wraps., one of 150 copies)
Cardozo, Efraim--El Imperio del Brasil.... Buenos Aires, 1961.
$12.50 (wraps.)
Cardozo, Jacob Newton--Reminiscences of Charleston. Charles-
ton, 1866. 1st ed. $150.00 (orig. wraps., lib. stamp, in-
scribed)
Carey, Arthur A.--Memoirs of a Murder Man. Garden City,
1930. $12.50, $12.00 (covers soiled)
Carey, Arthur Merwyn--American Firearms Makers. N.Y.,
(1953). $15.00 (cloth), $12.50
[Carey, Mathew]--The Olive Branch. Phila., 1815. $45.00
(boards, calf spine)
Cargill, John F.--The Big-Horn Treasure. Chi., 1897. $15.00
(one page damaged and mended)
Carillo, Carlos Antonio--Exposition Addressed to the Chamber
of Deputies of the Congress of the Union.... S.F., 1938.
$25.00 (boards, one of 650 copies on handmade paper)
Carleton, George Washington--Our Artist in Cuba. N.Y.,
1865. 1st ed. $85.00 (cloth faded, contemp. ink inscrip-
tion)
Carleton, James Henry--The Battle of Buena Vista.... N.Y.,
1848. 1st ed. $200.00 (orig. cloth, scattered light foxing,
previous owner's inscription)
Carley, Kenneth--Minnesota in the Civil War. Minne., 1961.
$12.50, $5.00
Carlisle, William L.--Bill Carlisle, Lone Bandit. Pasadena,
1946. 1st ed. $37.50
Carlson, John Roy, pseud.
See: Derounian, Arthur
Carleton, James Henry--The Prairie Logbooks. Chi., 1943.
1st ed. $85.00 (untrimmed)
Carmagnani, Marcello--El Salariado Minero en Chile Colonial.
(Santiago), 1963. $15.00 (wraps.)
Carman, Bliss--Behind the Arras. Bost., 1895. 1st ed.
$50.00 (signed by author, orig. boards, spine faded, front
cover lightly stained, bookplates)
Carman, Harry James--Jesse Buel, Agricultural Reformer.
N.Y., 1947. $20.00
Carmer, Carl Lamson--Dark Trees to the Wind. N.Y., (1949).
$6.50 (cloth)

--The Hudson, N.Y., (1939). 1st ed. $15.00
 Lond., (1951). $7.50
--My Kind of Country. N.Y., (1966). $7.50 (cloth)
--The Susquehanna. N.Y., 1955. 1st ed. $15.00 (spine
 faded)
Carnegie, Andrew--Autobiography of.... Bost., 1920. 1st
 ed. $20.00, $15.00. Camb., 1920. $15.00 (cloth)
--The Empire of Business. N.Y., 1902. 1st ed. $25.00
 (rubbed)
 Garden City, 1933. $12.50
--James Watt. N.Y., 1905. 1st ed. $25.00 (spine faded)
--Triumphant Democracy. N.Y., 1888. $12.00 (covers water-
 stained)
Carosso, Vincent P.--Investment Banking in America. Camb.,
 1970. $20.00
Carpenter, Frank D.--Adventures in Geyser Land. Caldwell,
 1935. $75.00
Carpenter, Frank George--The Tail of the Hemisphere.
 Garden City, 1923. 1st ed. $7.50 (binding lettering
 badly worn)
Carpenter, Liz--Ruffles and Flourishes. Garden City, 1970.
 1st ed. $20.00 (signed presentation copy)
Carpenter, Will Tom--Lucky 7. Austin, (1957). $17.50
Carpentier, Alejo--La Musica en Cuba. Mexico, (1946). 1st
 ed. $15.00 (owner stamp)
Carpio Castillo, Ruben--Mexico, Cuba y Venezuela. Caracas,
 1961. $12.50
Carr, Albert Z.--The World and William Walker.... N.Y.,
 (1963). 1st ed. $10.00
Carr, Archie--The Windward Road. N.Y., 1956. $8.00
Carr, Charles Carl--Alcoa.... N.Y., 1952. 1st ed. $10.00
 $10.00
Carr, Harry--Los Angeles.... N.Y., 1935. $27.50
--Old Mother Mexico. Bost., 1931. $11.50 (author auto-
 graphed, binding stained), $5.00
--The West is Still Wild. Bost., 1932. $10.00 (inscribed),
 $7.50 (spine label faded, owner name), $5.00
Carr, William H.A.--From Three Cents a Week. Englewood
 Cliffs, 1975. $12.50
--The Du Ponts of Delaware. N.Y., (1964). $15.00 (ex-lib.)
Carr, William Henry--Desert Parade. N.Y., 1947. $7.50
Carrigan, Wilhelmina Bruce--Captured by the Indians....
 (Buffalo Lake, Mn., 1912) $60.00
Carrington, Henry Beebe--The Indian Question. Bost., 1909.
 $32.50. N.Y., 1973. $15.00 (one of 500 copies), $10.00 (one
 of 500 copies)

--Letter From the Acting Secretary of the Interior.... Relative to Indian Operations on the Plains. Wash., 1887. $75.00 (disbound)

(Carrington, Margaret Irvin [Sullivant])--Ab-Sa-Ra-Ka, Home of the Crows. Phila., 1868. 1st ed. $125.00 (bookplate, lacks title corner)
Chi., 1950. $27.50

Carroll, Gordon, ed.--The Desolate South....
See: Trowbridge, John Townsend

Carroll, John Melvin--The Black Military Experience in the American West. N.Y., (1971). $20.00

Carse, Robert--Blockade. N.Y., (1958). $17.50, $16.50

--Rum Row. N.Y., (1959). 1st ed. $8.50

Carson, Christopher--Kit Carson's Autobiography. Chi., 1935. $10.00 (orig. cloth)

--Kit Carson's Own Story of His Life.... Taos, N.M., 1926. $125.00 (signed by the editor)

Carson, Gerald--Cornflake Crusade. N.Y., (1957). $17.50, $12.50

--The Social History of Burbon. N.Y., (1963). $10.00

Carson, James H.--Recollections of the California Mines. Oakland, 1950. $31.50 (one of 750 copies). $30.00 (orig. boards, limited to 750 copies)

Carson, Kit
See: Carson, Christopher

Carter, Boake--Made in U.S.A. N.Y., (1938). $16.00 (signed)

Carter, Clarence Edwin, ed.--The Territory of Louisiana-Mississippi....
See under Title

Carter, E.S.--The Life and Adventures of E.S. Carter.... St. Joseph, Mo., 1896. 1st ed. $1250.00 (orig. wraps., half morocco case)

Carter, Henry Lewis--Dear Old Kit. (Norman, 1968). 1st ed. $45.00

Carter, Hodding--The Angry Scar. Garden City, (1959). 1st ed. $12.50

--Doomed Road of Empire. N.Y., (1963). $18.00

Carter, John Franklin--American Messiahs. N.Y., 1935. $7.00

Carter, Samuel--Blaze of Glory. N.Y., (1971). $9.95

--Cherokee Sunset. Garden City, 1976. $10.00

--Cyrus Field. N.Y., (1968). $15.00

Carter, Thomas P.--Mexican Americans in School. N.Y., 1970. 1st ed. $15.00

Carter, William--Middle West Country. Bost., 1975. $28.50

Caruso, John Anthony--The Mississippi Valley Frontier. Ind.,
(1966). $15.00

Carvajal, Gaspar de--The Discovery of the Amazon.... N.Y.,
1934. 1st ed. $50.00, $30.00
N.Y., 1934. $20.00

Carver, Jonathan--Three Years' Travels Throughout.... the
Interior Parts of North America.... Walpole, 1813. $50.00

--Travels Through the Interior Parts of North-America....
Lond., 1778. 1st ed. $950.00 (half calf)

Cary, Seth Cooley--John Cary the Plymouth Pilgrim. Bost.,
1911. $12.00

Casas, Barlotome de las--An Account of the First Voyages
Made by the Spaniards in America.... Lond., 1699.
$750.00 (calf, rebacked, browning and foxing, some tape
repairs)

--Historia de las Indias. Mexico, 1877. 2 vols. $300.00
(some foxing)

Casasola, Gustavo--Historia Grafica de la Revolucion Mexicana,
1900-1960. Mexico, 1967. 4 vols. $250.00 (orig. cloth)

Case of the Black Warrior, and Other Violations of the Rights
of American Citizens by Spanish Authorities. Wash., 1854.
$50.00 (half morocco)

Case, Robert Ormond--Last Mountains. Garden City, 1945.
1st ed. $12.50

Casebier, Dennis G.--The Battle at Camp Cady. Norco, Ca.,
1972. $5.00

Casey, Robert Joseph--The Black Hills and Their Incredible
Characters. Ind., (1949). $33.50, $25.00

--Mr. Clutch.... Ind., (1948). 1st ed. $16.00, $10.00

--Pioneer Railroad. N.Y., (1948). $20.00 (small mark on
front cover), $18.00

--The Texas Border.... Ind., (1950). $26.50

Cassini, Igor--I'd Do it all Over Again. N.Y., 1977. $10.00

Cassity, John Holland--The Quality of Murder. N.Y., 1958.
$8.00

Casson, Herbert Newton--Cyrus McCormick. Freeport (1971).
$12.00

--The Romance of Steel. N.Y., 1907. $30.00

Castaneda, Carlos Eduardo--The Mexican Side of the Texas
Revolution.... Dallas, (1928). 1st ed. $125.00 (orig.
cloth)

Castel, Albert E.--A Frontier State at War. Ithaca, (1958).
$20.00, $12.50 (ex-lib.)

Castle, Henry Anson--The Army Mule and Other War Sketches.
Ind., 1898. 1st ed. $25.00 (orig. cloth, ex-lib.)

--History of St. Paul and Vicinity. Chi., 1912. 3 vols.
 $35.00
Castleman, John Breckinridge--Active Service. Lou., 1917.
 1st ed. $100.00
Castro, Fidel--Aniversarios del Triunfo de la Revolucion Cu-
 bana. Havana, (1967). $12.00 (wraps.)
--Esos Son Nuestros Caminos. (Havana, 1968). $6.00 (wraps.)
--Fidel in Chile. N.Y., (1972). $12.50
--La Historia Me Absolvera. (Havana, 1961). $6.00
Castro, Josue--Death in the Northeast. N.Y., (1966). 1st
 ed. $12.50, $7.00
Castro y Oyanguren, Enrique--Entre el Peru y Chile. Lima,
 1919. $20.00 (wraps.)
Caswell, John Edwards--Arctic Frontiers. Norman, (1956).
 $25.00
Caswell, Maryanne--Pioneer Girl. Toronto, (1964). $20.00
 (cloth)
Cate, Wirt Armistead--Two Soldiers. Chapel Hill, 1938. 1st
 ed. $27.50
Catesby, Mark--The Natural History of Carolina, Florida, and
 the Bahama Islands. Savannah, 1974. $295.00 (cloth)
Cather, Thomas--Journal of a Voyage to America in 1836.
 (Lond., 1955). $19.50 (boards)
Cather, Willa--April Twilights and Other Poems. N.Y., (1923).
 $150.00 (1st ltd. edition of 450 numbered copies, signed)
--Death Comes for the Archbishop. Lond., (1929). $75.00
 (owner's name on front fly, light fading to spine)
--Sapphira and the Slave Girl. N.Y., 1940. 1st ed. $15.00
 (name on endpaper), $8.50
--Shadows on the Rock. N.Y., 1931. 1st ed. $15.00 (cloth)
Catlin, George--Catlin's Notes of Eight Years' Travels and
 Residence in Europe.... Lond., 1848. 2 vols. $600.00
 (cloth)
--A Descriptive Catalogue of Catlin's Indian Collection. Lond.,
 1848. $300.00
--Last Rambles Amongst the Indians of the Rocky Mountains
 and the Andes. Lond., 1868. $125.00 (contemp. calf)
--Letters and Notes of the Manners, Customs, and Condition
 of the North American Indians. Lond., 1841. 2 vols.
 1st ed. $750.00 (orig. cloth, light outer wear and foxing
 to a few plates)
 Lond., 1842. 2 vols. $350.00 (rebound in half calf)
--North American Indians. Edin., 1903. 2 vols. $100.00
 (cloth)
 Edin., 1926. 2 vols. $400.00 (contemp. three-quarter mo-
 rocco)

Catterall, Ralph Charles Henry--The Second Bank of the
 United States. Chi., 1903. $35.00
Catton, Bruce--The American Heritage Picture History of the
 Civil War. N.Y., (1960). 2 vols., incl. index. $45.00
 (slipcased)
--The Army of the Potomac. Garden City, 1951-62. 3 vols.
 $22.50
--The Battle of Gettysburg
 See: Haskell, Franklin Aretas
--Glory Road. Garden City, 1955. $12.50
--Grant Moves South. Bost., (1960). $12.50
--Grant Takes Command. Bost., (1969). 1st ed. $14.50
--Mr. Lincoln's Army. Garden City, 1954. $13.50
--A Stillness at Appomattox. Garden City, 1953. $13.50
--This Hallowed Ground. Garden City, 1956. 1st ed. $10.00
--The War Lords of Washington. N.Y., (1948). 1st ed.
 $12.50
Catton, William Bruce--Two Roads to Sumter. N.Y., (1963).
 $13.50
Caughey, John Walton--The American West, Frontier & Region.
 L.A., (1969). $12.50
--Gold is the Cornerstone. Berkeley, 1948. 1st ed. $20.00
--History of the Pacific Coast. L.A., 1933. $10.00 (cloth,
 inking)
--Hubert Howe Bancroft.... Berkeley, 1946. 1st ed. $35.00,
 $24.50, $12.50
Caught in the Act. Moscow, 1963. $25.00 (wraps.)
La Causa Chicana. N.Y., (1972). $12.50
Cawelti, John G.--The Six-Gun Mystique. Bowling Green,
 1970. $10.00
Celesia, Ernesto H.--Rosas: Aportes Para su Historia. Buenos
 Aires, 1954. $30.00
Celiz, Fray Francisco--Diary of the Alarcon Expedition Into
 Texas, 1718-1719. L.A., 1935. $150.00
Cendrars, Blaise--Sutter's Gold. N.Y., 1926. 1st ed.
 $15.00 (boards, lightly worn), $6.00
Ceplecha, Christian--The Historical Thought of Jose Ortega y
 Gasset. Wash., 1958. 1st ed. $25.00
Cervantes de Salazar, Francisco--Cartas Recibidas de Espana.
 Mexico, 1946. $15.00
--Mexico en 1554. Mexico, 1964. $7.50 (wraps.)
Cespedez Bedregal, J. Teofilo--La Revolucion Peruana. Lima,
 1973. $10.00 (wraps.)
Chabot, Frederick Charles--San Antonio and its Beginnings.
 San Antonio, 1936. $15.00 (wraps.)

Chace, Elizabeth (Buffum)--Two Quaker Sisters. N.Y.,
(1937). $20.00
Chadbourne, Walter Whitemore--A History of Banking in
Maine.... Orono, 1936. $12.00
Chadwick, Edward Marion--The People of the Longhouse.
Toronto, 1897. $50.00 (orig. cloth, uncut)
Chadwick, French Ensor--The Gravis Papers and Other Docu-
ments Relating to the Naval Operations of the Yorktown
Campaign.... N.Y., 1916. $22.50 (orig. boards, one of
650 copies)
Chadwick, John White--Theodore Parker.... Bost., 1900.
1st ed. $12.50
Chafee, Zechariah--Free Speech in the U.S. Camb., 1946.
$15.00
Chafetz, Henry--Play the Devil.... N.Y., (1960). $7.50
(1st printing)
Chaffin, Lorah B.--Sons of the West. Caldwell, 1941. $36.50
(pages lightly warped)
Chaffin, Yule M.--Koniag to King Crab, Alaska's Southwest.
N.p., 1968. $15.00
Chalfant, Harry Malcolm--Father Penn and John Barleycorn.
Harrisburg, Pa., (1920). $10.00
Chalfant, Willie Arthur--Death Valley. Stanford, (1936).
$15.00 (cloth)
--Gold, Guns & Ghost Towns. Stanford, (1947). 1st ed.
$25.00
Chamberlain, Robert Stoner--The Conquest and Colonization
of Honduras.... Wash., 1953. 1st ed. $10.75 (wraps.)
Chamberlain, Samuel Emery--My Confession. N.Y., 1956.
1st ed. $200.00 (cowhide, one of 50 numbered copies),
$30.00 (trade ed.), $17.50 (one of 500 copies), $15.00,
$10.00, $10.00
--Recollections of a Rogue.... Lond., 1957. $30.00
Chamberlain, William Henry--History of Sutter County, Cali-
fornia. Berkeley, 1974. $20.00
Chambers, Andrew Jackson--Recollections. N.p., 1947. 1st
ed. $125.00 (half morocco)
Chambers, Julius--The Mississippi River and its Wonderful
Valley. N.Y., 1910. 1st ed. $12.50 (ex-lib.)
Chambers, Walter--Samuel Seabury. N.Y., (1932). $8.50
Chambers, William--Sketch of the Life of Gen. T.J. Chambers
of Texas. Galveston, 1853. 1st ed. $1000.00 (calf, title
foxed)
Chambers, William Nisbet--Old Bullion Benton.... Bost.,
(1956). 1st ed. $15.00, $10.00, $10.00

Chambrun, Charles Adolphe de Pineton--The Executive Power
in the U.S. Lancaster, Pa., 1874. $17.50
--Impressions of Lincoln and the Civil War. N.Y., (1952).
$16.00
Chandler, Billy Janes--The Bandit King; Lampiao of Brazil.
College Station, 1978. $17.50
Chandler, Charles de Forest--How Our Army Grew Wings.
N.Y., (1943). 1st ed. $35.00
Chandler, Joseph Everett--The Colonial House. N.Y., 1916.
1st ed. $30.00
Chandler, Lester Vernon--Benjamin Strong.... Wash., 1958.
1st ed. $15.00
Chandler, Peleg Whitman--American Criminal Trials. N.Y.,
(1970). 2 vols. $25.00
Chandler, Raymond--The High Window. N.Y., 1942. 1st ed.
$250.00 (cloth)
--The Midnight Raymond Chandler. Bost., 1971. $12.50 (1st
printing)
Chandler, Wilfred
See: Campbell, William Wilfred
Chandless, William--A Visit to Salt Lake. Lond., 1857. 1st
ed. $250.00 (backstrip wearing and fading), $200.00
(cloth, somewhat spoiled, edges of spine frayed), $175.00
(covers lightly soiled)
Channing Edward Tyrell--Lectures Read to the Seniors in
Harvard College. Bost., 1856. 1st ed. $15.00 (spine ends
worn, corners rubbed)
Channing, William Ellery--Thoreau, the Poet-Naturalist. Bost.,
1873. 1st ed. $35.00 (spine chipped)
Chanute, Octave--The Kansas City Bridge, N.Y., 1870.
$200.00 (orig. cloth, lightly worn and stained)
Chapelle, Howard Irving--The History of the American Sailing
Navy. N.Y., (1949). 1st ed. $35.00
--The History of the American Sailing Ships. N.Y., 1935.
1st ed. $47.50 (binding lightly stained)
Chapin, Edwin Hubbell--Moral Aspects of City Life. N.Y.,
1854. $15.00
Chapin, Gardner B.--Tales of the St. Lawrence. Montreal,
1873. 1st ed. $40.00 (orig. cloth, rebacked, new end-
papers)
Chapin, William--Wasted. N.Y., (1972). $6.00 (ex-lib.)
Chaplin, Ralph--Wobbly.... Chi., (1948). 1st ed. $17.50
Chapman, Arthur--Out Where the West Begins.... Bost., 1917.
1st ed. $5.00
--The Pony Express. N.Y., 1932. 1st ed. $40.00, $25.00

Chapman, Charles Edward--Colonial Hispanic America. N.Y.,
　　1933. 1st ed. $45.00 (orig. cloth), $8.00 (ex-lib.)
--A History of the Cuban Republic. N.Y., 1927. $15.00
　　(ex-lib.)
Chapman, Frank Michler--Color Key to North American Birds.
　　N.Y., 1912. $10.00 (cloth, some wear extremities)
Chapman, Isaac A.--A Sketch of the History of Wyoming.
　　Wilkesbarre, Pa., 1830. 1st ed. $100.00 (orig. calf)
Chapman, John Arthur--Tell it to Sweeney.... Garden City,
　　1961. 1st ed. $12.50
Chapman, Walker--The Golden Dream. Ind., (1967). $10.00,
　　$8.95
Chapman, Wendell--Wilderness Wanderers. N.Y., 1937.
　　$10.00
Chappell, Absalom Harris--Miscellanies of Georgia.... At-
　　lanta, (1900). $45.00 (orig. cloth)
Chappell, Edward--Narrative of a Voyage to Hudson's Bay....
　　Lond., 1817. 1st ed. $650.00 (contemp. half morocco)
Chaput, Donald--Francois X. Aubry. Glendale, 1975. $35.00,
　　$30.00 (cloth), $15.50
Chardon, Francis A.--Chardon's Journal at Fort Clark....
　　Pierre, S.D., 1932. $38.50
Charlevoix, Pierre Francois Xavier de--Histoire du Paraguay.
　　Paris, 1756. 3 vols. 1st ed. $750.00 (contemp. calf,
　　minor shelf wear and title of one vol. mended)
Charnay, Desire--The Ancient Cities of the New World. N.Y.,
　　1887. 1st ed. $150.00 (cloth, small ink mark on cover)
Charnwood, Godfrey Rathbone Benson--Abraham Lincoln. To-
　　ronto, 1920. $11.50
--Theodore Roosevelt. Bost., 1923. $8.00
Charters, Dean--Mountie, 1873-1973. Toronto, 1973. $9.00
Chasan, Daniel Jack--Klondike '70. N.Y., (1971). $7.00
Chase, Allan--Falange. N.Y., (1943). $12.50
Chase County Historical Sketches. (Cottonwood Falls, Ks.),
　　3 vols. 1940-66. $125.00
Chase, Harold Beverly--Auto-Biography. N.Y., (1955).
　　$12.00
Chase, J. Smeaton--Cone-Bearing Trees of the California
　　Mountains. Chi., 1911. 1st ed. $20.00 (orig. cloth)
Chase, Stuart--Mexico; a Study of Two Americas. N.Y.,
　　1931. 1st ed. $11.50, $7.50
Chatterton, Edward Keble--Captain John Smith. N.Y., 1927.
　　$10.00 (small gash and stain on back cover)
Chatterton, Fenimore--Yesterday's Wyoming. (Aurora, Co.),
　　1957. $35.00 (ltd. ed.)

Chatwin, Bruce--In Patagonia. N.Y., 1977. $6.50
Chavero, Alfredo, ed.--Obras Historicas de Don Fernando....
 See: Ixtlilxochitl, Fernando de Alva
Chavez Orozco, Luis--Bibliografia de Zacatecas.... Mexico,
 1932. $50.00 (half calf)
Chazanof, William--Welch's Grape Juice. Syracuse, 1977.
 $20.00
Cheever, John--Bullet Park. N.Y., 1969. 1st ed. $35.00
 (cloth, signed)
--Falconer. N.Y., 1977. $15.00 (cloth)
Cheney, Ednah D., ed.--Louisa May Alcott
 See: Alcott, Louisa May
Chennault, Anna--Chennault and the Flying Tigers. N.Y.,
 (1963). $10.00
--A Thousand Springs. N.Y., (1962). 1st ed. $4.00
Cherokee Nation--Constitution and Laws of the Cherokee Na-
 tion. S.L., 1875. 1st ed. $250.00 (calf)
 (Parsons, Ks., 1893). $250.00 (orig. boards, recased,
 with new acid free endsheets)
Chesen, Eli--President Nixon's Psychiatric Profile. N.Y.,
 (1973). 1st ed. $7.50
Chesham, Sallie--Born to Battle. Chi., (1965). $10.00
Chesnut, Mary Boykin Miller--A Diary From Dixie. Bost.,
 (1949). $15.00
 Bost., 1950. $7.50
Chessman, Caryl--Cell 2455; Death Row. Englewood Cliffs,
 (1960). $12.50
Chessman, G. Wallace--Governor Theodore Roosevelt. Camb.,
 1965. $15.00 (cloth)
Chesson, Frederick William--The Atlantic Cables. Lond.,
 1875. 1st ed. $35.00 (orig. wraps.)
Chester, Lewis--An American Melodrama. N.Y., 1969. $10.00
Chevigny, Hector--Lord of Alaska. N.Y., 1942. 1st ed.
 $10.00
--Lost Empire.... N.Y., 1937. 1st ed. $7.50
 Portland, Or., 1958. $12.50
--Russian American; the Great Alaskan Venture, 1741-1867.
 N.Y., 1965. $15.00
The Chicago Anarchists and the Haymarket Massacre
 See: (Bennett, Fremont O.)
Chicago Literary Club--The Chicago Literary Club. Chi.,
 1974. $15.00 (one of 450 copies)
Chicago Woman's Club--Annals of the Chicago Woman's Club....
 See: Frank, Henriette Greenbaum

Chickasaw Nation--Constitution, Laws, and Treaties of the....
 Sedalia, Mo., 1878. 1st ed. $450.00 (one of 300 copies)
Chickering, Jesse--Immigration Into the U.S. Bost., 1848.
 1st ed. $75.00 (self-wraps., sewn as issued)
Chickering, William Henry--Within the Sound of These Waves.
 N.Y., (1941). 1st ed. $16.00, $12.50
Child, Andrew--Overland Route to California. L.A., 1946.
 $33.50
(Child, Francis James)--War-Songs for Freemen. Bost., 1863.
 $12.50 (lacks stitching, wraps. and text loose), $10.00
 (wraps., some browning and staining)
Child, Lydia Maria (Francis)--Isaac T. Hopper. Bost., 1853.
 1st ed. $30.00 (later cloth, some pencil underlining in
 text, inner hinges cracking)
--Letters of Lydia Maria Child.... Bost., 1883. $15.00
Child, Theodore--Les Republiques Hispano-Americaines.
 Paris, (1891). $29.00 (half morocco, a bit worn)
--The Spanish American Republics. N.Y., 1891. $27.50
 (edges and corners rubbed)
Childs, Charles Frederick--Concerning U.S. Government
 Securities. Chi., 1947. $25.00
Childs, Herbert--El Jimmy, Outlaw of Patagonia.... Phila.,
 1936. $40.00 (cloth), $22.50 (bookplate)
Childs, Marquis William--Eisenhower. N.Y., (1958). 1st ed.
 $12.50
--The Farmer Takes a Hand. Garden City, 1952. 1st ed.
 $10.00
Chile. Ejercito--The Capture of Valparaiso in 1891. Lond.,
 1892. $30.00 (wraps., slipcased)
Chinard, Gilbert--Jefferson et les Ideologues.... Balt., 1925.
 1st ed. $20.00 (orig. wraps.)
Chipman, Daniel--The Life of Hon. Nathaniel Chipman....
 Bost., 1846. 1st ed. $30.00
Chipman, Donald E.--Nuno de Guzman and the Province of
 Panuco in New Spain.... Glendale, 1967. $20.00, $12.00,
 $11.00, $9.50 (bookplate)
Chipman, Norton Parker--The Tragedy of Andersonville.
 Sacramento, 1911. $35.00
Chisholm, James--South Pass, 1868. (Lincoln), 1960. 1st ed.
 $25.00 (offsetting to front endpapers), $23.50
Chittenden, Hiram Martin--The American Fur Trade of the Far
 West.... Stanford, 1954. 2 vols. $75.00, $62.50
--Life, Letters, and Travels of Father Pierre-Jean de Smet....
 See: De Smet, Pierre Jean
--The Yellowstone National Park.... Cinci., 1905. $15.00

Chittenden, Lucius Eugene--Personal Reminiscences.... N.Y.,
 1893. 1st ed. $14.50 (ex-lib.)
--An Unknown Heroine.... N.Y., 1893. 1st ed. $10.00,
 $7.50
Chitty, Arthur Ben--Sewanee Sampler. Sewanee, Tn., 1978.
 $12.00 (ex-L.C. copyright duplicate)
Choate, Anne Hyde--Juliet Low and the Girl Scouts. Garden
 City, 1928. 1st ed. $20.00
Chocano, Jose Santos--Spirit of the Andes. Portland, Me.,
 1935. 1st ed. $20.00 (boards, cover faded)
Chrisman, Harry E.--Fifty Years on the Hoot Owl Trail. Chi.,
 1972. $10.00
--Lost Trails of the Cimarron. Denver, (1961). 1st ed.
 $27.50 (signed by author, owner name)
Christ-Janer, Albert--George Caleb Bingham of Missouri.
 N.Y., 1940. $45.00
Christensen, Erwin Ottomar--The Index of American Design.
 Wash., 1950. 1st ed. $15.00 (cloth, 1st printing)
Christman, Enos--One Man's Gold. N.Y., 1930. 1st ed.
 $45.00, $45.00, $25.50 (half buckram), $15.00
Christy, Thomas--Thomas Christy's Road Across the Plains.
 Denver, 1969. $47.50
A Chronicle of Louisiana. N.Y., 1838. $25.00 (wraps., a bit
 soiled, 1 panel lacking)
The Chronicles of America. New Haven, 1918-21. 50 vols.
 $500.00 (leather)
 New Haven, 1924. 50 vols. $200.00
Chronicles of Canada. Toronto, 1922. 32 vols. $600.00 (one
 of 875 sets)
Chrysler, Walter Percy--Life of an American Workman. N.Y.,
 (1950). $10.00, $8.00
Chubb, Thomas Caldecot--If There Were no Losses. N.Y.,
 1957. $12.50
Church, John H.C.--Diary of a Trip Through Mexico and
 California. Pittsfield, 1887. $275.00 (orig. cloth)
Chruchill, Allen--The Splendor Seekers. N.Y., 1974. $12.50
Chute, Marchette Gaylord--The First Liberty. N.Y., 1969.
 1st ed. $10.00
Cipriani, Leonetto--California and Overland Diaries of....
 Portland, Or., 1962. $42.50
Cirerol Sansores, Manuel--Chi Cheen Itsa. (Merida, Yucatan),
 1948. 1st ed. $22 50 (wraps.)
Cist, Charles--Sketches and Statistics of Cincinnati in 1851.
 Cinci., 1851. $45.00 (cover almost detached, some foxing)

City Art Museum of St. Louis--Mississippi Panorama. (S.L.,
 1949). $25.00 (wraps.)
Clampett, Frederick William--Luther Burbank, "Our Beloved
 Infidel." N.Y., 1926. 1st ed. $15.00 (covers spotted,
 bookplate removed)
Clappe, Louise Amelia Knapp Smith--The Shirley Letters From
 California Mines in 1851-52. S.F., 1922. $65.00 (boards,
 one of 450 copies signed by editor)
 N.Y., 1961. $25.00
Clark, Ann (Nolan)--Brave Against the Enemy (Lawrence,
 Ks., 1944). $26.50
Clark, Blake
 See: Clark, Thomas Blake
Clark, C.M.--The Picturesque Ohio. Cinci., 1887. 1st ed.
 $10.00 (worn copy)
Clark, Carroll DeWitt--People of Kansas. Topeka, (1936).
 $15.00 (cloth)
Clark, Charles Edgar--Prince and Boatswain. Greenfield, Ma.,
 (1915). $45.00
Clark, Charles M.--A Trip to Pike's Peak.... San Jose, Ca.,
 1958. $40.00 (boards, one of 500 copies), $38.50 (boards)
Clark, Dan Elbert--The West in American History. N.Y.,
 (1938). $35.00
Clark, Daniel--Proofs of the Corruption of Gen. James Wilkin-
 son.... Phila., 1809. 1st ed. $250.00 (old boards,
 lightly rubbed, ex-lib.)
Clark, Dora Mae--British Opinion and the American Revolution.
 New Haven, 1930. 1st ed. $30.00
Clark, Ella Elizabeth--Indian Legends of the Pacific Northwest.
 Berkeley, 1953. 1st ed. $8.50 (signed by author)
Clark, Elmer Talmage--The Small Sects in America. Nash.,
 (1937). 1st ed. $6.50
Clark, Emmons--History of the Seventh Regiment of New
 York.... N.Y., 1890. 2 vols. $50.00 (rebound in cloth)
Clark Equipment Company--First Fifty Years. (Buchanan, Mi.,
 1953). $17.50
Clark, Galen--Indians of the Yosemite Valley.... Yosemite
 Valley, 1904. $60.00 (cloth), $29.50 (signed by the author)
Clark, George Thomas--Leland Sanford. Stanford, 1931.
 $45.00 (small tape stain to front pastedown, previous own-
 er's signature erased, very light stain to corner of 4 leaves)
Clark, Gerald--The Coming Explosion in Latin America. N.Y.,
 (1963). $8.00
Clark, James Anthony--Spindletop. N.Y., 1952. 1st ed.
 $22.50 (signed by authors)

Clark, James Hyde--Cuba and the Fight for Freedom. Phila.,
 (1896). $17.50 (spine base defective)
Clark, Janet, pseud.--The Fantastic Lodge. Bost., 1961.
 $12.00
Clark, John Garretson--The Grain Trade in the Old North-
 west. Urbana, 1966. 1st ed. $15.00
Clark, John S.--Selected Manuscripts of.... Athens, Pa.,
 1931. $30.00
Clark, Joseph G.--Lights and Shadows of a Sailor Life....
 Bost., 1847. 1st ed. $100.00 (orig. cloth)
Clark, Leon Pierce--Lincoln, A Psycho-Biography. N.Y.,
 1933. $16.00
Clark, Mary (Whatley)--Chief Bowles and the Texas Chero-
 kees. Norman, (1971). 1st ed. $10.00
Clark, Norman H.--Mill Town; a Social History of Everett,
 Washington.... Seattle, 1970. $20.00
Clark, Robert Donald--The Life of Matthew Simpson. N.Y.,
 1956. $10.00
Clark, Sydney--All the Best in Hawaii. N.Y., 1954. $10.00
--Cuban Tapestry. N.Y., (1936). $10.00
Clark, Thomas Blake--Hawaii.... Garden City, 1947. 1st ed.
 $10.00 (cloth)
Clark, Thomas Dionysius--The Kentucky. N.Y., (1942). 1st
 ed. $12.50
--A History of Kentucky. Englewood Cliffs, 1937. $15.00
--Kentucky, Land of Contrasts. N.Y., (1968). $15.00
--The Rampaging Frontier. Ind., (1939). 1st ed. $21.50,
 $10.00 (binding partly faded)
--The Southern Country Editor. Ind., (1948). 1st ed.
 $10.00 (cloth)
Clark, Walter--Histories of the Several Regiments and Bat-
 talions From North Carolina. Raleigh, 1901. 5 vols.
 $425.00
Clark, William--The Field Notes of Captain...., 1803-1805.
 New Haven, 1964. $200.00 (orig. cloth), $200.00 (cloth,
 name stamp), $150.00 (folio)
--Westward With Dragoons. Fulton, Mo., 1937. $15.00
Clark, William H.--The Soldier's Offering. Bost., 1875.
 $15.00 (presentation copy)
Clark, William Philo--Indian Sign Language. (San Jose, Ca.,
 1959). $30.00 (one of 500 numbered copies)
Clarke, Asa Bement--Travels in Mexico and California....
 Bost., 1852. $1000.00 (orig. printed wraps.)
Clarke, Caroline Cowles (Richards)--Diary of Caroline Cowles
 Richards, 1852-1872. Canandaigua, N.Y., 1908. $15.00

Clarke, Dwight Lancelot, ed.--The Original Journals of Henry
 Smith Turner....
 See: Turner, Henry Smith
Clarke, Laurence--South of the Rio Grande. N.Y., (1924).
 $4.50 (ink underlining)
Clarke, Thomas Wood--The Bloody Mohawk. N.Y., 1940. 1st
 ed. $17.50 (bookplate removed, light wear)
Clavigero, Francesco Saverio--Storia Antica de Messico....
 Cesena, 1780-81. 4 vols. 1st ed. $3000.00 (boards, un-
 cut, minor browning)
Clay, Henry--The Life and Speeches of.... N.Y., 1843. 2
 vols. $20.00
Clay, John--My Life on the Range. Chi., (1924). 1st ed.
 $150.00
 N.Y., 1961. $56.50 (one of 750 numbered copies), $54.50
 (one of 750 numbered copies)
Clayton, Merle--Union Station Massacre. Ind., 1975. $12.50
Clayton, William--William Clayton's Journal. S.L.C., 1921.
 $85.00
Cleaveland, Agnes Morley--No Life For a Lady. Bost., 1941.
 1st ed. $25.00, $20.00
Cleaveland, Frederic N.--Congress and Urban Problems
 See under Title
Cleaves, Freeman--Meade of Gettysburg, Norman, (1960).
 1st ed. $22.50
Clegern, Wayne M.--British Honduras. Baton Rouge, 1967.
 $12.50
Cleland, Robert Glass--March of Industry. S.F., (1929).
 $10.00, $7.50
--This Reckless Breed of Men. N.Y., 1950. 1st ed. $45.00,
 $43.50, $25.00
 N.Y., 1963. $10.00
Clemenceau, Georges Eugene Benjamin--South America To-Day.
 Lond., 1911. $15.00 (spine top pulled)
Clemens, Clara--My Father: Mark Twain. N.Y., 1931.
 $40.00
(Clemens, Samuel Langhorne)--The Adventures of Tom Sawyer.
 S.F., 1876. 1st American ed. $260.00 (2nd printing, issue
 A, binding repaired and restored with small portion of
 spine missing, new endpapers)
--The American Claimant. N.Y., 1892. 1st ed. $65.00
 (orig. cloth, worn)
--A Connecticut Yankee in King Arthur's Court. Toronto,
 1890. $100.00 (orig. cloth, corners bumped, extremities of
 spine moderately worn)

--The Curious Republic of Gondour, and Other Whimsical
 Sketches. N.Y., 1919. 1st ed. $185.00 (orig. boards)
--The Family Mark Twain. N.Y., 1935. 1st ed. $20.00
--The Gilded Age. Hart., 1874. 1st ed. $250.00 (orig.
 cloth, spine worn, inner hinges weak and cracking, book-
 plate of Albert Parsons Sachs)
--The Great Landslide Case. (Berkeley), 1972. $35.00,
 $20.00
--How to Tell a Story and Other Essays. N.Y., 1897. 1st
 ed. $30.00 (bottom portion of blank margin and part of
 back cover lightly stained, small tear bottom of title)
--The Innocents Abroad.... Hart., 1869. 1st ed. $200.00
 (1st issue, orig. cloth, spine ends frayed, cloth lightly
 wrinkled on front board, inner hinges cracking, bookplate
 of Joan Whitney)
--Life on the Mississippi. Bost., 1883. 1st ed. $45.00
 (ends of spine frayed, corners lightly rubbed, 2d state)
 N.Y., 1944. $235.00 (cloth, boxed, signed by illustrator,
 Thomas Hart Benton, one of 1200 copies)
--Mark Twain's Library of Humor. N.Y., 1888. 1st ed.
 $150.00 (1st state, lightly rubbed at tips of spine and
 back cover)
--The Prince and the Pauper. N.Y., 1891. $65.00 (edges
 shelf worn)
--Roughing It. Hart., 1872. 1st ed. $225.00 (lightly rubbed
 at extremities, cloth lightly wrinkled on the boards, owner
 inscription), $35.00 (later issue, leather binding repaired,
 end pages separated)
--1601.... N.Y., 1933. $30.00
--The Stolen White Elephant. Bost., 1882. $50.00 (covers
 soiled, new endpapers)
--Writings.... N.Y., 1929. 37 vols. $600.00 (orig. cloth,
 one of 1024 numbered sets, some spines rubbed)
Clemson, Floride
 See: Lee, Floride (Clemson)
Cleveland, Reginald McIntosh--Air Transport at War. N.Y.,
 (1946). $8.50
Cleveland, Robert Glass, ed.--Apron Full of Gold
 See: Megquier, Mary Jane (Cole)
Clews, Henry--Twenty-Eight Years in Wall Street. N.Y., 1887.
 1st ed. $25.00 (light wear)
 N.Y., 1888. $50.00 (ex-lib.)
Clifford, Harold Burton--Maine and Her People. Freeport,
 1958. $15.00

Clifton, Robert T.--Barbs, Prongs, Points, Prickers & Stickers
 Norman, (1970). $20.00
Clinchy, Everett Ross--All in the Name of God. N.Y., (1934).
 $10.00 (cloth)
Cline, A.J.--Henry Courtland. Phila., 1870. 1st ed. $27.50
 (orig. cloth, spine head chipped)
Cline, Gloria Griffen--Exploring the Great Basin. Norman,
 (1963). 1st ed. $31.50, $26.50
Cline, Howard Francis--Latin American History. Austin,
 (1967). 2 vols. $23.50
--Mexico. N.Y., 1962. $17.50
--The U.S. and Mexico. Camb., 1953. 1st ed. $15.00,
 $10.00 (presentation copy), $10.00 (cloth, ex-lib.)
Clinton, Joseph Daniel--Gomez, Tyrant of the Andes. N.Y.,
 1936. 1st ed. $10.00
Clough, Shepard Bancroft--A Century of American Life Insur-
 ance. N.Y., 1946. 1st ed. $10.00
Clugston, William George--Politics in Kansas.... Topeka,
 (1945). $6.00
Clum, John Philip--It All Happened in Tombstone. Flagstaff,
 Az., 1965. 1st ed. $15.00
Clum, Woodworth--Apache Agent.... Bost., 1936. 1st ed.
 $65.00 (cloth), $60.00 (chipped, endpapers browning)
Coan, Blair--The Red Web. Chi., (1925). 1st ed. $17.50
Coan, Charles Florus--A History of New Mexico. Chi., 1925.
 3 vols. $400.00
Coates, Robert Myron--The Outlaw Years. N.Y., 1930. 1st
 ed. $10.00 (cloth, name on half-title)
Coatsworth, Emerson S.--The Indians of Quetico. Toronto,
 1957. 1st ed. $8.50
Cobb, Irvin Shrewsbury--Exit Laughing. Ind., (1941).
 $12.50
--Old Judge Priest. N.Y., (1916). 1st ed. $35.00 (1st
 state)
Coblentz, Stanton Arthur--Villains and Vigilantes. N.Y.,
 1936. 1st ed. $10.00
Coburn, Foster Dwight--Swine in America. N.Y., 1909. 1st
 ed. $30.00
Cochran, Bert--Adlai Stevenson. N.Y., (1969). $10.00
--Harry Truman and the Crisis Presidency. N.Y., (1973).
 $10.00
Cochran, Hamilton--Blockade Runners of the Confederacy.
 Ind., (1958). 1st ed. $12.50
Cockburn, Alexander Peter--Political Annals of Canada. Lond.,
 1909. $20.00 (cloth, spine mended)

Codman, John, 1782-1847--Sermons Delivered on Various Oc-
 casions. Bost., 1834. $15.00 (few stains on portrait)
Codman, John, 1863-1897--Arnold's Expedition to Quebec.
 N.Y., 1902. $75.00 (modern buckram)
Codman, John Thomas--Brook Farm. Bost., 1894. 1st ed.
 $15.00 (some light binding stains)
Cody, William Frederick--An Autobiography of Buffalo Bill.
 N.Y., 1924. $11.50
--Buffalo Bill's Wild West Show....
 See under Title
--Story of the Wild West and Camp-Fire Chats.... Rich.,
 (1888). $30.00 (leather, rebacked)
--True Tales of the Plains. N.Y., 1908. 1st ed. $27.50
 (cloth, rear hinge starting)
Coe, Benjamin Hutchins--A New Drawing Book of American
 Scenery. N.Y., 1845. $75.00 (orig. boards, lacks three
 leaves, plates loose, some marginal tears, foxed)
Coe, Charles H.--Juggling a Rope.... Pendleton, Or., (1927).
 $50.00 (signed)
Coe, George Washington--Frontier Fighter.... Bost., 1934.
 1st ed. $50.00 (signed), $45.00
Coe, Michael D.--Mexico. N.Y., (1962). 1st ed. $10.00
Coe, Wilbur--Ranch on the Ruidoso.... N.Y., 1968. $20.00
Coffin, Charles--The Life and Services of Major General John
 Thomas. N.Y., 1844. 1st ed. $35.00 (orig. wraps.)
Coffin, Charles Carleton--The Boys of '76.... N.Y., (1918).
 $7.50
--The Seat of Empire. Bost., 1870. $20.00 (cloth dull)
Coffin, Morse H.--The Battle of Sand Creek. Waco, 1965.
 1st ed. $40.00 (one of 300 copies), $25.00 (orig. cloth,
 one of 300 copies)
Coffin, Robert Peter Tristram--Kennebec, Cradle of Americans.
 N.Y., (1937). 1st ed. $15.00
Coffinberry, Andrew--The Forest Rangers. Columbus, 1842.
 $150.00 (orig. boards)
Cohen, Isador--Historical Sketches and Sidelines of Miami....
 Miami, 1925. $16.00 (signed)
Coit, Daniel Wadsworth--Digging for Gold Without a Shovel.
 (Denver), 1967. 1st ed. $22.50
Coit, Margaret L.--Mr. Baruch. Bost., 1957. $10.00
Colange, Leo de--The American Dictionary of Commerce, Man-
 ufactures, Commercial Law, and Finance. Bost., 1880-81.
 2 vols. $50.00 (orig. half leather)
Colbert, Elias--Chicago and the Great Conflagration. Cinci.,
 1871. 1st ed. $30.00 (cloth, somewhat rubbed, hinges

cracked, scattered foxing), $17.50 (cloth, spine top repaired, some foxing)

Colby, Charles William--Canadian Types of the Old Regime.... N.Y., 1908. $25.00

Colby, John--The Life, Experiences and Travels, of.... Lowell, 1838. 2 vols. in 1. $22.50 (bookplate removed)

Colby, William E., ed.--Studies in the Sierra
See: Muir, John

Colcord, Joanna Carver--Roll and Go, Songs of American Sailormen. Ind., 1924. $27.50

--Songs of American Sailormen. N.Y., (1938). $17.50

Colden, Cadwaller David--The Life of Robert Fulton.... N.Y., 1817. 1st ed. $95.00 (orig. boards, spine chipped and reinforced, uncut)

--Memoir.... N.Y., 1825. $1000.00 (orig. boards, neatly rebacked, presentation label)

Cole, Cornelius--Memoirs.... N.Y., 1908. $125.00 (inscribed, cloth, hinges cracked, rubbed)

Cole, Gilbert L.--In the Early Days Along the Overland Trail in Nebraska Territory in 1852. K.C., (1905). 1st ed. $58.50, $40.00 (back cover dampstained)

Cole, Harry Ellsworth--Stagecoach and Tavern Tales of the Old Northwest. Cleve., 1930. 1st ed. $25.00 (uncut and unopened), $20.00 (ex-lib.)

Cole, James Reid--Miscellany. Dallas, 1897. $150.00 (inscribed presentation copy, orig. cloth)

Cole, Jean Murray--Exile in the Wilderness. Seattle, 1979. 1st ed. $21.50, $15.95

Cole, Martin, ed.--Don Pio Pico's Historical Narrative
See: Pico, Pio

Cole, Wayne S.--Senator Gerald P. Nye and American Foreign Relations. Minne., 1962. 1st ed. $15.00

Coleman, Charles Albert--Our Mysterious Panics, 1830-1930. N.Y., 1931. $12.00

Coleman, Charles M.--P.G. & E. of California. N.Y., (1952). $15.00

Coleman, James M.--Aesculapius on the Colorado. (Austin, 1971). $10.00

Coleman, John Winston--Stage-Coach Days in the Bluegrass.... Lou., 1935. $35.00 (light shelfwear, light cover speckles)
Berea, Ky., 1976. $12.50

Coleman, Roy V.--The First Frontier. N.Y., 1948. $16.50, $12.50

Coles, Robert--The Old Ones of New Mexico. Albuquerque, (1973). 1st ed. $15.00

Collier, John--The Awakening Valley. Chi., (1949). 1st ed. $12.50

--Patterns and Ceremonials of the Indians of the Southwest. N.Y., 1949. 1st ed. $35.00 (one of 1475 signed by author, backstrip discolored, foxing of preliminary and endpapers)

Collier, William Ross--Dave Cook of the Rockies. N.Y., 1936. 1st ed. $25.00, $25.00, $22.50, $17.50

Collings, Ellsworth--The 101 Ranch. Norman, 1938. $15.00 (owner name)

Collingwood, Herbert Winslow--Andersonville Violets. Bost., 1889. 1st ed. $17.50

Collins, David--"The Chesapeake," the Case of David Collins. Saint John, N.B., 1864. $75.00 (wraps. removed, last page loose)

Collins, Hubert Edwin--Warpath & Cattle Trail. N.Y., 1928. $25.00 (binding spotted)

Collins, June M.--Valley of the Spirits. Seattle, (1974). 1st ed. $12.50 (name removed from front free endpaper)

Colman, Edna Mary Hercher--White House Gossip. Garden City, 1927. $17.50

Colonial Church in the Original Colony of Virginia. Rich., 1908. $15.00 (some pencil underlining, ex-lib.)

Colonisation of Costa Rica, for the Development of its Rich Mines of Gold.... Lond., (1850). $225.00

The Colorado Directory of Mines. Denver, 1879. 1st ed. $750.00 (orig. cloth)

Colorado Towns and Resorts. Denver, 1892. $17.50 (covers a bit soiled)

Colton, Calvin--Tour of the American Lakes.... Lond., 1833. 2 vols. 1st ed. $250.00 (half morocco, lib. stamps)

Colton, Harold Sellers--Hopi Kachina Dolls. Albuquerque, 1949. 1st ed. $12.00

Colton, Walter--The California Diary. Oakland, 1948. $31.50, $25.00 (one of 1000 copies)

--Three Years in California.... N.Y., 1850. 1st ed. $185.00 (foxing)
Stanford, (1949). $25.00

Colum, Padraic--Legends of Hawaii. New Haven, 1937. 1st ed. $18.00

Columbus, Christopher--Journal of the First Voyage to America. N.Y., 1924. $12.50 (front cover stained)

--The Letter of Columbus on the Discovery of America. N.Y., 1892. $15.00

Colver, Anne--Mr. Lincoln's Wife. N.Y., (1943). $9.50

Colwell, Stephen--The Five Cotton States and New York.
 N.p. 1861. $35.00 (orig. front wrap. only)
--The South. Phila., 1856. 1st ed. $35.00 (orig. wraps.)
Coman, Katharine--The Industrial History of the U.S. N.Y.,
 1910. $18.00
Combs, Barry B.--Westward to Promontory. Palo Alto, (1969).
 $26.50 (buckram)
Comeau, Napoleon Alexander--Life and Sport on the North
 Shore of the Lower St. Lawrence and Gulf. Quebec,
 (1923). $40.00 (orig. wraps.)
Comer, Burt Fox--The Tale of a Fox. Wichita, Ks., (1936).
 $10.00
Comer, William R.--Landmarks "in the Old Bay State." Welles-
 ley, Ma., 1911. 1st ed. $15.00
Comfort, Charles Haines--This is Santa Fe.... Santa Fe.,
 1955. $7.50
Comfort, Will Levington--Somewhere South in Sonora. Bost.,
 1925. $17.50
Commager, Henry Steele--The Blue and the Gray. Ind.,
 (1950). 2 vols. 1st ed. $35.00, 1 vol. ed. $17.50
--The Spirit of 'Seventy-Six. Ind., (1958). 2 vols. 1st
 ed. $35.00 (boxed)
--Theodore Parker. Bost., 1947. $8.00 (orig. cloth, lightly
 rubbed)
Commerce of Kansas City in 1886
 See: (Howe, S. Ferdinand)
Commission on Boundary Lines Between Delaware, Maryland and
 Pennsylvania, 1850--Messages From the Governors of Mary-
 land and Pennsylvania....
 See: Graham, James Duncan
Conant, Roger--A Field Guide to Reptiles and Amphibians of
 Eastern North America. Bost., 1958. 1st ed. $7.50
Concivis
 See: (Belden, G.H.)
Condit, Carl W.--Chicago, 1910-29. Chi., 1973. $25.00
--The Rise of the Skyscraper. (Chi., 1952). 1st ed. $35.00,
 $15.00
Condon, William Henry--Life of Major-General James Shields....
 Chi., (1900). $50.00
Confederate Memorial Literary Society.... --A Calendar of
 Confederate Papers....
 See: Freeman, Douglas Southall
Congdon, Herbert Wheaton--The Covered Bridge. Brattleboro,
 (1941). 1st ed. $12.50
Congress and Urban Problems. Wash., (1969). $12.50

Conkling, Edgar--Benton's Policy of Selling and Developing
the Mineral Lands.... Cinci., 1864. 1st ed. $125.00
(cloth)
Connell, Robert--Arkansas. N.Y., 1947. $12.50
Connelley, William Elsey--An Appeal to the Record. Topeka,
Ks., 1903. $7.50 (bit of chipping)
--Fifty Years in Kansas. (Topeka, 1907). $6.00 (signed by
George Martin, title's subject)
--History of Kansas State and People. Chi., 1928. 5 vols.
$110.00
--History of Kentucky
See: Kerr, Charles
--John Brown. Topeka, 1900. 1st ed. $47.50
--Quantrill and the Border Wars. N.Y., 1956. $20.00 (owner
name, bookplate)
Connely, Willard--Lewis Sullivan. N.Y., 1960. $20.00
Conner, Daniel Ellis--A Confederate in the Colorado Gold
Fields. Norman, (1970). $15.00, $12.50
--Joseph Reddeford Walker and the Arizona Adventure.
Norman, (1956). $50.00, $20.00 (cloth)
Conner, Palmer--The Romance of the Rancheros. L.A., (1929).
$3.50 (covers separated)
Connolly, Alonzo P.--A Thrilling Narrative of the Minnesota
Massacre and the Sioux War of 1862-63. Chi., (1896), 1st
ed. $75.00
Connolly, James Austin--Three Years in the Army of the
Cumberland. Bloomington, (1959). 1st ed. $25.00
Connolly, James Brendan--The Book of the Gloucester Fisher-
man. N.Y., 1928. $12.50
Connolly, Joseph Peter--The Mineral Wealth of the Black Hills.
Rapid City, S.D., 1929. $10.00 (owner name)
Connor, Seymour V.--Broadcloth and Britiches. College Sta-
tion, 1977. $15.50
Conrad, Howard Louis--Uncle Dick Wootton. Chi., 1957.
$95.00 (orig. cloth, ex-lib.), $25.00, $15.00 (cloth)
Considine, John Joseph--New Horizons in Latin America.
N.Y., 1958. $12.50 (ex-lib. stamps)
Constant, Alberta Wilson--Paintbox on the Frontier. N.Y.,
1974. $12.50
Constantine, C.P.--Advertising in Action. Seattle, 1962.
$15.00
Conway, Jack--Midland Humor. N.Y., 1947. $12.50
Conway, Moncure Daniel--Omitted Chapters of History....
N.Y., 1888. 1st ed. $15.00 (ex-lib.)
Cook, Albert John--Birds of Michigan. Lansing, Mi., 1893.
$15.00 (wraps.)

Cook, Charles W.--The Valley of the Upper Yellowstone. Norman, (1965). 1st ed. $20.00
Cook, David J.--Hands Up. Denver, 1897. $97.50
 Norman, (1958). $15.00
Cook, Harold James--Tales of the 04 Ranch. Lincoln, 1969.
 $8.50, $7.50
Cook, Harvey Toliver--The Life and Legacy of David Rogertson Williams. N.Y., 1916. $45.00 (unopened)
Cook, James Henry--Fifty Years on the Old Frontier. New Haven, 1923. 1st ed. $31.50 (front flyleaf replaced)
 New Haven, 1925. $50.00, $35.00 (cloth, owner signature)
 Norman, (1957). $6.00 (ex-lib.)
Cook, Jim--Lane of the Llano. Bost., 1936. $22.50
Cook, Joel--America, Picturesque and Descriptive. Phila., (1900). 3 vols. $250.00 (large paper ed., one of 150 copies, cloth, bookplate)
(Cook, John R.)--The Border and the Buffalo. Chi., 1938. $25.00 (cloth)
Cook, Sherburne Friend--The Conflict Between the California Indian and White Civilization. Berkeley, (1976). $20.00
Cook, Thomas L.--Palmyra and Vicinity. Palmyra, N.Y., 1930. $30.00
Cooke, Donald Ewin--Marvels of American Industry. Maplewood, (1962). $18.00
Cooke, George Willis--A Bibliography of Ralph Waldo Emerson. Bost., 1908. 1st ed. $50.00 (one of 530 numbered copies, spine lightly worn)
--Early Letters of George Wm. Curtis....
 See: Curtis, George William
(Cooke, John Esten)--Leather Stocking and Silk. N.Y., 1854. 1st ed. $450.00 (orig. cloth, binding A, spine lightly faded and frayed at bottom)
--Stonewall Jackson and the Old Stonewall Brigade. Charlottesville, Va., (1954). $15.00
Cooke, Lawrence S., ed.--Lighting in America
 See under Title
Cooke, Morris Llewellyn--Brazil on the March. N.Y., (1944). 1st ed. $13.50
Cooke, Phillip St. George--The Conquest of New Mexico and California.... Albuquerque, 1964. $30.00
Cookridge, E.H.--The Baron of Arizona
 See: Spiro, Edward
Coolbrith, Ina Donna--Songs From the Golden Gate. Bost., 1895. $30.00

Cooley, Richard A.--Politics and Conservation. N.Y., (1963).
$10.50

Coolidge, Austin James--A History and Description of New
England.... Bost., 1860. $35.00

Coolidge, Calvin--The Autobiography of.... N.Y., 1931.
$7.50

--Have Faith in Massachusetts. Bost., 1919. $10.00

Coolidge, Dane--Fighting Men of the West. N.Y., (1932).
1st ed. $20.00 (binding lightly worn), $17.50 (backstrip
water stained)

--The Last of the Seris. N.Y., (1939). 1st ed. $25.00,
$24.50

--The Navajo Indians. Bost., 1930. 1st ed. $25.00 (book-
plate, backstrip faded and worn)

Coolidge, Louis Arthur--Ulysses S. Grant. Bost., 1917.
1st ed. $15.50
Bost., 1922. $13.50

Collier, Richard, ed.--Captain of the Queens
See: Grattidge, Harry

Coon, Horace--American Tel. & Tel. N.Y., 1939. $17.50
Plainview, (1976). $10.00

Cooney, Loraine Meeks--Garden History of Georgia, 1733-
1933. (Atlanta), 1976. $30.00

Cooper, Clayton Sedgwick--The Brazilians and Their Country.
N.Y., (1917). $8.50
Lond., 1919. $6.00 (hinges weak)

Cooper, Courtney Ryley--Here's to Crime. Bost., 1937.
$20.00

--High Country. Bost., 1926. $8.50, $8.50

Cooper, James Fenimore--The Borderers. Lond., 1829. 3
vols. $225.00 (contemp. boards, edges a bit rubbed,
spines faded, bookplates)

--The Deerslayer. Lond., 1841. 3 vols. $350.00 (three-
quarter morocco, lightly rubbed at spines)

--The Heidenmauer.... Phila., 1832. 2 vols. in 1. $55.00
(contemp. three-quarter calf)

--Homeward Bound. Phila., 1838. 2 vols. $650.00 (orig.
blue muslin with paper spine labels, labels lightly worn,
top cord in one vol. broken, bookplates removed, signa-
ture of William Cullen Bryant in vol. I)

--Lionel Lincoln. N.Y., 1825. 2 vols. in 1. $60.00 (con-
tempt. three-quarter leather, some staining)

--Notions of Americans. Lond., 1828. 2 vols. $65.00
(boards, spines chipped, front cover in vol. 1 is detached)

--The Pathfinder. N.Y., (1965). $15.00 (cloth, slipcased)

--Satanstoe. N.Y., 1845. 2 vols. $175.00 (lightly rubbed
 at outer hinges, later three-quarter calf)
--The Spy. N.Y., (1963). $20.00 (boards, slipcased)
Cooper, John Milton--Walter Hines Page. Chapel Hill, 1977.
 $15.00
Cooperman, Stanley--World War I and the American Novel.
 Balt., (1967). 1st ed. $15.00
Copeland, Jennie Freeman--Every Day but Sunday. Brattle-
 boro, (1936). $10.00
Copper Camp
 See: Writers' Program.
Copway, George--The Life, History, and Travels of....
 Phila., 1847. $45.00 (orig. cloth)
Coram, Robert--Political Inquiries. Wilmington, Del., 1791.
 1st ed. $65.00 (untrimmed)
Corbett, Edward M.--Quebec Confronts Canada. Balt., (1967).
 $35.00 (orig. cloth)
Corbett, Thomas B.--The Colorado Mining Directory
 See under Title, The Colorado Directory of Mines
Corbitt, David Leroy--The Formation of the North Carolina
 Counties. Raleigh, 1950. 1st ed. $30.00
Corby, William--Memoirs of Chaplain Life. Chi., 1893. 1st
 ed. $40.00
Corcoran, Michael--The Captivity of General Corcoran....
 Phila., 1864. $125.00 (orig. printed wraps.)
Corey, Lewis--The Decline of American Capitalism. N.Y.,
 (1934). 1st ed. $10.00
--The House of Morgan. N.Y., 1930. 1st ed. $15.00, $15.00
Corkran, David H.--The Cherokee Frontier.... Norman,
 (1962). 1st ed. $20.00 (cloth)
Corle, Edwin--Billy the Kid. N.Y., (1953). 1st ed. $19.50
--Coarse Gold. N.Y., 1942. 1st ed. $6.50
--Desert Country. N.Y., (1941). $24.50
--The Royal Highway (El Camino Real). Ind., (1949). $25.00,
 $12.50
--Three Ways to Mecca. N.Y. (1947). 1st ed. $7.50
Corliss, Carlton Jonathan--Main Line of Mid-America. N.Y.,
 1950. $20.00
Cornell, Katharine--I Wanted to Be an Actress. N.Y., (1939),
 $25.00, $10.00 (covers lightly stained)
Corner, George Washington--Doctor Kane of the Arctic Seas.
 Phila., 1972. $15.00
The Corpus Christi Caller-Times--King Ranch; 100 Years of
 Ranching
 See under Title

Correa de Costa, Sergio--Every Inch a King. N.Y., 1950.
1st ed. $7.50
Corser, Harry Prosper--Totem Lore and the Land of the
Totem. Juneau, Alaska, (1931?). $8.00 (covers soiled)
--Totem Lore of the Alaska Indians. Juneau, (192-?). 4th
ed. $10.00 (rebound)
Corso, Gregory--Gasoline. S.F., (1958). $12.50 (stiff
wraps., tape stains on spine and name inside front cover)
Cortes, Hernando--Historia de Nueva-Espana. Mexico, 1770.
1st ed. $3500.00 (19th century morocco, bookplate, ex-
lib.)
Corti, Egon Caesar--Maximilian and Charlotte of Mexico.
N.Y., 1929. 2 vols. $50.00
Corwin, Edward Samuel--The Twilight of the Supreme Court.
New Haven, 1935. $10.00
Cory, Charles Barney--The Birds of Eastern North America....
Bost., 1900. $29.00 (orig. wraps.)
Cosgrave, George--Early California Justice. S.F., 1948.
$72.50 (one of 400 copies)
Cosio Villegas, Daniel--The U.S. Versus Porfirio Diaz. Lin-
coln, 1965. $12.50
Cosman, Bernard--Republican Politics. N.Y., (1968). $12.50
Cossio de Pomar, Felipe--Victor Raul. Mexico, 1961. 1st ed.
$16.00 (wraps.)
Costa, Luiz Edmundo de--Rio in the Time of the Viceroys.
(Rio de Janeiro), 1936. 1st ed. $17.50
Costanso, Miguel--The Costanso Narrative of the Portola Ex-
pedition. (Newhall, 1970). $28.50
--The Narrative of the Portola Expedition of 1769-1770.
Berkeley, 1910. $15.00
--The Portola Expedition of 1769-1770. Berkeley, 1911.
$25.00 (orig. wraps.)
Cosulich, Bernice--Tucson. Tucson, (1953). 1st ed. $20.00
(signed by author, namestamp)
Cotter, Arundel--United States Steel. Garden City, 1921.
$16.00
Cotterill, Robert Spencer--The Southern Indians. Norman,
(1954). 1st ed. $20.00 (cloth)
Couch, William Terry--Culture in the South. Chapel Hill,
1934. 1st ed. $15.00 (cloth)
Coues, Elliott--Birds of the Colorado Valley.... Wash., 1878.
$44.00 (cloth, used)
--Birds of the Northwest. Wash., 1874. $37.00 (new cloth)
--New Light on the Early History of the Greater Northwest
See: Henry, Alexander

Coulter, Ellis Merton--The Civil War and Readjustment in Kentucky. Gloucester, 1966. $16.00
--William Montague Browne.... Athens, Ga., (1967). $12.50
Council on Foreign Relations Social Change in Latin America Today
See: Adams, Richard N.
Counting Electorial Votes. Wash., 1877. $50.00 (cloth)
Couper, William--Claudius Crozet.... Charlottesville, Va., 1936. $25.00 (wraps.)
Cour, Robert M.--The Plywood Age. Portland, Or., (1956). $12.50
Coursey, Oscar William--Beautiful Black Hills. Mitchell, S.D., (1926). $35.00
Cousins, Frank--The Colonial Architecture of Salem. Bost., 1919. $50.00 (orig. boards, one of 1200 copies)
Cousins, Norman--"In God We Trust." N.Y., (1958). $5.00
Coutant, Charles Griffin--History of Wyoming and (the Far West). N.Y., 1966. 2 vols. $37.50
The Covode Investigation. (Wash., 1860). $30.00 (newly rebound, some page edges stained)
Cowan, John--Canada's Governors-General.... Toronto, (1952). $25.00 (front cover lightly scratched)
Coward, Noel--Play Parade--Garden City, 1934. $8.50
Cowie, Alexander--John Trumbull, Connecticut Wit. Chapel Hill, 1936. 1st ed. $15.00 (cloth)
Cowing, Cedric B., ed.--The American Revolution
See under Title
Cowling, Ellis--Co-Operatives in America. N.Y., 1943. 1st ed. $12.50
Cox, Alex--Deer Hunting in Texas. San Antonio, (1947). 1st ed. $12.50
Cox, Jacob Dolson--Building an American Industry. Cleve., 1951. $10.00
Cox, James--My Native Land. Phila., 1903. $17.50
Cox, John E.--Five Years in the U.S. Army. N.Y., 1973. $15.00 (one of 500 copies), $13.50 (one of 500 copies)
Cox, Richard--Caroline Durieux.... Baton Rouge, 1977. $12.50
Cox, Ross--The Columbia River. Norman, (1957). $20.00
Cox, S.E.J.--Girls, Gushers and Rough Necks. San Antonio (1972). $12.00 (signed by author's wife)
Cox, William Edward--Southern Sidelights.... Raleigh, 1942. $15.00
Coxe, Daniel--A Description of the English Province Carolana. (Lond.), 1741. $650.00 (half morocco, bookplate)

Coxe, Emily (Bradham)--Mother of the Maid. N.Y., (1960).
1st ed. $20.00
Coy, Owen Cochran--Gold Days. L.A., (1929). 1st ed.
$10.00
--The Humboldt Bay Region, 1850-1875. L.A., 1929. 1st
ed. $90.00 (minor foxing to fore-edge)
Coyner, David H.--Lost Trappers. Cinc., 1955. $65.00
(binding worn, lightly water stained and foxed)
Cozzens, Samuel Woodworth--The Marvellous Country. Bost.,
(1876). $36.50 (inner hinges repaired)
Crabb, Alexander Richard--Empire on the Platte. Cleve.,
(1967). $25.00 (boards, one of 250 copies, signed by the
author), $10.00
Craddock, Charles Egbert, pseud.
See: Murfree, Mary Noailles
Crafton, Allen--Free State Fortress. Lawrence, (1954).
$30.00
Crafts, William Augustus--Life of Ulysses S. Grant. Bost.,
1868. 1st ed. $14.50 (faded, bit used)
--The Southern Rebellion.... Bost., 1862. 2 vols. $75.00
(rebound in buckram, text lightly soiled, small tear in two
pages)
Craig, Edward Marshall--Highways and Byways of Appala-
chia.... Kingsport, Tn., 1927. $27.50 (map of Appala-
chia tipped in at back endpaper)
Craig, Neville B.--The History of Pittsburg.... Pitts., 1851.
1st ed. $50.00 (orig. cloth, rebacked)
Craig, Reginald S.--The Fighting Parson. L.A., 1959. $53.50
Crail, Charles S.--My Twin Joe. Garden City, 1932. $19.50
Crain, Gustavus D., ed.--Teacher of Business
See: McGraw, James Herbert
Cramer, Zadok--The Navigator.... Pitts., 1817. $175.00
(front board detached, spine worn)
Pitts., 1821. $135.00 (leather, newly rebound, last seventy
pages photocopies)
Crampton, John A.--The National Farmers Union. Lincoln,
(1965). $22.50
Crane, Leo--Desert Drums. Bost., 1928. 1st ed. $33.50,
$20.00
--Indians of the Enchanted Desert. Bost., 1925. 1st ed.
$20.00 (one hinge broken)
Crane, Stephen--George's Mother. Lond., 1896. $125.00
(spine dull)
--Maggie: A Child of the Streets. Lond., 1896. 1st ed.
$175.00

--The Monster, and Other Stories. N.Y., 1901. $25.00
 (cover wear)
--The Red Badge of Courage. N.Y., (1931). $90.00 (one
 of 980 numbered copies)
--The Third Violet. Lond., 1897. $25.00 (backstrip faded
 and worn)
Crane, Verner Winslow--The Southern Frontier.... Durham,
 N.C., 1928. 1st ed. $12.50
Cranfill, James Britton--Dr. Cranfill's Chronicle. N.Y.,
 (1916). $46.50
Cranwell, John Philips--Men of Marque. N.Y., 1940. $45.00
Crary, Catherine S., ed.--Dear Belle
 See: McCrea, Tully
Crasswelder, Robert D.--Trujillo. N.Y., (1966). 1st ed.
 $15.00
Crater, Stella (Wheeler)--The Empty Robe. N.Y., 1961.
 1st ed. $15.00
Craven, Avery Odelle--Civil War in the Making.... Baton
 Rouge, 1955. $10.00
Craven, John J.--Prison Life of Jefferson Davis.... Lond.,
 1866. 1st ed. $35.00 (orig. cloth)
Craven, Thomas Tingey--Record of the Testimony Taken in
 the Trial of.... N.Y., 1866. $50.00 (wraps.)
Craven, Tunis Augustus Macdonough--A Naval Campaign in
 the Californias. S.F., (1973). $80.00 (one of 400 copies)
Cravens, John Nathan--James Harper Starr: Financier of the
 Republic of Texas. Austin, 1950. $20.00
Crawford, Ann Fears, ed.--The Eagle
 See: Santa Anna, Lopez de
Crawford, Charles--Scenes of Earlier Days in Crossing the
 Plains to Oregon.... Petaluma, Ca., 1898. 1st ed.
 $200.00 (orig. cloth)
Crawford, Francis Marion--Casa Braccio. N.Y., 1895. 2 vols.
 $15.00 (lacking front endsheets)
Crawford, Lewis Ferandus--Badlands and Broncho Trails.
 Bismarck, (1922). 1st ed. $40.00, $35.00 (cloth, spine
 lightly rubbed, owner signature)
--Rekindling Camp Fires. Bismarck, (1926). $60.00, $40.00
 (cloth, lightly stained, unopened), $35.00
Crawford, Mary Caroline--The Romance of the American The-
 atre. N.Y., (1940). $20.00 (minor shelf wear)
--Romantic Days in Old Boston. Bost., 1923. $7.50
Crawford, Medorem--Journal of.... Eugene, Or., 1897.
 $65.00 (stapled)

Crawford, Oswald, pseud.
 See: (Harris, William Richard)
Crawford, William Rex--A Century of Latin American Thought.
 Camb., 1944. 1st ed. $10.00
Creighton, Donald Grant--The Forked Road: Canada, 1939-
 1957. Toronto, 1976. $25.00 (cloth)
--The Road to Confederation. Toronto, 1964. 1st ed. $20.00
 (cloth)
--The Story of Canada. Bost., 1960. $10.00 (cloth)
Creighton, Helen--Maritime Folk Songs. Toronto, 1961. $20.00
Cremony, John Carey--Life Among the Apaches. Tucson, 1951.
 $29.50 (lower front cover corner chewed)
Cresswell, Nicholas--The Journal of.... N.Y., 1924. $20.00
 (boards age darkened)
Creuzbaur, Robert--Route From the Gulf of Mexico and the
 Lower Mississippi Valley to California.... N.Y., 1849.
 $3000.00 (orig. cloth)
Crichton, Kyle Samuel--Law and Order, Ltd. Santa Fe, 1928.
 1st ed. $85.00 (cloth, a few pages lightly soiled, owner
 signature)
Crick, Bernard R.--The American Science of Politics. Berkeley,
 1959. $15.00
Crissey, Forrest--Alexander Legge, 1866-1933. Chi., 1936.
 $20.00 (cloth, uncut and unopened)
--The Romance of Moving Money. Chi., 1934. $15.00
(Crocchiola, Stanley Francis Louis)--Fort Bascom: Comanche-
 Kiowa Barrier. Pampa, Tx., 1961. 1st ed. $25.00 (in-
 scribed)
--Fort Union, New Mexico. N.p., (1953). $50.00 (signed ed.)
--Jim Courtright. Denver, 1957. $37.50 (signed), $12.50
--The Kelly, New Mexico, Story. Nazareth, Tx., 1973. 1st
 ed. $10.00 (one of 400, signed copies)
--Longhair Jim Courtright....
 See his Jim Courtright....
--No Tears for Black Jack Ketchum. (Denver, 1958). $40.00
 (orig. wraps., one of 500 numbered and signed copies)
--The Signal Hill (Texas) Story. Nazareth, Tx., 1973. 1st
 ed. $10.00 (one of 400, signed copies)
Crocus, pseud.
 See: (Leonard, Charles C.)
Croft-Cooke, Rupert--Buffalo Bill. Lond., (1952). 1st ed.
 $15.00 (boards)
Crofutt, George A.--Crofutt's Grip-Sack Guide of Colorado.
 Omaha, Nb., (1881). 1st ed. $200.00 (leather, rebacked
 in cloth, back cover stained)

--Crofutt's Trans-Continental Tourist's Guide. N.Y., 1873.
$159.50 (orig. cloth, inside front hinge cracked, copy worn)
Crogan, John--Rambles in the Mammoth Cave.... Lou., 1845.
1st ed. $125.00 (half calf)
Croly, Herbert David--The Promise of American Life. Camb.,
1965. $20.00 (orig. cloth)
Cromie, Alice--A Tour Guide to the Civil War. Chi., 1965.
1st ed. $22.50
Crompton, Arnold--Apostle of Liberty.... Bost., 1950.
$10.00
--Unitarianism on the Pacific Coast. Bost., (1957). $12.50
Cronin, Bernard Cornelius--Father Yorke and the Labor Move-
ment in San Francisco.... Wash., 1943. $20.00 (wraps.)
Cronkhite, Daniel--Death Valley's Victims. Verdi, Nevada,
1968. 1st ed. $14.50 (wraps., numbered and signed)
--Recollections of a Young Desert Rat. Verdi, Nevada, 1972.
$17.50 (one of 777 signed and numbered copies)
Cronon, Edmund David--Joseph Daniels in Mexico. Madison,
1960. $12.50
Crook, George--General George Crook.... Norman, 1946.
1st ed. $25.00
Crook, Wilfred Harris--The General Strike. Chapel Hill, 1931.
$15.00
Crosby, Alexander L., ed.--Steamboat Up the Colorado
See: Ives, Joseph Christmas
Crosby, Elisha Oscar--Memoirs of Elisha Oscar Crosby....
San Marino, 1945. $10.00
Crosby, Everett Uberto--Nantucket in Print. (Nantucket,
Ma., 1946). $100.00
Crosby, Thelma--Bob Crosby.... Clarendon, Tx., 1966.
$35.00
Cross, Jack Lee--Arizona. Tucson, 1960. 1st ed. $25.00
Cross, Joe--Cattle Clatter. (K.C., 1938). $112.50
Cross, Osborne--The March of the Mounted Riflemen. Glen-
dale, 1940. $50.00 (cloth, uncut)
Crosskey, William Winslow--Politics and the Constitution in the
History of the U.S. Chi., (1953). 2 vols. 1st ed. $45.00
(cloth)
Crossley, Jill Lillie Emma--The Last of the California Rangers.
N.Y., 1928. $20.00
Crouch, Carrie (Johnson)--A History of Young County, Texas.
Austin, 1956. $18.50
Crouch, Lora--Hamlin Garland, Dakota Homesteader. (Sioux
Falls, S.D.), 1961. $10.00

Crouse, Nellis Maynard--In Quest of the Western Ocean.
N.Y., (1928). 1st ed. $17.50
--La Verendrye, Fur Trader and Explorer. Ithaca, 1956.
$27.50
Crouse, Russel--Mr. Currier and Mr. Ives. Garden City,
1930. 1st ed. $35.00 (one of 301 signed copies, boxed)
Garden City, 1936. $15.00
Crow, Carl--Meet the South Americans. N.Y., (1941). $6.00
Crow, John Armstrong--Mexico Today, N.Y., (1957). 1st ed.
$7.50
Crowell & Murray--The Iron Ores of Lake Superior.... Cleve.,
1911. $30.00 (binding flecked)
Crowell, John--Removal of the Winnebagoes. Wash., 1850.
$35.00 (disbound)
Crowfield, Christopher, pseud.
See: Stowe, Harriet Beecher
Crowther, Samuel--The Romance and Rise of the American
Tropics. Garden City, 1929. $10.00, $7.50
Croy, Homer--Corn Country. N.Y., (1947). $15.00
--He Hanged Them High. N.Y., (1952). 1st ed. $12.50
--R.F.D. No. 3. N.Y., 1924. 1st ed. $12.50
--Star Maker. N.Y., (1959). $12.50
--West of the Water Tower. N.Y., (1923). $8.50
--Wheels West. N.Y., (1955). $12.50 (author's presentation)
Cruden, Robert--James Ford Rhodes. Cleve., 1961. 1st ed.
$13.00
Cruickshank, Helen (Gere)--Flight Into Sunshine.... N.Y.,
1948. $10.00
The Cruise of the "Alabama...."
See: (Fullam, George Townley)
Cuba and the U.S. Wash., (1967). $10.00
Cubas, Antonio Garcia
See: Garcia Cubas, Antonio
Cuevas, Jose Luis--El Mundo de.... N.Y., 1969. $35.00
Culin, Stewart--Games of the North American Indians. Wash.,
1907. 1st ed. $40.00 (rebacked)
Cullen, James Bernard--The Story of the Irish in Boston.
Bost., 1889. 1st ed. $25.00 (cloth, one page torn)
Cullen, Joseph P.--The Peninsula Campaign, 1862. Harrisburg,
1973. $12.50
Culleton, James--Indians and Pioneers of Old Monterey.
Fresno, 1950. $25.00
Culley, John Henry--Cattle, Horses and Men of the Western
Range. L.A., (1940). 1st ed. $50.00 (cloth, hinges
cracked)

Cullinan, Gerald--The Post Office Department. N.Y., (1968).
$12.50
Culter, Richard V.--The Gay Nineties. Garden City, 1928.
$25.00
Cumberland, Charles Curtis--Mexico. N.Y., 1968. 1st ed.
$15.00 (cloth, ex-lib.)
Cuming, Fortescue--Sketches of a Tour to the Western Coun-
try.... Pitts., 1810. 1st ed. $250.00 (rebound in leather,
title reinforced)
Cumming, William Patterson--British Maps of Colonial America.
Chi., 1974. $20.00
--The Fate of a Nation. Lond., 1975. $14.95
Cummings, Byron--Indians I Have Known. Tucson, 1952.
$5.00
Cummings, Edward Estlin--Eimi. N.Y., 1933. 1st ed.
$150.00 (cloth, one of 1381 signed copies)
--R.E. Cummings, a Miscellany. N.Y., 1958. 1st ed. $25.00
--Selected Letters of.... N.Y., (1969). 1st ed. $25.00
(cloth)
--73 Poems. N.Y., (1962). 1st ed. $15.00 (boards, owner
inscription on endpaper)
Cummings, Homer Stille--Federal Justice. N.Y., 1937. 1st
ed. $35.00
Cummings, Sara J. Lemmon--Autobiography and Reminiscences....
N.p., 1914. $17.50 (wraps.)
Cuneo, John R.--Robert Rogers of the Rangers. N.Y., 1959.
$20.00
Cunningham, Eugene--Texas Sheriff. N.Y., 1934. $6.50
(owner name blocked out)
--Triggernometry. Caldwell, 1975. $25.00
Cunningham, Florence R.--Saratoga's First Hundred Years.
(San Jose, Calif.), 1967. 1st ed. $25.00
Cunningham, Frank--General Stand Watie's Confederate In-
dians. San Antonio, (1959). 1st ed. $45.00 (signed by
author)
Cunningham, William Patterson, ed.--The Exploration of North
America, 1630-1776
See under Title
Cunningham Graham, Robert Bontine--Bernal Diaz des Cas-
tillo. N.Y., 1915. $20.00
--Hernando de Soto. N.Y., 1924. $12.50
--The Horses of the Conquest. Norman, (1949). $45.00
--Jose Antonio Paez. Caracas, 1970. $10.00
--Rodeo. Garden City, 1936. 1st ed. $7.50 (bookplate,
stamp, back cover water stained)

Curle, J.H.--The Gold Mines of the World. N.Y., 1902.
$65.00

Curley, Edwin A.--Nebraska; its Advantages, Resources and
Drawbacks.... N.Y., 1876. $75.00 (orig. cloth)

Currey, Cecil B.--Code number 72/Ben Franklin. Englewood
Cliffs, (1972). $10.00

Currie, Barton--Booth Tarkington, a Bibliography. N.Y.,
1922. $50.00 (orig. cloth, boxed)

Currie, William--An Historical Account of the Climates and
Diseases of the U.S. Phila., 1792. 1st ed. $225.00 (old
calf)

Curry, George--George Curry, 1861-1947. (Albuquerque,
1958). 1st ed. $15.00

Curry, Jabez Lamar Monroe--Civil History of the Government
of the Confederate States.... Rich., (1900). 1st ed.
$20.00

Curry, Larry--The American West. (N.Y., 1972). $16.00

Curti, Merle Eugene--The Growth of American Thought. N.Y.,
(1943). $10.00 (underlining)

Curtin, Leonara Scott Muse--By the Prophet of the Earth.
Santa Fe, (1949). 1st ed. $25.00

Curtis, Edward S.--Indian Days of Long Ago. Yonkers-on-
Hudson, 1914. 1st ed. $72.50 (covers soiled, bookplate)
--Portraits From North American Indian Life. N.Y., (1972).
$50.00

Curtis, George Ticknor--Admission of Utah. N.Y., 1887.
1st ed. $30.00

Curtis, George William--Early Letters of George Wm. Curtis
to John S. Dwight. N.Y., 1898. 1st ed. $12.50

Curtis, Newton Martin--From Bull Run to Chancellorsville.
N.Y., 1906. 1st ed. $50.00 (inscribed copy)

Curtis, William Elroy--The Capitals of Spanish America. N.Y.,
1888. 1st ed. $18.00

Curtiss, Daniel S.--Western Portraiture and Emigrant's Guide.
N.Y., 1852. $300.00 (orig. cloth)

Cushing, Caleb--The Treaty of Washington. N.Y., 1873. 1st
ed. $27.50, $12.50

Cushing, Frank Hamilton--Zuni Folk Tales. N.Y., 1901. 1st
ed. $35.00 (cloth, small spot on front cover)

Cushing, George Holmes--The Human Side of Coal. N.Y.,
1924. $12.50 (cloth)

Cushman, Dan--The Great North Trail. N.Y., (1966). $8.50

Custer, Elizabeth (Bacon)--Boots and Saddles. N.Y., (1885).
$23.50, $17.50 (light wear, bookplate), $12.50
N.Y., 1913. $10.00

--Following the Guidon. N.Y., 1890. 1st ed. $30.00 (small
 crack in front hinge), $23.50 (some shelfwear, new end-
 papers)
 N.Y., 1898. $12.50
--Tenting on the Plains.... N.Y., 1889. $27.50
Custer, George Armstrong--Custer, in the Civil War. San
 Rafael, Ca., 1977. $45.00
--The Custer Story. N.Y., 1950. $16.50
--My Life on the Plains. Norman, (1962). $16.50, $7.50
--Wild Life on the Plains and Horrors of Indian Warfare.
 S.L., 1891. $20.00
Cutler, Frederick Morse--The Old Massachusetts Coast Artil-
 lery.... Bost., (1917). $20.00
Cutting, Elizabeth Brown--Jefferson Davis, Political Soldier.
 N.Y., 1930. $22.50, $10.00 (uncut)
Cutts, James Madison--The Conquest of California and New
 Mexico.... Phila., 1847. 1st ed. $550.00

- D -

Dabney, Joseph Earl--Mountain Spirits. N.Y., (1974). 1st
 ed. $10.00
Dabney, Owen P.--True Story of the Lost Shackle. (Salem,
 Or., 1897). 1st ed. $25.00
Dabney, William M.--William Henry Drayton & the American
 Revolution. Albuquerque, (1962). $12.50
Dacus, Joseph A.--A Tour of St. Louis. S.L., 1878. 1st
 ed. $35.00 (cloth, lightly worn), $25.00 (new binding)
Dahl, Arndt E.--Banker Dahl of South Dakota. Rapid City,
 S.D., (1965). $10.00
Dahlinger, Charles William--Pittsburgh. N.Y., 1916. $17.50
Dakin, Susanna (Bryant).--The Lives of William Hartnell.
 Stanford, (1949). 1st ed. $25.00, $20.00, $15.00, $15.00,
 $15.00
Dale, Edward Everett--Cherokee Cavaliers. Norman, 1939.
 1st ed. $45.00
--Cow Country. Norman, 1943. $12.50
 Norman, 1945. $26.00
--Frontier Trails
 See: Canton, Frank M.
--History of Oklahoma. N.Y., 1948. 1st ed. $12.50 (signed
 by author)
--The Indians of the Southwest. Norman, 1949. 1st ed.
 $35.00

The Dalton Brothers and Their Astounding Career of Crime
See: (Valcourt-Vermont, Edgar de)
Dalton, Emmett--When the Daltons Rode. Garden City, 1931.
1st ed. $82.50 (backstrip faded)
Dalton, John Edward--Sugar. N.Y., 1937. $30.00
Dalton, Kit--Under the Black Flag. (Memphis, 1914). 1st
ed. $22.50 (wraps., partly dampstained)
Dalzel, George Walton--The Flight From the Flag. Chapel
Hill, 1940. $17.50
Dana, Charles Anderson--The Life of Ulysses S. Grant....
See: Wilson, James Harrison
Dana, Edmund--Geographical Sketches on the Western Country.
Cinci., 1819. $255.00 (worn binding)
Dana, Julian--The Man Who Built San Francisco. N.Y., 1936.
$25.00 (signed), $10.00
--The Sacramento, River of Gold. N.Y., (1939). 1st ed.
$15.00, $15.00
Dana, Marshall Newport--Newspaper Story. Portland, Or.,
1951. $12.50, $9.25
Dana, Richard Henry--The Journal. Camb., 1968. 3 vols.
1st ed. $50.00, $45.00 (boxed)
--To Cuba and Back. Bost., 1859. 1st ed. $30.00 (ends
of spine lightly frayed)
Lond., 1859. $40.00 (spine ends chipped)
--Two Years Before the Mast. N.Y., 1840. 1st ed. $2500.00
(orig. muslin, 1st issue, front outer hinge cracking, slip-
cased)
L.A., 1964. 2 vols. $35.00
Danckaerts, Jaspar--Journal of a Voyage to New York....
Brooklyn, 1867. $25.00 (cloth, front panel somewhat water
damaged, first 100 pages a bit waterstained)
Dane, George Ezra--Ghost Town.... N.Y., 1941. $33.50,
$17.50 (cloth, light spine wear)
N.Y., (1948). $15.00
Dangerfield, George--Chancellor Robert R. Livingston of New
York.... N.Y., (1960). $20.00
Daniel, Hawthorne--The Hartford of Hartford. N.Y., (1960).
$12.50
Daniel, James--Strike in the West. N.Y., (1963). $8.00
Daniel, Jean Houston--Executive Mansions and Capitols of
America. Waukesha, Wi., (1969). $18.00
Danielian, Noobar Retheos--A.T. & T. N.Y., 1939. $15.00
Daniells, Roy--Alexander Mackenzie and the North West.
Lond., 1969. $30.00 (cloth)

Daniels, Daisy Paddock--Prairieville, U.S.A. Arlington
 Heights, 1971. $17.50
Daniels, Jonathan--The Devil's Backbone. N.Y., (1962).
 $12.50 (1st printing)
--Tar Heels. N.Y., 1941. $8.50 (front free endpaper with
 part of map removed)
Daniels, Margarette--Makers of South America. N.Y., 1916.
 $10.00
Danielson, Erik Georg--Anteckningar om Norra Amerikas Fris-
 taters Jerntillverkning.... Stockholm, 1845. $225.00
 (orig. wraps., uncut)
Dankers, Jaspan
 See: Danckaerts, Jaspar
Daran, Victor--Le General Miguel Miramon. Rome, 1886.
 $325.00 (contemp. morocco, brittle paper with some leaves
 chipped)
Darby, Edwin--It All Adds Up. (Chi., 1968). $10.00
Darby, William--A New Gazetteer of the United States of
 America. Hart., 1833. $75.00 (leather wearing, light
 foxing, owner's signature)
Dark, Richard--The Quest of the Indies. N.Y., (1960).
 $6.00
Darley, Felix Octavius Carr--Illustrations of Rip Van Winkle
 See: (Irving, Washington)
Darling, Jay Norwood--As Ding Saw Hoover. Ames, (1954).
 1st ed. $15.00
Darlington, Mary Carson (O'Hara)--Fort Pitt and Letters From
 the Frontier. Pitts., 1892. $150.00 (orig. cloth, one of
 200 copies)
--History of Colonel Henry Bouquet.... N.p., (1920). $75.00
 (one of 600 copies)
Darnell, Elias--A Journal, Containing an Accurate and Inter-
 esting Account.... Phila., 1854. $175.00 (orig. boards),
 $60.00 (printed board covers, leather spine shows some
 wear)
Darrach, Henry--Lydia Darrach.... Phila., 1916. $7.50
 (wraps.)
Darrah, William Culp--Powell of the Colorado. Princeton,
 (1970). $20.00
Darrow, Clarence--Attorney for the Damned. N.Y., 1957.
 1st ed. $10.00
Darton, Nelson Horatio--Story of the Grand Canyon of Arizona.
 K.C., (1921). $6.00
Dary, David--The Buffalo Book. Chi., (1974). 1st ed.
 $20.00 (1st printing)

--Comanche. Lawrence, Ks., 1976. $15.00 (cloth, one of 50 copies signed by author)

Dasch, George John--Eight Spies Against America. N.Y., (1959). $12.50

Dasmann, Raymond Frederic--The Destruction of California. N.Y., (1965). 1st ed. $6.00

Daughters, Charles G.--Wells of Discontent. N.Y., 1927. 1st ed. $12.50

Daugherty, Harry Micajah--The Inside Story of the Harding Tragedy. N.Y., 1932. 1st ed. $10.00

Daugherty, James Henry--Abraham Lincoln. N.Y., 1943. 1st ed. $45.00

Davalos y Lisson, Pedro--Bolivar (1823-1827). Barcelona, 1924. $10.00 (cloth, spine top torn)

David, Henry--The History of the Haymarket Affair. N.Y., (1936). 1st ed. $17.50 (part of endpaper and title clipped)

David, Robert Beebe--Finn Burnett, Frontiersman.... Glendale, 1937. $75.00

--Malcolm Campbell, Sheriff. Casper, (1932). $40.00 (spine faded)

Davidson, George--The Alaska Boundary. S.F., 1903. $50.00 (orig. cloth)

Davidson, Homer K.--Black Jack Davidson. Glendale, 1974. $25.00 (cloth), $15.50, $15.00

Davidson, Irwin D.--The Jury's Still Out. N.Y., (1959). $8.00

Davidson, Joe--Amelia Earhart Returns From Saipan. Canton, Oh., (1969). $20.00 (inscribed)

Davidson, Lallah--South of Joplin. N.Y., (1939). $25.00

Davidson, Levette Jay--A Guide to American Folklore. Denver, (1951). $17.50, $15.00 (cloth)

--The Literature of the Rocky Mountain West.... Caldwell, 1939. 1st ed. $20.00 (owner name)

Davidson, Marshall--Life in America. Bost., 1951. 2 vols. $40.00 (cloth), $20.00 (boxed), $20.00 (boxed), $15.00

Davidson, Nora Fontaine M.--Cullings From the Confederacy. Wash., 1903. $15.00 (wraps.)

Davidson, Robert--History of the Presbyterian Church in the State of Kentucky. N.Y., 1847. $35.00 (needs rebinding)

Davie, Oliver--Nests and Eggs of North American Birds. Columbus, 1889. $22.00 (paper browning, some marginal water staining)

Davies, Blodwen--Gaspe; Land of History and Romance. Toronto, (1949). $25.00 (cloth)

--Saguenay, "Saginawa." Montreal, (1930). $35.00

Davies, Edward--The Boy Preacher. Bost., (1881). $13.50
Davila, Carlos--We of the Americas. Chi., (1949). $8.50
Davis, Aaron J.--History of Clarion County, Pennsylvania.
 Syracuse, N.Y., 1887. $150.00 (cloth, rebacked)
Davis, Allen Freeman--Spearheads for Reform. N.Y., 1967.
 $15.00
Davis, Allison--Children of Bondage. Wash., 1940. $17.50
Davis, Angela Yvonne--If They Come in the Morning. N.Y.,
 (1971). 1st ed. $25.00
Davis, Arthur Kyle--Traditional Ballads of Virginia. Camb.,
 1929. 1st ed. $96.00
Davis, Ashel--Antiquities of America.... N.Y., 1847. $15.00
 (lacks wraps.)
Davis, Britton--The Truth About Geronimo. New Haven, 1929.
 1st ed. $47.50
Davis, Burke--The Billy Mitchell Affair. N.Y., (1967).
 $12.50
--Gray Fox. N.Y., (1956). 1st ed. $13.50 (spine lightly
 discolored)
--Jeb Stuart, the Last Cavalier. N.Y., (1957). $27.50
 (autographed), $22.50 (binding spotted, signed by author)
--To Appomattox. N.Y., (1959). 1st ed. $13.50
Davis, Charles Belmont, ed.--Adventures and Letters of Rich-
 ard Harding Davis
 See: Davis, Richard Harding
Davis, Clyde Brion--The Arkansas. N.Y., (1940). $15.00
 (ex-lib.), $15.00
Davis, Duke--Flashlights From Mountain and Plain. Bound
 Brook, N.J., 1911. $47.50
Davis, Edward J.P.--Historical San Diego. San Diego, 1953.
 $7.50
Davis, Edwin Adams--Of the Night Wind's Telling. Norman,
 1946. 1st ed. $15.00
Davis, Elmer--History of the New York Times.... N.Y.,
 1921. $25.00 (wraps., lightly chipped, pages a bit dog-
 eared, owner's signature)
Davis, Frederick Lionel--Notes on the Butterflies of British
 Honduras. Lond., 1928. $22.00 (boards)
Davis, George--A Historical Sketch of Sturbridge and South-
 bridge. West Brookfield, 1856. 1st ed. $47.50
Davis, Harold Eugene--Makers of Democracy in Latin America.
 N.Y., 1945. 1st ed. $5.00
Davis, Harry E.--A History of Freemasonry Among Negroes
 in America. N.p., (1946). $45.00

Davis, James Warren--Little Groups of Neighbors. Chi.,
(1968). 1st ed. $8.50
Davis, Jane Eliza--Round About Jamestown. (Hampton, Va.,
1907). $10.00
Davis, Jefferson--Jefferson Davis, Constitutionalist. Jackson,
Ms., 1923. 10 vols. $150.00 (some vols. lightly scuffed)
--The Rise and Fall of the Confederate Government. N.Y.,
1881. 2 vols. 1st ed. $50.00 (calf, hinges weak, binding
worn)
Davis, John--Travels of Four Years and a Half in the....
[U.S.A.] During 1798.... Lond., 1803. 1st ed. $400.00
(three-quarter morocco)
Davis, John F.--California, Romantic and Resourceful....
S.F., 1914. 1st ed. $13.50
Davis, John H.--The Bouviers. N.Y., (1969). $8.50
Davis, John Patterson--The Union Pacific Railway. Chi.,
1894. 1st ed. $75.00 (orig. cloth, small stamp removed
from title)
Davis, Julia--The Shenandoah. N.Y., (1945). $15.00
Davis, Kenneth Sydney--The Hero. Garden City, 1959.
$15.00
Davis, Mary Lee (Cadwell)--Sourdough Gold, the Log of a
Yukon Adventure. Bost., (1933). $17.50
--Uncle Sam's Attic.... Bost., (1930). $7.50 (lettering on
spine obliterated)
Davis, Norris G.--The Press and the Law in Texas. Austin,
1956. $15.00 (ex-lib.)
Davis, Richard Beale--Intellectual Life in Jefferson's Vir-
ginia.... Chapel Hill, (1964). $10.00 (ex-lib.)
Davis, Richard Harding--Adventures and Letters of.... N.Y.,
1917. $7.00
--The Bar Sinister. N.Y., 1903. 1st ed. $12.00 (cloth, ink
inscription)
--The Deserter. N.Y., 1917. 1st ed. $10.00 (boards)
--The King's Jackal. N.Y., 1898. 1st ed. $20.00 (2d state,
orig. cloth, rear cover lightly soiled, owner signature)
--The Princess Aline. N.Y., 1895. $15.00
--Soldier of Fortune. N.Y., 1897. $15.00
--Three Gringos in Venezuela and Central America. N.Y.,
1896. $32.50 (presentation copy), $15.00 (cloth)
--The West From a Car Window. N.Y., 1892. 1st ed. $20.00
(ex-lib. stamp, bookplate, binding edges wearing)
N.Y., 1903. $10.00
--The White Mice. N.Y., 1909. $15.00

Davis, Robert Hobart--Hawaii, U.S.A. N.Y., (1941). $8.00
(ex-lib.)
Davis, Stephen Chapin--California Gold Rush Merchant. San
Marino, 1956. 1st ed. $25.00
Davis, T.E.--From New Jersey to California, '97. Somerville,
N.Y., 1897. $17.50 (cloth)
Davis, Thomas Brabson--Aspects of Freemasonry in Modern
Mexico. N.Y., 1976. $15.00
--Carlos de Alvear.... Durham, 1955. 1st ed. $7.50
Davis, Varina Howell--Jefferson Davis.... N.Y., (1890).
2 vols. 1st ed. $75.00 (hinges weak)
Davis, Wallace--Corduroy Road. Houston, 1951. $20.00
Davis, William C.--Duel Between the First Ironclads. Garden
City, 1975. 1st ed. $12.50 (signed)
Davis, William F.--Christian Liberties in Boston. Chelsea,
Ma., 1887. $30.00 (orig. wraps.)
Davis, William Heath--Seventy-Five Years in California. S.F.,
1929. 1st ed. $87.00 (spine lightly faded), $80.00 (front
cover rubbed)
S.F., 1967. $25.00 (one of 2500 copies)
Davis, William Watts Hart--The Fries Rebellion.... Doyles-
town, 1899. 1st ed. $35.00 (ex-lib., some wear), $30.00
(orig. cloth)
--History of Bucks County, Pennsylvania.... N.Y., 1905.
3 vols. $250.00 (half leather)
Dawn in the Golden Valley. N.p., 1971. $50.00
Daws, Gavan--Shoal of Time. Honolulu, (1968). $8.00
(wraps.)
Dawson, Carl Addington--The Settlement of the Peace River
Country. Toronto, 1934. $100.00 (cloth)
Dawson, Charles--Pioneer Tales of the Oregon Trail and of
Jefferson County. Topeka, 1912. $85.00
Dawson, Charles Carroll--Saratoga: Its Mineral Waters....
N.Y., 1868. $89.50 (orig. printed wraps.)
Dawson, Joseph Martin--Jose Antonio Navarro.... (Waco,
1969). $30.00
Dawson, Nicholas--Narrative of Nicholas "Cheyenne" Dawson...
S.F., 1933. $85.00 (orig. boards, one of 500 copies)
Dawson, Samuel Edward--The Saint Lawrence.... N.Y., 1905.
$18.50
Dawson, Sarah (Morgan)--A Confederate Girl's Diary. Bost.,
1913. $45.00 (cloth, moderately worn)
Bloomington, (1960). $25.00
Dawson, Thomas Fulton--The Ute War. Denver, 1879. 1st
ed. $850.00 (calf, lower one-fourth of title torn away)

Day, Arthur Grove--Coronado's Quest. Berkeley, 1940. 1st
ed. $35.00
--A Hawaiian Reader. N.Y., (1959). 1st ed. $8.50
Day, Donald--Big Country: Texas. N.Y., (1947). $17.50
--Will Rogers.... N.Y., 1962. $10.00
Day, Frank A.--Life of John Albert Johnson. Chi., 1910.
1st ed. $12.50
Day, Luella--The Tragedy of the Klondike. N.Y., 1906.
$30.00, $25.00 (cloth, hinges cracked)
Day, Richard Ellsworth--Breakfast Table Autocrat. Chi.,
1946. $10.00
Dazey, Charles Turner--The Fine Book Club Presents the
First Book Appearance of Charles T. Dazey's Thrilling
American Drama, In Old Kentucky. Detroit, 1937. $20.00
(wraps., one of 1000 copies)
Deaderick, John Barron--Strategy in the Civil War. Harris-
Burg, 1946. 1st ed. $20.00
Dealey, Ted--Diaper Days of Dallas. Nash., (1966). 1st ed.
$6.50
Dean, Arthur Hobson--William Nelson Cromwell.... (N.Y.,
1957). $25.00
Dean, Silas--The Dean Papers.... 1774-1790. (N.Y., 1887-
90). 5 vols. $65.00
Dean, Thomas--Journal of Thomas Dean.... Ind., 1918.
$25.00 (orig. wraps.)
Deane, Frank Putnam, ed.--"My Dear Wife...."
See: Brett, David
DeArmond, Frederick Francis--The Laundry Industry. N.Y.,
(1950). $15.00
Deatherage, Charles P.--Early History of Greater Kansas City,
Missouri and Kansas. K.C., 1927. $55.00
--Steamboating on the Missouri River in the Sixties.... (K.C.,
1924). 1st ed. $7.50
DeBarthe, Joseph--Life and Adventures of Frank Grouard.
Norman, (1958). $17.50, $15.00 (cloth)
(DeBeck, William L.)--Murder Will Out. Cinci., 1867. $75.00
(wraps., lower corner front wrap. replaced in facs.)
Debo, Angie--Oklahoma, Foot-Loose and Fancy-Free. Norman,
1949. 1st ed. $25.00 (corner of front blank endpaper
clipped, owner name), $22.50, $17.50
--Prairie City. N.Y., 1944. 1st ed. $15.00, $11.50
--The Rise and Fall of the Choctaw Republic. Norman, 1934.
1st ed. $50.00 (material pasted on endpapers, bookplate,
1st state of binding, owner name)
Norman, (1961). $20.00, $15.00 (cloth)

116 / Debray, Xavier Blanchard

--The Road to Disappearance. Norman, 1941. 1st ed. $45.00
(author's presentation copy, owner name)
Debray, Xavier Blanchard--A Sketch of the History of De-
bray's (26th) Regiment.... Waco, 1961. $22.00 (one of
300 numbered copies)
Decatur, Stephen--Private Affairs of George Washington....
Bost., 1933. $35.00 (orig. boards, one of 160 signed and
numbered copies)
Decker, Malcolm
See: Decker, Peter
Decker, Peter--Benedict Arnold. N.Y., 1961. $50.00 (in-
scribed and signed copy, buckram)
DeConde, Alexander--This Affair of Louisiana. N.Y., 1976.
$9.95
DeCordova, Jacob--Lecture on Texas. Phila., 1858. 1st ed.
$125.00 (wraps., light marginal dampstaining on title)
DeFord, Mirian Allen--They Were San Franciscans. Caldwell,
(1941). 1st ed. $25.00, $17.50, $8.50 (bookplate removed,
owner name)
DeForest, John William--A Union Officer in the Reconstruction.
New Haven, 1948. 1st ed. $14.50
--A Volunteer's Adventures. New Haven, 1946. 1st ed.
$25.00
DeFoy, Francis R.--Kopaa. Norfolk Downs, Ma., 1927. $10.00
Degler, Carl N.--Out of Our Past. N.Y., (1962). $5.00
DeGrazia, Ted Ettore--Padre Kino. L.A., 1962. $37.50
DeHaas, Jacob--Louis D. Brandeis.... N.Y., 1929. $13.50
DeHass, Wills--History of the Early Settlement and Indian
Wars of Western Virginia. Wheeling, 1851. 1st ed. $75.00
(ex-lib., rubbed)
Delabarre, Edmund Burke--Dighton Rock. N.Y., 1928. 1st
ed. $35.00, $17.50 (backstrip dampstained)
Delano, Alonzo--Across the Plains and Among the Diggings.
N.Y., 1936. $35.00, $25.00
--Alonzo Delano's Pen-Knife Sketches. S.F., 1934. $65.00
(three-quarter calf and cloth, minor wear to top of spine)
--The Miner's Progress. Sacramento, 1853. 1st ed. $750.00
(occasional light marginal staining)
--Pen Knife Sketches. Sacramento, 1853. $600.00 (half
morocco)
De La Rhue, Trevino--Spanish Trails to California. Caldwell,
1937. $20.00 (covers lightly soiled)
De La Roche, Mazo--Quebec, Historic Seaport. Garden City,
1944. 1st ed. $10.00

Delavan, James--Notes on California and the Placers. Oakland,
1956. $30.00 (cloth, one of 700 copies), $25.00
DeLeeuw, Hendrik--Flower of Joy. N.Y., (1944). $6.00
Delke, James Almerius--History of the North Carolina Chowan
Baptist Association.... Raleigh, 1882. $50.00 (new cloth)
Dellenbaugh, Frederick Samuel--Fremont and '49. N.Y.,
1914. 1st ed. $35.00 (some spotting to covers, minimal
foxing), $30.00 (ex-lib.)
DeLoach, Robert John Henderson--Rambles With John Bur-
roughs. Bost., (1912). $7.50
DeLong, George Washington--Our Lost Explorers. Hart.,
1883. $27.50
DeMare, Marie--G.P.A. Healy, American Artist. N.Y., (1954).
$25.00
Deming, Barbara--Prison Notes. N.Y., 1966. 1st ed. $20.00
Deming, Henry Champion--The Life of Ulysses S. Grant....
Hart., 1868. 1st ed. $13.50
The Democrat
See: (Pye, Henry James)
Demond, Chester Whiting--Price, Waterhouse & Co. in America.
N.Y., 1951. 1st ed. $20.00
Dempsey, Hugh Aylmer--Crowfoot.... Norman, (1972).
$12.50
Dene, Shafto--Trail Blazing in the Skies. Akron, Oh., 1943.
$10.00
Denhardt, Robert Moorman--The Horse of the Americas. Nor-
man, 1947. 1st ed. $26.50
Denis, Alberta Johnson--Spanish Alta California. N.Y., 1927.
$27.50
Denison, Merrill--Bristles and Brushes. N.Y., (1949). $12.00
Denman, Leslie Van Ness--Pai Ya Tu Ma.... (N.p., 1955).
$15.00 (covers bent)
Dennett, Tyler, ed.--Lincoln and the Civil War
See: Hay, John
Dennis, Wayne--The Hopi Child. N.Y., 1940. 1st ed. $27.50
(some pencil underlining)
Denny, Ludwell--America Conquers Britain. N.Y., 1930.
$10.00
Densmore, Frances--Cheyenne and Arapahoe Music. L.A.,
1936. 1st ed. $20.00 (owner name)
--Chippewa Customs. Wash., 1929. 1st ed. $30.00
--Music of the Maidu Indians of California. L.A., 1958.
$10.00 (ex-lib.)
--Teton Sioux Music. Wash., 1918. $50.00

Denton, B.E.--A Two-Gun Cyclone. Dallas, 1927. $17.50
(owner stamp, backstrip faded)
Denton, Sherman Foote--Moths and Butterflies of the U.S.,
East of the Rocky Mountains. Bost., 1900. 2 vols.
$761.00 (half morocco, upper joints a bit rubbed, one of
500 numbered sets)
The Denver Post Rocky Mountain Empire
See: Howe, Elvon L.
DePuy, Henry Walter--Ethan Allen and the Green-Mountain
Heroes of '76. Bost., 1853. $20.00 (binding worn and a
little loose)
DeQuille, Dan, pseud.
See: Wright, William
DeQuincey, Thomas--California and the Gold Rush Mania.
(S.F.), 1945. $35.00 (boards, bookplate, one of 500 cop-
ies)
Derleth, August--Shadow of Night. N.Y., 1943. 1st ed.
$35.00 (orig. cloth, edges and corners lightly worn)
--Vincennes: Portal to the West. Englewood Cliffs, (1968).
$15.00
DeRoos, Robert William--The Thirsty Land. Stanford, 1948.
$20.00
Derounian, Arthur--Under Cover.... N.Y., 1943. $7.50
DeSchauensee, Rodolphe Meyer--A Guide to the Birds of Vene-
zuela. Princeton, 1978. $98.00 (cloth)
DeSchweinitz, Edmund Alexander--The Life and Times of David
Zeisberger.... Phila., 1870. $85.00 (orig. cloth)
Descourtilz, Jean Theodore--Ornitologia Brasileira.... Rio de
Janeiro, 1944. $131.00 (orig. wraps., margins and first
few leaves a bit foxed)
DeSmet, Pierre Jean--Life, Letters, and Travels.... N.Y.,
1905. 4 vols. $165.00 (uncut)
--New Indian Sketches. N.Y., 1865. $100.00 (front endpaper
removed)
Destler, Chester McArthur--Roger Sherman and the Independ-
ent Oil Men. Ithaca, 1967. $15.00
DeToledano, Ralph--R.F.K., the Man Who Would Be President.
N.Y., (1967). $6.50
Dett, Robert Nathaniel--The Religious Folk-Songs of the Negro
as Sung at Hampton Institute. Hampton, Va., 1927. $32.50
(light shelfwear, inner hinge starting)
Detzer, Dorothy--Appointment on the Hill. N.Y., (1948).
$10.00
Deuel, John Vanderveer--White Cayuca. Bost., 1934. $8.50
Deuel, Leo--Conquistadors Without Swords. N.Y., 1967. 1st
ed. $15.00

Devens, Richard Miller--The Pictorial Book of Anecdotes and Incidents of the War of the Rebellion. Hart., 1866. 1st ed. $25.00

Deverdun, Alfred Louis--The True Mexico. (Mexico), 1938. $15.00

DeVighne, Harry Carolos--The Time of My Life. Phila., (1942). 1st ed. $6.00

Devine, Edward James--The Jesuit Martyrs of Canada Together With the Martyrs Slain in the Mohawk Valley. $35.00 (light foxing, modern buckram)

DeVoto, Bernard Augustine--Across the Wide Missouri. Bost., 1947. 1st ed. $60.00, $25.00, $15.00, $12.50 (slight cover discoloration)

--The Course of Empire. Bost., 1952. 1st ed. $10.00

--The Journals of Lewis and Clark
 See: Lewis, Meriwether

--Mark Twain at Work. Camb., 1942. 1st ed. $45.00

--Original Journals of the Lewis and Clark Expedition
 See: Lewis, Meriwether

--The Year of Decision.... Bost., 1943. $22.50, $20.00 (cloth)

DeVylder, Stefan--Allende's Chile. Camb., 1976. $15.00

Dew, Charles--Ironmaker to the Confederacy. New Haven, 1966. $20.00 (presentation copy)

Dewees, Francis Percival--The Molly Maguires.... Phila., 1877. 1st ed. $85.00 (orig. cloth)

Dewell, James D.--Down in Porto Rico With a Kodak. New Haven, 1898. $55.00 (cloth)

Dewey, George--Autobiography.... N.Y., 1913. 1st ed. $15.00

Dewey, John--The Quest for Certainty. N.Y., 1929. 1st ed. $10.00 (cover worn and stained)

Dewhurst, William Whitwell--The History of Saint Augustine, Florida.... N.Y., 1881. 1st ed. $60.00 (orig. cloth)

DeWitt, David Miller--The Judicial Murder of Mary E. Surratt. Balt., 1895. $30.00

DeWolf, James M.--The Diary and Letters of.... (Bismarck, 1958). $15.00

Diamant, Gertrude--The Days of Ofelia.... Bost., 1942. $5.00

Diamond, Sigmund--The Reputation of the American Business-man. Camb., 1955. 1st ed. $10.00

The Diary of a Public Man. New Brunswick, (1946). $12.50

Diaz, F.J.
 See: Diaz Valderrama, Francisco Javier

Diaz del Castillo, Bernal--The Discovery and Conquest of Mexico, 1517-1521. N.Y., (1928). $25.00 (orig. cloth), $12.50

Lond., 1939. $20.00

(N.Y., 1956). $7.50

--The True History of the Conquest of Mexico. Salem, 1803.
2 vols. $375.00 (orig. calf, rebacked in calf with orig.
spine labels preserved)

Diaz Lozano, Argentina--Mayapan. Merida, Mexico, 1951.
$6.00

Diaz Valderrama, Francisco Javier--La Compana del Ejercito de
Los Andes en 1817. Santiago de Chile, 1917. $35.00
(owner stamp)

Dick, Everett Newfon--The Sod-House Frontier.... Lincoln,
(1954). 1st ed. $26.00, $25.00

--The Story of the Frontier. N.Y., (1941). $17.50 (ex-lib.),
$15.00, $12.50

--Vanguards of the Frontier. N.Y., 1941. 1st ed. $40.00,
$25.00

Dick, Jane--Whistle-Stopping With Adlai. Chi., 1952. $12.50

Dickason, David Howard--The Daring Young Men. Blooming-
ton, 1953. 1st ed. $25.00

Dickey, Herbert Spencer--My Jungle Book. Bost., 1932.
$8.00 (spine faded)

Dickey, James--Babel to Byzantium. N.Y., (1968). 1st ed.
$15.00

--Exchanges. (Bloomfield Hills, Mi., 1971). $37.50 (one of
200 signed and numbered copies)

--Spinning the Crystal Ball. Wash., 1967. $4.50 (stapled
wraps.)

Dickey, Marcus--The Maturity of James Whitcomb Riley. Ind.,
(1922). 1st ed. $10.00 (ex-lib., extremities lightly worn)

Dickinson, A. Bray--Narrow Gauge to the Redwoods. L.A.,
(1967). 1st ed. $20.00 (minor rubbing to bottom of spine)

Dickinson, Anna Elizabeth--A Ragged Register.... N.Y.,
1879. $40.00 (orig. cloth, corners and edges a bit worn,
bookplate, owner signature)

Dickinson, Asa Don--Booth Tarkington, a Gentleman From In-
diana. (Garden City, n.d.). $15.00 (edges lightly worn)

--Booth Tarkington, a Sketch. Garden City, 1926. 1st ed.
$15.00 (small tear to front wrap.)

Dickinson, Emily--Poems. N.Y., 1952. $15.00 (cloth, slip-
cased)

--Poems, First & Second Series. Cleve., (1948). $8.50

Dickinson, Thomas Herbert--Portrait of a Man as Governor.
N.Y., 1928. 1st ed. $6.00

Dickore, Marie Paula--General Joseph Kerr.... Oxford, Oh.,
1941. $25.00

Dickson, Lovat--Wilderness Man. Toronto, 1973. $10.00
Dieber, Eddie--General George Armstrong Custer's Biography
in Pictures. Grand Forks, N.D., 1968? $12.50
Dieck, Herman--The Johnstown Flood. N.p., (1889?). $5.00
Diefendorf, Mary Riggs--The Historic Mohawk. N.Y., 1910.
$25.00
Diereville, N. de--Relation du Voyage du Port Royal de L'
Acadie.... Rouen, 1708. 1st ed. $750.00 (1st issue, old
boards, laid in half calf slipcase)
Dies, Martin--Martin Dies' Story. N.Y., (1963). $12.50,
$6.50
--The Trojan Horse in America. N.Y., 1940. $12.50 (ex-lib.)
Dietrich--The German Emigrants. (Stanford, Ca.), 1949.
$31.50 (boards)
Dietz, David--The Goodyear Research Laboratory. Akron,
Oh., 1943. $10.00
Diggs, Annie Le Porte--The Story of Jerry Simpson. Wichita,
(1908). 1st ed. $8.50
Dillin, John Grace Wolf--The Kentucky Rifle. York, Pa.,
1959. $55.00 (slipcased)
Dillon, Emile Joseph--Mexico on the Verge. N.Y., (1921).
$15.00
Dillon, Richard--A Cannoneer....
See: Rice, Josiah M.
--Fool's Gold. N.Y., (1967). 1st ed. $25.00 (signed by au-
thor), $12.50
--Grizzly Adams. Davis, 1966. 1st ed. $20.00 (one of 400
copies, orig. printed wraps.)
--Images of Chinatown. S.F., 1976. $125.00 (one of 450
copies)
--The Legend of Grizzly Adams. N.Y., (1966). 1st ed.
$20.00 (signed by the author)
--Meriwether Lewis. N.Y., 1965. 1st ed. $20.00 (signed by
author), $12.50
--Siskiyou Trail. N.Y., (1975). 1st ed. $30.00 (signed by
the author), $15.00
--Wells Fargo Detective. N.Y., (1969). $20.00
Dimsdale, Thomas Josiah--The Vigilantes of Montana. Helena,
(1915). $45.00. Butte, Mt., 1945. $12.50
Butte, Mt., 1950. $10.00 (wraps.)
Norman, (1953). $10.00 (boards)
Dingwall, Eric John--The American Woman. N.Y., (1956).
$15.00
Dinsmoor, Robert--Incidental Poems.... Haverhill, Ma., 1828.
1st ed. $37.50 (orig. boards, spine worn and torn, cov-
ers loose, uncut)

Dippie, Brian--Bards of Little Big Horn. Bryan, Tx., 1978.
$75.00 (one of 350 copies)

DiPrima, Diane--Memoirs of a Beatnik. (N.Y., 1969). $20.00
(stiff wraps., light scuffing)

Dirks, Raymond L.--The Great Wall Street Scandal. N.Y.,
(1974). $10.00

Dirvin, Joseph I.--Mrs. Seton, Foundress of the American
Sisters of Charity. N.Y., 1962. 1st ed. $12.50

The Discovery of Florida
See: Gentlemen of Elvas--The Discovery of Florida

Disselhoff, Hans Dietrich--The Art of Ancient America. N.Y.,
(1961). $25.00
N.Y., (1966). $20.00
--Daily Life in Ancient Peru. N.Y., (1967). $15.00 (some
fore-edges of plates adhering to each other)

(Disturnell, John)--The Eastern Tourist. N.Y., (1848).
$32.50
--The Great Lakes, or Inland Seas of America.... Phila.,
1871. $72.50 (ex-private lib.)

Divided We Fought. N.Y., 1952. $20.00

Dix, Dorthea Lynde--Remarks on Prison Discipline in the U.S.
Bost., 1845. 1st ed. $60.00 (later buckram, ex-lib.)

Dix, Robert Heller--Colombia. New Haven, 1967. $15.00

Dixon, Billy--Life of "Billy" Dixon. Dallas, (1927). $28.50

Dixon, Joseph Kossuth--The Vanishing Race.... Garden City,
1913. 1st ed. $100.00
N.Y., 1914. $75.00 (cloth, name on endleaf, inscribed and
signed)

Dixon, Olive (King)--Life of "Billy" Dixon....
See: Dixon, Billy

Dixon, Samuel Houston--Robert Warren, the Texas Refugee....
N.Y., [1879?]. $50.00
--Romance and Tragedy of Texas History. Houston, 1924.
$45.00

Dixon, William Hepworth--History of William Penn. Lond.,
1872. $15.00 (contemp. three-quarter calf, rubbed)
N.Y., 1902. $100.00 (bookplate, one of 210 numbered cop-
ies)
--Spiritual Wives. Lond., 1868. 2 vols. $35.00 (orig. cloth,
ex-lib.)
--William Penn.... Lond., 1851. $10.00

Dixon, Winifred Hawkridge--Westward Hoboes.... N.Y., 1923.
$6.00

Doane, Gustavus Cheeny--The Report of Lieutenant.... Upon
the So-Called Yellowstone Expedition of 1870. Wash., 1871.
1st ed. $85.00 (wraps. bound in later cloth, ex-lib.)

Dobbins, William W.--History of the Battle of Lake Erie....
Erie, Pa., 1913. $20.00, $20.00
Dobie, Charles Caldwell--San Francisco, a Pageant. N.Y.,
1933. 1st ed. $15.00, $7.50 (owner name)
--San Francisco Tales. N.Y., 1935. $8.50
Dobie, James Frank--Apache Gold & Yaqui Silver. Bost.,
1939. 1st ed. $40.00, $30.00, $17.50
--Coronado's Children. Dallas, (1930). 1st ed. $72.50 (un-
cut). N.Y., 1931. $5.00 (owner name)
--44 Range Country Books.... Austin, 1972. $50.00 (boards,
ltd., ed., signed by Dykes), $25.00 (one of 1000 copies)
--I'll Tell You a Tale. Bost., (1960). 1st ed. $15.00
--The Longhorns. Bost., 1941. $47.50 (lightly soiled bind-
ing)
N.Y., (1941). $6.00 (paper)
--The Mustangs. Bost., (1952). 1st ed. $3000.00 (orig.
horsehide, slipcased, one of 100 numbered copies, signed
by author)
--Mustangs and Cow Horses. Dallas, (1961). $15.00
--On the Open Range. Dallas, (1931). $5.00 (rebound, ex-
lib.)
--Out of the Old Rock. Bost., 1972. 1st ed. $6.00, $5.00
--Rattlesnakes. Bost., 1965. $15.00
--Some Part of Myself. Bost., (1967). 1st ed. $10.00
--Southwestern Lore. Austin, 1931. $17.50
--Tales of the Mustang. Dallas, 1936. 1st ed. $1500.00
(orig. boards, one of 300 copies)
--A Texan in England. Bost., 1945. 1st ed. $35.00
--A Vaquero of the Brush Country.... Bost., (1957). $7.00
--The Voice of the Coyote. Bost., 1949. 1st ed. $17.50
Doble, John--Journal and Letters From the Mines. Denver,
(1962). $60.00 (uncut, one of 1000 copies)
Dobyns, Fletcher--The Amazing Story of Repeal. Chi., 1940.
1st ed. $10.00 (cover spotted)
Dockstader, Frederick J.--Indian Art in America.... Green-
wich, (1966). $25.00
La Doctrina Drago. Lond., 1908. $20.00
The Documentary History of the State of New-York. Albany,
(1849-51). 4 vols. $200.00 (large paper ed., vol. 1
lacks part of backstrip)
Documents Relative to the Colonial History of the State of New-
York. Albany, 1856-87. 15 vols. $850.00 (orig. cloth),
$675.00 (orig. cloth, some vols. mended)
Dod, Samuel Bayard--A Hillside Parish. N.Y., 1893. 1st ed.
$15.00 (orig. boards, binding soiled and rubbed, one of
100 large paper copies)

Dodd, Dorothy--Florida, the Land of Romance. Tallahassee,
1957. $5.00 (wraps.)
Dodd, William Edward--Jefferson Davis. Phila., (1907). 1st
ed. $13.50
Dodge, Ernest Stanley--New England and the South Seas.
Camb., 1965. $15.00
Dodge, Grenville Mellen--The Battle of Atlanta, and Other
Campaigns.... Council Bluffs, 1911. $19.00
--How We Built the Union Pacific Railroad. N.p., (1910).
$38.50 (cloth, back cover stained)
Dodge, Jacob Richards--West Virginia. Phila., 1865. $125.00
(orig. cloth)
Dodge, Richard Irving--Our Wild Indians. Hart., 1882. 1st
ed. $40.00
Hart., 1883. $15.00 (rebound)
--The Plains of the Great West and Their Inhabitants. N.Y.,
1877. 1st ed. $85.00 (orig. cloth, lib. stamps), $67.50
Dodge, William Sumner--A Waif of the War. Chi., 1866. 1st
ed. $150.00
Doerflinger, William Main--Shantymen and Shantyboys. N.Y.,
1951. 1st ed. $27.50
Doherty, Bill--Crime Reporter. N.Y., (1964). $12.50
Doherty, Robert W.--The Hicksite Separation. New Brunswick,
(1967). $12.50
Dohrman, H.T. California Cult. Bost., 1958. 1st ed. $8.50,
$7.50
Dolan, J.R.--The Yankee Peddlers of Early America. N.Y.,
(1964). $10.00
Dolch, Edward William--Stories From Hawaii. Champaign, 1960.
$10.00
Dolinger, Jane--Gypsies of the Pampa. N.Y., (1958). $10.00
Dollar, Robert--Memoirs of.... S.F., 1918-25. 4 vols. in 3.
$40.00 (signed presentation copy)
Dolson, Hildegarde--The Great Oildorado. N.Y., (1959).
$12.50, $10.00, $7.00 (ex-lib.)
Domenech, Emmanuel Henri Dieudonne--Seven Years' Residence
in the Great Deserts of North America.... Lond., 1860.
2 vols. 1st ed. $250.00 (half calf), $150.00 (rebound,
pages moderately age-darkened)
Domville-Fife, Charles William--Among Wild Tribes of the Ama-
zons. Phila., 1925. $35.00 (cloth)
--The Great States of Latin America. Lond., 1910. $15.00
--The States of South America. Lond., 1920. $12.00 (ex-lib.)
Donald, David Herbert--Charles Sumner and the Coming of the
Civil War. N.Y., 1961. $15.00

--Divided We Fought
 See under Title
--Lincoln's Herndon. N.Y., 1948. $13.50, $7.50
(Donan, Percival)--The Heart of the Continent. Chi., 1882.
 1st ed. $27.50
Dondore, Dorothy Anne--The Prairie and the Making of Middle
 America. N.Y., 1961. $25.00 (orig. cloth, one of 750 cop-
 ies), $20.00
Donehoo, George Patterson--A History of the Cumberland
 Valley.... Harrisburg, 1930. 2 vols. $100.00 (cloth)
Donizetti, Gaetano--Anne de Boulen; Opera en Trois Actes.
 New Orleans, 1847. $8.50 (wraps.)
Donnalley, Thomas K.--Hand Book to the Tribal Names of
 Pennsylvania.... Phila., 1908. $45.00
Donnavan, Corydon--Abenteuer in Mexiko.... Kutztown, Pa.,
 1848. $350.00 (orig. wraps., backstrip pieces missing)
Donnelly, Ignatius--Ragnarok. N.Y., 1883. $12.50
Donovan, Robert J.--Eisenhower. N.Y., 1956. 1st ed. $10.00
--PT 109. N.Y., 1961. $10.00
Dooley, John Edward--John Dooley, Confederate Soldier.
 (Wash.), 1945. 1st ed. $20.00, $15.00 (rubbed stamp on
 several leaves)
Dorf, Philip--The Builder. N.Y., 1952. 1st ed. $12.50
Dorfman, Joseph--Thorstein Veblen and His America. N.Y.,
 1935. $15.00 (spine faded)
Dorr, Benjamin--A Memoir of John Fanning Watson. Phila.,
 1861. $200.00 (three-quarter morocco, bookplate)
Dorsey, Florence L.--Master of the Mississippi. Bost., 1941.
 $30.00, $27.50 (bookplate, backstrip faded, covers soiled)
Dorsey, George Amos--The Cheyenne. Chi., 1905. 2 vols.
 1st ed. $125.00 (bound in later cloth)
Dorson, Richard Mercer--American Rebels. (N.Y., 1953).
 1st ed. $10.00
Dos Passos, John--Adventures of a Young Man. N.Y., (1939).
 $20.00 (cloth)
--Brazil on the Move. Garden City, 1963. 1st ed. $12.50
--The 42nd Parallel. N.Y., 1930. 1st ed. $100.00 (orig.
 boards, top of spine lightly rubbed, label somewhat dull,
 bookplate of Joan Whitney)
--The Head and Heart of Thomas Jefferson. Garden City,
 1954. $10.00 (backstrip sunned)
--In All Countries. N.Y., (1934). 1st ed. $125.00 (orig.
 cloth, small bookseller's ticket)
--Journeys Between Wars. N.Y., (1938). 1st ed. $85.00
 (lightly rubbed at edges, scotch-tape at spine ends, orig.
 cloth)

--The Men Who Made the Nation. N.Y., 1957. $10.00
--1919. N.Y., (1932). $100.00 (orig. cloth, scotch-tape over spine ends)
Dosch, Henry Ernst--Vigilante Days at Virginia City. Portland, Or., 1924. 1st ed. $8.50
Doster, William Emile--Lincoln and Episodes of the Civil War. N.Y., 1915. $25.00
Doten, Lizzie--A Review of a Lecture.... Bost., 1865. $25.00 (wraps., title corners torn away)
Dotson, Susan Merle--Who's Who in the Confederacy. (San Antonio, 1966). $15.00
Doubleday, Charles William--Reminiscences of the "Filibuster" War in Nicaragua. N.Y., 1886. 1st ed. $125.00 (cloth, name removed from title)
Doubleday, Frank Nelson--The Memoirs of a Publisher. Garden City, 1972. $14.00
Doubleday, Rhoda van Bibber (Tanner), ed.--Journals....
See: Barbour, Philip Norbourne
Doughty, Arthur George--The Cradle of New France. Montreal, 1908. $35.00 (orig. cloth)
--Quebec of Yester-Year. Toronto, 1932. 1st ed. $45.00 (orig. cloth, signed presentation copy)
--The Siege of Quebec and the Battle of the Plains of Abraham. Quebec, 1901. 6 vols. 1st ed. $175.00 (moderately rubbed, several hinges cracked, small dampstains)
Douglas, Claude Leroy--The Gentlemen in the White Hats. Dallas, (1934). $55.00 (owner's name, new endpapers)
--James Bowie; the Life of a Bravo. Dallas, (1944). 1st ed. $20.00
Douglas, Emily (Taft)--Margaret Sanger. N.Y., 1970. 1st ed. $15.00
Douglas Henry Kyd--I Rode With Stonewall. Chapel Hill, (1940). 1st ed. $13.50, $12.50
Douglas, James--Old France in the New World. Cleve., 1905. 1st ed. $27.50 (autographed, ex-lib.)
Douglas, William Orville--An Almanac of Liberty. Garden City, 1954. 1st ed. $10.00
--Go East, Young Man. N.Y., (1974). 1st ed. $10.00
--Mr. Lincoln & the Negroes. N.Y., 1963. $10.00
--My Wilderness. Garden City, 1960. 1st ed. $18.50, $10.00
Douglass, Frederick--Life and Times of Frederick Douglass....
Hart., 1882. $10.00 (shaken)
N.Y., (1962). $15.00
Douglass, William--A Summary, Historical and Political, of the First Planting, Progressive Improvements and Present State

of the British Settlements.... Lond., 1760. 2 vols.
$650.00 (leather, worn at edges)
Douville, Raymond--Daily Life in Early Canada.... Lond.,
1968. $20.00 (cloth), $12.50
N.Y., 1968. $12.50
Dow, Charles Mason--Anthology and Bibliography of Niagara
Falls. Albany, 1921. 2 vols. $45.00 (one corner bumped)
Dow, George Francis--The Pirates of the New England Coast.
Salem, Ma., 1923. $75.00 (cloth, faded spine)
Dowd, Clement--Life of Zebulon B. Vance. Charlotte, 1897.
$25.00
Dowd, Willis Bruce--James Grant, a Model American. Bost.,
1909. $7.50
Dowdey, Clifford--The Seven Days. Bost., (1964). $17.50
Downard, William L.--The Cincinnati Brewing Industry. (Ath-
ens, 1973). 1st ed. $12.50, $9.00
Downey, Fairfax Davis--Clash of Cavalry. N.Y., (1959).
$22.50 (inscribed copy), $15.00
--Fife, Drum & Bugle. (Fort Collins, 1971). $75.00 (leather,
one of 50 signed and numbered copies)
--Indian-Fighting Army. N.Y., 1941. 1st ed. $67.50
--Indian Wars of the U.S. Army.... Garden City, 1963. 1st
ed. $20.00 (inscribed copy), $15.00 (owner name), $15.00
--Our Lusty Forefathers.... N.Y., 1947. 1st ed. $10.00
(owner name)
--Portrait of an Era as Drawn by G.D. Gibson. N.Y., 1936.
$45.00
--Richard Harding Davis. N.Y., 1933. $15.00 (cloth, book-
plates, light wear and soil)
--Texas and the War With Mexico. N.Y., (1961). $6.00
Downey, Joseph T.--The Cruise of the Portsmouth.... New
Haven, 1963. $17.50
--Filings From an Old Saw. S.F., 1956. $36.50 (uncut),
$30.00
Downey, Sheridan--They Would Rule the Valley. S.F., 1947.
$10.00
Downie, J. Iverne, ed.--The Swedish Community in Transition
See under Title
Downs, Joseph--American Furniture.... N.Y., 1952. 1st
ed. $37.50
Downs, Robert Bingham--Books That Changed America. (N.Y.,
1970). $15.00 (inscribed copy)
Doyle, Emma (Lyons)--Makua Laiana. Honolulu, 1953. $20.00
(inscribed)

Doyon, Bernard--The Cavalry of Christ on the Rio Grande....
 Milwaukee, (1956). $25.00 (orig. cloth), $15.00 (ex-lib.)
Dozer, Donald Marquant--Are We Good Neighbors? Gaines-
 ville, 1959. 1st ed. $17.50 (cloth, ex-lib.)
Drache, Hiram M.--The Challenge of the Prairie. Fargo,
 (1971). $7.50
Drago, Harry Sinclair--The Great Range Wars. N.Y., (1970).
 $20.00
--Outlaws on Horseback. N.Y., (1964). $23.50
--Roads to Empire. N.Y., (1968). $6.50 (ex-lib.)
--The Steamboaters.... N.Y., (1967). $6.50
--Wild, Wooly & Wicked. N.Y., (1960). $29.00, $20.00, $12.50
Drake, Benjamin--Cincinnati in 1826. Cinci., 1827. $650.00
 (wraps., small stain on front cover)
Drake, Daniel--Malaria in the Interior Valley of North America.
 Urbana, 1964. $20.00 (cloth)
Drake, Francis Samuel, 1828-1885--The Indian Tribes of the
 U.S. Phila., 1884. 2 vols. 1st ed. $750.00 (folio ed.,
 new cloth and boards)
--The Town of Roxbury. Roxbury, 1878. $30.00 (cloth,
 hinges cracked, bookplate, marginal marking and under-
 lining)
Drake, Joseph Rodman--The Life and Works of.... Bost.,
 1935. 1st ed. $40.00 (orig. cloth, one of 750 copies,
 inscribed)
Drake, St. Clair--Black Metropolis. N.Y., (1945). 1st ed.
 $20.00
Drake, Samuel Adams--Historic Fields and Mansions of Middle-
 sex. Bost., 1874. $65.00
--The Making of the Great West. Lond., 1894. 1st ed.
 $7.50 (small gouge in spine)
--Making of the Ohio Valley States.... N.Y., 1922. $12.50
 (ex-lib.)
Drake, Samuel Gardner--Biography and History of the Indians
 of North America. Bost., 1834. $20.00
--The Old Indian Chronicle. Bost., 1836. 1st ed. $50.00
 (ex-lib., one of 500 copies)
Drannan, William F.--Capt. W.F. Drannan, Chief of Scouts.
 Chi., (1914). $8.50
--Chief of Scouts. Chi., 1910. $15.00 (cloth, binding lightly
 rubbed and endpapers a bit dusty, text stock yellowed)
--Thirty-one Years on the Plains and in the Mountains. Chi.,
 (1900). $31.50, $30.00
Draper, Lyman Copeland--Madison, the Capital of Wisconsin....
 Madison, 1857. 1st ed. $75.00 (orig. wraps.)

Draper, Theodore--The Roots of American Communism. N.Y.,
1957. $15.00, $6.00
Draper, William Richard--The Last Government Land Lottery.
Girard, Ks., 1946. $12.50 (wraps.)
--On the Trail of "Pretty Boy" Floyd. Girard, Ks., (1946).
$12.00 (wraps.)
Dreier, John C., ed.--The Alliance for Progress. Balt.,
(1962). $7.50
Dreiser, Theodore--Dawn. N.Y., (1931). 1st ed. $17.50
Dresser, Paul--The Songs of Paul Dresser. N.Y., 1927.
$30.00
Driggs, Howard Roscoe--Westward America. N.Y., (1942).
$55.00, $50.00
Drinker, Elizabeth Sandwith--Extracts From the Journal of....
Phila., 1889. 1st ed. $85.00 (orig. cloth, untrimmed)
Drinker, Sophie Lewis (Hutchinson)--Hannah Penn and the
Proprietorship of Pennsylvania. Phila., 1958. $10.00 (cloth)
Drinkwater, John--The World's Lincoln. N.Y., 1928. $25.00
(boards, one of 800 copies)
Dripps, Joseph H.--Three Years Among the Indians in Dakota.
N.Y., 1974. $15.00
Driscoll, Charles Benedict--Country Jake. N.Y., 1946. $5.00
(author's presentation copy)
Driscoll, Joseph--War Discovers Alaska. Phila., 1943. $10.00
Driscoll, Robert Edward--Seventy Years of Banking in the
Black Hills. Rapid City, S.D., (1948). $25.00
Driskill, Earl C.--Death Valley Scotty Rides Again
See: Scott, Walter
Drown, Frank--Mission to the Head-Hunters. N.Y., (1961).
1st ed. $6.00
Drucker, Peter Ferdinand--The Age of Discontinuity. N.Y.,
1969. 1st ed. $10.00
Drumm, Mark--Drumm's Manual of Utah.... (S.L.C., 1896).
$25.00 (orig. cloth)
Drumm, Stella M., ed.--Down the Santa Fe Trail....
See: Magoffin, Susan (Shelby)
--Journal of Fur-Trading Expedition on the Upper Missouri
See: Luttig, John C.
Drury, Aubrey--California, an Intimate Guide. N.Y., 1935.
$5.00 (owner name)
Drury, Clifford Merrill, ed.--The Diaries and Letters of Henry
H. Spalding....
See: Spalding, Henry Harmon
--Diary of Titian Ramsey Peale
See: Peale, Titian Ramsey

--Marcus Whitman, M.D., Pioneer and Martyr. Caldwell, 1937.
 $95.00, $50.00
--Nine Years With the Spokane Indians. Glendale, 1976.
 $25.00
--Presbyterian Panorama. Phila., 1952. $12.50
--William Anderson Scott. Glendale, 1967. $20.00 (author's
 presentation inscription), $6.50
Drury, John--Historic Midwest Houses. Minne., (1947). 1st
 ed. $25.00
Drury, Wells--An Editor on the Comstock Lode. N.Y., (1936).
 $20.00, $17.50 (backstrip faded)
 Palo Alto, 1948. $14.00
Dryden, Cecil Pearl--Give All to Oregon! N.Y., (1968).
 $7.00
Duane, William--Politics for American Famers. Wash., 1807.
 $35.00 (disbound)
--Report of a Debate, in the Senate of the United States....
 (Phila), 1804. $65.00 (disbound)
--The Two Americas, Great Britain, and the Holy Alliance.
 Wash., 1824. $45.00 (disbound)
Duane, William John--The Law of Nations.... Phila., 1809.
 $45.00 (disbound)
--Letters, Addressed to the People of Pennsylvania.... Phila.,
 1811. 1st ed. $85.00 (half morocco)
Dubay, Robert W.--John Jones Pettus. Jackson, Ms., 1975.
 1st ed. $10.50
Dubbe, Marvin C.--Grains of Wheat. Caldwell, 1934. $12.50
 (leather)
Dubbs, Joseph Henry--The Reformed Church in Pennsylvania.
 Lancaster, 1902. $40.00
Duberman, Martin--Charles Francis Adams.... Stanford, 1961.
 $15.00
Dublin, Louis Israel--A Family of Thirty Million. N.Y., 1943.
 $15.00
DuBois, John Van Deusen--Campaigns in the West, 1856-
 1861.... Tucson, 1949. $275.00 (boards with leather
 backstrip, 300 numbered copies signed by editor, G.P.
 Hammond)
Dubois, Jules--Fidel Castro. Ind., (1959). $12.50
--Operation America. N.Y., (1963). $8.50
(Duche, Jacob)--Caspipina's Letters. Bath, 1777. 2 vols.
 in 1. 1st ed. $175.00 (contemp. boards)
--Observations on a Variety of Subjects.... Phila., 1774.
 1st ed. $175.00 (calf, owner name)

Duchow, John Charles--The Duchow Journal. (Kentfield, Ca.), 1959. $275.00 (one of 200 copies)

Ducoudray-Holstein, Henri LaFayette Villaume--Memoirs of Simon Bolivar.... Bost., 1829. 1st ed. $175.00 (orig. cloth, light cover wear), $75.00 (buckram, ex-lib., lightly foxed)

Dudding, Earl Ellicott--The Trail of the Dead Years. Huntington, W. Va., 1932. $25.00, $12.00

Dudek, Louis--The Making of Modern Poetry in Canada. Toronto, (1967). $9.50

Duff, John J.--A. Lincoln: Prairie Lawyer. N.Y., (1960). $20.00

Duffus, Robert Luther--Queen Calafia's Island. N.Y., (1965). $5.00

--The Santa Fe Trail. Lond., 1930. 1st ed. $20.00
N.Y., 1931. $26.50
Lond., 1931. $8.50
N.Y., 1934. $17.50

--The Valley and Its People. N.Y., 1944. $25.00

Duffy, Clinton T.--88 Men and 2 Women. N.Y., 1962. $15.00

Duffy, Herbert S.--William Howard Taft. N.Y., 1930. $12.50

Dufour, Charles L.--Nine Men in Gray. Garden City, 1963. $10.00 (ex-lib.)

Duganne, Augustine Joseph Hickey--The Fighting Quakers. N.Y., 1866. $25.00

Dugmore, Arthur Radclyffe--The Romance of the Beaver.... Phila., (1914). $25.00 (cloth), $20.00

Duguid, Julian--Green Hell. Lond., 1931. $9.00

Duhl, Leonard J.--The Urban Condition. N.Y., (1963). 1st ed. $12.50

Duke, Basil Wilson--Morgan's Cavalry. N.Y., 1906. $75.00 (spine darkened)

Duke, Donald--Southern Pacific Steam Locomotives. San Marino, 1966. $10.00

Dulles, Foster Rhea--The American Red Cross. N.Y., (1950). 1st ed. $17.50

--America's Rise to World Power.... N.Y., (1955). 1st ed. $10.00 (cloth)

--The Road to Teheran. Princeton, 1944. $12.50

Dumarest, Noel--Notes on Cochiti, New Mexico. Lancaster, Pa., 1919. 1st ed. $25.00 (owner name)

Dumbauld, Edward--Thomas Jefferson, American Tourist.... Norman, 1946. 1st ed. $20.00

Dumke, Glenn S., ed.--Mexican Gold Trail
See: Evans, George W.B.

Dunbar, Paul Laurence--In Old Plantation Days. N.Y., 1903.
1st ed. $10.00
--The Life and Works of Paul Laurence Dunbar. Haperville,
Il., (1907). $20.00
--Lyrics of Love and Laughter. N.Y., 1903. 1st ed. $50.00
(orig. cloth, light browning on endpapers)
--Majors and Minors. (Toledo, 1895). 1st ed. $400.00 (bind-
ing lightly soiled and spotted, orig. cloth, spine rubbed,
owner signature)
--The Sport of the Gods. N.Y., 1902. 1st ed. $85.00
(orig. cloth, 1st binding, owner signatures, inner hinges
cracked, covers partially faded)
Dunbar, Seymour--A History of Travel in America.... N.Y.,
1968. 4 vols. $75.00 (orig. cloth), $65.00
Duncan, Dorothy--Here's to Canada! N.Y., 1941. $6.00
Duncan, Kunigunde--Mentor Graham. Chi., (1944). $12.50
Duncan, Robert Edward--Selected Poems. (S.F., 1959).
$35.00 (2nd state)
Duncan, Robert Lipscomb--Reluctant General. N.Y., (1961).
$7.50
Dunham, Mabel--The Trail of the Conestoga. Toronto, 1924.
1st ed. $10.00
Dunklee, Ivah--Burning of Royalton, Vermont, by Indians.
Bost., 1906. $42.00 (cover lightly soiled)
Dunlap, Kate--The Montana Gold Rush Diary of.... Denver,
1969. $25.00 (one of 200 copies), $15.00
Dunlap, William--A History of the American Theatre. N.Y.,
1832. 1st ed. $225.00 (orig. cloth, ads excised, front
outer hinge starting, faded)
Dunlop, Alexander Graham--Notes on the Isthmus of Pan-
ama.... Lond., 1852. $275.00 (modern boards)
Dunn, Allan
See: Dunn, Joseph Allan Elphinstone
Dunn, Edward Clare--USAA. N.Y., (1970). $12.50
Dunn, Jacob Piatt--Massacres of the Mountains. N.Y., 1958.
$32.50
--True Indian Stories.... Ind., 1909. $15.00
Dunn, James Taylor--The St. Croix. N.Y., (1965). $15.00
Dunn, Joseph Allan Elphinstone--Care-Free San Francisco.
S.F., 1913. $7.50 (boards)
Dunnack, Henry Ernst--Maine Forts. Augusta, 1924. $30.00
Dunne, Finley Peter--Mr. Dooley in Peace and War. Bost.,
1898. 1st ed. $7.00
Dunne, Gerald T.--Monetary Decisions of the Supreme Court.
New Brunswick, 1960. $10.00

Dunning, Albert Elijah--Congregationalists in America. N.Y.,
1894. $25.00
Dunning, Charles H.--Arizona's Golden Road. Phoenix, 1961.
$10.00
Dunning, William Archibald--Essays on the Civil War and Re-
construction.... N.Y., 1931. $17.50
--A History of Political Theories From Luther to Montesquieu.
N.Y., 1931. $20.00
Dunshee, Kenneth Holcomb--As You Pass By. N.Y., (1952).
$15.00 (cloth)
DuPont, Henry Algernon--Rear-Admiral Samuel Francis Du-
Pont.... N.Y., 1926. $15.00, $10.00
DuPont, the Autobiography of an American Enterprise. Wil-
mington, 1952. $12.00, $10.00
Dupre, Flint O.--Hap Arnold. N.Y., (1972). $12.50
DuPuy, William Atherton--Hawaii and Its Race Problem. Wash.,
1932. $12.50
Duran, Diego--The Aztecs. N.Y., (1964). $15.00
Durand, George Harrison--Joseph Ward of Dakota. Bost.,
(1913). $20.00 (owner name)
Durant, John--Pictorial History of the American Circus. N.Y.,
1967. $12.50
Durant, William James--The Mansions of Philosophy. N.Y.,
1929. $10.00
--Transition. N.Y., 1927. 1st ed. $12.00
Garden City, 1927. $4.00 (worn)
Duratschek, Claudia--Crusading Along Sioux Trails. (St.
Meinrad, Ind., 1947). 1st ed. $30.00 (cloth)
Durden, Robert Franklin--The Dukes of Durham.... Durham,
1975. $10.00
--James Shepherd Pike. Durham, 1957. 1st ed. $25.00 (in-
scribed copy)
Durkin, Joseph T., ed.--Confederate Chaplain
See: Sheeran, James B.
Durkin, Joseph Thomas, ed.--John Dooley, Confederate Sol-
dier
See: Dooley, John Edward
--Stephen R. Mallory. Chapel Hill, 1954. $15.00
Durrell, Gerald Malcolm--The Whispering Land. N.Y., 1962.
$6.00
Dusenberry, William Howard--The Mexican Mesta. Urbana,
1963. $17.50
Dustin, Fred--The Custer Tragedy. Ann Arbor, 1965. $40.00
(one of 200 copies)
--Echoes From the Little Big Horn Fight. Saginaw, 1953.
$125.00 (wraps.)

Dutton, Bertha Pauline--Sun Father's Way. Albuquerque, 1963.
1st ed. $15.00
Dutton, Charles Judson--The Samaritans of Molokai. Freeport,
(1971). $15.00
Dutton, William Sherman--DuPont.... N.Y., 1942. $20.00,
$12.50
Duval, John Crittenden--Early Times in Texas. Austin, 1892.
$50.00 (later binding)
Austin, 1935. $12.50
DuVal, Miles Percy--And the Mountains Will Move. Stanford,
(1947). 1st ed. $10.00
Duvall, Marius--A Navy Surgeon in California, 1846-1847.
S.F., 1957. 1st ed. $30.00 (one of 600 copies)
Dwight, Margaret Van Horn--A Journey to Ohio in 1810.
New Haven, 1920. $13.50 (light foxing)
Dwight, Timothy--Travels in New England and New York.
Camb., 1969. 4 vols. $25.00 (cloth)
Dwinelle, John Whipple--The Colonial History of the City of
San Francisco. S.F., 1867. $900.00 (contemp. three-
quarter morocco)
Dyar, Harrison Gray--The Mosquitoes of the Americas. Wash.,
1928. $7.50 (orig. wraps., ex-lib.)
Dyar, Ralph E.--News For an Empire. Caldwell, 1952. $12.50,
$7.50
Dye, Charity--Some Torch Bearers in Indiana. (Ind., 1917).
$15.00
Dye, Eva (Emery)--The Conquest. Chi., 1902. 1st ed.
$12.50 (front hinge tender)
--McDonald of Oregon. Chi., 1906. $12.50 (cover lightly
spotted)
--McLoughlin and Old Oregon. Garden City, 1921. $10.00
Dye, Job Francis--Recollections of a Pioneer. L.A., 1951.
$35.00
Dyer, David Patterson--Autobiography and Reminiscences.
S.L., 1922. $26.50 (boards)
Dyk, Walter--Son of Old Man Hat
See: Left Handed. Navaho Indian
Dykeman, Wilma--The French Broad. N.Y., (1955). 1st ed.
$15.00
Dykes, Jefferson Chenoweth--American Guide Series. College
Park, Md., n.d. $25.00 (cloth, one of 100 numbered and
signed copies)
--Fifth Great Western Illustrators. Flagstaff, (1975). $50.00
(cloth, 1st printing)

- E -

Earle, Alice Morse--Colonial Days in Old New York. N.Y.,
 1896. 1st ed. $15.00
--Curious Punishments of Bygone Days. Chi., 1896. 1st ed.
 $17.50 (binding darkened, few leaves carelessly opened)
--Stage-Coach and Tavern Days. N.Y., 1900. $25.00
Earle, Edwin Allan--Hopi Kachinas. N.Y., 1938. 1st ed.
 $200.00
Earle, Swepson--The Chesapeake Bay Country. Balt., 1923.
 1st ed. $200.00
Early Day History of Coffee County.... Burlington, Ks.,
 (1966). $9.00
Early, Eleanor--Behold the White Mountains. Bost., 1935.
 $10.00
Early, Jubal Anderson--Autobiographical Sketch.... Phila.,
 1912. $100.00
--A Memoir of the Last Year of the War For Independence.
 Lynchburg, Va., 1867. $57.50 (lacks wraps.)
Eastman, Charles Alexander--Indian Boyhood. Garden City,
 1914. $12.50
--Red Hunters and the Animal People. N.Y., 1904. 1st ed.
 $15.00 (owner name)
Eastman, Edwin--Seven and Nine Years Among the Camanches
 and Apaches. (Jersey City, 1873). 1st ed. $10.00 (some
 wear to backstrip, some dampstain to back cover)
Eastman, Max--Love and Revolution. N.Y., (1964). $12.50
Easton, Robert Olney--Lord of Beasts. Lond., (1964). $10.00
Eaton, Clement--Henry Clay and the Art of American Politics.
 Bost., (1957). $12.50
--A History of the Southern Confederacy. N.Y., 1954. 1st
 ed. $10.00
--Jefferson Davis. N.Y., (1977). $10.00 (boards)
Eaton, Elon Howard--Birds of New York. N.Y., 1914. 2
 vols. $90.00 (cloth, hinges cracked, worn and frayed
 along hinges and joints), $56.00 (cloth)
Eaton, Frank--Pistol Pete.... Bost., 1952. 1st ed. $25.00,
 $15.00
Eaton, Harriet Phillips--Jersey City and Its Historic Sites.
 Jersey City, (1899). $10.00
Eaton, Walter Prichard--The American Stage To-Day. Bost.,
 1908. $12.50 (some cover wear, page repaired, new rear
 endpapers, ex-lib.)
Eaton, William--The Life of.... Brookfield, 1813. $25.00
 (orig. calf, hinges starting, lacks portrait)

Eaves, Charles Dudley--Post City, Texas. Austin, 1952.
$22.50

Eberlein, Harold Donaldson--The Manors and Historic Homes
of the Hudson Valley. Phila., 1924. $30.00 (ltd. ed.)
--Portrait of a Colonial City, Philadelphia.... Phila., (1939).
$100.00 (orig. cloth, uncut)

Eberstadt, Edward & Sons, New York--Texas, Being a Collec-
tion of Rare & Important Books.... N.Y., 1964. $100.00
(orig. printed wraps.)

Eblen, Jack Ericson--The First and Second U.S. Empires.
Pitts., (1968). $15.00

Eccleston, Robert--The Mariposa Indian War, 1850-51....
S.L.C., 1957. 1st ed. $75.00 (tipped-in frontis., spine
label a bit frayed)

Echoing Footsteps: Powder River Country. (Butte, Mt.,
1967). $45.00

Eckenrode, Hamilton James--The Randolphs. Ind., 1946. 1st
ed. $15.00

Eckert, Edward K., ed.--Ten Years in the Saddle
See: Averell, William Woods

Eddy, Mary Baker--Mind-Healing. Bost., 1888. $7.50

Edge, Frederick Milnes--An Englishman's View of the Battle
Between the Alabama and the Kearsarge. N.Y., 1864.
$100.00 (wraps.)

Edmonds, Walter Dumaux--The Big Barn. Bost., 1930. $15.00
--Drums Along the Mohawk. Bost., 1936. 1st ed. $15.00
--The First Hundred Years.... (N.p., 1948). 1st ed. $10.00
--Rome Haul. Bost., 1929. 1st ed. $15.00
--Tom Whipple.... N.Y., 1942. 1st ed. $15.00

Edmonson, Munro S., ed.--Sixteenth-Century Mexico
See under Title

Edmundo, Luiz
See: Costa, Luiz Edmundo de

Edward, David B.--The History of Texas.... Cinci., 1836.
$600.00 (orig. cloth)

Edwards, Albert--Panama.... N.Y., 1911. 1st ed. $12.50

Edwards, Alberto--La Fronda Aristocratica en Chile. San-
tiago de Chile, 1936. $15.00 (covers chipped and taped,
fore-edge dampstained)
--La Organizacion Politica de Chile.... Santiago, (1943).
1st ed. $15.00 (wraps.)

Edwards, Charles--Pleasantries About Courts and Lawyers of
the State of New York. N.Y., 1867. $20.00

Edwards, Cyrus--Cyrus Edwards' Stories of Early Days....
Lou., 1940. 1st ed. $40.00

Edwards, Deltus Malin--The Toll of the Arctic Seas. N.Y.,
 1910. 1st ed. $45.00
Edwards, Jennie
 See: Edwards, Mary Virginia (Plattenburg)
Edwards, John Newman--Shelby and His Men. Cinci., 1867.
 1st ed. $37.50 (backstrip loose)
Edwards, Mary Virginia (Plattenburg)--John N. Edwards.
 K.C., 1889. $85.00 (cloth)
Edwards, Murray D.--A Stage in OUr Past. Toronto, 1968.
 $15.00
Edwards, Ninian Wirt--History of Illinois.... Springfield,
 1870. 1st ed. $30.00
Edwards, Philip Leget--California in 1837. Sacramento, 1890.
 1st ed. $200.00 (wraps., slipcased)
Edwards, Richard--New York's Great Industries. N.Y., 1884.
 1st ed. $16.00
Edwards, Ruthe M.--American Indians of Yesterday. San An-
 tonio, (1948). $12.50
Edwards, Samuel E.--The Ohio Hunter. Battle Creek, Mi.,
 1866. 1st ed. $500.00 (orig. cloth, expertly rebacked
 using original spine)
Edwards, William Bennett--Civil War Guns. Harrisburg, (1962).
 1st ed. $75.00 (inscribed)
Edwards Matt, Guillermo--El Club de la Union en Sus Ochenta
 Anos.... Santiago de Chile, 1944. $35.00 (inscribed, one
 of 300 copies)
Eells, Myron--Ten Years of Missionary Work.... Bost., (1886).
 1st ed. $30.00
Egan, Ferol--Fremont, Explorer For a Restless Nation. N.Y.,
 1977. $15.00
--With Fremont to California....
 See: Martin, Thomas Salathiel
Egan, Howard--Pioneering in the West.... Rich., Ut., 1917.
 $35.00
Egan, Maurice Francis--The Hierarchy of the Roman Catholic
 Church in the U.S. Phila., (1888). 2 vols. $40.00
 (three-quarter leather, somewhat worn, ex-lib.)
Ege, Robert J.--Tell Baker to Strike Them Hard. (Bellevue,
 Ne., 1970). 1st ed. $75.00 (leather, one of 50 copies,
 slipcased)
Eggan, Fred--Social Organization of the Western Pueblos.
 Chi., (1950). 1st ed. $40.00 (owner name)
Eggleston, Edward--The Circuit Rider. N.Y., 1874. 1st ed.
 $25.00 (edges worn)

Egle, William Henry--History of the Counties of Dauphin and
Lebanon.... Phila., 1883. 1st ed. $125.00 (rebound)
--An Illustrated History of the Commonwealth of Pennsylvania.
Harrisburg, 1876. $35.00
Egner, Philip, ed.--Songs of the U.S. Military Academy,
West Point....
See under Title
Ehrmann, Herbert Brutus--The Case That Will Not Die. Bost.,
1969. $25.00
--The Untried Case. N.Y., (1933). 1st ed. $35.00, $20.00
N.Y., 1960. $20.00
Eickemeyer, Carl--Among the Pueblo Indians. N.Y., (1895).
$65.00
--Over the Great Navajo Trail. N.Y., 1900. 1st ed. $65.00,
$50.00 (cloth)
Eide, Ingvard Henry--American Odyssey. Chi., (1969). 1st
ed. $28.50
Eisenhower, Dwight David--At Ease. Garden City, 1967.
$17.50, $10.00
--Mandate for Change.... N.Y., 1963. $10.00
Eisenhower, Milton Stover--The Wine is Bitter.... Garden
City, 1963. $7.50 (ex-lib.)
Eisenschiml, Otto--The American Iliad. Ind., (1947). 1st
ed. $16.00
--As Luck Would Have It.... Ind., (1948). $20.00
--The Hidden Face of the Civil War. Ind., 1961. 1st ed.
$15.00
--Reviewers Reviewed. Ann Arbor, 1940. $10.00 (paper)
--Why the Civil War? Ind., 1958. 1st ed. $15.00 (signed
by author)
Eisenstadt, Abraham Seldin--Charles McLean Andrews. N.Y.,
1956. 1st ed. $15.00
Elder, David Paul--Old Spanish Missions of California. S.F.,
(1913). $30.00 (boards, rebacked)
Eldredge, Charles C.--Ward Lockwood, 1894-1963. Lawrence,
Ks., 1974. $25.00
Eldredge, Zoeth Skinner--The Beginnings of San Francisco....
S.F., 1912. 2 vols. 1st ed. $120.00 (presentation in-
scription by author, spines faded), $90.00 (spines faded),
$75.00 (cloth, bookplates, covers faded), $70.00 (untrimmed)
--History of California. N.Y., (1915). 5 vols. $100.00
(three-quarter leather, spines rebacked, edges a bit worn)
Eldridge, Edward Fayette--The Sinbad Mines. Denver, (1905).
$15.00 (signed)

Eldridge, George Washington--Martha's Vineyard. Prov.,
1889. $47.50 (orig. wraps., few minor tears)
Eldridge, Shalor Winchell--Recollections of Early Days in Kan-
sas. Topeka, 1920. $17.50 (paper browning), $7.50
Elias, Christopher--Fleecing the Lambs. Chi., (1971). $8.95
Elias, Soloman Philip--Stories of Stanislaus. (L.A., 1924).
$35.00 (author's autograph)
Eliason, Adolph Oscar--The Rise of Commercial Banking Insti-
tutions in the U.S. N.Y., (1970). $6.00
Eliot, Thomas Stearns--For Lancelot Andrewes. Lond., (1928).
$200.00 (orig. cloth, portion of spine missing, verso re-
paired with tape, signed by author)
--Old Possum's Book of Practical Cats. Lond., (1939). 1st
ed. $350.00 (orig. cloth, one of 3005 copies)
--Selected Essays, 1917-1932. N.Y., (1932). 1st ed. $15.00
(cloth, spine rubbed)
--Thoughts After Lambeth. Lond., (1931). $200.00 (one of
300 bound in gray cloth boards, endpapers lightly foxed)
Elkins, John M.--Indian Fighting on the Texas Frontier.
(Amarillo), 1929. $28.50 (wraps.)
Ellenbecker, John G.--The Jayhawkers of Death Valley.
Marysville, 1938. $45.00 (wraps.)
Ellet, Elizabeth Fries (Lommis)--The Women of the American
Revolution. Phila., 1900. 2 vols. $55.00 (ink name on
title, corner cut off title not affecting text)
Elliot, L.E.--Chile Today and Tomorrow. N.Y., 1922. 1st
ed. $15.00
Elliott, Benjamin--The Militia System of South-Carolina....
Charleston, 1835. 1st ed. $125.00 (calf, inner hinges
repaired)
Elliott, Edward--Biographical Story of the Constitution. N.Y.,
1910. 1st ed. $12.50
Elliott, John F.--All About Texas. Austin, 1888. 1st ed.
$450.00 (wraps.)
Elliott, L.R.--Centennial Story of Texas Baptists. Dallas,
1936. $25.00
Ellis, Allen R.--Discovering Mayaland. Glendale, Ca., 1964.
$7.50
Ellis, Amanda Mae--Bonanza Towns. (Colorado Springs, 1954).
1st ed. $5.00 (wraps.)
Ellis, David Maldwyn--A Short History of New York State.
Ithaca, (1957). $30.00 (signed, foxing to endpapers)
Ellis, Edward Sylvester--The Life of Kit Carson. N.Y., 1889.
$25.00 (ex-lib.), $7.50

--Outdoor Life and Indian Stories. (Phila., 1912). $45.00
(buckram)
Ellis, Elmer--Henry Moore Teller, Defender of the West. Cald-
well, 1941. 1st ed. $20.00 (signed by author), $12.00
Ellis, Franklin--History of Fayette County, Pennsylvania.
Phila., 1882. $175.00 (rebound)
--History of Lancaster County. Phila., 1883. $150.00 (ex-
lib. stamp, rebound)
Ellis, George A.--Inside Folsom Prison. Palm Springs, 1979.
$5.00
Ellis, George Edward--Letters Upon the Annexation of Texas....
Bost., 1845. $275.00 (orig. wraps.)
Ellis, George F.--Bell Ranch As I Knew It. K.C., 1973.
$30.00, $25.00
Ellis, George William--King Philip's War. N.Y., (1906). 1st
ed. $20.00
Ellis, John B.--The Sights and Secrets of the National Cap-
ital.... N.Y., 1869. $17.50
Ellis, John Tracy--Documents of American Catholic History.
Milwaukee, (1962). $15.00
--The Life of James Cardinal Gibbons. Milwaukee, 1952. 2
vols. 1st ed. $25.00
Ellis, Thomas T.--Leaves From the Diary of an Army Surgeon....
N.Y., 1863. 1st ed. $22.50 (light dampstaining)
Ellison, Rhoda Coleman--A Check List of Alabama Imprints....
University, 1946. $20.00 (wraps.)
Ellison, Robert Spurrier--Fort Bridger, Wyoming. Sheridan,
1938. $37.50 (wraps.)
Elson, Louis Charles--The History of American Music. N.Y.,
1915. $28.00 (covers dampstained)
--The National Music of America and Its Sources. Bost.,
(1915). $7.50 (cloth, cover lightly worn, several pages
repaired, inner hinge reinforced, ex-lib.)
Emerson, Ralph Waldo--The Conduct of Life. Bost., 1860.
1st ed. $50.00 (contemp. cloth, cover spotted, 1st print-
ing, variant B)
--Essays. Lond., 1841-45. 2 vols. $600.00 (orig. cloth,
spine ends lightly frayed, outer hinges a little rubbed,
1st and 2nd series)
--Letters and Social Aims. Bost., 1876. 1st ed. $50.00
(cloth, bookplate removed, lacks front fly, cover lightly
worn)
--Poems. Bost., 1847. $250.00 (orig. boards, rebacked,
boards stained)
--Society and Solitude. Bost., 1870. 1st ed. $75.00 (1st
printing, orig. cloth)

Emerson, Sarah Hopper--Life of Abby Hopper Gibbons, Told
Chiefly Through Her Correspondence. N.Y., 1897. 2 vols.
$50.00 (ex-lib.)
Emerson, William Canfield--The Seminoles. N.Y., (1954). 1st
ed. $7.50
Emmet, Boris--Catalogues and Counters. (Chi., 1950). $30.00
Emmett, Chris--Fort Union and the Winning of the Southwest.
Norman, (1965). 1st ed. $45.00
Emmitt, Robert--The Last War Trail. Norman, (1954). 1st
ed. $25.00, $20.00
Emmons County History. N.p., 1976. $25.00
Emory, William H.--Notes of a Military Reconnoissance....
Wash., 1848. 1st ed. $300.00 (orig. cloth)
Emparan, Madie Brown--The Vallejos of California. (S.F.),
1968. 1st ed. $150.00 (one of 1000 copies, signed by the
author)
Encina, Francisco Antonio--Portales. Santiago, 1964. 2 vols.
$25.00
Endicott, William Crowninshield--Captain Joseph Peabody.
Salem, 1962. $25.00 (one of 600 copies, cover stains)
Engelhardt, Zephryin--Santa Barbara Mission. S.F., 1923.
$30.00 (cloth, a few pages slightly torn, owner's signature)
Englebert, Omer--The Hero of Molokai. Bost., 1954. $15.00
Engstrand, Iris Wilson--William Wolfskill.... Glendale, 1965.
$35.00
Enock, Charles Reginald--Peru. Lond., 1910. $10.00 (ex-
lib. stamps)
--The Secret of the Pacific. Lond., 1912. 1st ed. $40.00
(cloth, some foxing, preliminary pages slightly dog-eared,
previous owner's signature)
Enriquez, Luis Eduardo--Haya de la Torre.... Lima, (1951).
$9.00
Epstein, Edward Jay--Inquest. N.Y., (1966). $5.00
Errazuriz, Isidoro--Diario.... 1851-1856. Santiago de Chile,
1947. $75.00 (one of 101 numbered copies, slipcased)
Erskine, Albert Russel--History of the Studebaker Corporation.
(Chi., 1918). $20.00
Esarey, Logan--The Indiana Home. Crawfordsville, 1947.
$17.00 (slipcased)
Eshleman, Henry Frank--Lancaster County Indians. Lancaster,
Pa., 1808. 1st ed. $100.00 (orig. cloth, front inner
hinge weak, one of 550 copies)
Espinosa Moraga, Oscar--Bolivar y Mar.... Santiago, 1965.
$18.00 (wraps.)
Essays For Henry R. Wagner. S.F., 1947. $85.00 (one of
260 copies, boards)

Estergreen, M. Morgan--Kit Carson. Norman, (1962). $25.00, $12.00
 Norman, (1967). $12.50
Euler, Robert C.--The Hopi People. Phoenix, (1971). $15.00
Evans, Albert S.--A la California. S.F., 1873. 1st ed. $35.00 (bindings rubbed and somewhat worn)
Evans, Bessie--American Indian Dance Steps.... N.Y., 1931. 1st ed. $25.00 (bindings badly spotted, foxing to end-papers)
Evans, Elmwood--The State of Washington. N.p., (1893?). $9.50 (wraps., covers stained)
Evans, Frederick William--Shakers. N.Y., 1859. 1st ed. $62.50
Evans, George W.B.--Mexican Gold Trail. San Marino, 1945. $36.50
Evans, John Henry--Charles Coulson Rich. N.Y., 1936. $40.00, $40.00
--Joseph Smith.... N.Y., 1940. $25.00
--The Story of Utah.... N.Y., 1933. $17.50
Evans, Lewis K.--Pioneer History of Greene County, Pennsylvania. Waynesburg, 1941. 1st ed. $55.00
Evans, Max--Long John Dunn of Taos. L.A., 1959. $42.50
Evans, Rosalie (Caden)--The Rosalie Evans Letters From Mexico. Ind., (1926). $24.00
Evans, William Augustus--Mrs. Abraham Lincoln.... N.Y., 1932. $17.50
Evans, William McKee--Ballots and Fence Rails. Chapel Hill, (1967). 1st ed. $20.00
Evarts, Hal George--Jedediah Smith, Trail Blazer of the West. N.Y., 1958. 1st ed. $12.50
Everett, George G.--Cattle Cavalcade in Central Colorado. Denver, (1966). $30.00 (ink in foreward)
Everson, William--The Poet is Dead. S.F., 1964. $300.00 (boards, one of 205 copies)
Ewan, Joseph Andorfer--John Banister and His Natural History of Virginia.... Urbana, (1970). $20.00 (orig. cloth), $20.00 (cloth), $12.50
Ewart, John Skirving--The Manitoba School Question.... Toronto, 1894. $75.00 (orig. cloth)
Ewers, John Canfield, ed.--Adventures of Zenas Leonard
 See: Leonard, Zenas
--The Blackfeet. Norman, (1958). 1st ed. $20.00
--Teton Dakota Ethnology and History. Berkeley, Ca., 1938. $20.00

Ewing, John S.--Broadlooms and Businessmen. Camb., 1955.
$15.00
Exman, Eugene--The House of Harper. N.Y., (1967). $15.00
Experience of a Green Mountain Girl. N.p., 1832. $40.00
The Exploration of North America, 1630-1776. N.Y., (1974).
$30.00
Explorers and Settlers. Wash., 1968. $20.00 (cloth, ex-lib.)
Exquemeling, Alexandre Oliver--History of the Buccaneers of
America. Bost., 1856. $15.00 (foxed, binding skewed)
Eyre, Alice--The Famous Fremonts and Their America.
(Santa Ana), 1948. 1st ed. $65.00, $65.00
Bost., (1961). $25.00

- F -

Fabens, Joseph Warren--In the Tropics. N.Y., 1863. 1st
ed. $30.00 (ex-lib. stamps), $17.50 (new buckram, upper
corner stained, 2nd printing)
--A Story of Life on the Isthmus. N.Y., 1853. $100.00
Fabian, Josephine C.--The Jackson's Hole Story. S.L.C.,
1963. 1st ed. $15.00 (cloth, presentation copy)
Fäy, Bernard--Bernard Fäy's Franklin, the Apostle of Modern
Times. Bost., 1929. 1st ed. $12.50
--The Two Franklins. Bost., 1933. 1st ed. $10.00
Fages, Pedro--The Colorado River Campaign.... Berkeley,
1913. 1st ed. $25.00 (orig. wraps.)
--Letters of Captain Don.... S.F., 1936. $175.00 (wraps.,
one of 110 copies, inscribed by the editor)
Fairbanks, Douglas--Laugh and Live. N.Y., (1917). $12.50
(cloth lightly worn, some pencil and ink marks)
--Making Life Worth While. N.Y., (1918). $12.50 (cloth,
spine lightly stained)
Fairbanks, Edward Taylor--The Town of St. Johnsbury, Vt.
St. Johnsbury, 1914. $17.50
Fairfield, E. William--Fire & Sand. Cleve., 1960. 1st ed.
$15.00
Fairman, Charles--Mr. Justice Miller and the Supreme Court....
Camb., 1939. 1st ed. $8.50
Falls, DeWitt Clinton--History of the Seventh Regiment, 1889-
1922. N.Y., 1948. $30.00
Famous Adventures and Prison Escapes of the Civil War.
N.Y., 1917. $12.50 (used)
(Fane, Julian Henry Charles)--Tannhäuser. Mobile, 1863.

$125.00 (orig. wraps., sewn, thread broken and becoming
disbound, owner name)
Fanning, Leonard M.--Men, Money and Automobiles. Cleve.,
(1969). $15.00
--Over Mountains, Prairies and Seas. N.Y., (1968). $12.50
--The Rise of American Oil. N.Y., (1948). $12.00
Farb, Peter--Face of North America. N.Y., (1963). $8.50
Farber, James--Fort Worth in the Civil War. Belton, Tx.,
1960. $15.00
--Those Texans. San Antonio, (1946). $8.50
Faris, John Thomson--Historic Shrines of America. N.Y.,
(1918). 1st ed. $10.00 (light foxing on endpapers)
--Old Churches and Meeting Houses in and Around Philadel-
phia. Phila., 1926. $10.00
--Old Roads Out of Philadelphia. Phila., 1917. $20.00
--The Romance of Old Philadelphia. Phila., 1918. $12.50
--Seeing the Far West. Phila., 1920. 1st ed. $8.50
Farley, Alan W., ed.--The Battle of Sand Creek
See: Coffin, Morse H.
Farmer, Henry Tudor--Imagination. N.Y., 1819. 1st ed.
$27.50
Farmer, Silas--The History of Detroit and Michigan. Detroit,
1884. 1st ed. $110.00
Farnham, Charles Haight--A Life of Francis Parkman. Bost.,
1905. $10.00
Farnham, Joseph Ellis Coffee--Brief Historical Data and Mem-
ories.... (Providence, 1923). $25.00 (some water stain-
ing)
Farnham, Thomas Jefferson--Travels in California. (Oakland),
1947. $35.00, $30.00, $25.00 (one of 750 copies)
--Travels in the Great Western Prairies.... Poughkeepsie,
1841. 1st ed. $575.00 (orig. cloth)
N.Y., 1843. $78.50 (boards)
Farquhar, Arthur B.--The First Million the Hardest. Garden
City, 1922. $12.50
Farquhar, Francis Peloubet--History of the Sierra Nevada.
Berkeley, 1965. 1st ed. $65.00 (errata laid in)
--Up and Down California in 1860-1864
See: Brewer, William Henry
Farr, Finis--Black Champion: the Life and Times of Jack
Johnson. Lond., 1964. $22.50
--Margaret Mitchell of Atlanta. N.Y., 1965. 1st ed. $12.50
Farragut, Loyall--The Life of David Glasgow Farragut. N.Y.,
1879. 1st ed. $27.50 (ex-lib., bit used), $15.00 (ex-lib.,
rubbed backstrip partly torn), $10.00

Farrar, Emmie (Ferguson)--Old Virginia Houses Along the
James. N.Y., 1957. $20.00
Farrell, John C.--Beloved Lady; a History of Jane Addams'
Ideas on Reform and Peace. Balt., (1967). $22.00
Farrow, Tiera--Lawyer in Petticoats. N.Y., 1953. 1st ed.
$25.00, $7.50 (owner name)
Fast, Howard--The Last Frontier. Garden City, 1944. $6.00
--The Naked God. N.Y., (1957). 1st ed. $10.00
--The Passion of Sacco and Vanzetti. N.Y., 1953. $20.00
(signed)
Fate of the Steam-Ship President.... Bost., 1845. $100.00
(orig. wraps.)
Fatout, Paul--Meadow Lake, Gold Town. Bloomington, (1969).
$7.50
Faubel, Arthur Louis--Cork and the American Cork Industry.
N.Y., (1941). $15.00 (ex-lib.)
Faulk, Odie B.--Crimson Desert. N.Y., 1974. $15.00, $10.00
--Destiny Road. N.Y., 1973. $10.00, $6.00
--Dodge City. N.Y., 1977. $12.50, $8.50
--The Geronimo Campaign. N.Y., 1969. $8.50, $7.50 (light
underlining)
--The Modoc People. Phoenix, 1976. $15.00
--Tombstone. N.Y., 1972. $15.00
Faulkner, Harold Underwood--The Decline of Laissez Faire....
N.Y., 1961. $20.00
--Politics, Reform, and Expansion.... N.Y., (1959). 1st
ed. $8.50
Faulkner, William--Absalom, Absalom! N.Y., 1936. 1st ed.
$325.00
--As I Lay Dying. N.Y., (1930). 1st ed. $500.00 (1st
issue)
--Big Woods. N.Y., (1955). 1st ed. $100.00 (orig. cloth),
$75.00
--Doctor Martino: and Other Stories. N.Y., 1934. 1st ed.
$350.00
--A Fable. N.Y., (1954). 1st ed. $350.00 (one of 1000
signed copies, boxed), $250.00 (ltd. to 1000 copies, signed
by Faulkner)
--Go Down, Moses and Other Stories. N.Y., (1942). $350.00
--A Green Bough. N.Y., 1933. $450.00 (one of 360 signed
copies), $125.00 (orig. cloth, spine and covers chipped at
edges, tape-repaired, worn and faded, 1st trade ed.)
--The Hamlet. N.Y., 1940. 1st ed. $350.00
--Intruder in the Dust. N.Y., (1948). 1st ed. $150.00
--Knight's Gambit. N.Y., (1949). 1st ed. $150.00

--Light in August. N.Y., (1932). 1st ed. $450.00, $125.00
 (orig. cloth, 1st printing)
--The Mansion. N.Y., 1959. 1st ed. $150.00
--Miss Zilphia Gant. (Dallas), 1932. 1st ed. $750.00 (orig.
 cloth, one of 300 copies)
--Mosquitos. N.Y., 1927. 1st ed. $750.00
 Lond., 1964. $45.00
--New Orleans Sketches. New Brunswick, N.J., 1958. 1st
 ed. $75.00
--The Old Man. (N.Y., 1948). $7.00 (stamp, small chip on
 upper spine)
--Pylon. N.Y., 1935. 1st ed. $275.00 (cover lettering faded)
--The Reivers. N.Y., (1962). 1st ed. $150.00 (1st binding)
 Lond., 1962. $45.00
--Requiem For a Nun. N.Y., (1951). 1st ed. $200.00 (1st
 binding), $75.00 (cloth)
--Sanctuary. N.Y., (1931). 1st ed. $500.00
--Sartoris. N.Y., (1929). 1st ed. $750.00
--Selected Letters of.... N.Y., 1977. $20.00
--Soldiers' Pay. N.Y., 1926. 1st ed. $875.00
--The Sound and the Fury. N.Y., (1929). 1st ed. $1500.00
--Tandis que J'Agonise. Paris, 1946. $350.00 (wraps., loose
 in sheets as issued, boxed, one of 175 copies on Fil de
 Lana Paper)
--These 13. N.Y., (1931). 1st ed. $350.00
--This Earth. N.Y., 1932. 1st ed. $250.00 (orig. wraps.)
--The Town. N.Y., (1957). 1st ed. $300.00 (one of 450
 signed copies)
--The Unvanquished. N.Y., (1938). 1st ed. $325.00
--The Wild Palms. N.Y., (1939). 1st ed. $325.00 (1st bind-
 ing)
--William Faulkner: Early Prose and Poetry. Lond., (1963).
 $30.00
Fauset, Arthur Huff--Black Gods of the Metropolis. Phila.,
 1944. 1st ed. $25.00
Fausold, Martin L.--Gifford Pinchot.... Syracuse, 1961. 1st
 ed. $10.00
Fauteux, Aegidus, ed.--Journal du Siege de Quebec.... 1759
 See under Title
Faux, William--Memorable Days in America. Lond., 1823. 1st
 ed. $125.00 (rebound in half calf and cloth, a bit rubbed,
 somewhat foxed)
Favour, Alpheus Hoyt--Old Bill Williams, Mountain Man.
 Chapel Hill, (1936). 1st ed. $67.50, $40.00
 Norman, (1962). $35.00, $12.50

Fawcett, Percy Harrison--Lost Trails, Lost Cities. N.Y.,
1953. $6.00
Fawkes, Ulla Staley, ed.--The Journal of Walter Griffith Pig-
man
See: Pigman, Walter Griffith
Fay, Theodore Sedgwick--Ulric. N.Y., 1851. $25.00 (orig.
boards, worn, hinges weak, last two leaves stained)
Featherstonhaugh, George William--A Canoe Voyage Up the
Minnay Sotor. Lond., 1847. 2 vols. $250.00 (wear to
backstrips, some interior waterstaining). St. Paul, 1970.
2 vols. $24.00 (boxed)
Federal Writers' Project
See: Writers' Program
Feikema, Feike, pseud.
See: Manfred, Frederick
Feild, Robert Durant--The Art of Walt Disney. Lond., 1947.
$45.00 (cloth covers lightly worn and darkened, some
pages soiled)
Feldstein, Stanley--The Land I Show You. Garden City, 1978.
1st ed. $15.00
Fels, Mary Fels--The Life of Joseph Fels. N.Y., 1940. $15.00
Fenger, Frederic Abildgaard--Alone in the Caribbean. N.Y.,
(1917). 1st ed. $5.00 (ex-lib.)
Fenner, Phyllis Reid--Cowboys, Cowboys, Cowboys. N.Y.,
1950. 1st ed. $12.50
Ferguson, Charles D.--California Gold Fields. Oakland, 1948.
$32.50 (map laid in), $20.00
Ferguson, John Halcro--The Revolutions of Latin America.
(Lond., 1963). $7.50
Ferguson, Ted--Kit Coleman, Queen of Hearts. Garden City,
1978. 1st ed. $12.50
Fergusson, Erna--Chile. N.Y., 1943. $8.50
--Guatemala. N.Y., 1937. 1st ed. $10.00
--Our Hawaii. N.Y., 1942. 1st ed. $6.50 (minor cover
stains)
--Our Southwest. N.Y., 1940. 1st ed. $26.00
Fergusson, Russell Jennings--Early Western Pennsylvania Pol-
itics. (Pitts.), 1938. $30.00
Ferlinghetti, Lawrence--A Coney Island of the Mind. (N.Y.,
1958). $17.50 (wraps., paper yellowing)
Fermi, Laura--Atoms in the Family. (Chi., 1954). $12.00
(underlining, marginalia)
Fernald, Charles--A County Judge in Arcady. Glendale.
1954. $12.50
Fernandes, Florestan--The Negro in Brazilian Society. N.Y.,
1969. $11.00

Fernandez de Cordoba, Francisco--The Discovery of Yuca-
tan.... Berkeley, 1942. $100.00 (cloth, one of 250 num-
bered copies)
Fernandez y Garcia, Eugenio--El Libro de Puerto Rico. San
Juan, 1923. 1st ed. $125.00 (orig. cloth)
Fernow, Berthold--The Ohio Valley in Colonial Days. Albany,
1890. 1st ed. $55.00 (spine badly chipped, glazed boards)
Ferns, Henry Stanley--The Age of Mackenzie King. Lond.,
1955. 1st ed. $7.50
Ferragamo, Salvatore. Shoemaker of Dreams. N.Y., (1972).
$15.00
Ferris, Benjamin--A History of the Original Settlements on
the Delaware.... Wilmington, 1846. $125.00 (three-quarter
morocco)
Ferris, George Titus--Our Native Land. N.Y., 1886. $90.00
(half morocco)
Ferris, Jacob--The States and Territories of the Great West....
N.Y., 1856. 1st ed. $7.50
Ferris, Louanne--I'm Done Crying. N.Y., (1969). 1st ed.
$15.00
Fetterman, John--Stinking Creek. N.Y., 1967. 1st ed.
$17.50
Fewkes, Jesse Walter--Hopi Katchinas, Drawn by Native Art-
ists. Chi., (1962). $25.00
--A Prehistoric Island Culture of America. Wash., 1922.
$40.00 (cloth)
Fey, Harold Edward--Indians and Other Americans. N.Y.,
(1959). $8.50 (owner name)
Fibel, Pearl Randolph--The Peraltas. Oakland, 1971. $20.00
(wraps., signed by author)
Fidler, Isaac--Observations on Professions, Literature, Man-
ners, and Emigration, in the United States and Canada....
Lond., 1833. $100.00 (orig. boards)
Field, Eugene--Second Book of Tales. N.Y., 1896. 1st ed.
$150.00 (orig. cloth, edges lightly worn)
Field, Henry Martyn--Blood is Thicker Than Water. N.Y.,
1886. 1st ed. $15.00 (ex-lib., lacks front endleaf)
--Bright Skies and Dark Shadows. N.Y., 1890. 1st ed.
$30.00 (cover scratched)
Field, Maria Antonia--Chimes of Mission Bells. S.F., 1918.
$7.50
Field, Matthew C.--Matt Field on the Santa Fe Trail.... Nor-
man, (1960). 1st ed. $15.00
--Prairie and Mountain Sketches. Norman, (1957). $15.00

Field, Stephen Johnson--California Alcalde. Oakland, 1950.
$30, $30.00 (one of 600 copies)
Fielder, Mildred--The Treasure of Homestake Gold. (Aberdeen, S.D., 1970). $10.00
--Wild Bill and Deadwood. Seattle, (1965). 1st ed. $20.00
Fierro Blanco, Antonio de, pseud.
See: Nordhoff, Walter
Figueroa, Jose--The Manifesto to the Mexican Republic. Oakland, 1952. $25.00 (one of 750 copies)
Filisola, Vincente--Evacuation of Texas.... Waco, 1965.
$35.00
--Memorias Para la Historia de la Guerra de Tejas. Mexico, 1849. 2 vols. $450.00 (orig. calf)
Finch, Edward Ward--The Frontier, Army, and Professional Life. (New Rochelle, N.Y., 1909). $45.00 (orig. cloth, author's presentation)
Finch, John Bird--The People Versus the Liquor Traffic. Chi., (1883). 1st ed. $5.00
Findley, William--Observations on "The Two Sons of Oil." Phila., 1812. $150.00 (orig. boards)
Fine, Nathan--Labor and Farmer Parties in the U.S.... N.Y., (1928). 1st ed. $40.00
Finerty, John Frederick--War-Path and Bivouac. Chi., (1890). $26.50, $10.00 (binding soiled)
Chi., 1955. $15.00 (cloth), $10.00
Finger, Charles Joseph--Adventure Under Sapphire Skies. N.Y., 1931. $6.00
Finley, James Bradley--Life Among the Indians.... Cinci., n.d. $10.00
Finley, John Huston--The Coming of the Scot. N.Y., 1940.
$15.00 (cover spotted)
Finn, Henry James--Whimwhams....
See under Title
Finney, Charles Grandison--Memoirs of Rev.... N.Y., 1876.
1st ed. $15.00 (bookplate)
Firestone, Harvey Samuel--Man on the Move. N.Y., (1967).
$8.00
--Men and Rubber. Garden City, 1926. $18.00, $15.00, $15.00
Firth, Edith G.--The Town of York, 1815-1934. Toronto, 1966. $30.00
Fish, Joseph--The Life and Times of.... Danville, Ut., (1970).
$17.50
Fish, Stuyvesant--The New York Privateers, 1756-1763. N.Y., 1945. $32.50 (one of 400 copies)
Fisher, Albert Kendrick--The Hawks and Owls of the U.S....

Wash., 1893. 1st ed. $85.00 (cloth, covers soiled, most
plates moderately browned)
Fisher, Allen--Lutheranism in Bucks County.... Tinicum,
Pa., 1935. $25.00
Fisher, Anne (Benson)--No More a Stranger. Stanford, (1946).
$11.00
Fisher, Clay--Nino, the Legend of Apache Kid. N.Y., 1961.
1st ed. $17.50
Fisher, Douglas Alan--Steel Serves the Nation. (N.Y., 1951).
$16.00
Fisher, Edgar Jacob--New Jersey as a Royal Province, 1738
to 1776. N.Y., 1911. $25.00
Fisher, Irving--The "Noble Experiment." N.Y., 1930. $12.50
--Prohibition At Its Worst. N.Y., 1926. 1st ed. $10.00
Fisher, Jane Watts--Fabulous Hoosier. Chi., 1953. $12.50
Fisher, John Stirling--A Builder of the West. Caldwell, 1939.
1st ed. $65.00
Fisher, Lillian Estelle--The Last Inca Revolt. Norman, (1966).
$20.00
Fisher, Olive Margaret--Totem, Tipi and Tumpline.... Lond.,
1955. 1st ed. $15.00
Fisher, Sydney George--The True History of the American
Revolution. Phila., 1902. 1st ed. $10.00
--The True William Penn. Phila., 1900. $7.50 (uncut)
Fisher, Thomas Russell--Industrial Disputes and Federal Leg-
islation.... N.Y., 1940. 1st ed. $30.00
Fisher, Vardis--Gold Rushes.... Caldwell, 1968. $37.50
--In Tragic Life. Caldwell, 1932. 1st ed. $75.00 (presen-
tation copy, signed and dated)
--Pemmican. Garden City, 1956. 1st ed. $20.00
--Tale of Valor. Garden City, 1958. 1st ed. $15.00
--Toilers of the Hills. Bost., 1928. 1st ed. $15.00
Fisher, Waldo Emanuel--Minimum Price Fixing in the Bituminous
Coal Industry. Princeton, 1955. $27.50
The Fishermen's Own Book.... Glouchester, Ma., (1882).
$42.50 (cover stains and marginal stains in text)
Fiske, Frank Bennett--Life and Death of Sitting Bull. Fort
Yates, N.D., (1933). $35.00 (author's signed copy, orig.
wraps.)
Fiske, John--American Political Ideas Viewed From the Stand-
point of Universal History. Bost., 1911. $20.00
--The American Revolution. Bost., 1893. 2 vols. $10.00
Bost., 1898. 2 vols. $30.00
--The Critical Period in American History.... Bost., (1916).
$15.00

--Essays, Historical and Literary. N.Y., 1902. 2 vols. 1st
ed. $30.00 (hinges weak, ex-lib.)
N.Y., 1907. 2 vols. in 1. $30.00
--The Mississippi Valley in the Civil War. Bost., 1900. 1st
ed. $16.00
Camb., 1902. $17.50 (de Luxe ed., one of 1000 numbered
copies)
--Old Virginia and Her Neighbours. Bost., 1900. 2 vols.
$75.00
--The Unseeing World, and Other Essays. Bost., 1876. 1st
ed. $10.00 (presentation copy, ex-lib.)
Fiske, Samuel Wheelock--Mr. Dunn Browne's Experiences in
the Army. Bost., 1866. 1st ed. $17.50
Fitch, Abigail Hetzel--Junipero Serra.... Chi., 1914. 1st
ed. $30.00
Fitch, James Marston--American Building. Bost., 1948. 1st
ed. $10.00
Fitch, Jabez--Diary of Captain Jabez Fitch. (Brooklyn, 1899).
$35.00 (orig. wraps.)
Fite, Gilbert Courtland--George N. Peek and the Fight For
Farm Parity. Norman, 1954. $20.00
FitzGerald, Emily McCorkle--An Army Doctor's Wife on the
Frontier. Pitts., 1962. $22.00
Fitzgerald, Francis Scott--The Beautiful and Damned. N.Y.,
1922. 1st ed. $750.00 (orig. cloth, 1st issue, corners
and edges lightly worn)
--Flappers and Philosophers. N.Y., 1920. 1st ed. $200.00
(1st printing, orig. cloth, lightly soiled, bookplate, con-
temp. gift inscription)
--The Great Gatsby. N.Y., 1925. 1st ed. $200.00 (1st
printing, back endpapers browned by news clipping, book-
plate)
--Tender Is the Night. N.Y., 1934. 1st ed. $20.00 (cloth)
--The Vegetable.... N.Y., 1923. 1st ed. $400.00 (orig.
cloth)
Fitzgerald, John Dennis--Papa Married a Mormon. Englewood
Cliffs, (1955). 1st ed. $7.50
Fitzgibbon, Russell Humke--Uruguay. New Brunswick, 1954.
$15.00
Fitzpatrick, George--Profile of a State--New Mexico. Albu-
querque, 1964. 1st ed. $17.50
--This is New Mexico. Santa Fe, (1948). 1st ed. $15.00
(2nd printing)
Fitzpatrick, Lilian Linder--Nebraska Place-Names. Lincoln,
1925. 1st ed. $15.00 (cloth)

Flack, Horace Edgar--The Adoption of the Fourteenth Amend-
ment. Balt., 1908. $7.50 (paper)
Flagg, Arthur Leonard--Rockhounds & Arizona Minerals.
Phoenix, 1944. $17.50
Flagg, Wilson--The Woods and By-Ways of New England.
Bost., 1872. $17.50 (gash on back hinge)
Flaherty, Robert Joseph--My Eskimo Friends. N.Y., 1924.
$100.00
Flanders, Helen (Hartness)--The New Green Mountain Song-
ster. New Haven, 1939. $90.00
Flanders, Henry--The Lives and Times of the Chief Justices
of the Supreme Court of the U.S. Phila., 1859. 2 vols.
$45.00
Flanders, Robert Bruce--Nauvoo. Urbana, 1965. $18.50
Flandrau, Charles Eugene--The History of Minnesota and
Tales of the Frontier. St. Paul, 1900. $17.50
Flannagan, Roy C.--The Story of Lucky Strike. (Rich.,
1938). $15.00 (boards)
Fleischer, Nat--Jack Dempsey. New Rochelle, N.Y., (1972).
$12.50
Fleischman, Harry--Norman Thomas. N.Y., (1969). $15.00
Fleming, Ethel--New York. N.Y., 1929. $25.00 (cloth, lightly
worn and soiled)
Fleming, Peter--Brazilian Adventure. N.Y., 1934. $5.00
Fleming, Thomas--Around the Capital With Uncle Hank....
N.Y., 1902. $12.50
Fleming, Thomas J.--Now We Are Enemies. N.Y., 1960.
$7.50
Fleming, Walter Lynwood--Documentary History of Reconstruc-
tion. Cleve., 1906-07. 2 vols. 1st ed. $75.00 (ex-lib.)
Fletcher, Colin--The Complete Walker. N.Y., 1968. 1st ed.
$7.50
Fletcher, Fred Nathaniel--Early Nevada. (Reno, 1929).
$37.50
Fletcher, Robert Henry--Free Grass to Fences. N.Y., (1960).
$57.50
Fletcher, Sidney E.--The Cowboy and His Horse. N.Y.,
(1951). $10.00 (edges and corners of binding show wear)
Flexner, James Thomas--The Traitor and the Spy. N.Y.,
(1953). 1st ed. $7.50
Flick, Alexander C.--The American Revolution in New York.
Port Washington, (1967). $17.50
Flint, Charles Ranlett--Memories of an Active Life. N.Y.,
1923. $15.00
Flint, Henry Martyn--Mexico Under Maximillian. Phila., 1867.
1st ed. $60.00 (orig. cloth, light binding wear)

Flint, James--Letters From America.... Cleve., 1904. $50.00,
$30.00

Flint, Timothy--Francis Berrian, or the Mexican Patriot.
Bost., 1826. 2 vols. 1st ed. $1250.00 (orig. cloth, light
wear to spine extremities)

--The Lost Child. Bost., 1830. 1st ed. $12.50 (contemp.
boards, some foxing and stains in text, a few pages torn
with text missing, lacks leaves before title and blank leaves
at end)

--Recollections of the Last Ten Years. Bost., 1826. 1st ed.
$400.00 (orig. boards, bindstamp on title, boxed)

Floherty, John Joseph--Inside the F.B.I. Phila., (1943).
$10.00

--Moviemakers. N.Y., 1935. $8.50

Florida: Its Climate, Soil, and Production.... Jacksonville,
1869. $150.00 (orig. wraps., small corner of front wrap.
missing)

Florin, Lambert--Boot Hill. Seattle, (1966). 1st ed. $20.00,
$15.00

--Tales the Western Tombstones Tell. Seattle, (1967). $15.00

Flower, Milton Embick--James Parton.... Durham, 1951.
$12.00

Flower, Richard--Letters From the Illinois, 1820, 1821. Lond.,
1822. 1st ed. $850.00 (orig. wraps.)

Flowering Plants From Cuban Gardens
See: Woman's Club of Havana. Garden Section

Fluharty, Vernon Lee--Dance of the Millions. Pitts., (1957).
1st ed. $15.00 (cloth)

Flynn, Bess--Bachelor's Children. Chi., 1939. $25.00 (boards)

Flynn, John Thomas--God's Gold. N.Y., (1932). 1st ed.
$12.00 (binding worn)

Flynn, Stephen J.--Florida. Washington, (1962). $10.00
(d.w.)

Flynt, Josiah, pseud.
See: Willard, Josiah Flynt

Foerster, Norman--American Criticism. Bost., 1928. 1st ed.
$15.00 (cloth)

Foght, Harold Waldstein--Trail of the Loup. (Ord, Nebr.),
1906. 1st ed. $75.00 (backstrip faded)

Foley, Thaddeus J.--Memories of the Old West. N.p., 1930.
$27.50

Folsom, Franklin--Exploring American Caves.... N.Y., (1956).
$10.00

Folsom, George--History of Saco and Biddeford.... Saco,
1830. 1st ed. $85.00 (orig. boards)

Folwell, William Watts--Minnesota, the North Star State....
 Bost., 1908. $12.50
Font, Pedro--Font's Complete Diary. Berkeley, 1933. $100.00
 (orig. cloth), $85.00 (orig. cloth), $75.00
Foot, Samuel Alfred--Autobiography. N.Y., 1872. 2 vols.
 1st ed. $25.00 (author's presentation)
Foote, Henry Stuart--Texas and the Texans.... Phila., 1841.
 2 vols. 1st ed. $500.00 (contemp. morocco)
Foote, Mary (Hallock)--John Bodewin's Testimony. Bost.,
 1886. $20.00 (orig. cloth, blemish on spine, covers rubbed,
 front hinge starting, presentation copy, signed and dated)
--A Victorian Gentlewoman in the Far West.... San Marino,
 (1972). $10.00 (wraps.)
Forbes, Mrs. A.S.C.
 See: Forbes, Harrie Rebecca Piper Smith
Forbes, Allan--Towns of New England and Old England. N.Y.,
 1921. $15.00 (one corner lightly bumped)
Forbes, Ester--A Mirror for Witches.... Bost., 1928. 1st
 ed. $35.00 (one of 220 signed copies)
--Paul Revere & the World He Lived In. Bost., 1942. 1st
 ed. $8.00, $7.50
Forbes, Harrie Rebecca Piper Smith--Mission Tales in the Days
 of the Dons. Chi., 1909. 1st ed. $15.00 (cloth, light
 spine tip wear)
Forbes, Jack D.--Apache, Navaho and Spaniard. Norman,
 (1960). 1st ed. $25.00
--Warriors of the Colorado. Norman, (1965). $10.00 (bottom
 edges rippled)
Forbush, Edward Howe--A History of the Game Birds, Wild-
 Fowl and Shore Birds of Massachusetts and Adjacent
 States. (Bost., 1912). 1st ed. $22.50
Ford, Alice Elizabeth--John James Audubon. Norman, (1964).
 $25.00
Ford, Henry--The Case Against the Little White Slaver....
 Detroit, (1916). $29.50 (orig. wraps., lightly worn)
--My Life and Work. Garden City, 1926. $12.00
Ford, Bacon and Davis--For Human Needs.... N.Y., 1967.
 $12.50
Ford, Henry Jones--The Rise and Growth of American Politics.
 N.Y., 1898. 1st ed. $15.00 (cloth, ex-lib.)
Ford Motor Company--Ford at Fifty.... N.Y., 1953. $12.50
Ford, Paul Leicester--Franklin Bibliography.... N.Y., (1968).
 $40.00 (orig. cloth)
--The Honorable Peter Stirling.... N.Y., 1894. 1st ed.
 $60.00 (orig. cloth, spine faded)

Ford, Worthington Chauncey--A Cycle of Adams Letters....
Bost., 1920. 2 vols. $35.00, $15.00
Fordham, Elias Pym--Personal Narrative of Travels in Vir-
ginia.... Cleve., 1906. 1st ed. $35.00 (cloth, ex-lib.)
Fordin, Hugh--Getting to Know Him. N.Y., 1977. $15.00
Foreman, Carolyn (Thomas)--Indian Women Chiefs. Muskogee,
1954. $8.50
--Oklahoma Imprints, 1835-1907. Norman, 1936. $45.00
Foreman, Grant, ed.--Adventure on Red River
See: Marcy, Randolph Barnes
--The Five Civilized Tribes. Muskogee, 1966. $5.00
--A History of Oklahoma. Norman, 1945. $15.00
--Indians & Pioneers. Norman, 1936. $12.50
--The Last Trek of the Indians. Chi., (1946). 1st ed.
$45.00
--Marcy & the Gold Seekers. Norman, 1939. $30.00
Norman, 1968. $20.00
--A Pathfinder in the Southwest
See: Whipple, Amiel Weeks
--Sequoyah. Norman, 1938. 1st ed. $65.00 (author's pres-
entation inscription), $40.00
Norman, (1959). $15.00
Norman, (1970). $6.50 (ex-lib.)
--A Traveler in Indian Territory
See: Hitchcock, Ethan Allen
Forman, Samuel Eagle--The Woman Voter's Manual. N.Y.,
1920. $17.00 (head and tail of spine frayed)
Fornaro, Carlo de--Carranza and Mexico. N.Y., 1915. $15.00
(spine torn and repaired, some foxing)
Forrest, Archibald Stevenson--A Tour Through South America.
Lond., (1913?). $5.50 (few pages stained)
Forrest, Earle Robert--Lone War Trail of Apache Kid. Pasa-
dena, (1947). $60.00 (one of 250 author's signed and
numbered copies of deluxe ed.)
Forrestal, Dan J.--Faith, Hope and $5,000. N.Y., 1977.
$7.00
Forrester, Izola Louise--This One Mad Act. Bost., 1937.
$15.00
Fortina, Carl--The Accordion as Written. North Hollywood,
(1961). $20.00 (cloth, inscribed)
Fortune, Jan Isbelle--Elisabet Ney. N.Y., 1943. 1st ed.
$7.50
Fosburgh, Lacey--Closing Time. N.Y., 1977. 1st ed. $10.00
Fosdick, Raymond Blaine--John D. Rockefeller, Jr.... N.Y.,
(1956). $18.00, $12.50

Foss, Joe--Joe Foss, Flying Marine. N.Y., 1943. 1st ed.
$20.00

Fossett, Frank--Colorado.... N.Y., 1880. $17.50 (front
hinge cracked)

Foster, Harry La Tourette--If You Go to South America.
N.Y., 1928. 1st ed. $8.00

Foster, John Wells--The Mississippi Valley. Chi., 1869.
$20.00

Foster, Mulford Bateman--Brazil. N.Y., (1946). $8.50
(signed)

Foster, Sarah Haven--The Portsmouth Guide Book. Ports-
mouth, N.H., 1896. $15.00

Foster, Thomas--The Iowa. Cedar Rapids, 1911. $25.00
(bit of spine tip and corner rub)

Foulke, Roy Anderson--The Sinews of American Commerce.
(N.Y., 1941). $15.00

Founders and Frontiersmen. Wash., 1967. 1st ed. $20.00
(cloth, ex-lib.)

Fountain, Paul--The Great North-West.... Lond., 1904.
$40.00 (endpapers foxed)

Fowke, Edith Fulton--Folk Songs of Canada. Waterloo, Ont.,
(1954). 1st ed. $25.00

Fowle, George--Letters to Eliza.... Chi., (1970). $12.50

Fowler, Gene--Beau James. N.Y., 1949. 1st ed. $25.00
(inscribed, cloth, spine lightly sunned)

--Father Goose.... N.Y., (1934). 1st ed. $20.00 (spine
lightly soiled)

--Schnozzola.... N.Y., 1951. 1st ed. $12.50 (top foredge
lightly stained)

--A Solo in Tom-Toms. N.Y., 1946. 1st ed. $6.00

Fowler, Harlan Davey--Camels to California. Stanford, 1950.
$35.00

Fowler, Jacob--Journal of.... Minne., 1965. $12.95

Fowler, William Worthington--Woman on the American Frontier.
Hart., 1879. $45.00 (front endpapers torn along crease,
corners bumped, minor fraying of head and tail of spine)

Fox, Gustavus Vasa--Confidential Correspondence of....
N.Y., 1918-19. 2 vols. 1st ed. $50.00 (one of 1200
copies, slipcased)

Fraenkel, Osmond Kessler, ed.--The Sacco-Vanzetti Case
See: Sacco, Nicola

France, Lewis B.--Mountain Trails and Parks in Colorado.
Denver, 1887. $35.00

Franchere, Gabriel--A Voyage to the Northwest Coast of Amer-
ica. N.Y., (1968). $40.00 (small tape mends on front &
end flys), $5.50

Francis, Emerick K.--In Search of Utopia. Altona, Manitoba,
1955. $25.00
Franck, Harry Alverson--Roaming in Hawaii. N.Y., 1937.
$18.00
--Roaming Through the West Indies. N.Y., 1920. 1st ed. $5.00
--Vagabonding down the Andes. N.Y., (1917). $8.50 (covers
lightly stained)
--Working North From Patagonia. Garden City, 1921. $6.50
(ex-lib.)
--Zone Policeman 88. N.Y., 1913. $25.00, $10.00 (spine top
pulled, hinges weak)
Frank, Henriette Greenebaum--Annals of the Chicago Woman's
Club.... Chi., 1916. $20.00, $17.50
Frank, John Paul--The Warren Court. N.Y., (1964). $10.00
Frank, Waldo--City Block. N.Y., 1932. $75.00 (orig. cloth,
inscribed, spine lightly foxed, bookplate)
--Dawn in Russia. N.Y., 1932. 1st ed. $60.00 (inscribed,
orig. cloth.)
--The Death and Birth of David Markand.... N.Y., 1934.
1st ed. $50.00 (orig. cloth, spine badly faded, inscribed)
--In the American Jungle.... N.Y., (1937). 1st ed. $45.00
(orig. cloth, spine quite faded, spine ends frayed, inscribed)
--Island in the Atlantic. N.Y., (1946). 1st ed. $40.00 (orig.
cloth, inscribed)
--The Re-Discovery of America. N.Y., 1929. 1st ed. $40.00
(orig. cloth, inscribed)
N.Y., 1947. $40.00 (orig. cloth, inscribed)
Frankfurter, Felix--The Case of Sacco and Vanzetti. Bost.,
1927. 1st ed. $60.00
--Felix Frankfurter Reminiscences. N.Y., 1960. $12.00
--From the Diaries of Felix Frankfurter. N.Y., 1975. $10.00
--Of Law and Life.... Camb., 1967. $8.50
Franklin, Benjamin--Autobiography. N.Y., (1957). $8.50
--An Historical Review of Pennsylvania.... Phila., 1812.
$250.00 (rebound in three-quarter calf)
--An Historical Review of the Constitution and Government of
Pennsylvania.... Lond., 1759. 1st ed. $400.00 (contemp.
calf, extremities of spine worn, corners rubbed, light dust
soiling), $275.00 (later boards)
--Memoirs of the Life and Writings of.... Lond., 1818. 3
vols. $600.00 (contemp. boards)
--Political, Miscellaneous, and Philosophical Pieces.... Lond.,
1779. 1st ed. $600.00 (lightly foxed, bookplate), $550.00
(contemp. calf)
Franklin, Fabian--What Prohibition Has Done to America.
N.Y., (1922). $10.00

Franklin, George Cory--Wild Horses of the Rio Grande. Bost.,
1951. $12.50
Franklin, John--Narrative of a Journey to the Shores of the
Polar Sea.... Phila., 1824. $250.00 (half morocco)
Franklin, John Benjamin--A Cheap Trip to the Great Salt
Lake City. Ipswich, [1864]. $87.50 (orig. wraps., foxed)
Franklin, John Hope--The Emancipation Proclamation. Garden
City, 1963. 1st ed. $13.50
(Franklin, Lucia J.)--Stories and Facts of Alaska. Fairbanks,
(1921). $20.00
Franco, Victor--The Morning After. N.Y., (1963). $7.50
Frantz, Joe Bertram--The American Cowboy. Norman, (1955).
1st ed. $25.00
Fraser, Chelsea Curtis--Famous American Flyers. N.Y.,
1941. 1st ed. $15.00
Frazer, Joseph Jack--Iron Face. Chi., 1950. $50.00 (one of
500 copies)
Frazer, Robert Walter--Forts of the West. Norman, (1965).
1st ed. $15.00
Frazier, Edward Franklin--Race and Culture Contacts in the
Modern World. N.Y., 1957. 1st ed. $12.50
Frazier, Robert Walter, ed.--Mansfield on the Condition of the
Western Forts....
See: Mansfield, Joseph King Fenno
Frazier, Samuel Milligan--Secrets of the Rocks. Denver, 1905.
1st ed. $50.00 (owner name)
Frederic, Harold--Seth's Brother's Wife.... N.Y., 1887. 1st
ed. $30.00 (backstrip frayed)
Free Negroism. N.Y., 1862. 1st ed. $50.00 (orig. wraps.,
uncut)
Freece, Hans P.--The Letters of an Apostate Mormon to His
Son. (N.Y.), 1908. $27.50
Freehling, William W.--Prelude to Civil War. N.Y., (1966).
1st ed. $15.00
Freeman, Andrew A.--The Case for Doctor Cook. N.Y.,
(1961). $10.00
Freeman, Douglas Southall--A Calendar of Confederate Pa-
pers.... Rich., 1908. $37.50 (one of 1000 copies)
--George Washington, a Biography. N.Y., 1948(-57). 7 vols.
$125.00
--Lee's Dispatches
See: Lee, Robert Edward
--The Lengthening Shadow of Lee. Rich., 1936. $10.00
(signed)
--R.E. Lee.... N.Y., 1934-35. 4 vols. 1st ed. $90.00
(spine worn, presentation copy)

Freeman, John Dollivar--Life on the Uplands. Toronto, 1906.
1st ed. $7.50
Freeman, Lewis Ransome--Down the Columbia. N.Y., 1921.
$24.00
--Down the Yellowstone. N.Y., 1922. $12.50
Freeman, Lucy--"Before I Kill More...." N.Y., 1955. $10.00
Fremantle, James Arthur Lyon--The Fremantle Diary. Bost.,
(1954). $10.00
--Three Months in the Southern States. N.Y., 1864. $60.00
Fremont, Elizabeth Benton--Recollections of.... N.Y., 1912.
$25.00 (faint mark front cover, spine tip and corner rub)
Fremont, Jesse Benton--The Story of the Guard.... Bost.,
1863. $10.00, $7.50
Fremont, John Charles--California Claims. (Wash., 1848).
$75.00 (disbound)
--The Expeditions of John Charles Fremont. Urbana, 1970- .
4 vols., incl. 1 map portfolio. $100.00 (boxed)
--Geographical Memoir Upon Upper California. Wash., 1848.
1st ed. $250.00 (disbound), $100.00 (orig. wraps., bottom
corner torn away, ex-lib.)
--The Life of Col. John Charles Fremont. N.Y., 1856. 1st
ed. $90.00 (moderate fraying to front hinge, corners a
bit bumped, light cover wear, moderate foxing throughout)
--Memoirs of My Life. Chi., 1887. $300.00 (leather, scuffed)
--Narrative of Exploration and Adventure. N.Y., 1956. $20.00
N.Y., (1957). $15.00 (cloth)
--Notes of Travel in California
See under Title
--Report of the Exploring Expedition to the Rocky Mountains....
Wash., 1845. 1st ed. $1500.00 (orig. cloth, 1st issue,
author's autograph letter laid in), $600.00 (1st issue, orig.
cloth)
--A Report on an Exploration of the Country.... Wash., 1843.
1st ed. $500.00 (worn and browned)
French, Allen--The Taking of Ticonderoga in 1775. Camb.,
1928. $25.00 (one of 500 copies)
French, Benjamin Franklin--Historical Collections of Louisiana
and Florida. N.Y., 1875. $40.00 (cloth, spine pieces
missing)
French, Bruce Hartung--Banking and Insurance in New Jersey.
Princeton, 1965. $12.50, $8.00
French, Samuel Gibbs--Two Wars. Nash., 1901. 1st ed.
$50.00 (covers water spotted)
French, William--Some Recollections of a Western Ranchman.
Lond., 1927. 1st ed. $185.00

Frenchtown Historical Society--French Valley Footprints. Missoula, Mt., 1976. $30.00

Freneau, Philip Morin--Poems Relating to the American Revolution. N.Y., 1865. $40.00 (orig. cloth)

--Poems Written Between the Years 1768 & 1794. Monmouth, N.J., 1795. $450.00 (contemp. calf, hinges weak, spine ends and edges rubbed), $125.00 (contemp. calf)

Freuchen, Peter--Book of the Eskimos. Cleve., (1961). $10.00

Freyre, Gilberto--The Mansions and the Shanties.... N.Y., 1963. $12.50

--The Masters and the Slaves.... N.Y., (1946). $11.50, $9.50

--Le Portugais et les Tropiques. Lisbon, 1961. $12.50 (wraps.)

--The Portuguese and the Tropics. Lisbon, 1961. $12.50 (wraps.)

--Regiao e Tradicao. Rio de Janeiro, 1941. 1st ed. $12.50 (presentation copy)

Friedrichs, Irene Holmann--History of Goliad. Victoria, Tx., 1961. 1st ed. $45.00 (orig. wraps., signed by author)

Fries, Adelaide Lisetta--The Road to Salem. Chapel Hill, 1944. 1st ed. $10.00

Fries, Ulrich Englehart--From Copenhagen to Okanogan. Caldwell, 1951. 1st ed. $10.00 (bookplate, owner name, bit of flecking)

Frieze, Jacob--A Concise History of the Efforts to Obtain an Extension of Suffrage.... Prov., 1842. 1st ed. $20.00

Frink, Maurice--Cow Country Cavalcade. Denver, 1954. $31.50, $25.00 (orig. cloth, inscribed), $20.00

--When Grass Was King. Boulder, 1956. 1st ed. $62.50 (numbered ed.)

Frisbie, Charlotte Johnson--Kinaalda. Middletown, Ct., 1967. $30.00

Frizzell, Lodisa--Across the Plains to California in 1852. (N.Y.), 1915. $28.50 (stamp on title)

Froger, Francois--Relation d'un Voyage de la Mere de Sud.... Amsterdam, 1715. $450.00 (contemp. calf, skillfully rebacked)

From New Jersey to California '97
See: Davis, T.E.

Frontier Applications in Lower Central America. Phila., 1976. $11.50

Froom, Barbara--The Snakes of Canada. Toronto, (1972). $12.50

Frost, John--History of the State of California. Auburn,

N.Y., 1850. $35.00 (leather, rubbed, some illustrations
 supplied in facs.)
--The Mexican War and Its Warriors. New Haven, 1848. 1st
 ed. $25.00 (cloth, joints worn, scattered foxing)
Frost, John Edward--Fancy This; a New England Sketch Book.
 Bost., (1938). $6.00
Frost, Lawrence A.--The Court-Martial of General George
 Armstrong Custer. Norman, (1968). $25.00, $15.00
--The Custer Album. Seattle, 1964. 1st ed. $25.00 (inscribed
 copy), $25.00
--General Custer's Libbie. Seattle, 1976. $20.00
Frost, Max, ed.--The Land of Sunshine. (Santa Fe, 1904).
 $40.00 (cloth). Santa Fe, 1906. $30.00
Frost, Richard H.--The Mooney Case. Stanford, 1968. 1st
 ed. $12.50
Frost, Robert--A Boy's Will. Lond., 1913. 1st ed. $2250.00
 (1st issue, binding A, orig. cloth, slipcased)
--A Further Range. N.Y., (1936). $15.00 (cloth), $10.00
--In the Clearing. N.Y., (1963). $10.00
--A Masque of Reason. Lond., 1948. $135.00 (orig. cloth,
 edges lightly worn, slipcased)
--The Road Not Taken. N.Y., (1955). $10.00
--West-Running Brook. N.Y., (1928). $10.00
Frothingham, Richard--Life and Times of Joseph Warren.
 Bost., 1865. 1st ed. $17.50 (backstrip torn)
--The Rise of the Republic of the U.S. Bost., 1872. 1st
 ed. $7.50
Frothingham, Thomas Goddard--Washington, Commander in
 Chief. Bost., 1930. 1st ed. $17.50, $7.50 (ex-lib)
Frothingham, Washington--History of Montgomery County
 See under Title
Fuchs, Lawrence H.--Hawaii Pono. N.Y., (1961). 1st ed.
 $10.00, $8.50
Fuentes, Carlos--El Mundo de Jose Luis Cuevas
 See: Cuevas, Jose Luis
Fuermann, George Melvin--Houston: Land of the Big Rich.
 Garden City, 1951. $7.50
--Reluctant Empire. Garden City, 1957. $7.50 (signed by
 author)
A Full and Particular Account of ... the Loss of the Steamship
 Lexington.... Prov., 1840. $25.00 (old boards, orig.
 wraps. bound in)
(Fullam, George Townley)--The Cruise of the "Alabama"....
 Liverpool, 1863. 1st ed. $100.00
Fuller, Claud E.--Firearms of the Confederacy. Huntington,
 W.Va., 1944. 1st ed. $50.00

--The Rufled Musket. Harrisburg, 1958. $40.00
Fuller, George Washington--A History of the Pacific Northwest.
 N.Y., 1931. 1st ed. $22.50
Fuller, Henry Blake--The Chevalier of Pensieri-Vani.... Bost.,
 (1890). 1st ed. $60.00 (orig. cloth, ex-lib., labels re-
 moved)
Fuller, Hubert Bruce--The Speakers of the House. Bost.,
 1909. $10.00
Fuller, Margaret--Literature and Art. N.Y., 1852. $45.00
 (orig. cloth, title lightly foxed)
--Memoirs of Margaret Fuller Ossoli. Bost., 1852. 2 vols.
 1st ed. $45.00 (orig. cloth, extremities worn)
Fuller, Robert Higginson--Jubilee Jim. N.Y., 1928. $20.00
 (cloth), $10.00
Fulton, Maurice Garland--History of the Lincoln County War.
 Tucson, 1969. $22.50
Fulton, Robert Lardin--Epic of the Overland. L.A., 1954.
 $10.00
Fultz, Francis Marion--The Elfin-Forest of California. L.A.,
 1923. 1st ed. $65.00 (one of 100 signed copies)
 L.A., 1927. $35.00
Furlong Cardiff, Guillermo--Francisco J. Miranda y su Sinop-
 sis.... Buenos Aires, 1963. $12.50 (half cloth)
--Jose Manuel Peramus y su Diario del Destierro
 See: Peramus, Jose Manuel
Furnas, Joseph Chamberlain--Anatomy of Paradise. N.Y.,
 (1948). 1st ed. $8.50
--The Life and Times of the Late Demon Rum. N.Y., 1965.
 1st ed. $10.00
--The Road to Harper's Ferry. Lond., (1961). $12.50
Furnas, Robert Wilkinson--Forestry on the Plains. N.p.,
 (1883). $12.50
--Nebraska. Her Resources, Advantages, Advancement and
 Promises. New Orleans, 1885. $75.00 (orig. wraps.)
Fuson, Henry Harvey--Ballads of the Kentucky Highlands.
 Lond., (1931). 1st ed. $17.50
Futhey, John Smith--History of Chester County, Pennsylvania.
 Phila., 1881. $225.00

- G -

Gable, John E.--History of Cambria County, Pennsylvania.
 Topeka, 1926. 2 vols. $85.00
Gabriel, Ralph Henry--The Course of American Democratic
 Thought. N.Y., 1940. 1st ed. $17.50 (cloth)

--A Frontier Lady
See: Royce, Sarah (Bayliss)
--The Pageant of America....
See under Title
Gabrielson, Ira Noel--Wildlife Management. N.Y., 1951. $5.00
--Wildlife Refuges. N.Y., 1943. $6.00
Gaddis, John Lewis--The U.S. and the Origins of the Cold
War.... N.Y., 1972. $5.00 (wraps., rubbed)
Gaer, Joseph--Bibliography of California Literature. N.Y.,
(1970). $20.00
--The First Round. N.Y., 1944. $20.00, $12.50
Gage, Jack R.--Wyoming Afoot and Horseback. Cheyenne,
(1966). $20.00 (author's signed presentation)
Gage, Nicholas--The Mafia is Not an Equal Opportunity Em-
ployer. N.Y., 1971. $7.00
Gaisseau, Pierre Dominique--The Sacred Forest. N.Y., 1954.
$6.00
Galambos, Louis--Competition and Cooperation. Balt., (1966).
$12.50
Galbraith, John Kenneth--American Capitalism. Bost., 1956.
$4.00 (wraps.)
Galbraith, Robert Christy--The History of the Chillicothe
Presbytery.... Chillicothe, 1889. $40.00
Galbreath, Charles Burleigh--History of Ohio.... Chi., 1925.
5 vols. 1st ed. $65.00 (hinges cracked in one vol.)
Gale, Edwin, Oscar--Reminiscences of Early Chicago and Vi-
cinity. Chi., 1902. $45.00
Gale, George, 1816-1868--Upper Mississippi. Chi., 1867. 1st
ed. $150.00 (orig. cloth)
Gale, George, 1857--Historic Tales of Old Quebec. Quebec,
1923. $25.00 (cloth, spotted)
Gale, John--The Missouri Expedition, 1818-1820. Norman,
(1969). 1st ed. $20.00
Gall, John F., ed.--The Massacre of the Wigton Family
See under Title
Gallatin, Albert--Views of the Public Debt, Receipts, and Ex-
penditures of the U.S. Phila., 1801. $125.00 (leather)
--Writings. N.Y., 1960. 3 vols. $100.00 (orig. cloth, boxed)
Gallegos, Romulo--Dona Barbara. N.Y., (1942). $6.00 (pages
browning)
Gallico, Paul--The Hurricane Story. Garden City, 1960.
$8.50
Galloway, John Debo--The First Transcontinental Railroad.
N.Y., (1950). 1st ed. $32.50
Galpin, Samuel Arthur--Report Upon the Condition and

Management of Certain Indian Agencies.... Wash., 1877.
$200.00 (orig. wraps.)
Galpin, William Freeman--Pioneering for Peace. Syracuse,
1933. 1st ed. $12.50
Galvez, Bernardo de--Yo Solo. New Orleans, 1978. $30.00
(orig. wraps.)
Galvin, John, ed.--The First Spanish Entry....
See: Santa Maria, Vicente
--Western America in 1846-1847
See: Abert, James William
Gambrell, Herbert Pickens--Anson Jones.... Garden City,
1948. $21.00, $15.00
(Ganilh, Anthony)--Ambrosio de Letinez, or, the First Texian
Novel.... N.Y., 1842. 2 vols. 1st ed. $850.00 (orig.
boards, slipcased)
Gann, Thomas William Francis--The History of the Maya From
the Earliest Times to the Present Day. N.Y., 1931. $10.00
Gannon, Michael V.--The Cross in the Sand. Gainesville,
1967. $20.00
--Rebel Bishop. Milwaukee, 1964. $30.00 (inscribed copy)
Ganzel, Dewey--Mark Twain Abroad. Chi., (1968). $15.00
Garber, D.W.--Jedediah Strong Smith.... Stockton, 1973.
$20.00, $10.50
Garber, John Palmer--The Settlements on the Delaware.
Phila., 1909. $10.00 (wraps.)
--The Valley of the Delaware.... Phila., (1934). $20.00
Garces, Francisco Tomas Hermenegildo--On the Trail of a
Spanish Pioneer. N.Y., 1900. 2 vols. $275.00 (one of
950 copies)
--A Record of Travels in Arizona and California, 1775-1776.
(S.F.), 1965. $53.50, $40.00 (one of 1250 copies), $35.00
Garcia, Ruben--Aspectos Desconocidos del Aventurero Hernan
Cortes. Mexico, 1956. $12.50 (wraps.)
Garcia Cubas, Antonio--The Republic of Mexico in 1876....
Mexico, 1876. $125.00 (buckram)
Garcia Icazbalceta, Joaquin, ed.--Historia Eclesiastica In-
diana....
See: Mendieta, Geronimo
Garcilaso de la Vega, el Inca--Historia General del Peru.
Buenos Aires, (1944). 3 vols. $55.00 (orig. wraps., ex-
lib., spine taped)
Gard, Wayne--Cattle Brands of Texas. (Dallas, 1956). $20.00
(wraps.)
--The Chisholm Trail. Norman, (1954). $47.50 (signed)
--Frontier Justice. Norman, 1949. 1st ed. $26.00, $25.00,
$15.00

--The Great Buffalo Hunt. N.Y., 1960. $10.00, $8.50
--Sam Bass. Bost., 1936. 1st ed. $35.00
 Lincoln, 1969. $5.00
Garden Club of America--Gardens of Colony and State. (N.Y.),
 1931-34. 2 vols. $85.00 (boxed)
Garden Study Club of Nashville--History of Homes and Gardens
 of Tennessee. Nash., 1964. $30.00
Gardiner, Clinton Harvey--The Constant Captain, Gonzalo de
 Sandoval. Carbondale, Il., (1961). $20.00
--The Literary Memoranda of William Hickling Prescott
 See: Prescott, William Hickling
--Mexico, 1825-1828
 See: Tayloe, Edward Thornton
--The Papers of William Hickling Prescott
 See: Prescott, William Hickling
Gardiner, Florence Edwards, ed.--Cyrus Edwards' Stories of
 Early Days....
 See: Edwards, Cyrus
Gardiner, Howard Calhoun--In Pursuit of the Golden Dream.
 Stoughton, Ma., 1970. $60.00, $35.00 (cloth)
Gardner, Charles Milo--The Grange.... Wash., (1949). $12.50
Gardner, Erle Stanley--Hovering over Baja. N.Y., 1941. $10.00
--Off the Beaten Track in Baja. N.Y., 1967. $12.50
Gardner, Richard N.--Sterling-Dollar Diplomacy. N.Y., 1956.
 1st ed. $15.00
Gardner, Robert Edward--American Arms and Arms Makers.
 Columbus, Oh., 1944. $15.00
Garesche, William A.--Complete Story the Martinique and St.
 Vincent Horrors. (Chi., 1902). $20.00 (both hinges open,
 tear in spine)
Garfield, James Abram--The Works of.... Bost., 1882-83.
 2 vols. 1st ed. $75.00 (leather scuffed)
Garfield, Viola Edmundson--The Wolf and the Raven. Seattle,
 1948. 1st ed. $25.00
Garland, Alejandro--Peru in 1906. Lima, 1907. $75.00 (mor-
 occo, chipped, rebacked and rehinged)
Garland, Hamlin--Back-Trailers From the Middle Border.
 N.Y., 1928. $15.00
--The Book of the American Indian. N.Y., 1923. 1st ed.
 $225.00 (boards, joints moderately worn), $150.00, $50.00
--My Friendly Contemporaries. N.Y., 1932. 1st ed. $20.00
 (orig. cloth)
Garland, Joseph E.--That Great Pattillo. Bost., (1966). $15.00
Garner, Bess (Adams)--Mexico. Bost., 1937. $10.00
Garner, William Robert--Letters From California.... Berkeley,
 1970. $30.00

Garraghan, Gilbert Joseph--The Jesuits of the Middle U.S.
N.Y., 1938. 3 vols. 1st ed. $75.00
Garrard, Lewis Hector--Wah-to-Yah and the Taos Trail. Glen-
dale, 1938. $25.00 (tape stains to endpapers and ink under-
lining throughout)
Palo Alto, 1968. $15.00
Phila., 1974. $12.50
Garraty, John Arthur--The Nature of Biography. N.Y., 1957.
1st ed. $15.00
Garrett, Mitchell Bennett--Horse and Buggy Days on Hatchet
Creek. Tuscaloosa, 1957. 1st ed. $12.50
Garrett, Pat Floyd--Authentic Life of Billy the Kid. N.Y.,
1927. $50.00
Norman, (1954). $8.50
Albuquerque, 1964. $25.00
Garvin, Francis Patrick--Furniture and Silver by American
Master Craftsmen. N.Y., 1931. $50.00 (wraps.)
Gass, Patrick--A Journal of the Voyages and Travels of a
Corps of Discovery.... Pitts., 1807. 1st ed. $750.00
(orig. cloth, worn and foxed)
Minne., 1958. $40.00 (one of 2000 copies)
Gates, Reginald Ruggles--A Botanist in the Amazon Valley.
Lond., 1927. $44.00 (cloth)
Gatschet, Albert Samuel--A Dictionary of the Atakapa Lan-
guage.... Wash., 1932. $15.00 (wraps.)
Gauvreau, Emile Henry--Billy Mitchell.... N.Y., 1942.
$10.00
Gavin, Catherine Irvine--The Cactus and the Crown. Garden
City, (1962). 1st ed. $5.00
Gay, Mary Ann Harris--Life in Dixie During the War. Atlanta,
1897. $45.00 (cloth, endpapers a bit soiled, a few pages
creased)
Gay, Robert Malcolm--Emerson. Garden City, 1928. 1st ed.
$16.50
Gay, Theressa--James W. Marshall, the Discover of California
Gold. Georgetown, Ca., 1967. $45.00
Gaynor, William Jay--Some of Mayor Gaynor's Letters and
Speeches. N.Y., (1913). $25.00 (inscribed, cloth, hinges
cracked)
Gee, Nancie--Reflections in Pike Place Markets. Seattle, (1968)
$10.00
Geer, Theodore Thurston--Fifth Years in Oregon. N.Y.,
1912. 1st ed. $40.00
Geiger, Maynard J.--Franciscan Missionaries in Hispanic Cal-
ifornia. San Marino, 1969. $25.00, $15.00, $15.00

Gellermann, William--Martin Dies. N.Y., (1944). 1st ed.
$15.00
Gellert, Hugo--Comrade Gulliver. N.Y., (1935). $30.00
Gelpi, Albert J.--Emily Dickinson, the Mind of the Poet.
Camb., 1965. $12.00
Genthe, Arnold--As I Remember. N.Y., (1936). $20.00
Gentleman of Elvas--The Discovery of Florida. S.F., (1946).
$400.00 (orig. boards, one of 280 copies)
--A Relation of the Invasion and Conquest of Florida....
Lond., 1686. $1250.00 (calf, license and title in facs.)
--True Relation of the Hardships Suffered by Governor Fer-
nando De Soto. De Land, 1932. 2 vols. $185.00 (slip-
cased, one of 360 copies), $150.00 (one of 360 copies, boxed)
Gentry, Curt--The Madams of San Francisco. Garden City,
1964. 1st ed. $35.00
Gentry, Thomas George--Life-Histories of the Birds of Eastern
Pennsylvania. Phila., 1876-77. 2 vols. $116.00 (orig.
cloth)
Geology of New York. Albany, 1842-43. 4 vols. $325.00
(orig. cloth, spine head of vol. 4 snagged, scattered fox-
ing)
George, Alexander L.--Woodrow Wilson and Colonel House.
N.Y., 1956. $12.50
George, Henry--Social Problems. Chi., 1883. 1st ed. $35.00
(orig. cloth)
Chi., 1884. $65.00 (orig. wraps., extremities chipped)
Gerber, Albert Benjamin--Bashful Billionaire. N.Y., (1967).
$10.00, $10.00 (ex-lib.), $8.50 (little pencilling), $7.50
Gerbi, Antonello--La Disputo del Nuovo Mundo. Mexico, 1960.
$40.00
Gerhard, Peter--Pirates on the West Coast of New Spain.
Glendale, 1960. 1st ed. $45.00, $15.00 (unopened), $10.00
Gerhart, Eugene C.--America's Advocate.... Ind., (1958).
$17.50
Gerould, Katharine (Fullerton)--Hawaii; Scenes and Impres-
sions. N.Y., 1916. $8.50 (wear at edges)
Gerrish, Theodore--Army Life. Portland, Me., 1882. 1st
ed. $20.00
--Life in the World's Wonderland. N.p., 1886. 1st ed.
$50.00 (orig. cloth, back free endpaper stained), $40.00
Gerson, Noel Bertram--The Crusader. Bost., (1970). 1st
ed. $12.50 (ex-lib.)
--Harriet Beecher Stowe. N.Y., 1976. $7.50
--Kit Carson. Garden City, 1964. 1st ed. $7.50
--The Man Who Lost America. N.Y., 1973. $10.00

Gerstaecker, Friedrich--California Gold Mines. Oakland,
1946. $55.00 (boards, one of 500 copies), $41.00 (boards)
--Scenes of Life in California. S.F., (1942). $75.00 (dis-
bound, boards), $42.50 (one of 500 copies)
Gervasi, Frank Henry--But Soldiers Wonder Why. Garden
City, 1943. $12.50
Gessler, Clifford--Hawaii. N.Y., (1938). $12.50
--Tropic Landfall. Garden City, 1942. $15.00
Gettemy, Charles Ferris--The True Story of Paul Revere....
Bost., 1905. $10.00
Getty, Jean Paul--My Life and Fortunes. 1963. 1st ed.
$12.50
Gheerbrant, Alain--The Impossible Adventure. Lond., 1953.
$7.50
--Journal to the Far Amazon. N.Y., 1954. $7.50 (1st print-
ing)
Gibb, George Sweet--The Resurgent Years.... N.Y., (1956).
$20.00
--The Whitesmiths of Taunton. Camb., 1943. 1st ed. $30.00
Gibbon, Thomas Edward--Mexico Under Carranza. Garden
City, 1919. $12.50
Gibbons, James Sloan--The Banks of New-York.... N.Y.,
1858. $75.00 (cloth, hinges cracked)
Gibbs, George--Indian Tribes of Washington Territories.
Fairfield, Wa., 1972. $7.50
Gibbs, Josiah Francis--Lights and Shadows of Mormonism.
(S.L.C., 1909). $28.50 (backstrip edges worn)
--Mountain Meadows Massacre. S.L.C., 1910. 1st ed. $23.50
Gibson, Althea--I Always Wanted to Be Somebody. N.Y.,
(1958). 1st ed. $20.00
Gibson, Arrell Morgan--The Kickapoos. Norman, (1963).
$25.00, $20.00 (1st printing), $20.00, $20.00 (cloth)
--The Life and Death of Colonel Albert Jennings Fountain.
Norman, (1965). 1st ed. $15.00
Gibson, William Hamilton--Sharp Eyes. N.Y., 1897. $10.00
Giddens, Paul Henry--Early Days of Oil.... Princeton, 1948.
1st ed. $30.00, $25.00
--Standard Oil Company (Indiana). N.Y., (1955). $25.00
$17.50, $10.00
Giesler, Jerry--The Jerry Giesler Story. N.Y., 1960. $7.50
Giffen, Guy James--California Expedition. Oakland, 1951.
$30.00, $25.00 (one of 650 copies)
Giffen, Helen Smith--California Mining Town Newspapers. Van
Nuys, 1954. $60.00 (one of 400 copies, signed by the au-
thor)

--Trail-Blazing Pioneer. (S.F.), 1969. 1st ed. $17.50
Gifford, Edward S.--The American Revolution in the Delaware
 Valley. Phila., 1976. $12.50
Gihon, John H.--Geary and Kansas. Phila., 1857. 1st ed.
 $12.50 (some foxing, rebinding)
Gilbert, Dorothy Lloyd--Guilford, a Quaker College. Greens-
 boro, N.C., 1937. 1st ed. $12.50
Gilbert, Douglas--American Vaudeville.... N.Y., 1963.
 $11.00 (covers lightly worn and grubby)
Gilbert, Edmund William--The Exploration of Western America,
 1800-1850. Camb., 1933. $36.50
Gilbert, J. Warren--The Blue and the Gray. (Harrisburg),
 1922. 1st ed. $5.00 (wraps.)
Gildersleeve, Virginia Crocheron--Many a Good Crusade.
 N.Y., 1954. $15.00 (signed by author)
Giles, Charles--Pioneer. N.Y., 1844. 1st ed. $35.00 (calf)
Giles, Frye Williams--Thirty Years in Topeka. Topeka, 1886.
 1st ed. $75.00 (newly rebound, one of 100 copies)
 Topeka, 1960. $10.00 (cloth, one of 200 clothbound copies),
 $7.50
Giles, Harry F.--Homeseeker's Guide to the State of Washing-
 ton. Olympia, 1914. $16.50 (wraps.)
Giles, Rosena A.--Shata County, California.... Oakland,
 1949. $25.00
Giles, Valerius Cincinnatus--Rags and Hope.... N.Y., (1961).
 $12.50
Gilham, William--Manual of Instruction for the Volunteers and
 Militia of the Confederate States. Rich., 1862. $750.00
 (orig. cloth, spine faded and cloth glazed)
Gilkey, Helen Margaret--Handbook of Northwest Flowering
 Plants. Portland, Or., 1961. $10.00
Gillett, James B.--Six Years With the Texas Rangers.... Aus-
 tin, (1921). 1st ed. $82.50 (back cover lightly spotted)
 New Haven, (1925). $35.00, $20.00 (wear on spine)
Gilliam, Albert M.--Travels Over the Table Lands and Cor-
 dilleras of Mexico.... Phila., 1845. 1st ed. $400.00
 (orig. cloth, minor cover wear)
Gilliam, Harold--San Francisco Bay. Garden City, 1957. 1st
 ed. $12.50 (signed), $7.50
Gilliland, Maud Truitt--Horsebackers of the Brush Country.
 (Brownsville, Tx.), 1968. $31.50 (author's autograph)
Gillin, John Lewis--Wisconsin Prisoner. Madison, 1947.
 $18.00
Gillis, James Andrew--The Hawaiian Incident. Freeport, (1970).
 $8.00

Gillmor, Frances--The King Danced in the Marketplace. Tucson, 1964. 1st ed. $12.50
--Traders to the Navajos. (Albuquerque, 1952). $15.00
(ink inscriptions on both endpapers, cloth)
Gilman, Arthur, ed.--The Cambridge of 1776. Camb., 1876. $47.50 (light wear to extremities)
Gilpin, Laura--The Enduring Navaho. Austin, (1968). $50.00 (1st printing)
--Temples in Yucatan. N.Y., (1948). $75.00
Gimenez Caballero, Ernesto--Revelacion del Paraguay. Madrid, 1958. $16.00 (wraps.)
Ginger, Ray--Six Days or Forever? Bost., 1958. 1st ed. $12.50
Gingerich, Melvin--The Mennonites in Iowa. Iowa City, 1939. $45.00
Ginsberg, Allen--Airplane Dreams. Toronto, 1968. 1st ed. $10.00
--Carless Love. Madison, Wi., 1978. $40.00 (wraps., one of 280 signed copies)
--The Fall of America. S.F., 1972. $35.00 (white wraps.)
--Howl, and Other Poems. S.F., (1956). $750.00 (stiff wraps., bookplate, signed by author)
--Howl: for Carl Solomon. S.F., 1971. $350.00 (cloth, one of 275 signed copies)
--Iron Horse. (Toronto), 1972. 1st ed. $9.00
--Kaddish.... (S.F., 1961). 1st ed. $65.00 (stiff wraps.)
--T.V. Baby Poems. Lond., 1967. 1st ed. $135.00 (boards, one of 100 deluxe signed copies)
Gipson, Fred--Fabulous Empire. Bost., 1946. $22.50
Girard, Just, pseud.
 See: Roy, Just Jean Etienne
Gissing, George Robert--The Private Papers of Henry Ryecroft. Portland, Me., 1921. $25.00 (boards, one of 700 copies)
Gitlin, Todd--Uptown. N.Y., 1970. $12.50
Gitlow, Benjamin--I Confess; the Truth About American Communism. N.Y., (1940). 1st ed. $35.00, $12.50
--The Whole of Their Lives. N.Y., 1948. 1st ed. $10.00
 Freeport, 1971. $15.00
Gittinger, Roy--The Formation of the State of Oklahoma.... Berkeley, 1917. 1st ed. $75.00 (orig. wraps., frayed, bound in cloth)
 Norman, 1939. $21.00
Glaab, Charles Nelson--The American City. Homewood, Il., 1963. $15.00

--A History of Urban America. N.Y., (1967). $12.50
Glad, Betty--Charles Evans Hughes and the Illusions of In-
 nocence. Urbana, 1966. $15.00
Gladstone, Thomas H.--Kansas. Lond., 1858. $59.50 (re-
 bound in boards, paper label on spine)
Glamorous Louisiana Under Ten Flags
 See: Louisiana State Museum
Glasgow, Ellen Anderson Gholson--In This Our Life. N.Y.,
 (1941). 1st ed. $10.00 (cloth)
--Letters. N.Y., (1958). $10.00 (cloth)
--They Stooped to Folly. Garden City, 1929. 1st ed. $15.00
 (cloth)
--Vein of Iron. N.Y., (1935). $4.50 (cloth)
--The Wheel of Life. N.Y., 1906. 1st ed. $15.00 (cloth)
Glasscock, Carl Burgess--Gold in Them Hills. Ind., (1932).
 $25.00
--Here's Death Valley. Ind., (1940). $17.50
--The War of the Copper Kings. N.Y., 1966. $15.00
Glassley, Ray Hoard--Indian Wars of the Pacific Northwest.
 Port., 1972. $9.50
--Pacific Northwest Indian Wars. Portland, Or., 1953. 1st
 ed. $15.00
Glazebrook, George Parkin de Twenebroker--The Story of
 Toronto. (Toronto, 1971). $20.00
Glazier, Willard--Battles for the Union. Hart., 1875. $10.00
 Hart., 1878. $12.50
--The Capture, the Prison Pen, and the Escape. N.Y., 1868.
 $16.50 (binding little worn), $10.00
--Down the Great River. Phila., 1887. 1st ed. $12.50
 Phila., 1889. $10.00
 Phila., 1892. $35.00 (cloth, lightly worn)
--Headwaters of the Mississippi.... Chi., 1893. $15.00,
 $12.50 (cloth)
 Chi., 1894. $25.00
 Chi., 1897. $10.00
--Heroes of Three Wars.... Phila., 1880. $15.00
 Phila., 1884. $12.50
--Ocean to Ocean on Horseback. Phila., 1896. $15.00, $10.00
--Peculiarities of American Cities. Phila., 1884. $12.50
Gleig, George Robert--The Campaigns of the British Army at
 Washington and New Orleans in the Years 1814-1815. Lond.,
 1827. $350.00 (modern buckram, uncut)
Glick, Wendell--The Recognition of Henry David Thoreau.
 Ann Arbor, (1969). $14.00

Glimpses of the Monastery. Quebec, 1872. 1st ed. $75.00
(half morocco)

Glynn, Kate A.--The Girl From Oshkosh. Chi., (1896).
$40.00 (orig. cloth)

Gobright, Lawrence Augustus--Recollection of Men and Things
at Washington.... Phila., 1869. 1st ed. $20.00 (spine
faded)

Godcharles, Frederic Antes--Chronicles of Central Pennsylvania.
N.Y., (1944). 4 vols. $100.00

--Daily Stories of Pennsylvania. Milton, 1924. $17.50

--Pennsylvania. N.Y., (1933). 5 vols. $75.00

Godecker, Mary Salesia--Simon Brute de Remur.... St. Mein-
rad, In., 1931. $30.00 (ex-lib.)

Godfrey, Carlos Emmor--The Commander-in Chief's Guard....
Wash., 1904. 1st ed. $45.00

Godsell, Philip Henry--Arctic Trader. Lond., (1951). $35.00
(buckram)

Goetzmann, William H.--Exploration and Empire. N.Y., 1966.
1st ed. $20.00

Goff, Richard--Century in the Saddle. (Denver, 1967).
$35.00

--Confederate Supply. Durham, 1969. $16.50

Gohdes, Clarence Louis Frank--Bibliographical Guide to the
Study of the Literature of the U.S.A. Durham, 1963.
$10.00 (ex-lib.)

Gold, Douglas--A Schoolmaster With the Blackfeet Indians.
Caldwell, 1964. $10.00

Gold, Michael--Life of John Brown. N.Y., (1960). $7.50
(orig. wraps.)

Gold Rush Album
See: Jackson, Joseph Henry

A Gold Rush Voyage on the Bark Orion.... Glendale, 1978.
$15.00

Goldberg, Arthur J.--The Defenses of Freedom. N.Y., (1966).
$12.50

Goldberg, Harvey--American Radicals. N.Y., 1957. 1st ed.
$12.50

Golder, Frank Alfred--John Paul Jones in Russia
See: Jones, John Paul

Goldfarb, Ronald L.--The Contempt Power. N.Y., 1963. 1st
ed. $12.50

Goldman, Peter Louis--The Death and Life of Malcolm X.
N.Y., (1973). 1st ed. $15.00

Goldman, Solomon, ed.--The Words of Justice Brandeis
See: Brandeis, Louis Dembitz

Goldstein, David--Autobiography of a Campaigner for Christ.
Bost., (1936). $12.50
Gompers, Samuel--Labor in Europe and America. N.Y., 1910.
1st ed. $25.00
--Seventy Years of Life and Labor. N.Y., 1957. $15.00
Gongora, Mario--Origen de Los "Inquilinos" de Chile Central.
Santiago, 1960. 1st ed. $20.00 (wraps.)
Gooch, Fanny Chambers
See: Iglehart, Fanny (Chambers) Gooch
Good, James Isaac--History of the Reformed Church in the
U.S.... Reading, Pa., 1899. $20.00 (ex-lib.)
Goodale, Stephen Lincoln--A Brief Sketch of Gail Borden....
Portland, Or., 1872. $150.00 (wraps.)
Goode, John--Recollections of a Lifetime. N.Y., 1906. $40.00
(some flecking)
Goode, William Henry--Outposts of Zion.... Cinc., 1864.
$30.00
Goodman, David Michael--A Western Panorama, 1849-1875.
Glendale, 1966. $15.00, $11.00
Goodrich, Charles Augustus--The Family Tourist. Hart.,
1839. $100.00 (leather, text somewhat stained)
Goodrich, Joseph King--The Coming Hawaii. Chi., 1914.
$18.00
Goodrich, Lloyd--Winslow Homer
See: Homer, Winslow
Goodrich, Lucile--A Livingston County Scrapbook.... Pontiac,
Il., 1979. $12.50
Goodspeed, Bernice I.--Mexican Tales. Mexico, 1937. 1st ed.
$12.50 (cloth, wraps. bound in)
Goodsell, Charles T.--Administration of a Revolution. Camb.,
1965. $10.00
Goodspeed, Charles Eliot--Yankee Bookseller. Bost., 1937.
1st ed. $35.00 (orig. cloth, one of 310 numbered and
autographed copies)
Goodspeed, Edgar Johnson--History of the Great Fires in
Chicago and the West. N.Y., (1871). $45.00 (cloth, light
wear, some tape repairs on verso at folds)
Goodspeed, Thomas Harper--Plant Hunters in the Andes.
N.Y., (1941). $44.00 (cloth)
Godowin, Cardinal Leonidas--John Charles Fremont.... Stan-
ford, 1930. $45.00, $35.00, $30.00, $25.00
--The Trans-Mississippi West (1803-1853). N.Y., 1922. 1st
ed. $20.00 (some penciled marginal notes, owner name)
Goodwin, Charles Carroll--As I Remember Them. S.L.C.,
1913. 1st ed. $65.00

--The Comstock Club. S.L.C., 1891. 1st ed. $35.00
--The Wedge of Gold. S.L.C., 1893. 1st ed. $17.50 (marks on back cover)
Goodwin, Grenville--The Social Organization of the Western Apache. Chi., (1942). 1st ed. $75.00 (owner name)
Goodwin, Philip Lippincott--Brazil Builds. N.Y., 1943. $30.00
Goodwin, William Brownell--The Truth About Leif Ericsson and the Greenland Voyages. Bost., 1941. 1st ed. $37.50
Goodwyn, Frank--Life on the King Ranch. N.Y., (1951). $32.50
Goplen, Aronld O.--The Career of Marquis de Mores in the Bad Lands of North Dakota. N.p., (1946). $45.00, $5.00
Gordon, Albie, ed.--Dawn in the Golden Valley
See under Title
Gordon, Elizabeth Putman--Women Torch-Bearers. Evanston, Il., 1924. $15.00
Gordon, John Brown--Reminiscences of the Civil War. N.Y., 1903. 1st ed. $25.00
Gordon, Maurice Bear--Aesculapius Comes to the Colonies. Ventnor, 1949. $40.00, $12.50
Gordon, Suzanne--Black Mesa. N.Y., (1973). $10.00
Gordon, Thomas Francis--The History of Ancient Mexico.... Phila., 1832. 2 vols. $450.00 (light rubbing of labels)
--The History of Pennsylvania.... Phila., 1829. $175.00 (orig. boards, uncut), $50.00 (untrimmed, rebound)
Gordon, Wendell Chaffee--The Political Economy of Latin America. N.Y., 1965. $18.00
Gorer, Geoffrey--The American People. N.Y., (1948). $7.50
Gorgas, Josiah--The Civil War Diary of General Josiah Gorgas. University, 1947. $25.00
Gorgas, William Crawford--Sanitation in Panama. N.Y., 1915. $25.00
Gorman, John Alexander--The Western Horse.... (Danville, Il., 1939). 1st ed. $15.00
Gornick, Vivian--The Romance of American Communism. N.Y., 1977. $12.50, $12.00
Goslin, Ryllis Alexander
See: Lynip, Ryllis (Alexander Goslin)
Gosnell, Harold Foote--Machine Politics. Chi., (1937). 1st ed. $7.50 (cloth)
Gosnell, Harpur Allen--Rebel Raider. Chapel Hill, 1948. $15.00
Goss, Helen (Rocca)--The Life and Death of a Quicksilver Mine. L.A., 1958. $35.00

Goss, Nathaniel S.--History of the Birds of Kansas. Topeka,
1891. $51.00 (orig. cloth, rebacked, lightly used)
Gotlieb, Allan Ezra--Canadian Treaty-Making. Toronto, 1968.
$9.50
Gottfredson, Peter--History of Indian Depredations in Utah.
(S.L.C., 1919). $50.00
Gould, Bruce--American Story. N.Y., (1968). 1st ed. $15.00
Gould, Frank W.--Grasses of Southwestern United States.
Tucson, 1951. $35.00 (orig. wraps.)
Gould, John, 1804-1881--Birds of South America. Lond.,
1972. $22.00 (cloth)
Gould, John, 1908--Twelve Grindstones. Bost., (1970). 1st
ed. $15.00
Gould, Nathaniel Duren--Church Music in America.... Bost.,
1853. 1st ed. $17.50 (lightly rubbed, some light damp-
stains in text)
Gould, Ralph Ernest--Yankee Drummer. N.Y., (1947). 1st
ed. $8.00
Gouldner, Frank A.--John Paul Jones in Russia
See: Jones, John Paul
Govan, Gilbert Eaton--A Different Valor. Ind., (1956). 1st
ed. $30.00 (signed by authors)
Govan, Thomas Payne--Nicholas Biddle.... (Chi., 1959).
1st ed. $20.00
Gowans, Fred R.--Fort Bridger, Island in the Wilderness.
Provo, (1975). $20.00 (signed by authors), $13.50
Gowen, Herbert Henry--The Napoleon of the Pacific....
N.Y., (1919). 1st ed. $35.00
Grabhorn, Jane Bissell--A California Gold Rush Miscellany....
(S.F.), 1934. $75.00 (one of 550 copies, orig. announce-
ment laid in, corners with light wear)
Gracie, Archibald--The Truth About the Titanic. N.Y., 1913.
1st ed. $35.00
Graham, Hugh Davis--Violence in America. Beverly Hills, 1979.
$8.00
Graham, James Duncan--Messages From the Governors of
Maryland and Pennsylvania.... Chi., 1862. $50.00 (orig.
wraps.)
Graham, Jared Benedict--Handset Reminiscences. S.L.C.,
1915. $38.50
Graham, Maria
See: Callcott, Maria (Dundas) Graham
Graham, Stephen--The Soul of John Brown. N.Y., 1920. 1st
ed. $7.50 (owner name)

--Tramping With a Poet in the Rockies. N.Y., 1922. 1st
 ed. $15.00 (cloth, light foxing, inking on endpaper)
Graham, William Alexander--Abstract of the Official Record
 of Proceedings of the Reno Court of Inquiry....
 See: Reno, Marcus Albert
--The Custer Myth.... Harrisburg, (1953). 1st ed. $45.00,
 $25.00 (1st printing)
 N.Y., (1953). $25.00, $12.50
--The Story of the Little Big Horn. N.Y., (1926). $15.00
 (ex-lib.)
 Harrisburg, (1959). $12.50
 N.Y., (1959). $12.00
Granada, Daniel--Supersticiones del Rio de la Plata. Buenos
 Aires, (1947). 1st ed. $75.00 (orig. printed wraps.)
Grand, W. Joseph--Illustrated History of the Union Stockyards.
 Chi., (1901). $30.00, $30.00 (cloth, lightly worn)
Grant, Anne MacVicar--Memoirs of an American Lady. Lond.,
 1808. 2 vols. 1st ed. $300.00 (half calf and boards, one
 front panel partially detached)
Grant, Blanche Chloe--Taos Indians. Taos, 1925. 1st ed.
 $45.00
Grant, Charles S.--Democracy in the Connecticut Frontier
 Town of Kent. N.Y., 1961. $21.95
Grant, George Monro--Picturesque Canada. Toronto, (1882).
 2 vols. $125.00 (some rubbing and occasional foxing, vol.
 2 rebacked using orig. backstrip)
Grant, Joseph Donohoe--Redwoods and Reminiscences. S.F.,
 1973. $12.50
Grant, Robert--Jack Hall. Bost., 1888. 1st ed. $15.00
Grant, Ulysses Simpson--Letters of ... to His Father....
 N.Y., 1912. 1st ed. $40.00 (half leather and cloth, book-
 plate)
--Personal Memoirs.... N.Y., 1885. 2 vols. 1st ed. $20.00
 (one vol. lightly spotted and hinges frayed), $15.00 (vol.
 1 inner hinge cracked)
 Cleve., (1952). $17.50, $8.50
Gras, Norman Scott Brien--A History of Agriculture in Europe
 and America. N.Y., 1925. $14.00 (covers worn)
Grathwohl, Larry--Bringing Down America. New Rochelle,
 1976. $10.00
Grattidge, Harry--Captain of the Queens. N.Y., 1956.
 $15.00
Grau, Shirley Ann--The Keepers of the House. N.Y., 1964.
 $6.00 (cloth, light wear)
Graustein, Jeannette E.--Thomas Nuttall, Naturalist. Camb.,
 1967. $25.00

Graves, Jackson Alpheus--California Memories.... L.A., 1930.
 $8.50 (front of binding wrinkled)
--My Seventy Years in California. L.A., 1927. $15.00 (title
 browned from clipping)
 L.A., 1928. $35.00, $17.50 (new endpapers)
Graves, William White--The First Protestant Osage Missions....
 Oswego, Ks., 1949. $15.00
--The Legend of Greenbush. St. Paul, Ks., 1937. $8.50
--Life and Letters of Fathers Ponziglione, Schoenmakers and
 Other Early Jesuits at Osage Mission. St. Paul, Ks., 1916.
 1st ed. $45.00 (cloth, some flecking)
--Life and Letters of Rev. Father John Schoenmakers....
 Parsons, Ks., (1928). $15.00 (rebound in modern cloth)
--Life and Times of Mother Bridget Hayden. St. Paul, Ks.,
 1938. $45.00 (signed by author, owner name)
--The Poet Priest of Kansas. St. Paul, Ks., 1937. $4.00
Gravier, Gabriel--Decouverte de L'Amerique par les Normands
 au Xe Siecle. Paris, 1874. $85.00 (orig. wraps.)
Gray, Elma E.--Wilderness Christians. Toronto, (1956). 1st
 ed. $50.00 (orig. cloth)
Gray, Eunice T.--Cross Trails and Chaparral. Carmel, Ca.,
 1925. $7.50 (bookplate, cover label part of border missing)
Gray, Francine du Plessix--Hawaii. N.Y., 1972. $12.00
Gray, Frank S.--Pioneering in Southwest Texas. N.p., (1949).
 $31.50 (autographed)
Gray, James--Business Without Boundary. Minne., (1954).
 $12.50
--The Illinois. N.Y., 1940. $15.00
--Open Wide the Door. N.Y., 1958. $12.50
Gray, Jerome B.--One Hundred Years. Phila., 1943. $17.50
Gray, John Morgan--Lord Selkirk of Red River. East Lansing,
 1964. $12.50
Gray, Patrick Leopold--Gray's Doniphan County, Kansas.
 Bendina, Ks., 1905. $48.50
Gray, William Henry--A History of Oregon, 1792-1849.... Port-
 land, Or., 1870. $112.50 (edges lightly worn)
Gray, Wood--The Hidden Civil War. N.Y., 1942. 1st ed.
 $20.00
(Graydon, Alexander)--Memoirs of a Life.... Harrisburg, Pa.,
 1811. 1st ed. $100.00 (contemp. calf, spine extremities
 worn), $40.00 (rebound)
 Edinburgh, 1822. $40.00 (rebound)
--Memoirs of His Own Time. Phila., 1846. $50.00 (orig.
 cloth, worn spot on spine)
Grayson, Theodore Julius--Leaders and Periods of American
 Finance. N.Y., 1932. 1st ed. $20.00 (ex-lib.)

Greathouse, Charles H.--Ranch Life in the Old West. Holly-
wood, 1971. $35.00 (orig. cloth, ltd. to 1000 numbered
copies), $12.50
Greeley, Horace--The American Conflict. Hart., 1864-67. 2
vols. $40.00 (rebound in cloth, scattered foxing), $10.00
(leather)
--The Great Industries of the U.S. Hart., 1873. $35.00
(rebound)
--Overland Journey, From New York to San Francisco....
1859. N.Y., 1860. 1st ed. $45.00
Greely, Adolphus Washington--Reminiscences of Adventure and
Service. N.Y., 1927. $30.00
--True Tales of Arctic Heroism in the New World. N.Y.,
1923. $17.50
Green, Calvin--A Brief Exposition of the Established Principles
and Regulations of.... Hart., 1850. $65.00
Green, Charles Ransley--Early Days in Kansas. Olathe, Ks.,
1913. $15.00 (last few pages have light marginal water
stains)
Green, George Fuller--A Condensed History of the Kansas
City Area. K.C., (1968). $12.50 (signed by author)
Green, Jerome A.--Evidence and the Custer Enigma. K.C.,
1973. 1st ed. $10.00 (one of 500 numbered and signed
copies)
Green, John Williams--Johnny Green of the Orphan Brigade.
(Lexington, Ky., 1956). $40.00 (signed by editor)
Green, Mary Rowena (Maverick)--Samuel Maverick, Texan.
San Antonio, 1952. $47.50
Green, Nelson Winch--Fifteen Years Among the Mormons.
N.Y., 1859. $45.00
Green, Thomas Jefferson--Journal of the Texian Expedition
Against Mier. N.Y., 1845. $250.00 (orig. cloth, soiled
edges worn, bind stamp on title)
Green, Thomas Marshall--Historic Families of Kentucky.
Cinci., 1889. $100.00
--The Spanish Conspiracy. Cinci., 1891. 1st ed. $85.00
(binding spotted)
Greenbie, Marjorie Latta Barstow--Lincoln's Daughters of
Mercy. N.Y., (1944). $10.00, $6.00
Greenbie, Sydney--Furs to Furrows. Caldwell, 1939. $15.00
--Gold of Ophir. N.Y., 1937. $20.00, $12.50
Greene, A.C.--The Last Captive. Austin, (1972). $12.50
Greene, Bob--Johnny Deadline, Reporter. Chi., 1976. $10.00
Greene, Carla--A Trip to Hawaii. N.Y., (1959). $12.00 (in-
scribed)

Greene, Evarts Boutell--The Foundations of American Nationality. N.Y., 1968. $25.00

Greene, Graham--The Heart of the Matter. N.Y., 1948. 1st ed. $7.50

Greene, Jeremiah Evarts--The Santa Fe Trade. Worcester, Ma., 1893. $35.00 (wraps.)

Greene, Max--The Kanzas Region. N.Y., 1856. $275.00 (orig. cloth)

Greene, Welcom Arnold--The Providence Plantations for Two Hundred and Fifty Years. Prov., 1886. $100.00 (cloth, hinges cracked, bottom of spine lightly frayed, endpapers lightly foxed)

Greenhow, Robert--The History of Oregon and California.... Bost., 1845. $105.00 (neatly rebound with orig. cloth appliqued)
Bost., 1847. $100.00 (lightly worn cloth, scattered foxing, bookplate)

Greenleaf, Jonathan--Sketches of the Ecclesiastical History of the State of Maine.... Portsmouth, N.H., 1821. 1st ed. $75.00 (calf), $47.50 (contemp. calf, some rubbing, lacks blank endleaf)

Greenleaf, Margery, ed.--Letters to Eliza....
See: Fowle, George

Greenleaf, William--From These Beginnings. Detroit, 1964. $6.00

Greenough, William Parker--Canadian Folk-Life and Folk-Lore. N.Y., 1897. 1st ed. $35.00

Greenup, Ruth (Robinson)--Revolution Before Breakfast. Chapel Hill, 1947. 1st ed. $12.50

Greenway, John--Folklore of the Great West. Palo Alto, (1970). $15.00

Greenwood, Annie (Pike)--We Sagebrush Folks. N.Y., 1934. 1st ed. $17.50 (cloth)

Greenwood, John--The Revolutionary Services of John Greenwood of Boston and New York.... N.Y., 1922. 1st ed. $65.00 (cloth, one of 100 copies)

Greer, Thomas H.--American Social Reform Movements. N.Y., 1949. $15.00

Gregg, Frank Moody--The Founding of a Nation. Cleve., 1915. 2 vols. 1st ed. $40.00

Gregg, Josiah--Commerce of the Prairies. N.Y., 1844. 2 vols. 1st ed. $1250.00 (orig. cloth, light wear and few skillful repairs to binding), $1250.00 (contemp. calf over boards), $800.00 (contemp. calf)
Norman, (1954). $26.50, $20.00

Norman, (1958). $12.50

N.Y., (1968). $7.50

Gregg, Kate Leila--The Road to Santa Fe. Albuquerque, 1952. $15.00

--Westward With Dragoons
 See: Clark, William

Gregoire, M.--An Enquiry Concerning the Intellectual and Moral Faculties and Literature of Negroes. Brooklyn, 1810. 1st ed. $500.00 (orig. boards)

Gregory, Annadora Foss--Pioneer Days in Crete, Nebraska. Chadron, (1937). $25.00 (signed by author)

Gregory, Jack--Adventures of an Indian Boy. (Muskogee, 1972). $5.00 (wraps.)

Greiner, Henry C.--General Phil Sheridan as I Knew Him. Chi., 1908. $17.50 (ex-lib.)

Grenfell, Wilfred Thomason--Down to the Sea. Lond., 1910. $10.00

Gresham, Otto--The Greenbacks. Chi., 1927. $25.00

Gress, Edmund Geiger--Fashions in American Typography.... N.Y., 1931. $50.00 (lightly rubbed)

Grey Owl--The Men of the Last Frontier. Lond., (1935). $25.00 (orig. cloth)

--Tales of an Empty Cabin. Lond., (1936). $75.00 (one of 250 signed and numbered copies)

Grey, William, pseud.
 See: White, William Francis

Grey, Zane--The Call of the Canyon. N.Y., 1924. $10.00 (cloth, light wear)

--The Hash Knife Outfit. N.Y., 1933. $9.50 (cloth, initials on end-paper)

--Tales of Fishes. N.Y., (1919). $50.00 (cloth, title page foxed, inscription on fly)

--Wild Horse Mesa. N.Y., 1928. $6.50 (cloth, lightly worn and shaken)

Griffin, Appleton Prentiss Clark--Bibliography of American Historical Societies. Wash., 1896. $25.00 (orig. cloth)

Griffin, George Butler--Documents From the Sutro Collection. L.A., 1891. $175.00 (new cloth, some dust soiling)

Griffin, John Strother--A Doctor Comes to California. S.F., 1943. $51.50

Griffith, Cecil R.--The Missouri River. (Leawood, Ks., 1974). $15.00 (inscribed by editor, cloth)

Griffith, Helen--Dauntless in Mississippi. (N.p.), 1966. $20.00

Griffith, William--Mining Conditions Under the City of Scranton Pa. Wash., 1912. $25.00 (orig. wraps.)

Grigsby, Melvin--The Smoked Yank. N.p., (1888). $25.00
Grijalva, Juan de--The Discovery of New Spain in 1518.
 Berkeley, 1942. 1st ed. $125.00 (cloth, one of 200 num-
 bered copies)
Grimke, Angelina Emily--Appeal to the Christian Women of
 the South. (N.Y., 1836). $55.00 (self-wraps.)
Grimke, Sarah Moore--An Epistle to the Clergy of the Southern
 States. (N.Y., 1836). $65.00
Grinnell, George Bird--Beyond the Old Frontier. N.Y., 1913.
 1st ed. $65.00
--The Cheyenne Indians. N.Y., 1962. 2 vols. $27.50
--The Fighting Cheyennes. N.Y., 1915. 1st ed. $75.00
 Norman, 1956. $20.00
 Norman, 1963. $9.75
--Pawnee, Blackfoot, and Cheyenne. N.Y., (1961). $20.00
 (owner name)
--Two Great Scouts.... Cleve., 1928. 1st ed. $100.00
Grismer, Karl Hiram--The Story of St. Petersburg. St.
 Petersburg, Fl., (1948). $17.50
Grisson, Wilhelm--Beitrage zur Charakteristik der Vereingten
 von Nord-Amerika. Hamburg, 1844. $250.00 (boards and
 cloth)
Griswold, Don L.--The Carbonate Camp Called Leadville.
 (Denver), 1951. $85.00
Griswold, Wesley S.--A Work of Giants. N.Y., (1962). 1st
 ed. $20.00
Grivas, Theodore--Military Governments in California....
 Glendale, 1963. $40.00 (orig. cloth), $15.00, $15.00
Grodinsky, Julius--Jay Gould, His Business Career, 1867-
 1892. Phila., (1957). $30.00
Groner, Alex--The American Heritage History of American
 Business & Industry. N.Y., (1972). $12.50
Grove, Jesse Augustus--The Utah Expedition, 1857-1858.
 S.L.C., 1910. 1st ed. $92.50
Gruening, Ernest Henry--An Alaskan Reader.... N.Y., 1966.
 $12.50
--The Battle for Alaska Statehood. Seattle, (1967). $15.00
--Mexico and Its Heritage. N.Y., (1930). $10.00 (binding
 stamp, inscribed)
--The State of Alaska. N.Y., (1968). $27.50
Grunsky, Carl Edwald--Stockton Boyhood. Berkeley, 1959.
 $20.00 (one of 800 copies)
Gubser, Nicholas J.--The Nunamiut Eskimos. New Haven,
 1965. $20.00 (boards)
Gue, Benjamin F.--History of Iowa. N.Y., 1903. 4 vols.
 1st ed. $80.00

Guernsey, Alfred Hudson--Ralph Waldo Emerson.... N.Y.,
1881. 1st ed. $25.00 (orig. cloth, covers lightly soiled,
bookseller's stamp)
Guernsey, Charles Arthur--Wyoming Cowboy Days. N.Y.,
1936. $40.00
Guernsey, Orrin--History of Rock County.... Janesville, Wi.,
1856. $150.00 (orig. cloth, author's presentation), $35.00
(cloth, ex-lib.)
Guide to the Province of British Columbia, for 1877-8. Vic-
toria, 1877. $45.00
Guilday, Peter Keenan--The Life and Times of John England....
N.Y., 1927. 2 vols. $30.00 (owner stamp)
Guillet, Edwin Clarence--Early Life in Upper Canada. To-
ronto, 1933. 1st ed. $40.00 (cloth)
Guilty! The Confession of Franklin D. Roosevelt.... Garden
City, 1936. $17.50 (orig. boards)
Guiteau, Charles Julius--The Truth and the Removal. Wash.,
1882. $85.00 (one of 1000 copies)
Gulick, Bill--Snake River Country. Caldwell, 1971. $35.00
Gunckel, John Elstner--The Early History of the Maumee
Valley. (Toledo, 1913). $27.50
Gunn, John W.--The Humor and Wisdom of Abraham Lincoln.
Girard, Ks., 1923. $5.00
Gunther, John--Inside Latin America. N.Y., 1941. 1st ed.
$6.50
--Inside South America. N.Y., (1967). $5.00
Guptil, Arthur Leighton--Norman Rockwell, Illustrator. N.Y.,
1971. $40.00 (slipcased)
Gurko, Miriam--Indian America. N.Y., (1970). $9.50
Gutheim, Frederick Albert--The Potomac. N.Y., (1949). 1st
ed. $15.00
Guthrie, Alfred Bertram--The Blue Hen's Chick. N.Y., 1965.
$7.50 (ex-lib.)
--The Way West. N.Y., (1949). $6.00 (1st printing)
Guthrie, Dwight Raymond--John McMillan.... (Pitts., 1952).
$8.50
Gutierrez de Lara, Lazaro--The Mexican People. Garden City,
1914. 1st ed. $15.00 (ex-lib.)
Guy, Francis Shaw--Edmund Francis Shaw. Wash., 1934.
1st ed. $25.00
Gwyn, Richard J.--The Shape of Scandal. (Toronto, 1965).
$8.50

- H -

Habenstein, Robert Wesley--The History of American Funeral
 Directing. Milwaukee, 1955. 1st ed. $35.00, $15.00
Habenstreit, Barbara--Changing America and the Supreme
 Court. N.Y., (1970). 1st ed. $10.00
Haberland, Wolfgang--Gold in Alt-America. Hamburg, 1972.
 $15.00
Haberly, Lloyd--Pursuit of the Horizon.... N.Y., 1948.
 $37.50
Habig, Marion Alphonse--The Alamo Chain of Missions. Chi.,
 (1968). 1st ed. $6.50
Hacker, Louis Morton--Alexander Hamilton in the American
 Tradition. N.Y., (1957). 1st ed. $8.50
--The Triumph of American Capitalism. N.Y., 1940. $25.00
 N.Y., 1947. $15.00
--The World of Andrew Carnegie.... Phila., (1968). $20.00
Haddock, John A.--A Souvenir. Alexandria Bay, N.Y., 1895.
 1st ed. $25.00 (new endpapers, spine tip and edge wear)
Hadley, Samuel Hopkins--Down in Water Street. N.Y., (1902).
 1st ed. $10.00
Hafen, LeRoy Reuben--Broken Hand. Denver, 1931. 1st ed.
 $225.00 (ltd. ed., autographed), $85.00
 Denver, (1973). $40.00 (numbered and signed ed., slip-
 cased)
--Colorado. Denver, 1933. 1st ed. $55.00
--Fremont's Fourth Expedition. Glendale, 1960. $45.00 (cloth)
--Handcarts to Zion. Glendale, 1960. $45.00 (cloth, un-
 opened), $45.00, $27.50, $10.00
--Journals of Forty-Niners. Glendale, 1954. $45.00 (unopened)
 Glendale, 1960. $25.00
--The Joyous Journey.... Glendale, 1973. $11.50, $10.00
--The Mountain Men and the Fur Trade of the Far West.
 Glendale, 1966. $40.00 (cloth)
--Old Spanish Trail: Santa Fe to Los Angeles. Glendale,
 1954. $45.00 (cloth)
--The Overland Mail, 1846-1869. Cleve., 1926. 1st ed.
 $100.00 (bookplate)
--Powder River Campaigns and Sawyers' Expedition of 1865.
 Glendale, 1961. $45.00 (cloth, unopened)
--Relations With the Indians of the Plains.... Glendale, 1959.
 $45.00 (cloth, unopened)
--Reports From Colorado. Glendale, 1961. $45.00 (cloth,
 unopened)

--To the Rockies and Oregon.... Glendale, 1955. $45.00
(cloth, unopened), $40.00
--Western America. N.Y., 1947. $15.00
Hagedorn, Hermann--The Roosevelt Family of Sagamore Hill.
N.Y., 1954. $7.50
--Roosevelt in the Bad Lands. Bost., 1921. $60.00 (signed
copy of large paper ed., cloth somewhat rubbed and faded),
$30.00
Hagell, Edward Frederic--When the Grass Was Free. N.Y.,
1954. $20.00
Hageman, Edward R., ed.--Fighting Rebels and Redskins
See: Sanford, George B.
Hager, Alice (Rogers)--Frontier by Air. N.Y., 1942. $15.00
(some pages water stained)
Hager, John Manfred--Commercial Survey of the Southeast.
Wash., 1927. $30.00
Hagood, Johnson--The Services of Supply.... Bost., 1927.
$6.50
Hahn, Emily--Romantic Rebels. Bost., 1967. $10.00
Hahn, Jon K.--Legally Sane. Chi., (1972). $10.00
Haigh, Samuel--Viaje a Chile. Santiago de Chile, 1917. $8.00
(rebound)
Haight, Anne Lyon--Portrait of Latin America as Seen by Her
Print Makers. N.Y., (1946). $20.00
Haight, Canniff--Country Life in Canada Fifty Years Ago.
Toronto, 1885. $60.00 (leather, worn along edges, front
hinge cracked at top)
Hain, Harry Harrison--History of Perry County, Pennsylvania.
Harrisburg, 1922. $90.00
Haines, Francis--The Buffalo. N.Y., (1970). 1st ed. $12.50
--The Nez Perces. Norman, (1955). 1st ed. $55.00, $50.00,
$20.00
--Red Eagles of the Northwest.... Port., Or., 1939. 1st
ed. $60.00 (tipped-in frontis.)
Haldeman-Julius, Anna Marcet--Jane Addams as I Knew Her.
(Girard, Kansas, c1936). $15.00
Haldeman-Julius, Emanuel--The Big American Parade. Bost.,
(1929). $15.00
Hale, Carolyn Ernestine (Hale), ed.--The Log of a Forty-
Niner
See: Hale, Richard Lunt
Hale, Edward Everett--The Brick Moon. Barre, Ma., 1971.
$45.00 (one of 1950 copies, cloth, slipcased)
--A Family Flight Through Mexico. Bost., (1886). $17.50
(lacks endpapers)

--G.T.T.; or, the Wonderful Adventures of a Pullman. Bost.,
 1885. $30.00 (cloth, reading copy, well worn and stained)
--The New Harry and Lucy. Bost., 1892. 1st ed. $20.00
 (cloth)
Hale, John--California as it Is. (S.F.), 1954. $125.00
 (boards, one of 150 copies)
Hale, John Peter--Trans-Allegheny Pioneers. Cinci., 1886.
 1st ed. $75.00, $65.00
Hale, Nathaniel Claiborne--Virginia Venturer, a Historical
 Biography of William Claiborne, 1600-1677.... Rich.,
 (1951). 1st ed. $25.00 (orig. cloth)
Hale, Richard Lunt--The Log of a Forty-Niner. Bost., 1923.
 $40.00
Hale, Sarah Josepha Buell--Mercedes, a Story of Mexico.
 Louis., 1895. $20.00
Hale, Susan--The Story of Mexico. N.Y., 1889. $6.50 (ex-
 lib., few pages stained)
Haley, James Evetts--Charles Goodnight.... Bost., 1936.
 $75.00 (rebound)
 Norman, (1949). $35.00, $10.00
--Charles Schreiner, General Merchandise. Austin, 1944.
 $67.50
--Early Days on the Texas-New Mexico Plains
 See: Ogden, Bill Arp
--Erle P. Halliburton.... Duncan, Ok., 1959. 1st ed.
 $45.00 (orig. cloth)
--Focus on the Frontier. Amarillo, 1957. $25.00 (orig. wraps.)
--Fort Concho and the Texas Frontier. San Angelo, 1952.
 $112.50
--George W. Littlefield, Texan. Norman, 1943. 1st ed.
 $50.00
--Jeff Milton.... Norman, 1948. $52.50, $25.00
--Life on the Texas Range. Austin, 1952. 1st ed. $85.00
 (slipcased)
--Some Southwestern Trails
 See: Hertzog, Carl
--A Texan Looks at Lyndon. Canyon, Tx., 1964. 1st ed.
 $15.00, $10.50 (enclosed in crude hard cover), $5.00
Haley, James L.--The Buffalo War. Garden City, 1976. 1st
 ed. $15.00
(Haliburton, Thomas Chandler)--The Bubbles of Canada.
 Lond., 1839. 1st ed. $125.00 (buckram)
 Phila., 1839. $75.00 (orig. cloth, spine and hinges faded,
 and light foxing throughout, spine label faded)
--The Clockmaker. Lond., 1838. $65.00 (orig. cloth, some
 light foxing and front hinge cracked)

--The Letter Bag of the Great Western. Lond., 1840. $150.00
(orig. cloth)
--The Old Judge. Lond., (188-). $65.00 (cloth with light
wear, edges rubbed)
Halkett, John--Statement Respecting the Earl of Selkirk's Set-
tlement Upon the Red River.... Lond., 1817. 1st ed.
$750.00 (half morocco)
Hall, Basil--Travels in North America in the Years 1827 and
1828. Edin., 1829. 3 vols. $75.00 (rebound in cloth,
map torn, minor foxing)
Hall, Bert L., comp.--Roundup Years
See under Title
Hall, Charles Francis--Arctic Researches, and Life Among the
Esquimaux. N.Y., 1865. $50.00 (cover worn, part of
map missing)
Hall, David D.--The Antinomian Controversy.... Middletown,
Ct., (1968). $15.00
Hall, Elizabeth Boyd White--Popular Arts of Spanish New
Mexico. Santa Fe, 1974. $35.00
Hall, Eugene Raymond--American Weasels. Lawrence, Ks.,
1951. $55.00 (wraps.)
Hall, Florence Marion (Howe), ed.--Julia Ward Howe....
See: Howe, Julia Ward
--Memories Grave and Gay. N.Y., 1918. $30.00
Hall, Francis--Colombia: Its Present State.... Lond., 1824.
1st ed. $250.00 (half morocco, ex-lib.)
Hall, James--Legends of the West. Phila., 1832. $125.00
(contemp. half calf and boards)
--Sketches of History, Life, and Manners, in the West. Phila.,
1835. 2 vols. $50.00 (bookplates, half calf)
Hall, Joyce C.--When You Care Enough. K.C., 1979. $25.00
Hall, Thomas Cuming--The Religious Background of American
Culture. Bost., 1930. 1st ed. $15.00
Hall, Trowbridge--California Trails.... N.Y., 1920. 1st ed.
$23.50 (small spot on spine)
Hall, William Henry Bullock--Across Mexico in 1864-5. Lond.,
1866. $400.00 (orig. cloth, stamp erased from title)
Hall, William Logan--The Forests of the Hawaiian Islands.
Wash., 1904. $12.00 (wraps.)
Hallenbeck, Cleve--Land of the Conquistadores. Caldwell,
1950. 1st ed. $20.00 (cloth)
Halley, William--The Centennial Year Book of Alameda County,
California. Oakland, 1876. 1st ed. $125.00 (rebound)
Halliburton, Richard--The Royal Road to Romance. Ind.,
(1925). $15.00 (signed by author, cloth)

Halliwell, Leo B.--Light in the Jungle. N.Y., (1959). $3.50
Halpin, Marjorie--Catlin's Indian Gallery. Wash., 1965. $8.50
Halsell, H.H.--Cowboys and Cattleland. Nash., 1937. $35.00
Halsey, Francis Whiting--The Pioneers of Unadilla Village,
 1784-1850. Unadilla, N.Y., 1902. $30.00 (one of 650
 copies)
Haley, Gaius Leonard--Reminiscences of Village Life and of
 California and Panama From 1840 to 1850
 See: Halsey, Francis Whiting--The Pioneers of Unadilla
 Village, 1784-1850
Halstead, Murat--The Story of Cuba. S.L., (1898). $12.50
--Three Against Lincoln. Baton Rouge, 1960. $20.00
Hamblin, Jacob--Jacob Hamblin. S.L.C., 1909. $28.50,
 $25.00 (cover lightly flecked)
Hamburger, Estelle--It's a Woman's Business. N.Y., (1939).
 $16.00
Hamersly, Lewis Randolph--Records of Living Officers of the
 U.S. Army. Phila., 1884. 1st ed. $40.00 (cloth, binding
 lightly warped, ex-lib.)
--Records of Living Officers of the U.S. Navy and Marine
 Corps. Phila., 1870. 1st ed. $42.50 (new buckram)
Hamill, John--The Strange Career of Mr. Hoover Under Two
 Flags. N.Y., 1931. $10.00
Hamilton, Alexander--Alexander Hamilton and the Founding of
 the Nation. N.Y., 1957. 1st ed. $12.50
--Gentleman's Progress. Chapel Hill, 1948. 1st ed. $25.00
--Industrial and Commercial Correspondence of.... Chi.,
 1928. 1st ed. $25.00
--Observations on Certain Documents.... Phila., 1797. 1st
 ed. $225.00 (rebound, leather spine)
--Report of the Secretary of the Treasury.... Containing a
 Plan for the Further Support of Public Credit. Phila.,
 1795. 1st ed. $475.00 (half morocco)
Hamilton, Alice, 1869--Exploring the Dangerous Trades. Bost.,
 1943. $20.00
Hamilton, Alice--The Elements of John Updike. (Grand Rap-
 ids, Mi., 1970). $14.50
Hamilton, Alice McGuire--Blue Ridge Mountain Memories. At-
 lanta, 1977. $12.00
Hamilton, Charles--Braddock's Defeat. Norman, (1959).
 $20.00
Hamilton, Charles Franklin--As Bees in Honey Drown. South
 Brunswick, (1973). $20.00
Hamilton, Charles Walter--Early Day Oil Tales of Mexico.
 Houston, (1966). $12.50

Hamilton, Milton Wheaton--The Country Printer. N.Y., 1936.
1st ed. $30.00
Hamilton, Raphael N.--Marquette's Explorations. Madison,
1970. $25.00
Hamilton, Walton Hale--The Politics of Industry. N.Y., 1957.
1st ed. $10.00
Hamilton, William Thomas--My Sixty Years on the Plains....
N.Y., 1905. 1st ed. $75.00 (orig. cloth)
N.Y., 1909. $78.50
Hamlin, Charles Hunter--The War Myth in U.S. History. N.Y.,
(1927). 1st ed. $12.50, $10.00 (a few pages with under-
lining)
Hamm, Marcherita Arlina--Famous Families of New York. N.Y.,
(1902). 2 vols. $60.00 (boards, a bit soiled and worn,
light foxing)
Hammett, Arthur B.J.--The Empresario Don Martin de Leon.
Waco, 1973. $20.00
Hammond, George Peter--The Adventures of Alexander Bar-
clay.... Denver, 1976. $26.50
--Captain Charles M. Weber.... Berkeley, 1966. $45.00 (one
of 700 copies), $45.00 (cloth, one of 700 copies)
--Coronado's Seven Cities. Albuquerque, 1940. $25.00 (orig.
wraps.), $21.00 (wraps.)
Hammond, John Hays--The Autobiography of.... N.Y., (1935).
2 vols. $20.00
Hammond, John Winthrop--Men and Volts. N.Y., 1941. $15.00
Phila., (1941). $12.50
Hamner, Laura Vernon--The No-Gun Man of Texas. (Amarillo),
1935. 1st ed. $17.50
Hampton, Taylor--The Nickel Plate Road. N.Y., (1947).
$25.00
Cleve., (1947). $20.00
Cleve., 1949. $18.00
Hanaford, Phebe Ann (Coffin)--Daughters of America. Au-
gusta, Me., (1882). $20.00 (covers worn around edges)
Hancock, John--An Oration Delivered March 5, 1774.... Bost.
1774. 1st ed. $250.00 (sewn, stained, half-title soiled)
Hancock, Ralph--Baja California. L.A., (1954). $12.00
(boards)
--Fabulous Boulevard. N.Y., (1949). $7.50
Hand, Learned--The Spirit of Liberty. N.Y., 1953. $8.50
Handerson, Henry Ebenezer--Yankee in Gray. (Cleve., 1962).
$12.50
Handleman, Howard--Bridge to Victory. N.Y., (1943). $10.5

Handlin, Oscar--Al Smith and His America. Bost., (1958).
$12.50
--Facing Life. Bost., (1971). $20.00
--The Uprooted. Bost., 1951. 1st ed. $10.00 (cloth)
Hanke, Lewis--Aristotle and the American Indians. Chi.,
1959. $7.50 (ex-lib.)
Lond., (1959). $6.50 (ex-lib. stamps)
--The First Social Experiments in America. Camb., 1935.
$7.50 (ex-lib.)
--Gilberto Freyre. N.Y., 1939. $10.00 (wraps.)
--The Spanish Struggle for Justice in the Conquest of Amer-
ica. Phila., 1949. 1st ed. $17.50 (cloth), $15.00
Hanly, James Frank--Speeches of the Flying Squadron. Ind.,
(1915). $17.50
Hanna, Alfred Jackson--Flight Into Oblivion. (Rich., 1938).
1st ed. $17.50
Hanna, Charles Augustus--The Wilderness Trail. N.Y., 1911.
2 vols. $150.00 (cloth, hinges cracked in vol. I, one of
1000 copies), $100.00 (cloth, one of 1000 copies), $85.00
(light fraying to extremities of spines)
Hanna, Phil Townsend--California Through Four Centuries.
N.Y., (1935). $8.00
(Hannay, James Owen)--From Dublin to Chicago. N.Y., (1914).
$20.00
Hannett, Arthur Thomas--Sagebrush Lawyer. N.Y., (1964).
$15.00 (inscribed copy, ex-lib.)
Hans, Fred Malon--The Great Sioux Nation.... Chi., (1907).
1st ed. $75.00
Hansen, Harry--The Chicago. N.Y., (1942). $15.00
Hansen, Thorkild--The Way to Hudson Bay. N.Y., 1965.
$12.50
N.Y., (1970). $12.50
Hanshew, Thomas W.--The 'Forty-Niners. Clyde, Oh., 1879.
$17.50 (tear on left side of margins throughout)
Hanson, Angus Alexander--Grass Varieties in the U.S. Wash.,
1972. $4.00 (wraps.)
Hanson, Charles E.--The Plains Rifle. Harrisburg, 1960.
1st ed. $65.00
Hanson, Eric John--Dynamic Decade. Toronto, (1958). $12.00
Hanson, Joseph Mills--Bull Run Remembers. Manassas, 1953.
$5.00 (wraps.)
--The Conquest of the Missouri. N.Y., (1946). $40.00
Hanson, Kitty--Rebels in the Streets. Englewood Cliffs,
(1964). $10.00

Haraszthy, Arpad--Wine-Making in California. S.F., 1978. $90.00 (one of 600 copies)
Haraszti, Zoltan--John Adams & the Prophets of Progress. Camb., 1952. $21.95, $15.00
Harbeson, Georgiana (Brown)--American Needlework. N.Y., 1938. 1st ed. $60.00
Hard, Walter R., ed.--Mischief in the Mountains
See under Title
Hardin, John Wesley--The Life of.... Seguin, Tx., 1896. $67.50 (lower margin slightly chewed)
Harding, Addie Clark--America Rides the Liners. N.Y., (1956). $12.00 (ex-lib.)
Harding, Bertita (Leonarz)--Amazon Throne. Ind., (1941). 1st ed. $10.00 (light foxing)
--The Land Columbus Loved. N.Y., (1949). 1st ed. $7.50
--Phantom Crown. Ind., (1934). 1st ed. $6.50
Hardy, E.S. Craighill--Ancient Hawaiian Civilization
See under Title
Hardy, Jack--The First American Revolution. N.Y., (1937). $8.50
Hare, William Hobart--The Life and Labors of Bishop Hare.... N.Y., 1911. 1st ed. $15.00
Haring, Clarence Henry--The Buccaneers in the West Indies in the XVII Century. Hamden, 1966. $13.00
--Empire in Brazil. Camb., (1969). $10.00
Haring, John Vreeland--The Hand of Hauptmann. Plainfield, 1937. $75.00 (inscribed)
Harkins, Lee F., ed.--The American Indian, 1926-1931
See under Title
Harkness, Ruth--Pangoan Diary. (N.Y., 1942). $7.50 (ex-lib. stamp)
Harlan, Edgar Rubey--A Narrative History of the People of Iowa.... Chi., 1931. 5 vols. $65.00
Harlan, George H.--San Francisco Bay Ferry Boats. Berkeley, 1967. $20.00 (cloth)
Harlan, Jacob Wright--California, '46 to '88. S.F., 1888. $100.00 (orig. cloth, some staining and wear to cloth)
Harley, Timothy--Southward Ho! Lond., 1886. 1st ed. $40.00 (presentation copy)
Harlow, Alvin Fay--Old Bowery Days. N.Y., 1931. 1st ed. $60.00
--Steelways of New England. N.Y., (1946). $12.50
Harlow, William Morehouse--Trees of the Eastern U.S. and Canada. N.Y., 1942. 1st ed. $6.00

Harmon, Nolan Bailey--The Famous Case of Myra Clark Gaines.
Baton Rouge, 1946. $15.00 (hinges cracked)
Harmon, Thomas L.--Fifty Years of Parish History. Chi.,
(1916). $17.50
Harney, Richard J.--History of Winnebago County, Wisconsin,
and Early History of the Northwest. (Oshkosh), 1880.
$200.00 (orig. three quarter morocco)
Harper, Fowler Vincent--Justice Rutledge and the Bright Con-
stellation. Ind., (1965). $15.00
Harper, Henry Howard--A Journey in Southeastern Mexico.
Bost., 1910. $50.00 (half morocco, rubbed, ltd. ed.)
Harper, J. Russell, ed.--Paul Kane's Frontier
See: Kane, Paul
Harper, Robert S.--Lincoln and the Press. N.Y., (1951).
$16.50
Harpster, John W.--Pen Pictures of Early Western Pennsylvania.
(Pitts.), 1938. $5.00
Harriman Alaska Expedition, 1899--Alaska.... N.Y., 1902-14.
12 vols. in 13. $2500.00 (cloth)
Harrington, Fred Harvey--Hanging Judge. Caldwell, 1951.
1st ed. $25.00
Harrington, Jean Carl--Glassmaking at Jamestown.... Rich.,
(1952). $7.00 (wraps.)
Harris, Alexander--A Review of the Political Conflict in Amer-
ica.... N.Y., 1876. 1st ed. $40.00 (orig. cloth)
Harris, Benjamin Butler--The Gila Trail. Norman, (1960).
$20.00
Harris, Beth Kay--The Towns of Tintic. Denver, (1961).
1st ed. $17.50
Harris, Burton--John Colter.... N.Y., 1952. 1st ed. $90.00,
$85.00 (owner signature)
Harris, David Anthony--Socialist Origins in the U.S. Assen,
1966. $16.00
Harris, Edward--Up the Missouri With Audubon. Norman,
(1951). $35.00
Harris, Harry Lawrence--A History of the Second Regiment,
N.G.N.J.... Paterson, N.J., 1908. $25.00 (one of 1000
copies)
Harris, Joel Chandler--Daddy Jake the Runaway. N.Y.,
(1889). 1st ed. $50.00 (shows considerable use)
--Uncle Remus. N.Y., 1957. $60.00 (cloth, slipcased, one
of 1500 copies, signed by artist)
--Uncle Remus and His Legends of the Old Plantation. Lond.,
1881. $150.00 (orig. cloth, edges lightly worn, covers bit
soiled, frontis. and endpapers water stained)

--Uncle Remus, His Songs and His Sayings. N.Y., 1881.
1st ed. $365.00 (orig. cloth, 3rd state, incl. ALS from
author laid in, spine lightly faded and worn)
Harris, Leon A.--Merchant Princes. N.Y., 1979. 1st ed.
$15.00
Harris, Louis--Is There a Republican Majority? N.Y., (1954).
$12.50 (cloth, signed and inscribed)
Harris, Thaddeus Mason--The Journal of a Tour Into the Ter-
ritory Northwest of the Allegheny Mountains. Bost., 1805.
$650.00
Harris, William Hamilton--Keeping the Faith. Urbana, 1977.
1st ed. $10.00
(Harris, William Richard)--By Path and Trail. N.p., 1908.
$48.50
--The Cross-Bearers of the Saguenay. Lond., 1920. 1st
ed. $45.00 (cloth)
--History of the Early Missions in Western Canada. Toronto,
1893. $35.00
Harrison, Benjamin--Public Papers and Addresses of.... Wash.,
1893. 1st ed. $25.00
Harrison, Joseph Tecumseh--The Story of the Dining Fork.
Cinci., 1927. 1st ed. $50.00 (orig. cloth), $15.00 (ltd.
ed.)
Harrison, Peleg Dennis--The Stars and Stripes and Other
American Flags.... Bost., 1906. 1st ed. $30.00 (orig.
cloth)
Harrod, Howard L.--Mission Among the Blackfeet. Norman,
(1971). 1st ed. $10.00
Hart, Albert Bushnell, ed.--The American Nation....
See under Title
--Commonwealth History of Massachusetts. N.Y., 1927-30.
5 vols. 1st ed. $80.00, $50.00
Hart, Francis Russell--The Siege of Havana, 1762. Bost.,
1931. $30.00
Hart, Henry Cowles--The Dark Missouri. Madison, 1957.
$15.00
Hart, Herbert M.--Old Forts of the Northwest. Seattle,
(1963). 1st ed. $20.00
--Old Forts of the Southwest. Seattle, (1964). 1st ed.
$20.00
--Pioneer Forts of the West. Seattle, (1967). 1st ed. $15.00
Hart, James--The American Presidency in Action, 1789. N.Y.,
1948. $20.00
Hart, James David--A Companion to California. N.Y., 1978.
$18.50

--John Steinbeck. Apuntos, Ca., 1970. 1st ed. $39.50
 (orig. wraps., one of 150 copies)
Hart, Moss--Act One.... N.Y., (1959). 1st ed. $15.00
 (cloth)
--Lady in the Dark. N.Y., (1941). 1st ed. $20.00
Hart, Richard Henry, ed.--Edgar Allan Poe; Letters and
 Documents in the Enoch Pratt Free Library
 See: ' Poe, Edgar Allan
Harte, Bret--Concepcion de Arguello. S.F., 1926. $15.00
 (wraps.)
--The Lost Galleon: and Other Tales. S.F., 1867. 1st ed.
 $450.00 (orig. cloth, lightly frayed, endpapers bit dis-
 colored, slipcased, bookplate of Joan Whitney), $275.00
 (cloth)
--The Luck of Roaring Camp.... Bost., 1872. $20.00 (front
 endleaf and fly partly torn)
 Lond., 1882. $60.00 (orig. wraps., spine piece missing)
--Mrs. Skagg's Husbands, and Other Sketches. Bost., 1873.
 1st ed. $25.00 (some wear to cover, ink inscription on
 endpaper)
--The Pagan Child, and Other Sketches. Lond., (1885).
 $15.00 (orig. wraps., edges somewhat tattered)
--A Protegee of Jack Hamlin's, and Other Stories. N.Y.,
 1894. $7.50
--San Francisco in 1866. S.F., 1951. $52.50 (boards, one
 of 400 copies)
--A Sappho of Green Springs and Other Stories. Bost., 1891.
 1st ed. $18.00 (hinges weak)
--Sketches of the Sixties.... S.F., 1926. $50.00 (light
 rubbing at corners, one of 250 copies)
 S.F., 1927. $45.00 (boards lightly foxed)
--Tales of the Gold Rush. N.Y., (1944). $53.50 (boards)
--Tennessee's Partner. S.F., (1907). 1st ed. $75.00
 (boards, one of 1000 copies, bookplate)
--Three Partners. N.Y., 1897. $10.00
--The Writings of.... Bost., 1896. 20 vols. $65.00 (back-
 strips faded)
Hartje, Robert George--Van Dorn.... (Nash.), 1967. $25.00,
 $20.00
Hartsough, Mildred Lucille--From Canoe to Steel Barge on the
 Upper Mississippi. (Minne.), 1934. 1st ed. $25.00 (back-
 strip faded), $20.00 (binding faded)
Hartwick, Louis M.--Oceana County Pioneers and Business
 Men of To-Day. Pentwater, Mi., 1890. $85.00 (orig.
 cloth)

Harvey, Alexander Miller--Tales and Trails of Wakarusa. To-
peka, 1917. $30.00 (cloth, signed)
Harvey, George Brinton McClellan--Henry Clay Frick, the
Man. N.Y., 1928. $12.50
Harvey, T.J.--Apples of Gold in Pictures of Silver. S.F.,
1868. $75.00 (orig. printed wraps.)
Harwell, Richard Barksdale--The Confederate Reader. N.Y.,
1957. 1st ed. $20.00
--The Union Reader. N.Y., 1958. 1st ed. $10.00
Hasbrouck, Louise Seymour--Mexico From Cortes to Carranza.
N.Y., 1918. 1st ed. $12.50 (lightly worn)
Haskell, Franklin Aretas--The Battle of Gettysburg. 1st ed.
Bost., 1958. $12.50
Haskin, Frederic Jennings--The Panama Canal. Garden City,
1913. $10.00
Haskins, Caryl Parker--The Amazon. Garden City, 1943.
$10.00
Haskins, James--Adam Clayton Powell. N.Y., (1974). $15.00
Haslip, Joan--The Crown of Mexico. N.Y., 1971. 1st ed.
$10.00
Hassler, Edgar Wakefield--Old Westmoreland. Pitts., 1900.
1st ed. $65.00 (orig. cloth)
Hassrick, Peter H.--Frederic Remington. (N.Y., 1973).
$48.50 (boards)
Hastings, Sally
See: Hastings, Sarah (Anderson)
Hastings, Sarah (Anderson)--Poems on Different Subjects.
Lancaster, 1808. 1st ed. $200.00 (calf)
Hatch, Alden--American Express, a Century of Service.
Garden City, 1950. $7.00
Hatcher, Edmund Neuson--The Last Four Weeks of the War.
Columbus, Oh., 1892. $25.00 (ex-lib.), $25.00 (ex-lib.)
Hatcher, Harlan Henthorne--The Buckeye Country. N.Y.,
1940. $12.50 (signed by author)
--A Century of Iron and Men. Ind., (1950). 1st ed. $15.00
Hatcher, Orie Latham--Rural Girls in the City for Work.
Rich., 1930. $22.00 (spine soiled)
Hatin, Louis Eugene--Historie Pittoresque des Voyages en
Amerique. Paris, 1847. 2 vols. $55.00 (orig. wraps.
bound in)
Haug, Arthur--Chicago. Chi., (1948). $5.00
Haven, Charles T.--A History of the Colt Revolver. N.Y.,
1940. 1st ed. $125.00 (cloth, light foxing on half title,
ex-lib.)
Haven, Gilbert--Our Next-Door Neighbor. N.Y., 1875. $15.00

Havens, Catherine Elizabeth--Diary of a Little Girl in Old New
York. N.Y., 1920. $16.00
Havighurst, Walter--Land of Promise. N.Y., 1946. $12.50
(cloth, 1st printing)
--Upper Mississippi. N.Y., 1937. $15.00
N.Y., (1944). $15.00
--Voices on the River. N.Y., (1964). $18.00, $12.50
The Hawaii Book. Chi., (1961). $18.00 (ex-lib.)
Hawes, Charles Boardman--Gloucester, by Land and Sea.
Bost., 1923. 1st ed. $15.00 (orig. boards)
Hawgood, John Arkas--America's Western Frontiers. N.Y.,
1967. $12.50
--First and Last Consul
See: Larkin, Thomas Oliver
Hawk, Emery Quinter--Economic History of the South. N.Y.,
1934. $18.00 (ex-lib.)
Hawke, David Freeman--The Colonial Experience. Ind.,
(1966). $10.00
--In the Midst of a Revolution. Phila., (1961). 1st ed.
$10.00
Hawkins, Charles Augustus--Some Facts Concerning York and
York County. York, Pa., (1901). 1st ed. $17.50
Hawkins, Richmond Laurin--Madam De Staël and the U.S.
Camb., 1930. 1st ed. $15.00 (cloth)
Hawks, Francis Lister--Contributions to the Ecclesiastical His-
tory of the United States of America. N.Y., 1836-39. 2
vols. 1st ed. $125.00 (contemp. half morocco)
Hawley, Charles Arthur--Fifty Years on the Nebraska Fron-
tier. Omaha, 1941. $10.00 (cloth)
Hawley, Lowell Stillwell--Counsel for the Damned. Phila.,
(1955). $12.50
Hawthorne, Hildegarde--Romantic Rebel. N.Y., (1932). 1st
ed. $10.00 (1st printing, spine faded)
Hawthorne, Nathaniel--The House of Seven Gables. Bost.,
1851. 1st ed. $350.00 (orig. cloth, binding E, bookplate,
head of spine nicked, back cover lightly spotted)
--The Marble Faun. Bost., 1860. 2 vols. 1st ed. $650.00
(2nd issue, inscribed by publishers, bookplates, spine
wearing, covers soiled, orig. cloth)
Bost., 1890. 2 vols. $25.00 (half cloth, lightly faded and
soiled)
--Mosses From an Old Manse. N.Y., 1846. 2 vols. in 1.
$100.00 (later three-quarter morocco)
--Passages From the English Note-Books. Bost., 1870. 2
vols. 1st ed. $45.00 (orig. cloth)

--Passages From the French and Italian Note-Books. Bost.,
1872. $50.00 (orig. cloth, binding A)
--The Snow-Image, and Other Twice-Told Tales. Bost., 1852.
$60.00 (orig. cloth, spine ends lightly worn, catalogue re-
moved)
--Tanglewood Tales.... Lond., (1883). $100.00 (cloth, in-
side hinge starting, ex-lib.)
--Twice Told Tales. Bost., 1837. 1st ed. $150.00 (orig.
cloth, later endpapers)
Hay, David--The Last of the Confederate Privateers. N.Y.,
1977. $12.50
Hay, John--Lincoln and the Civil War in the Diaries and Let-
ters of John Hay. N.Y., 1939. 1st ed. $16.00 (spine
faded)
Hay, Thomas Robson--Hood's Tennessee Campaign. Wash.,
1929. 1st ed. $75.00
Hayashi, Tetsumaro--Steinbeck's Literary Dimensions. Me-
tuchen, N.J., 1973. $17.50
Hayden, Ferdinand Vandeveer--Sun Pictures of Rocky Moun-
tain Scenery.... N.Y., 1870. $2200.00 (orig. three-
quarter morocco, some scuffing)
Hayes, Jess G.--Apache Vengeance. Albuquerque. 1954.
$10.00
--Sheriff Thompson's Day. Tucson, (1968). $10.00
Hayes, Melvin L.--Mr. Lincoln Runs for President. N.Y.,
(1960). $12.50
Hayes, Rutherford Birchard--Hayes. N.Y., (1964). $15.00
--Mexican Border Troubles. Wash., 1877. $150.00
Haymaker, Richard E.--From Pampas to Hedgerows.... N.Y.,
(1954). $10.00
Hayman, H.H.--That Man Boone. Caldwell, 1948. $20.00
(signed copy)
Haynes, Fred Emory--The American Prison System. N.Y.,
1939. $20.00
--Third Party Movements Since the Civil War With Special
Reference to Iowa. Iowa City, 1916. 1st ed. $50.00
(orig. cloth)
Haynes, Robert V.--A Night of Violence. Baton Rouge, 1976.
$15.00
Haynes, Williams--Casco Bay Yarns. N.Y., (1916). $12.50
(cloth, spine lightly rubbed, bookplates removed)
--The Stone That Burns. N.Y., 1942. $15.00 (covers soiled,
tail frayed)
Hays, Arthur Garfield--Trial by Prejudice. N.Y., (1933).
1st ed. $10.00

Hays, Elinor (Rice)--Those Extraordinary Blackwells. N.Y., (1967). $10.00

Hays, Helen Ashe--The Antietam and Its Bridges. N.Y., 1910. $25.00 (cloth, rubbed, sig. partially detached, ex-lib.)

Hayward, Arthur H.--Colonial Lighting. Bost., 1927. $17.50

Hayward, Elizabeth (McCoy)--John M'Coy.... N.Y., (1948). $25.00 (orig. cloth)

Hayward, Walter Sumner--Chain Stores. N.Y., 1922. 1st ed. $18.00

Hazard, Ebenezer--Historical Collections.... Phila., 1792-94. 2 vols. $750.00 (morocco), $600.00 (half morocco)

Hazard, Joseph--Pacific Crest Trails From Alaska to Cape Horn. Seattle, (1946). $7.50

Hazard, Samuel--Annals of Pennsylvania.... Phila., 1850. 1st ed. $35.00

Head, Francis Bond--Rough Notes Taken During Rapid Journeys Across the Pampas.... Bost., 1826. $42.50 (half calf, joints worn, some spotting)

Headley, Joel Tyler--Grant and Sherman. N.Y., 1866. $12.50
--The Great Rebellion. Hart., 1863-66. 2 vols. 1st ed. $15.00
--The Life and Travels of General Grant. Phila., 1879. $10.50

Headley, John William--Confederate Operations in Canada and New York. N.Y., 1906. 1st ed. $100.00

Headley, Phineas Camp--The Life and Campaigns of Lieut.-Gen. U.S. Grant.... N.Y., 1866. 1st ed. $24.50

Heap, Gwinn Harris--Central Route to the Pacific....Phila., 1854. 1st ed. $125.00 (orig. cloth, spine ends chipped, ex-lib. stamp)
Glendale, 1957. $45.00 (cloth, unopened)

Heaps, Willard Allison--The Singing Sixties. Norman, (1960). $17.50

Heard, Isaac V.D.--History of the Sioux War and Massacre of 1862 and 1863. N.Y., 1863. 1st ed. $60.00

Hearn, Lafcadio--Appreciations of Poetry. N.Y., 1930. $10.00
--Interpretations of Literature. N.Y., 1926. 2 vols. $12.00 (writing on endpapers)
--Japan, an Attempt at Interpretation. N.Y., 1913. $10.00
--Some Chinese Ghosts. Bost., 1887. 1st ed. $50.00 (orig. cloth rubbed, slightly shaken)

Hearne, Samuel--A Journey From Prince of Wale's Fort in Hudson's Bay, to the Northern Ocean. Lond., 1795. 1st ed. $2000.00 (contemp. calf, expertly rebacked, some plates moderately browned, corners bumped)

Hearst Temperance Contest Committee--Temperance--or
Prohibition? N.Y., 1929. $6.50

Heartman, Charles Frederick--The Untimeliness of the Walt
Whitman Exhibition at the New York Public Library. N.p.,
(1925). 1st separate ed. $49.50 (one of 60 copies printed
in advnace of its appearance in the American Collector)

Heath, Lilian M.--The Red Telephone. N.p., (1905). $12.50

Heath, William--Memoirs of.... to Which Is Added the Accounts
of the Battle of Bunker Hill.... N.Y., 1901. $100.00
(orig. cloth, one of 75 numbered copies on large paper)

Heatherington, Alexander--A Practical Guide to Tourists,
Miners, and Investors, and All Persons Interested in the
Development of the Gold Fields of Nova Scotia. Montreal,
1868. 1st ed. $250.00 (orig. cloth)

Heaton, Eliza Putnam--The Steerage. (Brooklyn, 1919).
$10.00

Heaton, John Langdon--The Story of a Page. N.Y., 1913.
1st ed. $20.00

Hebard, Grace Raymond--The Bozeman Trail. Glendale, 1960.
$65.00

--Sacajawea, a Guide and Interpreter of the Lewis and Clark
Expedition. Glendale, 1957. $35.00

Hebert, Walter H.--Fighting Joe Hooker. Ind., (1944). 1st
ed. $15.00 (cloth, ex-lib.)

Heckewelder, John Gottlieb Ernestus--A Narrative of the Mis-
sion of the United Brethren Among the Delaware and
Mohegan Indians.... Phila., 1820. 1st ed. $200.00 (con-
temp. half calf)

--Thirty Thousand Miles With John Heckewelder. (Pitts.),
1958. 1st ed. $35.00

Heckscher, August--Alive in the City. N.Y., (1974). $12.00

Hedges, William Hawkins--Pike's Peak.... (Evanston), 1954.
$36.50

Hedgpeth, Don--Spurs Were A-Jinglin'. Flagstaff, 1975.
$15.00

Heg, Hans Christian--The Civil War Letters.... Northfield,
Mn., 1936. $22.50, $17.50

Heilner, Van Campen--Our American Game Birds. N.Y.,
1941. 1st ed. $60.00 (cloth)

Heilprin, Angelo--Explorations on the West Coast of Florida
and in the Okeechobee Wilderness.... Phila., 1887. $150.0(
(orig. cloth, autographed copy)

Heimann, Robert K.--Tobacco and Americans. N.Y., (1960).
$17.50

Hein, Otto Louis--Memories of Long Ago.... N.Y., 1925.
$60.00 (presentation copy)

Heizer, Robert Fleming--The California Indians. Berkeley,
 1960. $12.50
--The Four Ages of Tsurai. Berkeley, 1952. 1st ed. $25.00
 (cloth)
Helm, Linai Taliaferro--The Fort Dearborn Massacre.... Chi.,
 (1912). $30.00, $15.00 (cloth)
Helm, MacKinley--Angel Mo' and Her Son, Roland Hayes.
 Bost., (1943). $12.50 (cloth, covers lightly soiled)
--Fray Juniper Serra.... Stanford, 1956. $30.00 (author's
 presentation inscription)
--Journeying Through Mexico. Bost., 1948. $7.50, $5.00
Helm, Thomas B.--History of Carroll County, Indiana. Knights-
 town, Ind., 1966. $25.00
Helmer, William J.--The Gun That Made the Twenties Roar.
 N.Y., (1969). $17.50
Helms, Mary W., ed.--Frontier Applications in Lower Central
 America
 See under Title
Helper, Hinton Rowan--Dreadful California. Ind., 1948.
 $35.00
Helps, Arthur--The Spanish Conquest in America. Lond.,
 1855-61. 4 vols. 1st ed. $175.00, $37.00 (backstrip
 worn, inner hinges starting, some rubbing)
Hemingway, Ernest--Across the River and Into the Trees.
 N.Y., 1950. $150.00 (cloth), $35.00 (orig. cloth)
--Death in the Afternoon. N.Y., 1932. $250.00 (cloth, inner
 front hinge slightly opening, small book label removed)
--A Farewell to Arms. N.Y., 1929. 1st ed. $550.00 (1st
 issue, orig. cloth)
 Lond., (1929). $150.00 (orig. cloth, bookplate)
--For Whom the Bell Tolls. N.Y., 1940. 1st ed. $175.00
 (cloth), $50.00 (cloth), $40.00 (bookplate), $25.00
--The Hemingway Reader. N.Y., 1953. $15.00
--A Moveable Feast. N.Y., (1964). 1st ed. $15.00 (boards,
 tape stains on endpapers)
--Winner Take Nothing. N.Y., 1933. 1st ed. $135.00
 (cloth)
Hemingway, Mary--How it Was. N.Y., 1976. 1st ed. $10.00
Hemming, John--The Conquest of the Incas. N.Y., (1970).
 1st ed. $22.50
Henderson, George Francis Robert--Stonewall Jackson and the
 American Civil War. N.Y., 1906. 2 vols. $30.00
 N.Y., (1968). $20.00
Hendrick, Burton Jesse--The Jews in America. N.Y., 1923.
 1st ed. $7.50

--The Life and Letters of Walter H. Page. Garden City,
 1922-25. 3 vols. 1st ed. $50.00 (cloth, one of 377 cop-
 ies)
--The Life of Andrew Carnegie. Garden City, 1932. 2 vols.
 1st ed. $35.00 (spine lightly faded)
 Lond., 1933. $25.00
--Statesmen of the Lost Cause. N.Y., 1939. 1st ed. $15.00
 (cloth, light pencil underscoring), $12.00
Hendricks, George David--The Bad Man of the West. San
 Antonio, 1941. 1st ed. $36.50
 San Antonio, (1950). $10.00
--Mirrors, Mice & Mustaches. Austin, 1966. 1st ed. $7.50
Hendricks, Gordon--The Life and Work of Thomas Eakins.
 N.Y., 1974. $55.00
Hendrickson, James E.--Joe Lane of Oregon. New Haven,
 1967. $17.50
Henle, Fritz--Hawaii. N.Y., (1948). $16.00
Hennepin, Louis--Description de la Louisiane.... Paris, 1688.
 $400.00 (calf with marbled boards, lacks map and 6 pre-
 liminary leaves)
--A New Discovery of a Vast Country in America. Lond.,
 1698. $1000.00 (modern three-quarter calf)
Henry, Alexander--New Light on the Early History of the
 Greater Northwest. N.Y., 1897. 3 vols. $145.00 (ex-
 lib. bookplates, one partly removed)
 Minne., (1965). 2 vols. $35.00 (slipcased)
--Travels & Adventures in Canada and the Indian Territories.
 N.Y., 1969. $20.00 (orig. cloth)
Henry, Joseph Kaye--Flora of Southern British Columbia and
 Vancouver Island. Toronto, (1915). $10.00 (cloth)
Henry, O.
 See: Porter, William Sydney
(Henry, Ralph Chester)--The Majestic Land. Ind., (1950).
 1st ed. $8.50
Henry, Robert Selph--"First With the Most" Forrest. Ind.,
 (1944). 1st ed. $25.00, $17.50 (binding partly faded and
 occasional light spotting)
--The Story of Reconstruction. Ind., (1938). 1st ed.
 $9.00
--The Story of the Confederacy. N.Y., (1943). $6.50
--The Story of the Mexican War. Ind., (1950). 1st ed.
 $10.00
Hensel, William Uhler--The Christiana Riot and the Treason
 Trials of 1851. Lancaster, Pa., 1911. $65.00

Henson, Josiah--Father Henson's Story of His Own Life. Bost.,
 1858. $15.00 (light foxing of endpapers, light binding wear)
Hentoff, Nat--A Doctor Among the Addicts. N.Y., 1968.
 $10.00
--Peace Agitator. N.Y., 1963. $10.00
Hepburn, Alonzo Barton--A History of Currency in the U.S.
 N.Y., 1915. $10.00 (rebound)
Herberg, Will--Protestant, Catholic, Jew. Garden City, 1956.
 $10.00
Herbert, Hilary Abner--Why the Solid South? Balt., 1890.
 1st ed. $15.00
Hereford, Robert A.--Old Man River.... Caldwell, 1943.
 $25.00
Hergesheimer, Joseph--Sheridan; a Military Narrative. Bost.,
 (1931). $12.50 (binding little worn, spine lettering faded)
Heriot, George--Travels Through the Canadas.... Lond.,
 1807. $600.00 (contemp. boards, lacks 4 plates)
Hermann, Binger--The Louisiana Purchase and Our Title West
 of the Rocky Mountains. Wash., 1898. 1st ed. $75.00
 (two separate inscriptions by the author), $27.50 (cloth,
 endpapers lightly foxed)
 Wash., (1900). $60.00
Herndon, Booton--The Seventh Day. N.Y., (1960). 1st ed.
 $10.00
Herndon, William Henry--The Hidden Lincoln.... N.Y., 1938.
 1st ed. $15.00
Herndon, William Lewis--Exploration of the Valley of the
 Amazon. Wash., 1854. 4 vols. 1st ed. $500.00 (orig.
 cloth)
Herr, John Knowles--The Story of the U.S. Cavalry....
 Bost., (1953). $20.00
Herrera y Tordesillas, Antonio de--The General History of the
 Vast Continent and Islands of America. Lond., 1724-26.
 6 vols. $2000.00 (contemp. calf, expertly rebacked)
 Lond., 1740. 6 vols. $1000.00 (half calf over marbled
 boards)
--Histoire Generale des Voyages et Conqvestes des Castillans....
 Paris, 1660-71. vols. 1 and 2 of 3 vol. set. $850.00
 (contemp. calf, rebacked, few leaves in vol. 1 lightly
 dampstained)
Herreshoff, David--American Disciples of Marx. Detroit, 1967.
 $12.50
Herrick, Cheesman Abiah--White Servitude in Pennsylvania....
 Phila., 1926. 1st ed. $40.00
Herring, Harriet Laura--Passing of the Mill Village. Chapel
 Hill, 1949

Herring, Harriet Laura--Passing of the Mill Village. Chapel
 Hill, 1949. 1st ed. $8.00
Herring, Hubert Clinton--Good Neighbors.... New Haven,
 1941. $7.50
Herrington, Ray D.--The Western Gateway. N.Y., 1944.
 $17.50 (cloth, one of 1050 signed copies)
Herron, Francis--Letters From the Argentine. N.Y., (1943).
 $12.50
Herron, Paul--The Story of Capitol Hill. N.Y., 1963. $12.50
Hersey, Harold Brainerd--Pulpwood Editor. N.Y., 1937. 1st
 ed. $20.00
Hersey, John--The Wall. N.Y., 1957. $85.00 (one of 1500
 copies, slipcased, signed by illustrator)
Hersh, Burton--The Mellon Family. N.Y., 1978. $15.00 (un-
 corrected proofs)
Hershey, Burnet--The Odyssey of Henry Ford and the Great
 Peace Ship. N.Y., (1967). $10.00
Hershkowitz, Leo--Tweed's New York. Garden City, 1977.
 1st ed. $15.00
Hertz, Emanuel, ed.--The Hidden Lincoln....
 See: Herndon, William Henry
Hertzler, Arthur Emanuel--The Horse and Buggy Doctor.
 N.Y., 1938. $10.00 (bookplate, cloth)
Hertzog, Carl--Some Southwestern Trails. El Paso, 1948.
 $95.00 (one of 750 copies)
Herz, Henri--Mes Voyages en Amerique. Paris, 1866. $60.00
 (moderately rubbed, light foxing, owner signature)
Hesseltine, William Best--Civil War Prisons. Kent, Oh., (1962).
 $10.00
--Three Against Lincoln
 See: Halsted, Murat
Heverly, Clement Ferdinand--History and Geography of Brad-
 ford, Pennsylvania.... (Towanda, Pa., 1926). 1st ed.
 $35.00 (cloth)
Hewett, Edgar Lee--Ancient Andean Life. Ind., 1939. 1st
 ed. $10.00
Hewitt, Girart--Minnesota: Its Advantages to Settlers. St.
 Paul, 1867. $125.00 (orig. wraps.)
Hewlett, Samuel Mudway--The Cup and Its Conqueror. Bost.,
 1862. $25.00 (lacks endleaves)
Heyl, Francis--The Battle of Germantown. Phila., 1908.
 $5.00 (wraps.)
Heyman, Abigail--Growing Up Female. N.Y., (1974). 1st
 ed. $20.00

Heyward, DuBose--Carolina Chansons. N.Y., 1922. 1st ed.
 $40.00 (signed by Heyward, boards, two pages stained)
Hibben, Paxton--Henry Ward Beecher. N.Y., (1942). $7.50
Hibbert, Christopher--Wolfe at Quebec. Cleve., 1959. $20.00
Hickenlooper, Frank--An Illustrated History of Monroe County,
 Iowa.... Albia, 1896. $35.00
Hickman, William A.--Brigham's Destroying Angel. N.Y.,
 1872. 1st ed. $60.00 (binding worn and stained)
Hicks, Albert C.--Blood in the Streets. N.Y., (1946). $7.50
Hicks, Frederick Charles--High Finance in the Sixties.... New
 Haven, 1929. $30.00, $15.00, $15.00
Hicks, Granville--John Reed. N.Y., 1936. $12.00
Hicks, John Edward--Adventures of a Tramp Printer....
 K.C., (1950). $15.00 (cloth)
Hidy, Ralph Willard--The House of Baring in American Trade
 and Finance. Camb., 1949. 1st ed. $18.00,· $12.50
--Pioneering in Big Business.... N.Y., (1955). $18.00
--Timber and Men. N.Y., (1963). $30.00
Hiestand, Orville O.--See America First. Chi., 1922. $12.50
Higgins, Charles A.--To California Over the Santa Fe Trail.
 Chi., 1915. $8.25 (lacking 2 final leaves)
Higginson, Thomas Wentworth--Army Life in a Black Regiment.
 Ann Arbor, (1960). $12.50
--Life and Times of Stephen Higginson. Bost., 1907. $20.00
--Old Port Days. Bost., 1873. 1st ed. $75.00 (cloth, some-
 what frayed, spine worn)
Hildeburn, Charles Swift Riche--Issues of the Press in Phila-
 delphia.... Phila., 1886. 2 vols. $175.00 (cloth, some
 wear, one of 300 sets)
Hilger, Mary Inez--Huenun Namku. Norman, (1966). $8.00
 (ex-lib. stamps and ink numbers)
Hill, Frederick Trevor--Lincoln.... N.Y., 1928. $10.00
Hill, J. L.--End of the Cattle Trail. Long Beach, n.d.
 $28.00 (wraps.), $20.00 (orig. wraps.)
--The Passing of the Indian and Buffalo. Long Beach, (1917?).
 $35.00 (orig. wraps.)
Hill, Joseph John--History· of Warner's Ranch and Its Environs.
 L.A., 1927. $75.00 (one of 1000 numbered copies)
Hill, Lawrence Francis--Brazil. Berkeley, 1947. 1st ed.
 $18.00
Hill, Ralph N.--Sidewheeler Saga.... N.Y., (1953). $20.00
Hill, Roscoe R.--Descriptive Datalogue of the Documents Re-
 lating to the History of the U.S. in the Papeles Procedentes
 de Cuba.... Wash., 1916. $35.00 (orig. wraps., ex-lib.)

Hill, William B.--Experiences of a Pioneer Minister of Minnesota. Minne., 1892. $10.00

Hillman, William, ed.--Mr. President
 See: Truman, Harry S.

Hills, Patricia--The Painters' America. N.Y., (1974). $22.50

Hilsman, Roger--To Move a Nation. Garden City, 1967. 1st ed. $7.50 (cloth, some underlining last half)

Hilton, Conrad Nicholson--Be My Guest. Englewood Cliffs, 1958. $10.00

Hinchman, Lydia Swain (Mitchell)--Early Settlers of Nantucket. Phila., 1901. $50.00 (cloth)

Hinckley, Gordon Bitner--What of the Mormons? (S.L.C.), 1947. 1st ed. $12.50

Hind, Henry Youle--North-West Territory. Toronto, 1859. 1st ed. $425.00 (orig. cloth, neatly rebacked)

Hinds, Norman Ethan Allen--Evolution of the California Landscape. S.F., 1952. $25.00 (cloth)

Hines, Gordon--Alfalfa Bill. Oklahoma City, 1932. 1st ed. $30.00 (cloth)

Hinman, Wilbur--Corporal Si Klegg and His "Pard." Cleve., 1900. $15.00 (little rubbed)

Hinton, John Howard--The History and Topography of the United States of North America. Bost., 1834. 2 vols. $475.00 (in 20 small folio parts, each in printed wraps.)

Hirsch, Arthur Henry--The Huguenots of Colonial South Carolina. Durham, 1928. 1st ed. $37.50

Hirshon, Stanley P.--Grenville M. Dodge.... Bloomington, (1967). $15.00 (cloth)

--The Lion of the Lord. N.Y., 1969. 1st ed. $25.00

Hirst, William Alfred--Argentina. Lond., 1910. 1st ed. $6.00 (ex-lib., bookplate)

Hiss, Alger--In the Court of Public Opinion. N.Y., 1957. 1st ed. $20.00 (photo of Hiss laid in)

Historic Roadsides in New Jersey
 See: Society of Colonial Wars. New Jersey

Historic Santa Fe Foundation--Old Santa Fe Today. Santa Fe, (1966). $7.50

History of Allegheny County, Pennsylvania. Chi., 1889. 1st ed. $150.00 (boards, rebacked)

History of Crawford County, Pennsylvania. Chi., 1885. $150.00 (half calf, hinges weak, covers a bit worn)

History of Cumberland and Adams Counties, Pennsylvania. Chi., 1886. $175.00

The History of Don Francisco Miranda's Attempt to Effect a Revolution in South America
 See: (Biggs, James)

History of Erie County, Pennsylvania. Chi., 1884. $150.00
(half morocco)
History of Franklin County, Pennsylvania.... Chi., 1887.
1st ed. $150.00 (half leather, spine repaired)
History of Howard and Cooper Counties.... S.L., 1883. 1st
ed. $65.00 (lacks 1st 2 pages of text)
History of Montgomery County. Syracuse, 1892. $47.50 (half
leather, rubbed, hinges cracking)
History of Nevada
See: (Angel, Myron)
The History of North America. Phila., 1903-07. 20 vols.
$50.00 (orig. cloth, one of 1000 sets)
History of Pennsylvania Hall....
See: (Webb, Samuel)
History of Ray County, Mo. (N.p., 19--?). $25.00
History of St. Charles, Montgomery and Warren Counties....
S.L., 1885. $85.00 (leather, new backstrip with original
backstrip pasted on, new endpapers, scuffed)
History of Schuylkill County, Pa. N.Y., 1881. $110.00
(orig. cloth, rebacked)
History of Tama County, Iowa. Springfield, Il., 1883. 1st
ed. $85.00
History of the Big Spring Presbytery.... Harrisburg, Pa.,
1879. $17.50 (orig. cloth)
The History of the Late War.... Glasgow, 1765. $150.00
(title repaired, lacks endleaves, heavily browned)
History of the Ordinance of 1787.... Marietta, Oh., 1937.
$10.00 (wraps. bound in)
History of Tioga County.... Harrisburg, Pa., 1897. $175.00
(cloth, rebound)
History of Worcester County, Massachusetts.... Bost., 1879.
2 vols. $40.00
Hitchcock, Ethan Allen--A Traveler in Indian Territory.
Cedar Rapids, 1930. $120.00 (signed by the editor, Grant
Foreman), $65.00 (orig. cloth, presentation inscription from
Grant Foreman)
Hittell, John Shertzer--Hittell's Hand-Book of Pacific Coast
Travel. S.F., 1885. $100.00
Hittell, Theodore Henry--The Adventures of James Capen
Adams. N.Y., 1926. $25.00
--El Triunfo de la Cruz. S.F., (1963). $7.50 (printer's
copy)
Hobbs, Samuel Huntington--North Carolina, Economic and
Social. Chapel Hill, 1930. 1st ed. $10.00 (ex-lib.)
Hodge, Frederick Webb--Handbook of American Indians North
of Mexico. Wash., 1912. 2 vols. $100.00 (cloth)

--Hawikuh Bonework. N.Y., 1920. $20.00
Hodges, Lawrence Kaye--Twenty Eventful Years. N.Y., 1937.
 $10.00
Hodges, Luther Hartwell--Businessman in the Statehouse.
 Chapel Hill, N.C., (1962). $10.00
Hodgkin, Lucy Violet--Gulielma.... Lond., (1947). $8.50
Hoehling, Adolph A.--Last Train From Atlanta. N.Y., (1958).
 $16.00, $10.00
Hoffman, Frederick John--William Faulkner. (East Lansing,
 Mi.), 1951. 1st ed. $35.00 (orig. cloth, spine frayed)
Hoffman, William S.--Paul Mellon. Chi., (1974). $12.50
Hofstadter, Richard--The Age of Reform. N.Y., 1959. $6.50
--The Paranoid Style in American Politics.... N.Y., 1965.
 1st ed. $10.00
Hogan, Charles Beecher--A Bibliography of Edwin Arlington
 Robinson. New Haven, 1936. 1st ed. $35.00 (orig. cloth)
Hogarth, Paul--Artist on Horseback. N.Y., 1972. $35.00
Hogner, Dorothy Childs--Westward High, Low, and Dry. N.Y.,
 (1938). $17.50
Hoig, Stan--The Sand Creek Massacre. Norman, (1961).
 1st ed. $7.95
Holand, Hjalmar Rued--Explorations in America Before Colum-
 bus. N.Y., (1956). 1st ed. $7.50
--Wisconsin's Belgian Community. Sturgeon Bay, Wi., 1933.
 $20.00
Holborn, Hajo--American Military Government. Wash., (1947).
 1st ed. $12.00 (spine lettering faded)
Holbrook, Stewart Hall--Dreamers of the American Dream.
 Garden City, (1957). $15.00 (cloth)
--Ethan Allen. Port., 1958. $10.00
--Machines of Plenty. N.Y., 1955. 1st ed. $15.00 (boards)
--Promised Land.... N.Y., (1945). $7.50 (1st printing)
--The Rocky Mountain Revolution. N.Y., (1956). $25.00
 (signed by the author)
--The Story of American Railroads. N.Y., (1947). $15.00
 (cloth), $12.50 (pages wrinkled, spine bottom worn)
Holden, Arthur Cort--The Financial Plight of the City of New
 York. N.Y., 1976. $8.00
Holden, William Curry--A Ranching Saga. San Antonio, 1976.
 2 vols. $31.50 (boxed)
Holder, Charles Frederick--Recreations of a Sportsman on the
 Pacific Coast. N.Y., 1910. 1st ed. $30.00 (cloth)
Holdredge, Helen--The Woman in Black. N.Y., (1955). 1st
 ed. $17.50

Holiday, Billie--Lady Sings the Blues. Garden City, 1956. 1st ed. $25.00

Holland, Josiah Gilbert--The Life of Abraham Lincoln. Springfield, 1866. $14.50

Holland, Kenneth--Youth in the CCC. Wash., 1942. 1st ed. $15.00

Holland, Lydia--Greenwich Old & New. Greenwich, 1935. $20.00 (boards)

Holland, Mary A. Gardner--Our Army Nurses. Bost., 1895. 1st ed. $27.50

Holland, William Jacob--To the River Plate and Back. N.Y., 1913. $50.00

Holland, William M.--The Life and Political Opinions of Martin Van Buren.... Hart., 1835. 1st ed. $22.50 (bookplate, old boards)

Holley, George Washington--Niagara: Its History and Geology. 1st ed. N.Y., 1872. $27.50 (cloth, 2nd printing)

Holling, Holling Clancy--The Book of Cowboys. N.Y., (1931). $25.00 (cloth, name on endpaper, light cover wear)

Hollingsworh, John McHenry--The Journal.... S.F., 1923. $53.50 (buckram, ltd. ed.)

Hollis, Christopher--The American Heresy. Lond., 1927. 1st ed. $25.00

Hollis, Daniel Walker--Look to the Rock. Rich., 1961. $37.50

Hollister, Ovando James--Boldly They Rode. Lakewood, Co., 1949. $27.00

--Colorado Volunteers in New Mexico, 1862. Chi., 1962. $15.00

Hollon, William Eugene--Beyond the Cross Timbers. Norman, (1955). $25.00

--The Southwest. N.Y., 1961. 1st ed. $12.50 (presentation copy)

--William Bollaert's Texas
See: Bollaert, William

Hollyman, Thomas--The Oilmen. N.Y., 1952. $10.50

Holman, Louis Arthur--Scenes From the Life of Benjamin Franklin. Bost., 1916. $12.50 (orig. boards)

Holmberg, Allen--Nomads of the Long Bow. Garden City, 1969. $15.00 (wraps., stamp)

Holmes, Frederick Lionel--Alluring Wisconsin. Milwaukee, (1938). $11.50

--Badger Saints and Sinners. Milwaukee, 1939. $8.50

--Side Roads. Madison, 1949. $7.50

Holmes, Kenneth L.--Ewing Young, Master Trapper. Portland, Or., (1967). $12.50, $9.50, $7.50 (name on front endpaper)

Holmes, Louis A.--Fort McPherson, Nebraska.... Lincoln,
(1963). $35.00 (cloth, ltd. and signed ed.), $25.00 (ltd.,
signed ed.), $21.00 (ltd., signed ed.)
Holmes, Maurice G.--From New Spain by Sea to the Californias.
Glendale, 1963. 1st ed. $25.00, $20.00
Holmes, Oliver Wendell, 1809-1894--John Lothrop Motley.
Bost., 1891. $15.00
--Oration Delivered Before the City Authorities of Boston....
N.p., 1863. $300.00 (morocco, front cover skillfully re-
attached)
--The Poems of.... Bost., 1862. $50.00 (orig. cloth, rubbed,
signed by author)
--Urania. Bost., 1846. 1st ed. $50.00 (orig. wraps., back-
strip shot, wraps. soiled)
Holmes, Oliver Wendell, 1841-1935--Collected Legal Papers.
N.Y., 1920. 1st ed. $15.00
--The Dissenting Opinions of Mr. Justice Holmes. N.Y.,
(1929). 1st ed. $12.50
--The Mind and Faith of Justice Holmes. Bost., 1943. $8.50
(inscribed by editor)
Holmes, Thomas James--Cotton Mather.... Newton, Ma., 1974.
3 vols. $60.00 (cloth, one of 500 sets)
--Increase Mather.... Cleve., 1930. $12.50 (orig. wraps.)
Holmes, William F.--The White Chief. Baton Rouge, 1970.
$17.50
Holmes, William Henry--Aboriginal Pottery of the Eastern U.S.
Wash., 1903. $35.00 (binding loose, covers worn)
Holt, Roy D.--Heap Many Texas Chiefs. San Antonio, (1966).
$7.50
Holton, Isaac Farwell--New Granada. N.Y., 1857. 1st ed.
$85.00 (spine top repaired, endpapers stained), $65.00
(call number on spine but not ex-lib.)
Homans, Abigail Adams--Education by Uncles. Bost., 1966.
$6.00
Homenaje a Luis Pales Matos. (Rio Piedras, Puerto Rico),
1960. $25.00
Homer, Frederic D.--Guns and Garlic. West Lafayette, 1974.
$7.00
Homer, Winslow--Winslow Homer. (N.Y., 1973). $15.00 (lacks
front endpaper)
Homsher, Lola M., ed.--South Pass, 1868.
See: Chisholm, James
Hone, Philip--The Diary of...., 1828-1851. N.Y., 1927. 2
vols. $20.00
Hood, John Bell--Advance and Retreat. Bloomington, In.,
1959. $20.00

Hoopes, Alban Williamson--The Road to the Little Big Horn--
and Beyond. N.Y., 1975. $15.00
Hoover, Herbert--Addresses Upon the American Road....
N.Y., 1941. $12.50
--American Individualism. Garden City, 1922. 1st ed.
$22.50
--A Boyhood in Iowa. N.Y., 1931. $25.00 (buckram, one
of 1000 copies)
--The Challenge to Liberty. N.Y., 1934. $125.00 (author's
presentation copy, cloth, spine soiled)
--The Memoirs of.... N.Y., 1951-52. 3 vols. $35.00
--The Problems of Lasting Peace. N.Y., 1942. 1st ed.
$40.00 (presentation copy)
Hoover, Irwin Hood--Forty-Two Years in the White House.
Bost., 1934. $20.00, $10.00
Hoover, John Edgar--Masters of Deceit. N.Y., 1958. 1st ed.
$7.50
Hopkins, Charles Howard--History of the Y.M.C.A. in North
America. N.Y., 1951. $12.50
Hopkins, Garland Evans--The First Battle of Modern Naval
History. Rich., 1943. $35.00 (one of 199 copies, presen-
tation copy)
Hopkins, John Abel--Economic History of the Production of
Beef Cattle in Iowa. Ames, 1928. $35.00 (one of 600 cop-
ies)
Hopkins, John Castell--French Canada and the St. Lawrence....
Phila., (1913). 1st ed. $12.50 (ex-lib.)
Hopkins, Samuel--Historical Memoirs, Relating to the Housatun-
nuk Indians. Bost., 1753. 1st ed. $400.00 (old leather-
backed wooden boards, right margins cropped)
Hopper, Hedda--The Whole Truth and Nothing But. Garden
City, 1963. $8.50
Hoppin, James Mason--The Life of Andrew Hull Foote. N.Y.,
1874. $50.00, $35.00 (buckram, rebound)
Horan, James David--Confederate Agent.... N.Y., (1954).
$19.00
--Desperate Women. N.Y., (1952). $25.00 (cloth, rebound)
--The Gunfighters.... N.Y., (1976). $18.00
--The Life and Art of Charles Schreyvogel. N.Y., 1969. 1st
ed. $85.00
--The Outlaws.... N.Y., 1977. $18.00
--Pictorial History of the Wild West. N.Y., (1954). 1st ed.
$26.50 (boards)
--The Pinkertons. N.Y., (1967). 1st ed. $25.00, $17.50
Horgan, Paul--The Centuries of Santa Fe. N.Y., 1956. 1st

ed. $25.00 (tipped-in slip with author's presentation in-
scription)
--The Devil in the Desert. N.Y., 1952. $14.50
--Great River. N.Y., 1954. 2 vols. 1st ed. $175.00 (orig.
buckram, newly boxed, ltd. ed.), $125.00 (cloth, signed
and ltd. ed. of 1000 copies), $26.50 (slip cased)
--Mountain Standard Time. N.Y., (1962). $7.50
Horn, Calvin--New Mexico's Troubled Years. Albuquerque,
(1963). $20.00
Horn, Stanley Fitzgerald--The Army of Tennessee. Ind.,
(1941). $25.00
--Gallant Rebel. New Brunswick, 1947. $12.50
--Invisible Empire. Bost., 1939. 1st ed. $30.00 (presenta-
tion copy)
Horn, Stephen--The Cabinet and Congress. N.Y., 1960.
$20.00
Horn, William Franklin--The Horn Papers. Scottsdale, Pa.,
1945. 3 vols. $200.00 (orig. cloth)
Hornaday, William Temple--Camp-Fires in the Canadian Rockies.
N.Y., 1906. 1st ed. $50.00 (orig. cloth)
N.Y., 1907. $60.00 (orig. cloth, corners worn, partially
unopened copy)
--Extermination of the American Bison. Wash., 1887. $20.00
(wraps.)
Hornblow, Arthur--History of the Theatre in America....
Phila., 1919. 2 vols. $35.00 (light spine tip wear and
cover staining of vol. 1)
Horne, Lena--Lena. Garden City, 1965. 1st ed. $20.00
Horner, Charles Francis--The Life of James Redpath and the
Development of the Modern Lyceum. N.Y., (1926). $25.00
(orig. cloth)
Horner, Dave--The Blockade-Runners. N.Y., (1968). $15.00
Horner, Harlan Hoyt--Lincoln and Greeley. (Urbana, Il.),
1953. 1st ed. $13.50
Horner, John B.--Days and Deeds in the Oregon Country....
Portland, Or., 1928. $7.50
--Oregon Literature. Corvallis, 1899. 1st ed. $45.00 (orig.
cloth)
Horner, John Willard--Silver Town. Caldwell, 1950. $35.00
Horowitz, Irving Louis--Revolution in Brazil. N.Y., 1964.
$15.00
Horowitz, Louis Jay--The Towers of New York. N.Y., 1937.
$20.00
Horsford, Eben Norton--The Landfall of Leif Erikson, A.D.
1000.... Bost., 1892. 1st ed. $25.00

Horwood, Harold Andrew--Bartlett, the Great Canadian Explorer. Garden City, 1977. 1st ed. $20.00 (cloth)
Hosmer, James Kendall--The American Civil War. N.Y., 1913. 2 vols. $27.50
--The Color-Guard.... Bost., 1864. 1st ed. $12.50
--Life of Thomas Hutchinson. Bost., 1896. $22.50
--A Short History of the Mississippi Valley. Bost., 1901. 1st ed. $10.00
Hostetter, Gordon L.--It's a Racket! Chi., 1929. $15.00
Hotz, Gottfried--Indian Skin Paintings.... Norman, (1970). $10.00
Hough, Alfred Lacey--Soldier in the West. Phila., (1957). $15.00
Hough, Emerson--The Web. Chi., (1919). 1st ed. $10.00
Hough, Franklin Benjamin--A History of Lewis County, in the State of New York.... Albany, 1860. 1st ed. $50.00 (contemp. boards, rubbed)
Houghton, Louise (Seymour)--Our Debt to the Red Man. Bost., 1918. $20.00
Houghton, Samuel Gilbert--A Trace of Desert Waters. Glendale, 1976. $17.75
House, Boyce--Tall Talk From Texas. San Antonio, 1944. $6.00
--Texas, Proud and Loud. San Antonio, (1945). $6.00
House, Homer Doliver--Wild Flowers of New York. (Albany), 1921. $30.00 (orig. cloth portfolio)
House, Julius Temple--John G. Neihardt, Man and Poet. Wayne, Nb., 1920. 1st ed. $20.00 (cloth, cover lightly stained)
Houseman, John--Run-Through. N.Y., (1972). 1st ed. $15.00
Houston, Andrew Jackson--Texas Independence. Houston, 1938. $125.00 (cloth, one of 500 copies)
Houston, Neal B.--Ross Santee. Austin, (1968). $7.50 (orig. wraps.)
Houwald, Götz Dieter von--Los Allemanes en Nicaragua. (Managua, 1975). $10.00
Hovey, Horace Carter--Mammoth Cave of Kentucky. Lou., 1897. $25.00 (wraps., lightly faded)
Hovey, Tamara--John Reed. N.Y., 1975. 1st ed. $10.00
Howard, Guy--Walkin' Preacher of the Ozarks. N.Y., (1944). 1st ed. $10.00
Howard, Harold P.--Sacajawea. Norman, (1971). 1st ed. $15.00
Howard, Helen Addison--Saga of Chief Joseph. Caldwell, 1971. $17.50

Howard, James Quay--History of the Louisiana Purchase. Chi.,
 1902. $30.00
Howard, John Tasker--Stephen Foster, America's Troubadour.
 N.Y., (1935). $12.50, $12.50 (cloth)
 N.Y., 1943. $13.50
Howard, Joseph Kinsey--Montana; High, Wide, and Handsome.
 New Haven, (1944). $12.50, $8.50
--Montana Margins. New Haven, (1950). $12.50
--Strange Empire, a Narrative of the Northwest. N.Y., 1952.
 1st ed. $50.00 (cloth)
Howard, Robert West--This is the West. N.Y., (1957). $24.50
--Thundergate. Englewood Cliffs, 1968. $10.00
Howe, Daniel Walker--The American Whigs. N.Y., (1973).
 $8.50
Howe, Edgar Watson--A Man Story. Bost., 1889. 1st ed.
 $30.00 (cloth, some warping)
--Plain People. N.Y., 1929. $15.00 (cloth)
Howe, Elvon L.--Rocky Mountain Empire. Garden City, 1950.
 $10.00 (review pasted to fly, backstrip lightly faded),
 $6.00
Howe, Henry Forbush--Prologue to New England. N.Y., (1943)
 1st ed. $20.00
Howe, Julia Ward--Julia Ward Howe and the Woman Suffrage
 Movement. Bost., 1913. $15.00 (front hinge cracked, ex-
 lib.)
--Reminiscences, 1819-1899. Bost., 1899. $25.00
--A Trip to Cuba. Bost., 1860. 1st ed. $37.50 (backstrip
 worn, wear to extremities)
Howe, Irving--William Faulkner.... N.Y., (1952). 1st ed.
 $30.00 (1st printing, a few pages browned by newspaper
 clippings, bookplate)
Howe, Mark Anthony De Wolfe--The Boston Symphony Or-
 chestra.... Bost., (1914). $20.00 (one of 535 copies)
 Bost., 1931. $12.50 (minor shelfwear)
--The Humane Society of the Commonwealth of Massachusetts.
 Bost., 1918. $40.00 (orig. boards, ex-lib.)
--Life and Letters of George Bancroft. N.Y., 1908. 2 vols.
 1st ed. $40.00 (cloth)
Howe, Octavius Thorndike--Argonauts of '49. Camb., 1923.
 1st ed. $27.50 (boards)
(Howe, S. Ferdinand)--Commerce of Kansas City in 1886.
 K.C., 1886. 1st ed. $35.00 (water stains)
Howell, George Coes--The Case of Whiskey. Altadena, Ca.,
 1928. $12.50

Howells, William Dean--Between the Dark and the Daylight.
N.Y., 1907. $25.00 (orig. cloth, lightly rubbed at ends
of spine)
--Italian Journeys. N.Y., 1867. 1st ed. $65.00 (orig. cloth,
lightly rubbed at edges, early pencil inscription effaced)
--A Little Swiss Sojourn. N.Y., (1892). 1st ed. $35.00
(orig. cloth)
--Mrs. Farrell. N.Y., (1921). $25.00 (orig. cloth, binding
A, lightly rubbed at edges)
--The Mother and the Father. N.Y., 1909. 1st ed. $25.00
(orig. cloth, ends of spine lightly worn)
--The Mouse-Trap and Other Farces. N.Y., (1889). 1st ed.
$30.00
--No Love Lost. N.Y., 1869. $85.00 (orig. cloth, lightly
rubbed at extremities)
--An Open-Eyed Conspiracy. N.Y., 1897. 1st ed. $25.00
(orig. cloth, tips of spine lightly rubbed)
--Poems. Bost., 1886. $30.00 (1st binding, orig. parchment,
light soiling, spine lightly darkened, bookplate)
--The Seen and the Unseen at Stratford-On-Avon. N.Y.,
1914. 1st ed. $20.00 (1st issue, cloth)
--The Undiscovered Country. Bost., 1880. 1st ed. $35.00
(orig. cloth, printing and binding A, edges lightly worn)
--A Woman's Reason. Bost., 1883. $40.00 (orig. cloth)
Howenstine, Papa Jack--Papa Jack: Cowman From the Wichi-
tas. Norman, 1976. $12.00
Hower, Ralph Merle--History of Macy's of New York....
Camb., 1943. $25.00
Camb., (1967). $20.00
Howes, Barbara--From the Green Antilles. N.Y., (1966).
1st ed. $8.00 (1st printing)
Howling Wolf, Dan--Grasshopper, Ant and Mosquito Go Hunting.
Bismarck, N.D., 1977. $5.00
Hoyt, Edwin Palmer--Damn the Torpedos! Lond., (1970).
$12.50
--The Guggenheims and the American Dream. (N.Y., 1967).
$10.00
Hoyt, Harlowe Randall--Town Hall Tonight. Englewood Cliffs,
N.J., (1955). 1st ed. $15.00 (boards)
Hoyt, Henry Franklin--A Frontier Doctor. Bost., 1929. 1st
ed. $50.00
Hrdlicka, Ales--Alaska Diary, 1926-1931. Lancaster, Pa.,
1943. $20.00
--Recent Discoveries Attributed to Early Man in America.
Wash., 1918. 1st ed. $12.50

Hubbard, Earle R.--My Seventeen Years With the Pioneers.
 Raymond, S.D., 1950. $15.00
 --Sparks From Many Camp Fires. Clark, S.D., 1959. $12.50
Hubbard, Elbert--The Note Book.... N.Y., 1927. $12.50
Hubbard, John Niles--An Account of Sa-Go-Ye-Wat-Ha, or Red
 Jacket, and His People. Albany, 1886. 1st ed. $65.00
 (some rubbing, part of paper label lacking, lacks back
 endleaf)
Hubbs, Barbara Burr--Pioneer Folks and Places. Herrin, Il.,
 1939. 1st ed. $15.00 (cloth, cover stained, inscribed and
 signed)
Huberman, Leo--Cuba. N.Y., 1960. 1st ed. $8.50
Hudleston, Francis Josiah--Gentleman Johnny Burgoyne.
 Ind., (1927). $20.00
Hudson, Frederic--Journalism in the U.S., From 1690 to 1872.
 N.Y., 1968. $35.00 (cloth)
Hudson, William Henry--Idle Days in Patagonia. Lond., 1893.
 $65.00 (one of 1750 copies, inner hinge starting)
 N.Y., 1917. $15.00
 --Letters on the Ornithology of Buenos Ayres. Ithaca, (1951).
 $20.00
 --The Naturalist in La Plata. Lond., 1892. $44.00 (cloth,
 one of 750 copies, lightly foxed)
 Lond., 1903. $25.00 (some light pencil underlining)
 Lond., 1922. $20.00
 --Tales of the Pampas. N.Y., 1916. $125.00 (cloth)
 --W.H. Hudson's Tales of the Pampas. N.Y., 1939. $10.00
Hudson, Wilson Mathias--Andy Adams. Austin, (1967). $4.00
Hudson, Winthrop S.--American Protestantism. Chi., 1961.
 $6.00
Hueston, Ethel--Coasting Down East. N.Y., 1924. $17.50
Hughan, Jessie Wallace--American Socialism of the Present
 Day. N.Y., 1911. 1st ed. $27.50 (backstrip lightly worn)
 $25.00
Hughes, Everett Cherrington--French Canada in Transition to
 the Beginning of World War Two. Chi., (1943). $35.00
 (orig. cloth)
Hughes, Frank L.--Prejudice and the Press. N.Y., 1950.
 $12.50
Hughes, Helen (MacGill), ed.--The Fantastic Lodge
 See: Clark, Janet, pseud.
Hughes, John Taylor--Doniphan's Expedition.... Cinci., 1848.
 $112.50 (binding worn, front fly replaced)
 (Chi., 1962). $35.00

Hughes, John William--The Trial of Dr. John W. Hughes, for the Murder of Miss Tamzen Parsons. Cleve., 1866. $85.00 (some foxing)

Hughes, Langston--One-Way Ticket. N.Y., 1949. $75.00 (cloth and boards, inscribed)

--Simple Stakes a Claim. N.Y., (1957). $8.50 (boards, name on endpaper)

Hughes, Rupert--George Washington.... N.Y., 1926-30. 3 vols. $60.00 (each vol. inscribed, cloth)

--The Real New York. N.Y., 1904. 1st ed. $25.00 (cloth)

Hughes, William J.--Rebellious Ranger. Norman, (1964). 1st ed. $25.00

Hughs, Mary Robson--Emma Mortimer. Phila., 1829. 1st ed. $85.00 (orig. boards, spine top chipped, owner inscription)

Hulbert, Archer Butler--The Call of the Columbia. Denver, (1934). $38.50

--Forty-Niners. Bost., 1931. 1st ed. $25.00 (cloth, cover spotted), $17.50, $15.00

--The Oregon Crusade. Denver, (1935). $38.50

Hull, Augustus Longstreet--The Campaigns of the Confederate Army. Atlanta, 1901. 1st ed. $12.50

Hull, Isaac, 1773-1843. Commodore Hull. Bost., 1929. 1st ed. $12.50, $10.00

Hull, Isaac Harvey, 1884--Built of Men.... N.Y., (1952). $12.50

Hull, William--Defence of Brigadier General W. Hull. Bost., 1814. 1st ed. $35.00 (orig. boards, covers loose, lacks most of spine, binding partly broken)

--Memoirs of the Campaign of the North Western Army.... Bost., 1824. 1st ed. $500.00 (orig. wraps.), $150.00 (contemp. half calf, ex-lib. stamp)

Hull, William Isaac--William Penn and the Dutch Quaker Migration.... Swarthmore, Pa., 1935. $40.00

Hult, Ruby El--Steamboats in the Timber. Portland, Or., 1968. $10.00

Humboldt, Alexander von--The Island of Cuba. N.Y., 1856. $200.00 (orig. cloth)

--Letters of ... to Varnhagen von Ense.... N.Y., 1860. $40.00 (orig. cloth)

--Political Essay on the Kingdom of New Spain.... Lond., 1811. 4 vols., incl. atlas vol. $2500.00 (contemp. three-quarter calf, atlas in wraps., some light wear)

Hume, Brit--Death and the Mines. N.Y., 1971. $12.50

Humphrey, Seth King--Following the Prairie Frontier. (Minne.,
 1931). $15.00
Humphrey, Willis C.--The Great Contest. Detroit, 1886.
 $30.00
Humphrey, Zephine--'Allo Good-by. N.Y., 1940. $5.00
Humphreys, Charles Alfred--Field, Camp, Hospital and Prison
 in the Civil War.... Bost., 1918. 1st ed. $25.00
Humphreys, J.R.--The Lost Towns and Roads of America.
 Garden City, (1961). 1st ed. $5.00
Humphreys, Robin Arthur--Tradition and Revolt in Latin
 America. Lond., 1969. $10.00
Hundley, Norris--Dividing the Waters. Berkeley, 1966.
 $16.50
Hungerford, Edward--Pathway of Empire. N.Y., (1935).
 $15.00
--The Romance of a Great Store. N.Y., 1922. $15.00
--The Story of the Waldorf-Astoria. N.Y., 1925. $15.00
 (lettering on backstrip effaced)
--Timken at War--Canton, Oh., 1945. $20.00
--Wells Fargo.... N.Y., (1949). $27.50. $7.50
Hunnicutt, Benjamin Harris--Brazil Looks Forward. Rio de
 Janeiro, 1945. $20.00
Hunt, Aurora--Kirby Benedict, Frontier Federal Judge. Glen-
 dale, 1961. $25.00
--Major General James Henry Carleton, 1814-1873. Glendale,
 1958. 1st ed. $20.00
Hunt, Frazier--Cap Mossman, Last of the Great Cowmen.
 N.Y., (1951). $25.00
--Custer, the Last of the Cavaliers. N.Y., 1928. 1st ed.
 $40.00
--I Fought With Custer
 See: Windolph, Charles A.
Hunt, Henry M.--The Crime of the Century. N.p., (1889).
 $10.00 (stained back cloth)
Hunt, Lenoir--Bluebonnets and Blood. Houston, (1938).
 $35.00 (one of 500 copies, author's presentation, bookplate)
Hunt, Morton M.--The Mugging. N.Y., 1972. 1st ed. $15.00
Hunt, Rockwell Dennis--California Ghost Towns Live Again.
 Stockton, Ca., 1948. 1st ed. $13.00 (author's presenta-
 tion copy)
--John Bidwell.... Caldwell, (1942). $42.50
--A Short History of California. N.Y., (1929). $17.50 (bit
 of spine tip frey)
Hunt, Walter Benjamin--Indian and Camp Handicraft. N.Y.,
 (1940). $12.50 (cloth)

Hunter, George--Reminiscences of an Old Timer.... Battle
Creek, 1888. $45.00 (recent binding)
Hunter, John Marvin--Peregrinations of a Pioneer Printer.
Grand Prairie, Tx., 1954. $28.50
--The Trail Drivers of Texas. Nash., 1925. 2 vols. in 1.
$125.00 (cloth)
Hunter, William Albert--Forts on the Pennsylvania Frontier....
Harrisburg, 1960. $30.00
The Hunter's Guide and Trapper's Companion, Hinsdale, N.Y.,
1868. $15.00 (unbound, title torn, last page loose and
torn)
Hunting, Warren Belknap--The Obligation of Contracts Clause
of the U.S. Constitution. Balt., 1919. 1st ed. $12.50
(wraps.)
Huntington, Bill--Good Men and Salty Cusses. (Billings,
Mt., 1952). $31.50 (signed)
Huntington, George--Robber and Hero. Northfield, 1895.
1st ed. $125.00 (orig. cloth), $49.50 (orig. cloth)
Hurd, Charles--When the New Deal Was Young and Gay.
N.Y., (1965). $8.50
Hurn, Ethel Alice--Wisconsin Women in the War Between the
States. Madison, 1911. $35.00 (ex-lib.)
Hurston, Zora Neal--Dust Tracks on the Road. Phila., 1942.
1st ed. $20.00 (ex-lib.)
Huss, John Ervin--Senator for the South. Garden City, 1961.
$15.00
Huston, Paul Griswold--An Old-Fashioned Sugar Camp. Chi.,
(1903). $7.50 (autographed)
Hutchings, James Mason--Scenes of Wonder and Curiosity in
California. N.Y., 1870. $100.00 (cloth)
Hutchins, Thomas, 1730-1789--The Courses of the Ohio River
Taken by Lt. T. Hutchins.... Cinci., 1942. 1st ed.
$40.00
--A Topographical Description of Virginia, Pennsylvania, Mary-
land, and North Carolina.... Bost., 1787. $1000.00 (sewn,
slipcased, wanting two plans)
Hutchinson, William Henry--A Bar Cross Man
See: Rhodes, Eugene Manlove
--Oil, Land and Politics. Norman, (1965). 2 vols. $20.00
Hutchinson, William Thomas--Cyrus Hall McCormick. N.Y.,
1930-35. 2 vols. 1st ed. $40.00 (de luxe ed.)
Hutchison, Bruce--The Fraser. N.Y., (1950). 1st ed.
$15.00
Hutchison, John Russell--Reminiscences, Sketches and Ad-
dresses Selected From my Papers During a Ministry of

Forty-Five Years in Mississippi, Louisiana and Texas.
Houston, 1874. 1st ed. $150.00 (orig. cloth)
Huxley, Leonard, ed.--Scott's Last Expedition
 See: Scott, Robert Falcon
Huzar, Elias--The Purse and the Sword. Ithaca, 1950. 1st
 ed. $12.50 (cloth, ex-lib.)
Hyatt, Harry Middleton--Folk-Lore From Adams County, Illi-
 nois. (N.Y.), 1935. 1st ed. $50.00
Hyde, George E.--Indians of the High Plains.... Norman,
 (1959). 1st ed. $20.00 (cloth)
--Life of George Bent....
 See: Bent, George
--A Sioux Chronicle. Norman, (1956). 1st ed. $25.00,
 $21.00
--Spotted Tail's Folk. Norman, (1961). 1st ed. $25.50,
 $20.00 (cloth)
Hyde, Hartford Montgomery--John Law. Denver, (1948).
 $9.00
--Mexican Empire. Lond., 1946. $15.00
Hyde, S.C.--Historical Sketch of Lyon County, Iowa.... Le-
 mars, 1872. 1st ed. $200.00 (orig. wraps., soiled, bind
 stamp)
Hyer, Julien Capers--The Land of Beginning Again. Atlanta,
 (1952). 1st ed. $14.00
Hynd, Alan--The Giant Killers. N.Y., (1945). $15.00
Hyneman, Charles Shang--Bureaucracy in a Democracy.
 N.Y., (1950). 1st ed. $12.50
--The Supreme Court on Trial. N.Y., 1963. 1st ed. $10.00

- I -

Ianni, Francis A.J.--A Family Business. N.Y., (1972). 1st
 ed. $15.00
Ibar, Francisco--Muerte Politica de la Republica Mexicana....
 Mexico, 1829-30. 3 parts in 2 vols. $1500.00 (three-
 quarter sheep, part 3 wormed with some loss of letters)
Ickes, Harold LeClaire--America's House of Lords. N.Y.,
 (1939). 1st ed. $12.50
Ickis, Alonzo Ferdinand--Bloody Trails Along the Rio Grande.
 Denver, 1958. $75.00 (cloth, name on front endpaper, one
 of 500 copies signed by author)
Ide, Simeon--A Biographical Sketch of the Life of William B.
 Ide.... Glorieta, N.M., (1967). $15.00
--The Conquest of California. Oakland, 1944. $45.00 (ltd.
 to 500 copies, boards)

Ideas Necesarias a Todo Pueblo Americano Independiente
 See: (Rocafuerte, Vicente)
Iglauer, Edith--Denison's Ice Road. N.Y., 1975. 1st ed.
 $15.00 (cloth)
Iglehart, Fanny (Chambers) Gooch--Face to Face With the
 Mexicans.... N.Y., (1887). 1st ed. $150.00 (orig. cloth)
Ike, pseud.
 See: Glynn, Kate A.
Illinois in 1837. Phila., 1837. 1st ed. $125.00 (orig. wraps.,
 foxed), $38.50 (boards, some foxing)
Illustrated Life, Services, Martyrdom, and Funeral of Abraham
 Lincoln. Phila., (1865). $20.00 (binding rubbed and
 spotted, some stains in text)
In Perils by Mine Own Countrymen....
 See: McNamara, John--Three Years on the Kansas Border
Inchauspe, Pedro--La Tradicion y el Gaucho. Buenos Aires,
 1956. $40.00 (orig. wraps.)
Ingalls, John James--A Collection of the Writings of.... K.C.,
 1902. $15.00
Ingalls, Sheffield--History of Atchinson County, Kansas.
 Lawrence, Ks., 1916. $75.00
(Ingersoll, Charles Jared)--Inchiquin the Jesuit's Letters,
 During a Late Residence in the United States of America.
 N.Y., 1810. 1st ed. $50.00 (half calf), $45.00
Ingersoll, Chester--Overland to California in 1847. Chi.,
 1937. $47.50 (one of 350 copies)
Ingersoll, Ernest--Alaskan Bird-Life. N.Y., 1914. $37.50
 (paper)
Ingersoll, Robert Green--Crimes Against Criminals. East
 Aurora, 1906. $15.00 (suede, lightly worn and soiled)
--Works.... N.Y., 1903. 12 vols. $40.00 (light stains,
 some inner hinges starting)
Inglis, William--George F. Johnson and His Industrial Democracy.
 N.Y., (1935). $12.50
Ingraham, Edward Duncan--A Sketch of the Events Which Pre-
 ceded the Capture of Washington by the British.... Phila.,
 1849. 1st ed. $75.00 (cloth boards, spine frayed)
Ingraham, Joseph--Journal of the Brigantine Hope on a Voy-
 age.... Barre, Ma., 1971. $50.00 (cloth, one of 1950
 copies, slipcased)
Ingstad, Helge Marcus--Westward to Vinland. N.Y., (1969).
 $15.00
Inman, Henry--The Great Salt Lake Trail. N.Y., 1898.
 $77.50
--The Old Santa Fe Trail. N.Y., 1897. 1st ed. $135.00
 (front and back endpaper hinges cracking)

--Stories of the Old Santa Fe Trail. K.C., 1881. 1st ed.
$150.00 (gold worn off cover, edge wear)
--Tales of the Trail. Topeka, 1898. 1st ed. $50.00 (cloth)
Innes, John H.--New Amsterdam and Its People. N.Y., 1902.
$30.00
Innis, Ben--Briefly, Bufford, N.p., (1963). $7.50
Innis, Harold Adams--The Fur Trade in Canada. New Haven,
1930. $22.00 (cloth, rebound, ex-lib.)
Toronto, 1956.· $15.00
Institute de Estudios Historicos Sobre la Reconquista y De-
fensa de Buenos Aires--La Reconquista y Defensa de Buenos
Aires, 1806-1807. Buenos Aires, 1947. $60.00 (half mo-
rocco)
International Congress of Historians of the United States and
Mexico....--The New World Looks at Its History
See: Lewis, Archibald Ross, ed.
Ions, Edmund S.--The Politics of John F. Kennedy. N.Y.,
(1967). $12.50
Irvine, Leigh Hadley--The Follies of the Courts. L.A., 1925.
$15.00
Irving, John Treat--Indian Sketches, Taken During an Expe-
dition to the Pawnee Tribes, 1833. Norman, (1955).
$15.00 (cloth)
Irving, Washington--The Adventures of Captain Bonneville....
Norman, (1961). $35.00, $25.00, $15.00
--Astoria.... Phila., 1836. 2 vols. $225.00
N.Y., 1897. 2 vols. $100.00 (slightly age-darkened, re-
bound)
Phila., 1961. 2 vols. $6.00
--Biography and Poetical Remains of the Late Margaret Miller.
Phila., 1841. 1st ed. $7.50 (dull cloth, worn spine)
--Bracebridge Hall. Lond., 1822. 2 vols. $49.50 (calf,
lightly scuffed)
--The Christmas Dinner.... N.Y., 1929. $15.00 (boards)
--Diedrich Knickerbocker's History of New-York. N.Y.,
(1940). $15.00 (cloth)
--A History of New York. N.Y., 1809. 2 vols. 1st ed.
$650.00 (contemp. calf, some restorations to hinges and
spines)
N.Y., 1915. $100.00 (boards, covers lightly worn and
soiled, one page torn, prelims lightly foxed)
--Illustrations of Rip Van Winkle. (N.Y., 1848). $125.00
(later boards, orig. wraps. bound in)
--Illustrations of the Legend of Sleepy Hollow. (N.Y.), 1849.
$125.00

--Knickerbocker Papers.... Lond., 1914. $50.00 (boards, one of 1000 copies, endpapers lightly discolored)
--Life of George Washington. N.Y., 1857. 4 vols. $40.00 (cloth, light wearing, foxing)
--The Western Journals of Washington Irving. Norman, (1944). 1st ed. $10.00
--Works of.... N.Y., 1896-97. 40 vols. $300.00 (orig. cloth)
Irwin, Will--The House That Shadows Built. Garden City, 1928. 1st ed. $12.50
Isely, Jeter Allen--Horace Greeley and the Republican Party.... (Princeton, 1947). 1st ed. $17.50 (cloth)
Issler, Anne (Roller)--Our Mountain Hermitage. Stanford, (1950). 1st ed. $15.00
--Stevenson at Silverado. Caldwell, 1939. 1st ed. $60.00
Ives, Burl--The Wayfaring Stranger's Notebook. Ind., (1962). $15.00 (1st printing, cloth)
Ives, Joseph Christmas--Steamboat Up the Colorado. Bost., (1965). $23.50
Ives, Joseph Moss--The Ark and the Dove. Lond., 1936. 1st ed. $8.50
Ixtlilxochitl, Fernando de Alva--Obras Historicas de Don Fernando.... Mexico, 1891-92. 2 vols. $200.00 (half calf)

- J -

Jablonski, Edward--Flying Fortress. Garden City, (1965). $8.50
Jacker, Corinne--The Black Flag of Anarchy. N.Y., (1968). $10.00
Jackson, Bruce--Killing Time. Ithaca, 1977. $7.00
Jackson, Chrles Tenney--The Buffalo Wallow. Ind., (1953). 1st ed. $15.00 (cloth)
Jackson, Christopher--Manuel. N.Y., 1964. $10.00
Jackson, Clarence S., ed.--Picture Maker of the Old West
 See: Jackson, William Henry
Jackson, Donald Dean--Custer's Gold. New Haven, 1966. 1st ed. $22.50
Jackson, George--Sixty Years in Texas.... (Dallas, 1908). 1st ed. $200.00 (orig. cloth, moderate wear)
Jackson, Helen Maria (Fiske) Hunt--Ah-Wah-Ne Days. S.F., 1971. $100.00 (one of 450 copies)
--Glimpses of California and the Missions. Bost., 1919. $22.50
--Glimpses of Three Coasts. Bost., 1886. 1st ed. $20.00 (bit of spine tip frey, lettering flaked off spine)

--Poems. Bost., 1892. 1st ed. $40.00 (orig. three-quarter
morocco, one of 250 copies, ex-lib.)
--Ramona. Bost., 1884. 1st ed. $150.00 (cloth, marginal
foxing, some internal soiling, name on endpaper)
Bost., 1900. 2 vols. $150.00 (orig. half morocco over
suede)
L.A., 1959. $85.00 (cloth, one of 1500 copies, boxed,
signed by artist)
(Jackson, Isaac Rand)--A Sketch of the Life and Public Serv-
ices of William H. Harrison.... Hart., 1840. $50.00 (orig.
wraps.)
Prov., 1840. $35.00 (orig. wraps.)
Jackson, Joseph--Development of American Architecture....
Phila., (1926). $15.00
--Encyclopedia of Philadelphia. Harrisburg, 1931. 4 vols.
$225.00
Jackson, Joseph Henry--Anybody's Gold.... N.Y., 1941. 1st
ed. $35.00, $25.00 (cloth)
--Bad Company. N.Y., (1949). $18.50
--Gold Rush Album. N.Y., (1949). 1st ed. $45.00 (cloth),
$35.00, $25.00, $17.50 (cloth), $15.00
--Mexican Interlude. N.Y., 1936. $8.50
--Notes on a Drum. N.Y., 1937. $10.00
Jackson, Mary Anna Morrison--Life and Letters of General
Thomas J. Jackson.... N.Y., 1892. $30.00 (cloth, title
detached, ex-lib.)
Jackson, Stuart Wells--La Fayette; a Bibliography. N.Y.,
1968. $20.00 (cloth)
Jackson, Thomas William--Through Missouri on a Mule....
Chi., 1904. $10.00 (back cover is torn in many places,
soiled)
Jackson, William Henry--The Diaries of.... Glendale, 1959.
$45.00 (cloth, unopened)
--Picture Maker of the Old West. N.Y., 1947. 1st ed.
$65.00, $60.00 (cloth, corner bumped)
Jackson, William Turrentine--Treasure Hill. Tucson, 1963.
$20.00
Jacobs, James B.--Stateville. Chi., 1977. $5.00
Jacobs, James Ripley--Tarnished Warrior.... N.Y., 1938.
1st ed. $15.00 (1st printing, cloth)
Jacobs, Jane--The Life and Death of Great American Cities.
N.Y., 1961. $12.50
Jacobs, Lewis--The Rise of the American Film. N.Y., 1939.
1st ed. $15.00

Jacobs, Wilbur R.--The Historical World of Frederick Jackson
 Turner. New Haven, 1968. $20.00 (cloth)
--Turner, Bolton and Webb. Seattle, 1965. $7.50
Jaeger, Ellsworth--Tracks and Trailcraft. N.Y., 1948. $7.50
Jaffe, Bernard--Men of Science in America.... N.Y., 1944.
 $21.95
Jaffray, Julia Kippen--The Prison and the Prisoner. Bost.,
 1917. $15.00 (rubbed)
Jagger, William--To the People of Suffolk Co.... N.Y., 1856.
 1st ed. $10.00
Jahns, Patricia--The Frontier World of Doc Holliday.... N.Y.,
 (1957). 1st ed. $15.00
Jahoda, Gloria--The Trail of Tears. N.Y., 1975. $20.00
James, Arthur Wilson--Virginia's Social Awakening. Rich.,
 (1939). $25.00
James, Edwin, ed.--A Narrative of the Captivity and Adven-
 tures of John Tanner
 See: Tanner, John
James, George Wharton--California, Romantic and Beautiful.
 Bost., (1921). $25.00 (cloth)
--The Grand Canyon of Arizona. Bost., (1910). $12.00
 (backstrip faded), $7.50
--In and Out of the Old Missions of California. N.Y., (1927).
 $11.50
--The Indians of the Painted Desert Region. Bost., 1903.
 1st ed. $27.50 (cover lightly soiled, bit of spine tip and
 corner wear)
--The Influence of the Climate of California Upon Its Litera-
 ture. N.p., n.d. (1909?). 1st ed. $29.50 (orig. wraps.)
--The Old Franciscan Missions of California. Bost., 1913.
 1st ed. $22.50 (front endpaper missing, bit of spine tip
 rubbing)
--Our American Wonderlands. Chi., 1915. $8.50
--Through Ramona's Country. Bost., 1909. 1st ed. $10.00
--The Wonders of the Colorado Desert.... Bost., 1907. 2
 vols. $32.50 (ex-lib. blind stamps, some cover wear,
 hinges weak)
 Bost., 1918. $25.00 (cloth, lightly frayed)
James, Harry Clebourne--The Cahuilla Indians. L.A., 1960.
 $15.00 (one of 1250)
--The Treasure of the Hopitu. L.A., (1927). $27.50 (boards)
James, Henry--The Ambassadors. N.Y., (1963). $20.00
 (cloth, slipcased)
--The Author of Beltraffic.... Bost., 1885. 1st ed. $18.50

(cloth, front inner hinge cracked, light wear to spinal ex-
tremities)
--The Bostonians. Lond., 1886. $75.00 (orig. cloth, spine
faded)
--Embarrassments. N.Y., 1896. $85.00 (orig. cloth, bindery
B, edges and corners lightly worn, endpapers lightly foxed)
--Julia Bride. N.Y., 1909. 1st ed. $45.00 (orig. cloth,
spine and covers lightly faded and worn, owner signature)
--The Letters of.... N.Y., 1920. 2 vols. $30.00 (spines
bit dull, clippings pasted to fly)
--Master Eustace. N.Y., 1920. $10.00 (cloth, light wear)
--Notes of a Son and Brother. N.Y., 1914. $100.00 (cloth)
--Picture and Text. N.Y., 1893. 1st ed. $65.00 (orig.
cloth, 1st binding, bottom edge untrimmed, top of spine
lightly frayed, pencilled inscription)
--The Pupil. Lond., (1916). $45.00 (orig. cloth, spine and
covers worn)
--Richard Olney and His Public Service. Bost., 1923. $20.00
--The Spoils of Poynton. Bost., 1897. $165.00 (orig. cloth,
spine lightly worn, pages browning, bookplate)
--Theatre and Friendship. N.Y., 1932. 1st ed. $20.00
(orig. cloth, spine lightly faded, edges lightly worn)
--The Turn of the Screw. N.Y., (1949). $15.00 (cloth)
James, Henry Gerlach--The Republics of Latin America. N.Y.,
1923. $8.00
James, James Alton--The Life of George Rogers Clark. Chi.,
(1929). $13.50 (ex-lib.), $10.00
James, Marquis--Alfred I. DuPont. Ind., (1941). $15.00
--Andrew Jackson. N.Y., 1937. $10.00
--Biography of a Business.... Ind., 1942. 1st ed. $25.00
--The Cherokee Strip. N.Y., 1946. $14.00
--The Life of Andrew Jackson. Ind., 1938. $15.00, $10.00
--Mr. Garner of Texas. Ind., (1939). 1st ed. $10.00
--The Texaco Story. N.p., 1953. $15.00, $12.50
James, Preston Everett--Brazil. N.Y., (1946). $10.00
--Latin America. N.Y., (1942). $8.50
James, Sydney V.--A People Among Peoples. Camb., 1963.
$12.50 (orig. cloth)
James, Thomas--Three Years Among the Indians and Mexicans.
S.L., 1916. $118.50 (one of 365 copies)
Chi., 1953. $15.00 (cloth)
N.Y., (1966). $16.00
James, Will--The Drifting Cowboy. N.Y., 1926. $17.50 (cloth
and boards a bit worn)
--Home Ranch. Cleve., 1945. $12.50

--Lone Cowboy. N.Y., 1945. $12.50 (front endpaper missing)
--Smoky, the Cow Horse. N.Y., 1929. $17.50 (cloth, gold
 flaked off spine, bookplate)
James, William, d. 1827--A Full and Correct Account of the
 Military Occurrences of the Late War Between Great Britain
 and the United States of America. Lond., 1818. 2 vols.
 $195.00 (recent binding)
James, William, 1842-1910--Human Immortality. Bost., 1898.
 1st ed. $25.00
--The Varieties of Religious Experience. N.Y., 1902. $12.50
 (backstrip and part of covers faded)
Jameson, Henry B.--Heroes by the Dozen. Abilene, 1961.
 $29.50 (inscribed and signed), $12.50 (signed by author)
Jameson, John Franklin--The History of Historical Writing in
 America. N.Y., 1961. $15.00 (cloth, one of 750 copies)
--Privateering and Piracy in the Colonial Period.... N.Y.,
 1923. $35.00
Jamison, James Carson--With Walker in Nicaragua. Columbia,
 Mo., 1909. 1st ed. $150.00 (cloth, ex-lib.)
Jamison, James Knox--By Cross and Anchor. Paterson, N.J.,
 (1946). $10.00 (inner hinges cracked)
Janney, Samuel Macpherson--The Life of William Penn....
 Phila., 1852. $35.00 (orig. calf)
Jansma, Marvin--A Wandering Malahini. N.Y., 1959. $12.50
Jaques, William Henry--The Establishment of Steel Gun Fac-
 tories in the United States. Annapolis, 1884. $100.00
Jardim, Anne--The First Henry Ford. Camb., (1970). $10.00
Jardine, James Tertius--Range Management on the National
 Forests. Wash., 1919. $35.00
Jarratt, Rie--Gutierrez de Lara. Austin, 1949. 1st ed.
 $45.00 (orig. cloth, ltd. ed.)
Jarrell, Randall--Little Friend, Little Friend. N.Y., 1945.
 $50.00 (cloth, lightly sunned)
--Pictures From an Institution. N.Y., 1954. $35.00 (cloth)
Jarves, James Jackson--History of the Hawaiian or Sandwich
 Islands. Bost., 1844. $200.00 (leather, bookplate)
 Honolulu, 1847. $600.00 (contemp. calf, occasional foxing)
Jarvis, Lucy Cushing--Sketches of Church Life in Colonial
 Connecticut. New Haven, Ct., 1902. $12.50 (backstrip
 faded and frayed)
Jay, Charles W.--My New Home in Northern Michigan. Tren-
 ton, N.J., 1874. 1st ed. $27.50 (cloth, binding a bit
 stained)
Jay, John--The Correspondence and Public Papers of....
 N.Y., (1890-93). 4 vols. 1st ed. $150.00 (orig. half
 leather, one of 750 numbered sets)

Jay, William--A Review of the Causes and Consequences of the
Mexican War. Bost., 1849. 1st ed. $25.00 (orig. cloth,
some foxing and spotting)
--A View of the Action of the Federal Government, in Behalf
of Slavery. Utica, 1844. $12.50
Jeffers, Robinson--Hungerfield, and Other Poems. N.Y.,
(1954). $50.00 (orig. cloth, lightly soiled)
--Solstice and Other Poems. N.Y., 1935. 1st ed. $250.00
(one of 320 copies, signed ed.)
Jefferson, Joseph--The Autobiography of.... N.Y., (1890).
$25.00 (covers soiled, ex-lib.)
Camb., 1964. $15.00
Jefferson, Mark Sylvester William--Peopling the Argentine
Pampa. N.Y., 1926. 1st ed. $8.50 (binding soiled)
Jefferson, T.H.--Map of the Emigrant Road.... S.F., 1945.
$85.00 (one of 300 copies)
Jefferson, Thomas--An Account of Louisiana, Laid Before
Congress.... Prov., (1804). $125.00 (boards, spine
nearly shot, hinges weak)
--The Jeffersonian Cyclopedia. N.Y., 1900. $25.00
--Selected Writings. N.Y., (1960). $7.50
--The Writings of.... Wash., 1903-04. 20 vols. $50.00
(three bindings lightly stained)
Wash., 1904-05. 20 vols. $200.00 (buckram, few hinges
cracked, light wear)
N.Y., (1967). $20.00 (boards, slipcased)
Jeffrey, John Mason--Adobe and Iron. La Jolla, (1970).
$18.50 (wraps., 2nd printing)
Jehl, Francis--Menlo Park Reminiscences. Dearborn, 1937-38.
2 vols. $50.00 (wraps.)
Jenkins, Howard Malcolm--Pennsyvlania.... Phila., (1903).
4 vols. $45.00 (one of 300 copies)
Phila., 1903. 3 vols. $30.00 (cloth, untrimmed)
Jenkins, John S.--Daring Deeds of American Generals. N.Y.,
1857. $17.50 (newly rebound)
Jenkins, Kathleen--Montreal, Island City of the St. Lawrence.
Garden City, 1966. $12.50
Jenkins, Stephen--The Greatest Street in the World. N.Y.,
1911. $35.00 (spine top a bit worn), $25.00 (cloth, a bit
rubbed)
Jenkinson, Isaac--Aaron Burr. Cleve., (1902). $45.00
Jenness, Diamond--Indians of Canada. (Ottawa, 1958).
$25.00
Jenness, John S.--Transcripts of Original Documents in the
English Archives, Relating to the Early History of New

Hampshire. N.Y., 1876. $10.00 (wraps., spine repaired, part of title clipped)

Jennewein, John Leonard--Clamity Jane of the Western Trails. Huron, S.D., (1953). 1st ed. $25.00 (wraps.), $22.50 (wraps.)

Jennings, Dean Southern--We Only Kill Each Other. Englewood Cliffs, (1967). $12.50

Jennings, Napoleon Augustus--A Texas Ranger. Dallas, 1930. $45.00 (Vincent Starrett's signature on title), $35.00

Jennings, William Dale--The Cowboys. N.Y., 1971. $8.50

Jensen, Andrew--Joseph Smith as a Prophet. (S.L.C., 1891). $25.00 (disbound)

Jensen, Christen--The Pardoning Power in the American States. Chi., 1922. $30.00 (cloth, rebound)

Jensen, Joan M.--The Price of Vigilance. Chi., (1968). 1st ed. $12.50

Jenson, Andrew--Day by Day With the Utah Pioneers, 1847. (S.L.C., 1897). $75.00 (orig. wraps.)

Jerome, Jerome Klapka--Stage-Land. N.Y., (1894). $40.00 (wraps., some dampstaining and browning)

Jessel, George Albert--Elegy in Manhattan. N.Y., (1961). $12.50

--Halo Over Hollywood. Van Nuys, Ca., (1963). $12.50

Jesuits, Letters From Missions (North America)--Relations des Jesuites Contenant ce qui s'est Passe de Plus Remarquable dans les Missions des Peres de la Compagnie de Jesus dans la Nouvelle-France. Quebec, 1858. 3 vols. $150.00

Jett, Stephen C.--Navajo Wildlands: "As Long as the Rivers Shall Run." S.F., (1967). 1st ed. $50.00

Jewett, Charles--A Forty Years' Fight With the Drink Demon.... N.Y., 1872. 1st ed. $12.50 (binding faded)

Jewett, Sarah Orne--Betty Leicester. Bost., 1890. $15.00 (1st issue, some binding stains, cloth, small gash on front hinge)

--A Country Doctor. Bost., 1884. 1st ed. $60.00 (orig. cloth, covers lightly scratched, owner name on pastedown)

--The Life of Nancy. Bost., 1895. 1st ed. $150.00 (inscribed, spine lightly rubbed, bookplate)

--Strangers and Wayfarers. Bost., 1891. $150.00 (2nd printing, orig. cloth, signed by author, covers bit soiled, spine edges worn, bookplate)

--The Tory Lover. Bost., 1901. $150.00 (orig. cloth, later printing, inscribed, two small worm holes at inner margin of front endpapers)

Jewitt, John Rodgers--Narrative of the Adventures and Sufferings of.... N.Y., (1815). $650.00 (orig. boards, some outer wear)
Jillson, Willard Rouse--The Land Adventures of George Washington. Lou., 1934. $35.00
Jobim, Jose--Brazil in the Making. N.Y., 1943. $8.00
Joblin, Maurice--Cincinnati Past and Present. Cinci., 1872. $450.00 (leather, front hinges show wear)
Joerg, Wolfgang Louis Gottfried--The Work of the Byrd Anarctic Expedition, 1928-1930. N.Y., 1930. $35.00 (orig. wraps.)
Johns, A. Wesley--The Man Who Shot McKinley. South Brunswick, 1970. $15.00
Johns, Edward Bradford--Camp Travis and Its Part in the World War
See under Title
Johnson, Allen, ed.--The Chronicles of America
See under Title
Johnson, Amanda--Georgia as a Colony and State. Atlanta, (1938). 1st ed. $20.00
Johnson, Amandus--The Swedish Settlements on the Delaware.... N.Y., 1911. 2 vols. $100.00 (orig. cloth)
Johnson, Andrew--Trial of Andrew Johnson.... Wash., 1868. 3 vols. 1st ed. $125.00 (cloth), $65.00 (binding edges chipped), $62.50
Johnson, Arthur Menzies--The Development of American Petroleum Pipelines. Ithaca, 1956. $12.00
Johnson, Augusta Phillips--A Century of Wayne County, Kentucky. (Evansville, Ind., 1972). $20.00
Johnson, Benj. F., pseud.--Neighborly Poems....
See: Riley, James Whitcomb
Johnson, Brita Elizabeth--Maher-Shalal-Hash-Baz. Claremont, Va., (1923). $15.00, $12.00 (backstrip replaced with library tape)
Johnson, Charles Albert--The Frontier Camp Meeting. Dallas, (1955). $30.00
Johnson, Charles Spurgeon--Shadow of the Plantation. Chi., 1941. $25.00 (proofroom copy)
Johnson, Claudius Osborne--Borah of Idaho. N.Y., 1936. 1st ed. $8.50 (spine faded)
Johnson, Clifton--Highways and Byways of New England. N.Y., 1915. $15.00 (cloth)
--Historic Hampshire in the Connecticut Valley. Springfield, Ma., (1932). $30.00 (rebound in cloth)
--The New England Country. Bost., 1893. $55.00 (cloth, joints starting to split)

--The Picturesque St. Lawrence. N.Y., 1910. $20.00
--The Rise of an American Inventor
 See: Maxim, Hudson
Johnson, Earl--Justice and Reform. N.Y., (1974). $10.00
Johnson, Emory Richard--Ocean and Inland Water Transporta-
 tion. N.Y., 1906. 1st ed. $12.50
Johnson, Gerald White--Andrew Jackson.... N.Y., 1928.
 $10.00
Johnson, Helen Kendrick--Woman and the Republic.... N.Y.,
 1913. $17.00
Johnson, Jack--Jack Johnson is a Dandy. N.Y., (1969). 1st
 ed. $12.50
Johnson, James Weldon--The Book of American Negro Spir-
 ituals.... N.Y., 1926. $39.00 (covers worn and bruised,
 some foxing)
Johnson, Kenneth M.--The New Almanden Quicksilver Mine.
 Georgetown, Ca., 1963. $24.50
Johnson, Lyndon Baines--To Heal and to Build. N.Y., (1968).
 $10.00
Johnson, Melvin Maynard--Freemasonry in America Prior to
 1750. (Camb., 1917). $30.00
Johnson, Merle DeVore--You Know These Lines! N.Y., 1935.
 $45.00 (orig. cloth, one of 1000 copies, signed by author)
Johnson, P. Adelstein--The First Century of Congregationalism
 in Iowa. (Cedar Rapids), 1945. $30.00
Johnson, Philip A.--Call Me Neighbor, Call Me Friend. Garden
 City, 1965. $12.50
Johnson, Richard W.--A Soldier's Reminiscences in Peace and
 War. Phila., 1886. 1st ed. $30.00 (presentation copy),
 $27.50
(Johnson, Robert)--Nova Britannia.... N.Y., 1867. $25.00
 (one of 250 copies, boards, uncut, backstrip worn)
Johnson, Robert L.--Texas Power and Light Company....
 N.p., (1973). $20.00
Johnson, Rossiter--Campfire and Battle-Field. N.Y., (1896).
 $35.00 (cloth, hinges starting, endpapers chipped, text
 slightly chipped)
--The Fight for the Republic. N.Y., 1917. $30.00, $20.00
Johnson, Roy P.--Jacob Horner of the Seventh Cavalry. Bis-
 marck, N.D., (1949). $5.00 (wraps.)
Johnson, Sam Houston--My Brother, Lyndon. N.Y., (1970).
 $10.00
Johnson, Walter--1600 Pennsylvania Avenue. Bost., (1960).
 1st ed. $10.00
Johnson, Willis Fletcher--History of the Johnstown Flood....
 (Phila.), 1889. $5.00

--Life of Wm. Tecumseh Sherman.... (Phila., 1891). $17.50
--The Red Record of the Sioux. (Phila.), 1891. $15.00
Johnston, Annie Fellows--The Little Colonel's Holidays. Bost.,
 1935. $10.00
Johnston, Bernice Eastman--California's Gabrielino Indians.
 L.A., 1962. $11.50 (boards)
Johnston, Elizabeth (Lichtenstein)--Recollections of a Georgia
 Loyalist. N.Y., 1901. 1st ed. $37.50 (new lib. binding,
 ex-lib.)
Johnston, Harry V.--My Home on the Range. St. Paul,
 (1942). $12.50 (presentation copy), $10.00
Johnston, Henry Alan--What Rights Are Left. N.Y., 1930.
 $8.50
Johnston, Henry Phelps--The Yorktown Campaign and the Sur-
 render of Cornwallis.... N.p., 1958. $8.50
Johnston, Johanna--Runaway to Heaven. Garden City, 1963.
 $14.00
Johnston, John--Diary Notes of a Visit to Walt Whitman and
 Some of His Friends.... Manchester, 1898. $50.00
Johnston, Leah Carter--San Antonio. San Antonio, 1947. 1st
 ed. $12.50 (signed by author and illustrator, cloth edges
 faded)
Johnston, Verna R.--Sierra Nevada. Bost., 1970. $12.50
Johnston, William Graham--Overland to California. Oakland,
 1948. $25.00 (one of 1000 copies)
Joinville, Francois Ferdinand Philippe Louis Marie d'Orleans--
 The Army fo the Potomac. N.Y., 1862. $12.50 (lacks
 wraps.)
Jonas, George--By Persons Unknown. Toronto, 1977. $12.00
Jones, Alvin Lincoln--Under Colonial Roofs. Bost., 1894. 1st
 ed. $37.50 (worn at corners, backstrip lightly stained)
Jones, Andrew A.--Jones's Digest. N.Y., 1835. $20.00
 (rubbed, faded and occasionally foxed, lacks spine top)
Jones, Anson--Letters Relating to the History of Annexation.
 Phila., 1852. $275.00
Jones, Charles Colcock--The Dead Towns of Georgia. Savan-
 nah, 1878. 1st ed. $125.00 (inscribed, orig. cloth, one
 of 250 copies)
Jones, Chester Lloyd--Caribbean Backgrounds and Prospects.
 N.Y., 1931. 1st ed. $17.50
Jones, Daniel Webster--Forty Years Among the Indians.
 S.L.C., 1890. 1st ed. $75.00 (bit of edge rubbing)
Jones, Douglas C.--The Court-Martial of George Armstrong
 Custer. N.Y., 1976. $14.50

Jones, Edgar Robert--Those Were the Good Old Days. N.Y.,
 1959. 1st ed. $40.00
Jones, Evan--Citadel in the Wilderness. N.Y., 1966. 1st ed.
 $15.00
Jones, Howard Mumford--History of the Contemporary. Madi-
 son, 1964. $15.00
--Ideas in America. Camb., (1944). 1st ed. $25.00
--The Life of Moses Coit Tyler. Ann Arbor, 1933. $20.00
--The Theory of American Literature. N.Y., (1965). $8.50
Jones, James--From Here to Eternity. N.Y., 1951. 1st ed.
 $175.00 (boards)
 Lond., 1952. $100.00
Jones, James Pickett--Black Jack. Tallahassee, 1967. $25.00
Jones, John Paul--John Paul Jones in Russia. Garden City,
 1927. $65.00 (one of 1001 numbered copies, unopened,
 tips rubbed), $20.00 (orig. boards, boxed, one of 1001
 copies)
Jones, Jonathan H.--Condensed History of the Apache and
 Comanche Indian Tribes. San Antonio, 1899. 1st ed.
 $485.00 (orig. cloth)
--Indianology
 See: Jones, Jonathan H.--Condensed History of the
 Apache....
Jones, Joseph Roy--Memories, Men and Medicine. (Sacramento),
 1950. $47.50
Jones, LeRoi--Preface to a Twenty-Volume Suicide Note. N.Y.,
 (1961). 1st ed. $10.00 (stiff wraps., lightly dampstained,
 1st state)
Jones, Nard--Evergreen Land. N.Y., 1947. $8.00 (ex-lib.,
 stamps)
Jones, Oakah L.--Pueblo Warriors and Spanish Conquest.
 Norman, 1966. $20.00
Jones, Paul John--The Irish Brigade. Wash., (1969). $15.00
Jones, Richard--Community in Crisis. Toronto, (1967). 1st
 ed. $6.00
Jones, Robert Huhn--The Civil War in the Northwest. Norman,
 (1960). $20.00
Jones, Rufus Matthew--A Small-Town Boy. N.Y., 1941. 1st
 ed. $7.50
Jones, Sam--Sermons by Sam Jones.... Chi., n.d., $10.00
 (wraps.)
Jones, Thomas H.--The Experience of Thomas H. Jones....
 New Bedford, Ma., 1871. $20.00 (orig. wraps.)
Jones, Uriah James--History of the Early Settlement of the

Juniata Valley. Phila., 1856. 1st ed. $75.00 (orig. cloth),
$50.00 (rebound)
Harrisburg, Pa., 1889. $45.00 (orig. cloth)
Harrisburg, Pa., 1940. $35.00 (orig. cloth)
Jones, Virgil Carrington--Gray Ghosts and Rebel Raiders.
N.Y., 1958. $20.00
Jones, William A.--Report Upon the Reconnaissance of North-
western Wyoming. Wash., 1875. $210.00
Jordan, David Starr--American Food and Game Fishes....
N.Y., 1905. $40.00 (cloth)
Jordan, Donaldson--Europe and the American Civil War. Bost.,
1931. 1st ed. $22.50, $15.00 (cloth, ex-lib.)
Jordan, Grace (Edgington)--Home Below Hell's Canyon. N.Y.,
(1954). $12.50 (signed by author)
Jordan, John--Serious Actual Dangers of Foreigners and For-
eign Commerce, in the Mexican States. Phila., 1826.
$125.00
Jordan, Philip Dillon--The National Road. Ind., (1948). 1st
ed. $13.00
Jordan, Thomas--The Campaigns of Lieut.-Gen. N.B. For-
rest.... S.F., 1868. 1st ed. $100.00 (binding worn and
cracking)
Joseph, Alice--The Desert People. Chi., (1949). 1st ed.
$37.50
Josephs, Ray--Argentine Diary. N.Y., (1944). $12.50 (tape
marks on cover)
Josephson, Emanuel Mann--The Strange Death of Franklin D.
Roosevelt. N.Y., (1948). 1st ed. $12.50
Josephson, Hannah (Geffen)--The Golden Threads. N.Y.,
(1949). 1st ed. $20.00, $15.00
Josephson, Matthew--Infidel in the Temple. N.Y., 1967.
$10.00
--The Money Lords.... N.Y., (1972). $15.00
--The Robber Barons. N.Y., (1934). 1st ed. $10.00
N.Y., (1962). $5.00 (wraps.)
Josephy, Alvin M.--The Nez Perce Indians and the Opening
of the Northwest.
New Haven, 1965. 1st ed. $45.00
Joslin, Theodore Goldsmith--Hoover Off the Record. N.Y.,
1934. $9.50
Joughin, George Louis--The Legacy of Sacco and Vanzetti.
N.Y., 1948. 1st ed. $17.50 (presentation from author)
Jourdain, Vital--The Heart of Father Damien.... Milwaukee,
(1955). $8.50
Journal du Siege de Quebec.... 1759. Quebec, 1922. $65.00
(one of 200 numbered copies)

Journals of the Military Expedition of Major General John Sullivan. Auburn, 1887. $50.00 (cloth, somewhat scratched)
Joutel, Henri--Joutel's Journal.... Albany, N.Y., 1906. $65.00 (boards)
Joyce, Mary Hinchcliffe--Pioneer Days in the Wyoming Valley. (Phila., 1928). $25.00
Judd, A.N.--Campaigning Against the Sioux. N.Y., 1973. $12.50 (one of 500 copies)
Judd, Gerrit Parmele--Hawaiian Anthology. N.Y., (1967). $12.00
Judd, Henry Pratt--The Hawaiian Language. Honolulu, 1939. 1st ed. $20.00
Honolulu, 1943. $12.00 (bottom margin stained)
--Introduction to the Hawaiian Language.... Honolulu, 1945. $20.00
Judd, Laura Fish--Honolulu. Honolulu, 1928. 1st ed. $40.00
Chi., 1966. $16.00, $15.00, $12.50
Judd, Mary Catherine--Wigwam Stories. Bost., 1915. $10.00
Judd, Neil Merton--Archeological Observations North of the Rio Colorado. Wash., 1926. $20.00
Judd, Silas--A Sketch of the Life and Voyages of Captain Alvah Dewey. Chittenango, 1838. 1st ed. $850.00 (orig. boards)
Judson, Katherine Berry--Early Days in Old Oregon. Chi., 1916. 1st ed. $25.00 (spot on front cover)
Portland, Or., 1935. $17.50
--Montana, "the Land of Shining Mountains." Chi., 1918. $17.50
--Myths and Legends of California and the Old Southwest. Chi., 1912. 1st ed. $40.00 (cloth)
Judson, Lyman Spicer--Let's Go to Guatemala. N.Y., (1949). $8.50
Juettner, Otto--1785-1909. Daniel Drake and His Followers. Cinci., (1909). $75.00
Julien, Carl Thomas--Beneth So Kind a Sky.... Columbia, S.C., 1947. $20.00

- K -

Kaempffert, Waldemar Bernhard--A Popular History of American Invention.... N.Y., 1924. 2 vols. 1st ed. $50.00
Kahn, Edgar Myron--Cable Car Days in San Francisco. Stanford, (1945). $10.00
Kahn, Morton Charles--Djuka. N.Y., 1931. 1st ed. $12.50

Kaho, Noel--The Will Rogers Country. Norman, 1941. 1st
 ed. $15.00 (boards, signed)
Kalmbach, Albert Carpenter--Railroad Panorama. Milwaukee,
 1944. $12.50 (small ink mark on bottom of front cover)
Kamakau, Samuel Manaikalani--Ruling Chiefs of Hawaii. Hono-
 lulu, (1961). $25.00
Kamehameha IV, King of the Hawaiian Islands--The Journal
 of Prince Alexander Liholiho. (Hololulu), 1967. $8.00
 (ex-lib.)
Kane, Harnett Thomas--Bride of Fortune. Garden City, 1948.
 1st ed. $8.50, $7.50 (front endpaper missing)
--The Golden Coast. N.Y., (1959). $12.50
--Gone Are the Days. N.Y., 1960. 1st ed. $15.00, $15.00
--Natchez on the Mississippi. N.Y., 1947. $20.00
 N.Y., 1950. $6.00 (cloth, spot on front cover)
--Queen New Orleans. N.Y., 1949. $13.50, $12.50, $10.00
 $6.00 (Bonanza)
--Spies for the Blue and Gray. Garden City, (1954). $20.00
 (presentation copy), $12.50, $12.50 (owner name), $12.50
Kane, John Francis--Picturesque America. N.Y., 1925. 1st
 ed. $25.00 (bit of cover edge wear)
Kane, John Joseph--Catholic-Protestant Conflicts in America.
 Chi., 1955. $12.50
Kane, Paul--Paul Kane's Frontier. Austin, 1971. 1st ed.
 $125.00
Kane, Thomas Leiper--The Private Papers and Diaries of....
 S.F., 1937. $42.50
Kansas State Historical Society--History of Kansas Newspa-
 pers.... Topeka, 1916. $25.00
Kantor, MacKinlay--Missouri Bittersweet. Garden City, 1969.
 $10.00
--The Romance of Rosy Ridge. N.Y., (1937). $10.00 (two
 pages browned, cloth)
Kaplan, Justin--Mr. Clemens and Mark Twain. N.Y., (1966).
 1st ed. $16.00, $12.50
Karnes, Thomas L.--The Failure of Union. Chapel Hill, (1961).
 1st ed. $12.50
Karolevitz, Robert F.--Newspapering in the Old West. Seattle,
 1965. 1st ed. $17.50
 N.Y., (1965). $12.50
Karsner, David--Andrew Jackson, the Gentle Savage. N.Y.,
 1929. $20.00
Kaser, David--Messrs. Carey & Lea of Philadelphia.... Phila.,
 (1957). $20.00
Kasner, David--John Brown, Terrible Saint. N.Y., 1934.
 $20.00

--Silver Dollar. N.Y., (1932). $15.00, $10.00 (spine fading)
N.Y., (1952). $6.50
Kastrup, Allan--The Swedish Heritage in America. St. Paul,
1975. $25.00
Katcher, Leo--The Big Bankroll. N.Y., (1959). 1st ed.
$10.00 (rubbed)
Katz, Leonard--Uncle Frank. N.Y., (1973). 1st ed. $15.00
Kaufman, Henry J.--Early American Gunsmiths.... Harris-
burg, Pa., (1952). $15.00 (bookplate, owner name)
Kavaler, Lucy--The Astors. N.Y., (1966). $12.50
Kavanaugh, Ethel--Wilderness Homesteaders. Caldwell, (1951).
$13.00
Kean, Robert Garlic Hill--Inside the Confederate Government.
N.Y., 1957. 1st ed. $15.00
Kearny, John Watts--Sketch of American Finances.... N.Y.,
1887. 1st ed. $14.00 (lacks free endpaper)
Keating, Bern--The Flamboyant Mr. Colt and His Deadly Six-
Shooter. Garden City, 1978. $24.50, $15.00 (boards)
--An Illustrated History of the Texas Rangers. Chi., 1975.
1st ed. $22.50
--The Northwest Passage. Chi., (1970). $15.00
Keating, Cecil A.--Keating and Forbes Families of C.A. Keat-
ing.... Dallas, 1920. $100.00 (author's presentation copy,
orig. cloth)
Keating, Paul W.--Lamps for a Brighter America. N.Y., 1954.
$16.00, $12.50
Keats, John--Howard Hughes. N.Y., (1966). 1st ed. $10.00
Keckley, Elizabeth (Hobbs)--Behind the Scenes. N.Y., 1868.
1st ed. $30.00 (binding faded, ends of spine frayed)
Keeler, Charles Augustus--San Francisco and Thereabout.
S.F., 1903. $5.00 (cloth, waterstain top of pages, covers
worn)
Keen, Benjamin--David Curtis DeForest and the Revolution of
Buenos Aires. New Haven, 1947. 1st ed. $10.00
Keep, Austin Baxter--The Library in Colonial New York.
N.Y., 1970. $20.00 (cloth)
Kefauver, Estes--In a Few Hands. N.Y., (1965). 1st ed.
$12.50
Keim, De Benneville Randolph--Sheridan's Troopers on the
Borders. Phila., 1870. 1st ed. $50.00 (lacks front fly,
spine tips frayed, corner wear)
Keith, Charles Penrose--Chronicles of Pennsylvania.... Phila.,
1917. 2 vols. $40.00
--The Provincial Councillors of Pennsylvania.... Phila., 1883.
$75.00 (rebound, untrimmed)

Keithley, Ralph--Buckey O'Neill.... Caldwell, 1949. $40.00
Keleher, Julia--The Padre of Isleta. Santa Fe, (1940). $27.50
(presentation copy)
Keleher, William Aloysius--The Fabulous Frontier. Santa Fe,
(1945). 1st ed. $95.00, $35.00 (ex-lib., one of 500 cop-
ies)
Albuquerque, (1962). $22.50 (ex-lib., bookplate)
--Maxwell Land Grant. Santa Fe, 1942. 1st ed. $200.00
(orig. cloth), $135.00 (cloth)
--Memoirs, 1892-1969. Santa Fe, (1969). 1st ed. $22.50
(bookplate, owner name)
--Turmoil in New Mexico.... Santa Fe, (1952). 1st ed.
$60.00
--Violence in Lincoln County. Albuquerque, (1957). 1st ed.
$75.00, $60.00
Kelker, Luther Reily--History of Dauphin County, Pennsyl-
vania. N.Y., 1907. 3 vols. $175.00 (three quarter calf)
Keller, Allan--Thunder at Harper's Ferry. Englewood Cliffs,
(1958). $20.00
Keller, George--A Trip Across the Plains, and Life in Cali-
fornia. Oakland, (1955). $37.50 (one of 500 copies)
Keller, Helen--The World I Live In. N.Y., 1908. 1st ed.
$15.00
Keller, Robert Brown--History of Monroe County, Pennsyl-
vania. Stroudsburg, Pa., 1927. $40.00
Keller, Weldon Phillip--Under Desert Skies. Toronto, (1968).
1st ed. $12.50
--Under Wilderness Skies. Toronto, (1966). 1st ed. $12.50
Kelley, C.A.--Glimpses of the Far West. (N.p., 1902).
$50.00 (orig. cloth)
Kelley, Hall Jackson--A Geographical Sketch of That Part of
North America Called Oregon. Bost., 1830. 1st ed.
$2500.00 (orig. wraps., uncut, ex-lib., lightly foxed, in-
scribed)
--Hall J. Kelley on Oregon. Princeton, 1932. $43.50
--A Narrative of Events and Difficulties in the Colonization
of Oregon.... Bost., 1852. 1st ed. $2500.00 (orig.
wraps., chipped, ex-lib., slipcased)
Kelley, John Francis--A Treatise on the Law of Contracts of
Married Women. Jersey City, N.J., 1882. $75.00 (rubbed,
leather)
Kelley, Thomas P.--The Fabulous Kelley. Don Mills, 1974.
$20.00 (cloth)
Kellner, Bruce--Carl Van Vechten and the Irreverent Decades.
Norman, 1968. $17.50

Kellner, Ester--Moonshine. Ind., (1971). $10.00
Kellock, Harold--Houdini, His Life Story. N.Y., (1928).
 $25.00 (spine dull and lightly worn)
Kellogg, Harold--Indians of the Southwest. Chi., (1936).
 $10.00 (boards, covers rubbed, edge wear)
Kellogg, John Azor--Capture and Escape. Madison, 1908.
 $25.00 (minor soiling)
Kellogg, Louise Phelps--The French Regime in Wisconsin....
 Madison, 1925. 1st ed. $35.00
Kellogg, Miner Kilbourne--Texas Journal, 1872. Austin,
 (1967). $16.50, $10.00
Kellogg, Robert H.--Life and Death in Rebel Prisons. Hart.,
 1865. 1st ed. $49.50 (orig. cloth, worn, back inside
 hinge cracked, foxed)
 Hart., 1866. $10.00
 Hart., 1867. $12.50
Kelly, Charles--Holy Murder. N.Y., (1934). $65.00
--Old Greenwood. S.L.C., 1936. 1st ed. $150.00 (ltd. to
 350 copies, bookplate)
--Outlaw Trail. S.L.C., 1938. 1st ed. $100.00 (one of
 1000 copies)
 N.Y., 1959. $20.00
--Salt Desert Trails. S.L.C., 1930. 1st ed. $75.00, $68.50
Kelly, Daniel T.--The Buffalo Head. Santa Fe, 1972. $25.00
Kelly, Fanny (Wiggins)--Narrative of My Captivity Among the
 Sioux Indians. Hart., 1871. 1st ed. $35.00 (stain on
 lower corner of a few pages)
 Toronto, 1872. $65.00 (spine tips chipped, back hinge
 weak)
Kelly, Francis Clement--Blood-Drenched Altars. Milwaukee,
 (1935). $20.00 (ex-lib.)
Kelly, Fred Charters--One Thing Leads to Another. Bost.,
 1936. $10.00
Kelly, George E.--Allegheny County.... Pitts., 1938. $12.50
Kelly, George Henderson--Legislative History. Arizona....
 Phoenix, 1926. $32.50
Kelly, Hank
 See: Kelly, Henry Warren
Kelly, Henry Warren--Dancing Diplomats. (Albuquerque, 1950).
 $8.50, $7.50
Kelly, John Frederick--The Early Domestic Architecture of
 Connecticut. New Haven, 1935. $50.00
Kelly, Lawrence C.--The Navajo Indians and Federal Indians
 Policy.... Tucson, (1968). $17.50
--Navajo Roundup. Boulder, Co., (1970). $17.50

Kelly, Leroy Victor--The Range Men. Toronto, 1980. $25.00
(pictorial cards laid over cloth)
Kelly, William--A Stroll Through the Diggings of California.
Oakland, 1950. $25.00 (one of 750 copies), $15.00 (fore-
edge of covers lightly stained, one of 750 copies)
Kelly, William H.--Policing in Canada. Toronto, 1976. $25.00
Kelsey, Albert--Yucatecan Sights and Sounds. Phila., 1919.
$20.00
Kelsey, Vera--Seven Keys to Brazil. N.Y., 1940. $12.50
Kemble, Fanny
See: Kemble, Francis Anne
Kemble, Frances Anne--Journal of a Residence on a Georgia
Plantation in 1838-1839. Lond., 1863. $75.00 (three-
quarter morocco, bookplates)
Kemble, John Haskell, ed.--Journal of a Cruise to California....
See: Myers, William M.
--The Panama Route, 1848-1869. Berkeley, 1943. 1st ed.
$20.00
Kemnitzer, William J.--Rebirth of Monopoly. N.Y., 1938.
$16.00
Kemp, Ben W.--Cow Dust and Saddle Leather. Norman, (1968).
$25.00
Kemp, Louis Wiltz--The Battle of San Jacinto.... (Houston,
1947). $20.00 (signed)
--The Signers of the Texas Declaration of Independence.
Houston, 1944. 1st ed. $45.00 (cloth, some sigs. loose,
bookplate, owner name, one of 500 copies)
Kendall, Amos--Letters to John Quincy Adams. Lexington,
Ky., 1823. $45.00 (later three-quarter leather)
Kendall, George Wilkins--Letters From a Texas Sheep Ranch.
Urbana, 1959. $15.00
--Narrative of the Texan Santa Fe Expedition. N.Y., 1844.
2 vols. 1st ed. $350.00 (cloth, cover wear, a few page
stains)
Chi., 1929. $20.00
Kendall, Isabelle Carpenter--Across the Continent.... Seattle,
1911. $15.00 (wraps. chipped and a bit soiled)
Kenly, John Reese--Memoirs of a Maryland Volunteer. Phila.,
1873. 1st ed. $35.00 (front fly torn and part missing,
hinges weak)
Kennan, George--E.H. Harriman. Bost., 1922. 2 vols. 1st
ed. $50.00
Kennedy, Dan--Recollections of an Assinibone Chief. Toronto
1972. $7.50

Kennedy, John Fitzgerald--As We Remember Joe. Camb.,
1945. $1000.00 (cloth, some shelf wear, two newspaper
clippings laid in), $875.00 (1st printing)
--The Burden and the Glory. N.Y., (1964). $15.00 (cloth,
ex-lib.)
--Sam Houston & the Senate. Austin, 1970. $20.00
Kennedy, Joseph Patrick--I'm for Roosevelt. N.Y., (1936).
$10.00
--The Story of the Films. Chi., 1927. $50.00 (cover lightly
worn)
Kennedy, Marguerite (Wallace)--My Home on the Range. Bost.,
1951. $7.50 (ex-lib. stamps, cover soil and edge wear)
Kennedy, Mary Jeanette--Tales of a Trader's Wife. Albuquer-
que, 1965. $17.50 (signed by author)
--"The Wind Blows Free".... (Albuquerque), 1970. $17.50
(cloth, signed)
Kennedy, Michael Stephen, ed.--The Assinibones
See: Writers' Program
--Cowboys and Cattlemen. N.Y., (1964). $25.00
Kennedy, Millard Fillmore--Schoolmaster of Yesterday, N.Y.,
(1940). $15.00
Kennell, Ruth Epperson--Theodore Dreiser and the Soviet
Union.... N.Y., (1969). $20.00
Kenner, Charles L.--A History of New Mexican-Plains Indian
Relations. Norman, (1969). $17.50
Kennerly, William Clark--Persimmon Hill. Norman, 1948. 1st
ed. $15.00
Norman, 1949. $7.50
Kennon, Bob--From the Pecos to the Powder. Norman, (1965).
$25.00
Kenny, Hamill--West Virginia Place Names.... Piedmont, W.V.,
1945. $60.00
Kenny, Michael--Romance of the Floridas. N.Y., (1934).
1st ed. $20.00
Kenosha County in the Twentieth Century. (Kenosha, Wi.),
1976. $20.00
Kenrick, William--The American Silk Growers Guide. Bost.,
1839. $47.50 (orig. cloth)
Kent, Donald H.--The French Invasion of Western Pennsyl-
vania, 1753. Harrisburg, 1954. $7.50 (wraps.)
Kent, Dorman Bridgman Eaton--Vermonters. (Montpelier),
1937. $6.00
Kent, Kate Peck--The Story of Navaho Weaving. Phoenix,
1961. 1st ed. $7.50

Kent, Rockwell--It's Me, O Lord. N.Y., (1955). 1st ed.
$35.00 (ex-lib.)
--Wilderness. N.Y., (1937). $35.00
Kenton, Edna--Simon Kenton.... Garden City, 1930. 1st
ed. $27.50
Kephart, Horace--Our Southern Highlanders. N.Y., (1914).
$15.00 (cloth, light wear to cover)
Ker, Henry--Travels Through the Western Interior of the
United States. Elizabethtown, N.J., 1816. 1st ed.
$485.00 (1st issue)
Kerber, Linda K.--Federalists in Dissent.... Ithaca, (1970).
$20.00
Kerby, Robert Lee--The Confederate Invasion of New Mexico
and Arizona.... L.A., 1958. $27.50 (one of 850 copies)
--Kirby Smith's Confederacy. N.Y., 1972. $25.00
Kerney, James--The Political Education of Woodrow Wilson.
N.Y., 1926. $20.00
Kerouac, Jack--On the Road. N.Y., 1957. 1st ed. $250.00,
$175.00 (clo.h, name on endpaper)
N.Y., 1959. $10.00 (stiff wraps., paperback)
Kerr, Charles--History of Kentucky. Chi., 1922. 5 vols.
$90.00 (ex-lib. stamps)
Kerr, Robert S.--Land, Wood, and Water. N.Y., (1960).
1st ed. $7.25
Kersey, Ralph T.--History of Finney County, Kansas. N.p.,
1950-54. 2 vols. $50.00
Kessell, John L.--Friars, Soldiers, and Reformers. Tucson,
1976. $20.00 (corners lightly bumped)
--Mission of Sorrows. Tucson, (1970). $20.00 (cloth)
Kessler, Henry Howard--Peter Stuyvesant and His New York.
N.Y., (1959). $20.00
Ketcham, Byran E.--Covered Bridges on the Byways of In-
diana. (Lockland, Oh., 1949). 1st ed. $35.00 (signed
and numbered ed.)
Ketchum, Alton--Uncle Sam. N.Y., (1959). 1st ed. $12.50
Ketchum, Richard M., ed.--The American Heritage Picture
History of the Civil War
See: Catton, Bruce
Kettell, Russell Hawes--The Pine Furniture of Early New Eng-
land. Garden City, 1929. 1st ed. $45.00 (some damp-
staining on back cover and a few leaves, one of 999 copies)
Keyes, Erasmus Darwin--From West Point to California. Oak-
land, (1950). $20.00, $15.00
Keyes, Frances Parkinson--Steamboat Gothic. N.Y., (1952).
1st ed. $7.50

Keyes, Nelson Beecher--America's National Parks. N.Y.,
 (1957). $7.50
--The Real Book About Our National Parks. Garden City,
 (1957). 1st ed. $7.50
Keynes, John Maynard--The Economic Consequences of the
 Peace. N.Y., 1920. $6.00 (worn)
Kidder, Alfred Vincent--Archeological Explorations in North-
 eastern Arizona. Wash., 1919. 1st ed. $27.50
--The Artifacts of Pecos. New Haven, 1932. 1st ed. $65.00
--An Introduction to the Study of Southwestern Archaeology.
 New Haven, 1924. 1st ed. $65.00
--Pecos Explorations in 1924. (Santa Fe), 1931. $3.50
--The Story of the Pueblo of Pecos. (Santa Fe), 1951. $5.00
 (one of 2000 copies)
Kidder, Daniel Parish--Brazil and the Brazilians. Phila., 1857.
 1st ed. $50.00 (half calf, spine scuffed)
 Bost., 1968. $42.50 (extremities rubbed)
Kidder, Frederic--History of the Boston Massacre.... Albany,
 1870. 1st ed. $30.00 (boards)
Kidder, Glen M.--Railway to the Moon. Littleton, N.H.,
 (1969). $15.00 (one of 1500 numbered copies)
Kieran, John--A Natural History of New York City., Bost.,
 1959. 1st ed. $12.50 (cloth, 1st printing)
Kiger, Joseph Charles--American Learned Societies. Wash.,
 (1963). $5.00 (cloth, ex-lib.)
Kilbourne, Frederick Wilkinson--Chronicles of the White Moun-
 tains. Bost., (1922). $10.00
Kile, Orville Merton--The Farm Bureau Movement. N.Y.,
 1921. $20.00
Killebrew, Joseph Buckner--Tennessee. Nash., 1879. $20.00
 (orig. wraps., ex-lib.)
Kilman, Edward W.--Cannibal Coast. San Antonio, (1959).
 1st ed. $17.50
--Hugh Roy Cullen. N.Y., (1954). $9.00
Kilmer, Joyce--Trees. N.Y., (1925). $35.00 (orig. boards,
 covers lightly worn)
Kilpatrick, Jack Frederick--Friends of Thunder.... Dallas,
 (1964). 1st ed. $15.00 (cloth), $12.50
--The Shadow of Sequoyah. Norman, (1965). 1st ed. $12.50
Kilty, John--The Land-Holder's Assistant, and Land-Officer's
 Guide. Balt., 1808. 1st ed. $150.00 (half morocco)
Kimball, Maria Porter (Brace)--A Soldier-Doctor of Our Army....
 Bost., 1917. $100.00 (signed)
Kimmel, Stanley Preston--Mr. Davis' Richmond. N.Y., (1958).
 $20.00

--Mr. Lincoln's Washington. N.Y., (1957). $10.00
Kincaid, Robert Lee--The Wilderness Road. Ind., (1947).
 1st ed. $25.00, $12.50, $12.50
Kinch, Raymond Clark--Nebraska Weeds. Lincoln, 1953.
 $7.00 (wraps.)
Kinchen, Oscar Arvle--Daredevils of the Confederate Army.
 Bost., (1959). 1st ed. $20.00
Kinder, Francis Shanor--Evenings With Colorado Poets. Den-
 ver, 1894. 1st ed. $12.50 (cover spots)
King, Charles--Campaigning With Crook, and Stories of Army
 Life. N.Y., 1890. $35.00 (cloth, spine tip fray, bit of
 corner wear)
--The True Ulysses S. Grant. Phila., 1914. $17.50 (cloth)
--A War-Time Wooing. N.Y., (1888). $20.00 (cloth)
King, Clarence--Mountaineering in the Sierra Nevada. N.Y.,
 1907. $22.50
 N.Y., (1935). $10.00
King, Coretta Scott--My Life With Martin Luther King, Jr.
 N.Y., 1969. 1st ed. $25.00, $15.00 (cloth, signed)
King, Ernest Joseph--Fleet Admiral King.... N.Y., (1952).
 1st ed. $17.50
King, Frank Marion--Wranglin' the Past.... L.A., 1935. 1st
 ed. $95.00 (author's presentation copy)
King, Grace--New Orleans, the Place and the People. N.Y.,
 1896. $17.50 (spine tips slightly frayed)
King, Horatio--Tuning on the Light. Phila., 1895. $12.50
 (binding wear at extremities)
King, James T.--War Eagle. Lincoln, (1963). $15.00
King, Leonard--Port of Drifting Men. San Antonio, 1945.
 $10.00
King, Martin Luther--Stride Toward Freedom. N.Y., (1958).
 $25.00 (two newspaper clippings pasted in at rear, boards,
 faded spine)
King Ranch; 100 Years of Ranching. (Corpus Christi), 1953.
 $40.00, $30.00 (bit of cover soil), $27.50
King, Rosa Eleanor--Tempest Over Mexico. Bost., 1935. 1st
 ed. $12.50
 Bost., 1936. $10.00 (top edges of pages water stained)
 N.Y., 1944. $9.00
King, Roy David--Albany: Birth of a Prison. Lond., 1977.
 $17.50
King, Thomas Starr--The White Hills. N.Y., 1870. $300.00
 (half leather and marbled boards, front matter lightly
 dampstained along fore-edge, a bit rubbed)
King, Willard Leroy--Melville Weston Filler.... Chi., (1967).
 $5.00

King, William C.--Camp-Fire Sketches and Battlefield Echoes
of 61-5. Springfield, Ma., 1888. $17.50 (cloth, bottom
spine worn, cover stains, front hinge cracked, newspaper
clippings pasted to endpapers and flys)
Kingman, Bradford--History of North Bridgewater.... Bost.,
1866. $100.00 (leather, lightly rubbed, light foxing)
Kingsbury, George Washington--History of Dakota Territory.
Chi., 1915. 5 vols. 1st ed. $450.00 (half morocco)
Kingsley, Charles, ed.--South by West
See: (Kingsley, Rose Georgina)
(Kingsley, Rose Georgina)--South by West. Lond., 1874.
$75.00 (leather and boards, ex-lib. marks, front hinge
starting)
Kinietz, Vernon--Chippewa Village. (Bloomfield Hills, Mi.,
1947). 1st ed. $30.00
Kinkead, Elizabeth Shelby--A History of Kentucky, N.Y.,
(1896). 1st ed. $16.00
Kinnaird, Lawrence--The Frontiers of New Spain
See: Lafora, Nicolas de
Kinnell, Galway--Body Rags. Bost., 1968. 1st ed. $35.00
(cloth and boards)
Kinney, Jay P.--A Continent Lost--a Civilization Won. Balt.,
1937. 1st ed. $20.00 (ex-lib.)
Kino, Eusebio Francisco--Historical Memoir of Primeria Alta.
Cleve., 1919. 2 vols. $225.00 (orig. cloth, ex-lib., one
of 750 sets)
--Kino's Plan for the Development of Primeria Alta.... Tucson,
1961. $55.00 (cloth, one of 500 copies)
--Kino Reports to Headquarters.... Rome, 1954. $55.00
(wraps.)
Kinsbruner, Jay--Diego Portales. The Hague, 1967. $15.00
(ex-lib.)
Kinsley, D.A.--Favor the Bold. N.Y., 1967-68. 2 vols. 1st
ed. $37.50 (boards)
Kinzie, Juliette Augusta (Magill)--Wau-Bun.... Chi., (1901).
$15.00 (cloth, spine tip and corner worn), $15.00
Chi., 1932. $12.50 (spot on spine)
Kip, Leonard--California Sketches.... Albany, 1850. 1st
ed. $1000.00 (later half calf)
L.A., 1946. $20.00, $12.50 (one of 750 copies)
Kip, William Ingraham--Early Days of My Episcopate. Berk-
eley, 1954. $25.00 (one of 500 copies)
--The Early Jesuit Missions in North America.... N.Y., 1847.
2 vols. in 1. $100.00 (contemp. half morocco)
Albany, 1866. $25.00 (lacks maps)

Kipnis, Ira--The American Socialist Movement, 1897-1912.
N.Y., 1952. 1st ed. $17.50

Kipp, J.B.--The Colorado River. L.A., 1950. $45.00 (one
of 180 copies)

Kirk, Ruth F.--Introduction to Zuni Fetishism. Santa Fe,
1943. $12.50

Kirker, Harold--Bulfinch's Boston, 1787-1817. N.Y., 1964.
$22.50

Kirkland, Caroline Matilda (Stansbury)--Autumn Hours and
Fireside Reading. N.Y., 1856. $12.50

Kirkland, Edward Chase--Charles Francis Adams, Jr....
Camb., 1965. $15.00 (orig. cloth)
--A History of American Economic Life. N.Y., 1939. $12.00
(lacks fly)
--Industry Comes of Age. N.Y., 1961. 1st ed. $17.50
Chi., 1967. $4.00

Kirkland, Frazar, pseud.
See: Devens, Richard Miller

Kirkpatrick, Thomas Jefferson--The Kirkpatrick Story. Oak-
land, 1954. $12.50 (front cover stained)

Kirsch, Robert R.--West of the West. N.Y., 1967. $15.00,
$15.00

Kirschten, Ernest--Catfish and Crystal.... Garden City,
1960. 1st ed. $16.50

Kirwan, A.D., ed.--Johnny Green of the Orphan Brigade
See: Green, John Williams

Kirwan, John S.--Patrolling the Santa Fe Trail. (Topeka,
1955). $7.50

Kitter, Glenn D.--Hail to the Chief! Phila., 1965. $10.00

Kittredge, Henry Crocker--Cape Cod. Bost., 1930. 1st ed.
$15.00

Klah, Hasteen--Navajo Creation Myth. Santa Fe, 1942. 1st
ed. $85.00 (one of 1000 copies)

Klauber, Laurence Monroe--Taxonomic Studies of the Rattle-
snakes of Mainland Mexico. San Diego, 1952. $7.50
(wraps., a few pages damp cockled)

Klein, Benjamin Franklin--The Ohio River Handbook and Pic-
ture Album. Cinci., (1958). $20.00

Klein, Frederic Shriver--Lancaster County Since 1841. Lan-
caster, Pa., 1955. $12.50

Klein, Harry Martin John--The History of the Eastern Synod
of the Reformed Church in the U.S. (Lancaster, Pa.),
1943. $35.00, $25.00
--Lancaster County, Pennsylvania. N.Y., 1924. 4 vols.
$140.00 (half leather)

Klein, Henry H.--Dynastic America, and Those Who Own It.
N.Y., (1921). $7.00 (underlining)
--Politics, Government, and the Public Utilities in New York
City. (N.Y., 1933). $25.00 (inscribed, cloth, a bit soiled)
Klement, Frank L.--The Copperheads in the Middle West. Chi.,
1960. $21.95
Klett, Guy Souillard--Presbyterians in Colonial Pennsylvania.
Phila., 1937. $30.00
Klette, Ernest--The Crimson Trail of Joaquin Murieta. L.A.,
(1928). 1st ed. $17.50
Klinck, Richard E.--Land of Room Enough and Time Enough.
Albuquerque, (1953). 1st ed. $20.00
Albuquerque, (1958). $10.00 (covers stained, pages
browned)
Klitgaard, Kaj--Through the American Landscape. Chapel
Hill, (1941). $15.00
Klockars, Carl B.--The Professional Fence. N.Y., (1974).
$10.00
Kluckhohn, Clyde--Beyond the Rainbow. Bost., (1933).
$27.50
--A Bibliography of the Navaho Indians. N.Y., (1940). 1st
ed. $45.00
--The Navaho. Camb., (1946). 1st ed. $27.50 (name erased),
$18.00
Camb., 1958. $10.00
--Navaho Material Culture. Camb., 1971. $55.00
--Navaho Witchcraft. Bost., n.d. $10.00
--To the Foot of the Rainbow. N.Y., 1927. $27.50 (cloth)
Lond., 1928. $17.50 (cloth, few cover spots)
Knapsack and Rifle
See: (Patrick, Robert W.)
Knauth, Oswald Whitman--The Policy of the United States
Towards Industrial Monopoly. N.Y., 1913. 1st ed. $15.00
(orig. wraps.)
Kneale, Albert H.--Indian Agent. Caldwell, 1950. $30.00,
$25.00
Knee, Ernest--Santa Fe, New Mexico. N.Y., (1942). $15.00
Kneedler, H.S.--Through Storyland to Sunset Seas. Cinci.,
1896. $15.00 (spine chip and small pieces missing)
Knibbs, Henry Herbert--Songs of the Outlands. Bost.,
(1914). $9.00
Knickerbocker, Diedrick, pseud.
See: Irving, Washington
Kniffin, Gilbert Crawford--Assault and Capture of Lookout
Mountain. Wash., 1895. $12.50 (cover chipped and be-
coming detached)

Knight, Edward--Wild Bill Hickok. Franklin, N.H., 1959.
$6.00

Knight, Melvin Moses--The Americans in Santo Domingo. N.Y.,
(1928). $12.50

Knight, Oliver--Following the Indian Wars. Norman, (1960).
$20.00

--Fort Worth, Outpost on the Trinity. Norman, (1953).
$25.00

Knight, Thomas Arthur--The Strange Disappearance of Wil-
liam Morgan. Brecksville, Oh., (1932). $17.50 (cloth,
name on endpaper, scattered pin marks, some wear)

Knoblock, Byron William--Banner-Stones of the North Amer-
ican Indian. La Grange, Il., 1939. $110.00 (author's
presentation copy, cloth)

Knoblock, Curt George--Above Below. N.p., (1952). $15.00

Knollenberg, Bernhard--Pioneer Sketches of the Upper White-
water Valley.... Ind., 1945. $20.00

Knopf, Richard C., ed.--Anthony Wayne....
See: Wayne, Anthony

Knower, Daniel--The Adventures of a Forty-Niner. Albany,
1894. 1st ed. $65.00 (cloth, owner name)

Knowles, John--A Separate Peace. N.Y., 1960. $30.00 (cloth)

Knox, John--The Great Mistake. Wash., 1931. $8.50

Knox, John Clark--A Judge Comes of Age. N.Y., 1940.
$7.50

Kobal, John--Rita Hayworth. N.Y., 1978. $6.50

Kobler, John--Ardent Spirits. N.Y., (1973). 1st ed. $10.00,
$10.00, $6.00

--Capone. N.Y., (1971). 1st ed. $12.50

Koch, Adrienne, ed.--The Selected Writings of John and John
Quincy Adams
See: Adams, John

Koch, Frederick Henry--Carolina Folk Plays. N.Y., 1922.
1st ed. $12.50 (lettering on spine effaced)

Kocher, Alfred Lawrence--Colonial Williamsburg.... Williams-
burg, (1949). $15.00

Koebel, William Henry--Modern Argentina. Bost., (1912).
$10.00

--Uruguay. Lond., (1919). $15.00

Koehler, LeRoy Jennings--The History of Monroe County.
Monroe County, Pa., 1950. $27.50 (one of 1000 copies)

Koenig, Louis William--Bryan; a Political Biography.... N.Y.,
(1971). $20.00

Kohl, Edith Eudora--Denver's Historic Mansions. Denver,
(1957). $10.00 (some spine wear)

Kohl, Johann Georg--Kitchi-Gami. Minne., 1956. $15.00
Kolb, Ellsworth Leonardson--Through the Grand Canyon....
N.Y., 1914. $30.00 (light hinge wear), $25.00 (cloth,
spine tips rubbed)
Kolehmainen, John Ilmari--Haven in the Woods. Madison,
1951. 1st ed. $25.00
Kolko, Gabriel--Wealth and Power in America. N.Y., (1962).
1st ed. $11.25
N.Y., 1971. $5.00 (paper)
Konefsky, Samuel Joseph--Chief Justice Stone and the Supreme
Court. N.Y., 1945. $8.50
Konkle, Burton Alva--The Life of Andrew Hamilton, 1676-
1741.... Phila., 1941. $20.00
Koogler, C.V.--Aztec. (Fort Worth, Tx., 1972). $25.00
(label removed)
Koop, W.E.--Billy the Kid. (K.C.), 1965. $95.00 (one of 250
numbered and signed copies)
Kopman, Henry Hazlitt--Wild Acres. N.Y., 1946. $10.00,
$7.50
Koren, Elisabeth--The Diary of.... Northfield, Mn., 1955.
1st ed. $20.00
Kornbluh, Joyce L.--Rebel Voices. Ann Arbor, (1964). 1st
ed. $17.50
Korngold, Ralph--Two Friends of Man. Bost., 1950. 1st ed.
$17.50 (presentation copy)
Korns, J. Roderic--West From Fort Bridger.... S.L.C., 1951.
$35.00 (orig. wraps.)
Korson, George Gershon--Pennsylvania Songs and Legends.
Phila., 1949. 1st ed. $12.50
Kortright, Francis H.--The Ducks, Geese and Swans of North
America. Wash., 1943. $15.00 (spine faded)
Kour, Michael J.--Arms for Texas. (Fort Collins, Co., 1973).
$100.00 (leather, boxed, one of 50 signed copies)
Koury, Michael J.--Diaries of the Little Big Horn. (Fort Col-
lins, 1968). 1st ed. $25.00 (cloth, one of 500 signed
copies)
Kousser, J. Morgan--The Shaping of Southern Politics....
New Haven, 1974. $20.00
Kovacs, Ernie--Zoomar. Garden City, 1957. 1st ed. $10.00
Kraenzel, Carl Frederick--The Great Plains in Transition.
Norman, (1955). $15.00, $15.00
Kramer, Frank R.--Voices in the Valley. Madison, 1964.
$8.00
Krapp, George Philip--America, the Great Adventure. N.Y.,
1924. 1st ed. $15.00 (few cover spots)

Kraus, George--High Road to Promontory. Palo Alto, Ca.,
(1969). $17.50 (rubbed)
Krauss, Bob--Here's Hawaii. N.Y., 1960. 1st ed. $10.00
(ex-lib.)
Krechniak, Helen Bullard--Crafts and Craftsmen of the Ten-
nessee Mountains. Falls Church, Va., 1976. $12.00 (ex-
lib., minimal markings)
Krehbiel, Henry Edward--Afro-American Folksongs. N.Y.,
1914. $24.00
Kresge, Stanley Sebastian--The S.S. Kresge Story. Racine,
1979. $10.00
Krey, Laura (Smith)--And Tell of Time. Bost., 1938. $8.00
Krock, Arthur--Memoirs. N.Y., (1968). $17.50 (cloth)
Kroeber, Alfred Louis--The Arapaho. Fairfield, Wa., 1975.
$15.00 (one of 300 plus copies)
--Configurations of Culture Growth. Berkeley, 1944. 1st
ed. $15.00
--Handbook of the Indians of California. Berkeley, (1953).
$75.00 (typed letter signed by author laid in), $65.00
(cloth), $45.00
--The Seri. L.A., 1931. 1st ed. $10.00 (wraps. chipped)
Kroeber, Theodora--Ishi in Two Worlds. Berkeley, 1961.
$10.00
Kropp, Miriam--Cuzco. N.Y., (1956). $7.50
Krott, Peter--Demon of the North. N.Y., 1959. $7.50 (ex-
lib. stamps)
Krout, John Allen--The Origins of Prohibition. N.Y., 1925.
$20.00
Krug, Merton E.--DuBay: Son-in-Law of Oshkosh. Appleton,
Wi., 1946. $15.00, $8.50
Krumrey, Kate (Warner)--Saga of Sawlog. Denver, (1965).
$25.00
Kruse, Anne Applegate--The Halo Trail. Drain, Or., 1954.
$10.00
Kruse, Horace Warren--The Lure of the Roads in New Mexico.
(Raton, 1921). $37.50 (wraps. chipped, owner name)
Krutch, Joseph Wood--Edgar Allan Poe, a Study in Genius.
N.Y., 1926. 1st ed. $45.00 (orig. boards, one of 150
large paper copies signed by author, spine lightly soiled)
N.Y., 1931. $6.50 (ex-lib.)
--The Forgotten Peninsula. N.Y., 1961. 1st ed. $12.50
(owner name)
Kubler, George--The Religious Architecture of New Mexico....
Colorado Springs, 1940. 1st ed. $165.00 (one of 750 cop-
ies, wraps.)
(Chi., 1962). $20.00

Kuhlman, Charles--Did Custer Disobey Orders at the Battle
of the Little Big Horn? Harrisburg, Pa., (1957). 1st ed.
$18.00, $15.00
--The Frank Finkel Story. (Omaha, 1968). $7.50 (one of
500 signed copies)
--Legend Into History. Harrisburg, (1952). $25.00, $20.00
Fort Collins, Co., 1977. $22.50
Kuhn, Kate (Ray)--A History of Marion County. Hannibal,
Mo., 1963. $25.00
Kulp, George Brubaker--Families of the Wyoming Valley.
Wilkes-Barre, Pa., 1885-90. 3 vols. $275.00 (orig. cloth,
one cover soiled, uncut)
Kunhardt, Dorothy Meserve--Twenty Days. N.Y., 1965.
$17.50, $15.00 (pages have been damp, resulting in some
sticking)
Kunstler, William Moses--The Minister and the Choir Singer.
N.Y., 1964. $15.00
Kupper, Winifred--The Golden Hoof. N.Y., (1945). $45.00
Kurland, Philip B.--Mr. Justice Frankfurter and the Consti-
tution. Chi., (1971). $10.00
Kurtz, Stephen G.--The Presidency of John Adams. Phila.,
(1957). 1st ed. $20.00
Kuykendall, Ivan Lee--Ghost Riders of the Mogollon, San An-
tonio, (1954). $425.00 (one of 200 distributed before sup-
pression)
Kuykendall, Ralph Simpson--Hawaii. N.Y., 1948. 1st ed.
$12.00
Kuzara, Stanley A.--Black Diamonds of Sheridan. Sheridan,
1977. $25.00 (inscribed and signed)

- L -

Labaree, Benjamin W.--Patriots and Partisans. Camb., 1962.
1st ed. $10.00 (cloth)
Labbe, John T.--Railroads in the Woods. Berkeley, 1961.
$20.00
LaBree, Benjamin--The Confederate Soldier in the Civil War.
Paterson, N.J., (1959). $20.00
Lacasa, Pedro--Vida Militar y Politica del General Argentino
Juan Lavalle. (Buenos Aires, 1973). 1st ed. $6.50
(wraps.)
Lackey, Walter Fowler--History of Newton County, Arkansas.
Independence, Mo., (1950). $25.00
LaCour, Arthur Burton--New Orleans Masquerade. New Or-
leans (1952). 1st ed. $22.50 (orig. buckram, signed)

Ladd, Horatio Oliver--The Story of New Mexico. Bost.,
(1891). 1st ed. $77.50 (cloth, bit of cover wear, ex-lib.
stamps)
LaFarge, Christopher--Mesa Verde. (N.Y., 1945). $12.50
(one of 1000 copies, bookplate)
LaFarge, Oliver--As Long as the Grass Shall Grow. N.Y.,
(1940). 1st ed. $30.00, $25.00
--Behind the Mountains. Bost., 1956. 1st ed. $17.50 (au-
thor's photo laid in)
--The Mother Ditch. Bost., (1954). 1st ed. $15.00
--A Pictorial History of the American Indian. N.Y., (1956).
1st ed. $12.50
N.Y., (1957). $10.00 (corners bumped)
--Santa Fe. Norman, (1959). $15.00, $10.00
LaFeber, Walter--America in the Cold War. N.Y., (1969).
$5.00 (wraps.)
LaFlesche, Francis--A Dictionary of the Osage Language.
Wash., 1932. 1st ed. $25.00, $15.00 (wraps.)
--War Ceremony and Peace Ceremony of the Osage Indians.
Wash., 1939. 1st ed. $10.00
LaFollette, Robert Hoath--Eight Notches.... Albuquerque,
1950. $27.50 (presentation copy)
Lafora, Nicolas de--The Frontiers of New Spain. Berkeley,
1958. $95.00 (ltd. to 400 copies)
Lafore, Laurence Davis--American Classic. Iowa City, 1975.
$15.00
Lafuente Machain, Ricardo de--Buenos Aires en el Siglo XVIII.
Buenos Aires, 1946. $20.00 (morocco, padded)
Lahontan, Louis Armand de Lom d'Arce--New Voyages to North-
America.... Chi., 1905. 2 vols. $75.00
Laing, Alexander Kinnan--The Sea Witch. N.Y., 1944. $15.00
(spine dull)
Lait, Jack--Chicago Confidential! N.Y., 1950. $5.00
N.Y., 1951. $5.00
Lake, Stuart N.--Wyatt Earp, Frontier Marshall. Bost.,
(1931). 1st ed. $20.50, $12.50
LaLande, Jeffrey M.--Medford Corporation. Medford, Or.,
1979. $15.00
Lamar, Howard Roberts--The Far Southwest, 1846-1912. New
Haven, 1966. 1st ed. $22.50
Lamb, Arthur H.--Tragedies of the Osage Hills. Pawhuska,
Ok., n.d. $45.00 (signed by author, wraps., small piece
lacking at crown of spine)
Lamb, Dean Ivan--The Incurable Filibuster. N.Y., (1934).
$18.00

Lamb, Edgar--Colorful Cacti of the American Desert. N.Y.,
(1974). $4.50
Lamb, Martin Thomas--The Golden Bible. N.Y., 1887. $35.00
(covers worn, owner name)
Lamb, Ruth deForest--American Chamber of Horrors. N.Y.,
1936. 1st ed. $15.00
Lambourne, Alfred--The Pioneer Trail. S.L.C., 1913. $23.50
Lamers, Mary McGuire--Star Spangled Stories. Milwaukee,
(1950). $8.50
Lamers, William Mathias--The Edge of Glory. N.Y., (1961).
$25.00, $15.00
Lamon, Ward Hill--Recollections of Abraham Lincoln.... Wash.,
1911. $15.00
Lamott, Kenneth Church--The Moneymakers. Bost., (1969).
1st ed. $8.00
Lamson, Darius Francis--History of the Town of Manchester....
Massachusetts.... (Manchester, 1895). $35.00 (edge
wear), $35.00 (orig. cloth)
Lamson, Peggy--Few Are Chosen. Bost., 1968. $12.50
Lancaster, Samuel Christopher--The Columbia.... Portland,
Or., 1926. $15.00
Landers, Howard Lee--The Virginia Campaign and the Blockade
and Siege of Yorktown, 1781. Wash., 1931. $25.00 (au-
thor's presentation inscription)
Landis, Robert Wharton--Liberty's Triumph. N.Y., 1849.
1st ed. $9.00 (foxing)
Landon, Fred--Lake Huron. Ind., (1944). 1st ed. $8.50
(ex-lib., covers rubbed, owner name)
Landon, Melville DeLancey--Kings of the Platform and Pulpit.
Akron, Oh., 1911. $12.50 (covers worn)
Landor, Arnold Henry Savage--Across Unknown Latin America.
Bost., 1913. 2 vols. $32.50
Lane, Lydia Spencer (Blaney)--I Married a Soldier. Phila.,
1893. 1st ed. $125.00 (front endpaper worn)
Lane, Margaret--Edgar Wallace. N.Y., 1939. $14.00
Lane, Mark--Rush to Judgement. N.Y., (1966). $10.00
Lane, Walter Paye--The Adventures and Recollecitons of....
Marshall, 1887. 1st ed. $1250.00 (orig. wraps., half
morocco folding case)
Lane, Wheaton Joshua--Commodore Vanderbilt.... N.Y., 1942.
$20.00, $15.00
Lang, John D.--Report of a Visit to Some of the Tribes of
Indians.... N.Y., 1843. $150.00
Prov., 1843. $150.00

Lang, Ossian Herbert--History of Freemasonry in the State
of New York. N.Y., (1922). $17.50
Lange, Charles H.--Cochiti.... Austin, (1959). 1st ed.
$37.50
Lange, Dorothea--Dorothea Lange. Garden City, (1966). 1st
ed. $15.00
Langfield, William Robert--Washington Irving. N.Y., 1933.
$75.00 (orig. cloth, presentation copy from author, front
endpapers lightly browned)
Langford, Nathaniel Pitt--Diary of the Washburn Expedition
to the Yellowstone and Firehole Rivers in the Year 1870.
N.p., (1905). 1st ed. $90.00 (light rubbing to extremities,
rubber stamp on front free endpaper, inscribed by the
publisher), $50.00 (owner name), $50.00 (rear cover
stained)
--The Louisiana Purchase and Preceding Spanish Intrigues....
N.p., (1900). $15.00 (one corner stained)
--Vigilante Days and Ways. Bost., 1890. 2 vols. 1st ed.
$175.00 (half leather, front endpaper and fly missing on
Vol. I, Vol. II has small chip front bottom of spine and
bit of edge wear)
N.Y., 1893. 2 vols. $75.00 (presentation copies, newly
rebound), $47.50 (cloth, bookplate, bit of spine tip fray)
Chi., 1912. $30.00 (covers rubbed)
(Missoula, Mo., 1957). $15.00
Langtry, Albert Perkins--Metropolitan Boston. N.Y., 1929.
5 vols. $50.00 (boards)
Langworthy, Daniel Avery--Reminiscences of a Prisoner of
War and His Escape. Minne., 1915. 1st ed. $15.00
Langworthy, Lucius Hart--Dubuque. Dubuque, Ia., (1855).
1st ed. $275.00 (title and last leaf soiled, new wraps.)
Lanier, Henry Wysham--A Century of Banking in New York....
N.Y., 1922. $20.00, $12.00
--Greenwich Village. N.Y., (1949). 1st ed. $75.00 (cloth)
Lapham, Alice Gertrude--The Old Planters.... Camb., 1930.
$25.00
Lapham, Incerase Allen--Wisconsin.... Milwaukee, 1846.
$135.00 (bookplate, lib. stamps, spine tip and bit of edge
wear)
Lapp, Rudolph M.--Blacks in Gold Rush California. New Ha-
ven, 1977. $25.00
Lardner, Ring--Treat 'Em Rough. Ind., (1918). $25.00 (2nd
printing, orig. cloth, covers lightly worn and soiled)
Larke, Julian K.--General U.S. Grant. N.Y., (1885). $20.0(
(cloth, hinges weak, back cover bent and creased), $12.00
(binding faded)

Larkin, Lew--Bingham: Fighting Artist. K.C., (1954). 1st
ed. $35.00, $35.00 (cloth, endpapers browned)
--Vanguard of Empire. S.L., 1961. $20.00 (boards, book-
plate)
Larkin, Stillman Carter--The Pioneer History of Meigs County.
Columbus, 1908. 1st ed. $35.00
Larkin, Thomas Oliver--First and Last Consul. San Marino,
1962. $30.00 (cloth)
Larned, Charles W.--History of the Battle Monument at West
Point. West Point, 1898. $20.00 (lightly dustsoiled, one
of 1000 copies)
Larner, Jeremy--The Addict in the Street. N.Y., 1964. 1st
ed. $10.00
LaRochefoucauld Linacourt, Francois Alexandre Frederic--
Journal de Voyage en Amerique.... Balt., 1940. $25.00
(orig. wraps.)
Larpenteur, Charles--Forty Years a Fur Trader. Chi., 1933.
$27.50, $17.50
Larrabee, Eric--American Panorama. (N.Y.), 1957. $20.00
Larrison, Earl--Field Guide to the Birds of Washington State.
Seattle, 1962. $25.00 (wraps., signed by authors and
artist)
Larson, Agnes Mathilda--History of the White Pine Industry
in Minnesota. Minne., 1949. 1st ed. $25.00
Larson, Andrew Karl--I Was Called to Dixie. S.L.C., 1961.
$32.50 (ex-lib.)
Larson, Gustive Olof--Prelude to the Kingdom. Francestown,
N.H., (1947). 1st ed. $25.00 (signed by author, spine
tips bit rubbed), $25.00 (author's presentation copy)
Larson, Henrietta Melia--Guide to Business History. Bost.,
1964. $22.50 (cloth)
--New Horizons.... N.Y., (1971). $17.50
Larson, Herbert F.--Be-Wa-Bic Country. N.Y., (1963).
$20.00 (signed)
Larson, Robert W.--New Mexico's Quest for Statehood....
Albuquerque, (1968). $15.00
Larson, Taft Alfred--History of Wyoming. Lincoln, 1965.
1st ed. $25.00
Lasch, Robert--Breaking the Building Blockade. Chi.,
(1946). $10.00 (spine faded)
Laski, Harold Joseph--The American Democracy.... N.Y.,
1948. 1st ed. $8.50
--The American Presidency. N.Y., 1940. $10.00
Lasky, Victor--J.F.K.: the Man and the Myth. N.Y., 1963.
$10.00, $7.00

Lasswell, Mary--I'll Take Texas. Bost., 1958. $18.00

The Last of the Buffalo.... Cinc., 1909. $35.00 (orig. wraps.)

Latham, Hiram--Trans-Mississippi Stock Raising.... Denver, 1962. $25.00

Latham, Peter--Travel, Business, Study, and Art in the U.S.A. Lond., (1964). $5.00

Lathrop, Cornelia (Penfield)--Black Rock, Seaport of Old Fairfield.... New Haven, 1930. 1st ed. $50.00

Lathrop, Elise L.--Early American Inns and Taverns. N.Y., 1926. 1st ed. $20.00

--Historic Houses of Early America. N.Y., 1927. 1st ed. $25.00 (cloth, bookplate)

--Old New England Churches. Rutland, 1938. 1st ed. $12.00

Lathrop, George Parsons--Rose and Roof-Tree. Bost., 1875. $50.00 (orig. cloth, spine and covers lightly worn)

Latrobe, Benjamin--A Succinct View of the Missions Established Among the Heathen.... Lond., 1771. $250.00 (later boards, calf spine)

Latta, Robert Ray--Reminiscences of Pioneer Life. K.C., 1912. 1st ed. $27.50 (cloth)

Laubin, Reginald--The Indian Tipi. Norman, (1957). 1st ed. $25.00

Laude, G.A.--Kansas Shorthorns. Iola, Ks., (1921). $17.50 (spine lightly faded)

Laufe, Abe, ed.--An Army Doctor's Wife....
 See: FitzGerald, Emily McCorkle

Laughlin, Clarence John--Ghosts Along the Mississippi. N.Y., 1961. $12.50

Laughlin, Ruth--Caballeros. N.Y., 1931. $15.00 (backstrip lightly faded), $10.00 (backstrip faded)
 Caldwell, 1945. $15.00

Laune, Seigniora (Russell)--Sand in My Eyes. Flagstaff, (1956). $165.00 (one of 50 copies, leather and boards, boxed)

Lauritzen, Elizabeth Moyes--Shush' Ma. Caldwell, 1964. 1st ed. $17.50

Lauritzen, Jonreed--Arrows Into the Sun. N.Y., (1943). $20.00 (bit of cover soil)

--The Everlasting Fire. Garden City, 1962. 1st ed. $25.00

--Song Before Sunrise. Garden City, 1948. $12.50

Laut, Agnes Christina--The Blazed Trail of the Old Frontier. N.Y., 1926. $200.00 (buckram, one of 200 signed by author), $75.00 (in worn box), $65.00

--The Conquest of Our Western Empire. N.Y., 1927. $25.00

--The Conquest of the Great Northwest. N.Y., 1911. 2 vols.
 in 1. $20.00
--Enchanted Trails of Glacier Park. N.Y., 1926. $20.00
 (small cover crease)
--Lords of the North.... N.Y., 1906. $15.00 (cloth, name
 in ink, lightly worn)
--The Overland Trail. N.Y., 1929. $20.00
--Pathfinders of the West. N.Y., 1922. $15.00 (gold letter-
 ing flaking off spine)
--Pilgrims of the Santa Fe. N.Y., 1931. $10.00
--The Romance of the Rails. N.Y., 1929. 2 vols. 1st ed.
 $25.00
 N.Y., 1936. $17.50
--Through Our Unknown Southwest. N.Y., 1913. 1st ed.
 $15.00 (lettering flaked off spine, bit of edge rubbing)
 N.Y., 1915. $12.50, $12.00 (backstrip lightly marked)
LaVarre, William Jerome--Southward Ho! N.Y., 1940. $8.00
Laveille, E.--The Life of Father De Smet.... N.Y., 1915.
 1st ed. $20.00 (ex-lib., edge wear)
Lavender, David Sievert--Bent's Fort. Garden City, 1954.
 $18.00, $15.00 (owner name), $11.00 (backstrip sunned)
--California.... N.Y., (1972). $15.00
--David Lavender's Colorado. Garden City, 1976. $27.50
--Nothing Seemed Impossible. Palo Alto, (1975). $30.00
--One Man's West. Garden City, 1956. $7.50
--The Rockies. N.Y., (1968). 1st ed. $20.00 (photo of
 author laid in, review copy)
--Westward Vision, the Story of the Oregon Trail. Garden
 City, (1963). 1st ed. $10.00, $7.50
Lavine, Emanuel Henry--The Third Degree.... N.Y., (1930).
 $10.00
Law, Laura (Thompson)--History of Rolette County, North
 Dakota.... Minne., (1953). $30.00 (presentation copy)
Law, Reuben D.--The Founding and Early Development of
 the Church College of Hawaii. St. George, 1972. $20.00
Lawes, Lewis Edward--Meet the Murder. N.Y., (1940). $20.00
--Twenty Thousand Years in Sing Sing. N.Y., 1932. 1st
 ed. $10.00
Lawler, Lucille--Gallatin County. (Crossville, Il., 1968).
 $15.00 (wraps., inscribed copy)
Lawless, Ray McKinley--Folksingers and Folksongs in America.
 N.Y., (1960). 1st ed. $25.00 (cloth, lacks front endpa-
 per)
Lawrence, Charles--History of the Philadelphia Almhouses and
 Hospitals.... Phila., 1905. 1st ed. $30.00 (some under-
 lining to text)

Lawrence, David Herbert--Women in Love. N.Y., 1920. 1st
 ed. $75.00 (cloth, one of 1250 numbered copies)
Lawrence, Frieda von Richthofen--"Not I, But the Wind...."
 Santa Fe, (1934). 1st ed. $150.00 (orig. boards, one of
 1000 copies signed by author, boards lightly soiled, book-
 plate)
Lawrence, Joseph Stagg--Wall Street and Washington. Prince-
 ton, 1929. $20.00 (worn at extremities)
Lawrence, Robert Means--New England Colonial Life. Camb.,
 1927. $10.00
Laws of the Legislature of the State of New York, in Force
 Against the Loyalists
 See: New York (State). Laws, Statutes, etc.
Lawson, William Pinkney--The Log of a Timber Cruiser. N.Y.,
 1915. 1st ed. $32.50 (author's presentation copy, letter-
 ing worn off) .
Lawton, Eliza McIntosh Clinch (Anderson)--Major Robert An-
 derson and Fort Sumter, 1861. N.Y., 1911. $25.00 (edges
 faded, corner bumped)
Lawton, Harry W.--Willie Boy, a Desert Manhunt. (Balboa
 Island, 1960). 1st ed. $10.00
Lawyer, James Patterson--History of Ohio. Columbus, 1905.
 $25.00
Lea, Henry Charles--The Inquisition in the Spanish Depen-
 dencies.... N.Y., 1908. 1st ed. $45.00 (orig. cloth)
Lea, James Henry--The Ancestry of Abraham Lincoln. Bost.,
 (1909). 1st ed. $50.00 (buckram), $35.00 (boards and
 leather, most of spine missing)
Lea, Tom--The King Ranch. Bost., (1957). 2 vols. $100.00
 (owner signature in each vol., spines lightly soiled),
 $100.00, $70.00, $65.00
--A Picture Gallery. Bost., (1968). $100.00 (boxed)
--The Wonderful Country. Bost., (1952). 1st ed. $35.00
Leach, Douglas Edward--Flintlock and Tomahawk. N.Y., 1959.
 $20.00
--The Northern Colonial Frontier, 1607-1763. N.Y., (1966).
 $22.50
Leacock, Stephen Butler--All Right, Mr. Roosevelt. Toronto,
 1939. $22.50 (signed)
--Lincoln Frees the Slaves. N.Y., 1934. 1st ed. $65.00
 (orig. cloth, soiled, corner bumped)
--My Discovery of the West. Toronto, 1937. $10.00
Learned, Marion Dexter--Abraham Lincoln.... Phila., 1909.
 1st ed. $85.00 (backstrip faded, one of 500 copies)
Leather Stocking and Silk
 See: (Cooke, John Esten)

Leavitt, Jerome Edward--America and Its Indians. N.Y.,
(1962). $7.50
Leavitt, Robert Keith--Noah's Ark.... Springfield, Ma., 1947.
$15.00
Lebhar, Godfrey Montague--The Chain Store-Boon or Bane?
N.Y., 1932. $10.00
--Chain Stores in America.... N.Y., (1959). $10.00
Lechford, Thomas--Plain Dealing. Bost., 1868 [i.e. 1867].
$100.00 (one half leather, hinges weak, one of 35 copies
in royal quarto size)
Leckie, William H.--The Buffalo Soldiers. Norman, (1970).
$17.50
LeClercq, Chretien--First Establishment of the Faith in New
France.... N.Y., 1881. 2 vols. $550.00 (orig. wraps.,
slipcased, unopened)
Leconte, Caroline Eaton--Yo Semite, 1878.... S.F., 1944
[i.e. 1964]. $95.00 (one of 450 copies, orig. cloth)
LeConte, Joseph--The Autobiography of.... N.Y., 1903.
1st ed. $45.00 (orig. cloth)
LeDuc, William Gates--Recollections of a Civil War Quartermas-
ter. St. Paul, (1963). $10.50, $10.00
Ledyard, Edgar M., ed.--A Journal of the Birmingham Emi-
grating Company
See: Loomis, Leander Vaness
Ledyard, Isaac--An Essay on Matter. Phila., 1784. $225.00
(recent boards)
Lee, Arthur Tracy--Fort Davis and the Texas Frontier. Col-
lege Station, 1976. $20.00 (author's presentation inscrip-
tion), $12.00
Lee, Bourke--Death Valley. N.Y., 1930. 1st ed. $25.00
(spine tips lightly frayed)
--Death Valley Men. N.Y., 1932. $27.50 (covers bit soiled)
Lee, Charles S.--Pike's Peak, Colorado. Denver, 1893.
$25.00 (bit of spine tip wear, light corner wear)
Lee, Chauncey--The American Accomptant. Lansingburgh,
N.Y., 1797. 1st ed. $250.00 (leather, repaired, some-
what scratched and worn, foxed and stained, owner signa-
ture), $150.00 (contemp. calf)
Lee, Fitzhugh--General Lee. N.Y., 1894. 1st ed. $25.00
Lee, Floride (Clemson)--A Rebel Came Home. Columbia, 1961.
$20.00 (ex-lib.)
Lee, Francis Bazley--New Jersey as a Colony.... N.Y., 1903.
$38.50
Lee, Fred L.--John G. Neihardt. (K.C.), 1974. $27.50
(signed)

Lee, Guy Carleton, ed.--The History of North America
 See under Title
--The True History of the Civil War. Phila., 1903. 1st ed.
 $7.50 (front endpaper out, bit used)
Lee, Gypsy Rose--Gypsy. N.Y., 1957. 1st ed. $17.50
Lee, Harper--To Kill a Mockingbird. Lond., (1960). $35.00
 (boards)
Lee, Henry--Observations on the Writings of Thomas Jeffer-
 son.... Phila., 1839. $50.00 (orig. cloth)
(Lee, Ivy Ledbetter)--"Uncle Remus," Joel Chandler Harris
 as Seen and Remembered by a Few of His Friends. N.p.,
 1908. $150.00 (orig. boards, one of 300 copies, spine
 label and boards lightly soiled)
Lee, Mabel Barbee--Back in Cripple Creek. Garden City,
 1968. $10.00
Lee, Margaret Cabot--Letters and Diaries.... N.p., 1923.
 $25.00 (cloth)
Lee, Nelson--Three Years Among the Camanches.... Albany,
 1859. 1st ed. $1750.00 (orig. cloth)
 Norman, (1957). $10.00
Lee, Rebecca Washington (Smith)--Mary Austin Holley. Aus-
 tin, 1962. $25.00
Lee, Robert Edson--From West to East. Urbana, 1966. 1st
 ed. $10.00 (cloth)
Lee, Robert Edward--Lee's Dispatches. N.Y., 1915. $25.00
--Recollections and Letters of General Robert E. Lee. N.Y.,
 1904. 1st ed. $25.00 (bit of cover soil)
Lee, Wayne C.--Scotty Philip, the Man Who Saved the Buffalo.
 Caldwell, 1975. $15.00
Lee, William Storrs--The Great California Deserts. N.Y.,
 (1963). $15.00, $7.00
--The Green Mountains of Vermont. N.Y., (1955). 1st ed.
 $10.00 (light sunning of spine)
--The Islands. N.Y., (1966). $8.50
Leech, Margaret--In the Days of McKinley. N.Y., (1959).
 $10.00
--Reveille in Washington.... N.Y., (1941). 1st ed. $17.50
 (cloth)
Leeper, David Rohrer--The Argonauts of Forty-Nine. Colum-
 bus, 1950. $11.00
Leeper, Wesley Thurman--Rebels Valiant. (Little Rock, 1964).
 $30.00
Lees, James Arthur--B.C. 1887. Lond., 1888. $45.00 (orig.
 cloth, corners bumped, spine ends rubbed)
Leffman, Henry--Notes on the Secret Service of the Revolu-
 tionary Army.... Phila., 1910. $5.00 (wraps.)

Left Handed. Navaho Indian--Son of Old Man Hat. N.Y.,
(1938). 1st ed. $75.00, $62.50 (binding spotted)
LeHain, Geoffrey M.--Historic Montreal. Montreal, (193-?).
$20.00 (cover flecked)
Lehmann, Walter--L'Art Ancien du Mexique. Paris, 1922.
$45.00 (spine taped, plate margins water stained)
Leifermann, Henry P.--Crystal Lee, a Woman of Inheritance.
N.Y., 1975. 1st ed. $20.00
Leifur, Conrad W.--Our State, North Dakota. N.Y., (1953).
$5.00
Leigh, Randolph--Forgotten Waters. Phila., (1941). $15.00
(bit of edge wear)
Leighly, John Barger--California as an Island. S.F., 1972.
$1000.00 (one of 450 copies)
Leighton, Alexander Hamilton--The Navaho Door. Camb.,
1944. 1st ed. $30.00. Camb., 1945. $20.00
Leighton, Dorothea (Cross)--Children of the People. Camb.,
1947. 1st ed. $27.50
Camb., 1948. $10.00 (cloth)
--People of the Middle Place. New Haven, (1966). 1st ed.
$12.50
Leithäuser, Joachim G.--Worlds Beyond the Horizon. N.Y.,
(1955). $7.50
LeMoine, James MacPherson--The Chronicles of the St. Law-
rence. Montreal, 1878. 1st ed. $30.00 (cloth, bookseller's
stamp)
--Picturesque Quebec. Montreal, 1882. 1st ed. $60.00
(orig. wraps., spine chipped, part of front wrap. missing)
--Quebec Past and Present. Quebec, 1876. 1st ed. $85.00
(orig. cloth)
Leon, Alonso de--Historia de Nuevo Leon.... Mexico, 1909.
$150.00 (contemp. half calf)
Leon, Nicolas--Documentos Ineditos Referentes al Ilustrisimo
Senor Don Vasco de Quiroga. Mexico, 1940. $15.00
(wraps.)
(Leonard, Charles C.)--The History of Pithole. Balt., 1945.
$45.00 (orig. cloth, one of 400 copies), $15.00 (one of 400
copies)
Leonard, Elizabeth Jane--Buffalo Bill, King of the Old West.
N.Y., (1955). $25.00, $15.00, $15.00 (boards), $15.00
(boards)
--The Call of the Western Prairie. N.Y., (1952). $15.00
(bit of wear and chip to spine tips)
Leonard, John William--History of the City of New York....
N.Y., 1910. $60.00 (rebound in cloth)

Leonard, Olen Earl--Boliva. Wash., 1952. $15.00
Leonard, William--A Discourse on the Order and Propriety of
 Divine Inspiration.... Harvard, Ma., 1853. $150.00 (orig.
 cloth), $150.00 (orig. wraps.)
Leonard, Zenas--Adventures of Zenas Leonard. Norman,
 (1959). $15.00, $10.00
Leonhardt, Olive--New Orleans, Drawn and Quartered. Rich.,
 (1938). $35.00 (one of 1000 copies, spine and corners
 worn)
Lerner, Max, ed.--The Mind and Faith of Justice Holmes
 See: Holmes, Oliver Wendell
--The Unfinished Country. N.Y., 1959. $15.00
Lesley, Lewis Burt, ed.--Uncle Sam's Camels
 See: Stacey, May Humphries
[Leslie, Charles]--A New History of Jamaica.... Lond., 1740.
 $400.00 (half morocco)
Lester Gladstone Bugbee. Austin, 1945. $25.00 (orig. wraps.)
Lester, Paul--The Great Galveston Disaster. Chi., (1900).
 $25.00 (spine tips bit rubbed)
--The True Story of the Galveston Flood.... Phila., (1900).
 $12.50 (salesman's sample)
Lesure, Thomas B.--Adventures in Arizona. San Antonio,
 (1956). $20.00
LeTac, Sixte--Histoire Chronologique de la Nouvelle France
 ou Canada Despues sa Decouverte.... Paris, 1888. $100.00
 (orig. wraps., one of 300 numbered copies)
A Letter From an Elder in an Old Presbyterian Church to
 His Son at College. N.Y., 1863. $25.00 (orig. wraps.)
Lettermann, Edward J.--From Whole Log to No Log. Minne.,
 (1969). $25.00
Letts, John M.--California Illustrated. N.Y., 1852. $750.00
 (orig. cloth, occasional spotting, author's presentation in-
 scription)
 N.Y., 1853. $500.00 (orig. cloth)
Letwin, William--A Documentary History of American Economic
 Policy Since 1789. Chi., (1964). $12.50
Leupp, Francis Ellington--In Red Man's Land. N.Y., (1914).
 1st ed. $12.50
--The Indian and His Problem. N.Y., 1910. 1st ed. $20.00
 (bookplates, cloth)
--Notes of a Summer Tour.... Phila., 1897. $65.00 (owner
 name)
Lever, Janet--Women at Yale. Ind., 1971. $17.00
Levere, William Collin--The Evanston Poets. Evanston, 1903.
 $12.50

Levering, Julia Henderson--Historic Indiana. N.Y., 1909.
1st ed. $35.00 (library blindstamp, spine tips wearing,
owner name)
Levermore, Charles Herbert--Forerunners and Competitors of
the Pilgrims and Puritans. Brooklyn, 1912. 2 vols.
$50.00 (cloth, slightly scratched and frayed)
Levertov, Denise--Here and Now. S.F., (1957). $10.00 (3rd
printing, minor tape marks inside covers)
Levick, M.B.--Tulare County California. S.F., (1912).
$15.00 (covers chipped)
Levine, Daniel--Jane Addams and the Liberal Tradition. Mad-
ison, 1971. 1st ed. $12.50
Levine, David--No Known Survivors. Bost., 1970. $15.00
Levine, Isaac Don--Mitchell, Pioneer of Air Power. N.Y.,
(1943). 1st ed. $10.00
Levy, Florence Nightingale--Art Education in the City of New
York. N.Y., 1938. $10.00 (boards, ex-lib.)
Levy, Leonard Williams--Against the Law. N.Y., (1974).
$18.00
Lewis, Alfred Henry--Wolfville Days. N.Y., 1902. $50.00
(cloth, rubbed)
Lewis, Archibald Ross, ed.--The New World Looks at Its His-
tory. Austin, (1963). $7.50
Lewis, Arthur H.--Murder by Contract. N.Y., 1975. $15.00
Lewis, Charles Lee--David Glasgow Farragut, Admiral in the
Making. Annapolis, (1941). vol. 1 of 2. 1st ed. $25.00
(ex-lib. markings)
Lewis, Claudia Louisa--Children of the Cumberland. N.Y.,
1946. $20.00, $7.50
Lewis, John W.--The Life, Labors, and Travels of Elder
Charles Bowles.... Watertown, N.Y., 1852. $50.00 (part
of front cover lightly stained)
Lewis, Joseph--Thomas Paine.... N.Y., 1947. $10.00
Lewis, Lloyd--Captain Sam Grant.... Bost., 1950. $6.00
--Sherman, Fighting Prophet. N.Y., (1932). 1st ed. $20.00
(few cover spots), $13.50
Lewis, Marvin--The Mining Frontier. Norman, (1967). $15.00
Lewis, Meriwether--History of the Expedition of Captains Lewis
and Clark, 1804-5-6. Chi., 1924. 2 vols. $125.00
--History of the Expedition Under the Command of Captains
Lewis and Clark, to the ... Pacific Ocean. Phila., 1814.
2 vols. 1st ed. $3750.00 (contemp. calf), $2250.00 (re-
bound in calf with orig. endpapers restored)
--The Journals of Lewis and Clark. Bost., 1953. $12.50
Lond., 1954. $45.00 (cloth)

--The Journals of the Expedition.... N.Y., (1962). 2 vols.
 $72.50 (slipcased)
 N.Y., (1962). 2 vols. $45.00 (boards, slipcased)
--Original Journals of the Lewis and Clark Expedition. Bost.,
 1953. $21.00, $20.00
 N.Y., 1959. 8 vols. $375.00 (one of 750 sets, incl. atlas
 vol.)
--The Travels of Capts. Lewis and Clarke.... 1804, 1805, &
 1806....
 See under Title
--Travels to the Source of the Missouri River.... Lond.,
 1814. $3000.00 (half calf, occasional light foxing, map ex-
 pertly backed with linen)
Lewis, Oscar--Autobiography of the West. N.Y., (1958).
 $21.50 (boards, author's autographed presentation)
--Bay Window Bohemia. Garden City, 1956. 1st ed. $10.00
--The Big Four. N.Y., 1966. $10.00
--Bonanza Inn. N.Y., 1939. $12.00 (signed by author)
--California Heritage. N.Y., (1949). $15.00
--George Davidson.... Berkeley, 1954. $27.50, $20.00
--Hearn and His Biographers. S.F., 1930. $69.00 (boards,
 uncut and slightly rubbed, one of 350 copies)
--High Sierra Country. N.Y., (1955). 1st ed. $25.00 (in-
 scribed copy), $12.50 (back cover wearing)
--Lola Montez. S.F., (1938). 1st ed. $75.00 (one of 750
 copies, signed by author)
--On the Edge of the Black Waxy.... S.L., 1948. $22.50
--Pedro Martinez. N.Y., (1964). $10.00
--San Francisco. Berkeley, (1966). 1st ed. $17.50, $11.50
--Sea Routes to the Gold Fields. N.Y., 1949. $12.00
--Silver Kings. N.Y., 1947. 1st ed. $25.00
--Sutter's Fort. Englewood Cliffs, N.J., (1966). $10.00
 (rubber stamp on page edges)
--The Town That Died Laughing. Bost., (1955). $26.50
--La Vida. N.Y., 1966. 1st ed. $12.50
--The War in the Far West: 1861-1865. Garden City, 1961.
 $15.00
Lewis, Paul--The Grand Incendiary. N.Y., 1973. $11.00
--The Man Who Lost America
 See: Gerson, Noel Bertram
--Yankee Admiral.... (N.Y., 1968). $12.50
Lewis, Philip C.--Trouping. N.Y., (1973). $15.00
Lewis, Richard Warrington Baldwin--Edith Wharton.... N.Y.,
 (1975). $17.50
Lewis, Robert G.--Handbook of American Railroads. N.Y.,

(1951). 1st ed. $6.50 (boards, spine tips and corners wearing)

Lewis, Sinclair. Babbitt. N.Y., (1922). 1st ed. $75.00 (cloth, 1st issue, signed and inscribed by author, cover worn and dampstained, spine frayed and torn)

--The Man From Main Street. Lond., 1954. $6.95

--Storm in the West. N.Y., (1963). 1st ed. $10.00

Lewis, Thomas McDowell Nelson--Hiwasse Island.... Knoxville, 1946. 1st ed. $35.00 (wraps.)

Lewis, Tracy Hammond--Along the Rio Grande. N.Y., 1916. 1st ed. $65.00 (orig. cloth, author's inscription), $55.00 (newspaper book review tipped in)

Lewis, Virgil Anson--The Soldiery of West Virginia. Balt., 1972. $12.00

Lewis, Walker--Without Fear or Favor. Bost., 1965. $15.00

Lewis, Walter David--From Newgate to Dannemora. N.Y., 1965. $17.50

Lewis, Willie Newbury--Between Sun and Sod. Clarendon, Tx., (1938). $20.00

Lewisohn, Ludwig--Expression in America. N.Y., 1932. 1st ed. $15.00 (cover lightly worn, bookplate, cloth)

--The Story of American Literature. N.Y., (1939). $7.50

Lewiton, Mina
 See: Simon, Mina Lewiton

Libby, Orin Grant--The Arikara Narrative of the Campaign Against the Hostile Dakotas, June, 1876. Bismarck, 1920. 1st ed. $40.00 (cloth)

Liberman, Mark--Hidalgo. N.Y., (1970). $10.00

Liebling, Abbott Joseph--Chicago, the Second City. N.Y., 1952. 1st ed. $35.00

Lief, Alfred--The Firestone Story. N.Y., (1951). $15.00, $8.00 (ex-lib.)
 N.Y., 1955. $12.00

--Harvey Firestone.... N.Y., (1951). $12.50

--It Floats. N.Y., (1958). $10.00

--Metering for America. N.Y., (1961). $17.50

Lienhard, Heinrich--From St. Louis to Sutter's Fort, 1846. Norman, (1961). 1st ed. $20.00, $18.00

--A Pioneer at Sutter's Fort.... L.A., 1941. $57.50

Life and Adventures of Sam Bass.... (Austin, n.d.). $25.00 (orig. wraps.)

Life and Exploits of S. Glenn Young. Herrin, Il., n.d. $55.00, $45.00

Life and Reminiscences of Jefferson Davis. Balt., 1890. $35.00 (ex-lib., spine sunned)

The Life and Tragic Death of Jesse James.... (Austin, 1966).
$25.00
Life of John Tyler.... N.Y., 1843. 1st ed. $20.00 (wraps.,
some edge wear)
Liggett, Walter William--The Rise of Herbert Hoover. N.Y.,
(1932). $10.00
Light, Martin--The Quixotic Vision of Sinclair Lewis. West
Lafayette, 1975. $8.00
Lighting in America. N.Y., 1975. $17.50
Liholiho, Alexander
See: Kamehameha IV, King of the Hawaiian Islands
Lilienthal, David Eli--Big Business. N.Y., (1953). $15.00
Liliuokalani, Queen of the Hawaiian Islands--Hawaii's Story....
Bost., 1898. 1st ed. $50.00, $50.00 (rubbed)
Rutland, (1964). $20.00
Lillard, Richard Gordon--Desert Challenge.... N.Y., 1942.
1st ed. $40.00 (cloth), $10.00
N.Y., 1949. $12.50 (corner bump, cover soil)
--Hank Monk and Horace Greeley. Georgetown, Ca., 1973.
$7.50
Lincoln, Abraham--Collected Works. New Brunswick, 1953-55.
9 vols. $85.00 (orig. cloth)
--A House Divided Against Itself Cannot Stand.... Chi.,
1936. $25.00 (one of 140 copies)
--Lincoln Letters, Hitherto Unpublished. Prov., 1927. $15.00
(front cover lightly stained)
--New Letters and Papers of Abraham Lincoln. Bost., 1930.
$13.50
--Political Debates Between Hon. Abraham Lincoln and Hon.
Stephen A. Douglas.... Columbus, 1860. $50.00 (ex-lib.,
bit of spine tip and corner wear)
--The Speeches of.... N.Y., (1908). $10.00 (half leather,
spine ends worn, tops water stained)
--Uncollected Letters.... Bost., 1917. $75.00 (ltd. and num-
bered ed., boards)
Lincoln, Charles Henry--Naval Records of the American Revo-
lution.... Wash., 1906. $40.00 (ex-lib.)
Lincoln, Mrs. D.A.
See: Lincoln, Mary Johnson (Bailey)
Lincoln, Joseph Crosby--Cape Cod Ballads. Trenton, 1902.
1st ed. $125.00 (orig. cloth, small ink spot on one page)
Lincoln, Mary Johnson (Bailey)--Boston School Kitchen Text-
Book. Bost., 1887. 1st ed. $125.00 (orig. boards, worn
at extremities, shaken, lacks endpapers)
--Mrs. Lincoln's Boston Cook Book. Bost., 1884. 1st ed.

$1250.00 (orig. half cloth and boards, lightly rubbed on spine and extremities and bottom edge of cover)
Lincoln, William--History of Worcester.... Worcester, 1862. $35.00 (lib. bookplate, lacks front endleaf, sigs. pulled)
Lind, Andrew William--Hawaii's People. Honolulu, 1955. 1st ed. $8.00
Lindbergh, Anne Morrow--Listen! The Wind. N.Y., (1938). 1st ed. $12.50
--North to the Orient. N.Y., (1935). 1st ed. $20.00
--The Unicorn, and Other Poems. N.Y., (1956). 1st ed. $35.00 (boards, one of 850 copies)
Lindbergh, Charles Augustus--The Spirit of St. Louis. N.Y., 1953. 1st ed. $10.00, $8.50
--"We." N.Y., 1927. $5.00
Linderman, Frank Bird--American. N.Y., (1930). $20.00 (bit of spine tip wear), $10.00
--Blackfeet Indians. (St. Paul, 1935). $75.00 (lacks part of front free fly)
--Plenty Coups.... Lincoln, 1962. $5.00
Lindley, Walter--California of the South. N.Y., 1888. 1st ed. $45.00 (small dampstain on front cover, orig. cloth)
Lindquist, Gustavus Elmer Emanuel--The Indian in American Life. N.Y., (1944). 1st ed. $10.00
Lindquist, Willis--Alaska, the Forty-Ninth State. N.Y., (1959). $7.50
Lindsay, Vachel--The Art of the Moving Picture. N.Y., 1915. $15.00
--The Golden Book of Springfield. N.Y., 1920. 1st ed. $150.00
Lindstrom, Ralph Godfrey--Lincoln and Prevention of War. Harrogate, Tn., 1953. $12.50 (signed)
Linen, James--The Later Poems and Songs.... N.Y., 1873. $6.50 (cloth, rubbed)
Linford, Velma--Wyoming, Frontier State. Denver, 1947. $22.50
Link, Arthur Stanley--Writing Southern History. Baton Rouge, 1965. 1st ed. $25.00
Linn, John Blair--Annals of Buffalo Valley.... Harrisburg, Pa., 1877. $75.00 (orig. cloth)
Linn, Walter Armin--False Prophets of Peace. Harrisburg, Pa., (1939). 1st ed. $20.00
Linn, William Alexander--Horace Greeley.... N.Y., 1903. 1st ed. $10.00 (cloth)
--The Story of the Mormons.... N.Y., 1902. $35.00

Lipman, Jean--American Folk Art in Wood, Metal and Stone. (N.Y., 1948). 1st ed. $20.00 (ex-lib.)
--American Folk Decoration. N.Y., 1951. 1st ed. $15.00 (ex-lib.)
Lippard, George--Washington and His Generals. Phila., 1847. $45.00 (half leather, extremities worn, inner hinges weak)
Lippmann, Walter--Drift and Mastery. N.Y., 1914. 1st ed. $15.00 (cloth, name in ink on endpaper)
--Interpretations, 1931-32. N.Y., 1932. 1st ed. $15.00 (cloth)
--Interpretations, 1933-1935. N.Y., 1936. $15.00 (cloth, name on endpaper)
--Liberty and the News. N.Y., 1920. 1st ed. $15.00 (boards, cover worn)
--A Preface to Morals. N.Y., 1929. 1st ed. $15.00 (1st printing, cloth)
--The Stake of Diplomacy. N.Y., 1915. 1st ed. $15.00 (cloth, name on endpaper)
Lipps, Oscar H.--A Little History of the Navajos. Cedar Rapids, 1909. $45.00
Lipset, Seymour Martin--The First New Nation. N.Y., 1963. $15.00
Lipsey, Julia F.--Governor Hunt of Colorado Territory. Colorado Springs, 1960. $25.00 (orig. wraps., one of 400 numbered and signed copies), $6.00 (one of 400 signed copies)
Lipsner, Benjamin B.--The Airmail. Chi., (1951). $10.00
Liptzin, Sam--Tales of a Tailor. N.Y., 1965. $15.00 (inscribed copy)
Liston, Robert A.--Slavery in America. N.Y., 1970. 1st ed. $7.50
Litchfield, Henry Wheatland--Ancient Landmarks of Pembroke. Pembroke, Ma., 1909. 1st ed. $17.50
Litchfield, Paul Weeks--Why? (Cleve., 1945). 1st ed. $17.50 (inscribed and signed by author)
Literary History of the U.S. N.Y., 1948. 3 vols. $50.00 (orig. cloth, 1st printing)
Little, James A.--From Kirtland to Salt Lake City. S.L.C., 1890. $12.50
--Jacob Hamblin
 See: Hamblin, Jacob
Little, Richard Henry--Better Angels. N.Y., 1928. $10.00 (bit of spine wear at top)
Lively, Robert A.--Fiction Fights the Civil War. Chapel Hill, (1957). 1st ed. $20.00

Livermore, Mary Ashton (Rice)--My Story of the War. Hart.,
1889. $17.50, $12.50
Livernois, J.E.--Quebec of Today. Quebec, 1897. $15.00
Livingstone, Beulah--Remember Valentino. N.p., 1938.
$25.00 (wraps. repaired, paper yellowing)
Lizaso, Felix--Marti, Martyr of Cuban Independence. (Albu-
querque, 1953). 1st ed. $12.50
Llewellyn, Karl Nickerson--The Cheyenne Way. Norman, 1953.
$15.00
Lloyd, Nelson--The Soldier of the Valley. N.Y., 1904. $10.00
Lloyd, Thomas W.--History of Interesting Places on the Sus-
quehanna Trail. Williamsport, Pa., (1931). $6.50 (edges
sunned)
Lloyd, William--Letters From the West Indies.... Lond.,
(1839). 1st ed. $175.00 (front hinge strengthened, au-
thor's presentation inscription)
Lobeck, Armin Kohl--Airways of America. N.Y., 1933.
$25.00
Lockett, H. Claiborne--Along the Beale Trail. Lawrence, Ks.,
1940. $13.50
Lockley, Fred--Oregon Folks. N.Y., 1927. $17.50 (bookplate,
gold lettering flaked)
--Oregon Trail Blazers. N.Y., 1929. $20.00 (bookplate)
--Oregon's Yesterdays. N.Y., 1928. $17.50 (bookplate, spine
tip wear)
--Vigilante Days at Virginia City
See: Dosch, Henry Ernst
Lockridge, Ross Franklin--George Rogers Clark.... Yonkers-
on-Hudson, (1927). $15.00
Lockwood, Ethel K.--Side Roads Calling. N.Y., (1949). $7.50
Lockwood, Francis Cummins--The Apache Indians. N.Y.,
1938. $100.00
--Arizona Characters. L.A., 1928. $75.00 (owner name)
--The Life of Edward E. Ayer. Chi., 1929. $30.00, $17.50
(binding fading)
--More Arizona Characters. Tucson, 1942. 1st ed. $18.00
--Pioneer Days in Arizona.... N.Y., 1932. 1st ed. $75.00
(spine tip lightly worn), $40.00
--Story of the Spanish Missions of the Middle Southwest.
Santa Ana, Ca., 1934. $155.00
--Tucson--the Old Pueblo. Phoenix, (1930). $55.00 (bookplate
removed)
--With Padre Kino on the Trail. Tucson, 1934. $20.00
Lockwood, Luke Vincent--Colonial Furniture in America. N.Y.,
1913. 2 vols. $135.00 (cloth, rubbed at extremities)

Lodge, Henry Cabot--Life and Letters of George Cabot. Bost.,
1877. 1st ed. $25.00
--The Pilgrims of Plymouth. Bost., 1921. $40.00 (signed by
author, one of 575 copies, boards)
Logan, Andy--The Man Who Robbed the Robber Barrons.
N.Y., (1965). 1st ed. $12.50
Logan, Herschel C.--Buckskin and Satin. Harrisburg, Pa.,
(1954). $17.50
Logan, Mrs. John A.
See: Logan, Mary Simmerson (Cunningham)
Logan, John Alexander--The Great Conspiracy. N.Y., 1886.
$30.00, $20.00
--The Volunteer Soldier of America. Chi., 1887. 1st ed.
$35.00
Logan, Mary Simmerson (Cunningham)--Thirty Years in Wash-
ington. Hart., (1901). 1st ed. $22.50
Logan, Samuel Crothers--A City's Danger and Defense.
Scranton, Pa., 1887. 1st ed. $75.00 (orig. cloth)
Lomax, John Avery--Cowboy Songs and Other Frontier Bal-
lads. N.Y., (1965). $15.00
--Songs of the Cattle Trail and Cow Camp. N.Y., 1920.
$25.00 (light water stain on lower front cover)
--Will Hogg, Texan. Austin, 1956. $11.50 (boards)
Lomax, Louise--San Antonio's River.... San Antonio, (1948).
$12.50 (signed)
Lomen, Carl J.--Fifty Years in Alaska. N.Y., (1954). $10.00
(presentation copy)
London, Charmian Kittredge--Our Hawaii (Islands and Island-
ers). N.Y., 1922. $20.00 (bookplate)
London, Jack--Moon-Face, and Other Stories. N.Y., 1906.
1st ed. $200.00 (orig. cloth, covers lightly soiled, spine
bit worn, owner signature)
Long, A.L.--Memoirs of Robert E. Lee. Rich., 1886. $45.00
(owner name, corner bumped, small mark on cover)
Long, Francis A.--A Prairie Doctor of the Eighties. Norfolk,
Nb., 1937. 1st ed. $25.00 (cloth, ink inscription by au-
thor's daughter)
Long, Haniel--Interlinear to Cabeza de Vaca. Santa Fe, 1936.
1st ed. $87.50
--Pinon Country. N.Y., (1941). 1st ed. $30.00
Long, Huey Pierce--Every Man a King. New Orleans, 1933.
1st ed. $15.00 (spine little faded)
Long, Margaret--The Santa Fe Trail. Denver, 1954. $45.00
(one corner bumped)
--The Smoky Hill Trail.... Denver, (1953). $30.00

Long, Orie William--Literary Pioneers. Camb., 1935. 1st ed. $17.50
Long, Richard M.--Wichita, 1866-1883. Wichita, 1945. $37.50 (one of 300 numbered copies, ex-lib.)
Long, Stephen Harriman--Voyage in a Six-Oared Skiff to the Falls of Saint Anthony in 1817. Phila., 1860. $175.00 (orig. cloth)
Longfellow, Henry Wadsworth--Flower-de-Luce. Bost., 1867. $50.00 (orig. cloth, head and foot of spine lightly worn)
--In the Harbor: Ultima Thule. Part II. Bost., 1882. 1st ed. $25.00 (cloth, unopened, 1st issue)
--The New England Tragedies. Bost., 1868. 1st ed. $25.00 (cloth, 1st issue, cover lightly worn)
--Three Books of Song. Bost., 1872. 1st ed. $25.00 (cloth, cover lightly worn)
--Voices of the Night. Camb., 1839. 1st ed. $300.00 (orig. boards, spine worn at ends)
--The Works of.... (Bost., 1886-91). 14 vols. $100.00 (orig. cloth)
Longstreet, Helen Dortch--Lee and Longstreet at High Tide. Gainesville, Ga., 1904. 1st ed. $85.00 (bookplate lacks front endpaper, cover soiled)
Longstreet, James--From Manassas to Appomattox. Phila., 1903. $55.00 (covers bumped)
Longstreet, Stephen--Sportin' House. L.A., (1965). $20.00
Longstreth, Thomas Morris--The Adirondacks. N.Y., 1919. $20.00
N.Y., 1922. $10.00 (spine gold flaking)
--The Lake Superior Country. Toronto. (1924). $12.50 (minor gold flaking)
--The Laurentians. N.Y., 1922. $12.50 (gold flaking on spine)
--Quebec, Montreal, Ottawa. N.Y., (1933). $15.00
--To Nova Scotia.... N.Y., 1936. $10.00 (bit of spine tip and edge rubbing)
Longyear, Burton Orange--Trees and Shrubs of the Rocky Mountain Region.... N.Y., 1927. $8.50
Lonn, Ella--Foreigners in the Confederacy. Gloucester, 1965. $16.00
--Foreigners in the Union Army and Navy. N.Y., (1969). $20.00
--Reconstruction in Louisiana After 1868. N.Y., 1918. 1st ed. $50.00 (orig. cloth, autograph presentation copy)
Loomis, Leander Vaness--A Journal of the Birmingham Emigrating Company. S.L.C., 1928. $43.50

Loomis, Noel M.--Pedro Vial and the Roads to Santa Fe. Norman, (1967). $30.00
--The Texan-Santa Fe Pioneers. Norman, 1958. 1st ed. $35.00 (orig. cloth), $20.00, $16.50
--Wells Fargo. N.Y., (1968). $17.50
Loomis, Sylvia Glidden, ed.--Old Santa Fe Today
 See: Historic Santa Fe Foundation
Looney, Ralph--Haunted Highways. N.Y., (1968). 1st ed. $45.00
Lorang, Mary Corde--Footloose Scientist in Mayan America. N.Y., (1966). $10.00
Lorant, Stefan--The Life of Abraham Lincoln. N.Y., (1954). 1st ed. $10.00
--Lincoln: a Picture Story of His Life. N.Y., (1952). 1st ed. $27.50
 N.Y., (1957). $17.50
--The New World. N.Y., 1946. 1st ed. $75.00 (buckram), $45.00 (cloth), $25.00
--Pittsburgh. N.Y., (1964). 1st ed. $30.00, $15.00 (signed by author), $12.50
--The Presidency. N.Y., 1951. 1st ed. $50.00 (inscribed, cloth)
Lord, Eliot--Comstock Mining and Miners. Berkeley, 1959. $20.00
Lord, Elizabeth (Laughlin)--Reminiscences of Eastern Oregon. Portland, Or., 1903. 1st ed. $125.00
Lord, Francis Alfred--Civil War Sutlers and Their Wares. N.Y., 1969. $20.00
--Lincoln's Railroad Man. Rutherford, N.J., (1969). $15.50, $12.50
Lord, John--Frontier Dust. Hart., 1926. $22.50 (one of 1000 copies), $13.50
Lord, Walter--Dawn's Early Light. N.Y., (1972). 1st ed. $12.50 (owner name, d.j. description laid in)
--Day of Infamy. N.Y., (1957). 1st ed. $10.00
--The Fremantle Diary
 See: Fremantle, James Arthur Lyon
Lorenz, Lincoln--The Admiral and the Empress. N.Y., 1954. $6.00
Lorenzana, Francisco Antonio--Historia de Nueva-Espana
 See: Cortes, Hernando
Lorimer, George Horace--More Letters From a Self-Made Merchant to His Son. N.Y., 1927. $8.50
Loring, George Bailey--The Farm-Yard Club of Jotham. Bost. (1876). $45.00

Lossing, Benson John--Our Countrymen. N.Y., 1855. 1st
 ed. $20.00 (bit of foxing)
--The Pictorial Field-Book of the War of 1812. N.Y., 1896.
 $75.00 (orig. cloth)
--The Two Spies.... N.Y., 1918. $17.50 (postage stamp and
 illustration pasted on front fly)
Loth, David Goldsmith--Alexander Hamilton. N.Y., (1939).
 $8.50
Lothrop, Samuel Kirkland--Atitlan. (Wash.), 1933. $37.50
 (edges lightly dampstained)
Lottinville, Savoie, ed.--Life of George Bent....
 See: Bent, George
Loubat, Joseph Florimond--The Medallic History of America.
 N.Y., 1878. 2 vols. 1st ed. $250.00 (cloth, some soiling)
Louis-Phillippe, King of the French--Diary of My Travels in
 America.... N.Y., (1977). $20.00
Louisiana State Museum--Glamorous Louisiana Under Ten Flags.
 (New Orleans, 1937). $6.00
Love, Philip H.--Andrew W. Mellon.... Balt., 1929. $15.00
Love, Robertus--The Rise and Fall of Jesse James. N.Y.,
 1926. $27.50 (bookplate, spine tips and bit of corner wear)
Loveland, Cyrus C.--California Trail Herd. Los Gatos, 1961.
 $75.00 (one of 750 copies)
Low, Alfred Maurice--The American People.... Bost., 1909-
 11. 2 vols. 1st ed. $15.00 (small hole in one title)
Low, Garrett W.--Gold Rush by Sea. Phila., 1941. $10.00
Lowe, David--Lost Chicago. Bost., 1975. 1st ed. $35.00
Lowe, Percival Green--Five Years a Dragoon ('49 to '54)....
 K.C., 1906. 1st ed. $75.00
 Norman, (1965). $20.00
Lowell, Amy--Dream Drops. Bost., (1887). $1250.00 (orig.
 muslin, one of 99 copies specially bound)
Lowell, James Russell--The Complete Writings of.... 16 vols.
 $100.00 (orig. cloth, one of 1000 copies)
Lowell, Joan--Promised Land. N.Y., (1952). 1st ed. $8.50
 (endpaper staining)
Lowell, Robert--Life Studies. Lond., (1959). 1st ed. $100.00
 (cloth)
 N.Y., (1959). $50.00
Lowenfels, Walter, ed.--Walt Whitman's Civil War
 See: Whitman, Walt
Lowery, Woodbury--The Spanish Settlements Within the Present
 Limits of the U.S., 1513-1561. N.Y., 1901. 1st ed.
 $85.00
Lowie, Robert Harry--The Crow Indians. N.Y., (1935). 1st

ed. $65.00 (minor water glass mark on cover), $55.00
(bookplate, cloth flecked)
--Indians of the Plains. N.Y., (1954). 1st ed. $25.00
Garden City, 1963. $5.00
Lowther, Charles C.--Dodge City, Kansas. Phila., (1940).
$50.00 (lacks front and back flys), $45.00, $30.00
Lowther, Minnie Kendall--Blennerhassett Island in Romance
and Tragedy. Rutland, Vt., (1936). 1st ed. $30.00
(signed by author)
Lubbock, Francis Richard--Six Decades in Texas. Austin,
1900. $125.00 (recent binding)
Lubbock, Percy--Portrait of Edith Wharton. N.Y., (1947).
$18.00
Lucia, Ellis--Head Rig. Portland, Or., (1965). $20.00 (signed
by author)
Luckert, Karl W.--The Navajo Hunter Tradition. Tucson,
1975. 1st ed. $27.50
Ludewig, Hermann Ernst--The Literature of American Local
History. N.Y., 1846. 1st ed. $500.00 (occasional light
water staining)
(Ludlow, Fitz Hugh)--The Hasheesh Eater.... N.Y., 1857.
1st ed. $125.00 (orig. cloth, stained and worn, backstrip
faded)
--The Heart of the Continent. N.Y., 1870. 1st ed. $42.50
(covers worn, some foxing)
Ludwig, Emil--Lincoln. Bost., 1930. 1st ed. $37.50 (one of
775 copies, signed), $25.00 (ltd. ed., signed by author,
cloth and boards), $14.50
Lueders, August--Sixty Years in Chicago.... Chi., 1929.
$30.00
Luff, Joseph--Autobiography of Elder.... Lamoni, Ia., 1894.
$25.00 (owner name, few pages repaired)
Luhan, Mabel (Ganson) Dodge--Lorenzo in Taos. N.Y., 1932.
1st ed. $10.00 (cloth)
--Una and Robin. Berkeley, 1976. $20.00 (orig. wraps.)
Lull, Edward Phelps--History of the U.S. Navy-Yard at Gos-
port.... Wash., 1874. $50.00
Lumholtz, Karl Softus--El Mexico Desconocido, N.Y., 1904.
2 vols. 1st ed. $250.00 (orig. cloth)
--New Trails in Mexico. N.Y., 1912. 1st ed. $125.00 (orig.
cloth), $75.00, $50.00
--Unknown Mexico. Glorieta, (1973). 2 vols. $32.50
Lummis, Charles Fletcher--The Awakening of a Nation. N.Y.,
1898. $15.00
--A Bronco Pegasus. Bost., 1928. $24.00

--Bullying the Moqui. Prescott, Az., 1968. $15.00
--Flowers of Our Lost Romance. Bost., 1929. $32.50 (some
 corner and spine tip wear)
--General Crook and the Apache Wars. Flagstaff, (1966).
 1st ed. $65.00 (one of 250 copies)
--The King of the Broncos and Other Stories of New Mexico.
 N.Y., 1897. 1st ed. $42.50
--The Land of Poco Tiempo. N.Y., 1893. 1st ed. $65.00
 (owner name)
 N.Y., 1923. $25.00 (cloth)
--Mesa, Canon and Pueblo. N.Y., (1925). 1st ed. $50.00
--Pueblo Indian Folk-Stories. N.Y., 1910. 1st ed. $20.00
--Some Strange Corners of Our Country. N.Y., 1892. 1st
 ed. $20.00 (bookplate, spines slightly darkened)
--The Southwestern Wonderland. Albuquerque, (197-?).
 $17.50 (one of 500 copies)
--The Spanish Pioneers and the California Missions. Chi.,
 1936. $10.00 (bookplate, ex-lib., cover worn)
--A Tramp Across the Continent. N.Y., 1892. 1st ed.
 $37.50 (bookplate)
Lundwall, Nels Benjamin--The Fate of the Persecutors of the
 Prophet Joseph Smith. S.L.C., (1952). $12.50 (ex-lib.,
 nick on spine)
Lunt, Dolly Sumner
 See: Burge, Dolly Sumner (Lunt)
Lunt, Richard D.--The High Ministry of Government. Detroit,
 1965. $12.50
Luomala, Katharine--Maui-of-a-Thousand-Tricks. Honolulu,
 1949. 1st ed. $35.00
Lurie, Nancy (Oestreich), ed.--Mountain Wolf Woman....
 See: Mountain Wolf Woman
Luther, Tal--High Spots of Custer.... K.C., 1967. $25.00
 (one of 250 signed copies)
Luthin, Reinhard Henry--The First Lincoln Campaign. Camb.,
 1944. 1st ed. $20.00
Luttig, John C.--Journal of Fur-Trading Expedition on the
 Upper Missouri. N.Y., 1964. $30.00
Lutz, Francis Earle--Chesterfield, an Old Virginia County.
 Rich., 1954. $40.00, $20.00
Luzerne, Frank--The Lost City! N.Y., 1872. $50.00 (spine
 discolored, light tip wear)
Lydenberg, Harry Miller--Lincoln and Prohibition. Worcester,
 Ma., 1952. $7.50
Lyell, Charles--A Second Visit to the United States of North
 America. N.Y., 1849. 2 vols. $175.00 (cloth, extremities
 moderately worn)

--Travels in North America in the Years 1841-2. N.Y., 1845.
2 vols. $400.00 (contemp. calf)
Lyle, John H.--The Dry and Lawless Years. Englewood Cliffs,
1961. $12.50
Lyman, Albert--Journal of a Voyage to California. Hart.,
1852. 1st ed. $700.00 (orig. cloth, skillfully rebacked,
orig. spine), $450.00 (rebacked, minor dampstain)
Lyman, Albert R.--Indians and Outlaws. S.L.C., (1962).
$15.00
--The Outlaw of Navaho Mountain. S.L.C., 1963. $13.00
(bookplate, owner name)
Lyman, Chester Smith--Around the Horn to the Sandwich
Islands and California, 1845-1850. Freeport, (1971).
$15.00
Lyman, George Dunlap--John Marsh, Pioneer. N.Y., 1930.
1st ed. $125.00 (boxed, one of 150 copies, signed and
inscribed)
Chautauqua, N.Y., 1931. $15.00
--Ralston's Ring. N.Y., 1937. 1st ed. $20.00
--The Saga of the Comstock Lode.... N.Y., 1934. 1st ed.
$37.50, $30.00 (water stained and binding lightly warped),
$12.50, $10.00 (letters flaked, cover stains, spine tip
fray, owner name)
Lyman, William Denison--The Columbia River.... N.Y., 1917.
$20.00 (top spine tip fray)
Lynch, Denis Tilden--Criminals and Politicians. N.Y., 1932.
$17.50
Lynch, Dudley M.--The Hereford Brand.... Austin, Tx.,
(1967?). $10.00
Lynch, James--The New York Volunteers in California
See under Title
--With Stevenson to California. Oakland, 1954. $25.00 (one
of 500 copies), $20.00 (one of 500 copies)
Lynch, Jeremiah--Three Years in the Klondike. Chi., 1967.
$12.50
Lynip, Ryllis (Alexander) Goslin--Made in U.S.A. N.Y.,
1935. $7.00 (worn boards)
Lynn, Margaret--A Stepdaughter of the Prairie. N.Y., 1916.
$14.00
Lyon, Peter--To Hell in a Day Coach. Phila., 1968. $10.00
Lyons, Eugene--Herbert Hoover.... Garden City, 1964.
$10.00
--The Red Decade. Ind., (1941). $17.50
Lyons, Louis Martin--Newspaper Story. Camb., 1971. $20.00
Lysaght, Averil M.--Joseph Banks in Newfoundland....
Lond., 1971. $45.00 (orig. cloth)

Lytle, Andrew Nelson--Bedford Forrest and His Critter Company. N.Y., 1931. 1st ed. $60.00

- M -

Maass, John--The Gingerbread Age. N.Y., 1957. 1st ed. $20.00

Mabie, Hamilton Wright--Essays on Work and Culture. N.Y., 1899. $10.00 (cloth)

--Nature and Culture. N.Y., 1904. $8.00

McAdie, Alexander George--The Clouds and Fogs of San Francisco. S.F., 1912. $27.50 (owner name)

McAfee, Robert Breckinridge--History of the Late War in the Western Country. Lexington, Ky., 1816. $500.00 (orig. full sheet with morocco label, some wear) Bowling Green, (1919). $32.50 (binding dull, new endpapers)

McAlister, Lyle N.--The "Fuero Militar" in New Spain. Gainesville, 1957. 1st ed. $12.50 (front endpaper corner excised)

McArthur, Harry S.--Cambio Politico en Tres Comunidades Indigenas de Guatemala. Guatemala City, 1969. $4.00 (wraps.)

Macartney, Clarence Edward Noble--Lincoln and His Cabinet. N.Y., 1931. $15.00

Macaulay, Neill--The Sandino Affair. Chi., 1967. 1st ed. $25.00

McBeth, Frances Turner--Lower Klamath Country. Berkeley, (1950). $5.00 (signed by author)

McBeth, Reid Sayers--Oil. N.Y., 1919. $15.00

McBride, George McCutchen--Chile. N.Y., 1936. 1st ed. $17.50, $12.50

McBride, Herbert Wes--A Rifleman Went to War. Plantersville, S.C., (1935). $25.00 (bookplate, spine bit darkened, owner name)

McBride, Mary Margaret--Out of the Air. Garden City, 1960. 1st ed. $17.50

Macbride, Thomas Huston--In Cabins and Sod Houses. Iowa City, 1928. $6.00 (front inner hinge frayed)

McCabe, Charles R., ed.--Damned Old Crank See: Scripps, Edward Wyllis

(McCabe, James Dabney)--History of the Grange Movement. Chi., 1873. 1st ed. $30.00 (orig. cloth)

McCafferty, E.D.--Henry J. Heinz. N.p., 1951. $10.00 (cloth)

McCaleb, Walter Flavius--The Aaron Burr Conspiracy. N.Y.,
 1936. $25.00
--The Conquest of the West. N.Y., (1947). $12.50 (spine
 faded), $5.00
--The Spanish Missions of Texas. San Antonio, (1954). 1st
 ed. $7.50 (front cover, edges, illus. waterstained)
McCall, George Archibald--New Mexico in 1850. Norman,
 (1968). $15.00
McCall, William Anderson--Cherokees and Pioneers. Ashville,
 N.C., (1952). $8.50
McCallum, Henry D.--The Wire That Fenced the West. Nor-
 man, (1966). $15.00, $15.00
McCanse, Keith--Where to Go in the Ozarks. K.C., 1932.
 $7.50
McCarthy, Carlton--Detailed Minutiae of Soldier Life in the
 Army of Northern Virginia. Rich., 1899. $35.00 (book-
 plate)
McCarthy, John Russell--These Waiting Hills. L.A., (1925).
 $15.00 (spine tips and corners rubbing)
McCarthy, Justin--The Settlement of the Alabama Question.
 Lond., 1871. $100.00 (wraps., tape repairs on backstrip)
McCarty, Frank W.--Indian Fighting on the Texas Frontier
 See: Elkins, Frank W.
McCarty, John Lawton--Adobe Walls Bride. San Antonio,
 (1956). $12.50
--Maverick Town. Norman, 1946. 1st ed. $25.00 (cloth,
 lacks illustrated frontis.), $17.50
 Norman, 1952. $12.50
McCarty, Joseph Hendrickson--Two Thousand Miles Through
 the Heart of Mexico. N.Y., 1886. $18.00
McCauley, I.H.--Historical Sketch of Franklin County....
 Harrisburg, Pa., 1878. $60.00 (orig. cloth)
McCauley, James Emit--A Stove-Up Cowboy's Story.... Dallas,
 1965. $37.50
McClellan, Carswell--The Personal Memoirs and Military History
 of U.S. Grant.... Bost., 1887. 1st ed. $30.00 (wear at
 edges)
McClellan, George Brinton--Letter of the Secretary of War,
 Transmitting Report on the Organization of the Army of
 the Potomac. Wash., 1864. $27.50
--McClellan's Own Story. N.Y., 1887. $35.00 (cloth), $35.00
 (spine tips bit worn), $25.00 (cloth, corners lightly bumped)
--Manual of Bayonet Exercise. Phila., 1862. $37.50 (cloth,
 lightly worn, scattered foxing, bookplate)
--Report on the Organization and Campaigns of the Army of
 the Potomac. N.Y., 1864. $25.00 (spine and covers worn)

McClellan, Henry Brainerd--The Life and Campaigns of Major-General J.E.B. Stuart. Bost., 1885. $80.00 (covers bit soiled, some spine and corner wear)

McClellan, Rolander Guy--The Golden State. Phila., 1872. 1st ed. $75.00 (new binding, one page bit torn, owner name)

McClintock, Francis Leopold--A Narrative of the Discovery of the Fate of Sir John Franklin and His Companions. Bost., 1860. $45.00 (wear at edges)

McClintock, Gilbert Stuart--Valley Views of Northeastern Pennsylvania. Wilkes-Barre, 1948. $80.00 (orig. cloth, author's presentation)

McClintock, John S.--Pioneer Days in the Black Hills. Deadwood, S.D., (1939). $125.00 (boxed)

McClintock, Walter--Old Indian Trails. Bost., 1923. 1st ed. $35.00 (bookplate, cover damage, some pages bent)

McClumpha, Charles Flint--Minnesota Stories. Minne., 1903. $10.00

McClung, John Alexander--Sketches of Western Adventure. Dayton, 1854. $75.00 (rebound)

McClung, John W.--Minnesota as it is in 1870. (St. Paul), 1870. $25.00 (lacks map)

McClung, Paul, ed.--Papa Jack: Cowman....
See: Howenstine, Papa Jack

McClure, Alexander Kelly--Abraham Lincoln and Men of War-Times. Phila., 1892. $20.00 (rear endpaper cracked)

--Lincoln's Own Yarns and Stories. Chi., (1901). $15.00 (cloth, owner name)

--Old Time Notes of Philadelphia. Phila., 1905. 2 vols. $35.00 (one of 1000 sets, uncut)

McClure, James Baird--Stories and Sketches of Chicago. Chi., 1880. $20.00 (lib. pocket, owner name)

McClure, Michael--Dark Brown. S.F., 1961. 1st ed. $20.00 (wraps.)
S.F., 1967. $4.50

McClure, Robert John LeMesurier--The Discovery of the North-West Passage. Lond., 1856. $400.00 (half calf and marbled boards, lightly rubbed, bookplate removed)

McColgan, Daniel T.--Joseph Tuckerman. Wash., 1940. $60.00 (three-quarter leather and cloth, ex-private lib.)

McCollam, C. Harold--The Brick and Tile Industry in Stark County.... Canton, Oh., 1976. $12.00

McCollester, Sullivan Holman--Mexico, Old and New. Bost., 1899. $12.50

McComas, Evans Smith--A Journal of Travel. Portland, Or., 1954. $47.50, $43.50 (untrimmed)

McConathy, Dale--Hollywood Costume. N.Y., 1976. $65.00
(signed by author)
McConkey, Harriet E. Bishop--Dakota War Whoop. St. Paul,
1864. $75.00
McConnell, Burt M.--Mexico at the Bar of Public Opinion.
N.Y., 1939. $10.00
McConnell, Lela Grace--Hitherto and Henceforth in the Ken-
tucky Mountains. (Lawson, Ky.), 1949. $12.50
McConnell, Virginia
See: Simmons, Virginia McConnell
McConnell, William John--Frontier Law. Yonkers-on-Hudson,
1924. $35.00
McCook, Henry Christopher--The Latimers.... Phila., (1897).
$10.00
--The Martial Graves of Our Fallen Heroes in Santiago de
Cuba. Phila., 1899. $18.50 (joints broken)
McCorkle, John--Three Years With Quantrell. Armstrong, Mo.,
(1914). 1st ed. $300.00 (orig. wraps.)
N.Y., 1966. $30.00 (orig. cloth, ltd. ed. of 500 copies)
McCormick, Cunningham--Arizona. Tucson, 1968. $10.00
McCormick, Robert Rutherford--The American Revolution and
Its Influence on World Civilization. (Chi., 1945). $8.00,
$5.50
--The Sacking of America. (Chi., 1932). $6.00
--The War Without Grant. N.Y., 1950. $16.00
McCoy, Joseph Geiting--Historic Sketches of the Cattle Trade
of the West and Southwest. K.C., 1874. $750.00 (later
cloth), $750.00 (spine tips worn, corner wear, bit of split-
ting of cloth along hinges, owner name)
Glendale, 1940. $37.50 (gold flaked on spine, light corner
bump)
Columbus, 1951. $25.00 (cloth)
McCoy, Raymond Arthur--The Massacre of the Old Fort Mack-
inac. Bay City, Mi., (1956). $7.50
McCoy, Samuel Duff--This Man Adams. N.Y., 1928. $12.50
McCracken, Harold--The American Cowboy. N.Y., 1973.
$85.00 (ltd. ed.)
Garden City, 1973. $25.00
--The Charles M. Russell Book. Garden City, 1957. 1st ed.
$100.00 (buckram), $60.00 (inscribed)
--The Frank Tenney Johnson Book. Garden City, 1974. 1st
ed. $300.00 (leather, one of 350 numbered and signed
copies, boxed), $40.00
--The Frederic Remington Book. Garden City, 1966. $47.50
--Frederic Remington's Own West
See: Remington, Frederic

--George Catlin and the Old Frontier. N.Y., (1959). $45.00
(cloth), $25.00

--Portrait of the Old West. N.Y., 1952. 1st ed. $45.00,
$25.00 (cloth)

McCracken, Steven Bromley--The State of Michigan. Lansing,
1876. 1st ed. $25.00 (disbound), $15.00 (orig. wraps.,
partly torn along backstrip, front cover chipped)

McCrea, Tully--Dear Belle. Middleton, Ct., (1965). $13.50

McCreight, Major Israel--Firewater and Forked Tongues.
Pasadena, (1947). $32.50

McCullagh, Francis--Red Mexico. N.Y., 1928. $7.50 (ex-lib.,
spine top pulled, hinges open)

McCullers, Carson--The Member of the Wedding. Bost., 1946.
$45.00

McCullough, Boyd--The Experiences of 70 Years. Minne.,
1895. $15.00

McCullough, David G.--The Johnstown Flood, 1889. N.Y.,
(1968). $7.50 (autographed)

--The Path Between the Seas. N.Y., (1977). 1st ed. $10.00

McCullough, Esther Morgan--As I Pass, O Manhattan. (North
Bennington, Vt., 1956). $25.00 (cloth)

McCune, Wesley--The Nine Young Men. N.Y., 1947. 1st ed.
$10.00

McCurdy, James G.--By Juan de Fuca's Strait.... Port.,
Or., (1937). $17.50

McCutcheon, George Barr--Beverly of Graustark. N.Y., 1904.
1st ed. $15.00 (cloth)

McDaniel, Ruel--One More Sunrise. Port Lavaca, Tx., (1965).
$15.00

--Vinegarroon. Kingsport, (1936). $16.50, $13.00

McDermott, Edith (Swain)--The Pioneer History of Greeley
County, Nebraska. Greeley, Nb., (1939). 1st ed. $25.00
(author's presentation, few cover spots, light spine wear)

McDermott, Gerald--Arrow to the Sun. N.Y., (1974). 1st
ed. $27.50

McDermott, John Francis--The Early Histories of St. Louis.
S.L., 1952. $25.00

--George Caleb Bingham, River Portraitist. Norman, (1959).
$47.50

--The Lost Panoramas of the Mississippi. Chi., (1958). $15.00

--Memoir, or, a Cursory Glance at My Different Travels....
See: Milford, Louis

--Tixier's Travels on the Osage Prairies
See: Tixier, Victor

McDonald, A.B.--Hands Up!
See: Sutton, Fred Ellsworth

McDonald, Elwood L.--History of Buchanan County and St.
 Joseph.... St. Joseph, Mo., 1915. $50.00 (lettering worn
 off spine, spine tip and corner rub)
McDonald, John--Secrets of the Great Whiskey Ring.... Chi.,
 1880. 1st ed. $32.50
McDonald, Lucile Saunders--Coast Country. Portland, Or.,
 1966. $12.50
MacDonald, Malcolm--Down North.... N.Y., (1943). $10.00
 (bit of wear to bottom corners)
McDonough, James L.--Scholfield. Tallahassee, 1972. $15.00
McDougall, James Alexander--French Interference in Mexico.
 Balt., 1863. 1st ed. $15.00 (covers separated)
McDougall, Walter Byron--Plants of the Yellowstone National
 Park. Wash., 1936. 1st ed. $7.50 (owner name)
MacDowell, G.F.--The Brandon Packers Strike. Toronto,
 (1971). $7.50
Macedo Soares, Jose Carlos de--Brazil and the League of Na-
 tions. Paris, 1928. $75.00 (morocco, one of 20 numbered
 copies on Japan vellum)
McElroy, John--Andersonville. Toledo, 1879. $10.00 (rubbed)
McElroy, Robert McNutt--Grover Cleveland. N.Y., 1923. 2
 vols. 1st ed. $20.00
--Jefferson Davis; the Unreal and the Real. N.Y., 1937. 2
 vols. 1st ed. $55.00, $37.50
--Kentucky in the Nation's History. N.Y., 1909. $20.00
 (ex-lib., poor condition, reading copy only)
MacEwan, Paul--Miners and Steelworkers. Toronto, 1976.
 $20.00
McEwen, Inez (Puckett)--So This is Ranching! Caldwell,
 (1948). $15.00, $12.50
McEwen, J.D.--Brazil. Montreal, 1916. 1st ed. $6.50
McFadden, Elizabeth--The Glitter & the Gold. N.Y., 1971.
 $20.00
MacFadden, Harry Alexander--Rambles in the Far West. Hol-
 lidaysburg, Pa., 1906. 1st ed. $40.00 (spine tips and
 corners worn, front hinge bit weak, front endpaper missing
Macfarlan, Allan A.--American Indian Legends. N.Y., 1968.
 $25.00 (cloth, slipcased)
McFarland, Elizabeth (Fleming)--Forever Frontier. Albuquer-
 que, 1967. $10.00
McFarland, Henry--Sixty Years in Concord and Elsewhere.
 Concord, 1899. $15.00 (inner hinges partly cracked,
 presentation copy)
MacFarlane, W.G.--The Charm of New Orleans. Chi., (1928).
 $6.50

McFarling, Lloyd--Exploring the Northern Plains.... Caldwell, 1955. 1st ed. $27.50
Macfie, Harry--Wasa-Wasa. Lond., 1953. $11.00
McGavin, Elmer Cecil--The Mormon Pioneers. S.L.C., 1947. 1st ed. $30.00
McGaw, Martha Mary--Stevenson in Hawaii. Honolulu, 1950. 1st ed. $22.50 (signed by author)
McGaw, William Cochran--Savage Scene. N.Y., (1972). $13.00
McGee, Dorothy Horton--Herbert Hoover. N.Y., 1967. $10.00
McGee, Emma R.--Life of W.J. McGee.... Farley, Ia., 1915. $30.00
McGee, W.J.--The Seri Indians of Bahia Kino and Sonora. (Glorieta, N.M., 1971). $27.50
--The Sioux Indians
 See under Title
McGlashan, Charles Fayette--History of the Donner Party. Truckee, 1879. 1st ed. $750.00 (orig. cloth, some wear)
 Sacramento, 1907. $27.50 (minor spine tip and corner rub)
McGloin, John Bernard--Eloquent Indian. Stanford, (1949). 1st ed. $10.00
 Stanford, (1950). $15.00
McGowan, Edward--McGowan vs. California Vigilantes. Oakland, 1946. $75.00 (cloth, one of 675 numbered copies), $35.00 (one of 675 copies)
--Narrative of Edward McGowan. S.F., 1917. $100.00 (signed by editor, one of 200 copies, bookplate)
McGrath, Tom--Vicente Silva and His Forty Thieves. N.p., 1960. $15.00
McGraw, James Herbert--Teacher of Business. Chi., (1944). $10.00
MacGregor, Bruce A.--South Pacific Coast. Berkeley, 1968. $25.00
MacGregor, James Grierson--Edmonton: a History. Edmonton, Alta., (1967). 1st ed. $17.50 (signed)
McGregor, James Herman--The Wounded Knee Massacre.... Balt., (1940). $85.00
 Minne., (1950). $15.00
McGregor, John Charles--Southwestern Archaeology. N.Y., 1941. 1st ed. $45.00
McGroarty, John Steven--California, Its History and Romance. L.A., (1928). $10.00 (one corner bumped)
--California of the South. L.A., 1933-35. 5 vols. $100.00
--Just California Songs Along the Way. $5.00 (small ink mark on cover)

--Mission Memories.... L.A., 1929. $7.50 (boards, chip on
spine and corners)
McHugh, Tom--The Time of the Buffalo. N.Y., 1972. 1st
ed. $20.00
McIlhany, Edward Washington--Recollections of a Forty-Niner.
K.C., 1908. 1st ed. $55.00
McIlvaine, Mabel, comp.--Reminiscences of Chicago During the
Civil War. Chi., 1914. 1st ed. $20.00
N.Y., (1967). $12.50
--Reminiscences of Chicago During the Forties and Fifties.
Chi., 1913. $12.50 (cloth, spine ends rubbed)
Chi., 1914. $20.00
--Reminiscences of Chicago During the Great Fire. Chi., 1915.
$20.00
--Reminiscences of Early Chicago. Chi., 1912. $17.50 (cloth
mottled, publisher's complimentary card laid in and signed
by Reuben H. Donnelley)
McIlwaine, Shields--The Southern Poor-White From Lubberland
to Tobacco Road. Norman, 1939. 1st ed. $30.00
McIntosh, Burr--The Little I Saw of Cuba. Lond., (1899).
$14.00 (cloth)
McIntosh, Maria Jane--The Lofty and the Lowly. N.Y., 1854.
2 vols. $7.50
McIntyre, Oscar Odd--White Light Nights. N.Y., 1924. $25.00
(signed, one of 600 copies, boards, soiled)
MacIsaac, John--Half the Fun Was Getting There. Englewood
Cliffs, (1968). $10.00
Mack, Arthur Carlyle--The Palisades of the Hudson. Edge-
water, N.J., (1909). $17.50 (orig. boards, text lightly
dampstained)
Mack, Connie--My 66 Years in the Big Leagues. Phila., 1950.
$15.00
Mack, Effie Mona--Mark Twain in Nevada. N.Y., 1947. 1st
ed. $20.00 (author's presentation inscription)
Mack, Gerstle--The Land Divided. N.Y., 1944. 1st ed.
$15.00
Mackay, Alexander--The Western World. Lond., 1849. 3 vols.
$225.00 (orig. cloth, some stains, back inside hinge of vol.
3 cracked)
Mackay, Charles, ed.--The Mormons
See: (Mayhew, Henry)
MacKay, Donald, 1925--Anticosti. Toronto, 1979. $15.00
McKay, Donald Cope--The U.S. and France. Camb., 1951.
1st ed. $10.00 (cloth, ex-lib.)
Mackay, Malcolm S.--Cow Range and Hunting Trail. N.Y.,
1925. 1st ed. $200.00 (inscribed, cloth)

McKay, Richard Cornelius--Some Famous Sailing Ships....
N.Y., 1928. $55.00
McKee, James Cooper--Narrative of the Surrender of a Com-
mand of U.S. Forces.... N.Y., 1881. $400.00 (pamphlet,
boxed, signed by author)
Houston, 1960. $27.50 (one of 500 copies)
McKee, Russell--Great Lakes Country. N.Y., (1966). $10.00
McKee, Ruth (Karr)--Mary Richardson Walker. Caldwell,
1945. 1st ed. $35.00
MacKellar, Jean Scott--Hawaii Goes Fishing. N.Y., 1956.
1st ed. $15.00
McKelvey, Blake--The Urbanization of America.... New
Brunswick, N.J., (1963). $25.00
McKelvey, Susan Delano--Botanical Exploration of the Trans-
Mississippi West, 1790-1850. Jamaica Plain, 1955. $100.00
(orig. cloth)
McKenna, James A.--Black Range Tales. N.Y., 1936. 1st
ed. $75.00 (one of 500 copies), $45.00, $25.00
McKenney, Thomas Loraine--History of the Indian Tribes of
North America. Phila., 1848-50. 3 vols. $4500.00 (mo-
rocco, hinges starting, some foxing and browning)
--The Indian Tribes of North America.... Edin., 1933-34.
3 vols. $300.00 (cloth), $275.00 (previous owner's signa-
ture in each vol.), $250.00
--Memoirs, Official and Personal.... N.Y., 1846. 2 vols. in
1. $200.00 (cloth, some pages lightly foxed)
--Sketches of a Tour of the Lakes. Barre, Ma., 1972. $45.00
(cloth, one of 1950 copies, slipcased), $40.00 (cloth, boxed,
one of 1950 numbered copies)
Mackenzie, Alexander--First Man West. Berkeley, 1962. 1st
ed. $30.00 (previous owner's stamp on endpaper), $15.00
--Voyages From Montreal on the River St. Lawrence.... Rut-
land Vt., (1971). $25.00
McKeown, Martha (Ferguson)--Alaska Silver.... N.Y., 1951.
$7.50 (lib. stamps, description pasted to flys)
Mackesy, Piers--The War For America: 1775-1783. Camb.,
1965. $15.00
Mackie, John Milton--From Cape Cod to Dixie and the Tropics.
N.Y., 1864. 1st ed. $13.50 (ex-lib., spine faded)
McKim, Randolph Harrison--The Soul of Lee. N.Y., 1918.
$25.00 (gold worn off front cover)
McKinley, Silas Bent--Old Rough and Ready.... N.Y., 1945.
1st ed. $12.50
McKinstry, Byron Nathan--The California Gold Rush Overland
Diary of.... Glendale, 1975. $21.50, $15.00 (bottom cor-
ners lightly bumped)

McKnight, Charles--Our Western Border. Phila., 1876. $35.00
(leather)
McKnight, William James--A Pioneer Outline History of North-
western Pennsylvania. Phila., 1905. $60.00
McLanathan, Richard B.K.--Art in America. N.Y., (1973).
$15.00
McLaughlin, James--My Friend the Indian. Bost., 1910. 1st
ed. $55.00, $25.00 (lower edge lightly waterstained)
Seattle, (1970). $35.00 (ltd. ed., leatherette, in cloth
slipcase, bottom edge lacking, a few pages dog-eared)
McLaughlin, Robert William--Washington and Lincoln. N.Y.,
1912. $13.00
MacLaurin, Lois Margaret--Franklin's Vocabulary. Garden City,
1928. $15.00
Maclay, Samuel--Journal of.... While Surveying the West
Branch of the Susquehanna.... in 1790. Williamsport, Pa.,
1887. $75.00 (newly rebacked), $45.00 (half leather, lacks
half of backstrip, front hinge cracked)
Maclay, William--The Journal of.... N.Y., 1927. 1st ed.
$25.00
MacLean, John Patterson--Renaissance of the Clan MacLean.
Columbus, Oh., 1913. $20.00 (some rubbing, inner
hinges lightly cracked)
MacLeish, Archibald--The American Story. N.Y., (1944).
$15.00 (front endsheet clipped)
--The Fall of the City. N.Y., (1937). 1st ed. $15.00
(boards)
--Herakles. Bost., 1967. $10.00 (cloth, review copy)
--The Human Season. Bost., 1972. $35.00 (leatherette, one
of 500 signed copies)
--The Irresponsibles. N.Y., (1940). $10.00 (cloth)
--Songs for Eve. Bost., 1954. $15.00 (orig. cloth)
McLeod, Alexander, 1895--Pigtails and Gold Dust. Caldwell,
1948. $25.00
MacLeod, Alexander Samuel, 1888--The Spirit of Hawaii....
N.Y., (1943). $22.50
McLeod, Donald--History of Wiskonsan.... Buffalo, 1846.
1st ed. $350.00 (binding faded, tape repairs, sig. lightly
pulled)
McLoughlin, Emmett--An Inquiry Into the Assassination of
Abraham Lincoln. N.Y., (1963). $15.00
McLoughlin, John--The Letters of Dr. John McLoughlin....
Portland, Or., (1948). 1st ed. $12.50
McLoughlin, William Gerald--The Meaning of Henry Ward
Beecher. N.Y., 1970. $10.00

McLuhan, T.C.--Touch the Earth. N.Y., 1972. $7.50
McLure, Mary Lilla--History of Shreveport and Shreveport
 Builders. Shreveport, 1937. 2 vols. $35.00
Maclure, William--Education and Reform at New Harmony. Ind.,
 1948. 1st ed. $25.00 (orig. wraps.)
McMahon, William E.--Two Strikes and Out. Garden City,
 1939. $20.00
MacManus, Theodore Francis--Men, Money, and Motors. N.Y.,
 1929. $12.00
McMaster, John Bach--The Acquisition of Political, Social and
 Industrial Rights of Man in America. Cleve., 1903. 1st
 ed. $25.00 (orig. cloth, one of 500 numbered copies),
 $15.00 (one of 500 copies, ex-lib., presentation copy)
McMechen, Edgar Carlisle--The Moffat Tunnel of Colorado.
 (Denver, 1927). 2 vols. $75.00 (spine tips frayed and
 bit of edge wear)
--The Shining Mountains, Colorado. Denver, 1935. $10.00
 (bit of edge chip)
--The Tabor Story. (Denver, 1951). 1st ed. $6.00
MacMichael, Morton--A Landlubber's Log of a Voyage Round
 the "Horn." (Phila.), 1879. 1st ed. $100.00 (orig. cloth,
 chipped at top of spine)
McMinn, Edwin--A German Hero of the Colonial Times of Penn-
 sylvania. Moorestown, 1886. $45.00 (ex-lib.)
--On the Frontier With Colonel Antes. Camden, N.J., 1900.
 1st ed. $85.00 (orig. cloth, one of 1000 numbered copies),
 $85.00 (orig. cloth, one of 1000 copies)
McMurry, Donald Le Crone--The Great Burlington Strike of
 1888. Camb., 1956. 1st ed. $25.00
McMurtrie, Douglas Crawford--The Golden Book. Chi., 1927.
 1st ed. $125.00 (one of 220 copies signed by author,
 boxed)
--Jotham Meeker, Pioneer Printer of Kansas.... Chi., 1930.
 1st ed. $95.00 (one of 650 copies, uncut, orig. cloth, few
 pages lightly soiled), $60.00 (cloth, bumped, one of 650
 copies)
--Modern Typography and Layout. Chi., 1929. 1st ed.
 $25.00 (ex-lib.)
--Montana Imprints, 1864-1880. Chi., 1937. $55.00
McMurtry, Robert Gerald--The Lincoln Log Cabin Almanac.
 Harrogate, Tn., 1940. $12.50
McNally, E. Evelyn (Grumbine)--This is Mexico. N.Y., 1947.
 $10.00
McNally, William--Evils and Abuses in the Naval and Merchant
 Service, Exposed. Bost., 1839. 1st ed. $100.00 (orig.
 boards)

McNamara, Brooks--The American Playhouse in the Eighteenth
Century. Camb., 1969. $27.50
McNamara, John--Three Years on the Kansas Border. N.Y.,
1856. $45.00 (cloth, foxed, name on endpaper, marginal
water stain)
McNary, Laura (Kelly)--California Spanish and Indian Place
Names.... L.A., 1931. $15.00 (author's presentation)
McNaughton, Margaret--Overland to Cariboo. Toronto, 1896.
1st ed. $200.00 (orig. cloth)
N.Y., 1966. $25.00 (orig. cloth)
McNeal, Thomas Allen--When Kansas Was Young. N.Y., 1922.
1st ed. $35.00
Topeka, 1939. $15.00 (cloth, inscribed)
McNeer, May Yonge--The Alaska Gold Rush. N.Y., (1960).
$5.00
McNickle, D'Arcy--Indian Man. Bloomington, In., (1971).
1st ed. $8.50
McNitt, Frank--The Indian Traders. Norman, (1962). $35.00
Norman (1972). $24.50
--Navaho Expedition
See: Simpson, James Hervey
--Richard Wetherill. Albuquerque, (1957). 1st ed. $45.00
McNulty, Faith--The Whooping Crane. N.Y., 1966. 1st ed.
$12.50
McParlin de Elguera, Alida--Footprints on the Sands of Time....
(Lima), 1956. $5.00 (inscribed)
MacPhail, Archibald--Of Men and Fire. S.F., 1948. 1st ed.
$15.00 (orig. boards)
McPharlin, Paul--The Puppet Theatre in America. N.Y.,
(1949). 1st ed. $20.00 (cloth)
McPhaul, John J.--Deadlines & Monkeyshines. Englewood
Cliffs, (1962). 1st ed. $12.50
McPherson, Aimee Semple--This is That. L.A., (1923). $25.00
McPherson, Alex--The History of Faulkner County, Arkansas.
Conway, (1927). $12.50
MacPherson, Byron--Picturesque Washington. Seattle, 1945.
$25.00
McPherson, James M.--The Negro's Civil War. N.Y., (1965).
1st ed. $17.50
McQueen, Alexander Stephens--History of the Okefenokee
Swamp. Clinton, S.C., (1926). 1st ed. $30.00 (lettering
on backstrip effaced, lightly rubbed)
MacQuill, Thursty
See: Bruce, Wallace
Macrae, David--The American at Home. N.Y., 1952. $7.50

McReynolds, Edwin C.--Missouri. Norman, (1962). $20.00
--Oklahoma. Norman, (1954). 1st ed. $21.50
--The Seminoles. Norman, (1957). 1st ed. $25.00, $20.00
 (cloth)
McReynolds, Robert--Thirty Years on the Frontier. Colorado
 Springs, 1906. $75.00 (cloth, hinges starting, text lightly
 soiled, somewhat worn)
McRoskey, Racine--The Missions of California. S.F., 1914.
 $21.00 (boards)
McSherry, Richard--El Puchero. Phila., 1850. 1st ed. $200.00
 (orig. cloth, foxing, previous owner's inscription)
McSpadden, Joseph Walker--Beautiful Hawaii. N.Y., 1939.
 $10.00 (lib. blind stamps)
McWhiney, Gardy--Southerners and Other Americans. N.Y.,
 1973. $17.50
McWhorter, Lucullus Virgil--Hear Me, My Chiefs! Caldwell,
 1952. 1st ed. $100.00 (spine tips rubbing, front cover
 fading)
McWilliams, Carey--California, the Great Exception. N.Y.,
 1949. 1st ed. $15.00, $15.00
--A Mask for Privilege. Bost., 1948. 1st ed. $12.00
--Southern California Country. N.Y., 1946. 1st ed. $12.50,
 $10.00 (owner name)
--Witch Hunt. Bost., 1950. 1st ed. $12.50
Macy, John Albert--Socialism in America. Garden City, 1916.
 $20.00
Madariaga, Salvador de--El Auge del Imperio Espanol en Amer-
 ica. Buenos Aires, (1955). $10.00 (ex-lib.)
--Bolivar. Coral Gables, Fl., (1952). $12.00
--The Fall of the Spanish American Empire. N.Y., 1948.
 $12.50
--Hernan Cortes, Conqueror of Mexico. Chi., 1955 (i.e.,
 1956). $8.50
--Latin America Between the Eagle and the Bear. N.Y.,
 (1962). $8.50
--The Rise of the Spanish American Empire. N.Y., 1947.
 1st ed. $8.50 (lower corner of frontis. stained)
Maddox, Robert J.--The Unknown War With Russia: Wilson's
 Siberian Intervention. San Rafael, 1977. $15.00
Maddux, Percy--City on the Willamette. Portland, Or., (1952).
 $10.00
Madison, Charles Allan--Book Publishing in America. N.Y.,
 (1966). 1st ed. $20.00 (ex-lib.)
--Jewish Publishing in America. N.Y., 1976. $15.00
--The Owl Among Colophons. N.Y., 1966. $10.00

Madison, Lucy (Foster)--Lincoln. Phila., 1928. $25.00 (gold worn off spine)

Madison, Virginia--The Big Bend Country of Texas. Albuquerque, (1955). 1st ed. $20.00 (light spine rub)

Madlem, Wilma--San Jose Mission. San Antonio, 1935. $5.00 (covers faded)

Madsen, Ramus--Mine Rejjer i Amerika og Ostindien. Jordlose, Denmark, 1909. $75.00 (orig. wraps.)

Magalhaes de Gandavo, Pedro de--The Histories of Brazil. N.Y., 1922. 2 vols. $150.00 (boards, lightly foxed, one of 250 numbered copies)

Margaret, Helene--Father DeSmet, Pioneer Priest of the Rockies. N.Y., (1940). $12.50

Maginnis, Thomas Hobbs--The Irish Contribution to America's Independence. Phila., 1913. $17.50 (ends of spine frayed)

Magoffin, Susan (Shelby)--Down the Santa Fe Trail and Into Mexico. New Haven, 1926. 1st ed. $150.00 (cloth, lightly rubbed, bottom edge of last 50 pages moderately damp-stained), $125.00

Mahan, Alfred Thayer--Admiral Farragut. N.Y., (1892). $35.00 (large paper ed., one of 1000 copies, corners bumped, light cover soil)

--The Gulf and Inland Waters. N.Y., 1883. 1st ed. $20.00 (some spine and corner wear)

--The Influence of Sea Power Upon History.... Bost., 1890. 1st ed. $175.00 (half leather, extremities a bit rubbed)

--Naval Strategy.... Bost., 1918. $35.00 (newly rebound in cloth)

Mahan, Bruce Ellis--Old Fort Crawford and the Frontier. Iowa City, 1926. 1st ed. $25.00 (author's presentation copy)

Mahan, William--Padre Island.... Waco, 1967. 1st ed. $20.00

Mahoney, Tom--The Story of George Romney. N.Y., (1960). $7.00

Mailer, Norman--Barbary Shore. N.Y., (1951). $145.00 (boards, signed)

--The Naked and the Dead. N.Y., (1948). 1st ed. $225.00 (boards, bookplate)

--Why Are We in Vietnam? N.Y., (1967). 1st ed. $25.00 (orig. cloth, lightly worn at edges)

Mails, Thomas E.--The Mystic Warriors of the Plains. Garden City, 1972. $250.00 (one of 250 numbered and signed copies, leather, boxed)

--The People Called Apache. Englewood Cliffs, 1974. $37.50

Main, Jackson Turner--The Social Structure of Revolutionary America. Princeton, 1965. 1st ed. $12.50

Mair, Charles--Through the Mackenzie Basin. Toronto, 1908.
$45.00 (cloth, inner hinges broken, contents shaky and
lightly soiled, signature on endpaper)
Mais, Stuart Petre Brodie--A Modern Columbus. Phila., 1934.
$12.50
Maissin, Eugene, ed.--San Juan de Ulua....
See: Blanchard, P.
Majors, Alexander--Seventy Years on the Frontier.... Chi.,
1893. 1st ed. $75.00 (cloth, worn and lightly bumped,
ink inscription), $55.00 (cloth, some wear to binding edges
and spine tips)
Columbus, 1950. $12.50 (cloth), $10.00 (cloth)
Malach, Roman--Mohave County. Kingman, Az., 1974. $7.50
(signed by author)
Malkus, Alida Sims--Blue-Water Boundary. N.Y., (1960).
$13.50
--Caravans to Santa Fe. N.Y., 1928. $12.50 (bookplate)
--The Dragon Fly of Zuni. N.Y., (1928). $13.50 (light
spine tip rub)
Mallet, Thierry--Plain Tales of the North. N.Y., 1925. $29.50
(uncut, boards, moderate cover soil)
Mallison, Sam Thomas--The Great Wildcatter. Charleston,
(1953). $30.00 (inscribed)
Mallory, Daniel, ed.--The Life and Speeches of Henry Clay
See: Clay, Henry
Malo, David--Hawaiian Antiquities.... Honolulu, 1951. $18.00
Malone, Dumas--The Public Life of Thomas Cooper.... Co-
lumbia, S.C., 1961. $17.50 (cloth)
--The Story of the Declaration of Independence. N.Y., 1954.
1st ed. $17.50 (labels removed, small hole front endpaper)
Maltby, W.J.--Captain Jeff.... Colorado, Tx., 1906. $65.00
(spine gone, cover marked and faded)
Manchester, Herbert--Four Centuries of Sport in America....
N.Y., 1931. 1st ed. $200.00 (cloth, one of 850 copies)
Manchester, William Raymond--A Rockefeller Family Portrait....
Bost., (1959). $10.00
Mandel, Bernard--Samuel Gompers.... (Yellow Springs), 1963.
1st ed. $16.00
Manfred, Frederick Feikema--Boy Almighty.... St. Paul,
1945. $35.00 (orig. cloth, presentation copy)
--The Chokecherry Tree. Garden City, 1948. 1st ed. $17.50
(orig. cloth, owner stamp)
--Conquering Horse. N.Y., (1959). $50.00 (signed by au-
thor)
--The Golden Bowl. St. Paul, 1944. $37.50

--Lord Grizzly. N.Y., 1954. 1st ed. $20.00 (orig. cloth)
--The Man Who Looked Like the Prince of Wales. N.Y., 1965.
$7.50 (orig. cloth)
--Morning Red, a Romance. Denver, 1956. 1st ed. $65.00
(orig. cloth, one of 25 numbered and signed copies)
--The Primitive. Garden City, 1949. 1st ed. $12.50 (orig.
cloth, owner name)
--Riders of Judgment. N.Y., (1957). 1st ed. $17.50 (orig.
cloth)
--Scarlet Plume. N.Y., 1964. 1st ed. $50.00 (uncorrected
proofs)
--This Is the Year. Garden City, 1947. 1st ed. $22.50
(orig. cloth)
Mangan, Frank J.--Bordertown. El Paso, 1964. 1st ed.
$15.00
Mange, Juan Mateo--Unknown Arizona and Sonora.... Tucson,
1954. $20.00 (one of 1500 copies)
Mangold, Margaret M., ed.--La Causa Chicana....
See under Title
Manje, Juan Mateo--Unknown Arizona and Sonora, 1693-1721.
Tucson, 1954. $55.00 (cloth, one of 1500 numbered cop-
ies)
Manley, Atwood--Some of Frederic Remington's North Country
Associates. (Ogdensburg, N.Y.), 1961. $6.00 (wraps.)
Manly, William Lewis--Death Valley in '49. Chi., 1927.
$20.00, $17.50 (cloth, cover rubbed)
N.Y., (1929). $20.00
L.A., (1949). $50.00
Mann, Arthur--Yankee Reformers in the Urban Age. Camb.,
1954. 1st ed. $20.00
Mann, Edward Beverly--New Mexico, Land of Enchantment.
East Lansing, Mi., (1955). $20.00
Manners, William--Patience and Fortitude: Fiorello La Guardia..
N.Y., 1976. $8.95
Manross, William Wilson--A History of the American Episcopal
Church. N.Y., 1950. $20.00
Mansfield, Edward Deering--Life and Services of General Win-
field Scott. N.Y., 1852. 1st ed. $20.00 (spine worn at
tips and edges, repaired at top, brown spot on some pages,
corners worn)
--Lives of Ulysses S. Grant and Schuyler Colfax. Cinci.,
1868. $20.00 (bit of spine tip wear and corner bump)
Mansfield, Joseph King Fenno--Mansfield on the Condition of
the Western Forts.... Norman, (1963). $10.00
Mantell, Martin E.--Johnson, Grant, and the Politics of Recon-
struction. N.Y., 1973. $12.50

Manter, Ethel H. (Van Vick)--Rocket of the Comstock. Caldwell, 1950. 1st ed. $12.50
Marble, Annie (Russell)--The Women Who Came in the Mayflower. Bost., 1920. $15.00, $15.00
Marcantonio, Vito--Labor's Martyrs. N.Y., 1937. $10.00
March to Quebec. Garden City, 1942. $4.50
Marchant, Anyda--Viscount Maua and the Empire of Brazil. Berkeley, 1965. $12.00
Marco de Nizza, Padre--Discovery of the Seven Cities of Cibola. Albuquerque, (1926). $7.50
Marconi, Degna--My Father, Marconi. N.Y., (1962). 1st ed. $10.00
Marcoy, Paul, pseud.
 See: (Saint-Cricq, Laurent)
Marcus, Leonard S.--The American Store Window. N.Y., 1978. $20.00
Marcy, Randolph Barnes--Adventure on Red River. Norman, 1937. 1st ed. $25.00
--Thirty Years of Army Life on the Border. N.Y., 1866. 1st ed. $150.00 (orig. cloth)
Margo, Elisabeth--Taming the Forty-Niner. N.Y., (1955). $15.00
Margry, Pierre--Decouvertes et Etablissements des Francais.... Paris, 1876-88. 6 vols. 1st ed. $700.00 (orig. wraps.), $600.00 (orig. printed wraps.)
Maring, Norman Hill--Baptists in New Jersey. (Valley Forge, Pa., 1964). $20.00
Marion, John Huguenot--Notes of Travel Through the Territory of Arizona. Tucson, 1965. $25.00, $21.00
Marisal, Federico E.--Estudios Arquitectonico de las Ruinas Mayas.... Mexico, 1928. $110.00
Maritain, Jacques--Reflections on America. N.Y., (1958). $10.00
Markham, Richard--A Narrative History of King Philip's War.... N.Y., (1883). $20.00 (small mark on cover top, spine tips fray, bookplate, owner name)
Markley, Walter M.--Builders of Topeka. Topeka, 1934. $20.00 (cloth)
Markman, Sidney David--Colonial Architecture of Antigua, Guatemala. Phila., 1966. $45.00, $25.00
Marks, David--The Life of David Marks.... Limerick, Me., 1831. 1st ed. $47.50 (contemp. calf)
Marks, James Junius--The Peninsula Campaign in Virginia. Phila., 1864. 1st ed. $27.50 (minor spine tip and corner wear)

Marmier, Xavier--Lettres Sur l'Amerique. Bruxelles, 1851.
3 vols. $150.00 (orig. boards worn, some modest staining)
Marquand, John Phillips--Life at Happy Knoll. Bost., (1957).
1st ed. $20.00 (orig. cloth, pinhole in front cover)
Marquez Sterling, Manuel--Los Ultimos Dias del Presidente
Madero. (Habana, 1960). $20.00
Marquis, Don--Archy's Life of Mehitable. Garden City, 1933.
1st ed. $85.00 (cloth, lightly soiled and frayed, endpapers
lightly foxed)
--Chapters for the Orthodox. Garden City, 1934. 1st ed.
$15.00 (cloth, name on endleaf)
Marquis, Thomas Bailey--A Warrior Who Fought Custer. Minne.,
1931. 1st ed. $85.00 (cloth)
Marriott, Alice Lee--Dance Around the Sun. N.Y., 1977.
$15.00
--Maria, the Potter of San Ildefonso. Norman, 1948. 1st ed.
$40.00
--Peyote. N.Y., 1971. 1st ed. $20.00
--The Ten Grandmothers. Norman, 1945. $12.50
--These Are the People. Santa Fe, (1949). 1st ed. $20.00
(signed by author, contemp. road maps laid in)
--The Valley Below. Norman, 1949. $20.00
Marsh, James B.--Four Years in the Rockies. New Castle,
1884. $400.00 (orig. cloth, some wear)
Columbus, Ohio, n.d. $20.00, $15.00 (cloth, a lightly worn
copy)
Marsh, William Barton--An American Portrait. Newark, (1946).
$8.50
Marshall, Andrew--Brazil. N.Y., (1966). $7.50
Marshall, Christopher--Extracts From the Diary.... Albany,
1877. 1st ed. $42.50
Marshall, David--Grand Central. N.Y., 1946. $10.00
Marshall, James--Santa Fe, the Railroad That Built an Empire.
N.Y., 1945. $17.50 (bit of cover soil), $15.00 (cloth),
$12.50
Marshall, John--The Life of George Washington.... Phila.,
1805-07. 5 vols. plus Atlas. 1st ed. $400.00 (contemp.
calf, backstrips worn)
Marshall, John A.--American Bastile. Phila., 1875. $22.50
Marshall, Logan--The Story of the Panama Canal. (N.p.,
1913). 1st ed. $12.50
Phila., 1913. $10.00
--The True Story of the Great American Calamity.... N.p.,
1913. $12.50 (bit of spine top fray, one corner bumped)

Marshall, Samuel Lyman Atwood--Crimsoned Prairie. N.Y.,
(1972). 1st ed. $15.00, $9.95
--Night Drop. Bost., (1962). $9.50
Marshall, Theodora Britton--They Found it in Natchez. New
Orleans, 1939. 1st ed. $20.00 (signed)
Marsland, William David--Venezuela Through its History.
N.Y., (1954). 1st ed. $10.00
Marti, Jose--The America of Jose Marti. N.Y., 1953. 1st
ed. $8.50
Martin, Albert Harry--Dog Gone Hollywood. Hollywood, (1930).
$7.50 (boards)
Martin, Asa Earl--After the White House. State College, Pa.,
1951. $10.00
Martin, Charles Lee--A Sketch of Sam Bass, the Bandit.
Norman, (1956). $12.50
Martin, Cy--The Saga of the Buffalo. N.Y., (1973). $17.50
Martin, David Dale--Mergers and the Clayton Act. Berkeley,
1959. $17.50
Martin, Douglas DeVeny--The Earps of Tombstone. Tombstone,
Az., (1959). 1st ed. $10.00, $4.00
--Silver, Sex and Six Guns. Tombstone, Az., (1962). $12.50
--Tombstone's Epitaph. (Albuquerque), 1951. 1st ed.
$25.00, $25.00 (cloth), $20.00
--Yuma Crossing. Albuquerque, 1954. $20.00, $12.50 (presen-
tation copy)
Martin, Edward Winslow, pseud.
See: (McCabe, James Dabney)
Martin, Francois Xavier--The History of Louisiana, From the
Earliest Period. New Orleans, 1882. $100.00 (half leather)
Martin, Ismena Teresa, comp.--Recollections of Elizabeth Ben-
ton Fremont
See: Fremont, Elizabeth Benton
Martin, Paul Sidney--Indians Before Columbus. Chi., (1947).
$15.00 (cloth)
Martin, Sidney Walter--Florida's Flagler. Athens, (1949).
$8.50 (signed by author)
Martin, Thomas Salathiel--With Fremont to California and the
Southwest. Ashland, 1975. $35.00 (cloth)
Martin, Thomas Wesley--French Military Adventures in Ala-
bama.... Birmingham, 1940. $12.50
Martineau, Harriet--Retrospect of Western Travel. (N.Y.,
1942). 2 vols. $25.00 (cloth)
--Views of Slavery & Emancipation. N.Y., 1837. 1st ed.
$100.00

Martinez, Alberto B.--Baedeker of the Argentine Republic.
N.Y., 1915. $15.00

Martinez, Pablo L.--Historia de Baja California. Mexico, 1956.
$37.50 (boards)

Martinez, Raymond Joseph--The Immortal Margaret Haughery.
New Orleans, 1956. $17.00

Martinez del Rio, Pablo--"Alumbrado." Mexico, (1937). $15.00
(wraps.)

Marty, Martin E., ed.--The Religious Press in America
See under Title

Mason, Alpheus Thomas--Brandeis.... N.Y., 1946. 1st ed.
$12.00, $10.00

--Bureaucracy Convicts Itself. N.Y., 1941. $25.00

--Harlan Fiske Stone.... N.Y., 1956. 1st ed. $15.00

Mason, Bernard Sterling--The Book of Indian-Crafts and
Costumes. N.Y., (1946). 1st ed. $20.00 (light spine tip
and corner wear)

--Drums, Tom-Toms, and Rattles. N.Y., 1938. 1st ed.
$25.00 (cloth)

Mason, Gregory--Silver Cities of Yucatan. N.Y., 1927.
$40.00

Mason, Herbert Molloy--The Lafayette Escadrille. N.Y.,
(1964). $17.50

--The New Tigers. N.Y., (1967). 1st ed. $8.50

Mason, Otis Tufton--The Latimer Collection of Antiquities....
Wash., 1899. $7.50 (cover chipped and soiled, spine wear)

Mason, Richard Lee--Narrative of.... N.Y., (1915). $52.50
(boards, one of 160 numbered copies, spine chipped and
little stained)

Mason, Walt--"Horse Sense" in Verses Tense. Chi., 1915.
1st ed. $15.00 (cloth, inscribed and signed)

Masotti, Louis H.--Riots and Rebellion. Beverly Hills, (1968).
$16.00

The Massacre of the Wigton Family. Chillicothe, Oh., 1934.
$10.00

The Massacre of Wyoming. Wilkes-Barre, Pa., 1895. $35.00

Massett, Stephen C.--The First California Troubadour. Oak-
land, 1954. $25.00 (one of 500 copies)

Massey, Vincent--Speaking of Canada. Toronto, 1959. $6.50

Massie, Melville D.--Past and Present of Pike County, Illinois.
Chi., 1906. 1st ed. $85.00

Masson, Louis Francois Rodrique--Les Bourgeois de la Com-
pagnie du Nord-Ouest. N.Y., 1960. 2 vols. $50.00
(one of 750 sets)

Masters, Edgar Lee--Across Spoon River. N.Y., (1936). 1st ed. $30.00 (cloth, foxing)

--Lincoln the Man. N.Y., 1931. $12.50 (spine tips worn, newspaper articles taped and laid in on endpapers, gold flecked off spine, owner name)

--Mark Twain.... N.Y., 1938. 1st ed. $20.00

--The Sangamon. N.Y., (1942). $20.00, $15.00

--Songs and Satires. N.Y., 1916. $10.00 (cloth, corners lightly worn, bookplate)

--Spoon River Anthology. N.Y., 1915. 1st ed. $225.00 (1st issue, orig. cloth, spine ends lightly rubbed)

--Whitman. N.Y., 1937. 1st ed. $25.00

Masters, Joseph G.--Stories of the Far West. Bost., (1935). 1st ed. $12.50 (lacks front endpaper)

Masterson, James Raymond--Tall Tales of Arksansaw. Bost., 1943. $20.00 (ex-lib.)

Mather, Cotton--Baptistes. Bost., 1724. $1250.00 (orig. wraps., some fraying)

--The Life and Death of the Renown'd Mr. John Eliot. Lond., 1691. $1250.00 (contemp. half calf)

--Magnalia Christi Americana. Lond., 1702. 1st ed. $750.00 (calf, leather label)

--Pastoral Desires. Bost., 1712. 1st ed. $850.00 (new half calf, lacks 1st two lines of title, neatly rebacked)

Mather, Samuel--The Life of the Very Reverend and Learned Cotton Mather. Bost., 1729. $850.00 (contemp. calf, rebacked, spine skillfully laid down)

Mathers, James H.--From Gun to Gavel. N.Y., 1954. 1st ed. $17.50

Mathews, Alfred Edward--Pencil Sketches of Colorado. (Denver, 1961). $75.00

Mathews, Charles Elijah--Highlights of 100 Years in Mobile. Mobile, 1965. $15.00

Mathews, John Joseph--The Osages.... Norman, (1961). $35.00

--Wah'Kon-Tah. Norman, 1932. 1st ed. $25.00 (cloth, ink stains on fore-edge), $17.50, $15.00

Mathewson, Joe--Up Against Daley. LaSalle, Il., (1974). $12.50

Matschat, Cecile (Hulse)--Seven Grass Huts. N.Y., 1939. $8.50, $4.50

--Suwanee River. N.Y., (1938). 1st ed. $7.50

Mattes, Merrill J.--The Great Platte River Road. (Lincoln), 1969. 1st ed. $30.00, $20.00 (signed by author), $15.00

--Indians, Infants and Infantry. Denver, 1960. $14.50

--The Pony Express. (Omaha, 1960). $7.50

Matthews, Franklin--The New-Born Cuba. N.Y., 1899. $12.50 (ex-lib.)

Matthews, Frederick C.--American Merchant Ships.... Salem, Ma., 1930-31. 2 vols. $125.00

Matthews, Julian H.--Historical Reminiscences of the Ohio Penitentiary.... Columbus, 1884. $75.00 (wraps.)

Matthews, Leonard--A Long Life in Review. (S.L., 1928). $85.00 (gold flaking, few scuff marks)

Matthews, Sallie (Reynolds)--Interwoven. Houston, 1936. 1st ed. $325.00 (presentation copy)

Matthews, Washington--Ethnography and Philology of the Hidatsa Indians. Wash., 1887. 1st ed. $40.00 (spine tip fray, corner wear)

--The Mountain Chant. Wash., (1884). $25.00

--Navaho Legends. N.Y., 1897. 1st ed. $65.00 (front endpaper torn, spine tips and corners lightly rubbed)

--Navajo Weavers. Wash., (1882). $25.00 (later binding)

Matthews, William--American Diaries. Bost., 1959. $20.00 (orig. cloth, owner name on endsheet)
Bost., (1969). $25.00 (orig. cloth)

Mattingly, Garrett--Bernard DeVoto.... Bost., 1938. $10.00

Mattison, Ray H.--Fort Union. Bismarck, (1962). $6.00

Mattson, Hans--Reminiscences ... Ind., 1891. 1st ed. $30.00

Maurice, Frederick Barton--Robert E. Lee, the Soldier. Bost., 1925. $22.50, $12.50

--Statesmen and Soldiers of the Civil War. Bost., 1926. $22.50

Mauro, Frederic--Nova Historia e Novo Mundo. Sao Paulo, (1969). $10.00 (wraps.)

Maurois, Andre--Rio de Janeiro. (Paris, 1951). $10.00

Maury, Dabney Herndon--Recollections of a Virginian in the Mexican, Indian, and Civil Wars. N.Y., 1894. 1st ed. $65.00 (spine bit darkened)

Mautner, Herman Eric--Doctor in Bolivia. Phila., 1960. 1st ed. $12.50 (ex-lib. stamp)

Maverick, Augustus--Henry J. Raymond and the New York Press.... Hart., 1870. $75.00 (cloth, somewhat worn along joints and extremities, hinges cracked, ex-lib.)

Maverick, Maury--A Maverick American. N.Y., (1937). $13.00 (bookplate)

Maxim, Hudson--The Rise of an American Inventor. Garden City, 1927. $13.00

Maxon, Harold R.--A Practical Handbook With Useful Information Regarding Mexico City and Vicinity. Mexico City, 1920. $6.50 (spine tip bit frayed)

Maxwell, Helen--A Guide for the Big Bend. Marathon, Tx.,
(1950). $7.50 (cover separating)
Maxwell, Robert S.--La Folette and the Rise of the Progres-
sives.... (Madison, 1956). 1st ed. $12.00
May, Caroline--The American Female Poets. Phila., (1848).
1st ed. $15.00 (rubbed and partly faded)
May, Earl Chapin--Principio to Wheeling.... N.Y., (1945).
$40.00
--The Prudential. Garden City, 1950. $9.00
--2000 Miles Through Chile. N.Y., (1924). $10.00
May, John--The Western Journals of John May. (Cinci., 1961).
$15.00
May, Stella Burke--The Conqueror's Lady. N.Y., (1930).
$12.50 (ex-lib.)
Mayer, Brantz--Mexico as it Was. N.Y., 1844. 1st ed.
$35.00 (ex-lib. stamps, covers nearly detached, ink stains)
--Mexico, Aztec, Spanish, and Republican. Hart., 1852. 2
vols. in 1. $75.00 (leather and cloth, bookplate, later
binding)
--Tah-Gah-Jute. Albany, 1867. $100.00 (half morocco, pres-
entation copy by publisher)
Mayer, Frederick Emanuel--The Religious Bodies of America.
S.L., 1956. $20.00
Mayer, George H.--The Republican Party, 1854-1964. N.Y.,
1964. $22.50 (cloth, ex-lib.)
Mayer, Martin--Emory Buckner. N.Y., (1968). $12.50
--The Lawyers. N.Y., (1967). 1st ed. $10.00
Mayes, Herbert Raymond--Alger; a Biography without a Hero.
N.Y., 1928. $20.00 (ex-lib.)
Mayhall, Mildred P.--The Kiowas. Norman, (1962). 1st ed.
$25.00, $20.00
Mayhew, Experience--Observations on the Indian Language.
Bost., 1884. $35.00 (orig. wraps., one of 100 copies)
(Mayhew, Henry)--The Mormons. Lond., (1851). 1st ed.
$65.00 (orig. cloth)
--The Religious, Social, and Political History of the Mormons.
N.Y., 1956. $25.00 (orig. cloth, spine faded)
Maynard, D.S.--Historical View of Clinton County.... Lock
Haven, Pa., 1875. $45.00 (half leather, front hinge start-
ing, spine chipped)
Maynard, Theodore--Great Catholics in American History.
Garden City, 1957. 1st ed. $10.00
Mayne, Isabella Maud (Rittenhouse)--Maud. N.Y., 1939.
$16.00
Mayo, Morrow--Los Angeles. N.Y., 1933. $20.00

Mazzanovich, Anton--Trailing Geronimo. L.A., 1926. 1st ed.
$55.00

Mazzuchelli, Samuel Charles--Memoirs, Historical and Edifying
of a Missionary.... Chi., 1915. $25.00 (binding worn
and edges chipped)

Meacham, Walter E.--Bonneville the Bold. Port., Or., 1934.
$7.50

Mead, Charles Williams--Old Civilizations of Inca Land. N.Y.,
1932. $12.50

Mead, Margaret, ed.--An Anthropologist at Work
See: Benedict, Ruth

Mead, Sidney Earl--Nathaniel William Taylor.... Chi., 1942.
1st ed. $20.00

Meade, George Gordon--The Life and Letters of George Gordon
Meade.... N.Y., 1913. 2 vols. 1st ed. $100.00

Meadows, Don, ed.--The Cattle Drives of Edward E. Pleasants
See: Pleasants, Joseph Edward

Means, Florence (Crannell)--Sagebrush Surgeon. N.Y., 1956.
$10.00

--Whispering Girl. Bost., 1941. $12.50

Means, Gaston Bullock--The Strange Death of President Hard-
ing. N.Y., 1930. $12.50, $10.00

Means, Philip Ainsworth--Ancient Civilizations of the Andes.
N.Y., 1931. $20.00

--Fall of the Inca Empire.... N.Y., 1932. 1st ed. $20.00

--History of the Spanish Conquest of Yucatan and the Itzas.
Camb., 1917. 1st ed. $12.50 (orig. wraps.)

Meany, Edmond Stephen--Lincoln Esteemed Washington. Seat-
tle, 1933. $10.00 (bookplate, back cover lightly stained)

Meares, John--Voyages Made in the Years 1788 and 1789, from
China to the Coast of America. Lond., 1791. 2 vols.
$450.00 (calf, lacks one map)

Mearns, David Chambers--The Lincoln Papers. Garden City,
1948. 2 vols. 1st ed. $25.00, $17.50, $16.50

Mease, James--The Picture of Philadelphia.... Phila., 1811.
1st ed. $125.00 (rebound)

Mechem, Kirke, ed.--The Annals of Kansas....
See: Wilder, Daniel Webster

Mecklenburg, George--The Last of the Old West. Wash.,
(1927). $25.00, $15.00, $14.50

Medina County Historical Society--History of Medina County.
Fostoria, Oh., 1948. $25.00

Medina, Jose Toribio--Cosas de la Colonia. Santiago, 1952.
$17.50

--Historia del Tribunal del Santo Oficio.... Santiago de Chile
1890. 2 vols. $100.00 (half morocco, browned)

(Bogota, 1952). $20.00
--Memorias de un Oficial de Marina Ingles....
 See under Title
Meek, Stephen Hall--The Autobiography of a Mountain Man....
 Pasadena, 1948. $53.50 (ltd. ed.)
Meeker, Ezra--The Busy Life of 85 Years. Seattle, (1916).
 $25.00 (signed by author, waterstain bottom righthand
 corner, bit of spine tip and cover rub)
--The Ox Team. Omaha, (1906). $25.00 (covers wearing)
--Uncle Ezra's Short Stories for Children. Tacoma, Wa., n.d.
 $15.00
Meginness, John Franklin--Lycoming County. Williamsport,
 1895. $40.00 (boards, orig. wraps. bound in)
--Otzinachson. Phila., 1857. $55.00 (rebound)
 Williamsport, Pa., 1888-89. $200.00 (boxed, in 13 separate
 parts)
Megquier, Mary Jane Cole--Apron Full of Gold. San Marino,
 Ca., 1949. $15.00
Meier, Frank--Hurricane Warning. N.Y., 1947. $7.50
Meigs, John--The Cowboy in American Art. Chi., (1972).
 $25.00
Meleski, Patricia F.--Echoes of the Past. Albuquerque, (1972).
 $25.00
Meligokes, Nicholas Antonios--The Spirit of Gettysburg.
 Gettysburg, Pa., 1950. $20.00
Meline, James Florant--Two Thousand Miles on Horseback....
 N.Y., 1867. 1st ed. $125.00 (orig. cloth, light outer wear),
 $125.00
 N.Y., 1868. $75.00 (orig. cloth, light outer wear, few
 leaves foxed)
Mellen, Kathleen (Dickenson)--The Gods Depart. N.Y., (1956).
 $10.00
--Hawaiian Heritage. N.Y., (1963). $10.00
--The Lonely Warrior. N.Y., 1949. $10.00
Melton, Elston Joseph--Towboat Pilot. Caldwell, 1948. 1st
 ed. $17.50
Melville, Annabelle (McConnell)--John Carroll of Baltimore....
 N.Y., (1955). $12.50
Melville, Herman--The Apple-Tree Table and Other Sketches.
 Princeton, 1922. $50.00 (orig. boards, bookplate, one of
 1675 copies)
--Billy Budd, Sailor.... (Chi., 1962). $22.50
--The Confidence-Man. N.Y., 1857. $600.00 (orig. cloth,
 spine ends rubbed, ex-lib., lacks back fly)
--Israel Potter. N.Y., 1855. 1st ed. $750.00 (orig. cloth,
 minute signs of spine wear, 1st printing, 1st binding)

--Mardi: and A Voyage Thither. N.Y., 1849. 2 vols.
$125.00 (orig. cloth, one vol. faded with stamp on title)
--Moby-Dick. N.Y., 1871. 1st ed. $600.00 (orig. cloth,
minute wear)
--The Piazza Tales. N.Y., 1929. $35.00 (boxed, one of 750
copies)
--Pierre. N.Y., 1852. 1st ed. $500.00 (orig. cloth, neatly
recased in matching cloth)
--Typee. N.Y., 1848. $65.00 (orig. cloth faded, lacks front
endpaper)
Lond., 1850. $175.00 (old three-quarter calf)
N.Y., (1963). $30.00
Memorias de un Oficial de Marina Ingles.... Santiago de Chile,
1923. $40.00 (wraps.)
Men Who Lead Labor
See: (Bransten, Richard)
Mencken, August--By the Neck.... N.Y., (1942). $15.00
Mencken, Henry Louis--A Mencken Chrestomathy. N.Y., 1949.
$11.00
Mendez, Santiago--Reports on the Maya Indians of Yucatan
See: Saville, Marshall Howard
Mendieta, Geronimo--Historia Eclesiastica Indiana.... Mexico,
1870. 1st ed. $450.00 (orig. wraps. bound in, front
joint starting, one of 420 copies)
Mendinueta, Pedro Fermin de--Indian and Mission Affairs in
New Mexico.... Santa Fe, 1965. $9.00 (one of 250 copies)
Menn, Alfred E.--Texas as it is Today. Austin, 1925. 1st
ed. $22.50
Menpes, Mortimer--Whistler as I Knew Him. Lond., 1904.
$395.00 (one of 500 copies)
Mercer, Asa Shinn--The Banditti of the Plains. (Cheyenne,
1894). 1st ed. $2750.00 (orig. cloth, laid in slipcase)
Norman, (1959). $10.00
Meredith, Roy--The Face of Robert E. Lee in Life and Legend.
N.Y., 1947. 1st ed. $25.00 (tape mark front endpaper),
$20.00
--Mr. Lincoln's Contemporaries. N.Y., 1951. $25.00 (corner
bump)
--Mr. Lincoln's General. N.Y., 1959. 1st ed. $20.00 (corner
worn, owner name), $16.00
----Storm Over Sumter. N.Y., 1957. $12.50
Mereness, Newton Dennison--Travels in the American Colonies.
N.Y., 1916. 1st ed. $35.00 (orig. cloth)
Merington, Marguerite, ed.--The Custer Story
See: Custer, George Armstrong

Meriwether, David--My Life in the Mountains and on the Plains. Norman, (1965). $30.00

Merk, Frederick--Slavery and the Annexation of Texas. N.Y., 1972. $8.50

Merriam, Alan P.--Ethnomusicology of the Flathead Indians. Chi., (1967). $44.00

Merriam, Florence A. See: Bailey, Florence Augusta (Merriam)

Merriam, George Spring--The Life and Times of Samuel Bowles. N.Y., 1885. 2 vols. 1st ed. $15.00

Merrick, George Byron--Old Times on the Upper Mississippi. Cleve., 1909. 1st ed. $45.00 (ex-lib., nicely rebound)

Merrifield, Edward--The Story of the Captivity and Rescue From the Indians of Luke Swetland.... Scranton, Pa., 1915. $75.00

Merrill, Arch--The Lakes Country. Rochester, (1944). $7.50

--The Ridge. Rochester, (1944). $10.00

--A River Ramble. (Rochester, 1943). 1st ed. $10.00 (owner name)

Merrill, Horace Samuel--Bourbon Democracy of the Middle West.... 1st ed. Baton Rouge, (1953). $20.00, $20.00

--William Freeman Vilas, Doctrinaire Democrat. Madison, 1954. $8.00

Merrill, James Ingram--Nights and Days. N.Y., (1966). $55.00 (cloth)

Merrill, James M.--Spurs to Glory. N.Y., (1966). $20.00

Merry, William Lawrence--The Nicaragua Canal. S.F., 1895. $75.00 (orig. wraps., dampstained around backstrip)

Merwin, Henry Childs--The Life of Bret Harte. Bost., 1911. 1st ed. $57.50 (one of 200 copies, spine fading)

Merz, Charles--The Dry Decade. Garden City, 1931. 1st ed. $15.00

Message From the President of the U.S.... Upon the Destruction of the U.S. Battle Ship Maine in Havana Harbor. Wash., 1898. $20.00

Messick, Hank--John Edgar Hoover. N.Y., (1972). $10.00

--Secret File. N.Y., (1969). $12.00

Metraux, Alfred--The History of the Incas. N.Y., 1969. 1st ed. $5.25

Metz, Leon Claire--John Selman, Texas Gunfighter. N.Y., (1966). 1st ed. $27.50

Mexico. Legacion. U.S.--Correspondencia que ha Mediado la Legacion Extraordinaria.... Mexico, 1952. $12.50 (wraps.)

Mexico. Secretaria de Educacion Publica--Archeological Monuments of Mexico. N.Y., 1933. $20.00

Mexico (Viceroyality)--The Official Account of the Portola
　　Expedition of 1769-1770. Berkeley, 1909. $15.00
Meyer, Agnes Elizabeth (Ernst)--Out of These Roots. Bost.,
　　(1953). 1st ed. $12.50
Meyer, Carl--Nach dem Sacramento.... Aarau, 1855. 1st ed.
　　$125.00 (orig. printed wraps.)
Meyer, Roy Willard--History of the Santee Sioux. Lincoln,
　　(1967). $25.00
Meyers, William H.--Sketches of California and Hawaii....
　　(S.F.), 1970. $150.00 (one of 450 copies)
Meynen, Emil--Bibliographie des Deutschtums.... Bibliography
　　on German Settlements in Colonial North America. Leipzig,
　　1937. $60.00 (inscribed)
Meza Villalobos, Nestor--La Actividad Politica del Reino de
　　Chile.... (Santiago de Chile), 1956. 1st ed. $15.00
　　(wraps.)
Michaux, Francois Andre--Travels to the West of the Allegheny
　　Mountains. Lond., 1805. $275.00 (orig. binding)
Michaux, Henri--Ecuador. Seattle, (1970). $7.00
Michelson, Charles--The Ghost Talks. N.Y., (1944). $8.50
Michelson, Truman--Notes on the Buffalo-Head Dance....
　　Wash., 1928. 1st ed. $20.00
--Observations on the Thunder Dance.... Wash., 1929. 1st
　　ed. $15.00
Michener, Carroll Kinsey--Heirs of the Incas. N.Y., 1924.
　　1st ed. $10.00
Michener, James Albert--Kent State. N.Y., (1971). $8.50
Mickley, Joseph J.--Brief Account of Murders by the Indians...
　　Phila., 1875. $75.00
Middlebrook, Louis Frank--Seals of Maritime Michigan. Salem,
　　Ma., 1926. $17.50
Middleton, Lamar--Revolt, U.S.A. N.Y., (1938). 1st ed.
　　$8.50
Middleton, Lynn--Place Names of the Pacific Northwest Coast.
　　Seattle, (1969). $22.50
Miers, Earl Schenck--The American Civil War. N.Y., (1961).
　　$16.00
--The American Story. N.Y., (1956). 1st ed. $12.50
--Blood of Freedom. Williamsburg, Va., (1958). $10.00
--Gettysburg. New Brunswick, 1948. $12.50
--The Great Rebellion. Cleve., (1958). 1st ed. $15.00
　　(signed), $12.50
--The Last Campaign. Phila., (1972). $9.50
--The Web of Victory. N.Y., 1955. 1st ed. $22.50 (book-
　　plate)

Miers, John--Travels in Chile and LaPlata.... Lond., 1826.
2 vols. 1st ed. $550.00 (half calf)

Milam, Burt James--The Honest Farmer From Arkansaw on a
Lark Seein' the West. N.p., 1905. $75.00 (covers bit
spotted)

Miles, Ellen, ed.--Portrait Painting in America
See under Title

Miles, Nelson Appleton--Personal Recollections and Observa-
tions. $50.00 (cloth)

--Serving the Republic. N.Y., 1911. $57.50 (bit of spine
tip scuff)

Milford, Louis--Memoir, or, a Cursory Glance at My Different
Travels.... Chi., 1956. $17.50

The Military Companion. Newburyport, Ma., 1808. $125.00
(contemp. calf)

--The Military History of Ohio. N.Y., 1885. 1st ed. $50.00

Millar, John Fitzhugh--The Architects of the American Col-
onies.... (Barre), 1968. $20.00

Millard, Fred S.--A Cowpuncher of the Pecos. N.p., (1928).
$30.00 (one of 300 copies, bit of chip, separating)

Millay, Edna St. Vincent--The Buck in the Snow. N.Y.,
1928. 1st ed. $25.00

--Fatal Interview. N.Y., 1931. 1st ed. $25.00 (bookplate)

--Make Bright the Arrows. N.Y., 1940. 1st ed. $20.00

--Mine the Harvest.... N.Y., (1954). $20.00

--The Murder of Lidice. N.Y., 1942. 1st ed. $30.00 (wraps.)

Miller, Alfred Jacob--The West of.... (1837).... Norman,
(1951). 1st ed. $37.50

Miller, Alphonse Bertram--Thaddeus Stevens. N.Y., 1939.
1st ed. $20.00

Miller, Arthur--After the Fall. N.Y., (1964). 1st ed.
$75.00 (buckram, one of 999 signed copies)

--The Crucible. N.Y., (1953). $15.00

--Death of a Salesman. N.Y., 1949. $95.00 (cloth), $15.00

--A View From the Bridge. N.Y., (1955). $15.00

Miller, Chester Gore--Chihuahua: a New and Original Social
Drama.... Chi., 1891. 1st ed. $12.50

Miller, David E.--Hole-in-the Rock. S.L.C., 1959. 1st ed.
$37.50

Miller, David Humphreys--Custer's Fall. N.Y., 1957. $15.00

Miller, Douglas T.--Jacksonian Aristocracy.... N.Y., 1967.
$20.00

Miller, Edgar George--American Antique Furniture.... Balt.,
(1937). 2 vols. $47.50

Miller, Ernest Conrad--Oil Mania. Phila., (1941). $27.50

--This Was Early Oil. Harrisburg, Pa., 1968. $12.50
Miller, Floyd--Bill Tilghman. Garden City, 1968. $12.50
Miller, Francis Trevelyan--The Photographic History of the
 Civil War.... N.Y., 1911. 10 vols. 1st ed. $150.00
 (owner name, some vols. have new endpapers, covers
 worn, vol. 2 corner torn off)
 N.Y., (1957). 10 vols. in 5. $60.00 (cloth)
--Portrait Life of Lincoln. Springfield, Ma., 1910. 1st ed.
 $20.00 (light stain top of pages in margin)
Miller, Helen Hill--The Case for Liberty. Chapel Hill, (1965).
 $10.00
Miller, Helen Topping--Christmas With Robert E. Lee. N.Y.,
 1958. $10.00 (tape marks on endpapers)
Miller, Henry--Account of a Tour of the California Missions,
 1856. (S.F.), 1952. $145.00 (one of 375 copies)
--What Are You Going to Do About Alf? Berkeley, 1944.
 $50.00 (orig. wraps.)
--The World of Sex. (N.p., 1940). $75.00 (one of 250 copies)
Miller, Hugh Gordon--The Isthmian Highway. N.Y., 1929.
 1st ed. $15.00
Miller, James Martin--The Amazing Story of Henry Ford.
 (Chi., 1922). $16.00 (shaken)
Miller, Joaquin--The Building of the City Beautiful. Camb.,
 1894. $14.00 (untrimmed, some dampstaining)
 Trenton, N.J., 1905. $16.50, $10.00 (cloth)
--The Danites in the Sierras. Chi., 1889. $45.00 (orig.
 wraps., lightly chipped and soiled, pages browning)
--First Families of the Sierras. Lond., 1875. $25.00 (chipped
 boards and spine wear)
 Chi., 1876. $26.50 (covers lightly spotted), $25.00 (cloth,
 cover lightly worn and soiled)
--'49, the Gold-Seeker of the Sierras. N.Y., 1884. 1st ed.
 $75.00 (cloth and boards, bit of edge wear), $25.00 (orig.
 wraps., torn and chipped wraps.)
--Joaquin Miller, His California Diary. Seattle, 1936. $47.50
 (one of 700 copies)
Miller, John Chester--Crisis in Freedom. Bost., 1951. 1st
 ed. $10.00
--Origins of the American Revolution. Bost., 1943. 1st ed.
 $8.95, $8.50
Miller, Jonathan Wesley--History of the Diocese of Central
 Pennsylvania.... Frackville, Pa., 1909. 2 vols. (re-
 backed)
Miller, Joseph--Arizona Indians. N.Y., (1941). $15.00
 (signed)

--The Arizona Rangers. N.Y., (1972). $15.00
--The Arizona Story.... N.Y., (1952). $15.00
--Arizona; the Last Frontier. N.Y., (1956). $15.00, $15.00
--Monument Valley and the Navajo Country.... N.Y., (1951).
$15.00
Miller, Juanita Joaquina--My Father.... Oakland, (1941).
$27.50 (suede, edges faded)
Miller, Max--The Cruise of the Cow. N.Y., 1951. $20.00
--Harbor of the Sun. N.Y., 1940. 1st ed. $10.00 (covers
wearing, corners and spine rubbed)
--It Must Be the Climate. N.Y., (1941). 1st ed. $8.50
--Land Where Time Stands Still. N.Y., 1943. $15.00 (book-
plate, piece torn out of top of front endpaper)
--Mexico Around Me. N.Y., (1937). $6.00
Miller, Perry--Errand Into the Wilderness. N.Y., 1964. $4.00
--Life of the Mind in America.... N.Y., (1965). 1st ed.
$4.00
--The New England Mind. Bost., 1968. $4.00 (water stained)
Miller, Ronald Dean--Shady Ladies of the West. L.A., 1964.
$20.00
Miller, Timothy Lathrop--History of Hereford Cattle.... Chil-
licothe, Mo., 1902. $75.00 (cover marked, spine tip and
corner wear)
Miller, Warren--The Lost Plantation. Lond., (1961). $12.50
--90 Miles From Home. Bost., 1961. $12.50
Milligan, Maurice Morton--Missouri Waltz. N.Y., 1948. $15.00
(cloth, ink on endpaper)
Milling, Chapman James--Red Carolinians. Columbia, S.C.,
1969. $13.00
Millis, Walter--The Martial Spirit. Bost., 1931. $20.00 (cloth)
--Road to War, America, 1914-1917. Bost., (1935). $17.50,
$6.00 (name on fly)
Mills, Anson--My Story. Wash., 1921. $35.00
Mills, Charles E.--Fifty Years of Engineering. (Cleve., 1955).
$10.00
Mills, Charles Wright--Listen Yankee. N.Y., 1960. 1st ed.
$10.00
--White Collar. N.Y., 1953. $6.50
Mills, Enos Abijah--The Adventures of a Nature Guide. N.Y.,
1927. $10.00 (gold flaked off spine)
--Bird Memories of the Rockies. Bost., 1931. $17.50 (covers
fading, stamp on endpaper)
--The Grizzly. Bost., (1919). 1st ed. $20.00 (bit of spine
tip rub, cloth)
--In Beaver World. Lond., 1913. $20.00 (light spine fading)

--The Rocky Mountain National Park. Garden City, 1924.
$5.00 (ex-lib. stamps)
--The Rocky Mountain Wonderland. Bost., (1915). 1st ed.
$20.00 (cloth, spine tip rub, one corner bump)
--The Spell of the Rockies. Bost., 1911. 1st ed. $17.50
(spine darkened, letters flaked off)
--Waiting in the Wilderness. Garden City, 1927. 1st ed.
$7.50 (gold lettering flaked off spine, light tip fray, edge
bumped)
--Wild Life on the Rockies. Bost., (1909). 1st ed. $10.00
(cover wear)
--Your National Parks. Bost., (1917). $17.50 (cloth, book-
plate, spine and corners wearing)
Mills, George J.--Argentina. N.Y., 1914. $20.00
Mills, Joe--A Mountain Boyhood. N.Y., (1926). $10.00
Mills, Nellie Alice--Historic Spots in Old Barry County. Mon-
ett, Mo., (1952). $15.00, $12.50
Milner, Duncan Chambers--Lincoln and Liquor. N.Y., 1920.
1st ed. $10.00 (bit of spine wear)
Milner, Joe E.--California Joe.... Caldwell, 1935. $55.00
(binding rubbed)
Milnor, William--Memoirs of the Glouchester Fox Hunting
Club.... N.Y., 1927. $150.00 (orig. boards, uncut,
light wear, one of 375 copies)
Milton, George Fort--The Age of Hate. N.Y., 1930. 1st ed.
$25.00, $20.00 (bookplate, corner worn)
--The Use of Presidential Power.... Bost., 1944. $15.00
Milton, William Fitzwilliam--Voyage de l'Atlantique au Pacifique:
a Travers le Canada.... Paris, 1866. $250.00 (cloth)
Mims, Edwin--The Advancing South.... Garden City, 1926.
1st ed. $6.50
Min, Sarrahm C.K.--Hawaii Without Hawaiians.... Honolulu,
(1979). $7.00 (wraps.)
Mindlin, Henrique Ephim--Modern Architecture in Brazil. N.Y.
(1956). $15.00
Miner, Charles--History of Wyoming.... Phila., 1845. $65.00
Miner, Frederick Roland--The Outdoor Southland of California.
L.A., 1923. $15.00
Miner, H. Craig--The Corporation and the Indian. Columbia,
Mo., 1976. $8.00
(Miner, Lewis H.)--The Valley of Wyoming. N.Y., 1866.
$20.00
Miner, William Harvey, ed.--The Iowa
See: Foster, Thomas

The Miners' Own Book.... S.F., 1949. $125.00 (boards, one
of 500 copies), $35.00 (one of 500 copies, boards warped)
Mines, John Flavel--A Tour Around New York.... N.Y., 1893.
$25.00 (cloth)
Minnesota as a Home for Immigrants. St. Paul, 1865. 1st ed.
$65.00 (owner name, minor cover chip)
St. Paul, 1866. $75.00 (orig. wraps.)
Minnesota Historical Society--The Aborigines of Minnesota
See under Title
Minnesota in the Civil and Indian Wars.... St. Paul, 1891-93.
2 vols. $35.00 (three-quarter morocco)
Minnigh, Luther William--Gettysburg.... Gettysburg, Pa.,
(1892). $20.00
Minns, Susan--Book of the Silkworm. N.Y., 1929. $12.00
Minogue, Anna Catherine--The Story of the Santa Maria Insti-
tute. Cinci., 1922. $17.50
Minot, Henry Davis--The Land-Birds and Game-Birds of New
England. Salem, Ma., 1877. $29.00 (cloth, a bit worn)
Minsky, Hyman P.--John Maynard Keynes. N.Y., 1975. 1st
ed. $15.00 (rebound)
Minter, John Easter--The Chagres. N.Y., (1948). $15.00,
$15.00 (orig. cloth), $15.00
Minton, Bruce, pseud.
See: Bransten, Richard
Miranda, Francisco de--Diary.... N.Y., 1928. 1st ed.
$75.00 (cloth, editor's presentation inscription)
--The New Democracy in America. Norman, (1963). $30.00
Mirsky, Jeannette--The World of Eli Whitney. N.Y., 1952.
1st ed. $12.00
Mischief in the Mountains. Montpelier, Vt., 1971. $12.50
Mississippi Panorama
See: City Art Museum of St. Louis
Mitchell, Benjamin Wiestling--Trail Life in the Canadian Rock-
ies. N.Y., 1924. $20.00 (cloth)
Mitchell, Broadus--Alexander Hamilton. N.Y., (1970). $12.50
Mitchell, Carleton--Isles of the Caribbees. Wash., 1966. 1st
ed. $7.50
Mitchell, Donald Grant--American Lands and Letters. N.Y.,
1897. 1st ed. $25.00 (1st issue, orig. cloth, edges a bit
worn, endpapers soiled)
--Rural Studies.... N.Y., 1867. 1st ed. $45.00 (orig. cloth,
state 2, edges and corners lightly worn, bookplate)
Mitchell, Edwin Valentine--American Village. N.Y., (1938).
$20.00 (author's presentation)

Mitchell, Emerson Blackhorse--Miracle Hill. Norman, (1967).
1st ed. $20.00
Mitchell, Ewing Young--Kicked In and Kicked Out of the Pres-
ident's Little Cabinet. Wash., 1936. $12.50 (cloth)
Mitchell, John Donald--Lost Mines of the Great Southwest.
Phoenix, Az., (1933). 1st ed. $100.00
Palm Desert, Ca., (1958). $25.00
Mitchell, Joseph Brady--Decisive Battles of the Civil War.
N.Y., (1955). $17.50 (autographed)
Mitchell, Lelia Ayer--California. N.p., 1951. $8.50 (bit of
spine wear)
Mitchell, Margart Knox (Howell)--Observations on Birds of
Southeastern Brazil. Toronto, (1957). $37.00 (cloth,
owner mark)
Mitchell, Nicolas Pendleton--State Interests in American Trea-
ties. Rich., 1936. $20.00
Mitchell, Ruth--My Brother Bill.... N.Y., (1953). $8.50
Mitchell, Samuel Augustus--Illinois in 1837
See under Title
--Texas, Oregon, and California. Oakland, 1948. $18.50
(one of 750 copies)
Mitchell, Silas Weir--The Cup of Youth and Other Verses.
Bost., 1889. 1st ed. $40.00 (author's presentation copy,
orig. boards, tips of spine frayed, label rubbed, binding
soiled)
Mitchell, William Ansel--Linn County, Kansas. K.C., 1928.
$35.00
Mitchell, Wilmot Brookings--Abraham Lincoln. Portland, Me.,
1910. $10.00
Mitchell-Hedges, Frederick Albert--Land of Wonder and Fear.
N.Y., (1931). $7.50
Mitchener, Charles Hallowell--Ohio Annals. Dayton, 1876.
1st ed. $75.00 (cloth, name on endpaper, some wear and
soiling to cover, endleaves soiled)
Mixer, Knowlton--Porto Rico. N.Y., 1926. $12.50
Miyamoto, Kazuo--Hawaii. Rutland, Vt., 1964. 1st ed. $7.50
Mizener, Arthur--The Far Side of Paradise. Bost., (1951).
$15.00, $10.00
--Twelve Great American Novels. N.Y., (1967). 1st ed.
$10.00 (1st printing)
Moats, Leone (Blakemore)--Thunder in the Veins. N.Y.,
(1932). 1st ed. $10.00 (foxed, stamp)
Mode, Peter George--Source Book and Bibliographical Guide
to American Church History. Bost., 1964. $17.50 (orig.
cloth)

Modern Brazil. Gainesville, 1971. $8.25
Modoc County Cattleman's Association--Modoc County Brand
 Book. N.p., n.d. $4.50 (wraps.)
Möllhausen, Balduin--Vandringer Ginnem det Vestlige Nord-
 amerikas, Prairien.... Copenhagen, 1862. $225.00 (con-
 temp. three-quarter leather, hinges cracked)
Moers, Ellen--Two Dreisers. N.Y., (1969). $15.00
Mogelever, Jacob--Death to Traitors. Graden City, 1960.
 $20.00
Mohr, Charles E.--Celebrated American Caves. New Bruns-
 wick, (1955). $8.00
Moises, Rosalio--The Tall Candle. Lincoln, Nb., (1971). 1st
 ed. $13.00
Mokler, Alfred James--History of Natrona County, Wyoming,
 1888-1922. Chi., 1923. $185.00 (pages dampstained)
Moldenke, Harold Norman--American Wild Flowers. N.Y.,
 (1949). $12.50
Moley, Raymond--The Administration of Criminal Justice in
 Missouri. S.L., 1926. $6.00
Molina, Felipe--Memoir on the Boundary Question Pending Be-
 tween the Republic of Costa Rica and the State of Nic-
 aragua. Wash., 1851. $125.00
Molina, Gerardo--Las Ideas Liberales en Colombia, 1849-1914.
 (Bogata, 1970). $10.00 (wraps.)
Mollenhoff, Clark R.--George Romney, Mormon in Politics.
 N.Y., (1968). $10.00
Molyneaux, Peter--The Romantic Story of Texas. N.Y., 1936.
 $20.00 (covers lightly marked)
Mombert, Jacob Astor--An Authentic History of Lancaster
 County.... Lancaster, Pa., 1869. 1st ed. $75.00 (re-
 bound)
Monaghan, Frank--John Jay, Defender of Liberty. N.Y.,
 1935. 1st ed. $25.00 (orig. cloth)
Monaghan, James--The Book of the American West. N.Y.,
 (1963). 1st ed. $35.00 (offsetting to rear endpapers,
 spine ends lightly frayed)
--Civil War on the Western Border.... Bost., (1955). 1st
 ed. $20.00
--Custer. Bost., (1959). $47.50, $12.50 (binding faded)
--Diplomat in Carpet Slippers. Ind., (1945). 1st ed. $13.50
--The Great Rascal. Bost., 1952. $21.50, $15.00, $12.00
--Lincoln Bibliography, 1839-1939. Springfield, Il., 1943-45.
 2 vols. $75.00 (orig. cloth)
--The Overland Trail. Ind., (1947). 1st ed. $38.50
Monaghan, Michael--Dry America. N.Y., 1921. $10.00

Monahan, Robert Scott--Mount Washington Reoccupied. Brattleboro, 1933. $20.00

Mondot, Armand--Histoire des Indiens des Etats-Unis. Paris, 1858. $125.00 (orig. printed front wrap. bound in half morocco)

Monroe, Harriet--A Poet's Life. N.Y., 1938. $15.00

Montague, Gilbert Holland--The Rise and Progress of the Standard Oil Company. N.Y., 1903. 1st ed. $4.00 (worn, ex-lib.) N.Y., 1904. $10.00 (covers stained)

Montana, the Magazine of Western History--Cowboys and Cattlemen. N.Y., (1964). $325.00 (pony skin, one of 199 numbered copies, signed by editor), $25.00 (cloth)

Montaner y Bello, Ricardo--Historia Diplomatica de la Independencia de Chile. (Santiago de Chile), 1961. $20.00 (wraps.)

Montgomery, Morton Luther--History of Berks County, Pennsylvania.... Reading, Pa., 1894. $35.00

Montgomery, Richard Gill--The White-Headed Eagle. N.Y., (1934). $36.50 (author's signature), $12.50

Montgomery, Robert Humphrey--Sacco-Vanzetti.... N.Y., 1960. 1st ed. $20.00, $10.00 (lacks free endpaper)

Montgomery, Rutherford George--High Country. N.Y., (1938). $75.00 (cloth, one of 950 copies)

Montoya, Alfredo J.--Historia de los Saladeros Argentinos. Buenos Aires, (1956). $35.00 (wraps.)

Montoya, Juan de--New Mexico in 1602.... Albuquerque, 1938. $125.00 (cloth, one of 550 numbered copies)

Montross, Lynn--The Reluctant Rebels. N.Y., 1950. 1st ed. $12.50

--The Story of the Continental Army.... N.Y., (1967). $12.50

Montt, Pedro--Exposition of the Illegial Acts.... Wash., 1891. $25.00 (orig. wraps.)

Moodie, Susanna Strickland--Roughing it in the Bush. N.Y., 1852. 2 vols. $75.00 (backstrips lightly frayed, orig. cloth)

Moody, Dan W.--The Life of a Rover.... (Chi., 1926). 1st ed. $17.50 (wraps.)

Moody, Ralph--Shaking the Nickel Bush. N.Y., (1962). $8.50 (ex-lib.)

--Stagecoach West. N.Y., 1967. $8.50

Moody, William Revell--The Life of Dwight L. Moody. N.Y., 1900. 1st ed. $10.00

Mooney, Booth--Roosevelt and Rayburn. Phila., (1971). $12.50

Moore, Arthur Keister--The Frontier Mind. (Lexington, Ky.,
1957). 1st ed. $30.00

Moore, Colleen--Silent Star. Garden City, 1968. $10.00
(lacks front fly)

Moore, Cuninghame Wilson--A Practical Guide for Prospectors....
Lond., 1893. $22.00 (cloth)

Moore, Ethel--Ballads and Folk Songs of the Southwest. Nor-
man, (1964). $37.50

Moore, Frank--The Civil War in Song and Story.... N.Y.,
(1865). $7.50

--Women of the War. Hart., 1866. 1st ed. $20.00 (back-
strip lightly frayed)

Moore, Gay (Montague)--Seaport in Virginia. Rich., (1949).
$27.50 (inscribed by illustrator)

Moore, Guy W.--The Case of Mrs. Surratt. Norman, 1954.
$17.50

Moore, Jacob Bailey--Annals of the Town of Concord. Con-
cord, 1824. $50.00 (orig. wraps., spine partially perished,
some browning)

Moore, Joan W.--Homeboys. Phila., 1978. $6.00

Moore, Marianne--Letters From and to the Ford Motor Com-
pany. N.Y., 1958. $90.00 (cloth, one of 550 copies)

Moore, Robin--Mafia Wife. N.Y., 1977. $8.00

Moore, Truman E.--The Traveling Man. Garden City, 1972.
$12.50

Moore, William Francis--Indian Place Names in the Province of
Ontario. Toronto, 1930. $8.50

Moorehead, Warren King--Prehistoric Relics. Andover, Ma.,
(1905). $25.00

--Stone Ornaments Used by Indians.... Andover, Ma., 1917.
$100.00 (cloth)

Moorhead, Max L.--The Apache Frontier. Norman, (1968).
$8.50

--The Presidio. Norman, (1975). $15.00

Moorman, John Jennings--Virginia Sulphur Springs. Balt.,
1869. $35.00 (orig. wraps.)

Moquin, Wayne--A Documentary History of the Mexican Amer-
icans. N.Y., 1972. $15.00

Mora, Joseph Jacinto--Californios.... Garden City, 1949.
1st ed. $35.00

--Trail Dust and Saddle Leather. N.Y., 1946. $50.00 (owner
label), $32.50, $30.00

Morais, Herbert Montfort--The Struggle for American Freedom.
N.Y., (1944). $7.50

More, Charles Albert--Chevalier de Pontigibaud. Paris, 1898.
$40.00 (cloth and boards)

More, Hannah--Strictures on the Modern System of Female
 Education. Hart., 1801. 2 vols. in 1. $125.00
Morehouse, Marion--Adventures in Value.... N.Y., (1962).
 1st ed. $50.00 (cloth)
Morfi, Juan Agustin--Excerpts From the Memorias for the His-
 tory of the Province of Texas. San Antonio, 1932. 1st
 ed. $450.00 (orig. cloth, 1 of 200 numbered copies)
Morgan, Arthur Ernest--Edward Bellamy. N.Y., 1944. 1st
 ed. $12.50
Morgan, Dale Lowell--The Great Salt Lake. Ind., (1947).
 1st ed. $30.00, $25.00 (signed)
--The Humboldt.... N.Y., (1943). 1st ed. $15.00
--In Pursuit of the Golden Dream
 See: Gardiner, Howard Calhoun
--Jedediah Smith and His Maps of the American West. S.F.,
 1954. 1st ed. $750.00 (orig. cloth, one of 530 copies),
 $425.00 (one of 530 copies)
--The Rocky Mountain Journals....
 See: Anderson, William Marshall
--The West of William H. Ashley.... Denver, 1964. $120.00
Morgan, Edmund Sears--Virginians at Home. Williamsburg,
 (1952). 1st ed. $10.00, $5.00
Morgan, Eleanor Wickware--"Up the Front." (Toronto, 1964).
 $8.50 (owner inscription)
Morgan, George--The Issue. Phila., 1904. $6.00
Morgan, George Haeelnbrooke, 1828--Centennial.... Harris-
 burg, Pa., 1877. $40.00
Morgan, Lewis Henry--Houses and House-Life of the American
 Aborigines. Wash., 1881. $75.00 (cloth, somewhat worn
 and frayed, small tear in backstrip)
--The Indian Journals, 1859-62. Ann Arbor, (1959). $46.50,
 $40.00 (cloth)
--League of the Ho-De-No-Sau-Nee or Iroquois. N.Y., 1901.
 2 vols. $300.00 (of a total edition of 330, this is one of
 30 on Japanese vellum)
Morgan, Murray Cromwell--One Man's Gold Rush. Seattle,
 (1967). $25.00
Morgan, Nicholas Groesbeck--The Old Fort. S.L.C., 1964.
 $25.00 (orig. wraps.)
Morgan, Theodore--Hawaii. Camb., 1948. 1st ed. $17.50,
 $16.00
Morison, Bradley L.--Sunlight on Your Doorstep. Minne.,
 1966. $12.50
Morison, Samuel Eliot--Admiral of the Ocean Sea. Bost., 1942.
 2 vols. 1st ed. $125.00 (unexpurgated), $10.00

--By Land and By Sea. N.Y., 1953. $15.00
--The European Discovery of America. N.Y., 1971. 1st ed.
 $15.00
--The Growth of the American Republic. N.Y., 1930. 1st
 ed. $40.00 (cloth)
--Harrison Gray Otis.... Bost., 1969. $20.00
--The Life and Letters of Harrison Gray Otis, Federalist,
 1765-1848. Bost., 1913. 2 vols. $125.00
--The Maritime History of Massachusetts.... Bost., 1921.
 1st ed. $35.00
--"Old Bruin".... Bost., (1967). 1st ed. $10.00
--Strategy and Compromise. Bost., (1958). $12.50
--The Two-Ocean War. Bost., (1963). 1st ed. $12.50
Morley, Christopher--Hasta la Vista. Garden City, 1935.
 1st ed. $35.00 (orig. cloth, signed by author)
--Old Loopy. Chi., 1935. 1st ed. $25.00 (cloth)
Morley, John--Edmund Burke, a Historical Study. N.Y.,
 1924. $15.00 (one of 780 copies)
Moron, Guillermo--A History of Venezuela. N.Y., (1964).
 $12.50
Morris, Edmund--Derrick and Drill. N.Y., 1865. $250.00
 (orig. cloth)
Morris, Edward Parmelee--The Fore-and-Aft Rig in America.
 New Haven, 1927. $65.00 (one of 1000 copies)
Morris, Gouverneur--The Diary and Letters of.... N.Y.,
 1888. 2 vols. 1st ed. $75.00 (orig. cloth), $25.00 (ex-
 lib.)
Morris, H.S.--Historical Stories, Legends and Traditions.
 (Sisseton, S.D.), n.d. $7.50
Morris, Harrison Smith--Walt Whitman. Camb., 1929. 1st ed.
 $25.00 (orig. cloth)
Morris, Henry Curtis--The Mining West at the Turn of the
 Century. Wash., (1962). $28.50
Morris, Joe Alex--Nelson Rockefeller.... N.Y., (1960).
 $12.50
Morris, Lucile--Bald Knobbers. Caldwell, 1939. $50.00 (lib.
 marks and bookplate removed)
Morris, Richard Brandon, ed.--Alexander Hamilton and the
 Founding of the Nation
 See: Hamilton, Alexander
--The Peacemakers. N.Y., (1965). 1st ed. $20.00, $12.50
--Seven Who Shaped Our Destiny. N.Y., (1973). 1st ed.
 $10.00
Morrow, Ralph Ernest--Northern Methodism and Reconstruction.
 [East Lansing, Mi.], 1956. $20.00

Morse, Anson Ely--The Federalist Party in Massachusetts....
Princeton, 1909. 1st ed. $15.00 (spine lightly faded and
wrinkled)

Morse, Eric Wilton--Fur Trade Canoe Routes of Canada....
(Ottawa, 1969). $20.00

Morse, Jedediah--A Compendious History of New England....
Newburyport, N.H., 1809. $30.00 (rebound in cloth, map
somewhat split, text a bit foxed and stained, pages lightly
dog-eared)

Morse, John Frederick--Illustrated Historical Sketches of Cal-
ifornia.... Sacramento, 1854. 1st ed. $850.00 (orig.
wraps. bound in, half morocco)

Morse, John Torrey--The Life of Alexander Hamilton. Bost.,
1876. 2 vols. $10.00

Morse, Sidney--The Siege of University City.... S.L., 1912.
$35.00

Morton, Arthur Silver--A History of the Canadian West to
1870-71.... Lond., (1939). 1st ed. $250.00 (orig. cloth)

Morton, Edward Payson--Lake Huron and the Country of the
Algonquins. Chi., (1913). $7.50

Morton, John S.--A History of the Origin of the Appellation
Keystone State. Phila., 1874. $15.00

Morton, Louis--Robert Carter of Nomini Hall.... Williamsburg,
1941. 1st ed. $8.50

Morton, Nathaniel--New-England's Memoriall. Bost., 1903.
$70.00 (boards)

Moser, Charles--Reminiscences of the West Coast of Vancouver
Island. Victoria, B.C., (1926). 1st ed. $60.00 (orig.
printed wraps.)

Moser, Don--The Pied Piper of Tucson. (N.Y., 1967). $12.00

Moses, John--Illinois, Historical and Statistical. Chi., 1895.
2 vols. $75.00 (inner hinges weak)

Moses, Montrose Jonas--The American Dramatist. Bost., 1917.
$15.00 (spine lightly rubbed and cover lightly stained)

Moses, Robert--Public Works. N.Y., (1970). $12.50

Motolinia, Toribio--Motolinia's History of the Indians of New
Spain. Berkeley, 1950. 1st ed. $150.00 (orig. cloth, one
of 500 copies)

Mott, Abigail (Field)--Biographical Sketches and Interesting
Anecdotes of Persons of Color. N.Y., 1839. $75.00
(contemp. calf, one sig. loose)

--Narratives of Colored Americans. N.Y., 1882. $47.50
(cloth, spine faded, front inner hinge weak)

Mott, Frank Luther--Golden Multitudes. N.Y., 1947. 1st ed.
$15.00, $12.50

Mottelay, Paul Fleury--The Soldier in Our Civil War. N.Y.,
1890. 2 vols. $125.00 (backstrip taped)
Mountain, Armine Wale--A Memoir of George Jehoshaphat Moun-
tain.... Lond., 1866. $85.00 (orig. cloth)
Mountain Wolf Woman--Mountain Wolf Woman.... Ann Arbor,
(1961). $12.50, $10.00
Mowat, Farley--The Boat Who Wouldn't Float. Toronto, 1969.
1st ed. $7.50
--Never Cry Wolf. Toronto, 1963. 1st ed. $9.50
Moyer, Cecil C.--Historic Ranchos of San Diego. (San Diego,
1969). $27.50
Moyle, Seth--My Friend, O. Henry. N.Y., (1914). 1st ed.
$15.00 (orig. wraps.)
Moynihan, Daniel Patrick, ed.--The Defenses of Freedom
See: Goldberg, Arthur J.
Mudge, Robert W.--Adventures of a Yellowbird. Bost., (1969).
$15.00
Mueller, Henry Richard--The Whig Party in Pennsylvania.
N.Y., 1922. 1st ed. $17.50 (wraps.)
Muench, Josef--Salt Lake City. N.Y., (1947). $9.50 (edges
worn)
Mugaburu, Josephe de--Chronicle of Colonial Lima. Norman,
(1975). 1st ed. $10.00
Muir, Florabel--Headline Happy. N.Y., (1950). $10.00
Muir, John--The Cruise of the Corwin. Bost., 1917. $90.00
(owner signature)
--The Mountains of California. N.Y., 1903. $35.00 (spine a
bit darkened, owner signature)
--Our National Parks. Bost., 1901. 1st ed. $15.00
--Steep Trails. Bost., 1918. $125.00
--The Story of My Boyhood and Youth. Bost., 1913. 1st ed.
$125.00 (corners bumped, rear cover spot, 1st issue)
--Studies in the Sierra. S.F., (1950). $20.00
--A Thousand-Mile Walk to the Gulf. Bost., 1916. 1st ed.
$37.50 (lettering on backstrip partly effaced)
--Travels in Alaska. Bost., 1915. 1st ed. $29.00 (cloth)
Muir, William Ker--Police. Chi., 1977. $6.00
Mulder, William--Among the Mormons. N.Y., 1958. 1st ed.
$45.00, $15.00
Mulford, Prentice--Prentice Mulford's Story. Oakland, 1953.
$25.00 (one of 500 copies)
Mulkearn, Lois--A Traveler's Guide to Western Pennsylvania.
(Pitts.), 1954. $15.00
Mullan, John--Miners' and Travelers' Guide to Oregon, Wash-
ington, Idaho.... N.Y., 1865. 1st ed. $250.00

Muller, Dan--Horses. Chi., (1936). $60.00
--My Life With Buffalo Bill. Chi., (1948). $20.00, $7.50
Muller, Max--Prairie Carnegie. Lindsbourg, Ks., 1977.
 $10.00 (inscribed copy)
Mullins, Joseph G.--Hawaii. Honolulu, 1976. $20.00
Mumey, Nolie--Bloody Trails Along the Rio Grande
 See: Ickis, Alonzo Ferdinand
--Calamity Jane, 1852-1903. Denver, 1950. $182.50 (boards)
--Edward Dunsha Steele, 1829-1865
 See: Steele, Edward Dunsha
--History of the Early Settlements of Denver.... Glendale,
 1942. $125.00 (one of 500 signed copies), $125.00 (one of
 500 signed copies)
--The Life of Jim Baker.... Denver, 1931. $265.00 (book-
 plate, one of 250 signed and numbered copies)
 N.Y., 1972. $150.00 (half leather and boards, one of 126
 numbered copies)
--Old Forts and Trading Posts of the West. Denver, 1956.
 $125.00 (one of 500 numbered and signed copies)
--The Singing Arrow.... Denver, 1958. $12.00 (cloth, signed
 by author, one of 1000 copies)
Mumford, Elizabeth--Whistler's Mother. Bost., 1939. 1st ed.
 $20.00 (cover soiled)
Mumford, Lewis--The Brown Decades. N.Y., (1931). 1st
 ed. $15.00 (cloth, bookplate)
--Herman Melville. N.Y., 1929. $10.00 (cloth, spine faded)
Munk, Joseph Adams--Southwest Sketches. N.Y., 1920.
 $48.50 (neatly rebacked, new endpapers)
Munro, Dana Gardner--Intervention and Dollar Diplomacy in
 the Caribbean.... Princeton, 1964. 1st ed. $12.50
Munroe, Kirk--Campmates.... N.Y., 1891. 1st ed. $25.00
 (orig. cloth, spine extremities lightly rubbed)
Murder Will Out
 See: (DeBeck, William L.)
Murdoch, Angus--Boom Copper. N.Y., 1945. $17.50
Murfree, Mary Noailles--The Frontiersmen. Bost., 1904. 1st
 ed. $25.00 (1st printing, cloth, bookplate)
--In the Tennessee Mountains. Lond., 1884. $25.00 (cloth,
 bookplates)
Murie, Adolph--A Naturalist in Alaska. N.Y., 1961. 1st ed.
 $8.00
Murphy, Celeste G.--The People of the Pueblo. Sonoma,
 (1937, i.e. 1935). $25.00 (author's presentation inscrip-
 tion, corners bumped)

Murphy, DuBose--A Short History of the Protestant Episcopal Church in Texas. Dallas, (1935). $30.00

Murphy, Robert Cushman--Oceanic Birds of South America. N.Y., 1936. 2 vols. $200.00

Murphy, Thomas Dowler--Three Wonderlands of the American West.... Bost., 1913. $20.00
Bost., 1919. $39.50

Murray, John Wilson--Memoirs of a Great Canadian Detective. Toronto, 1977. $12.50

Murray, Keith A.--The Modocs and Their War. Norman, (1959). $25.00

Murray, Lieutenant, pseud.
See: (Ballou, Maturin Murray)

Murray, Louise Welles, ed.--Selected Manuscripts....
See: Clark, John S.

Murray, Norbert--Legacy of an Assassination. N.Y., (1964). $7.00

Murray, Robert A.--The Army on the Powder River. (Fort Collins, Co., 1972). $7.50

Murray, Tom G.--Seldom Seen Slim. San Fernando, Ca., 1971. $7.50

Museum of Graphic Art--American Printmaking.... Wash., (1969). $25.00

Museum of Modern Art (New York, N.Y.)--American Folk Art
See: Cahill, Holger

Musmanno, Michael Angelo--After Twelve Years. N.Y., 1939. $20.00

Musselman, Morris McNeil--Get a Horse! Phila., (1950). $8.00

Mussey, June Barrows--Yankee Life by Those Who Lived It. N.Y., 1947. $17.50

Muste, Abraham John--The Essays of.... Ind., (1967). 1st ed. $12.50

Myer, Dillon Seymour--Uprooted Americans. Tucson, (1971). $20.00

Myers, Albert Cook--Immigration of the Irish Quakers.... Swarthmore, Pa., 1902. $85.00 (orig. cloth)

Myers, Gustavus--The Ending of Hereditary American Fortunes. N.Y., 1939. 1st ed. $13.00 (covers water stained)
--The History of Tammany Hall. N.Y., 1917. $15.00 (wraps., presentation copy)
--History of the Supreme Court of the U.S. Chi., 1925. $15.00

Myers, John Myers--The Alamo. N.Y., 1948. 1st ed. $18.50
--The Deaths of the Bravos. Bost., (1962). $12.50

--Doc Holliday. Bost., (1955). 1st ed. $25.00, $10.00
 (spine lightly faded)
--San Francisco's Reign of Terror. Garden City, 1966. $7.50
--The Westerners. Englewood Cliffs, (1969). $10.00
Myers, Raymond E.--The Zollie Tree.... Lou., 1964. $20.00
Myers, Richmond E.--The Long Crooked River. Bost., 1949.
 $15.00
Myers, Samuel Dale, ed.--Pioneer Surveyor, Frontier Lawyer
 See: Williams, Oscar Waldo
Myers, William M.--Journal of a Cruise to California.... S.F.,
 1955. $215.00 (one of 400 copies)
Myers, William Star--The Hoover Administration. N.Y., 1936.
 1st ed. $12.50
Myrdal, Gunnar--An American Dilemma. N.Y., (1944). $25.00
 (cloth)
Myrick, David F.--Potosi: an Empire of Silver. Orinda, Ca.,
 1980. $22.50 (one of 150 copies)
Myrthe, A.T.--Ambrosia de Letinez....
 See: (Ganilh, Anthony)

- N -

Nabokov, Vladimir Vladimirovich--Lolita. Paris, (1955). 2
 vols. 1st ed. $300.00 (1st state, some dampstains on rear
 leaves, spines lightly sunned, name on endpapers)
 Lond., (1959). $75.00 (boards)
Nabuco, Joaquim--O'Aboliconismo. Lond., 1883. 1st ed.
 $10.00
Nadeau, Remi A.--Fort Laramie and the Sioux Indians. Engle-
 wood Cliffs, (1967). 1st ed. $15.00
--Ghost Towns and Mining Camps of California. L.A., (1965).
 $15.00, $15.00
--The Real Joaquin Murieta. Corona Del Mar, Ca., 1974.
 $17.50
Nader, Ralph--Unsafe at Any Speed. N.Y., 1965. 1st ed.
 $10.00
Naef, Weston J.--Era of Exploration. Bost., (1975). 1st ed.
 $35.00
Naipaul, Vidiadhar Suraprasad--The Loss of El Dorado. N.Y.,
 1969. 1st ed. $10.00
Nansen, Fridtjof--Fridtjof Nansen's Farthest North. N.Y.,
 1897. 2 vols. 1st ed. $150.00
Narrative of Some Things of New Spain.... N.Y., 1917.
 $125.00 (orig. cloth, one of 250 numbered copies)

Narrative of the Privations and Sufferings of U.S. Officers....
Bost., (1864). $8.50 (disbound)
Nasatir, Abraham Phineas--French Activities in California.
Stanford, 1945. 1st ed. $65.00, $50.00
--French Consuls in the U.S. Wash., 1967. $20.00 (orig.
wraps.)
--Spanish War Vessels on the Mississippi.... New Haven,
1968. 1st ed. $35.00
Nash, Howard Pervear--A Naval History of the Civil War.
South Brunswick, 1973. $12.50
--Stormy Petrel. Rutherford, (1969). $12.50
Nash, Mannering--Machine Age Maya. Glencoe, Il., (1958).
$12.50 (sewn)
Nash, Ogden--The Bad Parents' Garden of Verse. N.Y.,
1936. $20.00 (cloth)
--Good Intentions. Bost., 1942. 1st ed. $30.00 (cloth)
--I'm a Stranger Here Myself. Bost., (1938). 1st ed.
$15.00 (cloth)
--Many Long Years Ago. Lond., 1954. $40.00 (orig. wraps.,
lightly soiled, spine lightly worn)
--Versus From 1929 on. Bost., 1949. 1st ed. $15.00 (cloth)
Nason, George Washington--History and Complete Roster of the
Massachusetts Regiments.... Bost., 1910. $30.00 (lib.
stamp)
Nathan, George Jean--The Bachelor Life. N.Y., (1941).
$15.00 (cloth)
--Monks Are Monks. N.Y., 1929. $10.00 (cloth, name on
endpaper)
Nathan, Paul D., tr.--The San Saba Papers. S.F., (1959).
1st ed. $75.00 (cloth)
Nation, Carrie Amelia (Moore)--The Use and Need of the Life
of.... Topeka, Ks., 1904. 1st ed. $50.00 (orig. cloth,
soiled)
Topeka, 1905. $60.00 (orig. wraps., signed by author,
newspaper clippings pasted to endleaves)
Topeka, 1909. $20.00
National American Woman Suffrage Association--Victory, How
Women Won it. N.Y., 1940. $22.00
National Committee for the Defense of Political Prisoners--
Harlan Miners Speak. N.Y., (1932). 1st ed. $35.00
National Council of the Churches of Christ in the U.S.A.--
Christian Faith in Action.... N.p., 1951. $10.00
National Society of the Colonial Dames of America. Pennsyl-
vania--Forges and Furnaces in the Province of Pennsylvania.
Phila., 1914. $75.00

Naughton, W.W.--Kings of the Queensberry Realm.... Chi.,
(1902). $25.00

Naval Documents Relating to the Quasi-War Between the U.S.
and France....
See: U.S. Office of Naval Records and Library

Neal, John--Rachel Dyer. Portland, Me., 1928. 1st ed.
$75.00 (orig. boards, rebacked, later endleaves, piece
clipped from title)

Neal, Julia--By Their Fruits. Chapel Hill, 1947. $65.00

Neal, Marie Catharine--In Gardens of Hawaii. (Honolulu),
1965. $35.00 (name on half-title, cloth)

Neatby, Hilda--Quebec: the Revolutionary Age.... N.Y.,
1966. $17.50

Needler, George Henry--Louis Riel. Toronto, 1957. $25.00

Neese, Robert--Prison Exposures. Phila., (1959). $20.00

Nehemkis, Peter--Latin America: Myth and Reality. N.Y.,
1964. 1st ed. $15.00

Neighbors, Kenneth Franklin--Robert S. Neighbors and the
Texas Frontier.... Waco, 1975. $15.00

Neill, Edward Duffield--The History of Minnesota. Phila.,
1873. $35.00

Nellis, Milo--The Mohawk Dutch and the Palatines. St. Johns-
ville, N.Y., (1951). $6.00 (stiff wraps.)

Nelson, Charles P.--Abe, the War Eagle. N.p., 1903. $12.50

Nelson, Edna Deu Pree--O'Higgins and Don Bernardo. N.Y.,
1954. $10.00

Nelson, Jack--The FBI and the Berrigans. N.Y., (1972).
$15.00

Nelson, Oliver--The Cowman's Southwest. Glendale, 1953.
1st ed. $100.00

Nelson, William Hamilton--Alluring Arizona. S.F., 1927. 1st
ed. $13.50

Nemerov, Howard--Guide to the Ruins. N.Y., 1950. 1st ed.
$100.00 (cloth and boards, faint shelf wear, signed by
author)

Neprud, Robert E.--Flying Minute Men. N.Y., (1948).
$8.50

Neuenschwander, John A., ed.--Kenosha County in the Twen-
tieth Century
See under Title

--The Middle Colonies and the Coming of the American Revo-
lution. Port Washington, 1973. $15.00

Neustadt, Richard E.--Presidential Power. N.Y., (1960).
1st ed. $12.50

Neville, Alexander White--The Red River Valley, Then and
 Now. Paris, Tx., 1948. $50.00
Nevins, Allan--Abraham S. Hewitt.... N.Y., 1935. 1st ed.
 $10.00 (worn at extremities)
--The Burden and the Glory
 See: Kennedy, John Fitzgerald
--The Diary of Philip Hone, 1828-1851
 See: Hone, Philip
--The Emergence of Lincoln. N.Y., 1950. 2 vols. $15.00
 (ex-lib.)
--Ford, Decline and Rebirth.... N.Y., (1963). $25.00
--Ford, Expansion and Challenge, 1915-1933. N.Y., (1957).
 $25.00
--Fremont, Pathmarker of the West. N.Y., 1955. $21.95
--Fremont, The West's Greatest Adventurer.... N.Y., 1928.
 2 vols. $52.50 (backstrips faded)
--The Gateway to History. Bost., 1938. $15.00
--Grover Cleveland; a Study in Courage. N.Y., 1932. 1st
 ed. $15.00 (cloth, name on front fly)
 N.Y., 1933. $15.00
--Hamilton Fish. N.Y., 1936. 1st ed. $20.00
--History of the Bank of New York and Trust Company....
 N.Y., 1934. 1st ed. $20.00
--Narratives of Exploration and Adventure
 See: Fremont, John Charles
New Helvetia Diary. S.F., 1939. $100.00 (one of 950 copies),
 $85.00 (one of 950 copies)
New Mexico Historic Documents. Albuquerque, 1975. $8.00
New Mexico, the Land of Opportunity. Albuquerque, (1915).
 $35.00
New Mexico, the Last Great West. Chi., 1917. $30.00
New York (N.Y.). Committee on Debts of the Southern States
 --The Debts of the Southern States. N.Y., 1877. $60.00
 (orig. wraps.)
New York (State). Laws, Statutes, etc.--Laws of the Legis-
 lature of the State of New York, in Force Against the
 Loyalists. Lond., 1786. $150.00 (wraps., slipcased)
The New York Volunteers in California. Glorieta, N.M.,
 (1970). $8.50
Newcomb, Pearson--The Alamo City. San Antonio, (1926).
 $22.50
Newcomb, Rexford--In the Lincoln Country. Phila., 1928.
 $14.50
Newcombe, Jack--The Best of the Athletic Boys. Garden City,
 1975. $15.00

Newell, Robert--Memoranda. (Portland, Or.), 1959. $35.00
(one of 1000 copies)
--Robert Newell's Memoranda. Portland, Or., 1959. $25.00
Newey, Laverna Burnett--Remember My Valley. S.L.C., 1977.
$20.00
Newlands, David L.--Early Ontario Potters. Toronto, 1979.
$15.00
Newman, Ben-Allah--Rudolph Valentino. Hollywood, 1926.
$25.00 (wraps., lacks fly)
Newman, Eugene William--In the Pennyrile of Old Kentucky....
Wash., 1911. $85.00 (inscribed by "the author")
Newmark, Harris--Sixty Years in Southern California, 1853-
1913. Bost., 1930. $50.00
Newton, Alfred Edward--The Amenities of Book Collecting.
Bost., n.d. $15.00 (boards)
--Doctor Johnson. A Play. Bost., 1923. 1st ed. $45.00
(inscribed, orig. boards, covers lightly soiled and
scratched)
--A Tourist in Spite of Himself. Bost., 1930. 1st ed. $35.00
(inscribed, orig. cloth), $15.00 (cloth)
Newton, James King--A Wisconsin Boy in Dixie. Madison,
1961. 1st ed. $17.50
Newton, Joseph Fort--Lincoln and Herndon. Cedar Rapids,
1910. $45.00 (cloth)
Newton, Lewis William--A Social and Political History of Texas.
Dallas, (1935). $15.00
Newton, Norman--Thomas Gage in Spanish America. N.Y.,
(1969). $7.50
Newyhart, Louise (Albright)--Giant of the Yards. Bost.,
1952. $15.00
Nibley, Preston--Brigham Young.... S.L.C., 1936. 1st ed.
$30.00 (orig. cloth)
Nichols, Clinton Melvin--Life of Abraham Lincoln.... N.Y.,
1896. 1st ed. $8.50 (orig. wraps., bottom of spine torn)
Nichols, Edward Jay--Toward Gettysburg. University Park,
Pa., 1958. $30.00 (signed)
--Zach Taylor's Little Army. Garden City, 1963. $25.00
Nichols, George Ward--The Story of the Great March. N.Y.,
1865. 1st ed. $20.00, $20.00
Nichols, Herbert B.--Historic New Rochelle. New Rochelle,
N.Y., 1938. $20.00
Nichols, James Hastings--Democracy and the Churches.
Phila., (1951). 1st ed. $10.00
Nichols, Roger L.--General Henry Atkinson. Norman, (1965).
1st ed. $20.00 (corners bumped)

--The Missouri Expedition, 1818-1820
See: Gale, John
Nichols, Roy Franklin--Franklin Pierce.... Phila., 1931. 1st
ed. $17.50 (autographed)
Nicholson, Irene--The X in Mexico. Garden City, 1966. $7.00
Nickerson, Warren Sears--Land Ho! Bost., 1931. $30.00
(orig. boards)
Nicolay, John G.--Abraham Lincoln. N.Y., 1914. 10 vols.
$125.00 (cloth)
Nicollett, Joseph Nicolas--Joseph N. Nicollett on the Plains
and Prairies. St. Paul, 1976. $25.00
Niebuhr, Reinhold--The Irony of American History. N.Y.,
1954. $5.00 (ex-lib.)
Niederhoffer, Arthur--Behind the Shield. Garden City, 1967.
1st ed. $8.00
--The Police Family. Lexington, 1978. $7.00 (advance copy
in wraps.)
Niering, William A.--The Life of the Marsh. N.Y., (1966).
$7.50
Nietz, John Alfred--Old Textbooks. Pitts., (1961). $25.00
Niggli, Josephina--Mexican Village. Chapel Hill, (1945).
$5.00
Nile, LeRoy--Kennebago Summer. Farmington, Me., (1947).
$15.00
Niles, Blair--Peruvian Pageant. Lond., (1937). 1st ed.
$8.00
Niles, Blair, Mrs., ed.--Journeys in Time. N.Y., (1946).
$7.50
Niles, John Milton--History of South America and Mexico....
Hart., 1837. 2 vols. in 1. $450.00 (orig. calf, neatly
rebacked, foxing)
--A View of South-America and Mexico.... N.Y., 1825. 2
vols. in 1. 1st ed. $150.00 (orig. calf, moderately foxed)
N.Y., 1826. $85.00 (light foxing and tanning), $75.00,
$35.00 (sheep, binding worn)
Niven, John--Gideon Welles. N.Y., 1973. $20.00
Nixon, Edgar Burkhardt, ed.--Franklin D. Roosevelt and World
Affairs
See: Roosevelt, Franklin Delano
Nixon, Lily Lee--James Burd, Frontier Defender.... Phila.,
1941. $12.50
Nixon, Oliver Woodson--How Marcus Whitman Saved Oregon.
Chi., 1895. 1st ed. $30.00 (cloth, moderately worn, book
stamp)

Noel, Joseph--Footloose in Arcadia. N.Y., (1940). 1st ed.
$35.00

Noel, Theophilus--A Campaign From Santa Fe to the Mississippi.
Houston, 1961. $80.00 (one of 700 copies)

Noel-Baker, Francis Edward--The Spy Web. N.Y., (1955).
$16.00

Nolan, James Bennett--Early Narratives of Berks County.
Reading, Pa., 1927. $20.00

--The Schuylkill. New Brunswick, N.J., (1951). 1st ed.
$6.00

Noll, Arthur Howard--A Short History of Mexico. Chi., 1890.
1st ed. $37.50 (orig. cloth, rehinged)

Norbeck, Edward--Pineapple Town: Hawaii. Berkeley, 1959.
$20.00

Nordgang, Bruno--Patagonian Year. N.Y., 1938. $12.50
(minor marginal worming)

Nordhoff, Charles--California: for Health, Pleasure, and
Residence. N.Y., 1873. $22.50 (ex-lib., reading copy)

--The Communistic Societies of the United States. N.Y., 1875.
1st ed. $125.00

--The Cotton States in the Spring and Summer of 1875. N.Y.,
1876. 1st ed. $25.00 (rebound in old boards, backstrip
worn, ex-lib.)

--Politics for Young Americans. N.Y., 1875. $8.50 (rebacked)

Nordhoff, Walter--The Journey of the Flame. N.Y., 1933.
$5.00

Nordyke, Lewis--Cattle Empire. N.Y., (1950). $15.00 (cloth)

--Great Roundup.... N.Y., 1955. $24.50 (boards), $20.00
(presentation copy), $15.00, $12.50 (cloth, 3rd printing),
$10.00 (boards, bookplates)

--John Wesley Hardin, Texas Gunman. N.Y., 1957. $10.00

Norfleet, J. Frank--"Norfleet." Fort Worth, 1924. $14.50

Norgren, Paul Herbert--Employing the Negro in American In-
dustry. N.Y., 1959. $15.00 (ex-lib.)

Norlie, Olaf Morgan--History of the Norwegian People in Amer-
ica. Minne., 1925. $20.00

Norman, Benjamin Moore--Rambles in Yucatan.... N.Y., 1843.
$150.00 (orig. cloth, spine lightly faded)

Norman, Marc--Oklahoma Crude. N.Y., 1973. 1st ed. $12.50

Norman, Oscar Edward--The Romance of the Gas Industry.
Chi., 1922. $12.50

Norris, Frank--McTeague. S.F., 1941. $60.00 (one of 500
copies, bookplate)

--Works. Garden City, 1928. 10 vols. $1000.00

Norris, James D.--Frontier Iron. Madison, 1964. $15.00

Norris, John M.--Strangers Entertained. (Vancouver, 1971). $15.00

Norris, Thomas Wayne--A Descriptive & Priced Catalogue of Books.... Relating Directly or Indirectly to the History ... of California.... Oakland, 1948. $125.00 (one of 500 copies)

North, Arthur Walbridge--Camp and Camino in Lower California. Glorieta, 1977. $20.00

North Carolina and Its Resources. Winston, 1896. $50.00 (cloth, hinges starting)

North, Luther Hedden--Man of the Plains. Lincoln, 1961. $22.00 (boards)

North, Thomas--Five Years in Texas. Cinci., 1870. 1st ed. $250.00 (orig. cloth, light wear)

Northrop, Nira B.--Pioneer History of Medina County. Medina, 1861. $125.00 (orig. cloth)

Norton, Albert James--Norton's Complete Hand-Book of Havana and Cuba. Chi., (1900). $12.50

Norton, Charles Ledyard--Canoeing in Kanuckia. N.Y., 1878. $15.00 (wraps., binding stained and rubbed, lacks backstrip, some worming)

Norton, Henry Kittredge--The Coming of South America.... N.Y., (1932). $8.00 (cover stained)

Notes of Travel in California. N.Y., 1849. $68.50 (half leather, front hinge cracked)

Nowlin, William--The Bark Covered House. Detroit, 1876. 1st ed. $1250.00 (orig. cloth, spine and front hinge mended, in cloth slipcase)

Nugent, Walter T.K.--The Tolerant Populists. Chi., (1963). 1st ed. $25.00

Nunez Cabeza de Vaca, Alvar
See: Cabeza de Vaca, Alvar Nunez

Nussbaum, Arthur--A History of the Dollar. N.Y., 1958. $25.00

Nute, Grace Lee--Lake Superior. Ind., (1944). $15.00

Nutt, Charles--History of Worcester and Its People. N.Y., 1919. 4 vols. $60.00 (shelf worn bindings, owner's stamp, imitation leather)

Nutting, Wallace--Maine Beautiful. Framingham, Ma., (1924). $12.50

--New Hampshire Beautiful. Framingham, (1923). $10.00

--Pennsyvlania Beautiful. (Eastern). Framingham, Ma., (1924). $10.00

Nye, Russel Blaine--George Bancroft, Brahmin Rebel. N.Y., 1944. 1st ed. $15.00

--Midwestern Progressive Politics. (East Lansing), 1951.
1st ed. $20.00
Nye, Wilbur Sturtevant--Carbine and Lance. Norman, 1937.
$57.50
Nygaard, Norman Eugene--Walter Knott.... Grand Rapids,
(1965). $8.50

- O -

Oakes, William--Scenery of the White Mountains. Bost., (1848).
1st ed. $275.00 (orig. cloth, corners worn)
Oakley, Amy (Ewing)--Our Pennsylvania. Ind., (1950).
$10.00 (signed)
Oaks, George Washington--Man of the West. (Tucson, 1956).
$38.50 (wraps., one of 400 copies)
Oates, Stephen B.--To Purge This Land With Blood. N.Y.,
(1970). 1st ed. $17.50
--Visions of Glory. Norman, (1970). $10.00
--With Malace Toward None. N.Y., 1977. 1st ed. $20.00
Ober, Frederick Albion--Travels in Mexico.... Bost., 1885.
$25.00 (orig. cloth, ex-lib.)
Oberholser, Harry Church--The Bird Life of Louisiana. New
Orleans, 1938. $51.00
Obermann, Karl--Joseph Weydemeyer.... N.Y., (1947).
$15.00
Oberste, William Herman--"Remember Goliad!" N.p., 1949.
$125.00 (orig. wraps., presentation inscription)
Austin, 1949. $85.00 (orig. wraps., first leaf foxed, auto-
graphed by author)
O'Brien, Frank George--Minnesota Pioneer Sketches. Minne.,
1904. $17.50 (presentation copy, spine worn)
O'Brien, Howard Vincent--Notes For a Book About Mexico.
Chi., 1937. $12.50
O'Brien, Michael Joseph--Hercules Mulligan.... N.Y., (1937).
$27.50
O'Brien, Patrick Joseph--Will Rogers.... Phila., (1935).
$8.50 (cloth)
O'Brien, Philip J.--Allende's Chile
See under Title
Observations on the Commerce of Spain With Her Colonies.
Phila., 1800. $75.00 (later boards, few pen notes)
O'Byrne, Michael Cyprian--History of LaSalle County, Illinois.
Chi., 1924. 3 vols. $85.00

O'Callaghan, Edmund Bailey, ed.--The Documentary History
 of the State of New-York
 See under Title
--Documents Relative to the Colonial History of the State of
 New York
 See under Title
Ochoa, Guillermo--Reportaje en Chile. Mexico, 1972. $8.00
 (stamps)
O'Connor, Elizabeth (Paschal)--My Beloved South. N.Y., 1913.
 $7.50 (small dampstain on few blank margins)
O'Connor, Harvey--The Astors. N.Y., 1941. $15.00
--The Guggenheims. N.Y., (1937). $15.00
--Revolution in Seattle.... N.Y., 1964. 1st ed. $15.00
O'Connor, Jack--The Big Game Animals of North America.
 N.Y., 1961. 1st ed. $20.00
O'Connor, Richard--Courtroom Warrior. Bost., (1963). $10.00
--The German-Americans. Bost., (1968). $10.00
--The Oil Barons. Bost., (1971). $12.50
--Thomas, Rock of Chickamauga. N.Y., (1948). $15.00 (cloth)
--Wild Bill Hickok. Garden City, 1959. $7.50
O'Connor, Mrs. T.P.
 See: O'Connor, Elizabeth (Paschal)
O'Crouley, Pedro Alonso--A Description of the Kingdom of New
 Spain. (S.F.), 1972. 1st ed. $20.00
O'Daniel, Victor Francis--Dominicans in Early Florida. N.Y.,
 1930. $27.50
--The Father of the Church in Tennessee. Wash., (1926).
 $30.00
Odens, Peter--Fire Over Yuma. Yuma, 1966. $4.75
Odum, Howard Washington--Negro Workaday Songs. Chapel
 Hill, 1926. $26.00
O'Ferrall, Charles Triplett--Forty Years of Active Service.
 N.Y., 1904. 1st ed. $45.00 (cloth)
The Official Account of the Portola Expedition of 1769-1770
 See: Mexico (Viceroyality)
Ogburn, William Fielding--American Society in Wartime. Chi.,
 1943. 1st ed. $15.00
Ogden, Adele--The California Sea Otter Trade.... Berkeley,
 1941. 1st ed. $75.00 (orig. wraps.)
Ogden, Bill Arp--Early Days on the Texas-New Mexico Plains.
 Canyon, Tx., (1965). $38.50 (one of 750 c_pies)
Ogden, John Cosens--A Tour Through Upper and Lower Can-
 ada.... Litchfield (Ct.), 1799. 1st ed. $650.00 (orig.
 calf)

Ogg, Frederic Austin--The Opening of the Mississippi. N.Y.,
 1904. 1st ed. $45.00, $10.00 (cloth)
Oglesby, Richard Edward--Manuel Lisa and the Opening of the
 Missouri Fur Trade. Norman, (1963). $25.00
O'Gorman, Edith--Trials and Persecutions of Miss Edith O'Gor-
 man. Hart., (1871). $30.00 (head and tail of spine frayed,
 front hinge cracked)
O'Hara, Frank--Meditations in an Emergency. N.Y., (1957).
 $15.00 (stiff wraps.)
O'Hara, John--The Cape Cod Lighter. N.Y., (1962). 1st
 ed. $15.00 (cloth)
--Hellbox. N.Y., (1947). 1st ed. $35.00 (cloth)
The Ohio River Handbook. Cinci., 1949. $10.00 (owner name)
O'Kane, Walter Collins--The Hopis. Norman, (1953). 1st ed.
 $17.50
--Sun in the Sky. Norman, 1950. $26.50, $17.50 (ex-lib.)
O'Kieffe, Charley--Western Story. (Lincoln), 1960. $10.00,
 $10.00
Okinshevich, Leo, comp.--United States History & Historiog-
 raphy in Postwar Soviet Writings, 1945-1970. Santa Barbara,
 1976. $30.00
Old Man Coyote Races Buffalo. Bismarck, N.D., 1977. $5.00
Oldfield, Otis--A Pictorial Journal of a Voyage Aboard the
 Three Masted Schooner Louise.... S.F., 1969. $125.00
 (one of 400 copies)
Oldmixon, John--The British Empire in America. Lond.,
 1741. 2 vols. $485.00 (calf)
Olds, Robert--Helldiver Squadron.... N.Y., 1944. 1st ed.
 $25.00
Olender, Terrys T.--For the Prosecution. Phila., (1961).
 $12.50
Oliphant, James Orin--On the Cattle Ranges of the Oregon
 Country. Seattle, (1968). $35.00, $25.00
Oliphant, Laurence--Minnesota and the Far West. Edin., 1855.
 1st ed. $65.00
Oliva, Leo E.--Soldiers on the Santa Fe Trail. Norman,
 (1967). 1st ed. $20.00
Oliver, Herman--Gold and Cattle Country. Portland, Or.,
 1961. 1st ed. $35.00
Olmstead, Frederick Law--The Cotton Kingdom. N.Y., 1953.
 $15.00
Olmsted, Roger--Here Today. S.F., (1968). 1st ed. $20.00
Olshaker, Mark--The Instant Image. N.Y., 1978. $15.00
Olson, Charles--Call Me Ishmael. N.Y., (1947). $175.00
 (orig. cloth, presentation copy)

--The Maximus Poems. (N.Y., 1960). $25.00
--The Maximus Poems 1-10. Stuttgart, 1953. $250.00 (wraps.,
 one of 300 copies)
--The Maximus Poems/11-22. Stuttgart, 1956. $250.00 (wraps.,
 one of 350 copies)
Olson, Edmund T.--Utah. S.L.C., 1931. $25.00
Olson, James C.--History of Nebraska. Lincoln, 1955. 1st
 ed. $20.00, $18.50
Olson, Sigurd F.--Open Horizons. N.Y., 1969. $7.50
--The Singing Wilderness. N.Y., 1967. $7.50
Olsson, Jan Olof--Welcome to Tombstone. Lond., (1956).
 $15.00
O'Meara, James--Broderick and Givin. (L.A., 1932). $37.50
 (orig. suede, binding worn)
O'Meara, Walter--Guns at the Forks. Englewood Cliffs, N.J.,
 (1965). 1st ed. $15.00
Omwake, John--The Conestoga Six-Horse Bell Teams of Eastern
 Pennsylvania. Cinci., 1930. $85.00 (orig. cloth), $85.00,
 $75.00
Ona, Pedro--Arauco Tamed. Albuquerque, 1948. $35.00
O'Neil, James Bradas--They Die But Once. N.Y., 1935.
 $20.00
O'Neill, Eugene--All God's Chillun Got Wings and Welded.
 N.Y., (1924). 1st ed. $75.00 (boards, owner name on
 front endpaper)
--Days Without End. N.Y., (1934). 1st ed. $15.00
--Dynamo. N.Y., 1929. 1st ed. $25.00
--The Iceman Cometh. N.Y., (1946). 1st ed. $50.00 (cloth)
--A Moon for the Misbegotten. N.Y., (1952). 1st ed. $35.00
 (cloth)
--Mourning Becomes Electra. N.Y., 1931. 1st ed. $50.00
 (cloth)
--The Plays of.... N.Y., 1934-35. 12 vols. $650.00 (one
 of 770 numbered and signed sets)
Opotowsky, Stan--The Longs of Louisiana. N.Y., 1960.
 $12.50
Optic, Oliver, pseud.
 See: Adams, William Taylor
Orations, Delivered at the Request of the Inhabitants of the
 Town of Boston.... Bost., 1807. $35.00 (contemp. calf,
 lacks part of label, hinges cracked and weak)
Orcutt, William Dana--In Quest of the Perfect Book. Bost.,
 1926. 1st ed. $25.00 (cloth)
--Mary Baker Eddy and Her Books. Bost., (1950). 1st ed.
 $20.00

Order of Indian Wars--The Papers of the.... Fort Collins,
1975. $35.00

O'Rielly, Henry--Origin and Objects of the Slaveholders' Con-
spiracy Against Democratic Principles.... N.Y., 1862.
1st ed. $17.50 (orig. wraps., lower portion of text stained,
lacks bottom portion of front cover)

Ormsbee, Thomas Hamilton--Early American Furniture Makers....
N.Y., (1936). $15.00
N.Y., (1957). $8.00

Ormsby, Margaret Anchoretta--British Columbia. (Toronto,
1958). $25.00

Ormsby, Waterman Lilly--The Butterfield Overland Mail. San
Marino, (1942). 1st ed. $32.50
San Marino, 1955. $18.50

Ornes Coiscou, German E.--Trujillo. N.Y., (1958). $12.50

Orozco, Jose Clemente--An Autobiography. Austin, (1962).
$20.00

Orr, Robert Thomas--Wildflowers of Western America. N.Y.,
1974. 1st ed. $15.00

Orton, James--The Andes and the Amazon. N.Y., 1871.
$8.50
N.Y., 1876. $150.00 (orig. cloth), $35.00 (minor flecking)

Osborn, Chase Salmon--The Andean Land. Chi., 1909. 2
vols. 1st ed. $27.50

Osborn, Henry Fairchild--The Titanotheres of Ancient Wyoming,
Dakota, and Nebraska. Wash., 1929. 2 vols. 1st ed.
$140.00

Osborne, Harold--Bolivia. Lond., 1964. $15.00 (ex-lib.)

Osgood, Charles Stuart--Historical Sketch of Salem. Salem,
1879. $90.00 (owner signature and date, hinges starting,
materials laid in)

Osgood, Ernest Staples, ed.--The Field Notes of Captain Wil-
liam Clark, 1803-1805
See: Clark, William

O'Shaughnessy, Edith Louise (Coues)--Diplomatic Days. N.Y.,
(1917). $12.50
--A Diplomat's Wife in Mexico. N.Y., (1916). 1st ed. $15.00
(cloth, lightly worn, bookplate)

Oshinsky, David M.--Senator Joseph McCarthy and the Amer-
ican Labor Movement. (Columbia), 1976. $12.00

Oskison, John Milton--A Texas Titan. Garden City, 1929.
$21.50, $8.50

Osorio Lizarazo, Jose Antonio--Asi es Trujillo. (Buenes Aires)
1958. $12.50 (covers rubbed)
--The Illuminated Island. Mexico, 1947. $6.00 (wraps.)

Osterweis, Rollin Gustav--Judah P. Benjamin.... N.Y., 1933.
$27.50
Ostrander, Alson Bowles--After 60 Years.... (Seattle, 1925).
$25.00 (presentation copy)
--An Army Boy of the Sixties. Yonkers-on-Hudson, 1924.
$20.00
Ostrander, Gilman Marston--Nevada.... N.Y., 1966. $15.00
(boards)
Oswalt, Wendell H.--Mission of Change in Alaska. San Marino,
Ca., 1963. $20.00
Otero, Miguel Antonio--My Life on the Frontier, 1864-1882.
N.Y., 1935. vol. 1 of 2. 1st ed. $32.50
--The Real Billy the Kid. N.Y., 1936. 1st ed. $50.00
(previous owner's signature, light cover wear)
Otis, Fessenden Nott--Illustrated History of the Panama Rail-
road. Tucson, (1977). $12.00
Our Famous Women. Hart., 1884. $20.00 (worn and soiled
cover, lower right corner stain not affecting text)
Oursler, William Charles--From Ox Carts to Jets. Englewood
Cliffs, (1959). $12.00
Ouseley, William Gore--Views in South America. Lond., (1852).
1st ed. $150.00 (orig. wraps., endsheets lightly foxed)
Overton, Grant Martin--Portrait of a Publisher.... N.Y.,
1925. $25.00 (orig. boards, lightly worn and dusty)
Owen, David Dale--First Report of a Geological Reconnaissance
of the Northern Counties of Arkansas.... Little Rock,
1858. 1st ed. $135.00 (buckram, boxed, lib. stamps)
Owen, Jean A.
See: Visger, Jean Allan (Pinder) Owen
Owens, Hubert Bond--Georgia's Planting Prelate. Athens,
Ga., 1945. $15.00 (cloth, one of 1000 copies)
Owens, John Algernon--Sword and Pen. Phila., 1881. $12.50
Owsley, Frank Lawrence--King Cotton Diplomacy. Chi., 1959.
2nd ed. $25.00

- P -

Pace, Dick--Golden Gulch. (Virginia City, Mt., 1970).
$10.00 (wraps.)
Pace, William--Rifle and Light Infantry Tactics. S.L.C., 1865.
$1250.00 (orig. cloth)
Packard, Winthrop--Florida Trails as Seen From Jacksonville
to Key West.... Bost., (1910). 1st ed. $25.00

332 / Paden, Irene (Dakin)

Paden, Irene (Dakin)--The Big Oak Flat Road. S.F., (1955).
1st ed. $75.00 (one of 1000 copies, signed by authors)
--Wake of the Prairie Schooner. N.Y., 1943. 1st ed. $42.50,
$10.00 (cloth)
Padover, Saul Kussiel--To Secure These Blessings. N.Y.,
(1962). 1st ed. $20.00
Paez, Jose Antonio--Autobiografia.... N.Y., 1964. 2 vols.
$45.00 (buckram, orig. wraps. bound in)
Page, Joseph A.--The Revolution That Never Was. N.Y.,
1972. $12.50
Page, Thomas Nelson--In Ole Virginia. N.Y., 1887. 1st ed.
$30.00 (cloth, somewhat worn, hinges starting)
--John Marvel, Assistant. N.Y., 1909. 1st ed. $7.50 (back-
hinge slightly loose)
--The Negro: the Southerner's Problem. N.Y., 1904. 1st
ed. $17.50
--Robert E. Lee, Man and Soldier. N.Y., 1911. 1st ed.
$16.50
The Pageant of America. (New Haven, 1925-29). 15 vols.
$80.00
Paher, Stanley W.--Nevada Ghost Towns & Mining Camps.
Berkeley, 1970. 1st ed. $30.00
Paine, Albert Bigelow--The Arkansaw Bear. N.Y., 1898.
1st ed. $15.00 (orig. boards, inner hinges cracking)
N.Y., (1925). $10.00 (covers a bit worn)
Paine, Lauran--Conquest of the Great Northwest. N.Y., (1959).
1st ed. $6.50
Paine, Ralph Delahaye--Ships Across the Sea. Bost., 1920.
$20.00 (presentation copy)
Paine, Swift--Elley Orrum, Queen of the Comstock. N.Y.,
1929. $14.50
Paine, Thomas--Age of Reason. N.Y., (1942). $6.00
--The American Crisis. Lond., 1819. $75.00 (spine perished)
--The Decline and Fall of the English System of Finance.
Lond., 1796. $50.00
--The Life and Writings of.... N.Y., (1908). 10 vols.
$37.50 (one of 500 sets)
--Rights of Man. Lond., 1792. 2 vols. $125.00 (later
wraps.)
(Palacios, Nicolas)--La Raza Chilena. Valparaiso, 1904. 1st
ed. $25.00
Palcos, Alberto--Sarmiento. Buenos Aires, 1929. 1st ed.
$15.00 (wraps., spine defective, ex-lib.)
Palfrey, Francis Winthrop--Memoir of William Francis Bartlett.
Bost., 1878. 1st ed. $35.00 (cloth, small cracks at top
of spine)

Palmer, Charles--A History of Delaware County.... Harrisburg, Pa., 1932. 2 vols. $75.00 (orig. cloth)

Palmer, Frederick--Central America and Its Problems. N.Y., (1911). $15.00

--In the Klondike. N.Y., 1899. 1st ed. $50.00 (orig. cloth, few lib. rubber stamps in text)

Palmer, Friend--Early Days in Detroit. Detroit, (1906). 1st ed. $45.00

Palmer, Joel--Journal of Travels Over the Rocky Mountains.... Cinci., 1847. 1st ed. $1500.00 (later half morocco)

Palmer, Robert Roscoe--The Age of the Democratic Revolution. Princeton, 1959-64. 2 vols. 1st ed. $35.00

Palou, Francisco--Historical Memoirs of New California. Berkeley, 1926. 4 vols. 1st ed. $200.00

--Life of Fray Junipero Serra. Wash., 1955. $17.50 (ex-lib.)

Paltsits, Victor Hugo--A Bibliography of the Separate and Collected Works of Philip Freneau.... N.Y., 1903. 1st ed. $60.00 (orig. cloth, one of 115 copies)

Pannell, Walter--Civil War on the Range. L.A., (1943). $7.50 (wraps.)

Paredes, Americo--"With His Pistol in His Hand...." Austin, 1958. 1st ed. $37.50

Pareja Paz-Soldan, Jose--El Maestro Belaunde. (Lima, 1968). $15.00 (corners bumped)

Parisot, Pierre Fourier--The Reminiscences of a Texas Missionary. San Antonio, (1899). $35.00

Park, Maud (Wood)--Front Door Lobby. Bost., (1960). 1st ed. $15.00

Parke, John E.--Recollections of Seventy Years.... Bost., 1886. $35.00 (orig. cloth)

Parker, Amos Andrew--A Trip to the West and Texas. Concord, 1835. 1st ed. $450.00 (orig. cloth)

Parker, Augustus G.--Parker in America, 1630-1910. Buffalo (1911). $30.00 (rebound in half leather, a bit rubbed)

Parker, Donald Dean, ed.--The Recollections of Philander Prescott....
See: Prescott, Philander

Parker, Dorothy--Enough Rope. N.Y., (1928). $15.00 (boards)

--Not so Deep as a Well. N.Y., 1936. 1st ed. $10.00 (cloth, name on endpaper, 2 pages browned)

Parker, Emma (Krause)--Fugitives. Dallas, 1934. 1st ed. $35.00

Parker, John--Merchants & Scholars. Minne., (1965). $27.50

--Van Meteren's Virginia. Minne., (1961). $10.00 (one of 750 copies)

Parker, Nathan Howe--The Minnesota Handbook for 1856-7.
Bost., 1857. 1st ed. $45.00
Parker, Robert Allerton--A Yankee Saint.... N.Y., 1935.
$15.00
Parker, Samuel--Journal of an Exploring Tour Beyond the
Rocky Mountains. Ithaca, 1838. 1st ed. $450.00 (orig.
cloth, hinges reinforced)
Parker, Theodore--The Collected Works.... Lond., 1863-71.
14 vols. $60.00 (lightly rubbed and faded)
--Letter to the People of the United States Touching the Mat-
ter of Slavery. Bost., 1848. $15.00 (some dampstaining,
chipping at corners)
--The New Crime Against Humanity. Bost., 1854. $6.50 (dis-
bound, front wrapper present)
Parker, William B.--Notes Taken During the Expedition Com-
manded by Capt. R.B. Marcy.... Phila., 1856. 1st ed.
$650.00 (orig. cloth)
Parker, William Belmont--Edward Rowland Sill; His Life and
Work. Bost., 1915. 1st ed. $15.00
Parkes, Henry Bamford--A History of Mexico. Bost., 1950.
$10.00
Parkhill, Forbes--The Law Goes West. Denver, (1956). $16.50
Parkinson, Roger--Zapata: a Biography. N.Y., (1975). 1st
ed. $15.00
Parkman, Francis--The Jesuits in North America in the Seven-
teenth Century. Williamstown, Ma., 1970. $15.00 (cloth)
--Letters of.... Norman, 1960. 2 vols. 1st ed. $45.00
(slipcased), $20.00 (ex-lib.)
--The Oregon Trail. Bost., 1892. $325.00 (orig. cloth)
Bost., 1925. $200.00 (boards and cloth, one of 975 copies,
unopened, cover lightly stained and faded), $75.00 (orig.
calf, neatly rebacked)
N.Y., 1943. $22.00 (boxed)
--Works.... Bost., 1897-98. 20 vols. $750.00 (orig. three-
quarter morocco, one of 300 copies)
Bost., 1902-94. 17 vols. $85.00
Bost., 1909. 13 vols. $300.00 (three-quarter morocco and
boards)
Parmet, Herbert S.--Eisenhower and the American Crusades.
N.Y., (1972). $12.50
Parrish, Philip Hammon--Before the Covered Wagon. Portland,
Or., 1934. $6.00
Parry, Albert--Garrets and Pretenders. N.Y., 1933. $12.50
--Whister's Father. Ind., (1939). $25.00

Parry, Ellwood--The Image of the Indian and the Black Man in American Art. N.Y., (1974). $12.50 (autographed)

Parry, William Edward--Journal of a Voyage for the Discovery of a North-West Passage From the Atlantic to the Pacific. N.Y., (1968). $45.00 (orig. cloth)

N.Y., (1969). $45.00 (orig. cloth)

Parson Brownlow and the Unionists of East Tennessee. N.Y., (1862). 1st ed. $15.00 (bottom portion of back cover torn off)

Parsons, Elise Worthington Clews--American Indian Life. N.Y., 1925. 1st ed. $50.00 (cloth and boards, somewhat worn)

Parsons, Eugene--A Guidebook to Colorado. Bost., (1911). $25.00 (cloth, ex-lib.)

Parsons, George Frederic--The Life and Adventures of James W. Marshall.... Sacramento, 1870. 1st ed. $150.00 (orig. cloth, rebacked with orig. spine laid in)

Parsons, John--Beside the Beautiful Willamette. Portland, Or., 1924. $15.00

Parsons, John E.--The First Winchester. N.Y., 1955. 1st ed. $25.00

--Smith & Wesson Revolvers. N.Y., 1957. $45.00

Parsons, Louella (Oettinger)--The Gay Illiterate. Garden City, 1944. $8.50 (cloth)

(Patrick, Robert W.)--Knapsack and Rifle. Phila., 1889. $8.50 (orig. half leather, rubbed, hinges cracked)

Partridge, Bellamy--Country Lawyer. N.Y., 1939. $7.50

Pasternak, Joseph--Easy the Hard Way. N.Y., (1956). $12.50 (spine lightly soiled, inscribed)

Paton, Lucy Allen--Elizabeth Cary Agassiz. Bost., 1919. 1st ed. $10.00

Patrick, Kenneth Gilbert--Perpetual Jeopardy. N.Y., (1972). $16.00

Patterson, Floyd--Victory Over Myself. (N.Y., 1962). 1st ed. $10.00

Patterson, Raymond M.--Dangerous River. N.Y., (1954). 1st ed. $15.00

Patterson, Richard Sharpe--The Eagle and the Shield. Wash., 1978. $12.50

Patterson, Robert--A Narrative of the Campaign in the Valley of the Shenandoah, in 1861. Phila., 1865. $27.50 (rubbed, lacks half of backstrip, presentation from author)

Patterson, Samuel White--Old Chelsea and Saint Peter's Church. N.Y., 1935. $17.50

Paul, Elliot Harold--A Ghost Town on the Yellowstone. N.Y., (1948). $11.50

--My Old Kentucky Home. N.Y., (1949). $10.00
--That Crazy American Music. Ind., 1957. $12.50
Paul, James Laughery--Pennsylvania Soldiers' Orphan Home.
 Harrisburg, (1876). $35.00 (orig. cloth)
Paul, Rodman Wilson--California Gold. Camb., 1947. $20.00
 (spine faded)
--The California Gold Discovery. Georgetown, Ca., 1966.
 1st ed. $45.00, $45.00
--The Frontier and the American West. Arlington Heights,
 (1977). $22.50
Paul Wilhelm, Duke of Württemberg--Early Sacramento. (Sac-
 ramento?), 1973. $50.00 (one of 450 copies)
[Paulding, James Kirke]--The United States and England.
 N.Y., 1815. 1st ed. $125.00 (disbound)
Paullada, Stephen--Rawhyde and Song. N.Y., (1963). $15.00
Paullin, Charles Oscar--Commodore John Rodgers.... Cleve.,
 1910. 1st ed. $75.00 (foxed endpapers, presentation copy),
 $35.00
Pausch, Georg--Journal.... Albany, 1886. $85.00 (orig.
 cloth, 1st printing)
Paxson, Frederic Logan--History of the American Frontier....
 Bost., (1924). 1st ed. $20.00 (cloth, scored)
--The Last American Frontier. N.Y., 1922. $10.00
--T. Turnbull's Travels....
 See: Turnbull, Thomas
Payne, James L.--Labor and Politics in Peru. New Haven,
 1965. $12.50
Payne, Stephen--Where the Rockies Ride Herd. Denver, 1965.
 $10.00
Payne, Walter A.--A Central American Historian.... Gaines-
 ville, 1957. 1st ed. $8.00 (paper)
Paz, Octavio--A la Orilla del Mundo.... Mexico, 1942. 1st
 ed. $15.00 (inscribed)
--El Laberinto de la Soledad. Mexico, (1959). $7.50 (wraps.)
Peabody, George Augustus--South American Journals, 1858-
 1859. Salem, 1937. 1st ed. $75.00 (boards with cloth
 backstrip, boxed)
Peacock, Thomas Brower--Poems of the Plains and Songs of the
 Solitudes. N.Y., 1888. $25.00 (cloth, lightly worn, pres-
 entation copy)
Peak, John--Memoir of Elder.... Bost., 1832. $15.00 (orig.
 boards)
Peale, Norman Vincent--The Art of Living. N.Y., (1937).
 1st ed. $15.00 (autographed copy)

Peale, Titian Ramsey--Diary of Titian Ramsey Peale. L.A.,
1957. $20.00 (one of 300 copies)
Pearse, James--A Narrative of the Life of James Pearse....
Rutland, Vt., 1825. 1st ed. $200.00 (orig. half calf,
worn)
Pearson, Francis Calhoun--Sparks Among the Ashes. Phila.,
1873. $20.00
Pearson, Helen Hotchkiss--Vignettes of Portsmouth. Ports-
mouth, N.H., (1913). $10.00
Pearson, Henry Greenleaf--An American Railroad Builder.
Bost., 1911. 1st ed. $15.00 (incl. ALS from book's sub-
ject)
Pearson, Jonathan--A History of the Schenectady Patent in
the Dutch and English Times. Albany, 1883. 1st ed.
$95.00 (bookplate, one of 300 square octave copies)
Peary, Robert Edwin--Nearest the Pole. N.Y., 1907. 1st
ed. $65.00
Pease, Theodore Calvin--The Story of Illinois. Chi., 1949.
$12.50
Peattie, Donald Culross, ed.--Audubon's America
See: Audubon, John James
--Flora of the Indiana Dunes. Chi., 1930. $15.00
--Singing in the Wilderness. N.Y., 1935. $12.50
Peavy, Charles D.--Charles A. Siringo. Austin, (1967).
$4.50
Peavy, John R.--Echoes From the Rio Grande. (Brownsville,
1963). $45.00 (signed by the author)
Peck, Annie Smith--The South American Tour. N.Y., (1913).
1st ed. $6.00 (stamping flaking off)
Peck, Charles Henry--The Jacksonian Epoch. N.Y., 1899.
$17.50 (cloth), $12.50
Peck, George--Wyoming. N.Y., 1858. 1st ed. $30.00
(Peck, George Washington)--Aurifodina. S.F., 1974. $45.00
Peck, Harry Thurston--Twenty Years of the Republic....
N.Y., 1907. $20.00 (cloth)
Peck, John Mason--A Gazetteer of Illinois in Three Parts.
Jacksonville, Il., 1834. 1st ed. $200.00 (orig. cloth,
bookplate, presentation copy)
Peckham, Howard Henry--Pontiac and the Indian Uprising.
Princeton, 1947. 1st ed. $15.00 (cloth)
Pecora, Ferdinand--Wall Street Under Oath. N.Y., (1939).
1st ed. $15.00
Peden, Charles--Newsreel Man. Garden City, 1932. $12.50
Pedrick, Howard Ashley--Jungle Gold. Ind., (1930). $5.00
(small holes in spine)

Peet, Stephen--History of the Presbyterian and Congregational
Churches and Ministers in Wisconsin. Milwaukee, 1851.
1st ed. $100.00 (orig. cloth)

Peffer, William Alfred--Myriorama. Clarksville, Tn., 1869.
$85.00 (contemp. boards, worn)

Peirce, Bradford Kenney--Trials of an Inventor. N.Y.,
(1866). $15.00 (orig. cloth, tape mending at top of back-
strip, heavy fraying at bottom of backstrip)

Peirce, Ebenezer Weaver--Indian History, Biography and Gen-
ealogy. Abington, 1878. 1st ed. $75.00, $30.00 (corners
rubbed, few small tears in binding at hinges)

Peirce, Parker I.--Antelope Bill. Minne., 1962. $20.00 (cloth,
slipcased, one of 550 copies)

Peirson, Erma--The Mojave River and Its Valley.... Glendale,
1970. $20.00

Peixotto, Ernest Clifford--Pacific Shores From Panama. N.Y.,
1913. 1st ed. $12.50 (cover spotted, hinges starting)

Pell, John--Ethan Allen. Bost., 1929. $15.00

Pelzer, Louis--Marches of the Dragoons in the Mississippi
Valley. Iowa City, 1917. 1st ed. $90.00 (buckram),
$75.00

--The Prairie Logbooks
See: Carleton, James Henry

Pen and Sunlight Sketches of the Principal Cities in Wiscon-
sin.... Chi., n.d. $45.00

Pena, Jose Enrique de la--La Rebelion de Texas. Mexico,
1955. $85.00 (half calf)

--With Santa Anna in Texas. College Station, (1975). $15.00

Penafield, Antonio--Monumentos del Arte Mexicano Antiguo.
Berlin, 1890. 3 vols. $3500.00 (orig. boards, slipcased,
occasional light wear)

Pendergast, David M.--Palenque. Norman, (1967). $15.00

Penn, Granville--Memorials of the Professional Life and Times
of Sir William Penn.... Lond., 1833. 1st ed. 2 vols.
$125.00 (contemp. half morocco)

Penn, William--Correspondence Between William Penn and James
Logan.... Phila., 1870-72. 2 vols. $50.00 (orig. cloth)

--The Select Works of William Penn. Lond., 1771. $250.00
(half leather and cloth, rubbed, scattered foxing, owner
signature)

Pennell, Elizabeth R.--Life and Letters of Joseph Pennell.
Bost., 1929. 2 vols. 1st ed. $35.00 (cloth, light soil
and foxing)

--The Life of James McNeill Whistler. Lond., 1908. 2 vols.
1st ed. $40.00 (orig. boards)

Phila., n.d. $30.00 (boards, name on endpaper deleted)
Penney, James Cash--Fifty Years With the Golden Rule. N.Y.,
(1950). $8.00
Pennsylvania: a Guide to the Keystone State
See: Writers' Program
The Pennsylvania Hermit. Phila., 1839. $50.00 (orig. wraps.)
Pennypacker, Samuel Whitaker--Annals of Phoenixville and Its
Vicinity.... Phila., 1871. 1st ed. $75.00 (rebound, in-
scribed), $75.00 (orig. cloth)
--Historical and Biographical Sketches. Phila., 1883. 1st
ed. $50.00 (orig. cloth)
--Pennsylvania in American History. Phila., 1910. $35.00
(uncut)
--The Settlement of Germantown, Pennsylvania. Phila., 1899.
1st ed. $75.00 (uncut, one of 300 copies)
Pepper, Mary Sifton--Maids & Matrons of New France. Bost.,
1901. $15.00 (lightly rubbed)
Peralta, Manuel Maria de--El Canal Interoceanico de Nicaragua
y Costa Rica en 1620.... Bruselas, 1887. $50.00 (orig.
wraps.)
Peramus, Jose Manuel--Jose Manuel Peramus y su Diario de
Destierro. Buenos Aires, 1952. $15.00 (half cloth)
Perez Bustamente, Ciriaco--Los Origenes del Gobierno Vir-
reinal.... Santiago (de Compostela, Spain), 1928. $15.00
(ex-lib., tape on spine)
Perez de Luxan, Diego--Expedition Into New Mexico Made by
Antonio de Espejo, 1582-1583.... L.A., 1929. $250.00
(one of 500 numbered copies)
Perez de Ribas, Andres--My Life Among the Savage Nations
of New Spain. L.A., (1968). $15.00
Perez Rosales, Vincente--California Adventure. S.F., 1947.
$42.50
Perez Triana, Santiago--Down the Orinoco in a Canoe. N.Y.,
1902. $15.00
Perkin, Robert L.--The First Hundred Years. Garden City,
1959. $17.50
Perkins, Charles Elliott--The Pinto Horse. Santa Barbara,
1927. $130.00 (spine repaired, front cover warping)
Perkins, Dexter--Charles Evans Hughes.... Bost., (1956).
1st ed. $10.00
--The Education of Historians in the U.S. N.Y., 1962. 1st
ed. $5.00 (ex-lib.)
--Hands Off. Bost., 1941. 1st ed. $15.00
--The Monroe Doctrine, 1867-1907. Balt., 1937. 1st ed.
$10.00 (unopened)

--The U.S. and the Caribbean. Camb., 1947. 1st ed.
$12.50, $12.50 (cloth, ex-lib.)
Perkins, Mrs. George A.
See: Perkins, Julia Anna (Sheppard)
Perkins, Jacob Randolph--Trails, Rails and War. Ind., (1929).
1st ed. $30.00 (uncut)
Perkins, James Handasyd--Annals of the West. S.L., 1850.
$85.00 (newly rebound)
Perkins, Julia Anna (Sheppard)--Early Times on the Susque-
hanna. Binghamton, 1870. 1st ed. $50.00 (orig. cloth),
$32.50 (ex-lib., corners rubbed)
Perkins, Robert L.--The First Hundred Years.... Garden
City, 1959. $15.00 (cloth)
Perkins, Simeon--Diary.... 1797-1803. Toronto, 1967.
$60.00 (orig. cloth, one of 775 numbered copies, vol. #4
of set)
Perley, Sidney--The Dwellings of Boxford, Essex County,
Mass. Salem, 1893. $30.00 (later buckram)
--The Indian Land Titles of Essex County, Massachusetts.
Salem, 1912. $35.00 (boards, boxed)
Peroitti, Viola Andersen--Important Firsts in Missouri Imprints,
1808-1858. K.C., 1967. $25.00 (one of 500 copies)
Peron, Eva--La Razon de Mi Vida. Buenos Aires, 1951. 1st
ed. $25.00
Perrie, George W.--Buckskin Mose. N.Y., 1873. 1st ed.
$150.00 (orig. cloth)
Perry, Benjamin Franklin--Letters From My Father to My
Mother.... Phila., 1889. $85.00 (cloth, incl. presenta-
tion letter from Mrs. Perry)
Perry, Clair Willard--Underground New England. Brattleboro,
1939. $7.00 (ex-lib.)
Pershing, John Joseph--My Experiences in the World War.
N.Y., 1931. 2 vols. 1st ed. $75.00 (cloth, slipcased)
Persico, Joseph E.--My Enemy, My Brother. N.Y., 1977.
$12.50, $10.00
Peters, DeWitt Clinton--Kit Carson's Life and Adventures....
Hart., 1875 (i.e. 1873). $52.00
--The Life and Adventures of Kit Carson.... N.Y., 1858.
1st ed. $40.00 (front and back panels partially detached,
light foxing, bookplate)
--Pioneer Life and Frontier Adventures. Bost., (1880).
$27.50
Peters, Harry Twyford--California on Stone. Garden City,
1935. 1st ed. $500.00 (one of 501 numbered copies)

--Currier & Ives. Garden City, 1942. $15.00 (cloth, book-
plate)
 Garden City, 1943. $15.00
Petersen, William Ferdinand--Lincoln-Douglas.... Springfield,
 Il., 1943. $15.00
Petersen, William John--Steamboating on the Upper Mississippi.
 Iowa City, 1937. $80.00
 Iowa City, 1968. $45.00, $22.50
Peterson, Emil R.--A Century of Coos and Curry. Portland,
 Or., 1952. $40.00
Peterson, Florence--American Labor Unions. N.Y., (1945).
 1st ed. $12.50
Peterson, Harold Leslie--American Indian Tomahawks. (N.Y.),
 1965. 1st ed. $30.00 (printed wraps.)
Peterson, Merrill D.--The Jefferson Image in the American
 Mind. N.Y., 1962. $5.00 (paper)
Peto, Samuel Morton--Resources and Prospects of America.
 N.Y., 1866. $50.00 (cloth)
Pettijohn, Jonas--Autobiography.... Clay Center, Ks., 1890.
 1st ed. $300.00
Petrullo, Vincenzo--Puerto Rican Paradox. Phila., 1947.
 $6.50
Pettee, Julia--The Rev. Jonathan Lee and His Eighteenth
 Century Salisbury Parish. Salisbury, 1957. $25.00
Peyton, John Lewis--The American Crisis. Lond., 1867. 2
 vols. in 1. $67.50 (lib. bookplate, spine faded)
Peyton, John Rowzee--3 Letters From St. Louis. Denver,
 1958. 1st ed. $85.00 (one of 350 numbered copies)
Pfaller, Louis--Father DeSmet in Dakota. Richardson, N.D.,
 1962. 1st ed. $5.00
Pfandl, Ludwig--Sor Juana Inez de la Cruz. Mexico, 1963.
 1st ed. $15.00
Pfatteicher, Helen Emma--The Ministerium of Pennsylvania.
 Phila., 1938. $15.00
Pfeffer, Leo--This Honorable Court. Bost., 1965. 1st ed.
 $16.00, $10.00
Pfefferkorn, Ignaz--Sonora, a Description of the Province.
 Albuquerque, 1949. $100.00, $45.00
Pfeiffer, Ida Reyer--A Lady's Visit to California, 1853. Oak-
 land, 1950. $30.00 (untrimmed)
Phelps, Gilbert--The Green Horizons. N.Y., 1964. $7.50
--Tragedy of Paraguay. N.Y., 1975. $12.50
Phelps, Martha Bennett--Frances Slocum, the Lost Sister of
 Wyoming. Wilkes-Barre, Pa., 1916. $22.50 (cloth)

Phelps, Richard Harvey--Newgate of Connecticut. Hart., (1876). 1st ed. $20.00 (cloth)

Philadelphia and Its Environs. Phila., 1876. $50.00 (orig. wraps., ex-lib.)

Philadelphia in 1830-1. Phila., 1830. 1st ed. $125.00 (orig. half calf, hinges weak)

Philbrick, Thomas--James Fenimore Cooper and the Development of American Sea Fiction. Camb., 1961. $20.00

Philip, Cynthia Owen--Imprisoned in America. N.Y., 1973. $10.00

Philips, Shine--Big Spring. N.Y., 1942. 1st ed. $10.00 (cloth)

Phillips, Cabell B.--The Truman Presidency. N.Y., (1966). $12.50

Phillips, Catherine (Coffin)--Cornelius Cole.... S.F., 1929. $75.00

--Jessie Benton Fremont. S.F., 1935. 1st ed. $50.00 (cloth and boards)

--Portsmouth Plaza. S.F., 1932. 1st ed. $125.00 (one of 1000 copies, slipcased)

Phillips, Henry Albert--Argentina. N.Y., (1944). $10.00

--Brazil.... N.Y., (1945). $10.00

Phillips, John Charles--American Waterfowl.... Bost., 1930. $30.00 (covers lightly faded and soiled)

--A Bibliography of American Sporting Books. Bost., (1930). 1st ed. $85.00

Phillips, L.K., ed.--East of the Cascades
See: Brogan, Phil F.

Phillips, Paul Chrisler--The Fur Trade. Norman, (1961). 2 vols. 1st ed. $68.50 (boxed)

Phillips, Philip Lee--The Beginning of Washington. Wash., 1917. $25.00

Phillips, Ulrich Bonnell--Life and Labor in the Old South. Bost., 1929. 1st ed. $22.50, $8.50

Phillips, Walter Shelley--The Old-Timer's Tale. Chi., 1929. $30.00

Phippen, George--The Life of a Cowboy. Tucson, (1969). $26.50

Piatt, John James--The Lost Hunting-Ground.... Lond., 1893 $17.50 (orig. cloth, backstrip darkened)

Pickell, John--A New Chapter in the Early Life of Washington.... N.Y., 1856. 1st ed. $75.00 (orig. cloth, autographed presentation copy)

Pickett, Thomas Edward--The Quest for the Lost Race. Lou., 1907. $30.00 (wraps.)

Pickford, Mary--The Demi-Widow. Ind., 1935. $12.50 (cover
lightly marked, several page margins stained and torn)
--Why Not Try God? N.Y., 1934. $12.50 (cover lightly faded,
some pencil marks)
Pico, Pio--Don Pio Pico's Historical Narrative. Glendale, 1973.
1st ed. $20.00
A Pictorial Journal of a Voyage Aboard the Three Master
Schooner Louise....
See: Oldfield, Otis
Pier, Arthur Stanwood--The Pedagogues. Bost., 1899.
$25.00 (orig. cloth, spine and covers faded, worn and
lightly soiled)
Pierce, Carl Horton--New Harlem Past and Present. N.Y.,
1903. $35.00 (lacks 1 illus., cloth), $25.00 (cloth, name
in ink)
New Harlem, 1903. $25.00
Pierce, Richard A., comp.--H.M.S. Sulphur at California,
1837 and 1839. (S.F.), 1969. $50.00 (one of 450 copies)
--Rezanov Reconnoiters California, 1806. S.F., 1972. $75.00
(one of 450 copies)
Pierce, Wesley George--Goin' Fishin'. Salem, Ma., 1934.
$30.00 (cloth)
Pierson, Emily Catharine--Jamie Parker, the Fugitive. Hart.,
1851. 1st ed. $65.00 (orig. cloth, somewhat faded and
soiled)
Pierson, Hamilton W.--In the Bush. N.Y., 1881. 1st ed.
$85.00 (orig. cloth)
Pigman, Walter Griffith--The Journal of.... Mexico, Mo.,
1942. $50.00 (orig. boards, one of 200 copies)
Pike, Frederick B.--Chile and the U.S.... Notre Dame, In.,
1963. $17.50 (cloth, ex-lib.)
Pike, James--The Scout and Ranger. Cinci., 1865. 1st
ed. $450.00 (orig. cloth, with light wear to extremities,
1st issue)
Pike, James Shepherd--The New Puritan. N.Y., 1879. $10.00
(small gash on front hinge)
Pike, Zebulon Montgomery--An Account of Expeditions to the
Sources of the Mississippi. Phila., 1810. 2 vols. 1st ed.
$1650.00 (contemp. calf, spine restored)
--Exploratory Travels Through the Western Territories of
North America. Lond., 1811. $2500.00 (orig. boards, oc-
casional light foxing, uncut, slipcased)
Denver, 1889. $250.00 (minor binding wear, owner's ink
inscription), $75.00
--Voyage au Nouveau-Mexique.... 1805-1807.... Paris, 1812.

2 vols. $600.00 (wraps., maps with some browning and few tears in folds)

Pilling, James Constantine--Bibliography of the Athapascan Languages. Wash., 1892. 1st ed. $30.00 (rear wrapper only)

Pinchon, Edgcumb--Dan Sickles.... Garden City, 1945. $12.00

--Zapata, the Unconquerable. N.Y., 1941. $15.00 (ex-lib.), $15.00

Pinckney, Pauline A.--American Figureheads and Their Carvers. N.Y., (1940). 1st ed. $60.00

Pinkerton, Allan--Mississippi Outlaws and the Detectives. N.Y., 1887. $12.50 (fly loose)

--The Rail-Road Forger and the Detectives. N.Y., 1881. 1st ed. $12.50

--The Spy of the Rebellion. N.Y., 1888. $30.00, $25.00

Pioneer Days in the Southwest From 1850 to 1879. Guthrie, Ok., 1909. $60.00 (binding dull, light wear)

Pioneer Life in the West. Phila., (1858). $5.00 (shaken)

Piper, Charles Vancouver--Flora of the North West Coast.... Lancaster, Pa., 1915. $37.00 (cloth)

Piper, Marion J.--Dakota Portraits. Mohall, N.D., (1964). $17.50

The Pirate Boy, or, Adventures of Henry Warrington.... N.Y., (1844). $95.00 (orig. cloth)

Pitman, Robert Birks--A Succinct View and Analysis.... on the Practicability of Joining the Atlantic and Pacific Oceans.... Lond., 1825. $350.00 (boards, neatly re-backed, corner clipped from title with no loss of text, author's presentation note), $300.00 (orig. boards, expertly rebacked in cloth with paper label)

Pittenger, William--Capturing a Locomotive. Wash., 1897. $10.00 (paper yellowing)

--Daring and Suffering. N.Y., 1887. $25.00 (cloth, crown roughened, cloth on rear board bubbled)

Pizzarro, Pedro--Relation of the Discovery and Conquest of the Kingdoms of Peru. N.Y., 1921. 2 vols. $150.00 (cloth, one of 250 numbered copies), $75.00 (half boards, one of 250 copies)

Place, Marian Templeton--Tall Timber Pilots. N.Y., 1953. $5.00 (bookplate)

Plank, John, ed.--Cuba and the U.S.
See under Title

Plath, Sylvia--Ariel. Lond., (1965). 1st ed. $150.00 (orig. cloth)

--The Bell Jar. Lond., (1963). $595.00 (boards)
 N.Y., (1971). $8.50 (cloth and boards)
--The Colossus. Lond., (1960). $750.00 (cloth)
--The Colossus & Other Poems. N.Y., 1962. $75.00 (cloth)
--Crystal Gazer and Other Poems. Lond., 1971. 1st ed.
 $100.00 (orig. boards, one of 400 copies, ends of spine
 lightly rubbed)
Platt, Charles Davis--Ballads of New Jersey in the Revolution.
 Morristown, N.J., 1896. $30.00 (cloth, bookplate)
Platt, Rutherford Hayes--The Great American Forest. Engle-
 wood Cliffs, N.J., (1965). 1st ed. $5.00
Pleadwell, Frank Lester--The Life and Works of Joseph Rod-
 man Drake....
 See: Drake, Joseph Rodman
Pleasants, Joseph Edward--The Cattle Drives of Edward E.
 Pleasants.... (L.A.), 1965. $20.00 (one of 600 copies)
Pleasants, Samuel Augustus--Fernando Wood of New York.
 N.Y., 1948. 1st ed. $12.50 (orig. wraps.)
Plessix Gray, Francine du
 See: Gray, Francine du Plessix
Plummer, Mark A.--Frontier Governor. Lawrence, Ks., (1971).
 $12.50
Pocock, Hugh Raymond Spilsbury--The Conquest of Chile.
 N.Y., (1967). $9.00
Poe, Edgar Allan--Edgar Allan Poe: Letters and Documents
 in the Enoch Pratt Free Library. N.Y., 1941. 1st ed.
 $50.00 (one of 500 copies, inscribed by editor, Richard H.
 Hart)
--The Journal of Julius Rodman. S.F., 1947. $65.00 (orig.
 boards, one of 500 copies), $50.00 (one of 500 copies)
--The Raven. N.Y., 1884. $45.00 (some rubbing, back
 cover lightly stained, dampstain on blank fore-edge of
 margin of last 9 plates)
--Works. Lond., (1909). 10 vols. $125.00 (half morocco,
 one of 1000 sets)
Poe, John William--The Death of Billy the Kid. Bost., 1933.
 $35.00
Poe, Sophie (Alberding)--Buckboard Days. Caldwell, 1936.
 1st ed. $45.00 (binding a bit worn, front inner hinge
 fraying)
Poesch, Jessie--Titian Ramsay Peale ... and His Journals of
 the Wilkes Expedition.... Phila., 1961. $25.00
Poindexter, Miles--The Ayar-Incas. N.Y., 1930. 2 vols.
 $15.00 (binding dull, one hinge starting)

Poinsett, Joel Roberts--Notes on Mexico.... Lond., 1825.
$375.00 (contemp. boards, rebacked in calf)
Point, Nicolas--Wilderness Kingdom.... N.Y., (1967). 1st
ed. $40.00, $15.00
Poldervaart, Arie William--Black-Robed Justice. N.p., (1948).
$30.00
Polk, William Mecklenburg--Leonidas Polk, Bishop and General.
N.Y., 1893. 2 vols. 1st ed. $75.00 (wear at edges)
Poll, Willem Van de--Surinam, the Country and Its People.
The Hague, 1951. $10.00
Pollak, Louis H.--The Constitution and the Supreme Court.
Cleve., (1966). 2 vols. 1st ed. $38.00
Pollard, Edward Albert--Southern History of the War. N.Y.,
1863. $37.50 (spine faded, orig. cloth)
Pollock, John Charles--Moody. N.Y., (1963). 1st ed. $12.50
Pomeroy, Earl Spencer--The Pacific Slope. N.Y., 1965. 1st
ed. $20.00
Seattle, 1973. $17.50
Ponce de Leon: the Rise of the Argentine Republic. Buenos
Aires, 1910. $22.50 (foxed)
Pond, Samuel William--Two Volunteer Missionaries Among the
Dakotas. Bost., (1893). 1st ed. $125.00 (orig. cloth)
Pool, Maria Louise--Sand 'n' Bushes. Chi., 1899. 1st ed.
$12.50
Pool, Raymond John--Marching With the Grasses. Lincoln,
1948. $15.00
Poole, Edward--Nurses on Horseback. N.Y., 1933. $27.00
Popenoe, Dorothy (Hughes)--Santiago de los Caballeros de
Guatemala. Camb., 1935. $10.00
Porras Barrenecha, Raul--Pancho Fierro. (Lima, 1959).
$10.00
Porter, Horace--Campaigning With Grant. Bloomington, (1961).
$25.00, $17.50
Porter, Katherine Anne--A Christmas Story. N.Y., (1967).
1st ed. $75.00 (cloth, cased, one of 500 signed copies)
--The Collected Essays.... N.Y., (1970). 1st ed. $35.00
(cloth, signed)
--The Days Before. N.Y., (1952). 1st ed. $35.00 (cloth)
--The Leaning Tower, and Other Stories. N.Y., (1944).
1st ed. $40.00 (cloth)
--Ship of Fools. Bost., 1962. 1st ed. $50.00 (cloth, signed
Porter, Kenneth Wiggins--The Jacksons and the Lees....
Camb., 1937. 2 vols. 1st ed. $75.00 (orig. cloth)
N.Y., 1969. 2 vols. $30.00, $21.95
Porter, Russell Williams--The Arctic Diary of Russell Williams
Porter. Charlottesville, Va., 1976. $20.00

Porter, William Sydney--Postscripts. N.Y., 1923. 1st ed.
$85.00 (orig. cloth, edges lightly worn, probably 1st issue),
$15.00 (orig. cloth, spine and covers lightly soiled, owner
signature)
Porteus, Stanley David--And Blow Not the Trumpet. (Palo
Alto, Ca.), 1947. $10.00
--Calabashes and Kings. Palo Alto, Ca., (1945). 1st ed.
$8.50
Portola, Gaspar de--Diary of Gaspar de Portola During the
California Expedition of 1769-1770. Berkeley, 1909. $15.00
Portrait and Biographical Record of Macoupin County, Illinois.
Chi., 1891. $25.00 (needs rebinding)
Portrait Painting in America. N.Y., 1977. $4.00
Potsch, Waldemiro--Brazil.... Rio de Janeiro, 1960. $10.00
Pottawatomie County Historical Research Committee--Early His-
tory of Pottawatomie County. N.p., 1954. $7.50
Potter, David Morris--Lincoln and His Party in the Secession
Crisis. New Haven, 1942. 1st ed. $17.50 (cloth)
Potter, Elisah Reynolds--Memoir Concerning the French Settle-
ments and French Settlers in the Colony of Rhode Island.
Providence, 1879. 1st ed. $25.00 (orig. wraps.)
Potter, Jack--A Bibliography of John Dos Passos. Chi., 1950.
1st ed. $50.00 (cloth, a bit bubbled, one of 365 copies
printed on laid paper)
Potter, Stephen--Potter on America. Lond., 1956. 1st ed.
$7.50
Potter, Theodore Edgar--The Autobiography of.... (Con-
cord, N.H., 1913). 1st ed. $75.00
Potts, Ralph Bushnell--Seattle Heritage. Seattle, (1955).
$7.50 (ltd. ed., signed)
Pouchot, Pierre--Memoires sur la Derniere Guerre de l'Ameri-
que Septentrionale.... Yverdon, 1781. 3 vols. 1st ed.
$3500.00 (contemp. half morocco, lib. labels on inside
front cover)
Pound, Arthur--Industrial America. Bost., 1936. $16.00
--The Iron Man in Industry. Bost., (1922). 1st ed. $12.50
--The Only Thing Worth Finding. Detroit, 1964. $12.50
Pound, Ezra--The Pisan Cantos. N.Y., (1948). 1st ed.
$50.00 (spine lettering lightly rubbed)
Lond., (1949). $85.00
Pourade, Richard F., ed.--Historic Ranchos of San Diego
See: Moyer, Cecil C.
Pourtales, Albert, Graf von--On the Western Tour With Wash-
ington Irving. Norman, (1968). 1st ed. $15.00
Powdermaker, Hortense--Hollywood, the Dream Factory. Lond.,
1951. $12.50

Powell, Adam Clayton--Keep the Faith, Baby! N.Y., 1967.
$15.00
Powell, Donald M., ed.--Notes of Travel Through the Terri-
tory of Arizona
See: Marion, John Huguenot
--The Peralta Grant. Norman, (1960). $17.50
Powell, Edward Alexander--The End of the Trail. N.Y., 1914.
$42.50 (uncut and unopened)
--Marches of the North From Cape Breton to the Klondike.
N.Y., (1931). $18.00
Powell, Fred Wilbur--Control of Federal Expenditures. Wash.,
1939. $32.50 (cloth, ex-lib.)
Powell, H.M.T.--The Santa Fe Trail to California. S.F.,
(1931). $1250.00 (one of 300, one-fourth leather and buck-
ram, corners lightly bumped, bookplate, slipcased)
Powell, J.C.--The American Siberia. Chi., (1893). $49.50
(orig. cloth, worn, soiled, paper browned and brittle)
Powell, John Wesley--Canyons of the Colorado. Meadville, Pa.,
1895. 1st ed. $1250.00 (three-quarter morocco, light bind-
ing wear)
--Down the Colorado. N.Y., 1969. $40.00
--The Professor Goes West
See: Watson, Elmo Scott
Powell, Lawrence Clark--Bookman's Progress. (L.A.), 1968.
$20.00
--The Little Package. Cleve., (1964). 1st ed. $20.00 (auto-
graphed)
--A Passion for Books. Lond., (1959). $12.00 (autographed
copy)
Powell, Lyman Pierson--Historic Towns of the Middle States.
N.Y., 1899. $12.50 (lightly water stained)
Powers, Laura Bride--The Missions of California. S.F., 1897.
$35.00 (few pages crunched and flattened, author's presen-
tation inscription)
Powers, Mabel--The Portage Trail.... East Aurora, (1924).
$15.00 (autographed)
Powers, Stephen--Afoot and Alone: a Walk From Sea to Sea
by the Southern Route.... Hart., 1872. $100.00 (orig.
cloth)
Hart., 1884. $79.50 (orig. cloth, rubbed, spine cracked)
Powers, Thomas--Diana: the Making of a Terrorist. Bost.,
1971. $11.00
Prado, Pedro, pseud.--A Chronicle of Louisiana
See under Title
Pratt, Fletcher--Civil War in Pictures. Garden City, (1957).
$15.00

--Secret and Urgent. Ind., (1939). 1st ed. $10.00 (ex-lib.)
Pratt, Harry Edward--Abraham Lincoln Chronology, 1809-1865.
 Springfield, 1953. $5.00
--Lincoln, 1840-1846. Springfield, Il., (1939). $20.00
Pratt, Silas Gamaliel--The War in Song. N.Y., 1891. $17.50
 (author's presentation)
Prebble, John--The Darien Disaster. Lond., 1968. 1st ed.
 $7.50
Preble, George Henry--Origin and History of the American
 Flag.... Bost., 1917. 2 vols. $85.00 (orig. cloth with
 paper labels)
Pred, Allan R.--The Spatial Dynamics of U.S. Urban-Industrial
 Growth.... Camb., (1966). $17.50
Preece, Harold--Lone Star Man. N.Y., (1960). $10.50
Prescott, Philander--The Recollections of.... Lincoln, (1966).
 $10.00
Prescott, William Hickling--History of the Conquest of Mexico.
 N.Y., 1843. 3 vols., 1st ed. $450.00 (cloth, boxed, light
 wear to spine extremities)
 Paris, 1844. 3 vols. $65.00 (ends rubbed, some foxing)
--History of the Conquest of Mexico, and History of the Con-
 quest of Peru. N.Y., (1939). $10.00
--History of the Conquest of Peru.... N.Y., 1847. 2 vols.
 $175.00 (front free endpapers faded, orig. cloth), $7.50
 (spines chipped and shabby, some foxing)
 Mexico, 1957. $150.00 (calf, slipcased, one of 2500 num-
 bered copies), $100.00 (sheepskin, one of 1500 copies,
 signed by designer and illustrator, slipcased)
--The Literary Memoranda of William Hickling Prescott. Nor-
 man, 1961. 2 vols. $20.00 (paper)
--The Papers of William Hickling Prescott. Urbana, 1964.
 1st ed. $25.00, $15.00
--Works. Phila., 1869. 15 vols. $250.00 (three-quarter calf)
 N.Y., (1873). 16 vols. $325.00 (half morocco, one of 1000
 numbered sets)
 Phila., 1904. 22 vols. $450.00 (cloth)
Preston, John--Every Man His Own Teacher. Albany, 1817.
 1st ed. $100.00 (contemp. three-quarter calf, very worn,
 covers re-glued, stamp on title)
Preston, William--Journal in Mexico.... (Paris), n.d. $375.00
 (goatskin, binding lightly rubbed)
Preuss, Charles--Exploring With Fremont. Norman, (1958).
 $25.00
Price, George Frederic--Across the Continent With the Fifth
 Cavalry. N.Y., 1959. $72.50 (one of 750 numbered copies)

Price, John Ambrose--The Negro, Past, Present, and Future.
N.Y., 1907. 1st ed. $75.00 (orig. cloth)
Price, Marjorie Yates--Daughter of the Gold Camp. Rapid City,
S.D., 1962. $12.50 (signed)
Price, Rose Lambert--The Two Americas. Phila., 1877.
$35.00 (some wear to extremities)
Pride, Woodbury Freeman--The History of Fort Riley. N.p.,
1926. $35.00 (cloth, cover lightly worn)
Priest, Josiah--American Antiquities and Discoveries in the
West. Albany, 1833. $125.00 (leather, moderate foxing
and dampstains not affecting text)
Priest, William--Travels in the United States of America....
Lond., 1802. 1st ed. $350.00 (half calf, foxed, morocco
label), $100.00
Priestley, Herbert Ingram, ed.--The Colorado River Cam-
paign....
See: Fages, Pedro
--The Coming of the White Man. N.Y., 1930. $6.00
--Exposition Addressed to the Chamber of Deputies....
See: Carillo, Don Carols Antonio
Prieto, Guillermo--San Francisco in the Seventies. S.F.,
1938. $75.00 (boards, one of 650 copies, bookplate),
$70.00 (one of 650 copies), $50.00 (one of 650 copies)
Prime, Alfred Coxe--The Arts & Crafts in Philadelphia, Mary-
land and South Carolina. (Topsfield, Ma.), 1929-32. 2
vols. $125.00
Prince, John C.--Cuba Illustrated.... N.Y., 1893-94. $45.00
(cloth, light wear)
Principles and Objects of the American Party. N.Y., 1855.
$25.00 (wraps., light dampstaining)
Pritchett, Charles Herman--The Roosevelt Court. N.Y., 1948.
1st ed. $17.50
N.Y., 1963. $12.00
Pritt, Denis Nowell--An Appeal for Clemency. N.Y., n.d.
$15.00 (wraps., yellowed)
Proctor, Ben H.--Not Without Honor. Austin, (1962). 1st
ed. $7.50
Progress of the Union Pacific Railroad....
See: Union Pacific Railroad Company
Proper, Ida Sedgwick--Monhegan, the Cradle of New England.
Portland, Me., 1930. $25.00 (inscribed, one of 1000 cop-
ies, cloth and boards)
Prospector, Cowhand, and Sodbuster.... Wash., 1967. $20.0
(cloth, ex-lib.), $18.50

Proud, Robert--The History of Pennsyvlania, in North America. Phila., 1797-98. 2 vols. 1st ed. $450.00 (contemp. calf with morocco labels), $300.00, $150.00 (cloth, rebound), $90.00 (lacks map)

Prout, Henry Goslee--A Life of George Westinghouse. N.Y., 1921. 1st ed. $18.00

Pryor, Roger Atkinson--Essays and Addresses.... N.Y., 1912. $17.50

Pueyrredon, Carlos Gilbert--1810.... Buenos Aires, 1953. $35.00

Pupin, Michael Idvorsky--From Immigrant to Inventor. N.Y., 1925. $17.50 (cloth)

Purdy, James--Malcolm. N.Y., (1959). $40.00

Puryear, Pamela Ashworth--Sandbags and Sternwheelers. College Station, 1976. $12.50

Pusey, Merlo John--Charles Evans Hughes. N.Y., 1951. 2 vols. 1st ed. $22.00, $20.00

Putnam, George Haven--A Prisoner of War in Virginia.... N.Y., 1912. $25.00

Putnam, George Palmer--Andree; the Record of a Tragic Adventure. N.Y., 1930. $12.50

Putnam, George Rockwell--Lighthouses and Lightships of the U.S. Bost., 1917. 1st ed. $25.00

(Pye, Henry James)--The Democrat. N.Y., 1795. 2 vols. in 1. $200.00

Pyle, Howard--Howard Pyle's Book of Pirates. N.Y., 1921. $30.00 (orig. boards)

- Q -

Q., pseud.
 See: (Rosenberg, Charles G.)
Quaife, Milo Milton, ed.--Army Life in Dakota
 See: Trobriand, Regis de
--Checagou. Chi., (1933). $12.50
--Chicago's Highways Old and New. Chi., 1923. 1st ed. $30.00
--The Doctrine of Non-Intervention With Slavery in the Territories. Chi., 1910. 1st ed. $25.00
--Lake Michigan. Ind., 1944. $15.00 (signed)
--Pictures of Gold Rush California. Chi., 1949. 1st ed. $30.00
--The Siege of Detroit in 1763. Chi., 1958. $17.50
--A True Picture of Emigration
 See: Burlend, Rebecca

--War on the Detroit
 See: Vercheres de Boucherville, Rene Thomas
Quain, Eric Peer--Unforgettable Events. (Eugene, Or., 1948).
 $5.00
Quick, Arthur Craig--Wild Flowers of the Northern States and
 Canada. Chi., (1939). $8.00
Quick, Herbert--Mississippi Steamboatin'. N.Y., (1926).
 $75.00, $43.50, $27.50
Quiett, Glenn Chesney--They Built the West. N.Y., 1934.
 $25.00
Quinn, Arthur Hobson--American Fiction. N.Y., (1936).
 $11.00
Quinn, Denis Alphonsus--Heroes and Heroines of Memphis.
 Providence, 1887. 1st ed. $75.00 (orig. cloth)
Quinn, Sally--We're Going to Make You a Star. N.Y., (1975).
 $10.00
Quinn, Vernon--Beautiful Canada. N.Y., 1928. $6.00
Quinpool, John, pseud.
 See: (Regan, John William)
Quintanilla, Luis--A Latin American Speaks. N.Y., 1943.
 $11.00 (stamp), $10.00
Quirate, Jacinto--Mexican American Artists. Austin, (1973).
 $18.00
Quisenberry, Anderson Chenault--The Life and Times of Hon.
 Humphrey Marshall.... Winchester, Ky., 1892. 1st ed.
 $35.00 (orig. cloth)

- R -

Raab, Selwyn--Justice in the Back Room. Cleve., (1967).
 $10.00
Raaen, Aagot--Grass of the Earth. Northfield, Mn., 1950.
 $15.00
--Measure of My Days. Fargo, N.D., (1953). $6.50
Rachlis, Eugene--The Landlords. N.Y., 1963. $12.50
Raddock, Maxwell C.--Portrait of an American Labor Leader...
 N.Y., 1955. $15.00
Radisson, Pierre Espirit--The Explorations of Pierre Esprit
 Radisson. Minne., 1961. 1st ed. $35.00 (cloth)
Rae, John Bell--The American Automobile. Chi., (1965).
 $15.00
Rae, William Fraser--Westward by Rail. N.Y., 1974. $10.00
Raesly, Ellis Lawrence--Portrait of New Netherland. N.Y.,
 1945. 1st ed. $25.00

Ragen, Joseph Edward--Inside the World's Toughest Prison.
Springfield, (1962). $25.00 (ex-lib.)
Raht, Carlysle Graham--Romance of Davis Mountains and Big
Bend Country. Odessa, Texas, (1963). $22.00 (author's
inscription)
Railey, William Edward--History of Woodford County. Frank-
fort, Ky., 1938. $85.00 (wraps.)
Versailles, Ky., 1968. $35.00
Raine, James Watt--The Land of Saddle-Bags. N.Y., (1924).
$22.50, $12.50
Raine, Philip--Paraguay. New Brunswick, 1956. $15.00
(binding discolored)
Raine, William MacLeod--Famous Sheriffs and Western Outlaws.
Garden City, 1929. 1st ed. $10.00
Raines, Cadwell Walton--Bibliography of Texas. Houston, 1955.
$45.00 (orig. cloth, boxed, one of 500 copies)
Rainey, Thomas Clairborne--Along the Old Trail. Marshall,
Mo., 1914. $125.00 (wraps., some chipping)
Raleigh, Walter--The Discoverie of the Large, Rich and Bev-
vtifvl Empyre of Gviana.... (Cleve., 1966). $30.00 (cloth,
boxed)
Ralph, Julian--The Making of a Journalist. N.Y., 1903.
$8.50
--On Canada's Frontier. N.Y., 1892. 1st ed. $50.00 (orig.
cloth, inner front hinge neatly rebacked, some edgewear)
Ralston, James Kenneth--Rhymes of a Cowboy. Billings, 1969.
$25.00
Ralston, William M.--Those Were the Days. N.Y., (1970).
$12.50
Ramaley, Francis--Colorado Plant Life. Boulder, 1927. $20.00
Ramirez, Diego--Carta al Emperador de Diego Ramirez.... Mex-
ico, 1955. $45.00 (browned, one of 75 copies)
Ramirez, Jose Fernando--Mexico Durante su Guerra con los
Estados Unidos. Mexico, 1905. 1st ed. $125.00 (sheep)
Ramirez Novoa, Ezequiel--La Politica Yanqui en America La-
tina. (Lima, 1962-63). 2 vols. $15.00 (wraps.)
Ramon, the Rover of Cuba, and Other Tales. Bost., 1829.
1st ed. $87.50 (new cloth, ex-lib.)
Ramos, Samuel--Profile of Man and Culture in Mexico. (Aus-
tin, 1962). $12.50
Ramos Arizpe, Miguel--Report ... on the Natural, Political and
Civil Condition of the Provinces of Coahuila.... Austin,
1950. $50.00 (wraps., title foxed)
Ramsdell, George Allen--The History of Milford. Concord,
1901. $60.00

Ramsey, James Gettys McGready--The Annals of Tennessee to the End of the Eighteenth Century. Charleston, 1853. 1st ed. $75.00 (new boards, foxed)

Randall, Clarence Belden--Over my Shoulder.... Bost., 1956. $10.00

Randall, James Garfield--The Civil War and Reconstruction. Bost., (1953). $12.50

Randall, John Herman--The Landscape and the Looking Glass. Bost., 1960. 1st ed. $13.50

Randall, Ruth (Painter)--Mary Lincoln. Bost., (1953). 1st ed. $8.50

Randall, Thomas E.--History of the Chippewa Valley.... Eau Claire, Wi., 1875. $125.00 (orig. cloth)

Randolph, Edmund--Hell Among the Yearlings. N.Y., (1955). 1st ed. $17.50

Randolph, Edward--Edward Randolph. Bost., 1898-1909. 7 vols. $300.00 (orig. printed wraps., one of 250 copies)

Randolph, Vance--Ozark Superstitions. N.Y., 1947. 1st ed. $35.00

--The Truth About Casey Jones.... Girard, Ks., (1945). $7.00 (edges faded)

--We Always Lie to Strangers. N.Y., 1951. 1st ed. $17.50

Range, Willard--A Century of Georgia Agriculture.... Athens, Ga., (1954). $25.00

Ranking, John--Historical Researches on the Conquest of Peru, Mexico.... Lond., 1827. 1st ed. $225.00 (morocco, edges of few leaves reinforced)

Ransom, Frank Edward--A City Built on Wood. Ann Arbor, 1955. $20.00

Ransom, Frank Leslie--The Sunshine State. Mitchell, S.D., 1917. $3.50 (bit worn)

Ransom, James Harley--History of American Saddle Horses. Lexington, Ky., 1962. $30.00

Ransom, Jay Ellis--Fossils in America. N.Y., (1964). 1st ed. $10.00

Ranson, Nancy Richey--Texas Wild Flower Legends. Dallas, 1933. 1st ed. $12.50

Raper, Arthur Franklin--Tenants of the Almighty. N.Y., 1943. 1st ed. $20.00 (sticker removed from title)

Rapp, Marvin A.--Canal Water and Whiskey. N.Y., (1965). $12.50

Rath, George--The Black Sea Germans in the Dakotas. Freeman, S.D., 1977. $17.50

Rather, Lois--Jesse Fremont at Black Point. Oakland, 1974. $30.00

Ratto, Hector Raul--Historia de la Ensenanza Naval en la Argentina. (Buenos Aires, 1944). $15.00 (wraps.)

Rattray, Alexander--Vancouver Island and British Columbia.... Lond., 1862. $250.00 (orig. cloth, spine worn, blind stamp)

Rauch, Basil--American Interest in Cuba.... N.Y., 1948. 1st ed. $20.00 (inscribed copy)

Ravell, Charles H.--Sixty Years of Banking in Michigan. Battle Creek, Mi., 1910. $20.00

Raveneau de Lussan--Raveneau de Lussan.... Cleve., 1930. $75.00

Rawlings, Marjorie Kinnan--Cross Creek. N.Y., 1942. 1st ed. $15.00, $5.00

--Jacob's Ladder. Coral Gables, 1950. $15.00

Rawson, Jonathan--A Compendium of Military Duty.... Dover, N.H., 1793. 1st ed. $300.00 (new three-quarter calf, some foxing and minor damage to last leaf)

Ray, Arthur J.--Indians in the Fur Trade. Toronto, 1974. $25.00

Ray, George Whitfield--Through Five Republics on Horseback. Cleve., 1917. $6.50

Ray, Milton Smith--The Farallones.... S.F., 1934. 2 vols. $35.00 (corners nicked, spines a bit darkened, slipcased, one of 2000 copies, signed by author)

Raymond, Allen--Waterfront Priest. N.Y., (1955). $6.00 (ex-lib.)

Raymond, Daniel--Thoughts on Political Economy.... Balt., 1820. 1st ed. $650.00 (half morocco)

Raymond, Henry Jarvis--The Life and Public Services of Abraham Lincoln.... N.Y., 1865. $75.00 (rebound in buckram, text a bit waterstained)

--Lincoln, His Life and Times. Chi., 1891. 2 vols. $6.00

Raymond, Rossiter Worthington--Mineral Resources of the States and Territories West of the Rocky Mountains. Wash., 1869. $35.00

--Mines and Mining of the Rocky Mountains. N.Y., 1871. $65.00

Raymond, Sarah--Overland Days to Montana in 1865 See: Settle, Raymond W.

Raynolds, David R.--Rapid Development in Small Economies. N.Y., (1967). $12.00

La Raza Chilena See: (Palacios, Nicolas)

Read, Georgia Willis, ed.--Gold Rush See: Bruff, Joseph Goldsborough

Rebolledo, Miguel--Mexico y Estados Unidos. Paris, 1917. $45.00

Reck, Franklin Mering--On Time. N.p., (1948). $14.00
(wraps.)
Reckord, Barry--Does Fidel Eat More Than Your Father?
N.Y., (1971). 1st ed. $10.00
Red, William Stuart--A History of the Presbyterian Church
in Texas. (Austin, 1936). $20.00
--The Texas Colonists and Religion, 1821-1836. Austin (1924).
1st ed. $30.00 (orig. cloth, signed by author on endpaper)
Redfield, Robert--The Folk Culture of Yucatan. Chi., (1941).
1st ed. $12.50
Redpath, James--The Public Life of Capt. John Brown....
Bost., 1860. 1st ed. $30.00 (light wear to cover)
Redwood, Boverton--Petroleum: Its Production and Use.
N.Y., 1887. $17.50 (rebacked)
Reed, Alma M.--The Ancient Past of Mexico. N.Y., (1966).
$12.50
Reed, Earl H.--The Dune Country. N.Y., 1916. 1st ed.
$30.00 (cloth)
Reed, John--History of Erie County, Pennsylvania. Ind.,
1925. $75.00
Reed, Louis--Warning in Appalachia. Morgantown, 1967.
$25.00
Reed, St. Clair Griffin--A History of the Texas Railroads....
Houston, 1941. 1st ed. $350.00 (cloth, ltd. ed., signed
by author)
Reedstrom, Ernest Lisle--Bugles, Banners, and War Bonnets.
Caldwell, 1977. $17.95.
Reese, David Meredith--Letters to the Hon. William Jay....
N.Y., 1835. 1st ed. $20.00
Reese, John Walter--Flaming Feuds of Colorado County. Sa-
lado, Tx., 1962. $21.00 (ltd. ed.)
Reeves, Ira Louis--Ol' Rum River. Chi., 1931. $17.50 (in-
scribed copy)
(Regan, John William)--First Things in Acadia.... Halifax,
(1936). $25.00
Regoli, Robert M.--Police in America. Wash., 1977. $6.00
Regulations for the Granting of Land Under the Spanish Gov-
ernment of Louisiana. Wash., 1820. 1st ed. $175.00
(new cloth)
Rehwinkel, Bessie Lee (Efner)--Dr. Bessie. S.L., (1963).
$12.50
Reichmann, Felix--Sugar, Gold, and Coffee. Ithaca, 1959.
$15.00
Reid, Benjamin Lawrence--The Man From New York. N.Y.,
1968. $20.00

Reid, Ed--The Green Felt Jungle. N.Y., 1963. $6.00
--The Grim Reapers. Chi., (1969). 1st ed. $10.00
--Las Vegas.... Englewood Cliffs., (1961). $12.50
Reid, Ira De Augustine--The Negro Immigrant.... N.Y.,
 1939. 1st ed. $5.00 (cloth)
Reid, William Max--Lake George and Lake Champlain. N.Y.,
 1910. $22.50
Reimann, Lewis Charles--Between the Iron and the Pine.
 (Ann Arbor, 1951). $17.50 (cloth, signed by author)
Reinecke, John E.--Labor Unions of Hawaii. Honolulu, 1966.
 $8.00 (wraps.)
Reinholt, Oscar Halvorsen--Oildom. Phila., 1924-27. 2 vols.
 in 1. $40.00 (cloth)
Reitman, Ben Lewis--Sister of the Road. N.Y., (1937).
 $12.50
A Relation of the Invasion and Conquest of Florida.... Lond.,
 1686
 See: Gentleman of Elvas
The Religious Press in America. N.Y., (1963). 1st ed.
 $8.50
Remington, Frederic--Frederic Remington's Own West. N.Y.,
 1960. 1st ed. $27.50, $12.50
--Men With the Bark On. N.Y., 1900. 1st ed. $32.50 (ex-
 lib., cloth, well rubbed)
--Pony Tracks. Norman, 1961. $12.00 (boards)
--Remington's Frontier Sketches. Chi., (1898). 1st ed.
 $325.00 (boards, lightly soiled, owner inscription)
Remini, Robert Vincent--Martin Van Buren.... N.Y., (1968).
 $25.00
Reminiscences of a Campaign in Mexico
 See: (Robertson, John Blount)
Remsburg, John Eleazer--Charley Reynolds.... K.C., 1931.
 $95.00
Remy, Jules--A Journey to Great-Salt-Lake-City.... Lond.,
 1861. 2 vols. 1st ed. $172.50 (leather-backed)
Reno, Marcus Albert--Abstract of the Official Record of Pro-
 ceedings of the Reno Court of Inquiry.... Harrisburg,
 (1954). 1st ed. $45.00
Reppleir, Agnes--Junipero Serra. Garden City, 1933. $10.00
 (stamp)
Republican Party. National Committee, 1960-64. Women's Di-
 vision--The History of Women in Republican National Con-
 ventions and Women in the Republican National Committee.
 Wash., 1963. $17.00 (rebound in stiff boards, ex-lib.)
Restarick, Henry Bond--Hawaii, 1778-1920.... Honolulu,
 1924. $35.00 (orig. buckram, erratum leaf laid in)

--My Personal Recollections. (Honolulu, 1938). $25.00 (orig. buckram)

Reuben, William A.--The Atom Spy Hoax. N.Y., (1955). $12.50

Reuther, Walter P.--Selected Papers. N.Y., 1961. $12.50

Revere, Joseph Warren--Keel and Saddle.... Bost., 1872. 1st ed. $75.00 (orig. cloth)

--Naval Duty in California. Oakland, 1947. $30.00 (orig. cloth, one of 1000 copies), $25.00 (one of 1000 copies)

Revere, Paul--Paul Revere's Own Story. (Bost.), 1929. $50.00 (orig. boards, one of 500 copies)

Revolutionary Soldiers in Alabama. Montgomery, 1911. $25.00, $12.50 (orig. wraps.)

Reward for the Capture of Booth. (Wash., 1866). $50.00 (self wraps., sewn as issued)

Reyes Castaneda, Pedro--The Journey of Coronado.... N.Y., 1904. $65.00

Reynolds, Charles Bingham--Old Saint Augustine. St. Augustine, 1885. 1st ed. $50.00 (orig. cloth)

--Washington, the City Beautiful. Wash., (191-?). $10.00

Reynolds, George--The Myth of the "Manuscript Found." S.L.C., 1883. $79.50 (orig. cloth, soiled)

Reynolds, Helen (Baker)--Gold, Rawhide and Iron. Palo Alto, (1955). $17.50

Reynolds, James--Ghosts in American Houses. N.Y., (1955). $10.00 (discolored and stained covers)

Reynolds, John Schreiner--Reconstruction in South Carolina, 1865-1877. Columbia, 1905. 1st ed. $75.00 (orig. cloth, small lib. stamp on title)

Reynolds, Quentin James--The Amazing Mr. Doolittle. N.Y., 1953. 1st ed. $10.00

Reynolds (R.J.) Industries--Our 100th Anniversary.... (Winston-Salem, 1975). $7.00 (wraps., ex-lib.)

Reynolds, Winston Allin--Romancero de Hernan Cortes. Madrid, (1967). $8.50 (wraps.)

Rezanov Reconnoiters California, 1806
 See: Pierce, Richard A., comp.

Rhodes, Eugene Manlove--A Bar Cross Man. Norman, 1956. $37.50

--Good Men and True. N.Y., (1910). 1st ed. $100.00 (cloth)

Rhodes, James Ford--History of the U.S. From the Compromise of 1850. N.Y., 1900-19. 8 vols. $95.00 N.Y., 1928. 9 vols. $30.00

--The McKinley and Roosevelt Administrations.... N.Y., 1927. $17.50

Rhodes, May Davison--The Hired Man on Horseback. Bost.,
1938. $40.00
Rhys, Horton--A Theatrical Trip for a Wager! Vancouver,
1966. $45.00 (orig. cloth, one of 500 numbered copies)
Ribakove, Sy--Folk-Rock: the Bob Dylan Story. N.Y.,
(1966). $12.50 (wraps.)
Rice, Allen Thorndike--Reminiscences of Abraham Lincoln....
N.Y., 1886. $12.50
N.Y., 1909. $12.50
Rice, Josiah M.--A Cannoneer in Navajo Country. (Denver,
1970). $30.00 (one of 1500 copies)
Rice, Lee M.--They Saddled the West. Camb., 1975. $15.00
Rice, Nathan P.--Trials of a Public Benefactor.... N.Y.,
1859. 1st ed. $25.00 (cloth, extremities shelf worn)
Rice, William Hyde--Hawaiian Legends. Honolulu, 1977.
$12.00 (wraps.)
Rich, Bennett Milton--The Presidents and Civil Disorder.
Wash., 1941. 1st ed. $10.00
Rich, Russell Rogers--Land of the Sky-Blue Water. (Provo,
Ut.), 1963. $7.50
Rich, Virtulon--Western Life in the Stirrups. Chi., 1965.
$15.00 (ltd. ed.)
Richards, Benjamin B., ed.--California Gold Rush Merchant
See: Davis, Stephen Chapin
Richards, Colin--Bowler Hats and Stetsons. Lond., 1966.
$12.50
Richards, Laura Elizabeth (Howe)--Julia Ward Howe, 1819-1910.
Bost., 1916. 2 vols. $35.00
Richards, Ralph--Wichita, Kansas, as I Knew It. Fort Scott,
Ks., 1936. $5.00
Richards, Thomas Addison--Appleton's Illustrated Hand-Book
of American Travel
See under Title
Richardson, Albert Deane--Beyond the Mississippi. Hart.,
1869. $35.00 (cloth, hinges cracked, mild foxing, owner
signature)
--The Secret Service, the Field, the Dungeon, and the Escape.
Hart., 1865. 1st ed. $15.00 (leather, outer hinges tender)
Richardson, Edgar Preston--Washington Allston, a Study of
the Romantic Artist in America. Chi., (1948). 1st ed.
$50.00
Richardson, Frederick Hawkins--Along the Iron Trail. Rut-
land, Vt., (1938). 1st ed. $17.50
Richardson, James--Wonders of the Yellowstone. N.Y., 1873.
$60.00 (cloth, top and bottom of spine a bit frayed, hinges
starting)

Richardson, William H.--Journal of ... a Private Soldier....
N.Y., 1850. $550.00 (orig. wraps., spine restored, slip-
cased)

Rickard, Francis Ignacio--The Mineral and Other Resources
of the Argentine Republic (La Plata) in 1869. Lond., 1870.
$67.50 (spine torn, loose in covers, back cover detached)

Rickard, Thomas Arthur--Journeys of Observation. S.F.,
1907. 2 vols. in 1. $45.00

--The Romance of Mining. Toronto, 1944. 1st ed. $45.00

Rickey, Don--Forty Miles a Day on Beans and Hay. Norman,
(1963). 1st ed. $35.00

Riddle, Albert Gallatin--Recollections of War Times. N.Y.,
1895. 1st ed. $20.00 (two small tears along backstrip)

Riddle, Donald Wayne--Lincoln Runs for Congress. New
Brunswick, 1948. $20.00

Riddle, John Leonard--A Synopsis of the Flora of the Western
States. Cinci., 1835. 1st ed. $125.00 (old boards, some
pencil marks)

Riddleberger, Patrick W.--George Washington Julian.... (Ind.),
1966. $20.00

Rideal, Charles Frederick--The History of the E.I. DuPont de
Nemours Powder Company. N.Y., (1912). $30.00

Ridge, John Rollin--Poems. S.F., 1868. 1st ed. $90.00
(front cover stained, very light general wear), $50.00
(orig. cloth, bookplate)

Ridpath, John Clark--Beyond the Sierras. Oakland, 1963.
$25.00 (one of 600 copies)

--The Life and Trial of Guiteau the Assassin.... Cinc., 1882.
$37.50

Riesco, Jose Francisco--El Jazz Clasico y Johnny Dobbs, su
Rey Sin Corona. Santiago de Chile, 1972. $25.00 (wraps.)

Reisenberg, Felix--Golden Gate. N.Y., (1940). 1st ed.
$10.00

--The Golden Road. N.Y., (1962). $10.00

Riggs, Stephen Return--Mary and I. Chi., (1880). 1st ed.
$50.00 (cloth, binding worn and shaken)
Bost., (1887). $40.00

Riis, Jacob August--The Making of an American. N.Y., 1902.
$35.00 (cloth, a bit soiled and rubbed)

Riis, John--Ranger Trails. Rich., 1937. $12.50

Riley, Arthur Joseph--Catholicism in New England to 1788.
(Balt., 1936). $17.50 (orig. wraps., few dampstains,
presentation copy)

Riley, Charles Valentine--The Locust Plague in the U.S. Chi.,
1877. $35.00 (binding worn)

Riley, James Whitcomb--Afterwards. Ind., n.d. $35.00
 (orig. cloth, presentation copy)
--The Book of Joyous Children. N.Y., 1902. 1st ed. $40.00
 (orig. cloth, presentation copy dated)
 N.Y., 1903. $35.00 (orig. leather, worn at edges, presen-
 tation copy dated)
--The Complete Works of.... Ind., (1913). 6 vols. $50.00
 (orig. cloth)
 N.Y., 1916. 10 vols. $75.00 (orig. cloth)
--Neighborly Poems.... Ind., 1891. 1st ed. $25.00 (1st
 state, 2nd binding, orig. cloth, spine ends lightly worn,
 owner signature)
--An Old Sweetheart of Mine. Ind., (1902). $17.50 (cloth,
 ink stamp)
--Pipes O'Pan at Zekesbury. Ind., 1891. $45.00 (orig. cloth,
 presentation copy dated)
Riordan, Joseph W.--The First Half Century of St. Ignatius
 Church and College. S.F., 1905. $125.00 (morocco),
 $100.00 (orig. cloth)
Rios, Eduardo Enrique--Life of Fray Antonio Margil, O.F.M.
 Wash., 1959. $15.00 (signed by translator, Benedict Lue-
 tenegger)
Ripley, Ozark, pseud.
 See: Thompson, John Baptiste de Macklot
Ripley, Thomas--They Died With Their Boots On. Garden
 City, 1935. 1st ed. $25.00
Rippy, James Fred--Latin America, a Modern History. Ann
 Arbor, 1958. $7.50
--Latin America and the Industrial Age. N.Y., (1944). 1st
 ed. $12.50
--Mexico: American Policies Abroad. Chi., (1928). $20.00
--South America and Hemisphere Defense. Baton Rouge, 1941.
 $10.00
Rister, Carl Coke--Comanche Bondage.... Glendale, 1955.
 $100.00
--Robert E. Lee in Texas. Norman, 1946. $20.00
--Southern Plainsmen. Norman, 1938. $45.00
Ritch, John B.--Horse Feathers.... (Helena, Mt., 1941).
 $15.00
Ritchie, Anna Cora (Ogden) Mowatt--Mimic Life. Bost., 1856.
 1st ed. $10.00 (presentation copy, worn, some foxing,
 few sigs. lightly pulled)
Ritchie, Robert Welles--The Hell-Roarin' Forty-Niners. N.Y.,
 (1928). $28.50

Ritchie, Ward--Frederic Goudy, Joseph Foster, and the Press
at Scripps College. (S.F.), 1978. $40.00 (one of 550
copies)
Ritenour, John Sturgis--Old Tom Fossit. Pitts., 1926. $45.00,
$27.50
Rittenhouse, Jack DeVere--Maverick Tales. N.Y., (1971).
$25.00
Ritter, Abraham--Philadelphia and Her Merchants.... Phila.,
1860. 1st ed. $85.00
Ritz, Marie Louise (Beck)--Cesar Ritz.... Phila., 1938.
$12.50
Riva Palacio, Vicente--Mexico a Traves de Los Siglos....
Barcelona, (1887-90). 5 vols. 1st ed. $1750.00 (sheep,
some light cover wear)
The River Mississippi, From St. Paul to New Orleans.... N.Y.,
(1859). $250.00 (new half calf, bind stamp)
Rivero, Mariano--Peruvian Antiquities. N.Y., 1853. 1st ed.
$80.00
Rives, George Lockhart--The United States and Mexico, 1821-
1848. N.Y., 1913. 2 vols. $50.00
Roa Barceno, Jose Maria--Recuerdos de la Invasion Norte-
Americana, (1846-1848). Mexico, 1883. 1st ed. $150.00
(modern sheep)
Robb, John S.--Streaks of Squatter Rights, and Far-West
Scenes. Phila., 1847. 1st ed. $85.00 (disbound)
Robert, Joseph Clarke--The Story of Tobacco in America.
N.Y., 1952. $18.00
Roberts, Brigham Henry--The Mormon Battalion. S.L.C.,
1919. $25.00 (orig. wraps.)
Roberts, Carlos--Las Invasiones Inglesas del Rio de la Plata
(1806-1807).... Buenos Aires, 1938. $35.00 (sheep)
Roberts, Chalmers McGeagh--Washington, Past and Present.
Wash., 1949-50. $15.00
Roberts, Charles Rhoads--History of Lehigh County, Penn-
sylvania.... Allentown, 1914. 3 vols. $125.00 (half
leather, some binding wear)
Roberts, Edward Ferguson--Ireland in America. N.Y., 1931.
1st ed. $9.00
Roberts, Edwards--Shoshone and Other Western Wonders.
N.Y., 1888. $50.00 (cloth, owner inscription)
Roberts, Kenneth Lewis--Boon Island. N.Y., 1956. $12.00
--Cowpens. N.p., 1957. $90.00 (boards, one of 400 numbered
copies)
--March to Quebec
See under Title

--Northwest Passage. N.Y., 1937. 2 vols. 1st ed. $225.00
 (signed by author, one of 1050 copies, orig. cloth)
--Trending Into Main. Bost., 1938. $12.50
Roberts, Leslie--The Mackenzie. N.Y., (1949). 1st ed.
 $15.00
Roberts, Louisa J.--Biographical Sketch of Louisa J. Rob-
 erts.... Phila., 1895. 1st ed. $75.00 (orig. cloth)
Roberts, Orlando W.--Narrative of Voyages and Excursions....
 Edin., 1827. 1st ed. $300.00 (cloth, spine a bit worn,
 uncut)
Roberts, Philetus--Memoir of Mrs. Abigail Roberts. Irvington,
 N.J., 1858. $12.50 (some foxing)
Roberts, Robert Ellis--Sketches and Reminiscences of the City
 of the Straits and Its Vicinity. Detroit, 1884. $75.00
 (orig. cloth)
Roberts, Walter Adolphe--The Caribbean. Ind., (1940).
 $12.50
--Lake Pontchartrain. Ind., (1946). $15.00
Robertson, Alexander Farish--Alexander Hugh Holmes Stu-
 art.... Rich., (1925). $12.50
Robertson, Frank Chester--Boom Towns of the Great Basin.
 Denver, (1962). $25.00
--Fort Hall, Gateway to the Oregon Country. N.Y., (1963).
 $17.50, $15.00 (boards), $15.00
Robertson, James Alexander--Louisiana Under the Rule of
 Spain.... Cleve., 1911. 2 vols. $152.50
(Robertson, John Blount)--Reminiscences of a Campaign in
 Mexico. Nashville, 1849. $150.00
Robertson, John Ross--Old Toronto. Toronto, 1954. $12.50
Robertson, John Wooster--The Harbor of St. Francis....
 S.F., 1926. 1st ed. $125.00 (one of 100 copies, private
 printing)
Robertson, Thomas A.--A Southwestern Utopia. L.A., 1947.
 $35.00 (signed by author)
 L.A., 1964. $23.50
Robertson, William Parish--A Visit to Mexico.... Lond., 1853.
 2 vols. 1st ed. $250.00 (orig. cloth, subscriber's ed.)
Robinson, Charles Asbury--The Roving Red Rangers. Green-
 field, Ind., (1902). $17.50
Robinson, Claude Everett--Straw Votes. N.Y., 1932. 1st ed.
 $15.00
Robinson, Conway--An Account of Discoveries in the West
 Until 1519.... Rich., 1848. 1st ed. $45.00 (cloth)
Robinson, Daniel Merritt--Bob Taylor and the Agrarian Revolt
 in Tennessee. Chapel Hill, 1935. $22.50

Robinson, Doane--A Brief History of South Dakota. N.Y.,
(1905). $5.00
Robinson, Elwyn B.--History of North Dakota. Lincoln, 1966.
$10.00
Robinson, Frank--Frank: the First Year. N.Y., 1976. $12.50
Robinson, George O.--The Oak Ridge Story. Kingsport, Tn.,
(1950). $15.00
Robinson, Henry Morton--Stout Cortez. N.Y., (1931). $19.50
(front cover stained)
Robinson, John--The Sailing Ships of New England. Salem,
Ma., 1922. $65.00
Westminster, Md., 1953. $37.50
Robinson, John W.--Southern California's First Railroad.
L.A., 1978. $30.00 (one of 300 copies)
Robinson, Rowland Evans--Sam Lovel's Camps. N.Y., 1893.
$22.50
Robinson, Sara Tappan Doolittle Lawrence. Kansas.... Bost.,
1856. $60.00 (cloth, light foxing)
Robinson, Willard Bethurem--Texas Public Buildings of the
Nineteenth Century. Austin, (1974). $25.00
Robinson, William Davis--Memoirs of the Mexican Revolution....
Phila., 1820. 1st ed. $750.00 (orig. boards, neatly re-
hinged), $350.00 (new three-quarter calf, few tears re-
paired, uncut)
Robinson, William Joseph--Forging the Sword. Concord,
N.H., 1920. $20.00
Robinson, William Wilcox--The Forest and the People. L.A.,
1946. $15.00
--The Island of Santa Catalina. L.A., 1941. $5.00 (orig.
wraps.)
--Land in California. Berkeley, 1948. 1st ed. $60.00
--Panorama; a Picture History of Southern California. L.A.,
1953. $15.00
--Ranchos Become Cities. Pasadena, 1939. $65.00
Robley, Thomas Francis--History of Bourbon County, Kansas.
Ft. Scott, Ks., 1894. 1st ed. $50.00
Robotti, Frances Diane--Whaling and Old Salem. Salem, Ma.,
1950. 1st ed. $25.00
N.Y., (1962). $12.00
Robuck, J.E.--My Own Personal Experiences and Observations.
Memphis, n.d. $15.00
Roca, Paul M.--Paths of the Padres Through Sonora. Tucson,
1967. $35.00
(Rocafuerte, Vicente)--Ideas Necesarias a Todo Pueblo Amer-
icano Independiente. Phila., 1821. $175.00

Rock, R.W., pseud.
See: Thompson, John C.
Rockefeller, John Davidson--Random Reminiscences of Men and
 Events. N.Y., 1909. 1st ed. $25.00
 Toronto, 1909. $12.50
Rockwell, Charles--Sketches of Foreign Travel, and Life at
 Sea. Bost., 1842. 2 vols. in 1. $37.50 (corners rubbed)
Rockwell, Wilson--Sunset Slope. Denver, (1956). $25.50
Rodell, Fred--Nine Men. N.Y., (1955). $10.00
Rodgers, William H.--Rockefeller's Follies. N.Y., (1966).
 $15.00
Rodman, Selden--The Peru Traveler. N.Y., (1967). $7.50
Rodrigues, Jose Honorio--Brazil and Africa. Berkeley, 1965.
 $14.25
--Teoria de Historia do Brasil. Sao Paulo, (1957). 2 vols.
 $70.00
Rodriquez, Mario--A Palmerstonian Diplomat in Central Amer-
 ica. Tucson, 1964. $12.50
Rodriquez Casado, Vicente--Primeros Anos de Dominacion Es-
 panola en la Luisiana.... Madrid, 1942. $30.00
Rodway, James--Stark's Guide-Book and History of British
 Guiana. Bost., n.d. $15.00 (inner front hinge cracking),
 $13.50 (presentation copy)
Roe, Alfred Seelye--The Old Representatives' Hall, 1798-1895.
 Bost., 1895. $10.00 (presentation copy)
--The Thirty-Ninth Regiment Massachusetts Volunteers....
 Worcester, 1914. $50.00
Roe, Charles Francis--Custer's Last Battle on the Little Big
 Horn. (N.Y., 1927). 1st ed. $50.00
Roe, Clifford Griffith--The Great War on White Slavery. N.p.,
 (1911). 1st ed. $12.50
--What Women Might Do With the Ballot.... N.Y., 1912.
 $40.00 (wraps.)
Roe, Frank Gilbert--The Indian and the Horse. Norman,
 (1955). 1st ed. $22.50, $20.00 (cloth)
--The North American Buffalo. Toronto, 1951. 1st ed.
 $45.00
Roebling, Johann August--Diary of My Journey.... Trenton,
 N.J., 1931. $25.00
Roeder, Ralph--Juarez and His Mexico. N.Y., 1947 (i.e.,
 1948). $12.50
Roehrenbeck, William Joseph--The Regiment That Saved the
 Capital. N.Y., (1961). $17.50
Rogers, Betty (Blake)--Will Rogers; the Story of His Life.
 Garden City, (1943). $12.50

[Rogers, Carlton H.]--Incidents of Travel in the Southern
States and Cuba. N.Y., 1862. 1st ed. $175.00 (orig.
cloth)
Rogers, Fred Blackburn--Bear Flag Lieutenant. S.F., 1951.
$38.50 (one of 250 copies)
--Montgomery and the Portsmouth. (S.F.), 1958. $40.00
(one of 750 copies)
Rogers, James Sterling--History of Arkansas Baptists. Little
Rock, 1948. 1st ed. $25.00 (orig. cloth)
Rogers, John Almanza Rowley--Birth of Berea College. Phila.,
1903. 1st ed. $9.00 (few rubbed spots on edges)
Rogers, John Godfrey--Sport in Vancouver and Newfoundland.
N.Y., 1912. $50.00 (orig. cloth, top of spine chipped)
Rogers, John Pugh--The Doan Outlaws. Doylestown, Pa.,
1897. $50.00 (orig. cloth, rebacked, front cover cracked)
Rogers, John William--The Lusty Texans of Dallas. N.Y.,
1951. 1st ed. $12.50
Rogers, Joseph Morgan--True Henry Clay. Phila., 1904.
$20.00
Rogers, Lindsay--The Pollsters. N.Y., 1949. $15.00
Rogers, Robert--Reminiscences of the French War. Concord,
1831. $260.00
Rogers, Will--Autobiography. Bost., (1949). $12.50
--Ether and Me. N.Y., (1936). $7.50 (cloth)
--Will Rogers; the Story of His Life
 See: Rogers, Betty (Blake)
--Wit and Wisdom. N.Y., 1936. $10.00
Rogler, Lloyd Henry--Migrant in the City. N.Y., (1972).
1st ed. $12.50
Rogoff, Harry--An East Side Epic. N.Y., (1930). $17.50
Rogow, Arnold A.--James Forrestal.... N.Y., (1963). $15.00
(cloth, ex-lib., spine top torn)
Rohan, Jack--Yankee Arms Maker. N.Y., 1935. 1st ed.
$15.00 (binding lightly stained)
Rohrer, Fred--Saloon Fight at Berne, Ind. Berne, 1913.
1st ed. $20.00 (lib. marks)
Rojas, Robinson--The Murder of Allende.... N.Y., 1976.
$10.00
Rolfsrud, Erling Nicholai--The Story of North Dakota. Alex-
andria, Mn., (1964). $8.50
Rollins, Philip Ashton--The Cowboy. N.Y., 1922. 1st ed.
$22.00
Rollinson, John K.--Pony Trails in Wyoming. Caldwell, 1941.
1st ed. $43.50

--Wyoming Cattle Trails. Caldwell, 1948. 1st ed. $40.00
(cloth), $35.00
Rolph, George Morrison--Something About Sugar. S.F., 1917.
$24.50 (edges untrimmed)
Rolvaag, Ole Edvart--The Boat of Longing. N.Y., 1933.
$15.00
--The Giants in the Earth. N.Y., (1927). $15.00
--Peder Victorious. N.Y., 1929. $15.00
Romero, Jose--Mexican Jumping Bean. N.Y., (1953). $8.00
(inscribed)
Romero de Terreros y Vincent, Manuel--Hernan Cortes. Mex-
ico, 1944. $12.00 (wraps.)
Romero Flores, Jesus--Anales Historicos de la Revolucion Mex-
icana. Mexico, 1939. 4 vols. in 2. $35.00
Romig, Emily Craig--A Pioneer Woman in Alaska. Caldwell,
1948. $11.50
Romoli, Kathleen--Colombia. Garden City, (1941). $8.50
Roof, Katharine Metcalf--Colonel William Smith and Lady.
Lond., n.d. $8.50 (bookplate removed)
Roos, Charles O.--Green Timber.... (Wahpeton, N.D., 1945).
$4.00
Roosevelt, Eleanor--It's Up to the Women. N.Y., 1933. 1st
ed. $20.00
--This I Remember. N.Y., (1949). $6.00 (tanned)
Roosevelt, Franklin Delano--Franklin D. Roosevelt and Foreign
Affairs. Camb., 1969. 3 vols. $45.00
--On Our Way. N.Y., (1934). $12.50
Lond., 1934. $18.00
--Public Papers and Addresses.... N.Y., 1938. 5 vols.
1st ed. $75.00 (orig. cloth)
Roosevelt, Kermit--The Happy Hunting-Grounds. N.Y., 1920.
$8.00
Roosevelt, Theodore--African Game Trails. N.Y., 1920. 2
vols. $20.00
--American Ideals, and Other Essays.... N.Y., 1897. $13.00
--Nas Selvas do Brasil. Rio de Janeiro, 1943. $35.00 (hinges
starting)
--The Naval War of 1812. N.Y., 1882. 1st ed. $75.00
--Outdoor Pastimes of an American Hunter. N.Y., 1920.
$10.00
--The Rough Riders. N.Y., 1920. $10.00
--Theodore Roosevelt's Letters to His Children. N.Y., 1919.
$10.00 (1st issue)
--Through the Brazilian Wilderness. N.Y., 1920. $10.00,
$7.50 (cloth, covers a bit worn, incomplete index)

--Trailing the Giant Panda. N.Y., 1929. $25.00
--The Winning of the West. N.Y., 1889. 4 vols. 1st ed.
$450.00 (orig. cloth)
Root, Elihu--Speeches Incident to the Visit....
See under Title
Root, Frank Albert--The Overland Stage to California. To-
peka, 1901. 1st ed. $225.00 (orig. three-quarter morocco,
publisher's presentation binding)
Root, Jonathan--The Betrayers. N.Y., (1963). $15.00
Root, Nathaniel William Taylor--Songs of Yale. New Haven,
1853. $25.00 (three-quarter leather, some cover wear)
Root, Riley--Journal of Travels From St. Josephs to Oregon....
Oakland, 1955. $30.00 (cloth), $30.00 (one of 500 copies)
Root, Winfred Trexler--The Relations of Pennsylvania With
the British Government.... (Phila.), 1912. 1st ed.
$20.00
Rosa, Joseph G.--The Gunfighter.... Norman, (1969). $7.50
--They Called Him Wild Bill. Norman, (1964). 1st ed. $45.00,
$27.50
Rosales, Vicente Perez
See: Perez Rosales, Vicente
Roscoe, Theodore--U.S. Destroyer Operations in World War II.
Annapolis, (1953). 1st ed. $15.00
--U.S. Submarine Operations in World War II. Annapolis,
(1958). $15.00
Roscow, James P.--800 Miles to Valdez. Englewood Cliffs,
1977. $12.50
Rosenbach, Abraham Simon Wolf--An American Jewish Bibli-
ography.... (Balt.), 1926. $40.00 (orig. cloth)
--The Unpublishable Memoirs. Lond., (1924). $15.00
Rosenbault, Charles J.--When Dana Was the Sun. N.Y., 1931.
1st ed. $12.50
Rosenberg, Bruce A.--Custer and the Epic of Defeat. Uni-
versity Park, Pa., 1974. $15.00
(Rosenberg, Charles G.)--You Have Heard of Them. N.Y.,
1854. 1st ed. $35.00 (cover lightly worn)
Rosenberg, Ethel--Death House Letters of Ethel and Julius
Rosenberg. N.Y., 1953. $16.00 (wraps.)
Rosenberry, Lois (Kimball) Mathews--The Expansion of New
England. N.Y., 1962. $15.00
Rosenblat, Angel--Andres Bello.... Caracas, 1966. $5.00
(wraps.)
Rosenblatt, Stanley--Justice Denied. L.A., (1971). $10.00
Rosengarten, Frederic--Freebooters Must Die! Wayne, Pa.,
1976. $20.00

Roske, Ralph Joseph--Lincoln's Commando. N.Y., (1957).
$15.00, $12.50
Ross, Alexander Milton--The Birds of Canada. Toronto, 1872.
$27.00 (cloth)
Ross, Clinton--Chalmette. Phila., 1898. 1st ed. $10.00
Ross, Dorothy--Stranger to the Desert. (Lond., 1958). 1st
ed. $12.50
Ross, Edward Alsworth--South of Panama. N.Y., 1915. 1st
ed. $10.00
Ross, Ishbel--Angela of the Battlefield. N.Y., (1956). 1st
ed. $15.00
--The General's Wife. N.Y., 1959. $10.00
--The President's Wife. N.Y., (1973). $15.00
--Rebel Rose. N.Y., (1954). 1st ed. $13.50 (bit used)
Ross, Irwin--The Loneliest Campaign. (N.Y., 1968). 1st
ed. $10.00
Ross, James--Life and Times of Elder Reuben Ross. Phila.,
(1882). 1st ed. $40.00
Ross, James H.--A Martyr of To-Day. Bost., 1894. $15.00
(corners rubbed, backstrip torn)
Ross, Marvin Chauncey--The West of Alfred Jacob Miller
(1837)....
See: Miller, Alfred Jacob
Ross, Walter Sanford--The Last Hero. N.Y., (1968). $8.50
Ross, William Potter--The Life and Times of.... Fort Smith,
Ar., 1893. $43.50
Roth, Hal--Pathway in the Sky. Berkeley, (1965). $20.00
Rothert, Otto A.--The Story of a Poet: Madison Cawein.
Lou., 1921. $45.00
Rothery, Agnes Edwards--Central America and the Spanish
Main. Bost., 1929. $6.00
--The Ports of British Columbia. Garden City, 1943. $6.00
Roundup Years: Old Muddy to Black Hills. N.p., 1956.
$37.50
Rourke, Constance Mayfield--Audubon. N.Y., 1936. 1st ed.
$15.00, $12.50
--Troupers of the Gold Coast. N.Y., (1928). $12.50
Rourke, Thomas, pseud.
See: Clinton, Joseph Daniel
Rouse, John E.--The Criollo. Norman, 1977. $35.00, $12.50
Rovere, Richard Halworth--The General & the President....
(N.Y., 1951). 1st ed. $10.00
Rowland, Dunbar, ed.--Jefferson Davis, Constitutionalist
See: Davis, Jefferson
Rowlands, John J.--Cache Lake Country. N.Y., 1947. 1st
ed. $6.50

Roy, George Ross--Twelve Modern French Canadian Poets.
Toronto, 1958. 1st ed. $9.50 (ex-lib.)

Roy, Just Jean Etienne--Les Adventures d'un Capitaine Fran-
cais Planteur au Texas.... Tours, 1868. $200.00 (orig.
cloth, neatly rebacked)

--The Adventures of a French Captain.... N.Y., (1878).
$150.00 (orig. boards, binding rather worn)

Roy, Ralph Lord--Apostles of Discord. Bost., (1953). $10.00

Royall, Anne Newport--The Tennessean. New Haven, 1827.
1st ed. $125.00 (disbound, lacks top of title, foxed, un-
cut)

Royce, Charles C.--John Bidwell, Pioneer, Statesman, Philan-
thropist.... Chico, Ca., 1906. 1st ed. $600.00 (orig.
three-quarter morocco, one of 100 copies for private presen-
tation)

Royce, Josiah--California, From the Conquest in 1846 to the
Second Vigilante Committee.... N.Y., 1948. 1st ed.
$8.50

Royce, Sarah (Bayliss)--A Frontier Lady. New Haven, 1923.
1st ed. $35.00

Royer, Fanchon--The Tenth Muse. Paterson, N.J., 1952.
$12.50

Rubel, Arthur J.--Across the Tracks. Austin, (1966). 1st
ed. $35.00

Rudd, Hughes--My Escape From the CIA and Other Improb-
able Events. N.Y., 1966. $10.00

Rudo Ensayo. Phila., 1894. $15.00

Ruebel, Arthur J.--Across the Tracks. Austin, (1966). 1st
ed. $7.00

Rueda Medina, Gustavo--Las Islas Tambien Son Nuestras.
Mexico, 1946. $15.00 (wraps.)

Rugendas, Johann Moritz--Mexico. Landscapes and Popular
Sketches
See: Sartorius, Christian

--Mexico und die Mexicaner
See: Sartorius, Christian. Mexiko. Landschaftsbuilder...

Rugg, Winnifred King--Unafraid. Bost., 1930. 1st ed.
$22.00, $14.00 (binding lightly worn)

Ruiz Suarez, Bernardo--The Color Question in the Two Amer-
icas. N.Y., 1922. $10.00

Rundell, Walter--In Pursuit of American History. Norman,
(1970). $20.00

Runyan, Georgie W. (Drury)--400 Years of America. Spring-
field, Oh., 1892. $10.00

Rupp, Israel Daniel--The History and Topography of Dauphin,

Cumberland.... Lancaster, Pa., 1846. 1st ed. $100.00
(orig. calf), $50.00 (rebound, some staining)
--History of Lancaster County. Lancaster, Pa., 1844. $100.00
(orig. calf, lacks front fly)
--History of Northampton, Lehigh.... Harrisburg, Pa., 1845.
$50.00 (cloth, rebound)
--History of the Counties of Berks and Lebanon. Lancaster,
Pa., 1844. $110.00 (contemp. calf, covers rubbed)
Ruschenberg, William Samuel Waithman--Noticias de Chile....
$10.00 (wraps.)
Rushton, Gerald A.--Whistle Up the Inlet. Vancouver, B.C.,
1974. 1st ed. $7.00 (wraps.)
Rushton, William Faulkner--The Cajuns. N.Y., 1979. $17.50
(signed by author)
Rusling, James Fowler--Men and Things I Saw in Civil War
Days. N.Y., 1899. 1st ed. $30.00
Ruso d'Eres, Charles Dennis--Memoirs.... Exeter, N.H.,
1800. 1st ed. $600.00 (heavily foxed, affecting some text,
orig. calf)
Russell, Carl Parcher--Firearms, Traps & Tools of the Moun-
tain Men. N.Y., 1967. 1st ed. $50.00
--Guns on the Early Frontiers. Berkeley, 1957. 1st ed.
$30.00
--One Hundred Years in Yosemite. Stanford, 1931. 1st ed.
$40.00
Berkeley, 1947. $20.00 (inscribed copy), $20.00 (bookplate)
Russell, Charles Marion--The CMR Book. Seattle (1970). 1st
ed. $25.00 (leatherette)
--Good Medicine.... Garden City, N.Y., 1929. 1st ed.
$1250.00 (untrimmed, unopened leaves, with printer's trim
marks present in a cloth folding box)
N.Y., (1930). $45.00 (cloth)
--Trails Plowed Under. Garden City, 1927. $20.00
Russell, Francis, 1910--A City in Terror. N.Y., 1975. 1st
ed. $17.50
--The Shadow of Blooming Grove. N.Y., (1968). $10.00
--Tragedy in Dedham. Lond., 1963. $17.50
Russell, Israel Cook--North America. N.Y., 1904. $29.00
(cloth)
Russell, J.H.--Cattle on the Conejo. (Pasadena), 1957.
$35.00 (author's presentation inscription)
Russell, Lucy (Phillips)--A Rare Pattern. Chapel Hill, (1957).
$12.50
Russell, Marian (Sloan)--Land of Enchantment. Evanston,
1954. 1st ed. $38.00 (one of 750 copies)

Russell, Osborne--Journal of a Trapper. Portland, 1955.
 1st ed. $65.00 (one of 750 copies)
Russell, Phillips--Benjamin Franklin.... N.Y., 1929. $10.00
--John Paul Jones. N.Y., 1927. 1st ed. $12.50
--Red Tiger. N.Y., (1929). 1st ed. $65.00 (orig. parch-
 ment, one of 250 large-paper and numbered copies, signed
 by the author and illustrator)
 N.Y., 1932. $10.00
Russell, Thomas C., ed.--Narrative of Edward McGowan
 See: McGowan, Edward
--The Shirley Letters....
 See: Clappe, Louise Amelia Knapp Smith
Russo, Dorothy Ritter--A Bibliography of Booth Tarkington....
 Ind., 1949. $45.00
--A Bibliography of George Ade. Ind., 1947. $35.00 (orig.
 cloth)
Ruth, Kent--Great Days in the West.... Norman, (1963).
 $17.50
Rutledge, Louise--D. Boon, 1776. N.p., 1975. $5.00 (signed)
Ruxton, George Frederick Augustus--Adventures in Mexico
 and the Rocky Mountains. Lond., 1849. $145.00, $25.00
 (rubbed, some edgewear)
--Ruxton of the Rockies. Norman, 1950. 1st ed. $35.00
Ryan, Marah Ellis Martin--Flute of the Gods. N.Y., (1909).
 $55.00 (cover worn)
Ryder, David Warren--Memories of the Mendocino Coast. S.F.,
 1948. $25.00 (orig. boards)
Rye, Edgar--The Quirt and the Spur. Chi., 1909. 1st ed.
 $300.00 (cloth, slipcased)
Ryus, William Henry--The Second William Penn.... K.C.,
 (1913). $70.00 (cloth), $25.00 (printed wraps.), $20.00
 (orig. printed wraps.), $12.50 (orig. wraps.)

- S -

Sabin, Edwin Legrand--Kit Carson Days. N.Y., 1935. 2 vols.
 $50.00 (cloth)
--Wild Men of the Wild West. N.Y., (1929). 1st ed. $75.00
 (cloth)
Sacco, Nicola--The Letters of Sacco and Vanzetti. N.Y.,
 1928. 1st ed. $35.00
--The Sacco-Vanzetti Case. N.Y., 1931. $40.00
Sacramento, Calif. Chamber of Commerce--The Romance of
 California. (Sacramento, 1939). $5.00 (wraps.)

Saffin, John--John Saffin, His Book.... N.Y., 1928. 1st ed. $12.50 (one of 500 copies)

Safford, Henry Barnard--Mr. Madison's War. N.Y., (1936). $6.00

Sage, Rufus B.--Rocky Mountain Life.... Bost., 1857. $80.00 (some minor foxing, rebound in lib. cloth)

--Scenes in the Rocky Mountains.... Phila., 1846. 1st ed. $1500.00 (orig. three-quarter calf, rebacked)

Sageser, Adelbert Bower--Joseph L. Bristow. Lawrence, (1968). $15.00

Sahagun, Bernardino de--Histoire Generale des Choses de la Nouvelle-Espagne. Paris, 1880. $300.00 (contemp. three-quarter morocco)

--Historia General de las Cosas de Nueva Espana. Mexico, 1938. 5 vols. $150.00 (orig. cloth)

--A History of Ancient Mexico. Nashville, 1932- . $55.00

--Suma Indiana. Mexico, 1943. $9.00

--Veinte Himnos Sacros de los Nahuas. Mexico, 1958. $15.00 (wraps.)

St. Charles Hotel (New Orleans)--New Orleans, the Paris of America. (New Orleans, 1928). $12.50 (orig. wraps.)

(Saint-Cricq, Laurent)--Travels in South America.... Lond., 1875. 2 vols. $250.00 (three-quarter morocco, light cover wear)

St. John, Horace, Mrs.--Audubon, the Naturalist of the New World. Bost., 1863. $75.00 (cloth, spines worn at extremities)

St. John, John--The California Tourist's Guide Book. S.F., 1887. $79.50 (orig. wraps., cover stains)

St. John, Percy B.--The Trapper's Bride.... Lond., 1845. 1st ed. $485.00 (orig. cloth)

St. Martin, Thaddeus--Madame Toussaint's Wedding Day. Bost., 1936. $8.50

Soldias, Adolfo--Historia de la Confederacion Argentina. Buenos Aires, 1892. 5 vols. $400.00 (contemp. half morocco)

Sale, Edith Dabney (Tunis)--Old Time Belles and Cavaliers. Phila., 1912. $50.00 (one of 50 numbered copies, cloth, hinges starting, lightly foxed, bookplate), $20.00

Sales, Reno H.--Underground Warfare at Butte. (Butte), 1964. $15.00

Salinger, Jerome David--The Catcher in the Rye. Bost., 1951. 1st ed. $275.00 (cloth, bookplate)

--Nine Stories. Bost., (1953). $200.00 (name stamp on front free endpaper)

(N.Y., 1954). $10.00 (stiff wraps.)

Salisbury, Albert P.--Two Captains West. Seattle, (1950).
$37.50
N.Y., (1950). $20.00
Salisbury, Oliver Maxson--The Customs and Legends of the
Thlinget Indians.... N.Y., 1962. $4.45
Salmon, Lucy Maynard--The Newspaper and the Historian.
N.Y., 1923. $25.00
Salter, Edwin--A History of Monmouth and Ocean Counties....
Bayonne, 1890. $20.00 (leatherette, one of 1000 numbered
copies)
Samper, Jose Maria--Ensayo Sobre las Revoluciones Politicas....
(Bogata), 1969. $8.50 (wraps.)
Sampson, Anthony--The Sovereign State of ITT. N.Y., (1973).
1st ed. $16.00
Sams, Anita--Wayfarers in Walton. (Monroe, Ga., 1967).
$25.00 (presentation copy)
Samuels, Ernest--Henry Adams, the Middle Years. Camb.,
1958. $15.00
Sanborn, Ralph--A Bibliography of the Works of Eugene
O'Neill. N.Y., 1931. 1st ed. $65.00 (orig. cloth, one of
500 copies)
Sanchez, Jose Maria--Viage a Texas en 1828-1829. Mexico,
1939. $50.00 (orig. printed wraps, unopened)
Sanchez, Luis Alberto--Una Mujer Sola Contra el Mundo.
(Buenos Aires, 1942). $10.00 (wraps., lightly foxed)
--Victor Raul Haya de la Torre.... Lima, 1979. $12.00
(wraps.)
Sanchez Azcona, Juan--La Etapa Maderista de la Revolucion.
Mexico, 1960. $12.50 (wraps.)
Sancho, Pedro--An Account of the Conquest of Peru....
N.Y., 1917. $85.00 (cloth, one of 250 numbered copies)
Sandburg, Carl--Abraham Lincoln: the War Years. N.Y.,
(1939). 4 vols. 1st ed. $45.00
--Good Morning, America. N.Y., 1928. 1st ed. $35.00
(orig. cloth, edges and corners lightly worn)
--Home Front Memo. N.Y., (1942). 1st ed. $45.00
--A Lincoln Preface. N.Y., (1953). $10.00
--Remembrance Rock. N.Y., (1948). $35.00 (cloth)
Sandels, G.M. Waseurtz af--A Sojourn in California.... S.F.,
1945. $100.00 (one of 300 copies)
Sanders, Harland--Life as I Have Known It Has Been Finger
Lickin' Good. Carol Stream, 1974. $10.00
Sanders, Jennings Bryan--Evolution of Executive Departments
of the Continental Congress.... Chapel Hill, 1935. 1st
ed. $25.00

Sanders, John--Memoirs of the Military Resources of the Valley
of the Ohio. Pitts., 1845. $175.00 (half morocco, contemp.
manuscript corrections in ink)
Sanderson, Ivan Terence--The Natural Wonders of North
America. Lond., 1962. $37.00 (cloth)
Sandham, Alfred--Montreal and Its Fortifications. (Montreal,
1874). 1st ed. $100.00
Sandoz, Mari--The Buffalo Hunters. N.Y., 1954. 1st ed.
$35.00 (advance presentation copy)
--Crazy Horse.... N.Y., 1942. 1st ed. $22.50 (binding
lightly soiled)
--Old Jules. Bost., 1935. $50.00 (cloth, soiled, signed by
author, paper tipped in)
--Slogum House. Bost., 1937. 1st ed. $12.00
Sandzen, Birger--The Smoky Valley. K.C., 1922. $25.00
(boards)
Sanford, David A.--Indian Topics. N.Y., (1911). $45.00
(orig. cloth, spine faded)
Sanford, George B.--Fighting Rebels and Redskins. Norman,
(1969). $25.00, $22.50
Sanford, Laura G.--The History of Erie County.... Phila.,
1862. 1st ed. $60.00. N.p., 1894. $45.00
Sanford, Nettie--History of Marshall County, Iowa. Clinton,
1867. $95.00
Sanger, Margaret--Margaret Sanger. N.Y., (1938). 1st ed.
$47.50
--Motherhood in Bondage. N.Y., 1928. 1st ed. $20.00
(worn around edges)
--Woman and the New Race. N.Y., 1920. 1st ed. $11.00
(backstrip faded)
Sangster, Margaret Elizabeth (Munson)--The Little Kingdom
of Home. N.Y., (1904). 1st ed. $10.00
Sann, Paul--The Lawless Decade. N.Y., (1957). $12.50
Santa Anna, Antonio Lopez de--Apelacion al Buen Criterio de
los Nacionales y Estrangeros.... Mexico, 1849. $375.00
(new calf, few light title stains)
--The Eagle. Austin, 1967. $20.00
Santa Maria, Vicente--The First Spanish Entry Into San Fran-
cisco Bay, 1775. S.F., 1971. $50.00 (cloth, one of 5000
copies), $37.50, $25.00
Santee, Ross--Apache Land. N.Y., 1947. 1st ed. $46.50,
$20.00 (dampstain on back cover), $20.00 (ex-lib.)
--Men and Horses. N.Y., (1926). 1st ed. $100.00
Sapio, Victor A.--Pennsylvania & the War of 1812. Lexington,
Ky., (1970). $25.00

Sarabia Viejo, Maria Justina--Don Luis de Velasco, Virrey de
 Nueva Espana.... Sevilla, Spain, 1978. $12.50 (wraps.,
 inscribed)
Sargent, Fitzwilliam--Les Etats Confederes et l'Esclavage.
 Paris, 1864. $45.00 (disbound)
Sargent, Martin P.--Pioneer Sketches. Erie, Pa., 1891. 1st
 ed. $200.00 (orig. cloth, covers lightly worn and spotted)
Sargent, Nathan--Public Men and Events.... Phila., 1875.
 2 vols. 1st ed. $40.00, $30.00 (orig. cloth)
Sargent, Winthrop--The History of an Expedition Against Fort
 DuQuesne, in 1775.... Phila., 1855. $105.00 (half calf,
 endpapers free with entire case loose from the cover)
Sarmiento, Domingo Faustino--Facundo. Buenos Aires, 1940.
 $7.50 (wraps., front wrap. detached, edges of pages
 browned)
--Life in the Argentine Republic in the Days of the Tyrants....
 N.Y., (1868). $45.00
--Travels. Wash., 1963. $7.50
--Travels in the U.S. in 1847. Princeton, 1970. $10.00
Saroyan, William--The Adventures of Wesley Jackson. N.Y.,
 1946. 1st ed. $13.00
--A Native American. S.F., 1938. 1st ed. $225.00 (one of
 450 signed by author, covers lightly soiled)
Sartorius, Christian--Mexico, Landscapes and Popular Sketches.
 Lond., 1859. $1500.00 (orig. cloth, spine ends lightly
 worn)
--Mexico und die Mexicaner
 See his Mexiko. Landschaftsbuilder....
--Mexiko. Landschaftsbuilder und Skizzen aus dem Volksle-
 ben. Darmstadt, 1859. $1750.00 (cloth, text lightly foxed)
Satterlee, Leroy DeForest--American Gun Makers. Buffalo,
 1940. 1st ed. $25.00
Sauer, Carl Ortwin--The Early Spanish Main. Berkeley, 1966.
 $12.50
Saunders, Audrey--Algonquin Story. N.p., (1948). $15.00
Saunders, Charles Francis--The California Padres and Their
 Missions. Bost., 1915. $20.00 (cloth)
Saunders, Daniel--A Journal of the Travels and Sufferings
 of.... Salem, 1794. $75.00 (contemp. calf, ends rubbed,
 text stained and soiled)
Saunders, James Edmonds--Early Settlers of Alabama. New
 Orleans, 1899. $125.00
Saunders, John Van Dyke--Modern Brazil
 See under Title

Saunders, William--Through the Light Continent. Lond., 1879.
1st ed. $17.50 (inner hinges lightly cracked)
Sauvin, Georges--Un Royaume Polynesien. Iles Hawai. Paris,
1893. $35.00 (orig. wraps., mended)
Savage, Henry--Lost Heritage. N.Y., 1970. $12.50
Savage, Isaac O.--A History of Republic County, Kansas.
Beloit, Ks., 1901. $40.00 (last pages lightly waterstained)
Saveth, Edward Norman--Understanding the American Past.
Bost., (1954). $15.00
Saville, Marshall Howard--Reports on the Maya Indians of Yu-
catan. N.Y., 1921. $9.00
Savoyard, pseud.
See: Newman, Eugene William
Sawyer, Eugene Taylor--The Life and Career of Tiburcio
Vasquez.... Oakland, 1944. $55.00 (one of 500 copies,
bookplate, boards, bottom corners bumped), $48.50 (boards,
one of 500 copies)
Sawyer, Joseph Dillaway--The Romantic and Fascinating Story
of the Pilgrims and Puritans. N.Y., (1925). 3 vols.
$40.00 (ends of spines partly frayed, half leatherette)
Sawyer, Lorenzo--Way Sketches. N.Y., 1926. $62.50 (boards,
one of 385 copies)
Saxon, Lyle--Fabulous New Orleans. N.Y., (1929). $15.00
(few pages dampstained)
New Orleans, 1954. $10.00 (cloth)
--Father Mississippi. N.Y., (1927). 1st ed. $10.00
N.Y., 1928. $20.00
--The Friends of Joe Gilmore, and Some Friends of Lyle Saxon.
N.Y., (1948). $22.50
--Gumbo Ya-Ya....
See: Writers' Program. Gumbo Ya-Ya....
--Old Louisiana. N.Y., (1929). 1st ed. $10.00
Sayers, Michael--Sabotage! N.Y., (1942). 1st ed. $8.00
Scamehorn, Howard Lee--The Buckeye Rovers in the Gold
Rush. Athens, Oh., 1965. $12.25
Scanland, John Milton--Life of Pat F. Garrett.... (Colorado
Springs, 1952). $26.50
Scarlett, Peter Campbell--South America and the Pacific.
Lond., 1838. 2 vols. 1st ed. $325.00 (orig. cloth,
boxed)
Schaack, Michael J.--Anarchy and Anarchists. Chi., 1889.
1st ed. $125.00
Schachner, Nathan--Thomas Jefferson. N.Y., (1951). 2 vols.
$45.00 (inscribed, cloth, lightly chipped), $25.00

Schafer, Betty--Stump Town to Ski Town. Whitefish, Mt.,
 1973. $50.00 (signed)
Schafer, Joseph--Carl Schurz, Militant Liberal. (Evansville,
 Wi., 1930). 1st ed. $17.50
Schaff, Philip--America, a Sketch of Its Political, Social, and
 Religious Character. Camb., 1961. $15.00 (orig.
 cloth)
Schaper, William August--Sectionalism and Representation in
 South Carolina. Wash., 1901. 1st ed. $30.00 (cloth)
Scharf, John Thomas--History of Philadelphia.... Phila.,
 1884. 3 vols. $125.00
--History of Saint Louis City and County.... Phila., 1883.
 2 vols. in 4. 1st ed. $375.00 (later cloth)
Scharff, Robert Francis--Distribution and Origin of Life in
 America. Lond., 1911. $25.00 (cloth, crown lightly
 bumped)
Schaw, Janet--Journal of a Lady of Quality. New Haven,
 1923. $21.95
Scheips, Paul J.--Hold the Fort! Wash., 1971. $8.50 (wraps.,
 ex-lib.)
Schenck, J.S.--History of Warren County, Pennsylvania.
 Syracuse, 1887. $165.00 (rebound)
Schendel, Gordon--Medicine in Mexico. Austin, (1968).
 $25.00
Scherer, James Augustin Brown--The First Forty-Niner....
 N.Y., 1925. $11.50 (stamp on title, boards, covers worn)
--"The Lion of the Vigilantes." Ind., (1939). $25.00
Schertz, Helen Pitkin--Legends of Louisiana. New Orleans,
 (1922). $15.00
Schiel, Jacob Heinrich Wilhelm--Journey Through the Rocky
 Mountains.... Norman, (1959). $20.00
--The Land Between. L.A., 1957. $25.00
Schiffer, Margaret Berwind--Historical Needlework of Penn-
 sylvania. N.Y., (1968). $15.00
Schindler, Harold--Orrin Porter Rockwell. S.L.C., 1966.
 1st. $45.00, $25.00
Schiwetz, Edward Muegge--Buck Schiwetz' Texas. Austin,
 (1960). $18.00
Schlebecker, John T.--A History of Diary Journalism in the
 U.S.... Madison, 1957. $22.50
Schleiffer, Hedwig--Sacred Narcotic Plants of the New World
 Indians. N.Y., (1973). $7.50 (wraps.)
Schlesinger, Arthur Meier--The Imperial Presidency. Bost.,
 1973. $10.00
--New Viewpoints in American History. N.Y., 1923. $12.50
--Prelude to Independence. N.Y., 1958. $10.00

Schluter, Hermann--Lincoln, Labor and Slavery. N.Y., 1965. $15.00

Schmidt, Hans--The United States Occupation of Haiti, 1915-1934. New Brunswick, N.J., (1971). $7.95

Schmidt-Pauli, Edgar von, ed.--We Indians
See: White Horse Eagle

Schmitt, JoAnn--Fighting Editors. San Antonio, (1958). $15.00

Schmitt, Martin Ferdinand, ed.--The Cattle Drives of David Shirk....
See: Shirk, David Lawson

--Fighting Indians of the West. N.Y., 1948. 1st ed. $65.00

--The Settlers' West. N.Y., 1955. $20.00, 18.50, $15.00

Schmitt, Robert C.--Historical Statistics of Hawaii. Honolulu, 1977. $20.00

Schmoe, Floyd Wilfred--For Love of Some Islands. N.Y., 1964. $6.00

--Our Greatest Mountain. N.Y., 1925. $45.00 (cloth)

--Wilderness Tales. Seattle, 1930. $10.00 (wraps., presentation copy)

Schock, Adolph--In Quest for Free Land. San Jose, Ca., 1964. $6.50 (signed)

Schoepf, Johann David--Travels in the Confederation. Phila., 1911. 2 vols. $125.00 (orig. cloth)

Scholefield, Ethelbert Olaf Stuart--British Columbia.... Montreal, (1914). 2 vols. $150.00 (three quarter leather, rubbed)

Schoolcraft, Henry Rowe--History of the Indian Tribes of the U.S. N.p., (1976?). $50.00

--The Indian in His Wigwam. Buffalo, 1848. $100.00, $75.00 (some staining)

--Notes on the Iroquois.... N.Y., 1846. $125.00 (half morocco, small lib. stamp on title)

--Oneota.... N.Y., 1845. $150.00, $100.00

--Summary Narrative of an Exploratory Expedition to the Sources of the Mississippi River, in 1820. Phila., 1855. $100.00, $85.00 (ed. without maps)

--Travels in the Central Portions of the Mississippi. N.Y., 1825. 1st ed. $200.00 (orig. calf)

Schooling, William--The Governor and Company of Adventurers of England Trading.... Lond., 1920. $150.00 (wraps., bit chipped and soiled)

Schorer, Mark--Sinclair Lewis, and American Life. N.Y., (1961). $12.50

Schreiber, Georges--Portraits and Self-Portraits. Bost., 1936.
1st ed. $50.00 (orig. cloth, faded at spine, lightly frayed)
Schuchert, Charles--O.C. Marsh, Pioneer in Paleontology.
New Haven, 1940. $45.00
Schürmann, Joseph J.--Impresario Schürmann; une Tournee
en Amerique. Paris, (1896). 1st ed. $30.00 (orig. wraps.)
Schuler, Arthur--Guide Through North America. N.Y., (1898).
$25.00
Schuler, Stanley--America's Great Private Gardens. N.Y.,
(1967). $15.00 (boards, 1st printing)
Schultz, Christian--Travels on an Inland Voyage Through the
States of New-York, Pennsylvania ... in the Year 1807 and
1808.... N.Y., 1810. 2 vols. in 1. 1st ed. $450.00
(half morocco)
Schultz, Harald--Hombu. Amsterdam, 1962. 1st ed. $10.00
Schurz, Carl--Autobiography.... N.Y., 1961. $15.00
--The Reminiscences of.... N.Y., 1907-08. 3 vols. $35.00
Schurz, William Lytle--Brazil. N.Y., (1961). 1st ed. $6.50
--The Manila Galleon. N.Y., 1939. 1st ed. $45.00 (book-
plate, some edgewear)
Schutz, John A.--Thomas Pownall.... Glendale, 1951. $35.00
(orig. cloth)
Schwartz, George Melvin--Minnesota's Rocks and Waters.
Minne., (1954). $17.50
Schwartz, Stuart B.--Sovereignty and Society in Colonial
Brazil. Berkeley, (1973). 1st ed. $20.00
Schwatka, Frederick--A Summer in Alaska. S.L., 1894.
$45.00
Schweid, Richard--Hot Peppers. Seattle, 1980. $10.00 (minor
edge tear on back cover)
Scobie, James R.--Argentina. N.Y., 1971. $10.00
Scobie, William R.--Buenos Aires. N.Y., 1974. $8.25
Scott, Angelo C.--The Story of Oklahoma City. Oklahoma
City, (1939). $25.00 (ex-lib.)
Scott, Edward B.--A Saga of Lake Tahoe. Crystal Bay,
(1957). 1st ed. $60.00
Scott, Evelyn--Background in Tennessee. N.Y., (1937).
1st ed. $8.50 (bit worn)
Scott, Genio C.--Fishing in American Waters. N.Y., 1869.
1st ed. $75.00 (orig. cloth)
Scott, Hugh Lenox--Some Memories of a Soldier. N.Y., (1928)
$35.00 (1st printing, light mark on spine)
Scott, James Brown--De Grasse a Yorktown. Balt., 1931.
1st ed. $25.00 (orig. cloth)

Scott, James Knox Polk--The Story of the Battles at Gettysburg. Harrisburg, 1927. $12.50

Scott, Joseph--The United States Gazetteer. Phila., 1793. $500.00 (leather)

Scott, Marian Gallagher--Chautauqua Caravan. N.Y., 1939. $20.00

Scott, Ralph--"Country Style." Jamestown, N.D., 1976. $6.00 (signed)

Scott, Reva Lucile (Holdaway)--Samuel Brannan and the Golden Fleece. N.Y., 1944. $25.00

Scott, Robert Falcon--Scott's Last Expedition. N.Y., 1913. 2 vols. $110.00

Scott, Walter--Death Valley Scotty Rides Again. Death Valley, Ca., 1964. $5.00

Scott, Wellington, pseud.--Seventeen Years in the Underworld. N.Y., (1916). $15.00

Scott, William Berryman--A History of Land Mammals in the Western Hemisphere. N.Y., 1937. $20.00 (binding rubbed)

Scripps, Edward Wyllis--Damned Old Crank. N.Y., (1951). 1st ed. $8.00

Scudder, Horace Elisha--James Russell Lowell: a Biography. Bost., 1901. 2 vols. $30.00

Scudder, Ralph E.--Custer Country. Portland, Or., (1963). $13.50

Scully, Michael--This is Texas. Austin, 1936. $30.00

Seabury, Samuel--Letters of a Westchester Farmer (1774-1775). White Plains, N.Y., 1930. $25.00 (orig. cloth)

Seager, Robert--And Tyler Too. N.Y., (1963). $25.00

Sealock, Richard Burl--Bibliography of Place Name Literature. Chi., 1948. 1st ed. $20.00

Searight, Thomas Brownfield--The Old Pike.... Uniontown, Pa., 1894. 1st ed. $42.50

Sears, Alfred Byron--Thomas Worthington, Father of Ohio Statehood. Columbus, (1958). $12.50

(Sears, Robert)--The Shot Heard Round the World. Bost., 1889. $20.00 (cloth, back cover stained, hinges weak)

Seawell, Molly Elliot--The Ladies' Battle. N.Y., 1911. $21.00

Secoy, Frank Raymond--Changing Military Patterns on the Great Plains. Seattle, (1966). $15.00 (boards)

Sedgwick, Charles--Letters From ... to His Family and Friends. Bost., 1870. $17.50 (spine ends chipped)

Sedgwick, Henry Dwight--Cortes the Conqueror. Ind., (1926). $8.50

Sedgwick, Sarah Cabot--Stockbridge, 1739-1939. (Great Barrington, Ma.), 1939. $20.00

Sedgwick, Theodore--Thoughts on the Proposed Annexation of
Texas to the U.S. N.Y., 1844. $80.00 (wraps.)
See, Susan E. (Taylor)--These Also Served. Los Lunes,
N.M., (1960). $25.00
Seewerker, Joseph--Nuestro Pueblo. Bost., 1940. $8.50
(backstrip faded)
Segale, Blandina, Sister--At the End of the Santa Fe Trail.
Milwaukee, (1948). $5.00 (spine lightly torn)
Seger, John Homer--Early Days Among the Cheyenne and
Arapahoe Indians. Norman, (1956). $10.00
Seitz, Don Carlos--Famous American Duels.... N.Y., (1929).
1st ed. $20.00
--The Great Island. N.Y., (1926). $7.50
--Lincoln the Politician. N.Y., (1931). $25.00
Seldes, George--Witch Hunt. N.Y., 1940. $15.00
Sell, Henry Blackman--Buffalo Bill and the Wild West. N.Y.,
1955. 1st ed. $22.50, $20.00, $12.50
Sellar, Robert--The Tragedy of Quebec. Huntingdon, Que.,
1907. 1st ed. $50.00
Selleck, Bessie Janet Woods--Early Settlers of Douglas County,
Missouri. (Berkeley, Ca., 1952). $35.00
Sellers, Charles Coleman--Charles Willson Peale. N.Y., (1969).
$35.00
Sellers, Charles Grier--Andrew Jackson. N.Y., (1971).
$10.00
Selznick, Philip--TVA and the Grass Roots. Berkeley, 1953.
$22.50
Semmes, Raphael--The Campaign of General Scott in the Valley
of Mexico. Cinci., 1852. $150.00 (orig. cloth, binding
faded)
Senan, Jose Francisco de Paula--The Letters of Jose Senan....
(S.F.), 1962. $15.00 (one of 1000 copies)
Seng, R.A.--Brink's, the Money Movers. (Chi., 1959).
$14.50
Senn, Nicholas--In the Heart of the Arctics. Chi., (1907).
$35.00
Senour, Faunt--Morgan and His Captors. Cinci., 1865. $25.00
(binding faded and lightly rubbed)
Sergeant, John--Selected Speeches of.... Phila., 1832.
$17.50 (front board loose)
Servan--Schreiber, Jean Jacques--The American Challenge.
N.Y., 1968. 1st ed. $12.50 (cloth)
Service, Robert William--Ballads of a Bohemian. N.Y., 1921.
1st ed. $11.00
--Ballads of a Cheechako. N.Y., 1909. $11.00

--Ploughman of the Moon. N.Y., 1945. $15.00
--Rhymes of a Red Cross Man. N.Y., (1916). $11.00
 Toronto, 1916. $20.00 (light dampstain on part of front
 cover and endleaf)
--Rhymes of a Rolling Stone. Toronto, 1912. $30.00
--The Spell of the Yukon.... N.Y., (1907). $11.00
Seton, Ernest Thompson--Lives of the Hunted. N.Y., 1918.
 $7.50
--Two Little Savages. N.Y., 1925. $6.00
--Wild Animals I Have Known. N.Y., 1900. $7.50
Seton, Grace Gallatin--A Woman Tenderfoot. N.Y., 1901.
 $30.00
Settle, Raymond W.--Overland Days to Montana in 1865.
 Glendale, 1971. $25.00
--Saddles and Spurs. Harrisburg, (1955). 1st ed. $15.00
Settle, William A.--Jesse James Was His Name. Columbia,
 (1966). 1st ed. $20.00
 Caldwell, 1966. $22.50
Sevareid, Erich--Not So Wild a Dream. N.Y., 1946. 1st ed.
 $13.50
Severin, Timothy--Explorers of the Mississippi. N.Y., 1968.
 $35.00, $12.50
Severson, Thor--Sacramento.... (S.F., 1973). $20.00 (one
 of 5000 copies)
Sewall, Samuel--The Diary of Samuel Sewall, 1674-1729. N.Y.,
 1973. 2 vols. $30.00, $25.00 (orig. cloth, boxed)
Seward, Anne--The Women's Department. N.Y., 1924. $25.00
Sewell, Alfred L.--"The Great Calamity!" Chi., 1871. $27.50
 (ex-lib.)
Sexton, John--An Outline History of Tioga and Bradford Coun-
 ties in Pennsylvania. (Elmira, N.Y., 1885). $75.00 (orig.
 cloth)
Seymour, E.S.--Sketches of Minnesota. N.Y., 1850. 1st ed.
 $50.00 (rebound in cloth, ex-lib., pages lightly foxed and
 waterstained), $50.00
Seymour, Flora Warren Smith--Indian Agents of the Old Fron-
 tier. N.Y., 1941. 1st ed. $30.00
Seymour, Silas--Incidents of a Trip Through the Great Platte
 Valley.... N.Y., 1867. 1st ed. $85.00 (orig. cloth)
Shachtman, Max--Sacco and Vanzetti, Labor's Martyrs. N.Y.,
 1927. $60.00 (minor marginalia)
Shakers--A Summary View of the Millennial Church....
 See under Title
Shaler, Nathaniel Southgate--From Old Fields. Bost., 1906.
 $9.50 (two pages torn)

Shallenberger, Eliza Jane (Hall)--Stark County and Its Pio-
neers. Camb., Il., 1876. 1st ed. $65.00 (half leather,
some rubbing)

Shambaugh, Bertha Maud Horack--Amana That Was and Amana
That Is. Iowa City, 1932. $45.00

Shanks, Henry Thomas--The Secession Movement in Virginia,
1847-1861. Rich., (1934). 1st ed. $12.50

Shannon, David A.--The Socialist Party of America. N.Y.,
1955. $15.00 (1st printing)

Shannon, James Patrick--Catholic Colonization on the Western
Frontier. New Haven, 1957. 1st ed. $20.00

Shaplen, Robert--Free Love and Heavenly Sinners. N.Y.,
(1954). 1st ed. $10.00

Sharaff, Irene--Broadway & Hollywood. N.Y., 1976. $12.00

Sharp, Abbie (Gardner)--History of the Spirit Lake Massacre....
Des Moines, 1895. $25.00 (cloth, owner names, cover lightly
worn)

Sharp, Paul Frederick--Whoop-Up Country.... Minne., (1955).
1st ed. $17.50

Sharp, Ronald Hall--South America Uncensored. N.Y., 1945.
$12.50

Sharp, William Frederick--Slavery on the Spanish Frontier.
Norman, 1976. $15.00

Sharpe, Ernest--G.B. Dealey of the Dallas News. N.Y.,
(1955). $15.00

Sharpe, May Churchill--Chicago May, Her Story. N.Y., 1928.
$20.00

Sharpless, Isaac--Political Leaders of Provincial Pennsylvania.
N.Y., 1919. 1st ed. $22.50

Shaw, Albert--Abraham Lincoln.... N.Y., 1929. 2 vols.
1st ed. $27.50

Shaw, Elijah--A Short Sketch of the Life of.... Rochester,
1845. $65.00 (orig. wraps.)

Shaw, Frederic Joseph--Oil Lamps and Iron Ponies.... S.F.,
1949. $40.00 (boards)

Shaw, James--Early Experiences of Pioneer Life in Kansas.
(Atchison, Ks., 1886). $35.00

Shaw, James Clay--North From Texas. Evanston, Il., 1952.
$40.00 (boards, one of 750 numbered copies)

Shaw, John Robert--Narrative of the Life & Travels of....
(Lou., 1930). $75.00 (half leather, one of 300 copies)

Shaw, Luella--True History of Some of the Pioneers of Col-
orado. Hotchkiss, Co., 1909. 1st ed. $65.00 (wraps.),
$65.00 (orig. wraps.)

Shaw, Samuel--The Journals of Major Samuel Shaw.... Bost.,
1847. 1st ed. $25.00 (orig. cloth)
Shawkey, Morris Purdy--West Virginia, in History.... Chi.,
1928. 5 vols. $125.00
Shay, Felix--Elbert Hubbard of East Aurora. N.Y., 1926.
$10.00
Shea, John Dawson Gilmary--Dictionnaire Francais-Onota-
gue.... N.Y., 1859. $250.00 (one of 160 signed copies,
orig. wraps.)
--A French-Onondaga Dictionary.... 1859
See his Dictionnaire Francais-Onontague.... 1859
--A History of the Catholic Church in the U.S.... N.Y.,
(1886-92). 4 vols. $125.00 (orig. cloth, ex-lib.)
Sheardown, Thomas Simpson--Half a Century's Labors in the
Gospel.... Phila., 1865. 1st ed. $50.00 (orig. cloth)
Shearer, Frederick E.--The Pacific Tourist. N.Y., 1881.
$89.50 (orig. cloth, frayed, light dampstain in upper mar-
gins of a few of the pages)
--N.Y., (1970). $15.00
Shebl, James M.--King, of the Mountains. Stockton, 1974.
$15.00
Sheehan, Donald Henry--Essays in American Historiography....
N.Y., 1961. $20.00
Sheeran, James B.--Confederate Chaplain. Milwaukee, (1960).
$17.50
Sheffy, Lester Fields--The Life and Times of Timothy David
Hobart.... Canyon, Tx., 1950. $35.00, $35.00
Sheldon, Charles--The Wilderness of the North Pacific Coast
Islands. N.Y., 1912. $75.00 (cloth, inner hinges cracked,
covers bit soiled)
Sheldon, George--Half Century at the Bay.... Bost., 1905.
$22.50
Sheller, Roscoe--Ben Snipes: Northwest Cattle King. Port.,
(1957). 1st ed. $20.00
Shelley, Henry C.--John Underhill. N.Y., 1932. 1st ed.
$25.00 (cloth, one of 500 numbered copies)
Shelton, Marion Brown--An American Schoolmistress; the Life
of Eliza B. Masters, 1845-1921. N.Y., 1927. $18.00
Shelton, Mason Bradford--Rocky Mountain Adventures. Bost.,
1920. $37.50
Shenk, Hiram Herr--A History of the Lebanon Valley....
Harrisburg, Pa., 1930. 2 vols. $85.00
Shenton, James Patrick--The Reconstruction. N.Y., (1963).
1st ed. $12.50

Shepard, Odell--Pedlar's Progress. Bost., 1937. 1st ed. $60.00 (binding rubbed), $35.00 (cloth, one of 500 signed and numbered copies)

Shepherd, Grant--The Silver Magnet.... N.Y., (1938). 1st ed. $6.00

Shepherd, Jean--In God We Trust. Garden City, 1966. 1st ed. $12.50 (signed)

Sheppard, Muriel (Earley)--Cloud by Day. Chapel Hill, 1947. 1st ed. $30.00

Sheppe, Walter, ed.--First Man West
See: Mackenzie, Alexander

Shepperd, Eli, pseud.
See: Young, Martha

Shepperson, Wilbur Stanley--British Emigration to North America. Minne., (1957). $12.50

Shera, Jesse Hauk--Foundations of the Public Library. Chi., 1949. 1st ed. $15.00

--Historians, Books and Libraries. Cleve., 1953. $10.00

Sherer, Caroline Shaw--How Much He Remembered. N.p., 1952. $6.50

Sheridan, Clare Consuelo (Frewen)--My American Diary. N.Y., (1922). $15.00

Sherman, Eleazer--The Narrative of.... Prov., 1832. 3 vols. in 1. 1st ed. $25.00 (calf, rubbed)

Sherman, John--Recollections of Forty Years in the House, Senate and Cabinet. Chi., 1895. 2 vols. 1st ed. $25.00

Sherman, William Tecumseh--Home Letters of General Sherman. N.Y., 1909. $10.00 (ex-lib.)

--Memoirs of.... N.Y., 1891. 2 vols. in 1. $25.00

--Recollections of California.... Oakland, 1945. $38.50 (buckram, one of 625 copies), $30.00 (one of 625 copies)

--The Sherman Letters. N.Y., 1964. $10.00 (ex-lib., lightly worn)

Sherrill, Robert--The Saturday Night Special.... N.Y., (1973). $12.00

Sherrill, William Lander--Annals of Lincoln County, North Carolina. Charlotte, 1937. 1st ed. $85.00

Sherwell, Guillermo Antonio--Antonio Jose de Sucre.... Caracas, 1924. $15.00

Sherwood, Robert Emmet--Roosevelt and Hopkins.... N.Y., (1948). 1st ed. $20.00 (cloth)

Shettles, Elijah L.--Recollections of a Long Life. (Nash., 1973). $10.00

Shields, Joseph Dunbar--Natchez. Lou., 1930. $20.00 (ex-lib.)

Shiels, Archibald Williamson--The Purchase of Alaska. Seattle, (1967). $25.00

Shiels, William Eugene--King and Church. Chi., 1961. $15.00 (ex-lib. stamps)

Shindler, Mary Dana--A Southerner Among the Spirits. Memphis, 1877. 1st ed. $85.00 (orig. cloth, ends rubbed, spine darkened, bookplate partially removed)

Shinn, Charles Howard--Mining Camps. N.Y., 1948. 1st ed. $25.00

Shipek, Florence C.--Lower California Frontier. L.A., 1965. $15.00 (one of 600 copies)

Shipp, Barnard--The History of Hernando DeSoto and Florida. Phila., 1881. 1st ed. $150.00 (orig. cloth)

--The Indians and Antiquities of America. Phila., 1897. $125.00 (orig. cloth, incl. errata leaf)

Shippey, Lee--It's an Old California Custom. N.Y., (1948). $10.50

Shipton, Clifford Kenyon--Isaiah Thomas.... Rochester, 1948. $25.00 (orig. cloth)

Shiras, George--Justice George Shiras.... Pitts., (1953). $15.00

Shirk, David Lawson--The Cattle Drives of.... (Portland), 1956. $47.50 (uncut, one of 750 copies)

Shirley, Glenn--Heck Thomas, Frontier Marshal. Phila., 1962. $20.00

--Henry Starr, the Last of the Real Badmen. N.Y., (1965). $15.00

--Six-Gun and Silver Star. Albuquerque, 1955. $21.95

Shirley, James Clifford--The Redwoods of Coast and Sierra. Berkeley, 1937. $15.00 (wood veneer over boards)

Shoemaker, Floyd Calvin--Missouri and Missourians. Chi., 1943. 5 vols. 1st ed. $75.00

Shoemaker, Henry Wharton--Indian Folk-Songs of Pennsylvania. Ardmore, Pa., 1927. $42.00 (orig. cloth, one of 300 signed copies)

--Juniata Memories. Phila., (1916). $50.00 (orig. cloth, inscribed and signed)

--Mountain Minstrelsy of Pennsylvania. Bost., 1931. 1st ed. $35.00 (orig. cloth)

--North Pennsylvania Ministrelsy.... Altoona, Pa., 1923. $37.50 (orig. wraps.)

--South Mountain Sketches. Altoona, Pa., 1920. $60.00 (orig. cloth, with author's presentation slip pasted down on inside front cover)

Shortt, Adam--Canada and Its Provinces. Toronto, 1914-17. 23 vols. $650.00 (morocco, ltd. numbered ed.)

The Shot Heard Round the World
 See: (Sears, Robert)
Shrader, Forrest B.--A History of Washington County, Ne-
 braska. (Omaha, 1937). $30.00 (cloth, back hinge start-
 ing, cover lightly soiled)
Shriver, William Payne--Immigrant Forces. N.Y., 1913.
 $12.50 (wraps., edge wear)
Shulman, Harry Manuel--Slums of New York. N.Y., 1938.
 $17.50
Shulman, Irving--Valentino. N.Y., 1967. 1st ed. $12.50
Shumate, Albert--The California of George Gordon.... Glen-
 dale, 1976. 1st ed. $20.00
--Francisco Pacheco of Pacheco Pass. (Stockton, 1977). 1st
 ed. $15.00
Shutt, Edwin Dale--"Silver City".... (K.C.), 1976. $15.00
 (cloth, inscribed and signed by author)
Sibley, George Champlin--The Road to Santa Fe
 See: Gregg, Kate Leila
Sibley, Henry H., ed.--Iron Face
 See: Frazer, Joseph Jack
Sigourney, Lydia Howard (Huntley)--Poems. Phila., 1834.
 1st ed. $10.00 (binding faded, spine top torn)
--Traits of the Aborigines of America. Camb., 1822. $75.00
 (rebound in cloth and boards, small chip out of title, light
 foxing, ex-lib.)
Siguenza y Gongora, Carlos de--The Mercurio Volante of....
 L.A., 1932. 1st ed. $150.00 (one of 665 copies)
Silber, Irwin--Songs of the Civil War. N.Y., 1960. $30.00
Silcox, Charles Edwin--Catholics, Jews and Protestants. N.Y.,
 (1934). 1st ed. $20.00
Sill, Edward Rowland--The Poetical Works of.... Bost., (1906).
 $16.00
Silliman, Augustus Ely--A Gallop Among American Scenary.
 N.Y., 1881. $15.00
Silliman, Benjamin--A Description of the Recently Discovered
 Petroleum Region in California. N.Y., 1865. $1500.00
 (orig. printed wraps., slipcased)
--Remarks, Made on a Short Tour, Between Hartford and Que-
 bec.... New-Haven, 1820. 1st ed. $140.00 (boards,
 spine rubbed, lacks label)
Silva, E.R.S.--Mexican History. Mexico, 1965. $15.00 (wraps
Silva Castro, Raul--Prensa y Periodismo en Chile.... Santiago
 1958. $10.00 (covers and hinges taped, ink marked, read-
 ing copy only)

Silver, Arthur Peters--Farm-Cottage, Camp and Canoe in Maritime Canada. Lond., (1908). $30.00 (spine faded)
Silver, James W., ed.--The Confederate Soldier
 See: Wilson, LeGrand James
Silvert, Kalman H.--Reaction and Revolution in Latin America. New Orleans, (1961). 1st ed. $12.50
Simister, Florence Parker--The First Hundred Years. Prov., 1967. $12.50
Simkins, Francis Butler--Pitchfork Ben Tillman.... Baton Rouge, 1944. 1st ed. $45.00, $12.50
--The Women of the Confederacy. Rich., 1936. 1st ed. $30.00
Simmons, Dawn Langley--A Rose for Mrs. Lincoln. Bost., (1970). $12.50
Simmons, Marc--Witchcraft in the Southwest. Flagstaff, (1974). 1st ed. $18.50 (signed by author)
Simmons, Virginia McConnell--Ute Pass. Denver, (1963). $6.50
Simmons, Walter--Joe Foss, Flying Marine
 See: Foss, Joe
Simms, William Gilmore--The Yemassee. N.Y., (1898). 1st ed. $10.00
Simon, George Thomas--Glenn Miller and His Orchestra. N.Y., (1974). $17.50
Simon, Mina Lewiton--Lighthouses of America. N.Y., (1964). $10.00
Simonds, William Adams--Edison.... N.Y., (1940). $15.00
--Kamaaina, a Century in Hawaii. N.p., 1949. $25.00
Simons, Algie Martin--Social Forces in American History. N.Y., 1911. 1st ed. $19.00 (front endpaper lacking)
Simpkinson, Francis Guillemard--H.M.S. Sulphur at California....
 See: Pierce, Richard A., comp.
Simpson, Alexander G.--The Life of a Miner in Two Hemispheres. N.Y., (1903). 1st ed. $30.00
Simpson, Charles Torrey--In Lower Florida Wilds. N.Y., 1920. $15.00 (ex-lib.)
Simpson, George Lee--The Cokers of Carolina. Chapel Hill, 1956. $25.00
Simpson, James Hervey--Navaho Expedition. Norman, (1964). $30.00
Simpson, Lesley Bird--Many Mexicos. N.Y., 1946. $8.00
--The San Saba Papers....
 See: Nathan, Paul D.

Sims, Edward H.--American Aces in Great Fighter Battles of
World War II. N.Y., (1958). $10.00
Sims, Orland L.--Gun-Toters I Have Known. Austin, (1967).
$65.00 (orig. cloth, one of 750 copies)
Sinclair, Andrew--The Available Man. N.Y., (1965). $12.50
--Prohibition, the Era of Excess. Bost., (1962). $17.50
Sinclair, Bertha (Muzzy)--Chip of the Flying-U. N.Y., (1904).
1st ed. $15.00
--Good Indian. N.Y., 1912. 1st ed. $15.00
--The Heritage of the Sioux. Bost., 1916. $15.00
--Lonesome Land. Bost., 1912. $15.00
--Starr of the Desert. Bost., 1917. $15.00
Sinclair, Marjorie--Nahienaena, Sacred Daughter of Hawaii.
Honolulu, 1976. $8.00
Sinclair, Mary Craig (Kimbrough)--Southern Belle. Phoenix,
1962. $21.00
Sinclair Oil Company--A Great Name in Oil. (N.Y., 1966).
$12.50
Sinclair, Upton Beall--American Outpost. N.Y., (1932).
$19.50 (newly rebound in library buckram)
--The Brass Check.... Pasadena, (1920). $35.00 (orig.
cloth, inscribed by author to Hall Caine, edges worn, cov-
ers soiled and stained), $12.00 (wraps.)
--The Flivver King. Pasadena, (1937). 1st ed. $65.00 (orig.
wraps., wraps. a bit soiled and worn), $15.00
--A Giant's Strength.... Monrovia, Ca., (1948). 1st ed.
$35.00 (orig. printed wraps., edges and spine faded, fore-
edge lightly dampstained)
--The Goose-Step.... Pasadena, (1923). $20.00
--The Jungle. N.Y., 1906. $10.00 (binding strained and
lightly worn, upper margins lightly dampstained)
--100%. Pasadena, (1920). $45.00 (orig. wraps., spine
edges lightly worn, wraps. and pages lightly browned)
--Springtime and Harvest. N.Y., (1901). 1st ed. $95.00
(author's presentation copy)
--Upton Sinclair Presents William Fox. L.A., (1933). 1st
ed. $12.50, $7.50
--A World to Win. N.Y., 1946. $15.00
Singmaster, Elsie--Pennsylvania's Susquehanna. Harrisburg,
1950. $25.00
Sinnott, James J.--Downieville: Gold Town on the Yuba.
Volcano, Ca., 1972. 1st ed. $25.00 (signed by the au-
thor, some corrections by the author penned in)
The Sioux Indians. N.Y., 1973. $10.00 (one of 500 copies)
Sipe, Chester Hale--Fort Ligonier and Its Times. Harrisburg,
Pa., 1932. 1st ed. $50.00 (orig. cloth)

--The Indian Chiefs of Ṗennsyvlania. Butler, Pa., (1927).
$75.00 (orig. cloth)
--The Indian Wars of Pennsylvania. Harrisburg, 1929. $95.00
(orig. cloth, inner hinges weak)
Sipes, William B.--The Pennsylvania Railroad. Phila., 1875.
1st ed. $100.00 (light wear on spine; orig. cloth)
Siringo, Charles A.--History of "Billy the Kid." Austin,
(1967). $20.00
--A Lone Star Cowboy. Santa Fe, 1919. $100.00
--Riata and Spurs. Bost., 1927. 1st ed. $200.00 (orig.
cloth, light use), $65.00, $50.00 (cloth, lightly frayed at
top and bottom of spine)
Sisson, Daniel--The American Revolution of 1800. N.Y., 1974.
$10.00
Sisson, James E.--Jack London First Editions. Oakland, 1979.
$65.00 (autographed by authors)
Sisters of Charity of the Blessed Virgin Mary, Dubuque, Iowa
--In the Early Days. S.L., 1925. $22.00
Sitgreaves, Lorenzo--Report of an Expedition Down the Zuni
and Colorado Rivers. Wash., 1853. $300.00 (contemp.
calf, light binding wear), $175.00 (contemp. calf, orig.
wraps. bound in, lacks two reptile plates, foxed)
La Situacion Politica, Militar y Economica en la Republica Mex-
icana.... Mexico, 1913. 1st ed. $125.00 (orig. wraps.,
foot of spine mended)
Siviter, Anna (Pierpont)--Recollections fo War and Peace,
1861-1868. N.Y., 1938. 1st ed. $20.00 (ex-lib., light
wear to extremities)
Sixteenth-Century Mexico. Albuquerque, (1974). $15.00
Skaggs, William Henry--The Southern Oligarchy. N.Y., 1924.
1st ed. $12.50 (cloth)
Skarstedt, Ernst Teofil--California.... Seattle, 1910. $25.00
(covers dampstained)
Skarsten, M.O.--George Drouillard.... Glendale, 1964. 1st
ed. $50.00, $25.00, $20.00
Skeaping, John--The Big Tree of Mexico. Bloomington, 1953.
$6.50
Skelton, Raleigh Ashlin--The Vinland Map and the Tartar Re-
lation. New Haven, 1965. $50.00
Sketches of the Sixties
See: Harte, Bret
Skinner, Charles Montgomery--Myths & Legends of Our New
Possessions & Protectorate. Phila., 1900. $25.00 (lacks
free endpaper)
--Myths & Legends of Our Own Land. Phila., 1896. 2 vols.
$12.00 (cloth)

Skinner, Constance Lindsay--Beavers, Kings and Cabins.
N.Y., 1933. 1st ed. $10.00

Skinner, Harriet H.--Oneida Community Cooking. Oneida,
N.Y., 1873. $100.00 (orig. wraps., some soiling and
minor defects)

Skinner, Milton Philo--The Yellowstone Nature Book. Chi.,
(1924). 1st ed. $8.50

Slade, William--Speech of Mr. Slade, of Vermont, on the Right
of Petition. Wash., 1840. $8.50 (later wraps.)

Slattery, T.P.--The Assassination of D'Arcy McGee. Toronto,
1968. $25.00

Slaughter, Philip--A Sketch of the Life of Randolph Fairfax....
(Balt., 1878). $47.50 (binding faded and stained, lacks
part of back endleaf)

Sleeper, Jim--Turn the Rascals Out. Trabuco Canyon, Ca.,
1973. $15.00, $14.50 (signed)

Sletten, Harvey M.--Growing Up on Bald Hill Creek. Ames,
Ia., 1977. $6.50

Slevin, Joseph Richard--The Amphibians of Western North
America. S.F., 1928. $15.00

Slick, Sewell Elias--William Trent and the West. Harrisburg,
Pa., (1947). $25.00

Sloan, Alfred Pritchard--Adventures of a White-Collar Man.
N.Y., 1941. 1st ed. $12.00, $12.00

--My Years With General Motors. Garden City, 1964. $14.00,
$12.50

Sloan, Charles Henry--Biography of Frank W. Sloan, Banker....
Lincoln, 1937. $15.00 (author's autographed letter)

Sloan, Edward William--Benjamin Franklin Isherwood, Naval
Engineer. Annapolis, 1965. 1st ed. $20.00, $15.00

Sloan, John A.--North Carolina in the War Between the States.
Wash., 1883. 1st ed. 2 separate parts. $400.00 (orig.
printed wraps.)

Slocum, George Mertz--Where Tex Meets Mex. N.p., 1927.
1st ed. $40.00 (orig. cloth)

Slosser, Gaius Jackson--They Seek a Country. N.Y., 1955.
$15.00

Slosson, Edwin Emery--Easy Lessons in Einstein. N.Y., 1920.
1st ed. $17.50

Small, Henry Beaumont, comp.--The Canadian Handbook and
Tourist's Guide. Montreal, 1866. $225.00 (cloth, auto-
graphs on front fly)

Small, Herman Wesley--Hitory of Swan's Island.... Ellsworth,
Me., 1898. $35.00 (ex-lib.)

Smalley, George Herbert--My Adventures in Arizona. Tucson,
1966. $16.50

Smallwood, William Martin--Natural History and the American
Mind. N.Y., 1941. 1st ed. $35.00
Smart, Charles Allen--Viva Juarez! Phila., (1963). 1st ed.
$10.00 (owner name)
Smedley, Robert C.--History of the Underground Railroad in
Chester.... Lancaster, Pa., 1883. $75.00 (orig. cloth)
Smet, Pierre Jean de
See: DeSmet, Pierre Jean
Smith, Abbot Emerson--James Madison. N.Y., 1937. $25.00
Smith, Alfred Emanuel--Campaign Addresses.... Wash., (1929).
$30.00 (inscribed, cloth)
Smith, Alice Elizabeth--James Duane Doty, Frontier Promoter.
Madison, (1954). $7.50
Smith, Amanda (Berry)--An Autobiography.... Chi., 1893.
$15.00
Smith, Arthur Douglas Howden--Commodore Vanderbilt. N.Y.,
1927. 1st ed. $20.00
--John Jacob Astor.... Phila., 1929. 1st ed. $20.00 (a bit
rubbed and dull)
Smith, Ashbel--Reminiscences of the Texas Republic. Austin,
(1920). $75.00 (orig. wraps.)
Smith, Benjamin T.--Private Smith's Journal. Chi., 1963.
$15.00
Smith, Bradford--Yankees in Paradise. Phila., (1956).
$12.50
Smith, Charles Alphonso--O. Henry. Lond., 1916. $15.00
(orig. cloth, endpapers foxed)
Garden City, 1916. $27.50
Smith, Charles Card--A Short Account of the Massachusetts
Historical Society. Bost., 1908. 1st ed. $10.00
Smith, Clark Ashton--The Double Shadow and Other Fanta-
sies. (Auburn, Ca., 1933). 1st ed. $125.00 (orig. printed
wraps., inscribed and dated)
Smith, Clive Bamford--Builders in the Sun. N.Y., (1967).
$12.00
Smith, Dama Margaret--Hopi Girl. Stanford, 1931. $30.00
(bent and torn in margin, presentation copy)
--I Married a Ranger. Stanford, (1930). $20.00 (cloth,
lightly faded, owner inscription)
Smith, DeCost--Martyrs of the Oblong and Little Nine. Cald-
well, 1948. $25.00 (one of 1000 copies), $25.00
Smith, Dwight LaVern, ed.--Down the Colorado
See: Stanton, Robert Brewster
--From Greene Ville to Fallen Timbers. Ind., 1952. $15.00
(wraps.)

Smith, Edmund Banks--Governor's Island.... N.Y., 1923.
$25.00 (presentation copy)
Smith, Ellen Hart--Charles Carroll of Carrolton. Camb., 1942.
1st ed. $12.50 (cloth)
Smith, Francis Hopkinson--Colonel Carter's Christmas. N.Y.,
1903. 1st ed. $45.00 (inscribed, bookplate, edges and
corners lightly worn, lettering lightly rubbed)
--A Gentleman Vagabond and Some Others. Bost., 1895.
$50.00 (orig. cloth, author's presentation copy, spine
darkened, edges lightly rubbed)
--Kennedy Square. N.Y., 1911. 1st ed. $65.00 (advance
copy, head of spine lightly worn)
Smith, Frank--Thomas Paine, Liberator. N.Y., 1938. $12.50
Smith, Gene--The Shattered Dream. N.Y., 1970. 1st ed.
$10.00
Smith, George--History of Delaware County, Pennsylvania.
Phila., 1862. $50.00
Smith, George Winston--Life in the North During the Civil
War. (Albuquerque, 1966). $15.00 (cloth)
Smith, Hannah Whitall--Philadelphia Quaker.... N.Y., (1950).
$10.00 (orig. cloth)
Smith, Harold S.--I Want to Quit Winners. Englewood Cliffs,
(1961). $12.50
Smith, Harvey H.--Lincoln and the Lincolns. (N.Y., 1931).
$35.00
Smith, Helen Evertson--Colonial Days & Ways as Gathered
From Family Papers. N.Y., 1901. $15.00
Smith, Helena Huntington--The War on the Powder River.
N.Y., (1966). 1st ed. $20.00
Smith, Henry Justin--Chicago.... N.Y., (1931). $15.00
--Deadlines. Chi., 1922. $25.00
Smith, Jedediah Strong--The Southwest Expedition of Jedediah
S. Smith. Glendale, 1977. $75.00, $45.00
--The Travels of Jedediah Smith. Santa Ana, 1934. $200.00
(binding yellowed and somewhat soiled)
Smith, Jerome--Natural History of the Fishes of Massachu-
setts.... Bost., 1833. $25.00 (contemp. boards, ends
rubbed, paper darkened, hinge repaired)
Smith, John--The Generall Historie of Virginia, New-England
and the Summer Isles. Cleve., (1966). $125.00 (vellum),
$30.00 (box soil)
Smith, Joseph--Old Redstone. Phila., 1854. $45.00 (orig.
cloth)
Smith, Lawrence Breese--Dude Ranches and Ponies. N.Y.,
1936. $25.00

Smith, Lincoln--The Power Policy of Maine. Berkeley, 1951.
$25.00
Smith, Matthew Hale--Bulls and Bears of New York. Hart.,
1873. 1st ed. $55.00
Smith, Nicol--The Jungles of Dutch Guiana. Garden City,
(1943). $8.50
Smith, Oliver Hampton--Early Indiana Trials. Cinci., 1858.
$30.00
Smith, Page--As A City Upon a Hill. N.Y., 1971. $10.00
--John Adams. Garden City, 1962. 2 vols. $25.00
Smith, R.A.--Philadelphia as it is in 1852. Phila., 1852.
$175.00 (orig. cloth), $50.00 (orig. cloth, rubbed, lacks
map)
Smith, Rembert Gilman--Politics in a Protestant Church. At-
lanta, 1930. $30.00
(Smith, Richard McAllister)--The Confederate Spelling Book....
Rich., 1865. $150.00 (contemp. boards, front cover de-
tached, lacks endpapers)
Smith, Samuel--History of the Province of Pennsylvania.
Phila., 1913. $25.00
Smith, Samuel Francis--Poems of Home and Country. Bost.,
1895. $10.00
Smith, Samuel Robert--History of the Wyoming Valley. Kings-
ton, Pa., 1906. $10.00
Smith, Tevis Clyde--Frontier's Generation. Brownwood, Tx.,
1931. 1st ed. $35.00 (orig. wraps.)
Smith, Thomas Lynn--Brazil. Baton Rouge, 1954. $15.00
(one stamp)
Smith, Truman--Speech of Mr. Truman Smith of Connecticut,
on the Physical Character of the Northern States of Mex-
ico.... (Wash., 1848). $25.00 (self-wrap.)
Smith, Walter J.--Legends of Wailua. (Lihue, Hawaii), 1955.
$7.00 (wraps.)
Smith, William--A Brief State of the Province of Pennsylvania.
N.Y., 1865. $35.00 (wraps., one of 200 copies)
Smith, William Fielding--Diamond Six. Garden City, 1958.
1st ed. $10.00
Smith, William Henry--The St. Clair Papers. Cinci., 1882.
2 vols. 1st ed. $125.00 (orig. cloth, hinges mended, light
wear to spine)
Smith, William L.G.--Fifty Years of Public Life.... N.Y.,
1856. $50.00 (orig. cloth, frayed)
--Life at the South. Buffalo, 1852. 1st ed. $100.00 (cloth,
few spots on cover), $22.50 (binding lightly faded)
Smith, William Rudolph--Incidents of a Journey From

Pennsylvania to Wisconsin Territory, in 1837. Chi., 1927.
$65.00 (one of 115 copies), $35.00 (cloth, one of 115 cop-
ies)

Smith, William Stephens--The Trials of William S. Smith, and
Samuel G. Ogden for Misdemeanours.... N.Y., 1807.
$125.00 (calf)

Smith, Zachary Frederick--The Battle of New Orleans. Lou.,
1904. $30.00

Smither, Harriet, ed.--Journals of the Sixth Congress of the
Republic of Texas, 1841-1842....
See: Texas (Republic) Congress

Smole, William J.--The Yanoama Indians. Austin, 1976. $15.00

Smucker, Samuel Mosheim, ed.--The Religious, Social and Po-
litical History fo the Mormons
See: (Mayhew, Henry)

Smurr, J. W.--Historical Essays on Montana and the North-
west. Helena, 1957. 1st ed. $15.00 (wraps., one of
2000 copies)

Smyth, Emily Lane--Discourses and Letters Commemorative of
Emily Lane Smyth
See: Smyth, Frederick

Smyth, Frederick--Discourses and Letters Commemorative of
Emily Lane Smyth. Manchester, N.H., 1885. $37.50
(backstrip lightly faded)

Smyth, Henry DeWolfe--A General Account of the Development
of Methods Using Atomic Energy for Military Purposes....
Wash., 1945. $450.00 (orig. wraps.)

(Snelling, William Joseph)--A Brief and Impartial History of
the Life and Actions of Andrew Jackson. Bost., 1831.
$35.00 (orig. boards, lacks endleaves and frontis.)

Snively, William Daniel--Satan's Ferryman. (N.Y., 1968).
$10.00 (inscribed copy) .

Snow, Edward Rowe--Famous Lighthouses of America. N.Y.,
1955. $12.50

--Great Storms and Famous Shipwrecks of the New England
Coast. Bost., (1943). 1st ed. $20.00 (cloth, spine
lightly rubbed)

--The Romance of Boston Bay. Bost., 1946. $12.50

Snowden, James Henry--The Truth About Mormonism. N.Y.,
(1926). $30.00

Snyder, Albert Benton--Pinnacle Jake.... Caldwell, 1953.
$15.00 (cloth)

Snyder, Gary--Regarding Wave. Iowa City, (1969). $100.00
(one of 280 signed copies)

Snyder, John Francis--Adam W. Snyder.... Virginia, Il.,
1906. $50.00 (cloth, ink stain on top edge, inscribed and
signed by author)
Sobel, Lester A.--Chile & Allende. N.Y., 1974. $10.00
Sochen, June--The Black Man and the American Dream. Chi.,
1971. $15.50
Society of Colonial Wars. New Jersey--Historic Roadsides in
New Jersey. Plainfield, N.J., (1928). $10.00 (extremities
lightly worn)
Society of the Cincinnati. Massachusetts. Institution of the
Society of Cincinnati.... Bost., 1859. $40.00 (orig. cloth)
Solis y Ribadeneyra, Antonia de--Histoire de la Conquete du
Mexique. Paris, 1724. 2 vols. $500.00 (contemp. calf,
spines lightly worn, slipcased)
--Historia de la Conquista de Mexico. Brussels, 1704. $900.00
(calf)
--The History fo the Conquest of Mexico by the Spaniards.
Lond., 1724. $650.00 (contemp. calf, skillfully rebacked,
light cover wear), $400.00 (contemp. calf, rebacked, label,
corners bumped, ex-lib. stamp)
Sollid, Roberta Beed--Calamity Jane. (Helena?), 1958. $12.50
Solorzano Pereyra, Juan de--Politica Indiana.... Madrid,
(1930). 5 vols. $125.00 (wraps.)
Some Early American Hunters. N.Y., 1928. $125.00 (boards,
one of 375 copies)
Somers, A.N.--History of Lancaster, New Hampshire. Con-
cord, 1899. $35.00 (binding partly faded)
Somkin, Fred--Unquiet Eagle. Ithaca, (1967). $12.50 (cloth,
ex-lib.)
Songs of the Cattle Trail....
See: Lomax, John Avery
Songs of the U.S. Military Academy, West Point.... West
Point, (1933). $25.00 (cloth)
Songs of Yale
See: Root, Nathaniel William Taylor
Sonnichsen, Cahrles Leland--I'll Die Before I'll Run. N.Y.,
(1951). 1st ed. $28.50 (signed by author), $17.50
--The Mescalero Apaches. Norman, (1958). 1st ed. $15.00
--Roy Bean. N.Y., 1943. 1st ed. $32.50 (1st printing)
Sorenson, Theodore C.--Kennedy. N.Y., (1965). $10.00
Sorensen, Virginia Eggertsen--A Little Lower Than the An-
gels. N.Y., 1942. $6.00
Sorin, Scota--Blackbird. Detroit, 1907. $12.50 (orig. cover)
Sotheby, William--Saul. Bost., 1808. $10.00 (orig. boards)
Soule, Frank--The Annals of San Francisco. N.Y., 1855.

$300.00 (cloth, light wear and fading to cover, endpapers
soiled, two small marginal tears to map), $300.00 (rebound,
using front and rear original leather), $250.00 (morocco,
binding a bit rubbed), $225.00 (rebound in cloth, ex-lib.,
small map tear), $200.00 (rebound)
Palo Alto, 1966. $150.00 (one of 960 copies)
Soulsby, Hugh Graham--The Right of Search and the Slave
Trade.... Balt., 1933. 1st ed. $15.00 (wraps., front
wrap. torn)
Sousa, John Philip--The Fifth String. Ind., (1902). 1st
ed. $12.50, $10.00
Soustelle, Jacques--Mexico. Cleve., (1967). $12.00
The South Bend Fugitive Slave Case. N.Y., 1851. 1st ed.
$50.00 (orig. wraps.)
South Carolina's Distinguished Women of Laurens County
See: Tolbert, Marguerite
Southard, Charles Zibeon--The Evolution of Trout and Trout
Fishing in America. N.Y., 1928. $150.00 (presentation
copy)
Southern Pacific Company--Along the Rio Grande. Houston,
n.d. $65.00 (orig. wraps.)
The Southern Primer. Rich., 1860. $12.50 (orig. wraps.,
back cover torn)
Sowers, Roy Vernon, ed.--Early California Justice
See: Cosgrave, George
Spain, August O.--The Political Theory of John C. Calhoun.
N.Y., 1951. $20.00
Spalding, Charles Warren--The Spalding Memorial
See: Spalding, Samuel Jones
Spalding, Henry Harmon--The Diaries and Letters of Henry
H. Spalding and Asa Bowen Smith Relating to the Nez
Perce Mission, 1838-1842. Glendale, 1958. 1st ed. $50.00
Spalding, Martin Jones--Miscellanea. Lou., 1855. 1st ed.
$45.00 (orig. cloth, spine mended)
Spalding, Samuel Jones--The Spalding Memorial. Chi., 1897.
1st ed. $35.00 (orig. cloth, recased)
Spanish Approaches to the Island of California, 1628-1632.
S.F., 1975. $75.00 (one of 400 copies)
Spanish Explorers in the Southern U.S., 1528-1543. N.Y.,
1907. $85.00 (orig. cloth)
Sparkes, Boyden--The Witch of Wall Street. Garden City,
1935. $12.00
Sparks, Edwin Erle--The Expansion of the American People.
Chi., 1900. 1st ed. $12.50 (cloth)

Sparks, Jared--The Life of George Washington. Bost., 1839.
$75.00 (rebound in cloth and boards, lightly soiled, owner
signature)
--The Life of John Ledyard, the American Traveller. Camb.,
1828. 1st ed. $450.00 (contemp. calf, neatly rebacked,
lightly foxed)
Camb., 1829. $225.00 (orig. boards, upper cover reat-
tached)
Sparks, Ray G.--Reckoning at Summit Springs. N.p., 1969.
$10.00 (wraps.)
Spaulding, Kenneth A., ed.--On the Oregon Trail
See: Stuart, Robert
Spaythe, Jacob A.--History of Hancock County, Ohio.... To-
ledo, 1903. 1st ed. $45.00 (photostat title, rebound),
$35.00
Speakman, Harold--Mostly Mississippi. N.Y., 1927. 1st ed.
$10.00
Spear, J.W.--"Uncle Billy" Reminisces. Phoenix, 1940. $5.00
Spearman, Frank Hamilton--Whispering Smith. N.Y., 1906. 1st
ed. $20.00 (cloth, bookplate)
Spears, John Randolph--Illustrated Sketches of Death Valley.
(Morongo Valley), 1977. $10.00
Speck, Frank Gouldsmith--Naskapi. Norman, 1935. 1st ed.
$8.50
--A Study of the Delaware Indian Big House Ceremony. Har-
risburg, 1931. 1st ed. $25.00
Speck, Gordon--Northwest Explorations. Portland, Or., (1954).
1st ed. $12.50
Speeches Incident to the Visit of Secretary Root to South
America.... Wash., 1906. $25.00 (ex-lib.)
Spencer, Ambrose--A Narrative of Andersonville.... N.Y.,
1866. $32.50 (ex-lib., lacks back endleaf)
Spencer, Betty Goodwin--The Big Blowup. Caldwell, 1956.
$12.50
Spendlove, F. St. George--The Face of Early Canada. To-
ronto, (1958). $30.00
Spengemann, William C.--Mark Twain and the Backwoods An-
gel. Kent, Oh., (1966). $18.00
Spiller, Robert Ernest--The Cycle of American Literature.
N.Y., (1967). $14.00 (orig. cloth)
--Literary History of the U.S.
See under Title
Spinden, Herbert Joseph--Maya Art and Civilization. Indian
Hills, Co., (1957). $20.00
Spiro, Edward--The Baron of Arizona. N.Y., (1967). $8.50

Spivak, John Louis--Georgia Nigger. N.Y., 1932. 1st ed.
$15.00
--Pattern for American Fascism. N.Y., 1947. $8.00
Spofford, Harriet Elizabeth Prescott--Ballads About Authors.
Bost., (1887). $17.50 (few spots in text, ends of spine
frayed, large paper printing in the A binding)
Spofford, Horatio Gates--A Gazetteer of the State of New
York. Albany, 1813. 1st ed. $50.00 (rebound in cloth,
lacks 2 plates, foxing)
Spolansky, Jacob--The Communist Trail in America. N.Y.,
1951. $8.50
Sprague, Dean--Freedom Under Lincoln. Bost., 1965. $13.50
Sprague, Marshall--Money Mountain. Bost., (1953). $10.00
Spring, Agnes Wright--A Bloomer Girl on Pike's Peak, 1858.
(Denver, 1949). $35.00 (orig. boards)
Spruce, Richard--Notes of a Botanist on the Amazon & Andes.
Lond., 1908. 2 vols. 1st ed. $450.00 (cloth, boxed)
Sprunt, Alexander--South Carolina Bird Life. N.Y., (1949).
1st ed. $50.00 (cloth, author's presentation inscription)
Spurr, George Graham--The Land of Gold. Bost., 1881.
1st ed. $12.50
Bost., 1883. $45.00 (signed by author, front hinge cracked,
rubbed at extremities)
Squier, Ephraim George--Adventures on the Mosquito Coast.
N.Y., 1888. $12.50 (binding worn)
--Nicaragua, Its People, Scenery, Monuments.... N.Y., 1852.
2 vols. 1st ed. $400.00 (orig. cloth, bookplates in both
vols., occasional light foxing)
--Notes on Central America. N.Y., 1855. 1st ed. $375.00
(some wear and browning)
--Peru. N.Y., 1877. $250.00 (cloth, bookplate), $40.00
(inner hinges cracking, bottom margins lightly dampstained,
light rubbing)
Lond., 1877. $275.00 (contemp. three-quarter morocco)
--Waikna. N.Y., 1855. $110.00, $40.00
Squires, William Henry Tappey--The Land of Decision. Ports-
mouth, Va., 1931. $40.00 (autographed by author, num-
bered ed., slipcased)
--Unleashed at Long Last.... Portsmouth, Va., 1939. $40.00
(autographed by author, slipcased)
Stacey, May Humphries--Uncle Sam's Camels. Camb., 1929.
1st ed. $25.00 (ex-lib., corners and spine tips wearing)
Stackpole, Edward James--From Cedar Mountain to Antietam...
Harrisburg, (1959). $17.50
--They Met at Gettysburg. Harrisburg, (1956). 1st ed.
$17.50, $15.00

Stackpole, Edwin James--Behind the Scenes With a Newspaper
Man. Phila., 1927. $15.00 (cloth)
Stafford, Jean--The Mountain Lion. N.Y., (1947). 1st ed.
$9.50 (orig. cloth)
Stahle, William--The Description of the Borough of Reading....
Reading, 1841. $125.00 (orig. boards)
Stampp, Kenneth Milton--The Era of Reconstruction.... N.Y.,
1965. 1st ed. $9.50
Standing Bear, Luther--My People the Sioux. Bost., 1928.
1st ed. $35.00
Stanger, Frank Merriman--Sawmills in the Redwoods. (San
Mateo), 1967. 1st ed. $35.00
--South From San Francisco. San Mateo, 1963. $35.00
--Who Discovered the Golden Gate? (San Mateo, Ca.), 1969.
$15.00 (one of 1500 numbered copies)
Stanley, F., pseud.
See: (Crocchiola, Stanley Francis Louis)
Stanley, George F.G., ed.--Mapping the Frontier
See: Wilson, Charles William
Stanley, Henry Morton--The Autobiography of.... Bost.,
(1909). 1st ed. $15.00
Stanton, Elizabeth (Cady)--Eighty Years and More. N.Y.,
(1970). $17.50
Stanton, Gerrit Smith--"When the Wildwood Was in Flower."
N.Y., (1910). $30.00
Stanton, Henry Thompson--Poems of the Confederacy. Lou.,
1900. $25.00
Stanton, Robert Brewster--Down the Colorado. Norman,
(1965). $25.00
Stanton, William Ragan--The Great U.S. Exploring Expedition
of 1838-1842. Berkeley, 1975. $20.00
Stare, Frederick Arthur--The Story of Wisconsin's Great Can-
ning Industry. Balt., 1949. $30.00
Stark, George Washington--The Best Policy. Detroit, 1959.
$15.00
Stark, James Henry--The Loyalists of Massachusetts and the
Other Side of the American Revolution. Bost., 1910.
$22.50
Starkey, Marion Lena--The Devil in Massachusetts. N.Y.,
1950. 1st ed. $5.00
--A Little Rebellion. N.Y., 1955. $15.00
Starnes, George Talmage--Sixty Years of Branch Banking in
Virginia. N.Y., 1931. $17.50
Starr, Frederick--Indians of Southern Mexico. Chi., 1899.
$1200.00 (cloth, one of 500 numbered copies, signed by
author)

Starr, Louis Morris--Bohemian Brigade. N.Y., 1954. $20.00,
$16.00
Starrett, Vincent--Books Alive. N.Y., 1940. 1st ed. $13.50
(binding lightly faded and rubbed)
State Farm Insurance Companies--The First 40. Bloomington,
Il., 1962. $12.50
State Papers and Publick Documents of the U.S. Bost., 1819.
12 vols. $300.00 (cloth, rebound, some browning)
A Statistical Inquiry Into the Condition of the People of
Colour.... Phila., 1849. 1st ed. $300.00
Stearn, William Thomas--Humboldt, Bonpland, Kunth and Trop-
ical American Botany. Lehre, 1968. $15.00 (wraps.)
Stearns, Harold Joseph--A History of the Upper Musselshell
Valley of Montana (to 1920). Reygate, Mt., 1966. $25.00
(spiral binding, signed)
Stearns, Norah Dowell--An Island is Born.... Honolulu, 1935.
$18.00 (inscribed, head chipped)
Stearns, Winfrid Alden--Labrador. Bost., 1884. $15.00 (lacks
binding)
Stebbens, Jane E.--Fifty Years History of the Temperance
Cause.... Hart., 1876. $65.00 (cloth, endpapers lightly
foxed)
Stedman, Edmund Clarence--Nature and Elements of Poetry.
Bost., 1892. $13.50
Stedman, John Gabriel--The Journal of.... Lond., (1962).
$12.50
Steele, Arthur Robert--Flowers for the King. Durham, 1964.
$15.00
Steele, Edward Dunsha--Edward Dunsha Steele, 1829-1865.
Boulder, Co., 1960. $40.00 (one of 500 signed copies)
Steele, James--Old California Days. Chi., 1889. 1st ed.
$27.50 (covers and backstrip soiled)
Steele, James William--To Mexico by Palace Car. Chi., 1884.
1st ed. $100.00 (wraps.)
Steele, John--Across the Plains in 1850.... Chi., 1930.
$150.00 (orig. boards, one of 350 copies)
Steele, Robert V.P.--Between Two Empires. Bost., 1969.
$7.50
--The First President Johnson.... N.Y., 1968. $20.00
Steele's Western Guide Book.... Buffalo, 1846. $35.00 (lacks
map)
Steen, Ralph Wright--The Texas News. Austin, (1955).
$30.00
Steere, Thomas--History of the Town of Smithfield.... Prov.
1881. $20.00

Stefansson, Vilhjalmur--Hunters of the Great North. N.Y.,
(1922). 1st ed. $15.00 (spine lettering effaced, binding
stained, author's presentation)
--Not By Bread Alone. N.Y., 1946. $15.00 (1st printing)
Steffens, Lincoln--The Autobiography of.... N.Y., 1931.
$17.50 (orig. cloth)
Stegner, Wallace Earle--Beyond the Hundredth Meridian.
Bost., 1954. 1st ed. $28.50, $25.00 (cloth)
--The Gathering of Zion. N.Y., (1964). 1st ed. $25.00
Stein, Emanuel--The Labor Boycott. Newton, Ma., 1974.
$15.00 (orig. cloth, one of 500 copies)
Stein, Gertrude--An Acquaintance With Description. Lond.,
1929. $600.00 (orig. white cloth, one of 225 copies signed
by author), $500.00 (buckram, one of 225 copies, signed
by author)
--Tender Buttons.... N.Y., 1914. 1st ed. $375.00 (orig.
boards, a bit rubbed)
Steinbeck, John--Bombs Away. N.Y., 1942. $200.00 (cloth),
$12.50
--Cannery Row. N.Y., 1945. 1st ed. $10.00
--East of Eden. N.Y., 1952. 1st ed. $75.00 (bookplate)
--The Forgotten Village. N.Y., 1941. $185.00 (cloth), $35.00
(orig. cloth, edges lightly soiled), $12.50
--Journal of a Novel. N.Y., (1969). $50.00 (boards, boxed,
one of 600 copies)
--Of Mice and Men. N.Y., 1937. $4.00
--The Pearl. N.Y., 1947. $65.00 (orig. cloth, edges lightly
worn), $7.50
--A Russian Journal. N.Y., 1948. 1st ed. $175.00 (cloth)
--The Short Reign of Pippin IV. N.Y., 1957. 1st ed. $10.00
--Sweet Thursday. N.Y., 1954. 1st ed. $15.00
--The Winter of Our Discontent. N.Y., (1961). 1st ed.
$15.00
Steinberg, Alfred--The First Ten. Garden City, 1967. $10.00
--The Man From Missouri. N.Y., (1962). $20.00, $12.50
Stellman, Louis John--Sam Brannan.... N.Y., 1953. 1st ed.
$27.50
Stelzle, Charles--A Son of the Bowery. N.Y., (1926). 1st
ed. $12.50
Stenzel, Franz--James Madison Alden. Fort Worth, 1975. 1st
ed. $20.00
Stepan, Alfred C.--The Military in Politics. Princeton, 1971.
$10.00
Stephens, Alexander Hamilton--A Contitutional View of the
Late War Between the States. Phila., 1868-70. 1st ed.
$47.50 (newly rebound)

Stephens, Alva Ray--The Taft Ranch. Austin, (1964).
 $15.50 (bookplate)
Stephens, John Lloyd--Incidents of Travel in Central Amer-
 ica.... N.Y., 1841. 2 vols. 1st ed. $750.00 (cloth),
 $425.00 (orig. cloth)
 N.Y., 1848. 2 vols. $250.00 (cloth, somewhat worn along
 extremities, joints of vol. I worn, one plate and one free
 endpaper partially detached)
 Lond., 1854. $375.00 (orig. cloth, spinehead lightly worn)
 New Brunswick, 1949. 2 vols. $45.00 (boxed), $40.00
 (cloth), $20.00
--Incidents of Travel in Yucatan. N.Y., 1843. 2 vols. 1st
 ed. $750.00 (cloth), $600.00 (orig. cloth)
 Lond., 1843. 2 vols. $600.00 (contemp. calf, rebacked)
 N.Y., 1848. 2 vols. $250.00 (cloth, moderately worn along
 edges, light foxing)
Stephens, William Picard--American Yachting. N.Y., 1904.
 $25.00 (ex-lib.)
Stephenson, John B.--Shiloh. Lexington, Ky., 1968. $17.50
Stephenson, Nathaniel Wright--Lincoln, an Account of His Per-
 sonal Life. Ind., (1924). $10.50 (binding bit soiled and
 worn at ends of spine)
 N.Y., (1924). $6.50
--Texas and the Mexican War.... New Haven, 1921. 1st ed.
 $45.00 (orig. cloth)
Stephenson, Wendell Holmes--The Political Career of General
 James H. Lane. Topeka, 1930. $22.50
Stephenson, William--The Store That Timothy Built. Toronto,
 (1969). $20.00
Sterling, Dorothy--Wall Street. Garden City, 1955. $5.00
 (ex-lib.)
Sterling, George--The Testimony of the Suns. S.F., 1927.
 $70.00 (boards), rebacked, light edge wear, one of 300
 numbered copies)
Stern, Norton B.--California Jewish History. Glendale, 1967.
 $25.00
Stern, Philip M.--The Oppenheimer Case. N.Y., 1969. 1st
 ed. $12.50
Stern, Philip Van Doren--The Confederate Navy. Garden
 City, 1962. $20.00
--An End to Valor. Bost., 1958. $16.00
 N.Y., 1958. $10.00
--The Man Who Killed Lincoln. N.Y., 1939. 1st ed. $15.00
Steuben, Friedrich Wilhelm August Heinrich Ferdinand von--
 Regulations for the Order and Discipline of the Troops of

the U.S. Phila., 1794. 2 vols. in 1. $225.00 (contemp. wraps., spine perished, stained)

Stevens, George E.--The City of Cincinnati.... Cinci., 1869. $200.00 (rebound in half leather)

--The Queen City in 1869 See his The City of Cincinnati....

Stevens, George Roy--The Canada Permanent Story.... N.p., 1955. $10.00

Stevens, George Thomas--Three Years in the Sixth Corps. Albany, 1866. $65.00

Stevens, Harry Robert--The Early Jackson Party in Ohio. Durham, 1957. 1st ed. $17.50

Stevens, Henry Newton--Lewis Evans, His Map of the Middle British Colonies.... Lond., 1905. 1st ed. $50.00 (orig. wraps.)

Stevens, Isaac Ingalls--Campaigns of the Rio Grande and of Mexico.... N.Y., 1851. $450.00 (orig. printed wraps., including slipcase)

Stevens, James--Big Jim Turner.... Garden City, 1948. 1st ed. $10.00

Stevens, John Harrington--Personal Recollections of Minnesota and Its People.... Minne., 1890. 1st ed. $25.00

Stevens, Mark--"Like No Other Store in the World." N.Y., 1979. $12.50

Stevens, Montague Farquhard Sheffield--Meet Mr. Grizzly, a Saga on the Passing of the Grizzly. Albuquerque, 1944. $20.00 (new front endpapers)

Stevens, Wallace--Notes Toward a Supreme Fiction. Cummington, Ma., 1942. 1st ed. $1000.00 (one of 80 copies on World Hand and Arrow paper, signed)

Stevens, Walter Barlow--A Reporter's Lincoln.... S.L., 1916. $17.50 (one of 600 copies, rubbed)

Stevens, William Burnham--History fo the Fiftieth Regiment of Infantry, Massachusetts Volunteer Militia.... Bost., 1907. $27.50 (ex-lib.)

Stevenson, Adlai Ewing--Major Campaign Speeches.... N.Y., 1953. $40.00 (signed, one of 1000 copies), $14.00

--What I Think. N.Y., (1956). 1st ed. $12.00

--The Wit and Wisdom of.... N.Y., (1965). $10.00

Stevenson, John Reese--The Chilean Popular Front. Phila., 1942. $18.00

Stevenson, Matilda Coxe (Evans)--The Zuni Indians. Wash., 1904. 1st ed. $125.00 (orig. cloth, rubbed, bumped, lightly shaken)

Stevenson, Robert Louis--Silverado Journal. S.F., 1954. $50.00 (orig. cloth, one of 400 copies)
--The Silverado Squatters. S.F., 1952. $45.00 (one of 900 copies, boards)
Ashland, Or., 1972. $30.00 (boards, one of 500 numbered copies)
Stevenson, Sara (Yorke)--Maximilian in Mexico. N.Y., 1899. $15.00 (covers tanned)
Stevenson, William G.--Thirteen Months in the Rebel Army. N.Y., 1862. 1st ed. $22.50 (binding faded)
Stewart, Donald M.--Frontier Port. L.A., 1966. $7.50 (slip-cased)
Stewart, Edgar Irving--Custer's Luck. Norman, 1971. $22.50
Stewart, George Rippey--The California Trail. N.Y., (1962). 1st ed. $12.50
--Committee on Vigilance. Bost., (1964). 1st ed. $10.00 (cloth)
--Ordeal by Hunger. N.Y., (1936). 1st ed. $35.00, $15.00 Bost., 1960. $22.50
--Take Your Bible in One Hand. S.F., 1939. $10.00 (boards)
Stewart, Lucy Shelton--The Reward of Patriotism. N.Y., 1930. $25.00 (spine faded), $15.00
Stewart, Ramona--Desert Town. N.Y., 1946. 1st ed. $12.50
Stewart, William Brenton--Medicine in New Brunswick. New Brunswick, 1974. $20.00 (inscribed copy)
Stickney, Charles E.--A History of the Minisink Region.... Middletown, N.Y., 1867. 1st ed. $37.50 (spine faded)
Stidger, William LeRoy--Henry Ford.... N.Y., (1923). 1st ed. $10.00
Stiles, Ezra--Letters & Papers.... New Haven, 1933. $20.00 (boards)
--The Literary Diary.... N.Y., 1901. 3 vols. 1st ed. $100.00 (orig. cloth), $100.00 (orig. cloth)
Stiles, Henry Reed--Bundling. N.Y., (1934). $12.00
Stiles, Lela--The Man Behind Roosevelt. Cleve., (1954). $6.50
Still, Bayard--Mirror for Gotham. N.Y., 1956. 1st ed. $35.00 (inscribed, cloth and boards)
Stillman, Chauncey Devereux--Charles Stillman, 1800-1875. N.Y., 1956. $125.00 (cloth, one of 505 numbered copies)
Stillman, Jacob Davis Babcock--An 1850 Voyage. Palo Alto, 1967. $25.00 (orig. cloth, ltd. ed.)
--The Gold Rush Letters of J.D.B. Stillman. Palo Alto, 1967. $15.00 (ltd. ed.)
Stillwell, Lucille--John Cabell Breckinridge.... Caldwell, 1936. $45.00

Stilwell, Hart--Fishing in Mexico. N.Y., 1948. $10.00
--Hunting and Fishing in Texas. N.Y., 1946. $10.00
Stilwell, Joseph Warren--The Stilwell Papers. N.Y., (1948).
1st ed. $14.00
Stimson, Henry Lewis--American Policy in Nicaragua. N.Y.,
1927. 1st ed. $10.00 (cloth)
--On Active Service in Peace and War. N.Y., (1948). 1st
ed. $21.00
Stiness, John Henry--A Century of Lotteries in Rhode Island,
1744-1844. Prov., 1896. $35.00 (orig. wraps., one of
250 copies)
Stirling, Patrick James--The Australian and California Gold
Discoveries.... Edin., 1853. 1st ed. $150.00 (orig. cloth,
top of spine chipped)
Stirling, Yates--Fundamentals of Naval Service. Phila., (1917).
$15.00 (orig. cloth)
Stobo, Robert--Memoirs of Major Robert Stobo, of the Virginia
Regiment. Pitts., 1854. $195.00
Stocker, Harry Emilius--A History of the Moravian Church in
New York City. N.Y., 1922. $15.00 (signed by author,
covers dingy)
Stoddard, Henry Luther--As I Knew Them. N.Y., 1927. 1st
ed. $13.50, $12.50
--Horace Greeley.... N.Y., (1946). 1st ed. $10.00
Stoddard, Herbert L.--The Bobwhite Quail. N.Y., (1931).
1st ed. $100.00
Stoddard, Richard Henry--Henry Wadsworth Longfellow. N.Y.,
1882. $25.00 (corners and spine worn, orig. cloth)
Stoddard, William Osborn--The Battle of New York. N.Y.,
1892. $22.50 (cloth)
Stokes, Thomas Lunsford--The Savannah. N.Y., (1951).
1st ed. $15.00
Stone, Alfred Holt--Studies in the American Race Problem.
N.Y., 1908. $10.00 (binding rubbed and stained, pencil
marks)
Stone, Edwin Martin--The Invasion of Canada in 1775. Prov.,
1867. 1st ed. $22.50 (spine end worn)
Stone, Elizabeth Arnold--Uinta County.... (Laramie, 1924).
$72.50 (one of 500 copies), $65.00 (one of 500 copies,
hinges cracked, some cover wear), $50.00
Stone, Harlan Fiske--Public Control of Business.... N.Y.,
(1940). $15.00
Stone, Irving--Men to Match My Mountains. Garden City,
(1956). 1st ed. $17.95 (author's autograph)
--They Also Ran.... Garden City, 1943. 1st ed. $6.50
Garden City, 1944. $8.50

Stone, Ralph Walter--Pennsylvania Caves. Harrisburg, 1932.
$7.00 (wraps.)

Stone, Rufus Barrett--McKean, the Governor's County. N.Y.,
1926. $22.50 (orig. cloth)

Stone, Walton Edgar--Walton Stone.... N.Y., 1931. 1st ed.
$12.50

Stone, William Hale--Twenty-Four Years a Cowboy and Ranch-
man in Southern Texas and Old Mexico.... Norman, (1959).
$7.50

Stone, William Leete--Letters of Brunswick and Hessian Of-
ficers.... Albany, 1891. 1st ed. $45.00 (owner name)

--Life of Joseph Brant.... N.Y., 1838. 2 vols. 1st ed.
$150.00 (boards and cloth chipped at corners, rebacked,
light foxing, owner signature), $85.00

--The Poetry and History of Wyoming. N.Y., 1841. $25.00
(contemp. three-quarter calf)

--Visits to the Saratoga Battle-Grounds.... Albany, 1895.
1st ed. $35.00

Stone, Witmer--American Animals. Garden City, 1913. $19.50

Strong, Philip Duffield--Horses and Americans. N.Y., 1939.
1st ed. $25.00

Storick, William C.--Gettysburg.... Harrisburg, (1932).
$18.50

Stories and Facts of Alaska
See: (Franklin, Lucia J.)

The Story of Banking in Kansas. (Topeka, 1937). $20.00

Stotler, Jacob--Annals of Emporia and Lyon County. Emporia,
Ks., 1882. $60.00 (ex-lib. markings, bound in hard cov-
ers)

Stotz, Charles Morse--The Architectural Heritage of Early
Western Pennsylvania. (Pitts.), 1966. $35.00

Stotz, Louis--History of the Gas Industry. (N.Y., 1938).
$17.50 (ex-lib.)

Stoughton, John Alden--A Corner Stone of Colonial Commerce.
Bost., 1911. $30.00 (boards, some wear to cover)

Stourzh, Gerald--Benjamin Franklin and American Foreign
Policy. Chi., (1954). 1st ed. $20.00

Stout, Hosea--On the Mormon Frontier. (S.L.C., 1964). 2
vols. 1st ed. $75.00

Stout, Joseph A.--Apache Lightning. N.Y., 1974. $12.50

Stout, Peter F.--Nicaragua. N.Y., 1859. $35.00 (half calf,
lacks spine and map)

Stoutamire, Albert--Music of the Old South. Cranbury, N.J.,
1972. $28.00

Stoutenburgh, John Leeds--Dictionary of the American Indian.
N.Y., (1960). $8.50
Stover, Clara (Lewis)--The Life of Russell Stover. N.Y.,
1957. 1st ed. $15.00 (boards, 1st printing, lacks front
free endpaper)
Stowe, Harriet Beecher--The Chimney-Corner. Bost., 1868.
1st ed. $25.00 (cloth)
--Dred. Bost., 1856. 2 vols. 1st ed. $100.00 (cloth, spine
ends worn, light soiling), $25.00
--A Key to Uncle Tom's Cabin. Bost., 1853. 1st ed. $60.00
(cloth, cover worn, foxing)
--Lives and Deeds of Our Self-Made Men. Hart., 1872. 1st
ed. $15.00 (part of two pages missing, leather, hinges
cracked and lightly rubbed)
--Oldtown Folks. Bost., 1869. 1st ed. $27.50 (some wear
and soil)
--Uncle Sam's Emancipation. Lond., 1853. $40.00 (cloth)
Stowell, John--Don Coronado Through Kansas, 1541.... (Sen-
eca, Ks., 1908). $30.00 (cloth, cover soiled)
Strachan, Grace Charlotte--Equal Pay for Equal Work. N.Y.,
1910. $35.00
Strahorn, Carrie Adell--Fifteen Thousand Miles by Stage.
N.Y., 1911. 1st ed. $175.00 (cloth, erasure streaks on
coated front free endpaper, spine base lightly rubbed)
Strangeways, Thomas--Sketch of the Mosquito Shore, Including
the Territory of Poyais. Edin., 1822. 1st ed. $175.00
(orig. cloth, leather label on spine)
Stratford, Jessie Perry--Butler County's Eighty Years....
N.p., (1934). 1st ed. $50.00
--The Kingdom of Butler, 1857-1970. El Dorado, Ks., (1970).
$12.50 (signed copy)
Stratton, Ella Hines--Wild Life Among the Indians. Phila.,
(1916). $10.00
Strauss, Lewis L.--Men and Decisions. Garden City, (1962).
1st ed. $18.00
Strayer, Martha--The D.A.R. Wash., (1958). 1st ed. $8.50
Street, George Edward--Mount Desert. Bost., 1905. 1st ed.
$20.00 (ex-lib., title repaired)
Street, George G.--Che! Wah! Wah!.... Rochester, 1883.
$1250.00 (orig. morocco)
Street, James--The Civil War. N.Y., (1953). $6.50
--The Revolutionary War. N.Y., 1954. $7.50
Street, Julian Leonard--Abroad at Home. N.Y., 1914. 1st
ed. $15.00 (cloth, ink subscription on endpaper)

Streete, Lemuel Alex--The Stirring Clans. N.Y., (1936).
 1st ed. $17.50
Streeter, Floyd Benjamin--Ben Thompson, Man With a Gun.
 N.Y., (1957). $20.00
--The Kaw. N.Y., (1941). 1st ed. $15.00
Streeter, Nelson R.--Gems From an Old Drummer's Grip.
 (Groton, N.Y.), 1889. $10.00
Streeter, Thomas Winthrop--Bibliography of Texas, 1795-1845.
 Camb., 1955-60. 3 vols. in 5. 1st ed. $850.00 (one of
 600 sets, orig. cloth)
Strong, James Clark--Wah-Kee-Nah and Her People. N.Y.,
 1893. 1st ed. $25.00 (cloth)
Strong, Robert--A Yankee Private's Civil War. Chi., 1961.
 $16.50
Stroup, John Martin--The Pioneers of Mifflin County....
 Lewistown, Pa., 1942. $10.00
Strout, Cushing--Intellectual History in America. N.Y.,
 (1968). $5.00 (ex-lib.)
--The Pragmatic Revolt in American History. Ithaca, (1966).
 $5.00 (paper)
[Strubberg, Friedrich Armand]--The Backwoodman. Bost.,
 1866. $475.00 (orig. cloth)
Stryker, Lloyd Paul--Courts and Doctors. N.Y., 1932. 1st
 ed. $12.50
Stuart, Graham Henry--The Tacna-Arica Dispute. Bost.,
 1927. $8.00 (wraps., spine taped)
Stuart, Granville--Dairy & Sketchbook of a Journey to "Amer-
 ica" in 1866.... L.A., 1963. $40.00 (one of 500 copies),
 $35.00 (one of 500 copies)
--Forty Years on the Frontier.... Glendale, 1957. 2 vols.
 in 1. $50.00
 Glendale, 1967. $45.00
Stuart, Robert--On the Oregon Trail. Norman, (1953). $20.0C
 $13.50
Stuart, Ruth (McEnery)--The River's Children.... N.Y.,
 1904. $10.00 (cloth, binding lightly rubbed)
Stuart-Wortley, Emmeline Charlotte Elizabeth Manners--Travels
 in the United States.... N.Y., 1851. $60.00 (cloth, spine
 crown frayed, lightly foxed)
Stubbs, Stanley A.--Bird;s Eye-View of the Pueblos. Norman
 (1950). $17.50 (inscribed, ex-lib.)
Stuck, Hudson--Voyages on the Yukon and Its Tributaries.
 N.Y., 1917. $25.00 (owner signature, cloth)
Studenski, Paul--Financial History of the U.S. N.Y., 1952.
 1st ed. $20.00 (cloth, ex-lib.)

Studer, Clara--Sky Storming Yankee. N.Y., 1937. 1st ed.
$25.00

Sturge, Joseph--A Visit to the U.S. in 1841. Lond., 1842.
$75.00 (orig. cloth)

Styron, Arthur--The Last of the Cocked Hats. Norman, 1945.
$17.50

Suffern, Arthur Elliott--The Coal Miners' Struggle for Indus-
trial Status. N.Y., 1926. $30.00

Sullivan, Edward Dean--Rattling the Cup on Chicago Crime.
Freeport, 1971. $14.00

Sullivan, Mark--The Education of an American. N.Y., 1938.
1st ed. $16.00, $8.50

Sullivan, Mary--My Double Life. N.Y., (1938). 1st ed.
$12.50

Sullivan, Maurice S.--Jedediah Smith, Trader and Trailbreaker.
N.Y., 1936. 1st ed. $80.00 (top of spine repaired)

Sully, Langdon--No Tears for the General. Palo Alto, (1974).
$8.50

A Summary View of the Millennial Church.... Albany, 1823.
$100.00 (orig. boards), $85.00 (contemp. calf), $50.00
(front cover gone, spine worn, ex-lib.)

Sumner, Charles--Prophetic Voices Concerning America. Bost.,
1874. 1st ed. $15.00 (cloth, front board lightly creased
and stained)

Sumner, William Graham--The Challenge of Facts and Other
Essays. New Haven, 1914. 1st ed. $20.00

--Collected Essays in Political and Social Science. N.Y., 1885.
1st ed. $25.00

--Earth Hunger, and Other Essays. New Haven, (1914).
$20.00

--Folkways. Bost., 1940. 1st ed. $20.00 (underlining)

--The Forgotten Man and Other Essays. New Haven, 1918.
$15.00

--War and Other Essays. New Haven, 1919. $20.00

Sunder, John Edward--Joshua Pilcher, Fur Trader and Indian
Agent. Norman, (1968). $20.00

--Matt Field on the Santa Fe Trail
See: Field, Matthew C.

Sutherland, George--Constitutional Power and World Affairs.
N.Y., 1919. 1st ed. $10.00

Sutley, Zack Taylor--The Last Frontier. N.Y., 1930. 1st
ed. $30.00

Sutro, Theodore--Thirteen Chapters of American History.
N.p., 1905. $12.50 (orig. boards)

Sutter, John Augustus--New Helvetia Diary
See under Title

Sutton, Ann--Yellowstone. N.Y., (1972). 1st ed. $25.00

Sutton, Anthony C.--Wall Street and FDR. New Rochelle, 1975. $12.50

Sutton, Charles--The New York Tombs. Montclair, 1973. $18.00

Sutton, Fred Ellsworth--Hands Up! Ind., (1927). $15.00 (spine worn)

Sutton, Richard L., ed.--The Missouri River See: Griffith, Cecil R.

Swan, Howard--Music in the Southwest.... San Marino, 1952. 1st ed. $14.50, $12.50 (ex-lib.)

Swanberg, W.A.--Jim Fisk. N.Y., (1959). 1st ed. $10.00

--Sickles the Incredible. N.Y., 1956. $15.00, $15.00, $10.00, $9.50 (binding lightly faded)

Swann, Don--Colonial and Historic Homes of Maryland. Balt., (1975). $50.00

Swann, Harry Kirke--Nature in Acadie. Lond., 1895. $29.00 (cloth)

Swannack, Jervis D.--Big Juniper House.... Wash., 1969. $15.00

Swanson, Neil Harmon--The Perilous Flight. N.Y., (1945). $15.00 (orig. cloth)

Swanton, John Reed--The Indian Tribes of North America. Grosse Pointe, Mi., 1968. $15.00

Sward, Keith--The Legend of Henry Ford. N.Y., 1948. 1st ed. $12.50 (occasional light staining)

Swarth, Harry Schelwald--Birds and Mammals of the Stikine River Region of Northern British Columbia and Southeastern Alaska. Berkeley, 1922. 1st ed. $18.00 (wraps.)

Swartzbaugh, Constance H.--The Episcopal Church in Fulton County, Illinois.... Canton, Il., 1959. $15.00

The Swedish Community in Transition. Rock Island, 1963. $10.00

Sweet, Alexander E.--On a Mexican Mustang Through Texas. Hart., 1883. 1st ed. $17.50 (few pages dampstained)

Sweetser, Moses Foster--Picturesque Maine. Port., (1880). $100.00 (cloth, stain affecting top border)

--Summer Days Down East. Port., Me., 1883. $300.00 (cloth, light wear and soiling)

Sweney, Fredric--Painting the American Scene in Watercolor. N.Y., (1964). $20.00

Swett, Charles--A Trip to British Honduras.... New Orleans 1868. $125.00 (orig. wraps.)

Swift, Louis Franklin--The Yankee of the Yards. Chi., 1927. 1st ed. $12.50

N.Y., 1935. $18.00

Swiggett, Howard--The Extraordinary Mr. Morris. Garden
City, 1952. $10.00
Swihart, Altman K.--Since Mrs. Eddy. N.Y., 1931. $30.00
(ex-lib.)
Swisher, Carl Brent--Roger B. Taney.... N.Y., 1936.
$20.00
Syrett, Harold Coffin--Interview in Weehawken. Middletown,
Ct., 1960. $12.50
Szalewicz, Steve S.--Oil Moon Over Pithole. (Titusville),
1958. $12.00
Szash, Margaret--Education and the American Indian. Albu-
querque, 1974. 1st ed. $17.50

- T -

Tabb, John Banister--John Bannister (sic) Tabb on Emily
Dickinson. N.Y., 1950. $25.00 (orig. wraps., one of 500
copies, covers lightly worn and soiled)
Tabeau, Pierre Antoine--Tabeau's Narrative of Loisel's Expe-
dition to the Upper Missouri. Norman, 1939. 1st ed.
$50.00, $45.00, $32.50
Norman, (1968). $7.50
Taft, Helen (Herron)--Recollections of Full Years. Dodd,
Mead, 1914. 1st ed. $30.00
Taft, Philip, ed.--Seventy Years of Life and Labor
See: Gompers, Samuel
Taft, Robert--Artists and Illustrators of the Old West. N.Y.,
1953. 1st ed. $40.00, $25.00
Taft, Mrs. William Howard
See: Taft, Helen (Herron)
Talbot, Ethelbert--My People of the Plains. N.Y., 1906. 1st
ed. $15.00 (cloth, some wear to cover, name stamped on
endpaper)
Tales of Our Coast. Bost., 1896. 1st ed. $65.00 (orig.
cloth, covers lightly soiled, spine top lightly frayed)
Tallant, Robert--Ready to Hand. N.Y., (1952). $16.00
--The Romantic New Orleanians. N.Y., 1950. $12.50
Tallmadge, Thomas Eddy--The Story of Architecture in Amer-
ica. N.Y., 1936. $15.00
Tamaron y Romeral, Pedro--Bishop Tamaron's Visitation of
New Mexico, 1760. Albuquerque, 1954. $20.00
Tanenbaum, Robert--Badge of the Assassin. N.Y., 1979.
1st ed. $8.00
Tannenbaum, Frank--Ten Keys to Latin America. N.Y., 1962.
1st ed. $10.00 (orig. cloth)

Tanner, Henry Schenck--Memoir on the Recent Surveys, Observations and Internal Improvements in the United States....
Phila., 1829. 1st ed. $175.00 (half morocco)
Tanner, John--A Narrative of the Captivity and Adventures of John Tanner. Lond., 1830. 1st ed. $475.00 (half morocco, hinges mended)
Tansill, Charles Callan--America Goes to War. Bost., 1938. 1st ed. $20.00
--Back Door to War. Chi., 1952. 1st ed. $18.00
--The Congressional Career of Thomas Francis Bayard....
Wash., 1946. 1st ed. $25.00 (inscribed copy, orig. cloth)
--The Foreign Policy of Thomas F. Bayard.... N.Y., 1940.
1st ed. $25.00 (orig. cloth)
Taraval, Sigismundo--The Indian Uprising in Lower California, 1734-1737. L.A., 1931. $150.00 (one of 665 copies)
Tarbell, Ida Minerva--All in a Day's Work. N.Y., 1939.
$21.95
--The History of the Standard Oil Company. N.Y., (1904).
2 vols. 1st ed. $20.00
Lond., 1912. 2 vols. $20.00
--The Life of Abraham Lincoln. N.Y., 1924. 2 vols. $16.00
--The Life of Elbert H. Gary. N.Y., 1925. 1st ed. $25.00, $17.50
Tarducci, Francesco--The Life of Christopher Columbus. Detroit, 1890. 2 vols. 1st ed. $25.00 (ex-lib.)
Tarkington, Booth--Cherry. N.Y., 1903. 1st ed. $15.00 (cloth)
--Claire Ambler. N.Y., 1928. $85.00 (orig. boards, one of 500 signed by author and publishers, covers lightly soiled)
Garden City, 1928. $75.00
--Gentle Julia. Garden City, 1922. 1st ed. $14.50 (cloth)
--The Gibson Upright. Garden City, 1919. $45.00 (orig. cloth, binding worn and soiled)
--In the Arena. N.Y., 1905. 1st ed. $25.00 (orig. cloth, author's presentation copy, binding worn and soiled, inner hinges cracked, lacks rear free endpaper)
--Looking Forward; and Others. Garden City, 1926. 1st ed. $75.00 (orig. cloth)
--Mary's Neck. Garden City, 1932. $65.00 (orig. cloth)
--The Midlander. Garden City, 1923. 1st ed. $60.00 (one of 377 copies signed by author, orig. boards, bookseller's catalog entry pasted to front free endpaper)
--Presenting Lily Mars. Garden City, 1933. 1st ed. $60.00 (orig. cloth, lightly frayed at top of spine)
--The Turmoil. N.Y., 1915. 1st ed. $14.00

--The Two Vanrevels. N.Y., 1902. 1st ed. $15.00
--The World Does Move. Garden City, 1928. 1st ed. $60.00
(orig. boards)
--Young Mrs. Greeley. Garden City, 1929. 1st ed. $75.00
(orig. cloth, small spot on back cover)
Tarrant, John J.--Drucker.... Bost., 1976. 1st ed. $12.00
Tascher, Harold--Maggie and Montana; the Story of Maggie
Smith Hathaway. N.Y., (1954). $25.00 (signed by Hatha-
way)
Tate, Allen--A Southern Vanguard. N.Y., (1947). 1st ed.
$30.00
Tate, Merze--The United States and the Hawaiian Kingdom.
New Haven, 1965. $25.00, $17.50
Tatsch, Jacob Hugo--Freemasonry in the Thirteen Colonies.
N.Y., 1929. 1st ed. $35.00
Tatum, Edward Howland--The U.S. and Europe, 1815-1823.
Berkeley, 1936. 1st ed. $25.00
Taubman, Hyman Howard--The Making of the American Theatre.
N.Y., (1965). 1st ed. $16.00
--Music on My Beat. N.Y., 1943. 1st ed. $8.50
Taussig, Charles William--Rum, Romance & Rebellion. N.Y.,
1928. $20.00
Taussig, Frank William--A Tariff History of the U.S. N.Y.,
1905. $14.00
Taverner, Percy Algernon--Birds of Eastern Canada. Ottawa,
1922. $25.00 (cloth, spine chipped)
--Taverner's Birds of Eastern Canada. Toronto, 1974. $25.00
--Taverner's Birds of Western Canada. Toronto, 1974. $25.00
Tayloe, Edward Thornton--Mexico, 1825-1828. Chapel Hill,
(1959). $10.00
Taylor, Albert Pierce--Under Hawaiian Skies.... Honolulu,
1926. $37.50 (orig. cloth, presentation copy)
Taylor, Bayard--Eldorado.... N.Y., 1857. $37.00 (leather,
rebacked)
N.Y., 1949. $25.00
--New Pictures From California. Oakland, 1951. $35.00 (one
of 600 copies)
Taylor, Benjamin Cook--Annals of the Classics of Bergen, of
the Reformed Dutch Church, and of the Churches Under
Its Care. N.Y., (1857). $20.00
Taylor, Benjamin Franklin--Pictures of Life in Camp and Field.
Chi., 1875. $15.00 (worn copy)
Taylor, Bride (Neill)--Elisabet Ney, Sculptor. N.p., (1938).
$15.00

Taylor, Carl Cleveland--Rural Life in Argentina. Baton Rouge, 1948. 1st ed. $15.00

Taylor, Conyngham Crawford--Toronto "Called Back," From 1886-1850. Toronto, 1886. 1st ed. $75.00 (cloth, light wear to extremities)

Taylor, Deems--Music to My Ears. N.Y., 1949. $10.00

--The Well Tempered Listener. N.Y., 1940. $10.00

Taylor, Francis Richards--Life of William Savery of Philadelphia. N.Y., 1925. $20.00

Taylor, Frank J.--From Land and Sea. S.F., 1976. $25.00

Taylor, Frank Hamilton--"Away Down East".... N.Y., (1881). $15.00 (orig. wraps.)

Taylor, Henry Clay--The Nicaragua Canal. N.Y., (1886?). $10.00

Taylor, Landon--The Battlefield Reviewed. Chi., 1881. 1st ed. $45.00 (cloth, cover lightly worn, ex-lib.)

Taylor, Mart--The Gold Digger's Song Book.... S.F., 1975. $65.00 (one of 400 copies)

Taylor, Morris F.--First Mail West. Albuquerque, (1971). $25.00 (minor worn spot to front free endpaper)

Taylor, Paul Schuster--An American-Mexican Frontier.... (Chapel Hill), 1934. $100.00 (buckram)

Taylor, Richard--Destruction or Reconstruction. N.Y., 1890. $17.00 (inner hinges broken)

Taylor, Robert Lewis--Vessel of Wrath. (N.Y., 1966). $15.00 (cloth)

--W.C. Fields. Garden City, 1949. $12.50 (cover lightly stained)

Taylor, William Robert--Cavalier and Yankee. N.Y., 1961. 1st ed. $12.50

Tebbel, John Williams--The American Indian Wars. N.Y., (1960). $15.00

--The Marshall Fields. N.Y., 1947. $12.50

Tefft, Benjamin Franklin--The Far West.... Ind., 1845. $125.00 (sewn)

Teggart, Frederick John, ed.--The Portola Expedition of 1769-1770
See: Costanso, Miguel

Teichmann, Emil--A Journey to Alaska in the Year 1868. N.Y., 1963. $50.00 (leatherette, one of 97 numbered copies)

Teichmann, Howard--George S. Kaufman. N.Y., (1972). $12.50

Teja Zabre, Alfonso--Guide to the History of Mexico. Mexico, 1935. 1st ed. $22.50 (wraps., paper brittle)

--Historia de Mexico.... (Mexico), 1951. $15.00 (wraps.,
 some light water stains)
Teller, Judd L.--Strangers and Natives. N.Y., (1968).
 $15.00
Tellez, Indalicio--Historia Militar de Chile, 1541-1883. Santi-
 ago de Chile, 1946. 2 vols. in 1. $60.00 (morocco)
Temple, Neville, pseud.
 See: (Fane, Julian Henry Charles)
Temple, Wayne C., ed.--Campaigning With Grant
 See: Porter, Horace
Templeman, Eleanor Lee (Reading)--Arlington Heritage. (Ar-
 lington, Va., 1961). $12.50
Tempsky, Gustav Ferdinand von--Mitla. Lond., 1858. $750.00
 (orig. cloth)
Tennant, Richard B.--The American Cigarette Industry. New
 Haven, 1950. 1st ed. $30.00
Tenney, Edward Payson--The New West.... Camb., 1878.
 $50.00 (roig. wraps., torn, small tears in map)
Tercentenary History of Maryland
 See: Andrews, Matthew Page
Terrell, Alexander Watkins--From Texas to Mexico.... Dallas,
 1933. $250.00 (orig. cloth, light binding wear)
Terrell, John Upton--Apache Chronicle. N.Y., (1972). $15.00,
 $13.00
--Black Robe. Garden City, 1964. 1st ed. $12.00
--Bunkhouse Papers. N.Y., 1971. $12.50
--Furs by Astor. N.Y., (1964). $20.00
--Land Grab. N.Y., 1972. $8.50
--LaSalle. N.Y., (1968). $15.00 (boards)
--Pueblos, Gods, and Spaniards. N.Y., 1973. $12.00
--The Six Turnings. Glendale, 1968. $20.00, $15.00
--War for the Colorado River. Glendale, 1965. 2 vols. $35.00
Terrell, William H.H.--Indiana in the War of the Rebellion.
 (Ind.), 1960. $10.00 (wraps.)
Terrien, Ferdinand--Douze ans Dans L'Amerique Latine.
 Paris, 1903. $50.00 (paper brittle and some pages chipped)
The Territory of Louisiana-Mississippi.... Wash., 1948-49.
 2 vols. $65.00
Terry, Thomas Philip--Terry's Guide to Mexico. Bost., 1930.
 $10.00
Tetlow, Edwin--Eye on Cuba. N.Y., 1966. $14.00 (inscribed,
 binding lightly spotted)
Texas, Convention, 1861--Journal of the Secession Convention
 of Texas, 1861. (Austin), 1912. $150.00 (new cloth, 1st
 printing)

Texas (Republic). Congress--Journals of the Sixth Congress
of the Republic of Texas. Austin, (1940-45). 3 vols.
$45.00 (orig. wraps.)
Thane, Elswyth--The Fighting Quaker. N.Y., (1972). $12.50
Thane, Eric, pseud.
See: (Henry, Ralph Chester)
Thanet, Octave--The Missionary Sheriff. N.Y., 1897. $20.00
(cloth, lacks front endpaper)
Thayer, Caroline Matilda Warren--Religion Recommended to
Youth.... N.Y., 1819. $30.00 (orig. boards, spine
chipped)
Thayer, Ernest Lawrence--Casey at the Bat. N.Y., (1901).
$300.00 (orig. wraps., becoming disbound)
Thayer, William Makepeace--The Pioneer Boy, and How He
Became President. Bost., 1864. $5.00
Thayer, William Roscoe--Letters of.... Bost., 1926. $25.00
--The Life and Letters of John Hay. Bost., (1915). 2 vols.
$50.00 (cloth, one of 300 copies, uncut), $30.00 (cloth,
autograph letter signed by author laid in), $25.00
--Volleys From a Non-Combatant. Garden City, 1919. $15.00
(autographed)
They Build a City....
See: Writers' Program
They Talked Navajo.... Window Rock, Az., (1971?). $12.50
Thom, Helen (Hopkins)--Johns Hopkins. Balt., 1929. 1st
ed. $15.00
Thomas, Benjamin Platt--Stanton. N.Y., 1962. 1st ed.
$15.00
--Three Years With Grant
See: Cadwallader, Sylvanus
Thomas, Ebenezar Smith--Reminiscences of the Last Sixty-Five
Years. Hart., 1840. 2 vols. $75.00
Thomas, Edith May (Bertels)--Mary at the Farm, and Book of
Recipes.... Harrisburg, Pa., 1928. $75.00 (cloth, presen-
tation copy)
Thomas, Gabriel--An Account of Pennsylvania.... Cleve.,
1903. $40.00 (orig. boards, one of 250 copies, uncut)
--An Historical and Geographical Account of the Province....
(N.Y., 1848). $65.00
Harrisburg, 1935. $17.50
Thomas Gilcrease Institute of American History and Art, Tulsa,
Oklahoma--Frederic Remington. Tulsa, 1961. $15.00 (one
of 500 copies)
Thomas, Gordon--The Day the Bubble Burst. Garden City,
1979. 1st ed. $12.50

Thomas, Howard--Boys in Blue From the Adirondack Foothills.
N.Y., 1960. $25.00
Thomas, Hugh--Cuba. N.Y., (1971). $20.00
Thomas, Isaiah--History of Printing in America. N.Y., (1970).
1st ed. $15.00 (cloth)
Thomas, James A.--A Pioneer Tobacco Merchant in the Orient.
Durham, 1928. $35.00
--Trailing Trade a Million Miles. Durham, 1931. $20.00
Thomas, Jeannette Bell--The Sun Shines Bright. N.Y., 1940.
1st ed. $17.50
Thomas, Lately, pseud.
See: Steele, Robert V.P.
Thomas, Lowell--Hungry Waters.... Phila., (1937). 1st ed.
$25.00
--Wings Over Asia. Phila., (1937). $15.00
Thomas, Norman Mattoon--After the New Deal, What? N.Y.,
1936. $12.50
--America's Way Out. N.Y., 1931. $15.00, $10.00 (edges
lightly worn)
--As I See It. N.Y., 1932. $12.50
--The Challenge of War. N.Y., 1923. 1st ed. $5.00 (wraps.,
some underlining)
--Human Exploitation in the U.S. N.Y., 1934. $20.00
--Mr. Chairman, Ladies and Gentlemen.... N.Y., 1955.
$8.50
--Socialism on the Defensive. N.Y., 1938. $17.50
--Socialism Re-Examined. N.Y., (1963). $17.50
--A Socialist's Faith. N.Y., (1951). 1st ed. $8.50
--We Have a Future. Princeton, 1941. $17.50
Thomas, William--Pennsy-iana. Harrisburg, 1972. $15.00
(leatherette, signed by author)
Thomas, William Henry, 1824-1895--Recollections of Old Times
in California. Berkeley, 1974. $15.00
--Running the Blockade. Bost., 1876. $20.00
Thomason, John William--Jeb Stuart. N.Y., 1930. 1st ed.
$25.00 (spine sunned)
Thompson, Arthur Beeby--Black Gold. Garden City, 1961.
$15.00
Thompson, Arthur W.--They Were Open Range Days. Denver,
1946. $50.00
Thompson, Edward--Sir Walter Raleigh, Last of the Elizabeth-
ans. New Haven, 1936. $15.00
Thompson, Edward Herbert--People of the Serpent. Bost.,
1932. 1st ed. $10.00 (ex-lib.)
Thompson, Era Bell--American Daughter. Chi., 1946. $35.00

Thompson, George--Prison Life and Reflections.... Hart.,
1847. $85.00 (orig. cloth, ends rubbed, lacks backstrip)
Hart., 1853. $17.50 (shelf wear extremities)
Thompson, Hunter S.--Hell's Angels. N.Y., (1967). 1st ed.
$12.50
Thompson, John Baptiste de Macklot--Sport in Field and For-
est. N.Y., 1926. $12.50 (spine faded, corners rubbed)
Thompson, John C.--History of the Eleventh Rhode Island
Volunteers in the War of the Rebellion. Prov., 1881.
$60.00
Thompson, John Eric Stanley--The Civilization of the Mayas.
(Chi., 1958). $6.00 (wraps.)
--Maya History and Religion. Norman, (1970). $18.50
--The Rise and Fall of Maya Civilization. Norman, 1954.
1st ed. $40.00 (cloth), $17.50
Norman, (1955). $9.00 (lacks front free endpaper)
Norman, (1967). $10.00
Thompson, Lawrance Roger--Melville's Quarrel With God.
Princeton, 1973. $15.00
Thompson, Lawrencè Sidney--Printing in Colonial Spanish
America. Hamden, Ct., (1962). $20.00 (orig. cloth)
Thompson, Maurice--Stories of Indiana. N.Y., 1898. $10.00
Thompson, Richard Wigginton--Recollections of Sixteen Presi-
dents From Washington to Lincoln. Ind., 1896. 2 vols.
$25.00 (lettering dull)
Thompson, Robert A.--The Russian Settlement in California.
Oakland, 1951. $35.00 (one of 750 copies)
Thompson, Robert Luther--Wiring a Continent.... Princeton,
1947. 1st ed. $20.00 (ex-lib.), $10.00
Thompson, Robert Means, ed.--Confidential Correspondence
of Gustavus Vasa Fox
See: Fox, Gustavus Vasa
Thompson, Slason--Eugene Field. N.Y., 1901. 2 vols. $85.00
(uncut and unopened)
N.Y., 1974. 2 vols. $57.50
--A Short History of American Railways.... Chi., 1925. 1st
ed. $30.00
N.Y., 1925. $8.00 (covers water stained)
Thompson, Stith--Tales of the North American Indians. Camb.,
1929. $55.00 (cloth, lightly stained and soiled, owner
stamp)
Thompson, Vivian Laubach--Hawaiian Myths of Earth, Sea,
and Sky. N.Y., (1966). $7.00
Thomson, Osmond Rhodes Howard--History of the "Bucktails"...
Phila., 1906. $85.00

Thorburn, Grant--Forty Years' Residence in America. Lond.,
1834. $75.00 (orig. cloth)
Thoreau, Henry David--Autumn.... Bost., 1892. 1st ed.
$275.00 (orig. cloth, two bookplates, boxed, bookseller's
catalogue entry tipped onto first blank leaf, two leaves
lightly torn at upper margin not affecting text)
--Cape Cod. Bost., 1865. 1st ed. $500.00 (orig. cloth,
spine ends lightly frayed, owner name on front free end-
paper)
Bost., 1951. $6.00
--Correspondence. N.Y., 1958. 1st ed. $35.00 (orig. cloth,
bookplate, owner signature)
--Excursions. Bost., 1863. 1st ed. $450.00 (orig. cloth,
three minor dents at edges of front cover)
Bost., 1883. $15.00 (cloth)
--The First and Last Journeys of Thoreau.... Bost., 1905.
2 vols. $85.00 (half maroon vellum)
--Letters to Various Persons. Bost., 1865. 1st ed. $50.00
(cloth, spine faded)
--The Maine Woods. Bost., 1868. $20.00 (cloth, spine
chipped)
--Walden. Bost., 1854. 1st ed. $2000.00 (orig. cloth, ends
of spine and corners lightly frayed, slipcased)
Lond., 1886. $175.00 (orig. cloth, extremities rubbed,
bookplate)
N.Y., 1899. $7.50
Bost., 1929. $7.50 (cloth)
--A Week on the Concord and Merrimack Rivers. Bost., 1868.
$25.00 (spine chipped)
Avon, Ct., 1975. $60.00 (boards, one of 2000 copies)
Thorfinnson, S.M.--Ransom County History. N.p., 1975.
$15.00
Thorning, Joseph Francis--Miranda. Gainesville, 1952. 1st
ed. $6.00
Thornton, Jesse Quinn--The California Tragedy. Oakland,
1945. $35.00 (one of 1500 copies)
Thornton, John Wingate--The Historic Relation of New Eng-
land to the English Commonwealth. (Bost.), 1874. $15.00
--The Pulpit of the American Revolution. Bost., 1860. 1st
ed. $35.00 (orig. cloth, lib. stamps)
Thorp, Margaret Farrand--America at the Movies. Lond.,
(1946). $7.50 (ex-lib., bit of wear)
Thorp, Raymond W.--Crow Killer. Bloomington, 1969. $17.00
Thorp, Willard--American Writing in the 20th Century. Camb.,
1960. 1st ed. $15.00

Thorpe, Francis Newton--The Federal and State Constitu-
tions.... Wash., 1909. 7 vols. $200.00 (cloth, a few vols.
shaken)
Thrapp, Dan L.--Al Sieber, Chief of Scouts. Norman, 1964.
$35.00
--The Conquest of Apacheria. Norman, 1967. $25.00, $20.00
Thrasher, Frederic Milton--The Gang.... Chi., (1929).
$13.50 (slipcased)
Thrum, Thomas George--More Hawaiian Folk Tales. Chi.,
1923. 1st ed. $15.00
Thurber, James--The Beast in Me and Other Animals. N.Y.,
(1948). 1st ed. $16.00
--Credos and Curios. N.Y., (1962). $12.00 (orig. cloth)
--Further Fables for Our Times. N.Y., 1956. 1st ed. $10.00
(cloth, boxed)
--The Thurber Album. N.Y., 1952. $16.00
--Thurber Country. N.Y., 1953. 1st ed. $9.50
--The Years With Ross. Bost., (1959). 1st ed. $16.00
Thurman, Michael E.--The Naval Department of San Blas.
Glendale, 1967. 1st ed. $10.00
Thurston, Lorrin Andrews--A Hand-Book on the Annexation of
Hawaii. (St. Joseph, Mi., 1898). $100.00 (orig. wraps.,
mended)
Thurston, Lucy (Goodale)--The Missionary's Daughter....
N.Y., 1842. $18.00 (worn)
Thwaites, Reuben Gold--The Fur Trade in Wisconsin....
Madison, 1911. $25.00
--The Story of Wisconsin. Bost., (1899). $9.75
Thwing, Annie Haven--The Crooked & Narrow Streets of Bos-
ton. Bost., 1920. 1st ed. $20.00 (corners lightly worn)
Tibbles, Thomas Henry--The Ponca Chiefs. Bellevue, Ne.,
1970. $35.00 (cloth, one of 300 copies)
Tice, John H.--Over the Plains, on the Mountains. St. Louis,
1872. $75.00
Ticknor, George--Life, Letters and Journals of.... Bost.,
1909. 2 vols. $25.00
--Life of William Hickling Prescott. Phila., 1875. $19.00
Tiffany, Francis--Life of Dorothea Lynde Dix. Bost., (1918).
$17.50
Tilden, Samuel Jones--The New York City "Ring." N.Y.,
1873. 1st ed. $25.00 (orig. wraps.)
Tileston, Edward Griffin--Handbook of the Administrations of
the U.S. Bost., 1871. $17.50 (cloth)
Tilghman, Zoe Agnes (Stratton)--Marshal of the Last Frontier.
Glendale, 1949. 1st ed. $40.00

--Outlaw Days. (Oklahoma City), 1926. $30.00 (wraps.)
Tillotson, Harry Stanton--The Beloved Spy.... Caldwell,
 1948. $20.00 (ltd. ed., signed by author)
Tily, James C.--Uniforms of the U.S. Navy. N.Y., (1964).
 $20.00
Timberlake, Henry--The Memoirs of Lieut. Henry Timberlake.
 Lond., 1765. 1st ed. $500.00 (half calf, with folding
 map supplies in facs.)
Timberman, O.W.--Mexico's "Diamond in the Rough." L.A.,
 1959. $27.50
Timlow, Elizabeth Weston--The Heart of Monadock.... Bost.,
 1922. $12.50
Timmons, Bascom Nolly--Garner of Texas. N.Y., (1948).
 1st ed. $10.00
Timmons, Wilbert H.--Morelos. El Paso, 1963. 1st ed. $25.00
 (Mexican coin embedded in cover, signed), $12.50
Timmons, William--Twilight on the Range. Austin, (1962).
 1st ed. $15.00
Tinker, Edward Larocque--The Horsemen of the Americas....
 N.Y., 1953. 1st ed. $15.00
--The Machiavellian Madam of Basin Street & Other Tales of
 New Orleans. Austin, 1969. $35.00 (orig. boards)
Tinker, George H.--Northern Arizona and Flagstaff in 1887.
 Glendale, 1969. $12.50, $10.00
Tinkle, Lon--An American Original. Bost., 1978. 1st ed.
 $18.00
Tippett, Thomas--When Southern Labor Stirs. N.Y., (1931).
 1st ed. $35.00
Tirrell, John F.--Gems of Lincolniana. Bost., (1965). $12.50
 (autographed, one of 300 copies)
Titowsky, Bernard--American History. Brooklawn, N.J.,
 (1964). $12.50 (cloth, ex-lib.)
Tittsworth, W.G.--Outskirt Episodes. Avoca, Ia., 1927. 1st
 ed. $300.00 (cloth, lightly rubbed)
Tixier, Victor--Tixier's Travels on the Osage Prairies. Nor-
 man, 1940. 1st ed. $35.00
Tobias, Andrew P.--Fire and Ice. N.Y., 1976. 1st ed.
 $10.00
Tocqueville, Alexis de--Democracy in America. Lond., 1862.
 2 vols. $40.00 (boards scuffed)
Todd, Alden--Justice on Trail. N.Y., (1964). 1st ed. $10.00
Todd, Charles Burr--A General History of the Burr Family
 in America. N.Y., 1878. 1st ed. $75.00 (orig. cloth)
Todd, Frank Morton--The Story of the Exposition. N.Y.,
 1921. 5 vols. $125.00 (orig. cloth)

Todd, Helen--A Man Named Grant. Bost., 1940. $15.00

Todd, Millicent--Peru. Bost., 1914. $7.50 (spine top lightly worn)

Todd, Richard Cecil--Confederate Finance. Athens, 1954. $25.00

Tofsrud, Ole T.--Fifty Years in Pierce County. N.p., 1943. $12.50

Tolbert, Frank X.--Neiman-Marcus, Texas. N.Y., (1953). 1st ed. $10.00

Tolbert, Marguerite--South Carolina's Distinguished Women of Laurens County. Columbia, 1972. $25.00

Tolmie, William Fraser--Comparative Vocabularies of the Indian Tribes of British Columbia. Montreal, 1884. 1st ed. $50.00 (orig. printed wraps., spine chipped)

Tombstone, Epitaph--The Earps of Tombstone
 See: Martin, Douglas DeVency

Tomlinson, Edward--Battle of the Hemisphere. N.Y., 1947. $7.50

--New Roads to Riches in the Other Americas. N.Y., 1939. $8.00

--The Other Americans. N.Y., (1943). $7.50

Tompkins, Frank H.--Riparian Lands of the Mississippi River.... New Orleans, 1901. $50.00 (hinges, cracked endpapers a bit chipped, cloth somewhat rubbed)

Tompkins, Hamilton Bullock--Bibliotheca Jeffersoniana. Austin, 1969. $15.00

Tonk, William--Memoirs of a Manufacturer. N.Y., 1926. 1st ed. $20.00

Toor, Frances--Three Worlds of Peru. N.Y., (1949). $8.00

Toponce, Alexander--Reminiscences of.... (Norman, 1971). $12.50

Toppin, Edgar Allen--A Biographical History of Blacks in America Since 1528. N.Y., (1971). $4.95

Topping, Eugene Sayre--The Chronicles of the Yellowstone. St. Paul, 1888. $200.00

Torchiana, Henry Albert Willem van Coenen--California Gringos. S.F., (1930). $75.00 (cloth, signed by author)

Torres, Elias L.--Twenty Episodes in the Life of Pancho Villa. Austin, 1973. $30.00

Torrey, Bradford--A Florida Sketch-Book. Bost., 1895. $15.00 (owner's stamp)

--Footing It in Franconia. Bost., 1901. 1st ed. $12.50 (ex-lib.)

Totten, George Oakley--Maya Architecture. Wash., (1926). 1st ed. $250.00

Tourgee, Albion Winegar--Bricks Without Straw. Baton Rouge,
(1969). $10.50
--A Fool's Errand. N.Y., 1880. $12.50
Toussaint, Adele (Samson)--A Parisian in Brazil. Bost., 1891.
$35.00 (cover lightly stained)
Townley, Wayne Carlyle--Two Judges of Ottawa. Carbondale,
Il., (1948). $20.00 (cloth, cover lightly mottled, inscribed
and signed by author)
Townsend, Edward Davis--The California Diary of General
E.D. Townsend. (L.A., 1970). $25.00
Townsend, George Alfred--Rustics in Rebellion. Chapel Hill,
(1950). 1st ed. $17.50
Townsend, John Kirk--Narrative of a Journey Across the Rocky
Mountains.... Phila., 1839. 1st ed. $135.00 (contemp.
cloth, lacks backstrip, leaf torn, leaves stained)
Townsend, William Henry--Lincoln and Liquor. N.Y., 1934.
$20.00
--Lincoln and the Bluegrass. (Lexington, Ky.), 1955. $25.00
Townshend, Frederick Trench--Ten Thousand Miles of Travel,
Sport, and Adventure.... Lond., 1869. 1st ed. $150.00
(half morocco)
Townshend, Richard Baxter--Last Memories of a Tenderfoot.
Lond., (1926). $15.00
--The Tenderfoot in New Mexico. N.Y., 1924. $60.00
Tracy, Milton Cook--The Colonizer. El Paso, 1941. $12.00
The Traffic in Habit-Forming Narcotic Drugs. Wash., 1924.
$45.00 (buckram)
Train, Arthur Cheney--On the Trail of the Bad Men. N.Y.,
1925. $20.00
Train, George Francis--Union Speeches Delivered in England
During the Present American War. Phila., 1862. $60.00
(spine broken)
Trasenster, Paul--Aux Etats-Unis. Paris, 1885. 1st ed.
$75.00 (contemp. half morocco)
Trattner, Walter I.--Crusade for the Children. Chi., 1970.
$25.00
The Travels of Capts. Lewis and Clarke.... 1804, 1805 &
1806. Lond., 1809. $1250.00 (morocco, linen-backed map)
Travis, Helga (Anderson)--The Umatilla Trail. N.Y., (1951).
$17.50 (signed by author)
Treaty Between the U.S.A. and the Senecas, Mixed Senecas
and Shawnees.... Wash., 1868. $250.00 (sewn)
Tredwell, Daniel M.--Personal Reminiscences of Men and Things
on Long Island. Brooklyn, 1912-17. 2 vols. $150.00 (3
plates photo-reproduced, morocco, one of 500 copies)

Trefethen, James B.--Americans and Their Guns. (Harrisburg, 1967). $25.00

Trefousse, Hans Louis--The Radical Republicans. N.Y., 1969. $25.00

Trego, Charles B.--A Geography of Pennsylvania.... Phila., 1843. $25.00 (orig. boards)

Trenholm, Virginia Cole--Footprints on the Frontier. (Douglas, Wy., 1945). $100.00 (one of 1000 signed and numbered copies, cloth, lightly rubbed)

Trevathan, Charles E.--The American Thoroughbred. N.Y., 1905. $17.50

Trinka, Zena Irma--North Dakota of Today. St. Paul, 1920. $12.50

Tripp, C.E.--Ace High.... S.F., 1948. $50.00 (one of 500 copies)

Trobriand, Philippe Regis de--Army Life in Dakota. Chi., 1941. $20.00

--Military Life in Dakota. St. Paul, (1951). $38.50

Trollope, Frances Milton--Domestic Manners of the Americans. N.Y., (1927). $20.00

--The Life and Adventures of Jonathan Jefferson Whitlaw. Paris, 1836. $30.00 (half leather and boards, lacks front free endpaper, rubbed)

Troncosco, Francisco P.--Las Guerras Con las Tribas Yaqui y Mayor del Estado de Sonora. Mexico, 1905. 1st ed. $300.00 (wraps.)

Trow, Harrison--Charles W. Quantrell
 See: Burch, John P.

Trowbridge, John Townsend--The Desolate South.... N.Y., (1956). 1st ed. $14.50

--The South. Hart., 1866. 1st ed. $20.00

A True and Particular Relation of the Earthquake That Happen'd at Lima.... Lond., 1748. $175.00 (buckram, exlib., some stains)

True Relationship of the Hardships Suffered by Governor Fernando de Soto
 See: Gentleman of Elvas

True West--The Best of the True West
 See under Title

Truesdale, John--The Blue Coats.... Phila., (1867). $17.50 (spine ends lightly worn), $15.00 (covers and text margins dampstained, salesman's sample)

Truett, Velma Stevens--On the Hoof in Nevada. L.A., 1950. $40.00 (buckram)

Trujillo Molina, Rafael Leonidas--The Evolution of Democracy

in Santo Domingo. Ciudad Trujillo, 1950. $30.00 (wraps., stamp)

Truman, Harry S.--Memoirs.... Garden City, 1955-56. 2 vols. $15.00

--Mr. Citizen. (N.Y., 1960). 1st ed. $125.00 (half calf, inscribed, signed, and dated by author), $10.00

--Mr. President. N.Y., (1952). $30.00 (cloth)

Trumbull, Henry--History of the Indian Wars.... Bost., 1841. $10.00 (binding spotted)

Trumbull, John--The Autobiography of Colonel John Trumbull.... New Haven, 1953. 1st ed. $12.50

Trumbull, Truman--The New Yankee Doodle. N.Y., 1868. $10.50

The Truth Unveiled. Phila., 1844. 1st ed. $50.00 (wraps.)

Truxall, Ada Craig, ed.--"Respects to All"
See: Bright, Adam S.

Tryon, Warren Stenson--A Mirror for Americans. Chi., (1952). 3 vols. 1st ed. $20.00 (cloth)

Tsa To Te, Monroe--The Peyote Ritual.... S.F., (1957). $525.00 (boards, one of 325 copies)

Tucker, George Fox--The Monroe Doctrine. Bost., 1885. 1st ed. $12.50 (newspaper clipping inside front cover)

Tucker, George Wellford--Lee and the Gettysburg Campaign. (Rich., 1932). $25.00 (cloth, uncut)

Tucker, Glenn--Dawn Like Thunder. Ind., (1963). $7.50 (1st printing)

--Hancock the Superb. Ind., (1960). 1st ed. $22.50

--Mad Anthony Wayne and the New Nation. (Harrisburg, Pa., 1973). $12.50

--Poltroons and Patriots. N.Y., (1954). 2 vols. $30.00 (cloth, slipcased, 2 sigs. bound upside down in vol. 2)

--Zeb Vance. Ind., (1965). 1st ed. $20.00

Tucker, Nathaniel Beverley--The Partisan Leader. N.Y., 1861. 2 vols. in 1. 1st ed. $25.00 (corners rubbed)

Tucker, Sophie--Some of These Days. N.p., (1945). 1st ed. $12.50 (inscribed)

Tuckerman, Henry Theodore--America and Her Commentators.... N.Y., 1864. 1st ed. $75.00 (orig. cloth) N.Y., 1961. $20.00 (one of 750 copies), $15.00 (orig. cloth, ltd. edition of 750 copies)

Tull, Charles J.--Father Coughlin and the New Deal. (Syracuse), 1965. $6.50

Tullidge, Edward Wheelock--History of Salt Lake City and Its Founders. S.L.C., (1886). $167.50 (three quarter morocco)

Tully, Jim--Beggars of Life. N.Y., 1924. 1st ed. $16.00
Tunney, Gene--A Man Must Fight. Bost., 1932. $150.00
(one of 550 copies, inscribed, and boxed)
Turkus, Burton B.--Murder, Inc.... N.Y., (1951). 1st ed.
$12.00
Turnbull, Archibald Douglas--John Stevens, an American
Record. N.Y., (1928). $17.50
(Turnbull, Robert James)--The Crisis. Charleston, 1827.
$175.00 (half morocco)
Turnbull, Thomas--T. Turnbull's Travels.... Madison, 1914.
$25.00
Turner, Frederick Jackson--The Character and Influence of
the Indian Trade in Wisconsin. N.Y., 1970. $15.00 (orig.
cloth)
--The Significance of Sections in American History. N.Y.,
(1932). 1st ed. $35.00
Turner, George Edgar--Victory Rode the Rails. Ind., (1953).
1st ed. $30.00
Turner, Henry Smith--The Original Journals of.... Norman,
(1966). 1st ed. $4.00 (orig. wraps.)
Turner, Wallace--The Mormon Establishment. Bost., 1966.
$12.50
Turner-Turner, J.--Three Years' Hunting and Trapping in
America.... Lond., 1888. 1st ed. $85.00 (orig. boards,
rubbed, corners worn)
Turrill, Charles F.--California Notes. S.F., 1876. 1st ed.
$175.00
Turrill, Gardner S.--A Tale of the Yellowstone.... Jefferson,
Ia., 1901. $400.00 (inscribed presentation copy from au-
thor, orig. cloth)
Tuthill, Franklin--The History of California. S.F., 1866.
$125.00 (three-quarter morocco, rebound)
Twain, Mark, pseud.
See: (Clemens, Samuel Langhorne)
Twitchell, Ralph Emerson--Historical Sketch of Governor Wil-
liam Carr Lane. (Santa Fe), 1917. $20.00 (cover chipped)
--The History of the Military Occupation of the Territory of
New Mexico.... Denver, 1909. 1st ed. $100.00 (front
cover stained)
--Leading Facts of New Mexican History. Cedar Rapids, 1911-
17. 5 vols. 1st ed. $1500.00 (orig. cloth)
--Old Santa Fe. Chi., (1963). $35.00
Twomey, Arthur Cornelius--Needle to the North. Bost.,
(1942). $20.00
Tyler, David Budlong--The Bay and the River, Delaware.
Camb., 1955. 1st ed. $25.00

Tyler, Daniel--A Concise History of the Mormon Battalion in
the Mexican War. S.L.C., 1881. $215.00 (leather, stamps)

Tyler, Gus--Organized Crime in America. Ann Arbor, 1962.
1st ed. $15.00

Tyler, Hamilton A.--Pueblo Gods and Myths. Norman, (1964).
1st ed. $15.00 (cloth)

Tyler, John--U.S. Troops in Rhode Island.... Wash., (1844).
$35.00 (disbound)

Tyler, Mason Whiting--Recollections of the Civil War. N.Y.,
1912. 1st ed. $35.00

Tyler, Parker--Magic and Myth of the Movies. N.Y., (1947).
1st ed. $13.50

Tyler, Royal--The Algerine Captive. Hart., 1816. $200.00
(contemp. calf)

Tyler, Samuel--Memoir of Roger Brooke Taney.... Balt.,
1872. 1st ed. $30.00

Tymeson, Mildred McClary--Worcester Bankbook. Worcester,
Ma., 1966. $12.50

(Tyrrell, Henry Franklin)--Semi-Centennial History of the
Northwestern Mutual Life Insurance Company.... Milwau-
kee, 1908. $25.00 (inscribed copy)

Tyson, James Lawrence--Dairy of a Physician in California.
Oakland, 1955. $25.00 (one of 500 copies), $20.00 (title
dull, one of 500)

- U -

Uchill, Ida Libert--Pioneers, Peddlers, and Tsadikim. Den-
ver, (1957). 1st ed. $25.00

Udall, David King--Arizona Pioneer Mormon. Tucson, 1959.
$33.50

Udderzook, William Eachus--The Goss-Udderzook Tragedy.
(Balt.), 1873. 1st ed. $15.00 (orig. wraps.)

Uhden, Hermann Ferdinand--The New England Theocracy.
Bost., 1859. $15.00 (ends of spine frayed)

Unamuno, Miguel de--The Tragic Sense of Life in Men and in
People. N.Y., 1931. $14.50 (orig. cloth)

"Uncle Remus," Joel Chandler Harris as Seen and Remembered
by a Few of His Friends
See: (Lee, Ivy Ledbetter)

Underhill, Ruth Murray--First Penthouse Dwellers in America.
N.Y., (1938). 1st ed. $45.00 (boards, lightly worn)

Underwood, William Lyman--Wild Brothers. Bost., 1923.
$20.00

Union Pacific Railroad Company--Progress of the Union Pacific Railroad West From Omaha.... N.Y., 1868. $125.00 (orig. wraps., small tear in back cover, some dampstaining)

U.S. Army. Dept. of the Columbia--Report of the Secretary of War, Communicating ... the Report of Captain H.D. Wallen of His Expedition in 1850....
See: Wallen, Henry D.

U.S. Bureau of Labor--A Report on Labor Disturbances in the State of Colorado....
See: Wright, Carroll Davidson

U.S. Congress--Abridgement of the Debates of Congress, From 1789 to 1856
See: Benton, Thomas Hart

--Counting Electoral Votes....
See under Title

U.S. Congress. House. Committee on Claims--Reward for the Capture of Booth
See under Title

U.S. Congress. House. Committee on Foreign Affairs--The Traffic in Habit-Forming Narcotic Drugs
See under Title

U.S. Congress. House. Select Committee on Alleged Corruptions in Government--The Covode Investigation
See under Title

U.S. Dept. of State--The Assassination of Abraham Lincoln....
See under Title

--The Aves Island Case
See under Title

--Case of the Black Warrior....
See under Title

--The Revolutionary Diplomatic Correspondence of the U.S.
See: Wharton, Francis

U.S. Dept. of the Interior--Letter From the Acting Secretary of the Interior.... Relative to Indian Operations on the Plains
See: (Carrington, Henry Beebee)

U.S. Geological Exploration of the Fortieth Parallel--Report of the.... Wash., 1870-78. First 4 vols. of 7. $145.00 (cloth, a bit soiled)

U.S. National Park Service--Founders and Frontiersmen
See under Title

--Prospector, Cowhand, and Sodbuster....
See under Title

U.S. Naval Court of Inquiry Upon Destruction of Battleship
Maine--Message From the President....
See under Title

U.S. Northwest Territory Celebration Commission--History of
the Ordinance of 1787....
See under Title

U.S. Office of Naval Records and Library--Naval Records Re-
lating to the Quasi-War Between the U.S. and France.
Wash., 1835-38. 7 vols. $100.00

U.S. President, 1801-1809 (Jefferson)
See: Jefferson, Thomas

U.S. President, 1841-1845 (Tyler)
See: Tyler, John

U.S. Sanitary Commission--Narrative of the Privations and
Sufferings of U.S. Officers....
See under Title

U.S. Spruce Production Corporation--History of Spruce Pro-
duction Division, U.S. Army.... (Portland, Or.), n.d.
$35.00

U.S. War Dept.--Adventure on Red River
See: Marcy, Randolph Barnes

--The Report of Lieutenant Gustavus C. Doane Upon the So-
Called Yellowstone Expedition of 1870
See: Doane, Gustavus Cheeny

--Reports of Explorations and Surveys.... Wash., 1855-60.
12 vols. in 13. $2000.00 (buckram, rebound)

University of Wyoming--Studies in Literature of the West.
Laramie, 1956. $15.00

Untermeyer, Louis--Makers of the Modern World. N.Y., 1955.
$10.00

--A Treasury of Laughter. N.Y., 1946. $15.00

Up De Graff, Fritz W.--Head Hunters of the Amazon. N.Y.,
1923. 1st ed. $20.00

Updike, John--Bech; a Book. N.Y., 1970. $50.00 (one of
500 numbered and signed copies)

--The Coup. N.Y., 1978. 1st ed. $10.00 (cloth)

--Midpoint, and Other Poems. N.Y., 1969. 1st ed. $75.00
(cloth, boxed, one of 350 signed and numbered copies),
$20.00 (cloth)

--The Music School. N.Y., 1966. 1st ed. $50.00 (boards,
1st issue)

--Of the Farm. N.Y., 1965. 1st ed. $25.00 (cloth)

--Rabbit Redux. N.Y., 1971. 1st ed. $15.00 (cloth)

Upham, Charles Wentworth--Life, Explorations and Public Serv-
ices of John Charles Fremont. Bost., 1856. 1st ed. $50.00,
$50.00 (cloth, spine and extremities worn, lightly foxed)

Uris, Leon Marcus--QB VII. Garden City, 1970. 1st ed.
$35.00 (cloth, signed)
Urofsky, Melvin I.--Big Steel and the Wilson Administration.
Columbus, Oh., 1969. $15.00
Uruchurtu, Manuel R.--Apuntes Biograficos del Senor D. Ra-
mon Corral.... Mexico, (1910). $65.00 (orig. wraps., un-
opened)
Utley, Henry Munson--Michigan.... (N.Y.), 1906. 4 vols.
$60.00 (cloth)
Utley, Robert Marshall--Frontier Regulars. N.Y., (1973). 1st
ed. $30.00, $20.00, $20.00
--Life in Custer's Cavalry
See: Barnitz, Albert Trovillo Siders
Uzes, Francois D.--Chaining the Land. Sacramento, 1977.
1st ed. $25.00

- V -

Vachell, Horace Annesley--Bunch Grass. Lond., 1912. 1st
ed. $37.50 (orig. cloth)
Vail, Robert William Glenroie--The Voice of the Old Frontier.
N.Y., 1970. $30.00 (cloth)
Valcarcel Esparza, Carlos Daniel--La Rebelion de Tupac Amaru.
Mexico, (1965). $7.50
[Valcourt-Vermont, Edgar de]--The Dalton Brothers and Their
Astounding Career of Crime. N.Y., 1954. $28.50
Vale, Gilbert--The Life of Thomas Paine.... Bost., 1859.
$20.00 (orig. cloth, extremities worn)
Vale, Robert B.--Wings, Fur, & Shot. N.Y., 1936. 1st ed.
$30.00 (cloth)
Valjean, Nelson--John Steinbeck, the Errant Knight. S.F.,
1975. $10.00, $7.50
Vallandigham, Clement Laird--Speeches, Arguments, Addresses,
and Letters of.... N.Y., 1864. $95.00 (spine faded,
small gash)
The Valley of Wyoming
See: (Miner, Lewis H.)
Van Alstyne, Richard Warner--American Crisis Diplomacy.
Stanford, (1952). $16.00
--The Rising American Empire. N.Y., 1960. $10.00 (under-
lining)
Van Cise, Philip Sidney--Fighting the Underworld. N.Y.,
1936. $18.00

Van Cleve, Charlotte Ouisconsin (Clark)--"Three Score Years
and Ten,".... Minne., 1895. $40.00
Van Cleve, Spike--40 Years' Gatherin's. K.C., 1977. $15.00
(cloth)
Vandenberg, Arthur Hendrick--The Greatest American, Alex-
ander Hamilton. N.Y., 1922. $7.50
Van den Berghe, Pierre L.--Inequality in the Peruvian Andes.
Columbia, 1977. $12.00
Van Denburgh, Elizabeth Douglas--My Voyage in the U.S.
Frigate "Congress." N.Y., (1913). $17.50
Vande Poll, Willem
See: Poll, Willem Vande
Vanderbilt, Cornelius--Farewell to Fifth Avenue. N.Y., 1935.
$10.00
--Ranches and Ranch Life in America. N.Y., (1968). $12.50
Vandercook, John Womack--King Cane. N.Y., 1939. 1st ed.
$12.50
Van de Water, Frederic Remington--Rudyard Kipling's Vermont
Feud. N.Y., (1937). 1st ed. $12.50 (backstrip lettering
effaced)
Vandiver, Frank Everson--Rebel Brass. Baton Rouge, (1956).
1st ed. $17.50 (signed)
--Essays on the American Civil War. Austin, (1968). $10.00
Van Doren, Carl, ed.--An American Omnibus....
See under Title
--Benjamin Franklin. N.Y., 1938. $20.00, $8.50
--The Great Rehearsal. N.Y., 1948. 1st ed. $15.00 (cloth)
--Mutiny in January. N.Y., 1943. 1st ed. $8.50, $6.00
(ex-lib.)
--Secret History of the American Revolution. N.Y., 1941.
1st ed. $10.00
--Three Worlds. N.Y., 1936. 1st ed. $16.50
Van Doren, Charles Lincoln--Letters to Mother. N.Y., (1959).
1st ed. $7.00
Van Doren, Mark--Autobiography. N.Y., (1958). $16.00
(ex-lib.)
Van Dusen, C.--The Indian Chief. Lond., 1867. 1st ed.
$150.00 (orig. cloth, small hole in spine)
Van Dyke, John Charles--The New New York. N.Y., 1909.
1st ed. $22.50 (cloth)
Van Dyke, Woodbridge Strong--Horning Into Africa. (L.A.,
1931). $25.00
Van Every, Edward--Sins of America as "Exposed" by the
Police Gazette. N.Y., 1931. $15.00

Vanger, Milton I.--Jose Batlle y Ordonez of Uruguay. Camb.,
 1963. $16.75
Van Natter, Francis Marion--Lincoln's Boyhood. Wash., (1963).
 $17.50
Van Ness, William Peter--An Examination of the Various Charges
 Exhibited Against Aaron Burr.... N.Y., 1803. $100.00
 (rebound)
Van Nuys, Laura (Bower)--The Family Band. Lincoln, Nb.,
 1961. $10.00 (cloth, small stamp on title)
Van Orman, Richard A.--Room for the Night. Bloomington,
 (1966). 1st ed. $10.00 (cloth)
Van Sinderan, Adrian--Foundation Stones. N.Y., 1952.
 $30.00 (cloth and boards, one of 700 copies)
--A Journey Into Neolithic Times. N.Y., 1947. $30.00 (one
 of 600)
Vanstory, Burette (Lighte)--Georgia's Land of the Golden
 Isles. Athens, Ga., (1956). 1st ed. $15.00 (signed)
Van Tyne, Calude Halstead--The War of Independence....
 Bost., 1929. $20.00 (cloth)
Van Tramp, John C.--Prairie and Rocky Mountain Adventures.
 Columbus, 1867. $45.00 (recent binding)
Van Vechten, Carl--Parties.... N.Y., 1930. $16.50 (backstrip
 faded)
--The Tattooed Countess. N.Y., 1924. 1st ed. $15.00
Van Voorhis, John Stogdell--The Old and New Monongahela.
 Pitts., 1893. $75.00
Van Winkle, Daniel--History of the Municipalities of Hudson
 County.... Chi., 1924. 3 vols. $75.00 (spine tops of
 2 vols. neatly repaired)
Van Wyck, William--Robinson Jeffers. L.A., 1938. $35.00
 (orig. boards, edges lightly worn, one of 250 copies)
Van Zandt, Roland--The Catskill Mountain House. New Bruns-
 wick, (1966). $20.00
Varas, Florencia--Coup! N.Y., 1975. $5.00
Vass, Lachlan Cumming--History of the Presbyterian Church
 in New Bern, N.C.... Rich., 1886. $85.00
Vaucaire, Michel--Bolivar the Liberator. Bost., 1929. $12.50
 (cloth)
Vaughn, Jesse Wendell--The Battle of Platte Bridge. Norman,
 (1963). $10.00 (boards, 1st printing, bookplate)
--The Reynolds Campaign on Powder River. Norman, (1961).
 $27.50
Vazquez de Coronado, Francisco--Coronado's Letter to Men-
 doza.... (Bost., 1896). $10.00 (wraps.)
Veech, James--The Monongahela of Old. Pitts., 1892. $85.00
 (contemp. half leather, worn)

Pitts., (1910). $50.00 (orig. cloth)
Vega, Garcilaso de la
 See: Garcilaso de la Vega, el Inca
Veglahn, Nancy--The Tiger's Tail. N.Y., (1964). $12.00
Veiller, Bayard--The Trial of Mary Dugan. N.Y., 1928. 1st
 ed. $13.00
Velazquez Chavez, Agustin--Contemporary Mexican Artists.
 N.Y., (1937). 1st ed. $35.00
Venegas, Miguel--Juan Maria de Salvatierra.... Cleve., 1929.
 $400.00 (orig. cloth)
Vercheres de Boucherville, Rene Thomas--War on the Detroit.
 Chi., 1940. $20.00 (cloth)
Verckler, Stewart P.--Cowtown-Abilene. N.Y., 1961. $12.50
Verhoeff, Mary--The Kentucky Mountains.... Lou., 1911.
 $30.00
Vermont, the Land of Green Mountains. Essex Junction,
 (1913). $6.50 (stiff wraps.)
Verrill, Alpheus Hyatt--Great Conquerors of South and Cen-
 tral America. N.Y., (1943). $7.50
--Old Civilizations of the New World. N.Y., (1942). $6.00
--Smugglers and Smuggling. N.Y., 1924. $12.50
Vestal, Stanley--Bigfoot Wallace.... Bost., 1942. $30.00
--The Missouri. N.Y., (1945). 1st ed. $15.00
--The Old Santa Fe Trail. Bost., (1939). $15.00
--Queen of Cowtowns: Dodge City.... N.Y., (1952). $10.00
--Short Grass Country. N.Y., (1941). $7.50
--Sitting Bull, Champion of the Sioux. Bost., 1932. 1st ed.
 $43.50
 Norman, (1957). $15.00 (cloth)
--Warpath and Council Fire. N.Y., (1948). 1st ed. $12.50
Vicuna Mackenna, Benjamin--Historia Critica y Social de la
 Ciudad de Santiago.... Valparaiso, 1869. 2 vols. $75.00
--Historia de los Diez Anos de la Administracion de Don Man-
 uel Montt. Santiago, 1862-63. 5 vols. $150.00 (foxing,
 first few pages of vol. 1 lightly wormed not affecting text)
Vidal, Humberto--Vision del Cuzco. Cuzco, 1958. $12.00
 (wraps.)
A View of South America and Mexico
 See: (Niles, John Milton)
Villacorta, Jose Antonio Villacorta Calderon--Historia de la
 Capitania General de Guatemala. Guatemala City, 1942.
 $50.00 (wraps., uncut)
Villagra, Gaspar Perez de--History of New Mexico.... L.A.,
 1933. $125.00 (cloth), $110.00 (one of 665 numbered cop-
 ies, boards, uncut)
 (Chi., 1962). $20.00

Villalobos, Sergio--Tradicion y Reforma en 1810. (Santiago de Chile, 1961). $10.00 (loose in wraps., underlining and marginalia in ink)

Villard, Henry--The Past and Present of the Pike's Peak Gold Regions. Princeton, 1932. 1st ed. $8.50 (ex-lib.)

Villard, Oswald Garrison--John Brown.... Bost., 1910. 1st ed. $20.00 (minor cover stains)

Villavicencio, Manuel--Geografia de la Republica del Ecuador. N.Y., 1858. $120.00 (buckram, orig. wraps. bound in)

Villiers du Terrage, Marc, baron de--La Decouverte du Missouri. Paris, 1925. $95.00 (one of 350 copies)

Viola, Herman J.--The Indian Legacy of Charles Bird King. Wash., 1976. 1st ed. $20.00

Visger, Jean Allan (Pinder) Owen--The Story of Hawaii. Lond., 1898. $14.00 (lacks plates)

Vitray, Laura--The Great Lindbergh Hullabaloo. N.Y., 1932. $25.00 (binding worn)

Vollmar, Edward R.--The Catholic Church in America. N.Y., 1963. $25.00 (orig. cloth)

Volney, C.F.--View of the Climate and Soil of the U.S. Lond., 1804. $100.00 (leather, somewhat rubbed and worn, front free endpaper partially detached, bookplate)

Volwiler, Albert Tangeman--George Croghan and the Westward Movement. Cleve., 1926. 1st ed. $20.00

Von Hagen, Victor Wolfgang--The Ancient Sun Kingdoms of the Americas.... Cleve., (1961). 1st ed. $15.00

--The Aztec and Maya Papermakers. N.Y., (1944). $50.00 (frontis. tipped in), $25.00 (ex-lib.)

--The Golden Man. Lond., 1974. $13.50

--The Green World of the Naturalists.... N.Y., (1948). $12.50

--Highway of the Sun. N.Y., (1955). 1st ed. $10.00, $10.00

--Jungle in the Clouds. N.Y., 1946. $15.00 (stains on back cover)

--Maya Explorer, John Lloyd Stephens and the Lost Cities.... Norman, 1947. 1st ed. $15.00

--South America Called Them. N.Y., 1945. 1st ed. $12.50 (covers soiled and spine sunned)

--South America, the Green World of the Naturalists. Lond., 1951. $12.50

Von Holst, Hermann--The Constitutional and Political History of the U.S. Chi., 1881-92. 8 vols. $125.00 (cloth)

--The Constitutional Law of the U.S.... Chi., 1887. $20.00

Von Tempski, Armine--Born in Paradise. N.Y., 1940. 1st ed. $20.00

 N.Y., 1968. $15.00

Vorpal, Ben Merchant--My Dear Wister. Palo Alto, Ca.,
 (1972). $13.50
Voyages and Discoveries in South-America. Lond., 1698.
 $1000.00 (contemp. calf, minor marginal worming, light
 water stains, front joint starting)

- W -

Wade, Richard C.--The Urban Frontier. Camb., 1959. $12.50
Wagemann, Clara Eola (Summers)--Covered Bridges of New
 England. Rutland, Vt., 1931. $35.00 (orig. boards, one
 of 500 signed copies)
Wagley, Charles--The Latin American Tradition. N.Y., 1968.
 $10.00 (colored underlining)
Wagner, Geoffrey Atheling--Parade of Pleasure. Lond., (1954).
 1st ed. $35.00
Wagner, Harr--Joaquin Miller and His Other Self. S.F.,
 (1929). $27.50 (one of 1100 numbered copies)
Wagner, Henry Raup--The Discovery of New Spain in 1518
 See: Grijalva, Juan de
--The Discovery of Yucatan
 See: Fernandez de Cordoba, Francisco
--The Plains and the Rockies. S.F., 1937. $165.00 (one of
 600 copies), $125.00 (orig. cloth, lacks spine label, one of
 600 copies)
--The Rise of Fernando Cortes. Berkeley, 1944. 1st ed.
 $150.00 (cloth, one of 300 copies, few leaves lightly foxed)
--The Spanish Southwest, 1542-1794. Albuquerque, 1937. 2
 vols. $500.00 (orig. boards)
Wagner, Susan--Cigarette Country. N.Y., (1971). $10.00
Wagoner, Junior Jean--History of the Cattle Industry in South-
 ern Arizona, 1540-1940. Tucson, 1952. $25.00 (orig.
 wraps.)
Wainwright, Nicholas B.--History of the Philadelphia National
 Bank. Phila., 1953. $10.00
Waite, Catherine Van Valkenburg--The Mormon Prophet and
 His Harem. Chi., 1868. $27.50 (cloth, faded)
Waldeck, Jean Frederick Maximilien--Monuments Anciens du
 Mexique
 See: Brasseur de Bourbourg, Charles Etienne
Walden, Arthur Treadwell--A God-Puncher on the Yukon.
 Bost., 1928. $12.50
Waldo, Lewis Patrick--The French Drama in America.... Balt.,
 1942. 1st ed. $30.00

Waldorf, John Taylor--A Kid on the Comstock. (Berkeley), 1968. $30.00 (spine a bit darkened) Palo Alto, Ca., (1970). $6.00

Walker, Anne Kendrick--The Storied Kendalls. Rich., 1947. $25.00 (cloth, light foxing, owner inscription)

Walker, C.B.--The Mississippi Valley, and Prehistoric Events.... Burlington, Ia., 1881. $65.00

Walker, Franklin Arthur--Catholic Education and Politics in Ontario. (Don Mills, Ont., 1964). $20.00

Walker, Franklin Dickerson--A Literary History of Southern California. Berkeley, 1950. $25.00 (orig. cloth) --San Francisco's Literary Frontier. N.Y., 1939. 1st ed. $25.00 (orig. cloth), $20.00

Walker, Henry Pickering--The Wagonmasters. Norman, (1966). $20.00

Walker, Hovenden--A Journal; or, Full Account of the Late Expedition to Canada. Lond., 1720. 1st ed. $1250.00 (contemp. calf)

Walker, James Herbert--The Johnstown Horror!!! Syracuse, (1889). $7.50 --Rafting Days in Pennsylvania. Altoona, 1922. $50.00 (orig. cloth)

Walker, Judson Elliott--Campaigns of General Custer in the North-West.... N.Y., (1966). $7.50

Walker, Mary Alden--The Beginnings of Printing in the State of Indiana. Crawfordsville, In., 1934. 1st ed. $125.00 (orig. cloth)

Walker, Robert Averill--The Planning Function in Urban Government. Chi., 1951. $15.00

Walker, William--La Guerra de Nicaragua.... Managua, 1884. $425.00 (calf, small hole in title not affecting text) --The War in Nicaragua. Mobile, 1860. 1st ed. $100.00 (orig. cloth, ex-lib.), $30.00 (rebound, waterstained)

Walkinshaw, Robert--On Puget Sound. N.Y., 1929. 1st ed. $12.50

Wall, Alexander James--A Sketch of the Life of Horatio Seymour, 1810-1886.... N.Y., 1929. $25.00 (orig. cloth, one of 300 numbered copies)

Wall, Bernhardt--Following Abraham Lincoln. Lime Rock, Ct., (1943). $12.50

Wall, Oscar Garrett--Recollections of the Sioux Massacre.... (Lake City, Mn.), 1909. $65.00

Wallace, Edward Seccomb--Destiny and Glory. N.Y., (1957). $12.50 (stamp) --The Great Reconnaissance. Bost., (1955). $20.00, $10.00

Wallace, Ernest--The Comanches: Lords of the South Plains.
Norman, (1952). 1st ed. $20.00 (cloth)
Wallace, George Selden--Cabell County Annals and Families.
Rich., 1935. $50.00
Wallace, Henry Agard--Corn and Its Early Fathers. (East
Lansing, Mi.), 1956. $6.00
Wallace, Irving--The Square Pegs. N.Y., 1957. 1st ed.
$7.50
Wallace, Paul A.W.--The Muhlenbergs of Pennsylvania. Phila.,
1950. 1st ed. $15.00
--Thirty Thousand Miles With John Heckewelder
See: Heckewelder, John Gottlieb Ernestus
Wallen, Henry D.--Report of the Secretary of War, Commun-
icating ... the Report of Captain H.D. Wallen of His Ex-
pedition in 1859.... (Wash.), 1860. $125.00 (half morocco)
Waller, George--Kidnap. N.Y., 1961. $12.00
--Saratoga, Saga of an Impious Era. Englewood Cliffs, 1966.
$15.00
Wallis, George A.--Cattle Kings of the Staked Plains. Den-
ver, (1964). $7.50
Wallis, Wilson Dallam--The Micmac Indians of Eastern Canada.
Minne., (1955). 1st ed. $30.00
Walsh, Henry L.--Hallowed Were the Gold Dust Trails. Santa
Clara, 1946. 1st ed. $30.00 (orig. cloth)
Walsh Heritage: a Story of Walsh County. N.p., (1976).
2 vols. $60.00
Walsh, Richard John--The Making of Buffalo Bill. Ind., (1928).
1st ed. $37.50 (cloth), $22.50 (ex-lib.)
Walsh, William Shepard--Abraham Lincoln and the London
Punch. N.Y., 1909. $22.50 (lightly rubbed)
Walters, Lorenzo D.--Tombstone's Yesterday. Tucson, 1928.
1st ed. $100.00 (cloth, hinges starting, endpapers soiled
and chipped, bookplate, owner inscription)
Walton, Frank Ledyard--Pillars of Yonkers. N.Y., 1951.
$25.00
Walton, George H.--Sentinel of the Plains. Englewood Cliffs,
(1973). $15.00
Walton, James Solomon--Conrad Weiser and the Indian Policy
of Colonial Pennsylvania. Phila., (1909). 1st ed. $75.00
(orig. cloth)
Walton, Richard J.--Cold War and Counterrevolution. N.Y.,
(1972). $18.00
--Henry Wallace, Harry Truman, and the Cold War. N.Y.,
1976. $18.00
Walton, William--The Evidence of Washington. N.Y., (1966).
1st ed. $17.50

Walton, William M.--Life and Adventures of Ben Thompson.... Houston, 1954. $12.50

Walzer, Michael--The Evolution of the Saints. Camb., 1965. 1st ed. $20.50

Wandell, Samuel Henry--Aaron Burr. N.Y., 1925. 2 vols. 1st ed. $22.50

Wansey, Henry--An Excursion to the United States of North America, in the Summer of 1794. Salisbury, England, 1798. $75.00 (lacking frontis., joints cracked)

War-Songs for Freemen
See: (Child, Francis James)

Warburton, Austen D.--Indian Lore of the North Carolina Coast. Santa Clara, 1966. $8.75

Warburton, Eliot
See: Warburton, George Drought

Warburton, George Drought--Hochelaga. Lond., 1847. 2 vols. $60.00 (orig. cloth)

Ward, Christopher--The Delaware Continentals.... Wilmington, 1941. $35.00 (ex-lib.)
--The War of the Revolution. N.Y., 1952. 2 vols. $15.00

Ward, Henry George--Mexico in 1827. Lond., 1828. 2 vols. 1st ed. $650.00 (contemp. three-quarter morocco, occasional light foxing, bookplate), $250.00 (one front board detached)

Ward, John--The Overland Route to California.... N.Y., 1875. $125.00 (orig. cloth)

Ward, John William--Andrew Jackson.... N.Y., 1955. 1st ed. $15.00

Ward, Lynd Kendall--Madman's Drum. N.Y., (1930). 1st ed. $75.00 (one of 309 signed copies), $17.50 (some rubbing on edges of covers)

Warde, Frederick B.--Fifty Years of Make-Believe. L.A., 1923. $20.00

Warden, David Bailie--A Chorographical and Statistical Description of the District of Columbia.... Paris, 1816. 1st ed. $150.00 (half morocco, lacks map)

Ware, Eugene Fitch--The Indian War of 1864. N.Y., (1960). $15.00

Ware, John--Memoir of the Life of Henry Ware, Jr. Bost., 1846. vol. 1 of 2 vol. set. $25.00 (cloth, joints tender, spine extremities frayed)

Warfield, Ethelbert Dudley--Joseph Cabell Breckinridge, Junior Ensign.... N.Y., 1898. $15.00 (lacks front endleaf)

Warren, Charles--Congress, the Constitution, and the Supreme Court. Bost., 1935. $12.00

Warner, Charles Dudley--The Complete Writings of.... Hart.,
1904. 15 vols. $500.00 (autograph ed., some corners and
edges lightly rubbed, one of 612 sets, three-quarter mo-
rocco)

Warren, Frank A.--An Alternative Vision. Bloomington, (1974).
$25.00

Warren, Harris Gaylord--Paraguay, an Informal History.
Norman, 1949. 1st ed. $20.00, $12.50

Warren, Robert Penn--Audubon, a Vision. N.Y., (1969).
1st ed. $50.00 (buckram, boxed, one of 300 signed and
numbered copies)

Warren, Sidney--American Freethought, 1860-1914. N.Y.,
1943. 1st ed. $25.00 (orig. wraps.)

Warshow, Robert Irving--Alexander Hamilton.... N.Y., (1931).
$7.50

--The Story of Wall Street. N.Y., (1929). 1st ed. $20.00

Warwick, Charles Franklin--Warwick's Keystone Commonwealth.
Phila., 1913. $10.00

Waseurtz af Sandels, G.M.
See: Sandels, G.M. Waseurtz af

Washburn, Emory--Historical Sketches of the Town of Leices-
ter, Massachusetts.... Bost., 1860. $45.00 (spine ends
lightly frayed)

Washington, Booker T.--Up From Slavery. N.Y., 1901. 1st
ed. $40.00 (cloth, a bit rubbed, hinges starting, book-
plate)

Washington, George--The Diaries of George Washington, 1748-
1799. Bost., 1925. 4 vols. $100.00

--Facsimiles of Letters From His Excellency.... Wash., 1844.
$45.00 (orig. cloth, spine reinforced, some foxing)

--The Writings of George Washington.... Bost., 1839. 12
vols. $150.00 (ex-lib., orig. calf, foxing)
Wash., (1931-44). 39 vols. $850.00 (ex-lib.), $850.00
(ex-lib.)

Wasser, Henry Hirsch--The Scientific Thought of Henry Ad-
ams. Thessaloniki, 1956. $20.00 (paper)

Wasson, E.A.--Religion and Drink. N.Y., 1914. $8.50

Wasson, Robert Gordon--The Hall Carbine Affair. N.Y., 1948.
$25.00 (one of 750 copies, ex-lib.)

Wasson, Woodrow W.--James A. Garfield. Nash., 1952. $10.00
(ex-lib.)

Waterman, Thomas Tileston--The Mansions of Virginia, 1706-
1776. Charlotte, N.C., (1945). 1st ed. $27.50

Waters, Frank--The Colorado. N.Y., (1946). 1st ed. $15.00

--The Earp Brothers of Tombstone. N.Y., (1960). 1st ed.
$12.50

Waters, Walter W.--B.E.F. N.Y., 1933. 1st ed. $15.00
Waterton, Charles--Wanderings in South-America, the North-
 West of the United States.... Lond., 1825. 1st ed.
 $500.00 (calf, lacks half-title, light foxing), $75.00 (calf,
 ex-lib., lacks plates)
Watkins, Arthur Vivian--Enough Rope. Englewood Cliffs,
 (1969). $12.50
Watkins, Tom H.--California. Palo Alto, (1973). 1st ed.
 $35.00, $25.00
--Gold and Silver in the West. Palo Alto, Ca., (1971).
 $17.50
--Mirror of the Dream. S.F., 1976. $15.00
Watson, Douglas Sloane--California in the Fifties. S.F., 1936.
 $175.00 (light fading and spotting on cover)
Watson, Elmo Scott--A History of Newspaper Syndicates in the
 U.S., 1865-1935. Chi., 1936. 1st ed. $20.00 (cloth)
--The Professor Goes West. Bloomington, 1954. $15.00 (cloth)
Watson, Henry Clay--Camp-Fires of the Revolution. Provi-
 dence, 1859. $35.00 (cloth)
--Lives of the Presidents of the U.S. Bost., 1853. $15.00
Watson, James Eli--As I Knew Them. Ind., (1936). $10.00
Watson, John Fanning--Annals of Philadelphia.... Phila.,
 1830. 1st ed. $100.00 (later binding, some pages and
 plates tape repaired)
 Phila., 1868. 2 vols. $35.00 (orig. cloth)
--Historic Tales of Olden Time. Phila., 1833. $75.00 (orig.
 cloth, rebacked)
Watson, Margaret G.--Silver Theatre. Glendale, 1964. 1st
 ed. $20.00, $19.50
Watson, William--Life in the Confederate Army. Lond., 1887.
 1st ed. $250.00
Watson, William Henry--History of the Michigan Conference of
 the Evangelical Church.... Harrisburg, Pa., 1942- . 3
 vols. $45.00
Watt, Roberta Frye--Four Wagons West. Portland, Or., (1931)
 $9.00
 Portland, Or., (1944). $23.50
Watters, Reginald Eyre--British Columbia: a Centennial An-
 thology. Toronto, 1958. $20.00
Watterson, Henry--The Editorials of Henry Watterson. Lou.,
 1923. $15.00
--History of the Manhattan Club. N.Y., (1915). $60.00 (one
 of 650 numbered copies, cloth)
Waugh, Julia (Nott)--Castro-Ville and Henry Castro, Empre-
 sario. San Antonio, 1934. $45.00 (wraps.)

Waxman, Percy--The Black Napoleon.... N.Y., (1931).
$15.00 (cloth)

Way, Frederick--The Saga of the Delta Queen. Cinci., 1951.
$27.50

Wayne, Anthony--Anthony Wayne, a Name in Arms. Pitts.,
(1959). $17.50

We Were 49ers! Pasadena, (1976). 1st ed. $15.00, $10.00

Wear, George W.--Pioneer Days and Kebo Club Nights. Bost.,
1932. $25.00 (tattered)

Weaver, Emily Poynton--Old Quebec, the City of Champlain.
Toronto, 1907. $12.00

Weaver, John Downing--Warren, the Man, the Court, the Era.
Bost., 1967. 1st ed. $8.50

Webb, Nancy (Bukeley)--The Hawaiian Islands.... N.Y.,
1956. 1st ed. $10.00

--Kaiulani: Crown Princess of Hawaii. N.Y., (1962). $18.00,
$10.00

(Webb, Samuel)--History of Pennsylvania Hall, Which Was
Destroyed by a Mob.... Phila., 1838. $150.00 (orig. half
leather), $85.00 (orig. cloth, rebacked, light foxing)

Webb, Samuel Blackley, 1753-1807--Correspondence and Jour-
nals of.... N.Y., 1893. 3 vols. $350.00 (three-quarter
morocco, one of 350 copy sets)

Webb, Walter Prescott--The Great Frontier. Bost., 1952.
$20.00

--The Great Plains. Bost., 1931. $25.00
Bost., 1936. $23.50 (ex-lib.)

--The Texas Rangers. Bost., 1935. $57.50, $10.00 (worn,
backstrip lightly faded)

--The Texas Rangers in the Mexican War. Austin, 1975. 1st
ed. $45.00 (morocco, slipcased, ltd. ed. of 90 copies)

Webb, Willard--Crucial Moments of the Civil War. N.Y.,
(1961). $14.50, $7.50

Webb, William Seward--California and Alaska.... N.Y., 1890.
$500.00 (leather, worn edges and scuffing, one of 500
numbered copies)

Webber, Charles Wilkins--The Gold Mines of the Gila....
N.Y., 1849. 2 vols. in 1. $450.00 (orig. half morocco
and cloth), $375.00 (half morocco)

Weber, Francis J.--California's Reluctant Prelate. L.A., 1964.
$10.00

Webster, George G.--Around the Horn in '49. Wethersfield,
Ct., 1898. $175.00 (orig. cloth)

Webster, Noah--An American Dictionary of the English Lan-
guage. N.Y., 1828. 2 vols. 1st ed. $2200.00 (contemp.
calf and boards, rebacked)

--A Collection of Essays and Fugitive Writings. Bost., 1790.
1st ed. $250.00 (new boards)
--A Letter to the Honorable John Pickering.... Bost., 1817.
1st ed. $125.00 (new half calf, text browned)
Webster, Paul--The Mighty Sierra. Palo Alto, (1972). 1st
ed. $25.00 (slipcased)
Wedda, John--Gardens of the American South. (Rich., 1971).
$16.00
Weddle, Robert S.--Plow-Horse Cavalry. Austin, (1974).
$15.00
Weeden, William Babcock--War Government.... Bost., 1906.
$15.00 (cloth, ex-lib.)
Weeks, Alvin Gardner--Massasoit of the Wampanoags. (Nor-
wood, Ma.), 1920. $10.00 (cloth), $10.00
Weems, John Edward--Dream of Empire. N.Y., (1971). $10.00
Weems, Mason Locke--A History of the Life and Death.... of
General George Washington. Elizabeth-Town, (1802?).
$85.00 (half morocco)
Wehle, Louis Brandeis--Hidden Threads of History.... N.Y.,
1953. $10.00
Weichmann, Louis J.--A True History of the Assassination of
Abraham Lincoln. N.Y., 1975. 1st ed. $10.00
Weidling, Philip--Checkered Sunshine. Gainesville, 1966.
$12.50
Weight, Harold--Lost Mines of Death Valley. Twentynine
Palms, (1953). 1st ed. $28.50 (wraps.)
Weightman, Richard Hanson--To the Congress of the U.S.
Wash., 1851. $150.00 (orig. wraps.)
Weigold, Marilyn--The American Mediterranean. Port Wash-
ington, N.Y., 1974. $25.00
Weil, Felix Jose--Argentine Riddle. N.Y., (1944). $14.00
Weil, Martin--A Pretty Good Club. N.Y., 1978. $15.00
Weil, Thomas E.--Area Handbook for Paraguay. Wash., 1972.
$12.50
Weinberg, Arthur--The Muckrakers. N.Y., 1961. 1st ed.
$15.00
Weintraub, Hyman--Andrew Furuseth.... Berkeley, 1959.
1st ed. $15.00
Weir, Hugh--The Conquest of the Isthmus. N.Y., 1909. 1st
ed. $12.50 (ex-lib.)
Weisberger, Bernard A.--Reporters for the Union. Bost.,
(1953). 1st ed. $12.00
Weisenburger, Francis Phelps--Idol of the West. (Syracuse,
N.Y., 1965). $20.00, $16.50

Weiser, Clement Zwingli--The Life of (John) Conrad Weiser....
Reading, Pa., 1876. 1st ed. $75.00 (orig. cloth)
Reading, Pa., 1899. $20.00
Welch, G. Murlin--Border Warfare in Southeastern Kansas....
Pleasanton, Ks., 1977. $15.00
Weld, Isaac--Travels Through the States of North America.
Lond., 1799. 1st ed. $500.00 (later cloth, some pages
repaired)
Weld, Ralph Foster--Brooklyn Village, 1816-1834. N.Y.,
1938. $30.00 (cloth)
Weller, Allen Stuart--Art: USA: Now. N.Y., (1963). 2
vols. $65.00
Weller, Jack E.--Yesterday's People. (Lexington, Ky., 1965).
1st ed. $8.00
Welles, Gideon--Diary of.... Bost., 1911. 3 vols. $15.00
(ex-lib., front covers of two vols. water-stained)
Welles, Sumner--The Time for Decision. N.Y., (1944). $6.00
Wellman, Francis Lewis--Gentlemen of the Jury. N.Y., 1931.
$12.50
Wellman, Manly Wade--Rebel Boast. N.Y., 1956. 1st ed.
$12.50
Wellman, Paul Iselin--Death in the Desert. N.Y., 1935. 1st
ed. $50.00
--Death on Horseback. Phila., (1947). $35.00
--Death on the Prairie. N.Y., (1934). 1st ed. $35.00
--A Dynasty of Western Outlaws. Garden City, 1961. 1st
ed. $31.50, $12.50
Wells, Carolyn--Abeniki Caldwell. N.Y., 1902. 1st ed.
$15.00 (orig. boards, edges lightly worn, covers lightly
soiled)
Wells, Charles Wesley--Frontier Life. Cinci., (1902). $67.50
Wells, Edmund W.--Argonaut Tales.... N.Y., (1927). $40.00
Wells, Evelyn--Champagne Days of San Francisco. Garden
City, 1947. $12.00, $5.00
--The 49ers. Garden City, 1949. $15.00
--Fremont Older. N.Y., 1936. 1st ed. $10.00
Wells, Frederic Palmer--History of Newbury, Vermont.... St.
Johnsbury, Vt., 1902. $35.00 (cloth, backstrip frayed and
worn, pages a bit dog-eared)
Wells, Henry Parkhurst--City Boys in the Woods. N.Y., 1890.
$8.50 (some shelf wear)
Wells, William Vincent--The Life and Public Services of Sam-
uel Adams.... Bost., 1865. 3 vols. 1st ed. $37.50
(ends of spines frayed)

--Walker's Expedition to Nicaragua. N.Y., 1856. $450.00
(cloth)
Welsh, F.R.--America's Greatest Peril. N.p., n.d. $25.00
(wraps.)
Welty, Eudora--Delta Wedding. N.Y., (1946). 1st ed. $85.00
(orig. cloth, name on endsheet)
--Losing Battles. N.Y., (1970). 1st ed. $100.00 (buckram,
one of 300 signed copies)
--The Robber Bridegroom. N.Y., (1942). 1st ed. $15.00
--A Sweet Devouring. N.Y., 1969. $110.00 (wraps., one of
110 signed copies)
Welty, Susan Elizabeth Fulton--Look Up and Hope! N.Y.,
(1961). $25.00
Wemett, William Marks--A Geography of North Dakota. Fargo,
N.D., (1929). $6.00
--The Indians of North Dakota. Fargo, N.D., 1927. $5.00
(worn copy)
--The Story of the Flickertail State. Valley City, N.D., 1923.
$2.50 (ex-lib.)
Wenkam, Robert--Kauai and Park Country of Hawaii. S.F.,
(1967). 1st ed. $40.00, $35.00
Wentworth, Edward Norris--America's Sheep Trails. Ames,
Ia., 1948. 1st ed. $55.00
Wentz, Abdel Ross--History of the Evangelical Lutheran Synod
of Maryland.... Harrisburg, 1920. $35.00 (orig. cloth)
Werner, Emmy E.--Kauai's Children Come of Age. Honolulu,
1977. $12.00
Werner, Morris Robert--Barnum. N.Y., (1923). $12.50 (spine
and cover lightly bumped)
--Brigham Young. N.Y., (1925). 1st ed. $21.50 (binding
dull), $18.50
--Teapot Dome. N.Y., 1959. 1st ed. $6.00
Wertenbaker, Thomas Jefferson--Torchbearer of the Revolu-
tion. Princeton, 1940. 1st ed. $25.00
West, J.B.--Upstairs at the White House. N.Y., (1973).
$10.00
West, John--The Substance of a Journal During a Residence
at the Red River Colony.... Lond., 1824. 1st ed. $550.0(
(calf)
West, John C.--A Texan in Search of a Fight. Waco, 1901.
1st ed. $225.00 (author's presentation copy, orig. wraps.,
worn and frayed)
The West of Buffalo Bill. N.Y., (1974). $43.50, $25.00
West, Ray Benedict--Kingdom of the Saints. N.Y., 1957.
$15.00, $15.00 (edges faded), $12.50, $8.50

West, Richard Sedgewick--Gideon Welles.... Ind., (1943).
$12.50
--The Second Admiral. N.Y., 1937. $25.00
Westermeier, Clifford Peter--Trailing the Cowboy.... Cald-
well, 1955. 1st ed. $22.50
--Who Rush to Glory. Caldwell, 1958. $25.00
Westervelt, William Drake--Hawaiian Historical Legends. N.Y.,
(1923). 1st ed. $15.00, $15.00
--Legends of Maui.... Melbourne, (1913?). $25.00
Westmoreland, Sally (Lee) Bonner--The Common Herd....
(San Diego, 1955). $7.50
Weston, Otheto--Mother Lode Album. (Stanford, 1948). $20.00
Wetmore, Alphonso--Gazetteer of the State of Missouri....
S.L., 1837. 1st ed. $500.00 (orig. cloth)
Wetmore, Helen (Cody)--Last of the Great Scouts. (Duluth,
1899). 1st ed. $150.00 (cloth, a bit worn, pages somewhat
darkened and brittle), $25.00
Chi., (1899). $15.00
Weyer, Edward Moffat--Jungle Quest. N.Y., (1955). 1st ed.
$10.00 (signed by author)
Weygandt, Cornelius--The Heart of New Hampshire. N.Y.,
(1944). $7.50
--New Hampshire Neighbors. N.Y., (1937). $10.00
--The White Hills. N.Y., (1934). $15.00
Weyl, Nathaniel--Red Star Over Cuba. N.Y., 1960. 1st ed.
$4.00 (signed)
Weymouth, Lally--Thomas Jefferson. N.Y., (1973). $15.00
Wharton, Clarence Ray--El Presidente. Austin, (1926). $17.50
--Remember Goliad. Glorieta, N.M., (1968). 1st ed. $10.00
Wharton, Edith--A Backward Glance. N.Y., 1934. 1st ed.
$15.00 (orig. cloth, light foxing)
--The Children. N.Y., 1928. 1st ed. $16.00
--House of Mirth. N.Y., (1951). $16.00 (ex-lib.)
--Madam DeTreymes. N.Y., 1907. $45.00 (orig. cloth, spine
ends lightly rubbed)
--The Mother's Recompense. N.Y., 1925. $25.00 (orig. cloth,
bookplate, spine lightly soiled)
--A Son at the Front. N.Y., 1923. $25.00 (orig. cloth,
spine a bit dull, bookplate), $18.00
Wharton, Francis--The Revolutionary Diplomatic Correspondence
of the U.S. Wash., 1889. 6 vols. $140.00 (calf worn)
Wharton, May (Cravath)--Doctor Woman of the Cumberlands.
Pleasant Hill, Tn., (1953). $12.50 (tears repaired)
Wharton, William H.--Texas. N.Y., 1836. 1st ed. $1250.00
(new half morocco, scattered light foxing, untrimmed)

Wheat, Carl Irving--Books of the California Gold Rush. S.F.,
1949. 1st ed. $175.00 (boards, one of 500 copies, brown-
ing along edges of paper)
--Mapping the Transmississippi West, 1540-1861. S.F., 1957-
63. 5 vols. in 6. 1st ed. $1750.00 (orig. cloth), $1400.00
(ltd. to 1000 copies)
--The Pioneer Press of California. Oakland, 1948. $135.00
(one of 450 copies)
--Trailing the Forty-Niners Through Death Valley. S.F.,
1939. $55.00 (orig. wraps.), $45.00 (cover chipped and
soiled, spine taped, author's presentation inscription)
Wheatley, Phillis--Poems on Comic, Serious, and Moral Sub-
jects. Lond., (1773). $2500.00 (later three-quarter
leather)
--Poems on Various Subjects. Lond., 1773. 1st ed. $850.00
(new calf, lacks portrait)
Wheeler, Daniel Edwin, ed.--The Life and Writings of Thomas
Paine
See: Paine, Thomas
Wheeler, Edward Smith--Scheyichbi and the Strand.... Phila.,
1876. $35.00 (cloth, lightly foxed)
Wheeler, Homer Webster--Buffalo Days. Ind., (1925). $40.00,
$35.00 (cloth, covers lightly worn), $20.00
N.Y., (1925). $21.00
Wheeler, Kenneth W.--To Wear a City's Crown. Camb., 1968.
$15.00 (cloth), $15.00
Wheeler, Olin Dunbar--The Trail of Lewis and Clark, 1804-
1904. N.Y., 1904. 2 vols. 1st ed. $125.00 (cloth)
Wheeler, Osgood Church--The Chinese in America. Oakland,
1880. $50.00 (orig. printed wraps.), $49.50 (wraps.)
Wheeler, Robert R.--Oil, From Prospect to Pipeline. Houston,
1975. $8.00
Wheeler, Ruth Carr--We Follow the Western Trail. N.Y.,
1941. $7.50
Wheeler, Ruth Robinson--Concord. Concord, Ma., 1967.
$12.50
Wheelock, Eleazar--A Brief Narrative of the Indian Charity-
School
See: (Whitaker, Nathaniel)
Whelan, Russell--The Flying Tigers. N.Y., 1942. 1st ed.
$10.00
Whetten, Nathan Laselle--Rural Mexico. Chi., (1948). $13.50
Whimwhams, by the Four of Us. Bost., 1828. 1st ed. $42.50
(spine loose, title and text stained)

Whipple, Amiel Weeks--A Pathfinder in the Southwest. Norman,
 1941. 1st ed. $50.00
 Norman, (1968). $15.00
Whipple, Edwin Percy--Recollections of Eminent Men, With
 Other Papers. Bost., 1887. $9.00
Whipple, Henry Benjamin--Lights and Shadows of a Long
 Episcopate. N.Y., 1902. $15.00
Whipple, Maurine--This is the Place. N.Y., 1945. $15.00
 (lacks endpaper), $8.50
Whipple, Sidney Beaumont--The Lindbergh Crime. N.Y.,
 (1935). $18.00 (reading copy)
Whistler, James McNeil--Eden Versus Whistler. N.Y., 1899.
 $200.00 (boards, one of 250 copies, owner name, cover
 worn and soiled)
--The Gentle Art of Making Enemies. Lond., 1890. $100.00
 (boards, endpapers browned, cover worn)
Whitaker, Arthur Preston--Argentine Upheaval. N.Y., (1956).
 $10.00
--Nationalism in Contemporary Latin America. N.Y., (1966).
 $12.00
--The United States and South America. Camb., 1948. 1st ed.
 ed. $10.00
--The Western Hemisphere Idea. Ithaca, (1954). 1st ed.
 $7.50
Whitaker, John Thompson--Americans to the South. N.Y.,
 1939. $8.50
(Whitaker, Nathaniel)--A Brief Narrative of the Indian Charity-
 School.... Lond., 1766. 1st ed. $200.00 (sewn)
White, Alma--Woman's Chains. Zarephath, N.J., 1943. $27.00
White, Andrew Dickson--Autobiography of Andrew Dickson
 White. N.Y., 1906. 2 vols. $30.00
White, Charles Thomas--Lincoln and Prohibition. N.Y.,
 (1921). $8.50
White, David, pseud.
 See: Place, Marian Templeton
White, Edward Lucas--El Supremo. N.Y., (1916). $10.00
White, Elijah--A Concise View of Oregon Territory. Wash.,
 1846. $3500.00 (orig. wraps., owner name, slipcased)
White, Eric Walter--Images of H.D. Lond., 1976. $40.00 (one
 of 50 copies, signed)
White, Ernest William--Cameos From the Silver-Land. Lond.,
 1881-82. 2 vols. $87.00 (cloth)
White, Gerald Taylor--Formative Years in the Far West. N.Y.,
 (1962). 1st ed. $15.00, $12.50

White, Helen (McCann)--Ho! For the Gold Fields. St. Paul, 1966. $10.00

White Horse Eagle--We Indians. N.Y., (1931). 1st ed. $30.00 (cloth), $25.00

White, John Duncan--The Trials of John Duncan White Alias Charles Marchant.... Bost., 1827. $30.00

White, John W.--Argentina.... N.Y., 1942. $9.00, $5.00

White, Joseph M.--A New Collection of Laws.... Phila., 1839. 2 vols. 1st ed. $750.00 (sheep, occasional light damp-staining and foxing)

White, K.--A Narrative of the Life, Occurrences, Vicissitudes and Present Situation of.... Schenectady, 1809. $650.00 (orig. boards, lacks parts of boards, title torn)

White, Leonard Dupree--The Republican Era.... N.Y., 1958. $15.00 (1st printing)

White, Owen Payne--The Autobiography of a Durable Sinner. N.Y., 1942. 1st ed. $45.00 (orig. cloth, 1st issue)

--Texas, an Informal Biography. N.Y., (1945). $10.00 (cloth)

--Them Was the Days. N.Y., 1925. 1st ed. $35.00 (orig. cloth)

White, Philo--Narrative of a Cruize in the Pacific to South America and California.... Denver, (1965). $65.00 (orig. cloth, one of 1000 copies), $27.50 (one of 1000 copies)

White, Stewart Edward--Daniel Boone, Wilderness Scout. Garden City, (1922). 1st ed. $20.00 (corners lightly rubbed)
Garden City, 1930. $10.00
Garden City, 1935. $9.00

--The Forty-Niners. New Haven, 1920. $15.00

White, Theodore Harold--The Making of the President. N.Y., 1962. $6.00
N.Y., 1973. $6.00

White, Trumbull--Our New Possessions. Cleve., 1898. $25.00 (worn)

White, William Allen--The Autobiography of.... N.Y., 1946. 1st ed. $15.00, $7.00

--Calvin Coolidge. N.Y., 1925. $10.00

--In Our Town. N.Y., 1906. 1st ed. $87.50 (signed and inscribed)

--A Puritan in Babylon.... N.Y., 1938. $7.50

White, William Francis--A Picture of Pioneer Times in California. S.F., 1881. 1st ed. $37.50 (newly rebound)

White, William Lindsay--Bernard Baruch.... N.Y., 1950. 1st ed. $8.00

Whitehouse, Arthur George Joseph--The Years of the Sky
Kings. Garden City, 1959. $8.50

Whiting, Joseph Samuel--Forts of the State of California.
(Seattle), 1960. $20.00

Whitman, Alden--Portrait-Adlai E. Stevenson. N.Y., (1965).
$12.50

Whitman, George Washington--Civil War Letters of.... Dur-
ham, 1975. 1st ed. $12.50

Whitman, Walt--Leaves of Grass. N.Y., 1942. 2 vols. $1000.00
(Limited Editions Club, orig. glassine and slipcase)

--Memories of President Lincoln. Port., Me., 1912. $25.00
(boards a bit browned, crown of spine lightly scuffed,
bookplate, one of 300 copies)

--Specimen Days & Collect. Phila., 1882-83. 1st ed. $50.00
(orig. cloth, 2nd issue, bookplate, cloth lightly soiled)

--Walt Whitman's Civil War. N.Y., 1961. $15.00

Whitney, Caspar--Hawaiian America. N.Y., 1899. 1st ed.
$50.00

Whitney, Josiah Dwight--The Yosemite Book: a Description
of the Yosemite Valley and the Adjacent Region of the
Sierra Nevada. N.Y., 1868. 1st ed. $4750.00 (orig.
three-quarter morocco, rebacked with orig. spine laid
down, ltd. to 250 copies)

Whitney, Louisa Maretta (Bailey)--Goldie's Inheritance. Bur-
lington, Vt., 1903. $12.50

Whitney, Orson Ferguson--Popular History of Utah. S.L.C.,
1916. $25.00 (three-quarter leather, lacks front fly)

Whitney, Richard Merrill--Reds in America. N.Y., 1924.
$35.00 (rubbed), $30.00 (rubbed, worn at extremities)

Whittemore, Charles Park--A General of the Revolution....
N.Y., 1961. $20.00

Whittier, John Greenleaf--The Complete Poetical Works of....
Bost., 1892. $20.00

--In War Time, and Other Poems. Bost., 1864. 1st ed.
$15.00 (binding partly faded)

--The Poetical Works of.... Bost., 1888. $7.50

--Snow-Bound. Bost., (1905). $95.00 (title sig. lightly
pulled)

--Works. Bost., (1892). 7 vols. in 2. $100.00 (Artists'
Ed., one of 750 sets, stain on prelim. leaves of one vol.),
$65.00 (orig. cloth)

Whittlesey, Charles--Fugitive Essays.... Hudson, Oh., 1852.
1st ed. $125.00 (orig. cloth)

Whitton, Frederick Ernest--Wolfe and North America. Bost.,
1929. 1st ed. $17.50

Wicker, Anna--Coyote Chief and the Two Blind Men. Bis-
marck, N.D., 1978. $5.00
Widmann, Otto--A Preliminary Catalogue of the Birds of Mis-
souri. N.p., (1907). $44.00 (cloth)
Wieners, John--Ace of Pentacles. N.Y., 1964. $26.00 (cloth)
Wienpahl, Robert W., ed.--A Gold Rush Voyage on the Bark
Orion....
See under Title
Wierzbicki, Felix Paul--California as It Is & as It May Be.
S.F., 1933. $120.00 (one of 500 copies)
Wiesendanger, Martin W.--Grant and Carolyn Foreman, a Bib-
liography. Tulsa, 1948. $20.00
Wiggins, Lida Keck, comp.--The Life and Works of Paul Laur-
ence Dunbar
See: Dunbar, Paul Laurence
Wilbur, Ray Lyman--The Hoover Policies. N.Y., 1937. 1st ed.
$15.00
Wilbur, Richard--Things of This World. N.Y., (1956). $45.00
(cloth)
Wilcox, Alanson--A History of the Disciples of Christ in Ohio.
Cinci., (1918). $15.00
Wilcox, Walter Dwight--The Rockies of Canada. N.Y., 1900.
$40.00 (cloth, ink inscription, bookplate)
Wilcoxson, William Howard--History of Stratford, Connecticut,
1639-1939. Stratford, 1939. $35.00 (autographed)
Wild Life on the Plains and Horrors of Indian Warfare
See: (Custer, George Armstrong)
Wilder, Daniel Webster--The Annals of Kansas, 1886-1925.
Topeka, Ks., (1954-56). 2 vols. $27.50
Wilder, David--The History of Leominster.... Fitchburg,
1853. 1st ed. $20.00 (binding partly faded)
Wilder, Thornton--The Eighth Day. N.Y., (1967). 1st ed.
$40.00 (buckram, boxed, one of 500 numbered and signed
copies)
--Heaven's My Destination. N.Y., 1935. $15.00 (cloth, cover
lightly worn and soiled)
Wiles, Robert--Cuban Sugar Cane.... Ind., 1916. $15.00
(boards, spine worn)
Wiley, Bell Irvin--The Life of Billy Yank. Ind., (1952). 1st
ed. $17.50
Wilgus, Alva Curtis--The Development of Hispanic America.
N.Y., (1941). $10.00
Wilhelm, H.R.H., Duke Paul
See: Paul Wilhelm, Duke of Württemberg
(Wilhelm, Honor L.)--Will B. More Letters. Seattle, 1900.
1st ed. $60.00 (orig. cloth)

Wilhelm, Stephen R.--Cavalcade of Hooves and Horns. San
Antonio, (1958). $8.00 (imitation leather)
Wilkes, Charles--Columbia River to the Sacramento. Oakland,
1958. $25.00 (one of 600 copies)
--Commodore Charles Wilkes's Court-Martial. Wash., 1864.
$75.00 (half morocco)
--Narrative of the United States Exploring Expedition....
Phila., 1845. 6 vols., incl. atlas. $1250.00 (orig. cloth
with atlas vol. in contemp. sheep, ltd. to 1000 copies),
$650.00 (atlas binding differs from other vols.)
--Synopsis of the Cruise of the U.S. Exploring Expedition,
During the Years 1838, '39, '40, '41, & '42. Wash., 1842.
$275.00 (disbound, slipcased)
Wilkin, Robert Nugen--The Spirit of the Legal Profession.
New Haven, 1938. 1st ed. $10.00
Wilking, James F.--An Artist on the Overland Trail. San
Marino, Ca., 1968. 1st ed. $35.00
Wilkins, Burleigh Taylor--Carl Becker. Camb., 1961. 1st ed.
$20.00
Wilkinson, James--Memoirs of My Own Times.... Phila., 1816.
4 vols. $1000.00 (atlas included, cloth)
Willard, Francis Elizabeth--Glimpses of Fifty Years. Chi.,
1889. $20.00 (minor front hinge repair, wear to extrem-
ities)
Willard, Josiah Flynt--Notes of an Itinerant Policeman. Free-
port, (1972). $12.00
--The World of Graft. N.Y., 1901. 1st ed. $25.00 (cloth,
owner name)
Willard, Theodore Arthur--The City of the Sacred Well. N.Y.,
(1926). 1st ed. $10.00
Willcox, William Bradford--Portrait of a General. N.Y., 1964.
$20.00
Willebrandt, Mabel (Walker)--The Inside of Prohibition. Ind.,
(1929). $17.50
Williams, Ben Ames--The Happy End. N.Y., (1939). $100.00
(cloth, one of 1250 copies)
Williams, Bernard--Jailbait! N.Y., 1950. $8.00
Williams, Carl Mark--Silversmiths of New Jersey, 1700-1825....
Phila., 1949. $40.00 (ex-lib.)
Williams, David A.--David C. Broderick; a Political Portrait.
San Marino, 1969. 1st ed. $7.50
Williams, Eleazer--Life of Te-Ho-Ra-Gwa-Ne-Gen.... Albany,
1859. $100.00 (half leather and boards, bookplate, some
underlining, piece lacking from crown of backstrip)
Williams, Eric Eustace--History of the People of Trinidad and
Tobago. (Lond., 1964). $22.50 (orig. cloth)

Williams, Frances Leigh--Matthew Fontaine Maury.... New
 Brunswick, (1963). $15.00
--Plantation Patriot. N.Y., (1967). $10.00
Williams, George Washington--A History of the Negro Troops
 in the War of the Rebellion.... N.Y., (1969). $16.50
 (buckram)
Williams, Harry Lee--History of Craighead County, Arkansas.
 Little Rock, Ar., 1930. $40.00 (cloth, cover lightly worn)
Williams, Henry T.--The Pacific Tourist. N.Y., 1880. $95.00
 (orig. cloth boards, inside front hinge cracked, backstrip
 faded)
Williams, John H.--Yosemite and Its High Sierra. Tacoma,
 1914. 1st ed. $45.00 (endpapers lightly foxed)
Williams, Joseph John--Whisperings of the Caribbean. N.Y.,
 1925. $10.00
Williams, Meade Creighton--Early Mackinac. S.L., 1901. $10.00
Williams, Oscar Waldo--Pioneer Surveyor, Frontier Lawyer.
 El Paso, 1966. 1st ed. $40.00 (signed by Carl Hertzog,
 designer)
Williams, Ronald John--Jennie McGraw Fiske. Ithaca, 1949.
 $15.00 (ex-lib.)
Williams, Samuel--The Natural and Civil History of Vermont.
 Burlington, Vt., 1809. 2 vols. $150.00 (recent cloth,
 blind stamp on titles), $25.00 (spine covers worn, one front
 cover loose)
Williams, Stanley T.--The Life of Washington Irving. N.Y.,
 1935. 2 vols. 1st ed. $30.00
Williams, Stephen West--A Biographical Memoir of the Rev.
 John Williams.... Greenfield, 1837. 1st ed. $100.00
 (orig. boards)
Williams, Tennessee--A Streetcar Named Desire. (N.Y., 1947).
 1st ed. $90.00 (light wear and sunning, boards)
Williams, Thomas Harry, ed.--Hayes
 See: Hayes, Rutherford Birchard
--Lincoln and His Generals. N.Y., 1952. $12.50
Williams, William--Journal of the Life, Travels and Gospel
 Labours of William Williams.... Cinci., 1828. $225.00
 (calf), $100.00 (contemp. calf, rubbed, ex-lib.), $17.00
 (title in facs., contemp. calf)
Williamson, Harold Francis--Winchester. Wash., (1952). $300.0
 (boards, slipcased, one of 100 copies signed by author)
Williamson, James Alexander--The Voyages of the Cabots and
 the English Discovery of North America.... Lond., 1929.
 1st ed. $100.00 (cloth, one of 1050 numbered copies)
Willis, Charles Ethelbert--Scouts of '76. Rich., 1924. 1st ed.
 $15.00

Willis, Nathaniel Parker--American Scenery. Lond., 1852. 2
 vols. $500.00 (cloth, corners bumped, light to moderate
 foxing to half the plates)
--Canadian Scenery. Lond., (1842). 2 vols. in 1. 1st ed.
 $2400.00 (half calf, outer hinges rubbed)
--Poems of.... $12.50 (morocco, lacks backstrip top)
Willison, Charles A.--Reminiscences of a Boy's Service....
 (Menasha, Wi., 1908). $15.00
Willison, George Findlay--Here They Dug the Gold. Lond.,
 1952. $7.50
--Patrick Henry and His World. Garden City, 1969. $12.50
Willkie, Wendell--This is Wendell Willkie. N.Y., 1940. $12.50
Willoughby, Malcolm Francis--Rum War at Sea. (Wash., 1964).
 1st ed. $10.00
Willoughby, Westel Woodbury--The Supreme Court of the U.S.
 Balt., 1890. $12.50 (cloth)
Willoughby, William R.--The St. Lawrence Waterway. Madison,
 1961. $20.00
Wills, Bernt Lloyd--North Dakota.... Ann Arbor, Mi., 1972.
 $12.50
Willson, Beckles--America's Ambassadors to England (1785-
 1929). N.Y., 1929. 1st ed. $10.00 (ex-lib.)
--America's Ambassadors to France (1777-1927). N.Y., 1928.
 1st ed. $10.00 (ex-lib.)
--The Story of Rapid Transit. N.Y., 1903. 1st ed. $17.50
Willson, Marcius--American History. N.Y., 1847. $16.50
 (spine worn)
Willson, Meredith--And There I Stood With my Piccolo. Garden
 City, 1948. 1st ed. $8.50 (cover lightly stained)
Wilmerding, John--Fitz Hugh Lane. N.Y., (1971). $30.00
--James Monroe.... New Brunswick, (1960). 1st ed. $10.00
Wilson, Adelaide--Historic and Picturesque Savannah. (Bost.),
 1889. $75.00 (cloth, somewhat rubbed, light foxing)
Wilson, Alan--The Clergy Reserves of Upper Canada. Toronto,
 1968. 1st ed. $17.50
Wilson, Amos--The Pennsylvania Hermit
 See under Title
Wilson, Arthur Herman--A History of the Philadelphia The-
 atre.... N.Y., 1968. $25.00 (orig. cloth)
Wilson, Charles Morrow--Aroostook: Our Last Frontier.
 Brattleboro, Vt., (1937). $12.50
--Backwoods America. Chapel Hill, 1935. $10.00
--Central America. N.Y., 1941. $10.00
--Empire in Green and Gold. (N.Y., 1947). $12.50
--Meriwether Lewis of Lewis and Clark. N.Y., (1934). $15.00

Wilson, Charles William--Mapping the Frontier. Toronto,
(1970). $10.00
Wilson, Francis--Joseph Jefferson. N.Y., 1906. $15.00 (light
cover wear)
Wilson, Henry--History of the Reconstruction Measures of the
Thirty-Ninth Congress.... Hart., 1868. $27.50 (ex-lib.,
binding a bit damp speckled)
Wilson, Herbert Earl--The Lore and the Lure of Sequoia.
L.A., 1928. 1st ed. $10.00
Wilson, James, 1742-1798--The Works of.... Camb., 1967.
2 vols. $40.00
Wilson, James Grant, ed.--The Life of John James Audubon....
See: Audubon, John James
Wilson, James Harrison, 1837-1925--The Life of Charles A.
Dana. N.Y., 1907. $15.00
--The Life of Ulysses S. Grant.... Springfield, Ma., 1868.
1st ed. $16.00
Wilson, Iris (Higbie)
See: Engstrand, Iris Wilson
Wilson, LeGrand James--The Confederate Soldier. Memphis,
(1973). $13.50
Wilson, Neill Compton--Silver Stampede. N.Y., 1937. 1st ed.
$15.00
Wilson, Peter, 1797-1826--The Letters of.... Balt., 1940.
$21.00
Wilson, Peter Mitchel, 1848-1939--Southern Exposure. Chapel
Hill, 1927. $15.00
Wilson, Robert Anderson--A New History of the Conquest of
Mexico.... Phila., 1859. 1st ed. $475.00 (orig. cloth,
spine repaired, owner's signature)
Wilson, Robert Forrest--Crusader in Crinoline. Phila., 1941.
$24.00 (inscribed, minor soiling to cover)
Wilson, Rufus Rockwell--Lincoln in Caricature. N.Y., 1953.
$16.00
--New York in Literature. N.Y., 1947. $25.00 (cloth,
lightly worn, trade ed.)
--Out of the West. N.Y., 1936. $25.00 (cloth, lightly soiled),
$25.00 (cloth, one of 300 copies signed by the author),
$15.00
Wilson, Terry P.--The Cart That Changed the World. Norman,
1978. $9.00
Wilson, Thomas--Picture of Philadelphia, for 1824.... Phila.,
1823. $200.00 (half calf)
Wilson, William Edward--The Wabash. N.Y., (1940). $15.00

Wilson, Woodrow--Cabinet Government in the United States. Stanford, 1947. $25.00 (boards, one of 1000 copies)
--A History of the American People. N.Y., 1902. 5 vols. $85.00 (cloth)
--The State. Bost., 1899. $18.00 (newly rebound in cloth)
Wilstach, Paul--Hudson River Landings. Ind., (1933). 1st ed. $25.00 (signed copy, cloth, endpapers lightly foxed)
Wiltse, Charles Maurice--The Jeffersonian Tradition in American Democracy. N.Y., (1960). $5.00 (paper)
Wimberly, Lowry Charles--Mid Country. Lincoln, 1945. $10.00 (cloth)
Winchester, Alice--Versatile Yankee. Princeton, 1973. $30.00
Wind, Herbert Warren--The Gilded Age of Sport. N.Y., 1961. $12.50
Windolph, Charles A.--I Fought With Custer. N.Y., 1947. 1st ed. $52.50
N.Y., 1950. $15.00 (endpapers yellowed)
Windrow, John Edwin--John Berrien Lindsley.... Chapel Hill, 1938. 1st ed. $20.00 (corner of endpaper clipped)
Winfield, Charles Hardenburg--History of the County of Hudson, New Jersey.... N.Y., 1874. 1st ed. $65.00 (half morocco)
Wingate, George Wood--History of the Twenty-Second Regiment of the National Guard of the State of New York. N.Y., (1896). 1st ed. $35.00 (cloth, back cover water damaged)
Winkelman, Barnie F.--John D. Rockefeller. Chi., 1937. $20.00
--John G. Johnson.... Phila., 1942. $17.50
Winkler, Ernest William--Check List of Texas Imprints, 1846-1860. Austin, 1949. 1st ed. $20.00 (orig. cloth)
--Check List of Texas Imprints, 1861-1876. Austin, 1963. 1st ed. $30.00 (orig. cloth)
--Journal of the Secession Convention of Texas, 1861
See: Texas, Convention, 1861
Winkler, John Kennedy--Five and Ten. N.Y., (1940). 1st ed. $20.00, $15.00
--John D. N.Y., 1929. $12.00 (dime missing from cover), $5.00 (ex-lib., reading copy)
--Morgan the Magnificent. Garden City, 1930. $15.00
--Tobacco Tycoon.... N.Y., (1942). $8.50
--W.R. Hearst.... N.Y., 1928. $12.50
--William Randolph Hearst.... N.Y., (1955). $12.50
Winningham, Geoff--Going Texan. N.p., (1972). $21.00
Winship, George Parker--The Journey of Francisco Vazquez de

Coronado, 1540-1542.... S.F., 1933. $60.00 (one of 500
copies, covers a bit foxed and dull)
Winslow, Anna Green--Diary of Anna Green Winslow, a Boston
School Girl of 1771. N.Y., 1894. 1st ed. $35.00 (orig.
cloth, worn, backstrip discolored, some marginal pencil
notes)
Winsor, Justin--A History of the Town of Duxbury.... Bost.,
1849. $60.00 (rubbed)
--The Memorial History of Boston.... Bost., (1880-81). 4
vols. 1st ed. $100.00 (cloth, somewhat frayed and worn,
bookplates)
--Narrative and Critical History of America. Bost., 1886-89.
8 vols. $150.00 (newly rebound, one vol. lacks title)
Winston, Robert Watson--Andrew Johnson.... N.Y., (1928).
1st ed. $17.50 (cloth), $12.50
Winter, Nevin Otto--Texas the Marvellous. Bost., 1916.
$37.50 (1st impression)
Winther, Oscar Osburn, ed.--The Private Papers and Diaries
of Thomas Leiper Kane
See: Kane, Thomas Leiper
Winthrop, Theodore--The Canoe and the Saddle.... Bost.,
1863. $90.00, $35.00 (orig. cloth, minor foxing)
Portland, Or., (1955). $10.00
Wisbey, Herbert Andrew--Pioneer Prophetess: Jemima Wilkin-
son.... Ithaca, (1964). $25.00
--Soldiers Without Swords. N.Y., 1956. $10.00
Wisconsin in Three Centuries....
See: (Campbell, Henry Colin)
Wise, David--The U-2 Affair. N.Y., (1962). $20.00
Wise, Isaac Mayer--Reminiscences. Cinci., 1901. 1st ed.
$25.00 (lib. bookplate)
Wise, Jennings Cropper--The Red Man in the New World
Drama. N.Y., (1971). $10.00
Wise, John Sergeant--The End of an Era. Bost., 1899. 1st
ed. $12.50
Wissler, Clark--The American Indian. N.Y., 1917. $40.00
(cloth, hinges cracked, 1 small tear in map)
--Indians of the U.S. N.Y., 1940. 1st ed. $20.00 (cloth)
Wistar, Isaac Jones--Autobiography, 1827-1905. Phila., 1937.
$35.00, $35.00 (cloth)
Wister, Charles Jones--The Labour of a Long Life. German-
town, Pa., 1866-86. 2 vols. $85.00 (orig. cloth)
Wister, Owen--The Virginian. N.Y., 1902. 1st ed. $25.00
(backstrip ends frayed, corners rubbed, inner back hinge
cracked, tape repairs)

--The Writings of.... N.Y., 1928. 11 vols. $150.00 (orig. cloth)

Wister, Sally--Sally Wister's Journal.... Bost., (1902). $15.00 (backstrip faded)

With Christ in Kansas
 See: Allison, George William

Withers, Alexander Scott--Chronicles of Border Warfare. Clarksburg, Va., 1831. 1st ed. $225.00 (contemp. calf, lacks front endleaves, leaf torn)

Withington, Antionette--The Golden Cloak. (Honolulu, 1953). $15.00

Woldman, Albert A.--Lincoln and the Russians. Cleve., (1952). $20.00

Wolf, Edmund Jacob--The Lutherans in America. N.Y., 1890. $15.00

Wolf, Edwin--Rosenbach. Cleve., (1960). $27.50

Wolfe, Bertram David--Diego Rivera. N.Y., 1939. 1st ed. $50.00

Wolfe, Linnie Marsh--Son of the Wilderness. N.Y., 1945. $25.00, $15.00 (spine and fore-edge faded)

Wolfe, Reese--Yankee Ships.... Ind., (1953). $10.00 (ex-lib.)

Wolfe, Thomas--Mannerhouse. N.Y., 1948. 1st ed. $200.00 (orig. cloth, spine a bit darkened, one of 500 copies, boxed)

--Of Time and the River. N.Y., 1935. 1st ed. $250.00 (orig. cloth, endpapers browned)

--The Short Novels of.... N.Y., 1961. 1st ed. $35.00

Wolff, Cynthia Griffin--A Feast of Words. N.Y., 1977. 1st ed. $18.00

Wolff, Leon--Lockout: the Story of the Homestead Strike of 1892. Lond., 1965. $20.00

Wolle, Muriel Vincent Sibell--The Bonanza Trail. Bloomington, 1953. 1st ed. $30.00 (light rubbing to extremities, signed by author)

--Stampede to Timberline. Chi., 1971. $10.00

Womack, John--Zapata.... N.Y., 1969. $18.50, $5.00 (underlining in ink)

Woman's Club of Havana. Garden Section--Flowering Plants From Cuban Gardens. N.Y., (1958). $7.50

Wood, Edith--Middletown's Days and Deeds. N.p., (1946). $20.00 (owner name on title)

Wood, Elizabeth (Lambert)--Pete French, Cattle King. Portland, Or., (1951). 1st ed. $15.00

Wood, Ellen Lamont--George Yount.... S.F., 1941. $135.00 (one of 200 copies, signed by author)

Wood, Frederick James--The Turnpikes of New England....
 Bost., 1919. $25.00 (1st printing)
Wood, Harvey--Personal Recollections. Pasadena, 1955. $90.00
 (one of 100 numbered copies, signed by editor)
Wood, Lewis Keysor--The Discovery of Humboldt Bay. S.F.,
 1932. $65.00 (orig. wraps., one of 100 copies)
Wood, Raymund Francis--California's Agua Fria. Fresno, 1954.
 1st ed. $15.00
Wood, Richard George--Stephen Harriman Long.... Glendale,
 1966. 1st ed. $20.00
Wood, Silas--A Sketch of the First Settlement of the Several
 Towns on Long-Island. Brooklyn, 1828. $65.00 (new
 cloth, text partly water stained)
Wood, Stanley--Over the Range to the Golden Gate. Chi.,
 1891. $35.00
 Chi., 1897. $20.00 (cloth, small name stamp on endpaper)
 Chi., 1904. $9.50
Woodbury, John Hubbard--How I Found It, North and South.
 Bost., 1880. $10.00 (ex-lib., title partly torn)
Woodcock, George--Incas and Other Men. Lond., 1959. $9.50
Wooddy, Carroll Hill--The Case of Frank L. Smith. Chi.,
 (1931). 1st ed. $15.00
Woodruff, Francis Eben--The Woodruffs of New Jersey....
 N.Y., 1909. $18.50
Woodruff, Janette--Indian Oasis. Caldwell, 1939. $17.50
 (light soiling and wear at edges)
Woodruff, Mathew--A Union Soldier in the Land of the Van-
 quished. University, Al., (1969). $10.50
Woodruff, Press--A Bundle of Sunshine. Chi., (1901). $20.00
Woods, John--Two Years' Residence in the Settlement of the
 English Prairie, in the Illinois Country, United States....
 Lond., 1822. 1st ed. $1250.00 (orig. boards, cloth slip-
 case)
Woodson, William H.--History of Clay County, Missouri. To-
 peka, 1920. 1st ed. $50.00 (cloth, covers lightly worn and
 soiled)
Woodward, Arthur, ed.--Man of the West
 See: Oaks, George Washington
--Trapper Jim Waters. (L.A., 1953). $8.50 (ltd. and num-
 bered ed.)
Woodward, Augustus Brevoort--Considerations on the Execu-
 tive Government of the United States of America. Flatbush,
 1809. 1st ed. $175.00 (half morocco)
Woodward, Grace Steele--The Cherokees. Norman, (1963).
 1st ed. $30.00

--Pocahontas. Norman, 1970. $20.00
Woodward, Patrick Henry--Guarding the Mails. Hart., 1876.
$75.00 (leather, hinges cracked, covers partially detached,
some pages dog-eared)
--The Secret Service of the Post-Office.... Hart., 1886.
1st ed. $40.00 (covers lightly stained)
Woodward, William E.--Lafayette. N.Y., (1938). $7.50
--Meet General Grant. N.Y., 1928. $10.50
--Tom Paine. N.Y., 1945. 1st ed. $8.50
Woodward, Woody--Jazz Americana. (L.A., 1956). $12.50
(wraps.)
Wooldridge, Clifton Rodman--Hands Up! Chi., 1906. $25.00
(orig. cloth, binding lightly worn and rubbed, bookplate)
Woolman, John--Journal fo the Life, Gospel Labours and
Christian Experiences of That Faithful Minister of Jesus
Christ, John Woolman. Phila., 1880. $12.50
Wootton, Richeus Lacy--Uncle Dick Wootton. Chi., 1957.
$10.00
Workman, James--Essays and Letters on Various Political Sub-
jects. N.Y., 1809. $850.00 (orig. boards, leather spine)
Wrede, Friedrich W. von--Lebensbilder aus den Vereinigten
Staaten von Nord Amerika und Texas.... Cassal, 1844.
1st ed. $3500.00 (orig. boards)
Wright, Carroll Davidson--A Report on Labor Disturbances in
the State of Colorado.... Wash., 1905. 1st ed. $30.00
Wright, Mrs. D.G.
See: Wright, Louise Wigfall
Wright, Harold Bell--That Printer of Udell's. N.Y., 1903.
$45.00 (front lettering flaked)
Wright, Henry H.--A History of the Sixth Iowa Infantry.
Iowa City, 1923. $45.00 (spine snagged, few pages care-
lessly opened)
Wright, James North--Where Copper Was King. Bost., 1905.
$10.00
Wright, John A.--A Paper on the Character and Promise of
the Country on the Southern Border.... Phila., 1876.
$150.00 (orig. front wrap.)
Wright, Louis Booker--The Cultural Life of the American Col-
onies.... N.Y., (1957). $8.00 (covers water stained)
--Gold, Glory, and the Gospel. N.Y., 1970. $15.00, $12.00
Wright, Louise Wigfall--A Southern Girl in '61. N.Y., 1905.
$30.00 (ex-lib.)
Wright, Muriel Hazel--A Guide to the Indian Tribes of Okla-
homa. Norman, (1951). 1st ed. $19.50
Wright, Nathalia--Horatio Greenough.... Phila., (1963). $30.00

Wright, Olgivanna Lloyd--Our House. N.Y., 1959. $20.00
 (spine little faded)
Wright, Richard--The Long Dream. Garden City, 1958. 1st
 ed. $10.00 (owner name, cloth)
--Native Son. N.Y., 1940. $15.00 (cloth)
Wright, Richard Robert--The Negro in Pennsylvania. (Phila.,
 1912). $50.00 (orig. wraps.)
Wright, Richardson Little--Hawkers & Walkers in Early Amer-
 ica. Phila., 1927. 1st ed. $17.50
Wright, Robert Marr--Dodge City, the Cowboy Capital....
 [Wichita, 1913]. $50.00 (orig. cloth)
Wright, Theon--Rape in Paradise. N.Y., (1966). 1st ed.
 $10.00
Wright, William--The Big Bonanza. N.Y., 1947. $36.50,
 $25.00
 N.Y., 1967. $17.50
--History of the Big Bonanza. Hart., 1877. $75.00
--A History of the Comstock Silver Lode.... Virginia, Nv.,
 (1889). $80.00
 N.Y., 1974. $14.00, $7.00
--The Oil Regions of Pennsylvania. N.Y., 1865. 1st ed.
 $200.00 (orig. cloth), $200.00 (orig. cloth)
Wright, William Greenwood--Colored Plates of the Butterflies
 of the West Coast. San Bernardino, 1907. $50.00 (cloth,
 lightly faded)
Wrigley, Henry E.--Special Report on the Petroleum of Penn-
 sylvania.... Harrisburg, 1875. $50.00 (binding worn)
Wriston, Roscoe C.--Hawaii Today. Garden City, 1926.
 $30.00, $15.00, $10.00
Writers' Program--Arizona. N.Y., 1940. 1st ed. $7.50
 (bookplate)
 N.Y., (1956). $22.50
--The Assinibones. Norman, (1961). $20.00 (cloth)
--Atlanta, a City of the Modern South. N.Y., (1942). 1st
 ed. $22.50, $20.00 (ex-lib.)
--California. N.Y., (1947). $7.50
 N.Y., 1954. $15.00
--Colorado. N.Y., 1941. 1st ed. $20.00 (1st printing)
--Cooper Camp. N.Y., (1943). 1st ed. $15.00
--Death Valley. Bost., 1939. 1st ed. $10.00
--Delaware. N.Y., 1938. 1st ed. $20.00
--Florida. N.Y., (1944). $20.00
--Georgia. Athens, 1940. 1st ed. $25.00, $22.50 (ex-lib.)
--Ghost Towns of Colorado. N.Y., (1947). $17.50
--God Bless the Devil. Chapel Hill, 1940. 1st ed. $25.00

--A Guide to Alaska.... N.Y., 1943. $22.50
 N.Y., 1945. $17.50 (owner name)
--A Guide to Key West. N.Y., (1949). $12.50
--Gumbo Ya-Ya. Bost., 1945. $20.00, $15.00 (crack in front
 hinge)
--Hands That Built New Hampshire. Brattleboro, Vt., (1940).
 $25.00 (spine little faded)
--Illinois. Chi., 1939. 1st ed. $20.00
 Chi., 1947. $25.00
--Kansas. N.Y., 1939. 1st ed. $22.50
--Lamps on the Prairie. (Emporia, Ks.), 1942. 1st ed.
 $22.50
--Los Angeles. N.Y., (1951). $20.00
--Louisiana. N.Y., 1945. $25.00
--A Maritime History of New York. N.Y., 1941. 1st ed.
 $20.00 (spine faded)
--Maryland. N.Y., (1940). 1st ed. $25.00
--Massachusetts. Bost., (1937). $22.50
--Michigan. N.Y., (1946). $25.00
 N.Y., 1947. $25.00
--Minnesota. N.Y., 1938. 1st ed. $25.00
 N.Y., 1947. $25.00
--Missouri.... N.Y., (1941). $25.00
--Monterey Peninsula. Stanford, (1941). 1st ed. $12.50
--Nevada. Portland, Or., (1940). 1st ed. $25.00
--New Mexico. Albuquerque, 1947. $22.50
--New York City Guide. N.Y., 1939. $15.00
--New York Panorama. N.Y., (1938). 1st ed. $22.50
--North Carolina. Chapel Hill, (1944). $22.50 (spine sunned)
--The Ocean Highway. N.Y., (1938). 1st ed. $22.50
--Oregon, End of the Trail. Portland, (1940). 1st ed.
 $25.00 (bookplate)
 Portland, (1951). $22.50
--Pennsylvania. N.Y., 1940. 1st ed. $25.00, $20.00
--Philadelphia.... (Phila.), 1937. $50.00 (lacks one map)
--Rhode Island. Bost., 1937. 1st ed. $22.50
--Rochester and Monroe County. Rochester, N.Y., 1937.
 1st ed. $25.00
--San Francisco.... N.Y., 1940. 1st ed. $20.00
--Santa Barbara.... N.Y., 1941. 1st ed. $20.00
--Savannah. Savannah, 1937. 1st ed. $17.50
--South Carolina.... N.Y., (1941). $22.50
--A South Dakota Guide. (Pierre, S.D.), 1938. 1st ed.
 $75.00 (ex-lib.)
 N.Y., (1952). $22.50

--Texas. N.Y., 1945. $25.00
 N.Y., (1954). $22.50
--They Built a City.... (Cinci.), 1938. $16.00
--Vermont. Bost., 1937. 1st ed. $22.50
--Virginia: a Guide to the Old Dominion. N.Y., 1952. $22.50
--Virginia; the Old Dominion in Pictures. N.Y., (1941). 1st
 ed. $10.00
--Washington, a Guide to the Evergreen State. Portland, Or.,
 1941. $22.50
--Washington, City and Capital. Wash., (1937). 1st ed.
 $30.00
--Wisconsin. N.Y., (1941). 1st ed. $22.50
--Wyoming, a Guide to Its History.... N.Y., 1941. $20.00
 (spine edge bumped)
Wrong, George McKinnon--The Canadians.... N.Y., 1942.
 $7.50
--Chronicles of Canada
 See under Title
Wroth, Lawrence Counselman--American Woodcuts and Engrav-
 ings, 1670-1800. Prov., 1946. $15.00 (orig. wraps.)
--The Colonial Printer. Portland, Me., 1938. $125.00 (in-
 scribed, one of 1500 copies, orig. cloth)
--A History of Printing in Colonial Maryland. (Balt.), 1922.
 1st ed. $75.00 (orig. cloth)
Wuorinen, John Henry--The Finns on the Delaware.... N.Y.,
 1938. 1st ed. $20.00
(Wyatt, Sophia Hayes)--The Autobiography of a Landlady....
 Bost., 1854. $25.00 (lightly rubbed, lacks front endleaf)
Wyeth, John Allan--With Sabre and Scalpel. N.Y., 1914.
 $45.00 (new endpapers)
Wyeth, John B.--Oregon. (N.Y., 1966). $7.50
Wykeham, Peter--Santos-Dumont; a Study in Obsession. N.Y.,
 1962. 1st ed. $20.00
Wylie, Elinor--Black Armour. Lond., 1927. $250.00 (cloth,
 signed and inscribed)
--Nets to Catch the Wind. N.Y., 1921. 1st ed. $20.00 (1st
 printing)
--The Venetian Glass Nephew. N.Y., 1925. 1st ed. $7.50
 (backstrip lettering faded)
Wyman, Walker Demarquis--California Emigrant Letters. N.Y.,
 1952. 1st ed. $15.00
--The Frontier in Perspective. Madison, 1957. 1st ed. $35.0
Wynn, Marcia Rittenhouse--Desert Bonanza. Glendale, 1963.
 $45.00

Wynne, James--Memoir of Major Samuel Ringgold, U.S. Army.
Balt., 1847. 1st ed. $375.00 (three-quarter morocco,
bookplate)
Wyoming Historical and Geological Society, Wilkes-Barre, Pa.
--The Massacre of Wyoming
See under Title

- X -

Xarque, Francisco--Ruiz Montoya en Indias (1608-1652). Ma-
drid, 1900. 4 vols. $100.00
Ximenes, Ben Cuellar--Gallant Outcasts. San Antonio, (1963).
$8.00
Ximenez, Francisco--Historia de la Provincia de San Vincente
de Chiapa y Guatemala.... Guatemala, 1929-31. 3 vols.
$175.00 (wraps.)
--Historia Natural del Reino de Guatemala.... (Guatemala),
1967. $50.00 (wraps.)

- Y -

Yanes, Francisco Javier--Relacion Documenta.... Caracas,
1943. 2 vols. $85.00 (buckram, wraps. bound in)
Yard, Robert Sterling--The Book of the National Parks. N.Y.,
1919. 1st ed. $20.00
Yates, John--A Sailor's Sketch of the Sacramento Valley in
1842. (Berkeley), 1971. $15.00 (orig. printed wraps.)
Ybarra, Tomas Russell--Young Man of Caracas. Garden City,
(1941). 1st ed. $7.50
Yeates, Maurice--The North American City. N.Y., (1971).
1st ed. $7.50
Yesteryears and Pioneers. (Harlowton, Mt.), 1972. $45.00
Yoakum, Henderson K.--History of Texas, From ... 1685 to
... 1846. N.Y., 1855. 2 vols. 1st ed. $850.00 (1st
issue, orig. cloth)
York, Herbert Frank--The Advisors. S.F., 1976. $6.95
Young, Agatha, pseud.
See: Young, Agnes Brooks
Young, Agnes Brooks--The Women of the Crises. N.Y.,
(1959). 1st ed. $16.50
Young, Anna G.--Great Lakes' Saga. Owen Sound, Ont.,
1965. $30.00 (signed)

Young, Egerton Ryerson--Algonquin Indian Tales. N.Y.,
(1903). $13.50
--By Canoe and Dog Train Among the Cree and Salteaux In-
dians. Lond., 1890. $45.00 (cloth)
N.Y., 1893. $35.00
Young, Eleanor May--Forgotten Patriot. N.Y., 1950. $15.00
(Young, Francis Crissey)--Across the Plains in '65. Denver,
1905. 1st ed. $125.00 (one of 200 numbered copies)
Young, Harry--Hard Knocks. Portland, Or., 1915. $60.00
(boards, some cover wear)
Young, John Philip--Journalism in California. S.F., (1915).
$25.00
Young, Levi Edgar--The Founding of Utah. N.Y., (1923).
1st ed. $19.50
N.Y., 1924. $17.50
Young, Martha--Plantation Songs for My Lady's Banjo, and
Other Negro Lyrics. N.Y., 1901. $20.00 (partly time-
darkened, lacks frontispiece)
Young, Otis E.--The First Military Escort on the Santa Fe
Trail, 1829. Glendale, 1952. $50.00
Young, Rosamond McPherson--Boss Ket. N.Y., (1961).
$12.50
--Made of Aluminum. N.Y., 1965. $12.50
Young, Samuel--The History of My Life. Pitts., 1890. 1st
ed. $100.00 (orig. cloth)
Young, Samuel Baldwin Marks--In the Department of the In-
terior. Berkeley, 1962. $15.00 (one of 400 copies)
Young, Samuel Grant--Retrospections of a Sheriff, Soldier,
Horseman. S.L.C., 1972. $25.00 (orig. cloth)
Young, Samuel Hall--Hall Young of Alaska. N.Y., (1927).
$15.00
Young, Stanley Paul--The Puma.... Wash., 1946. 1st ed.
$110.00 (cloth)
--Sketches of American Wildlife. Balt., 1946. $12.50
--The Wolves of North America. Wash., 1944. 1st ed. $30.00
(cloth), $27.50 (ex-lib.)
Younger, Edward, ed.--Inside the Confederate Government
See: Kean, Robert Garlic Hill
Youngs, Benjamin Seth--The Testimony of Christ's Second
Appearing. Albany, 1810. $125.00 (contemp. calf, front
cover loose)
Yount, George Calvert--George C. Yount and His Chronicles
of the West. Denver, 1966. $55.00, $50.00 (one of 1250
copies)

- Z -

Zabala, Romulo--Historia de la Piramide de Mayo. Buenos
 Aires, 1962. $15.00 (wraps.)
Zack, Samuel--Arbitration of Labor Disputes. Great Neck,
 N.Y., (1947). $15.00
Zapiola, Jose--Recuerdos de Treinta Anos. Santiago de Chile,
 1974. $10.00 (wraps.)
Zarate Salmeron, Geronimo de--Relaciones.... (Albuquerque,
 1966). $35.00
Zaslow, Morris--Reading the Rocks. Toronto, 1975. $25.00
Zavala, Lorenzo de--Ensayo Historico de las Revoluciones de
 Mexico.... Mexico, 1845. 2 vols. $850.00 (c ntemp. calf)
Zea, Leopoldo--The Latin-American Mind. Norman, (1963).
 $8.00 (ex-lib., many stamps)
Zelaya, Jose Santos--La Revolucion de Nicaragua y los Estados
 Unidos. Madrid, 1910. $125.00 (orig. cloth)
Zenger, John Peter--The Tryal of John Peter Zenger....
 Lond., 1738. $650.00 (new half calf)
Zierold, Norman J.--Little Charley Ross. Bost., (1967). 1st
 ed. $16.00, $10.00
Ziff, Larzer--The Career of John Cotton. Princeton, 1962.
 $12.50
Zimmerman, Arthur Franklin--Francisco de Toledo, Fifth Vi-
 ceroy of Peru.... Caldwell, 1938. 1st ed. $42.50, $8.50
Zimmerman, James Fulton--Impressment of American Seamen.
 N.Y., 1925. $25.00 (orig. wraps.)
Zimmerman Zavala, Augusto--La Historia Secreta del Petroleo.
 (Lima, 1968). $25.00 (orig. printed wraps.)
Zink, Harold--City Bosses in the U.S. (Durham, 1930). 1st
 ed. $17.50 (cloth)
Zochert, Donald--Walking in America. N.Y., 1974. $10.00
Zornow, William Frank--Lincoln & the Party Divided. Norman,
 (1954). 1st ed. $12.50
Zorraquin Becu, Ricardo--Historia del Derecho Argentino.
 Buenos Aires, 1966-69. 2 vols. $20.00 (wraps.)
Zubillaga, Felix--La Florida. Rome, (1941). $15.00 (ex-lib.
 stamps)
Zubof, Roman Ivanovitch--Violet, the American Sappho.
 Bost., 1893. 1st ed. $45.00 (orig. wraps. a bit soiled
 and frayed)
Zucker, Norman L.--George W. Norris. Urbana, 1966. $17.50
Zukor, Adolf--The Public is Never Wrong. N.Y., (1953).
 1st ed. $12.50

Zumarraga, Juan de--The Doctrina Breve in Fac-Simile....
 N.Y., 1928. 1st ed. $125.00
Zumwalt, Elmo R.--On Watch.... N.Y., 1976. $14.00 (ex-
 lib.), $12.50
Zurita, Alonso de--Life and Labor in Ancient Mexico. New
 Brunswick, (1963). $35.00
Zweig, Stefan--Conqueror of the Seas. N.Y., 1938. $15.00
 (cloth, name on endpaper), $7.50, $6.00